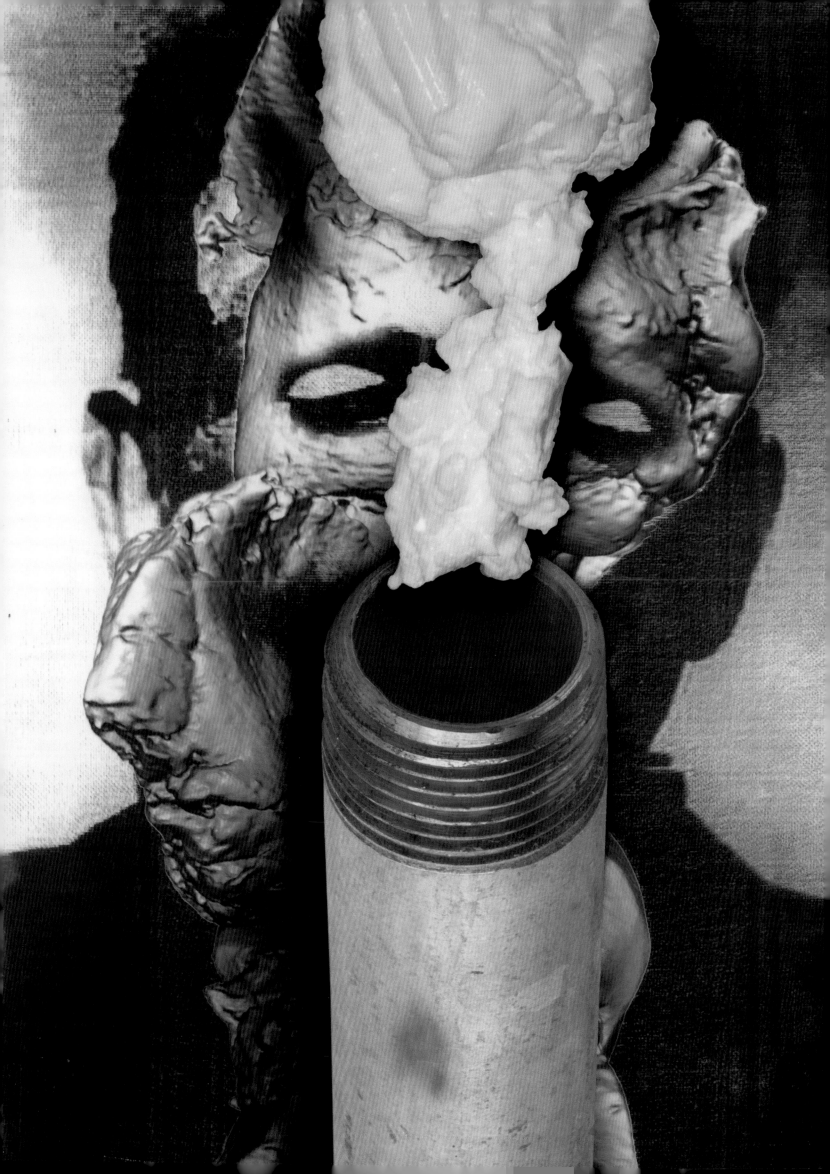

URS FISCHER
SHOVEL IN A HOLE

NEW MUSEUM
NEW YORK
10/28/09 – 1/24/10

TABLE OF CONTENTS

First edition published October 2009 in conjunction with the exhibition "Urs Fischer: Marguerite de Ponty," organized by Massimiliano Gioni, Director of Special Exhibitions, New Museum.

Printed in Switzerland, NZZ-Fretz AG

ISBN 978-3-03764-037-1

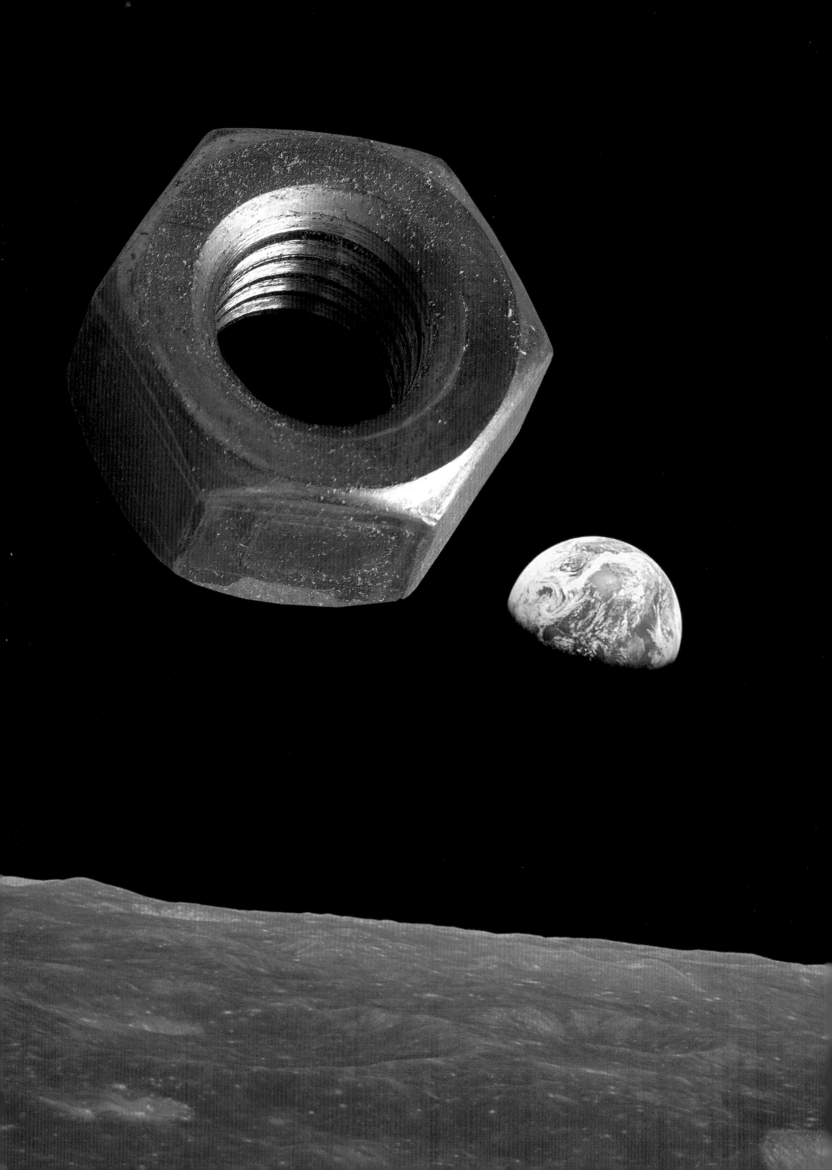

Photo: Lina Bertucci

Lisa Phillips

*T*he New Museum is very pleased to present the first solo museum exhibition of Urs Fischer's work in the United States. Neither a survey nor a retrospective but an "introspective," as curator Massimiliano Gioni calls it, this exhibition is the culmination of four years of work and is choreographed entirely by the artist, offering visitors an immersion into his world. Filling all three of the New Museum gallery floors, the exhibition includes massive new aluminum sculptures, casts of objects that seem to be melting in space, and a new series of photo-silkscreened mirrored pieces, among other works that reveal the range of materials and the many working methods that Fischer employs.

Fischer is perhaps best known for his memorable installations: a chalet made out of bread, an excavated gallery floor, and a replicated exhibition with many simulated details. He has worked in a wide array of mediums including sculpture, painting, drawings, photographs, prints, and books. With a style that is based on constant shifts and changes, Fischer has often been an artist difficult to grasp. At the New Museum, we feel his work captures the spirit of our times with his distinctive combination of brute force, archetypal images, charged materiality, and unstable forms that disturb normal perception and alter the relationship between viewer and object.

This accompanying catalogue is a parallel project—an ambitious compilation of images of nearly every sculpture that Fischer has completed to date. Verging on the encyclopedic in scope, it is an excellent complement to the more selective focus of the exhibition. The book would not have been realized without the partnership of JRP|Ringier, to whom we owe our most sincere thanks, and especially Michael Ringier, a member of our Leadership Council, who has been a most generous collaborator.

On behalf of the Museum, I would like to extend our deepest gratitude to the individual funders who helped to make this exhibition possible: the Brant Foundation; the Burger Collection, Hong Kong; the Steven A. and Alexandra M. Cohen Foundation, Inc.; Jeffrey Deitch; Dakis Joannou; Amalia Dayan and Adam Lindemann; Eugenio López; the LUMA Foundation; the Peter Morton Foundation; François Pinault; the Ringier Collection; Tony Salame; and the Teiger Foundation. Their help has been critical to the success of this presentation. Additional support has also been provided by the National Endowment for the Arts and Pro Helvetia, Swiss Arts Council.

Massimiliano Gioni, Director of Special Exhibitions, first proposed this project when he joined the Museum three years ago and I am grateful for his vision and passion in making it a reality. Finally, I would like to thank Urs Fischer for his unbridled invention, which is immediately discernable in both the pages of this book and throughout the exhibition.

Lisa Phillips
Toby Devan Lewis Director

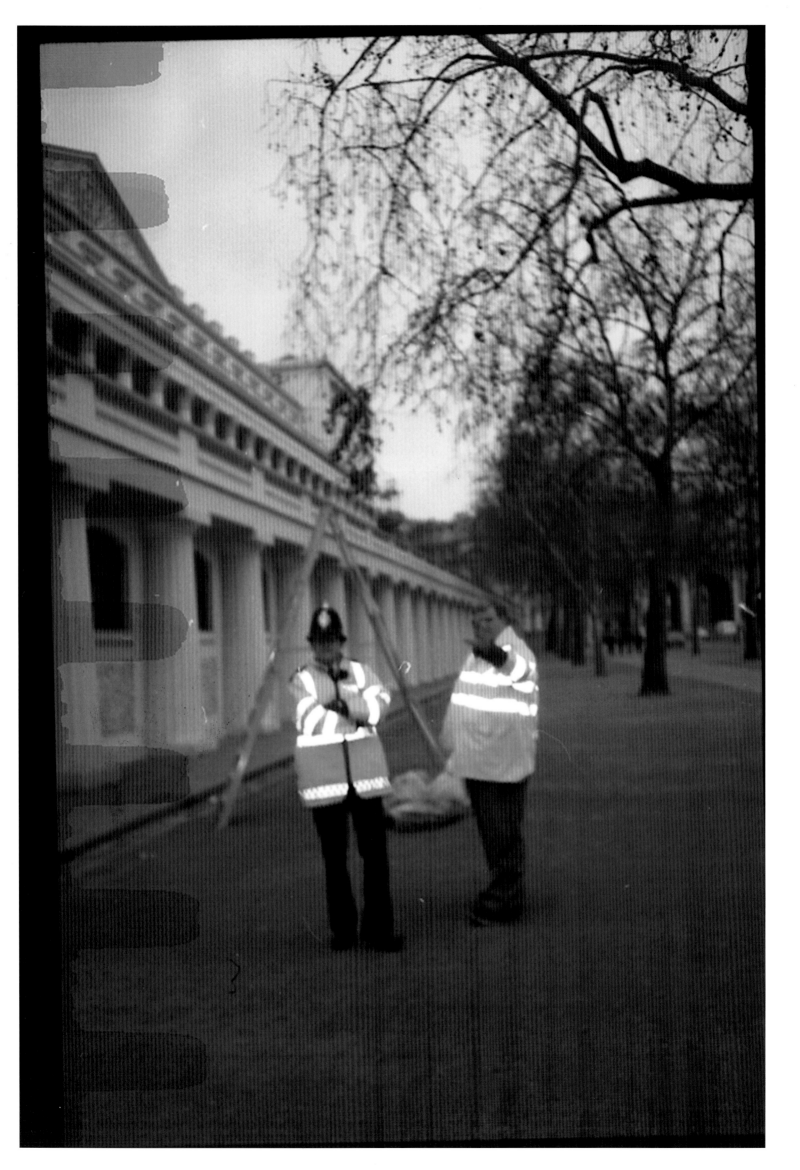

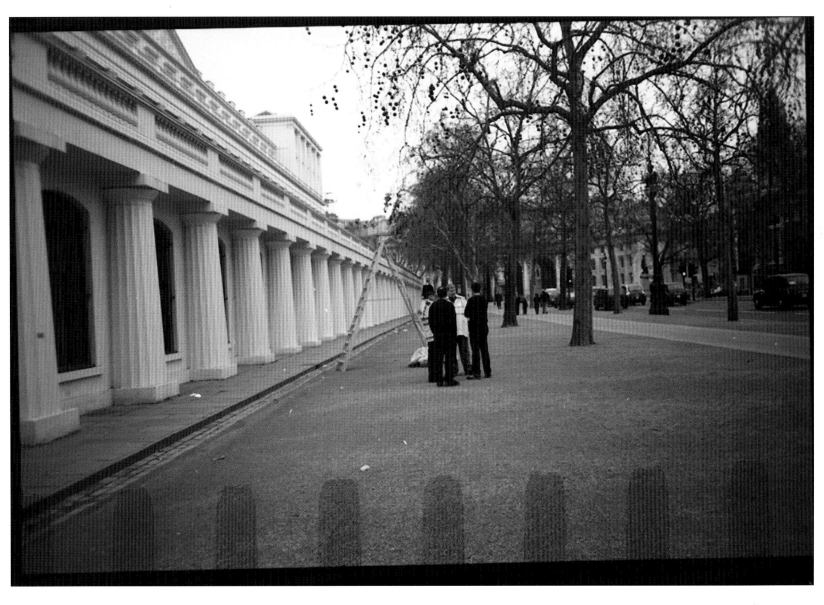

Failed installation of green leaves on winter tree outside exhibition window,
"Without a Fist—Like a Bird," Institute of Contemporary Arts, London,
January 2000

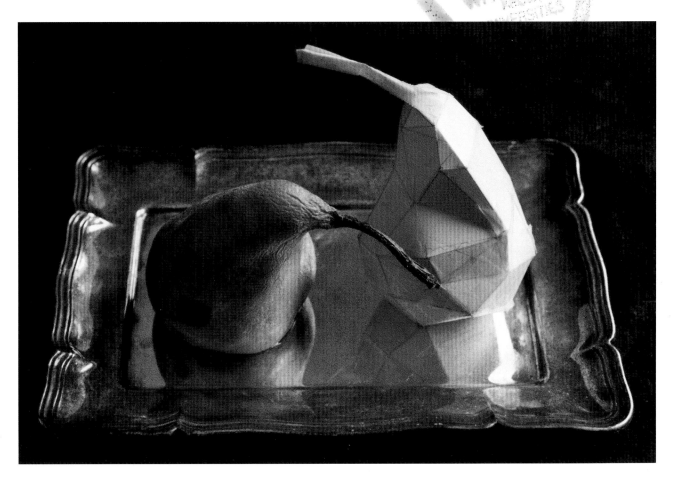

Paper sculpture photographed
with silver tray and pear, 1997

So Long Good Smell
2000
Wood, clay, ink, silicone, glass, raw egg, carved egg
(polystyrene, filler, acrylic paint), wire, wood glue
Dimensions variable

Untitled (Eierschale)
2000
MDF, clay, acrylic paint, wood glue, oil paint,
marker, eggs, hairspray, matte varnish
19 x 38 x 29 cm; 7 ½ x 15 x 11 ⅜ in.

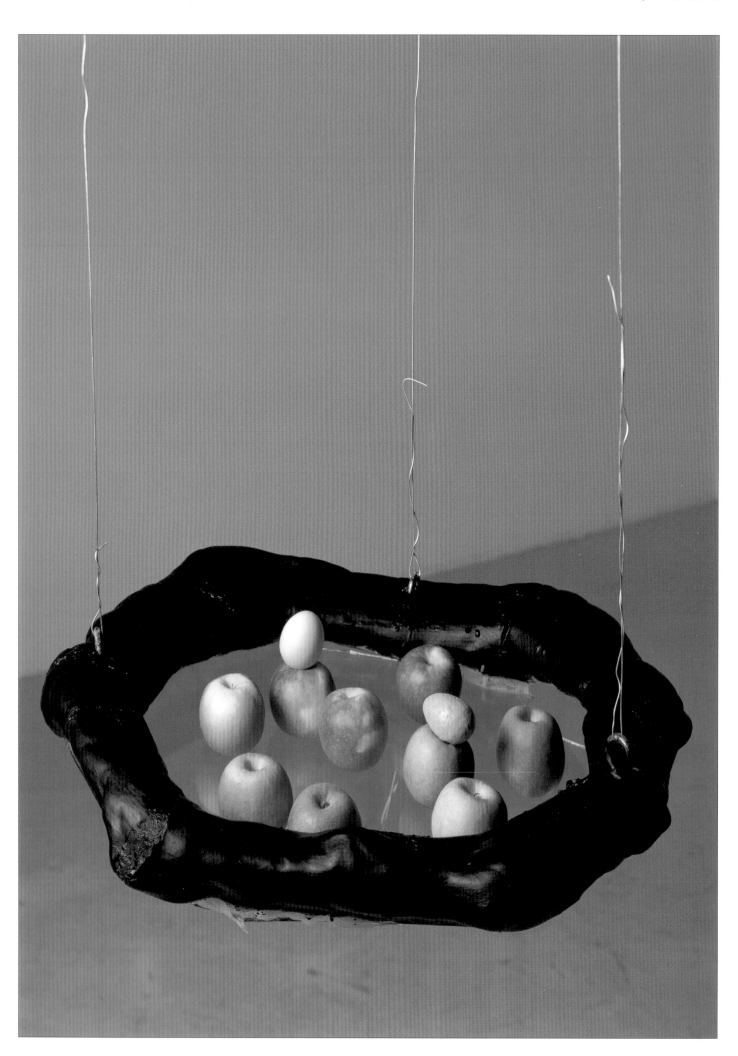

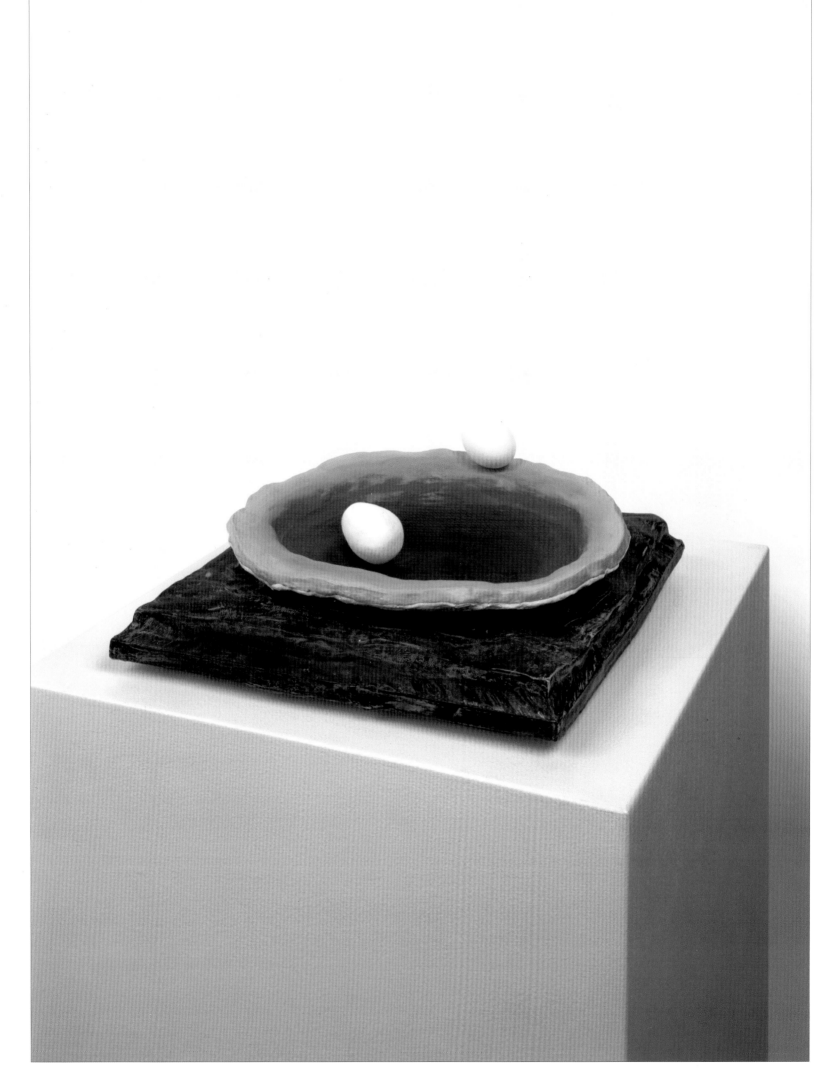

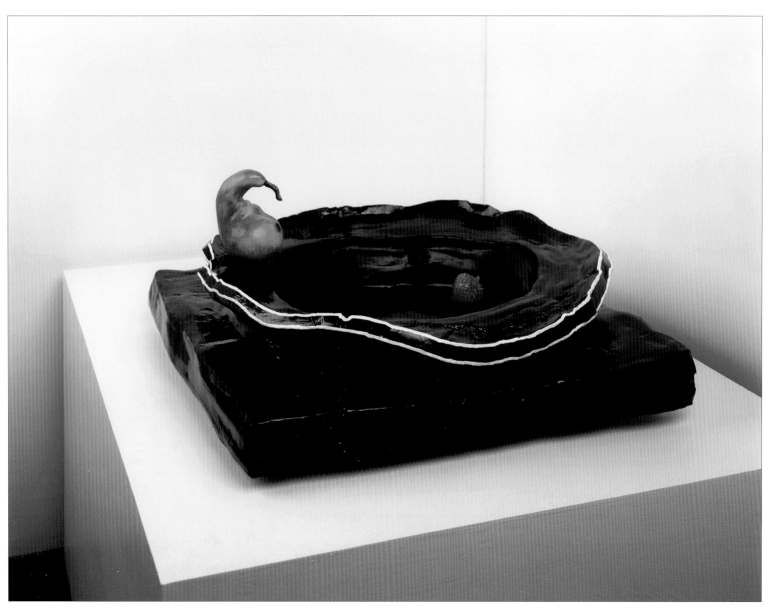

Good Luck / Bad Luck Bowl
2002
Clay, wood, acrylic paint, wire, cast polyurethane pear,
real strawberry, screws, wood glue
19 x 38 x 29 cm; 7 ½ x 15 x 11 ⅜ in.

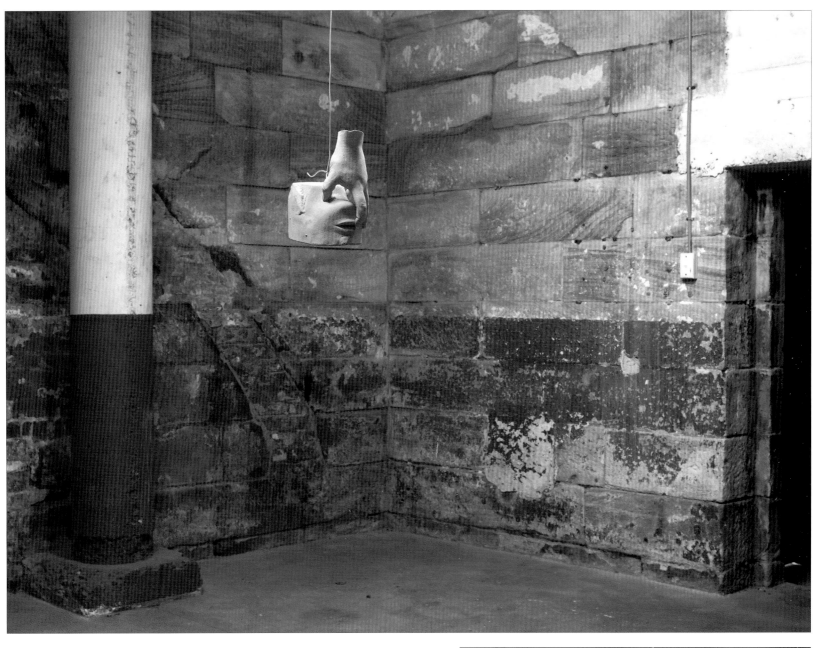

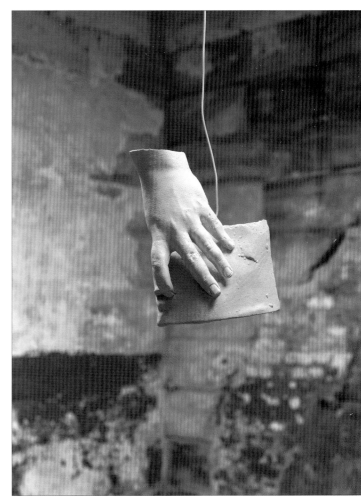

Old Pain
2007
Plaster, pigment, screw, polyurethane glue, wire
26 x 25 x 15 cm; 10 ¼ x 9 ⅞ x 6 in.
Installation view, Cockatoo Island, Kaldor Art Projects
and the Sydney Harbour Federation Trust, Sydney, 2007

SPACES GENERATED BY VISION
OR BASEMENTS SAVE WINDOWS
BY BICE CURIGER

Meltdown

Urs Fischer is an artist who comes to grips with things in a radical manner. If artists are equipped with the ability to make us experience the world in new ways and see it differently, then Fischer achieves this by digging into reality with particularly large claws.

■ The newspapers talked of a "grid meltdown" when a power failure plunged New York into darkness in 2003. The incident certainly disrupted the lives of those affected, but for people schooled in the language of modernist art, the combination of the words "grid" and "meltdown" conjures a different kind of disruption, shifting it onto a plane more abstract than that occupied by the electricity grid serving an urban environment like Manhattan.

■ The grid is a cornerstone of modernism.[1] As such, over past decades it has figured with increasingly monotonous regularity as the subject of countless art-school papers and seminars up and down the country. The grid paradigmatically embodies the claims to autonomy advanced by art in the twentieth century, and is also an omnipresent emblem of modern life, penetrating its very fabric and playing an integral part in our pleasure and pain. The abstract, modernist grid has melded with the concrete grid, so that by now we are aware that grids underlie how our world functions, from the standardized sizes of bedsheets to the electrical circuitry of computers.

■ With cool precision Urs Fischer has arranged an agglomeration of urban features in the New Museum. He invites us to take a stroll in surroundings that are in the grip of an uncanny meltdown. Fischer is not one of those artists who oppose the grid—and there have always been plenty of them— and he is certainly not one of the majority who ignore it. His work cannot be encompassed by the usual Surrealist or Expressionist labels; it is not defiantly unenlightened, backward looking, or desperately naive. Avoiding obscurantist mystification, Fischer operates with a series of crystal-clear indicators. These reveal a quite specific artistic intelligence, signaling meanings with a light, mischievously matter-of-fact touch. Fischer uses them to penetrate to the depths of the terrifying realm of civilization

fallout, cutting through its musty odor in the best comic-strip tradition with the exact, virtuosic gestures of a master swordsman. As we proceed, we watch him dangle a twisted modernist grid from the point of his sword like some trashy spiderweb, while we look up through the burnt beams to a sky studded with fleecy clouds. And we begin to wonder whether the structures apparently supporting us are virtual, rather than real.

■ When we enter this or any other exhibition by Fischer, the sense of enlightened amusement and whimsical cheerfulness makes us feel that clouds of smoke have just parted to reveal a sky painted by some latter-day Tiepolo—post-apocalyptic, neo-existentialist, or perhaps pre-catastrophic.

Mirror City

In most of his recent works Fischer develops themes touched on in some of his very early pieces involving mirrors. In 1999, at age twenty-six, he produced the extensive sculpture *Dr. Katzelberg (Zivilisationsruine)* (1999), which contained a landscape of a large number of mirrored cubes placed at right angles to one another and a few small pieces of mirror configured to represent cats. This arrangement of voluminous forms of varying height privileged uncertainty and vagueness, cleverly promoting a notion of sculpture as somehow fleeing. The cat, one of Fischer's preferred motifs, can be understood as a symbol of independence and elegance, of the lurking forces of superstition, and of dark, nocturnal powers. When presented as a victim, it can also stand for childish cruelty, as in the artist's *Walking Heads/ Thinking Feet* (2002), in which an arm protruding from the wall holds up a cat by its tail. In *Skyline* (2002), Fischer uses the means of sculpture to give a witty, sexual twist to the unexpected formal correspondences between a stylized high-heeled shoe and a stylized cat.

■ These works show Fischer giving shape to his artistic aims with a beguiling casualness: He integrates animal creatures and abstract motives, the organic and the inorganic, the Other and the mundane, conjuring a universe in which everything appears intangible, in an all-distorting hall of mirrors. And also add to this the physical danger evoked by pieces of broken glass illuminated with a spotlight that causes them to flash like crystal and cast the shadow of a cat with arched back onto the wall.

■ In 2004 Fischer staged a wide-ranging, highly subtle distortion of space at Zurich's Kunsthaus. The visitor's gaze first encountered a sculpture that resembled a labyrinth, before being plunged a moment later into a 230-foot-long space. Several large holes appeared in the exhibition walls, one behind the other, and it was not immediately apparent whether or not they resulted from an optical illusion produced by mirrors.

■ Fischer is clearly interested in virtuality, less in computer-generated "virtual reality" than in the archaic symbolic force of the mirror image as pretense and deception, as the source of an illusory space extending into infinity. The mirror image has possessed ambivalent connotations since time immemorial. It has appeared in the context of mythology (Narcissus), fairy tales (Snow White), superstition (the broken mirror), the history of art (Baroque cabinets of mirrors), and literature (the motif of the doppelgänger), as well as in modern psychology (Lacan's "mirror stage") and the magical world of fun fairs and freak shows. (Come and see the woman with no legs!) The mirror symbolizes both vanity and self-knowledge, deception and truth.

■ The cityscape with mirrored boxes that Fischer has constructed for the New Museum forms a sort of crazy labyrinth through which the visitor

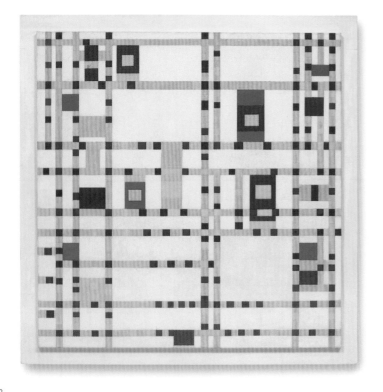

Piet Mondrian, *Broadway Boogie Woogie*, 1942–43. Oil on canvas, 127 x 127 cm; 50 x 50 in. The Museum of Modern Art, New York. © 2009 Mondrian / Holtzman Trust c/o HCR International, Virginia. Digital image © The Museum of Modern Art / Licensed by SCALA / Art Resource, New York.

Photo: Willy Spiller

Bice Curiger

form of a special mise-en-scène that zooms in to exclude everything incidental, all the physical trappings of a city. The facades, the walls, the cars, other people, and even oneself are either nonexistent or will sooner or later dissolve and vanish into thin air.

■ Mirrors are classic instruments of deception, excluding things and confusing the viewer. This function in Fischer's installation contrasts with the clear-cut construction and arrangement of the boxes. So, while the artist's city grid evokes Manhattan (with the diagonal formed by Broadway easily identifiable), his work transforms the kind of rationalism embodied in Mondrian's *Broadway Boogie Woogie* (1942–43) into some thrift-shop version of a hallucinatory, late-capitalist hall of mirrors. Our own image plays a part in this ghostly world of reflections. A trancelike feeling goes hand in hand with a sense of being watched—a clear indication that perception has become disassociated from physical being. Reality slips away from us while imposing itself. This form of self-alienation, this state of being, might perhaps be termed the pathology of contemporary normality.

■ The images we walk past in Fischer's exhibition do not move like film sequences. All the movement emanates from the viewers. When we enter this cemetery with tombstones of shiny chrome steel, everything is stationary, hovering, and light; we ourselves, our motions, and our actions unleash the cascading series of uncontrollable visual experiences, both animated and animating.

■ As we walk through this work, our gaze opens up fresh areas of infinite, intangible reality. Our every footstep turns over a new page, generating a different constellation in the representation of reality. None of us can keep pace and maintain a clear, analytical stance, registering what has happened to us, where we stand, and what exactly we see. Our own image multiplies into a plurality of independent mirror images and mingles with masklike objects apparently consisting of nothing but a husk floating in space or a layer of oil lying on water or ice. "What you see is what you see," said Frank Stella in 1964. But in Fischer's installation the unmitigated factuality of Minimalist art seems to have drifted off into a bottomless pit of hallucination. *Räume, die im Sehen entstehen* (Spaces generated by vision), the title of a book on Baroque architect Balthasar Neumann (1687–1753), would be a more appropriate description than Stella's dictum.[2] Baroque artists and architects sought to involve the viewer visually and physically in the apparently limitless spaces of their work. Similarly, Fischer's installation for the New Museum invites visitors to embark on a mental journey in space, the act of viewing creating new, imaginary spaces for them to plunge into.

Working Through Art

On my desk lies an invitation to "Mapping the Museum Experience: The Psychological and Geographical Mapping of Museums," a research project being carried out this year by an art college in cooperation with a museum,[3] in which visitors to the museum are given an arm strap containing various measuring devices. The undertaking typifies the exceptionally self-reflective character of the current art world. In his work Fischer apparently aims to satisfy this need for self-reflection while letting it implode on itself. The self-reflection he addresses is both personal, engaging with perception and its contexts and conditions, as outlined above, and thematic, embracing references to art and its history.

■ Fischer incorporates finely orchestrated allusions to other artists and art

enters an intangible reality. In that sense it forms part of the tradition represented by cabinets of mirrors. But viewers are also subjected to another kind of experience, which adds to their confusion. Photographs of objects are printed onto the mirrors with a hyperrealistic precision; created by combining six or seven hundred photographs of objects on a computer, then printing the results on surfaces of polished chrome steel, they confound the viewer through exaggerated clarity. Hovering in midair, as it were, they challenge us, gently but firmly, to engage with the realm of everyday things. They depict items from the world of consumer goods that bear traces of use and seem to have acquired a life of their own, expanding on a surreally huge scale. It is as if Fischer wished to eliminate every element of uncertainty before embedding the images made in this way in a situation that brings together people, objects, and space in a dizzy, bottomless, uncontrollable interaction, which is magical and uplifting in its immateriality, but also disturbing.

> There are no limits to Fischer's perceptions and psychological penetration of our contemporary soul.

■ The hugely enlarged objects appear to have been captured in a grid, transposed onto a two-dimensional plane, and then pressed into blocks. This cubing of the sphere, so to speak, recalls the broom that Fischer set up in 2007 at the London gallery Sadie Coles HQ, as a kind of art trap, causing the informed visitor immediately to think of an early work by Michelangelo Pistoletto, but ultimately revealing itself to have been transferred from two dimensions to three. Sharply focused photographs of the broom had been taken from six sides and attached to the six faces of the mirrored object, which the artist then propped up against the wall like an actual broom.

■ In Fischer's installation, as in real life, we encounter quotidian items from the world. Consumer goods accompany us everywhere when we walk along the street. Yet their presence here is slightly more insistent, as though the viewer perceived them while in the grip of a fever. These wares, unlike those promoted by advertising, have no lifestyle appeal: They are of questionable taste and they are not new or fresh. The fruit, for example, has started to rot. The scale and significance of the objects are fraught with ambiguity. And there is an aura of willful indiscretion, like that exuded by the young, half-naked bodies that appear on gigantic billboards in the streets of our cities, spreading over six-story facades, twisting, turning, and leaping at the tiny passersby in acts of unsolicited harassment. To pass through Fischer's work is to reenact this kind of urban experience in the

FOOTNOTES

▲ 1 It is no accident that Rosalind Krauss made grids the subject of the first section of "Modernist Myths," a chapter in her *The Originality of the Avant-Garde and Other Modernist Myths* (Cambridge, Massachusetts: MIT Press, 1985), 8–23.

▲ 2 Erich Franz, *Räume, die im Sehen entstehen: Ein Führer zu sämtlichen Bauten Balthasar Neumanns* (Stuttgart: Edition Tertium, 1998).

▲ 3 "The museum-going experience will be analyzed from a psycho-geographical perspective, encompassing the emotional, cognitive, and physical effects upon viewer reception, and how those factors influence the implicit decision-making processes of visitors." From the website for "eMotion: Mapping Museum Experience," a 2009 exhibition at the Kunstmuseum St. Gallen produced by the University of Applied Sciences Northwestern Switzerland, Academy of Art & Design.

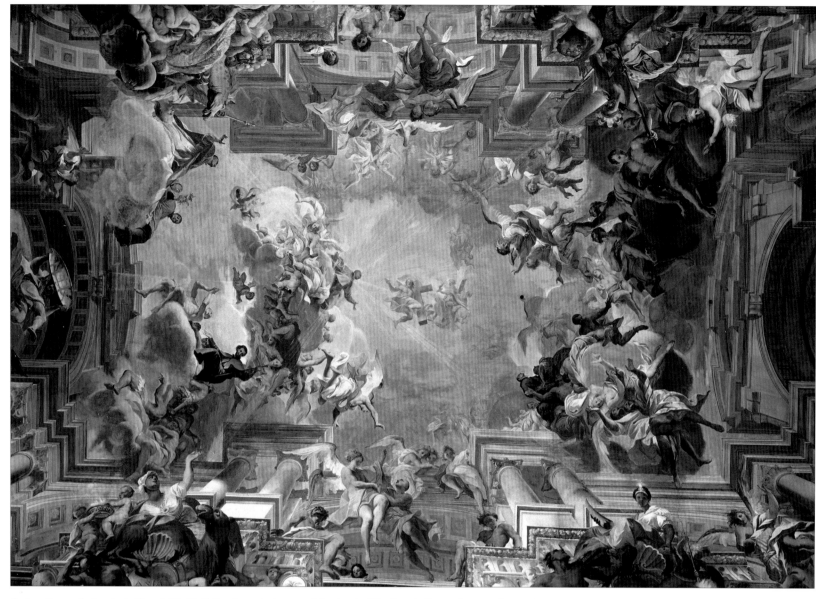

Andrea Pozzo, *St. Ignatius in Glory*, 1691–94. Ceiling fresco in the nave of the church of San Ignazio, Rome. Courtesy Alinari / Art Resource, New York.

into his works. Indeed, at times his works almost seem to overflow with such references, as though the artist wished to test the Pavlovian responses of his audience. The references are shadowy conjurings rather than visual quotations or appropriations—a kind of momentary trompe l'oeil. Fischer has ranged widely in this regard. He has evoked Bruce Nauman in such sculptural elements as heads, hands, and a multitude of feet (for example, in *September Song*, 2002) and has combined them with references to the loneliness of life in the studio. At the same time, he operates at a deeper level. For instance, his richly allusive studio environments—one of which was included in his exhibition at the Kunsthaus in Zurich—have offered visitors a view inside disparate situations that depict the anxiety and boredom of the creative process: *Sodbrennen* (Heartburn) (2000), for example, is a large mirrored cube containing a mixture of coffee, orange juice, and cigarettes, a particularly unhealthy diet that immediately evokes endless days spent in the studio, smoking, thinking, and worrying about the next show. In all these interventions Fischer clearly seeks to blur the distinctions between the symbolic and the real. Recently, as in his 2008 show "Who's Afraid of Jasper Johns?" at Tony Shafrazi Gallery, he has taken to papering gallery walls with reproductions of exhibition installation views, before hanging works on them.[4]

■ The walls of art spaces have attracted Fischer in other ways. An intervention in his exhibition "Mary Poppins," held at the Blaffer Gallery in Houston in 2006, showed him responding in an extreme fashion and with sardonic humor to the white-cube discourse of recent years. The whitewash on the walls frayed at the lower edges, revealing the layer of black paint beneath. Applied boldly in broad strokes, the white dripped down the walls. In domestic surroundings this would customarily be seen as evidence of sloppy, unfinished workmanship, but in the context of an art gallery it could not fail to evoke the expressionist gestures of Robert Motherwell or Franz Kline. Fischer repeated this procedure the following year at the Museum Boijmans Van Beuningen in Rotterdam, where post-1945 pictures from the museum's collection were hung on walls painted in this symbolically ambivalent way.

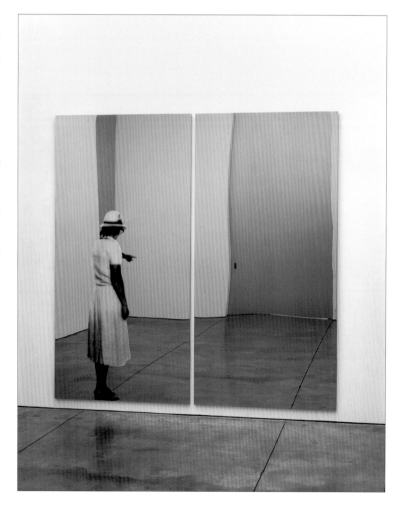

■ Fischer probes the limits of the art space with relish and wit, arriving at complex results as he teases a variety of hidden potential from the white cube. Having turned its walls into membranes engaged in an unsettling osmotic process between inside and out, he has naturally also addressed its floors. As we have seen, holes figure regularly in Fischer's artistic repertoire. In 2007 he showed a hole at Sadie Coles HQ in London that could be viewed from below, as though illustrating the saying "*die Radieschen* [or "*den Rasen*"] *von unten anschauen*"—"looking at radishes [or "grass"] from below," a German equivalent of "pushing up the daisies" as a way of stating that someone is dead and buried. On the lower floor of the building visitors could examine what appeared to be a giant metal sack—the negative form of the hole reaching down into the space below, cast in aluminum. It is tempting to view this as a new kind of sculptural experience, but applying traditional categories to Fischer's work is always tricky. What is it—a sculpture, an installation, a *gesamtkunstwerk*? Such terms are far too narrow and conventional to encompass a practice that revolves around space as such and operates with the abrupt effect of images.

■ Time and again Fischer employs a kind of cheerful science to play serious pranks on art and its history. Take the huge, shaky lines that crisscross the space in his installation at Regen Projects in 2007. They resemble temperature curves or three-dimensional drawings, but also evoke a sort of spatial craquelure or hairline cracks. Moreover, they resurrect with an infinitely light touch the notion of *disegno* sacred to Renaissance art, that noble, all-encompassing, ordering power. In Fischer's work the act of drawing appears as a grotesque, masklike presence that has been set free in space. In the center of the floor stands a worn-out office chair that appears to be on the point of "pulling itself together" and regenerating itself. For the artist, this bizarre object, resembling some bodily organ, plays the part of the figures in landscape paintings with whom the viewer is intended to identify.[5] As an animated ersatz person, the chair thus metamorphoses into a figure like that in Caspar David Friedrich's *Monk by the Sea*.

Radicality: The Reevaluation of Values

Modernism has always opposed illusionism, the notion that an image is a window onto the world. Fischer, with his basic aim of digging deep, acts in accordance with his maxim "Basements Save Windows."[6] He inserts gaps like rests into our life and into art. In doing so, he opens up "spaces generated by vision," as cited above, embracing everything that constitutes them, everything that they represent, and all the symbolic baggage from or with which they have been liberated, burdened, or reinvested.

■ In 2007 Fischer had a huge hole dug for his exhibition at the Gavin Brown Gallery in New York. Titled *You*, it appeared like an irreverent anti-art gesture in the context of decadent, pre-crisis New York. However, its symbolic power was so compelling that the critic Jerry Saltz was moved to write of a "Herculean project ... brimming with meaning and mojo."[7] On the one hand, he declared, *You* evoked the groundlessness of existence, naked fear, and many a phobia, but, on the other, it also made heavenly ecstasy a reality, as an "inversion machine" that "pulsates with erotic energy."[8]

■ This vibrant mixture of the symbolic and the real characterizes Fischer's oeuvre as a whole. The fracturing and digging generates a wide range of associations and projections, as does the Baroque-style experience of space when the viewer gazes upward after descending. But the artist's work is also notable for the raw immediacy with which it engages with physical reality (an important part in *You*, for example, was played by the structural engineer who oversaw the digging, which could easily have caused the building to collapse). In turn, Fischer's shows of strength vis-à-vis reality clearly possess a symbolic dimension, directed against the orthodoxies and conventions of the present age and art world. He prefers going his own, resolute way rather than aping tried-and-tested artistic strategies. In pursuing that individual path, he transports viewers into what seems like a word-free zone: Fischer's art is anti-academic not because it refuses to engage with theory or with a complex understanding of art history—it is individual and personal because it operates on a richly intricate visual level, liberating his work from any excess of explanation and linguistic interpretation. It has the street credibility of a raw, punk gesture combined with the carefully controlled movement of a magician.

■ Fischer's artistic practice is broad-based, far-reaching, sharply focused, raw, clever, and disarming. He applies a scalpel to the tissues of the exhibition

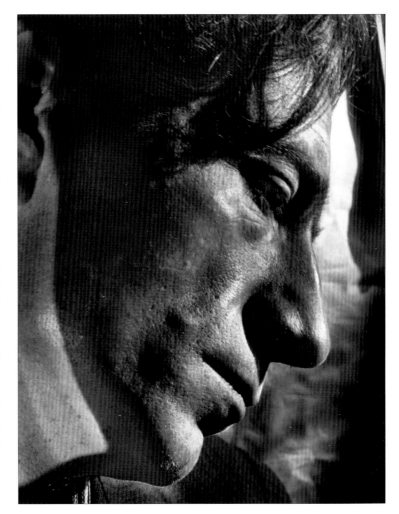

Helmar Lerski, *Deutscher Arbeiter*, 1928–31. Gelatin silver print, 29 x 23 cm; 11 ⅜ x 9 in. © Estate Helmar Lerski, Museum Folkwang, Essen. Image courtesy George Eastman House.

world and indulges his love of anatomy, both real and symbolic. His early drawings already show him dissecting bodies, revealing skeletons, brains, intestines, and genitals, as well as showing fingers cut off and reattached incorrectly. The drawings also engage with penetration as one of the basic facts of human and animal existence, confronting us with the intense physical presence of a thumb stuck into a lemon or a penis entering one ear and coming out the other. This is Bruce Nauman as a pubescent toilet scribbler. Is it realist symbolism or symbolic realism? Then, in *100 Years* (2006),

F O O T N O T E S

▲ 4 For "Who's Afraid of Jasper Johns?" mounted at the Tony Shafrazi Gallery in New York, Fischer produced a complete photographic record of the gallery's previous exhibition and had it reproduced as wallpaper. In this way, a huge reproduction of a Keith Haring came to form the background of a painting by Malcolm Morley, a work by Donald Baechler was set off against one by Francis Picabia, and, most jarring of all, a Francis Bacon was hung against a Kenny Scharf, which in turn had been partly painted over by Lily van der Stokker.

▲ 5 Urs Fischer, in conversation with the author, March 2009.

▲ 6 Urs Fischer, in *Kir Royal*, exh. cat., Kunsthaus Zürich, 2004: 180.

▲ 7 Jerry Saltz, "Can You Dig It? At Gavin Brown, Urs Fischer takes a jackhammer to Chelsea itself." *New York*. December 3, 2007: 90–92.

▲ 8 In his inspired critique Saltz (ibid.) cites Correggio and Tiepolo, David and Ingres, in connection with *You*. He also mentions that such an undertaking had cost the gallerist $250,000. It has since emerged that the hole belonged to an edition of three, at least one of which has been sold.

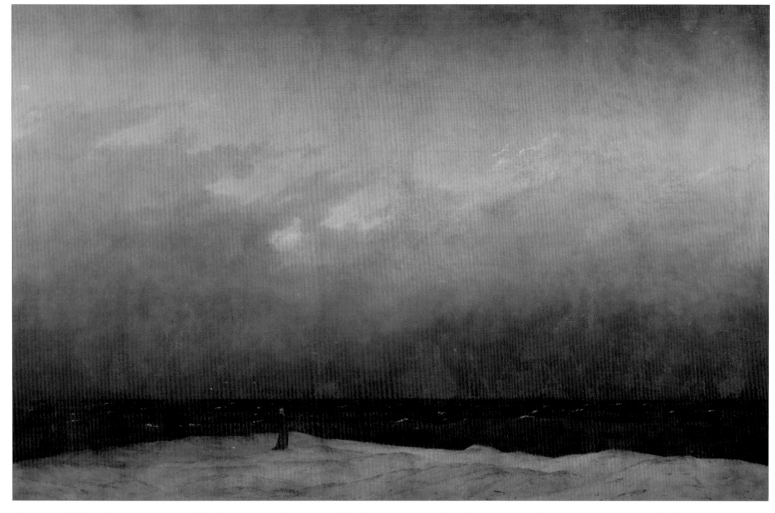

Caspar David Friedrich, *Monk by the Sea*, 1809. Oil on canvas, 110 x 172 cm; 43 ¼ x 67 ¾ in. Courtesy Bildarchiv Preussischer Kulturbesitz / Art Resource, New York and Nationalgalerie, Staatliche Museen zu Berlin. Photo: Joerg P. Anders.

there is a small, nondescript, hyper-realistic egg penetrated by a pencil and attached to the wall. This object may appear crudely explicit, but it is also amazingly delicate, compellingly poetic, and remarkably simple in its symbolic effect.

■ There are no limits to Fischer's perceptions and psychological penetration of our contemporary soul. His delight in acquiring knowledge via the senses can only be described as Baroque, focusing on reality throughout the 360 degrees of its compass. Large numbers of *vanitas* symbols, candles really burning, and vegetables actually rotting combine with horror and trash symbolism inspired by heavy metal and references to the work of Martin Kippenberger to address the widespread cultural phenomenon of pleasure in angst, the secret delight in terror. With his typical sense of humor Fischer takes to heart the sentiments expressed in the title of a 1991 Kippenberger catalogue, *Durch die Pubertät zum Erfolg* (Through Puberty to Success), but, unlike the German artist, Fischer never provokes merely for the sake of provoking. In the morass of adolescent taste Fischer discovers possibilities for expanding art's frame of reference, recognizing a rich and vital vein of imaginative potential. The imagination is the agent of Fischer's realism and symbolism.

■ The aluminum sculptures that the artist is showing at the New Museum are greatly enlarged versions of forms modeled in clay. These huge works, bulging irregularly and imposing almost to the point of intimidation, recall de Kooning's late bronzes, which consist of vastly enlarged casts of hand-sized forms. Fischer would seem to be engaging in a kind of negative dialectics, releasing a core of latent potential from de Kooning's sculptures that wrests them from the numbing grip of sculptural history. A publication

on Fischer's modeled sculptures shows him collaging pages with the help of Photoshop so as to bring out the horrific aspect of such amorphous forms when they appear in fantastical guise on the street and elsewhere in daily life. The book also emphasizes how different these works are from the kind of grand public art produced by Henry Moore, Jean Dubuffet, and some contemporary artists. Its illustrations make it clear that Fischer's sculptures "represent" movement in space in its own right, swelling and subsiding, expanding and contracting. They are intruders in the world. The volume contains no text, but the name of the photographer Helmar Lerski (1871–1956) appears enigmatically on the back cover. Lerski opposed the *Neue Sachlichkeit* of August Sander and others by taking pictures of faces modeled by light, reopening photography to the realm of fantasy and the symbolist imagination of the day.

■ In his book *Aesthetic Theory*, philosopher Theodor Adorno stated: "Modern art is as abstract as the real relations among men. Such notions as realism and symbolism have been completely invalidated. Since the magical grip that external reality has on the subjects and their modes of behaviour has become absolute, the work of art can oppose that sway only by assimilating itself to it."[9] Fischer set about reevaluating values and has escaped from the "grip" described by Adorno. His work reinstates the realistic and the symbolic with compelling force—and at the cutting edge of current developments. Perhaps the cat cited above has helped to generate the notion of a new autonomous urban subject, overcoming Adorno's pessimistic vision of the controlled subject.

F O O T N O T E S

▲ 9 T.W. Adorno, *Aesthetic Theory*, trans. C. Lenhardt, ed. Gretel Adorno and Rolf Tiedemann (London, Boston, Melbourne, and Henley: Routledge & Kegan Paul, 1984), 45–46.

Untitled
1993
Blue paint applied to wall to neutralize
orange glow from streetlight
Latex paint, pigments, existing streetlight
Dimensions variable

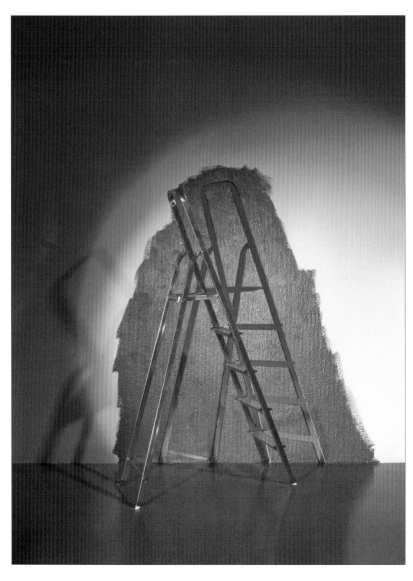
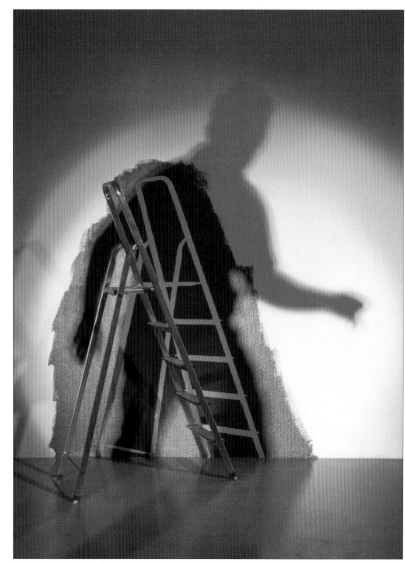

Leiter (Ladder)
1997
Aluminum ladder, latex paint, theater spotlights
Dimensions variable
Installation view, "Hammer," Galerie Walcheturm,
Zurich, 1997

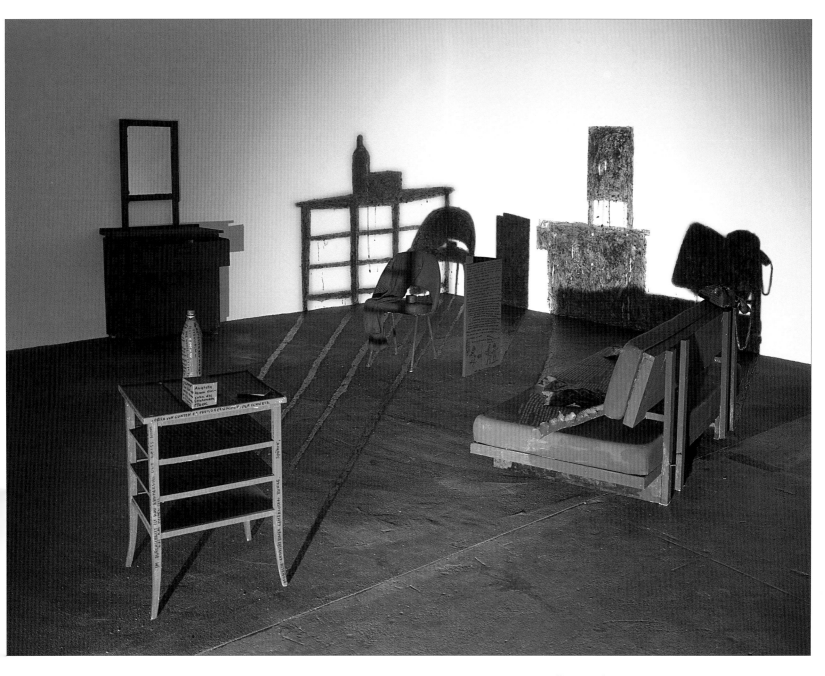

Boffer Bix Kabinett
1998
Found furniture, fabric, foam, mirror, latex paint, marker,
paper, branch, bottle, telephone, jam, screws, spotlight
Dimensions variable
Installation view, "ironisch / ironic: maurizio cattelan,
urs fischer, alicia framis, steve mcqueen, aernout
mik / marjoleine boonstra," Migros Museum für
Gegenwartskunst, Zurich, 1998

Untitled
1996
Found stool, found bottle, hammer, strawberry jam
Dimensions variable
Studio view, Wildbachstrasse, Zurich

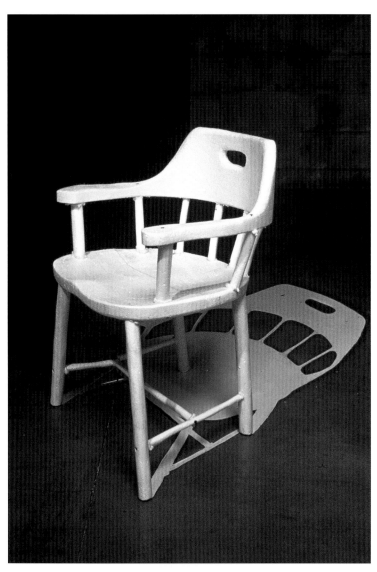

Studio view, Delfina, London, 2000

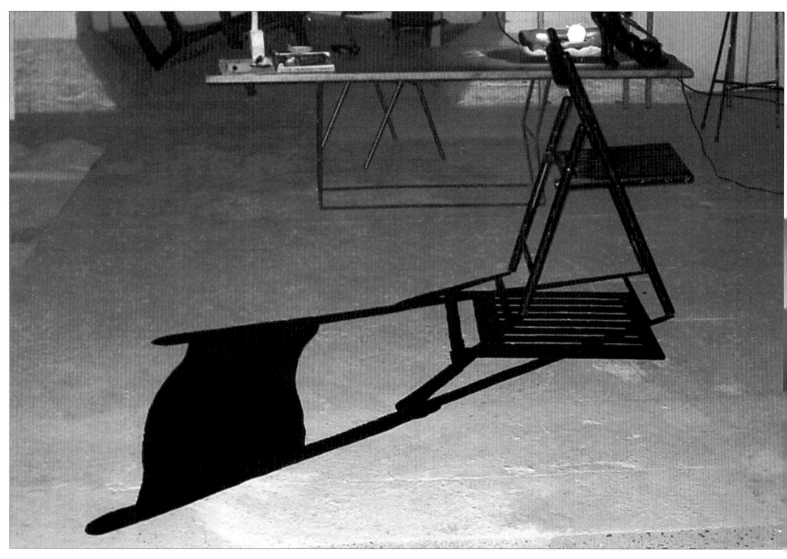

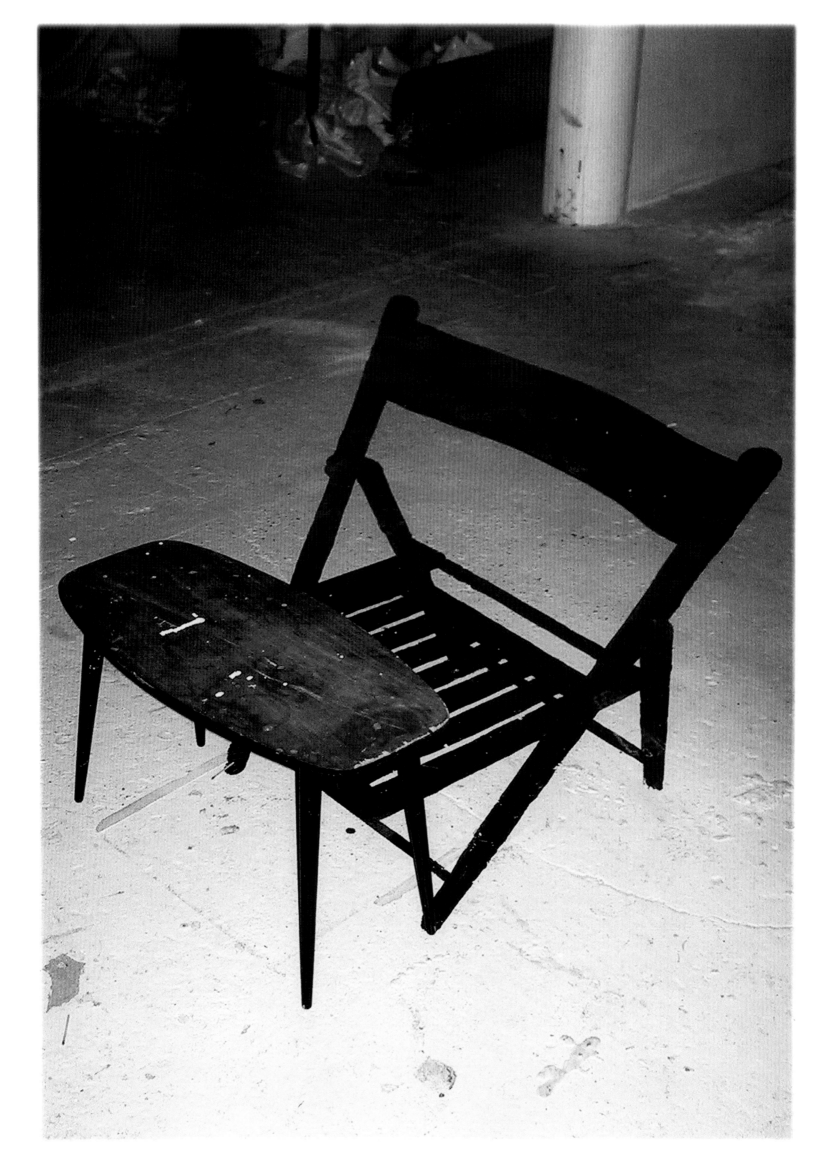

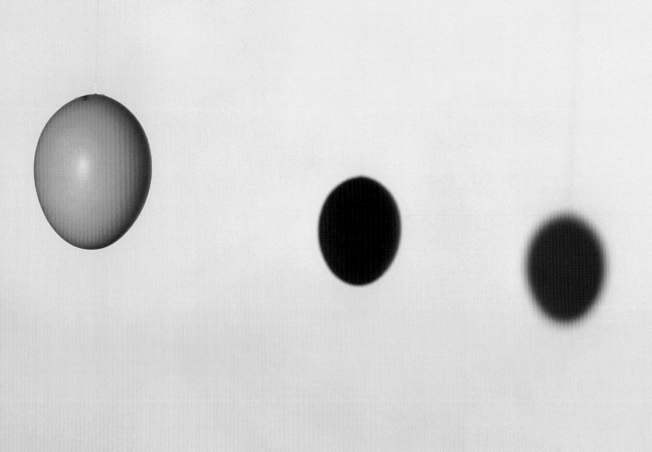

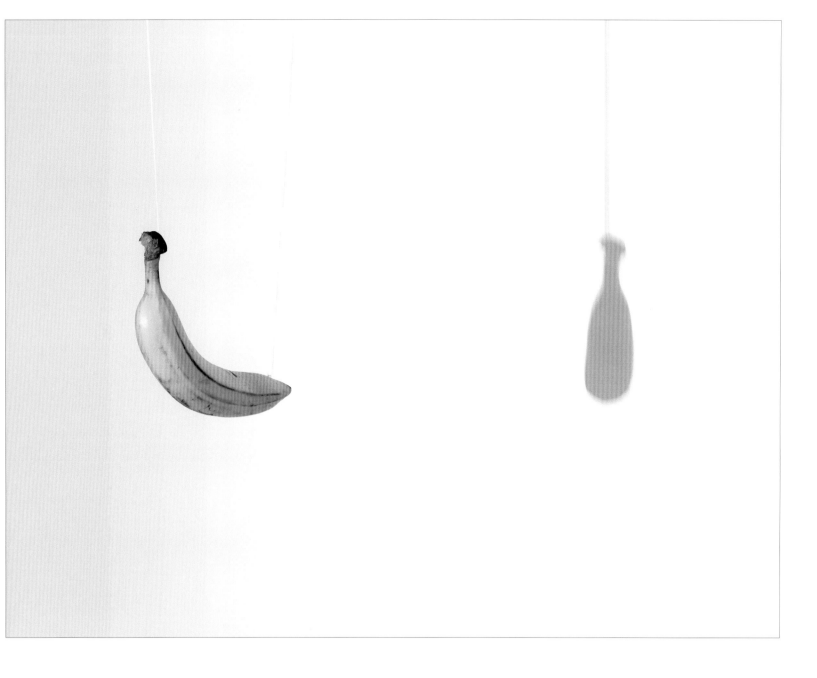

Untitled
2003
Nylon filament, banana, theater spotlight
Dimensions variable

Installation view, "Kunstpreis der Böttcherstrasse," Kunsthalle Bremen, Germany, 2003
Untitled, 2003

Opposite page:

Gänseeier Eclipse
2002
Two goose or chicken eggs, nylon filament, glue, theater spotlight
Dimensions variable

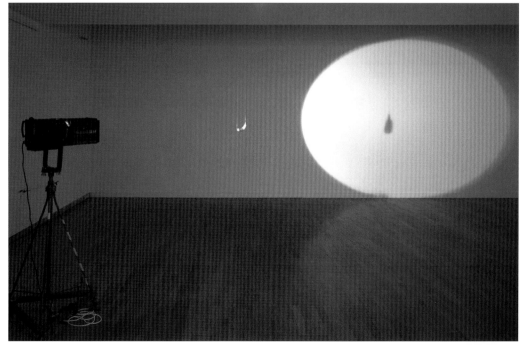

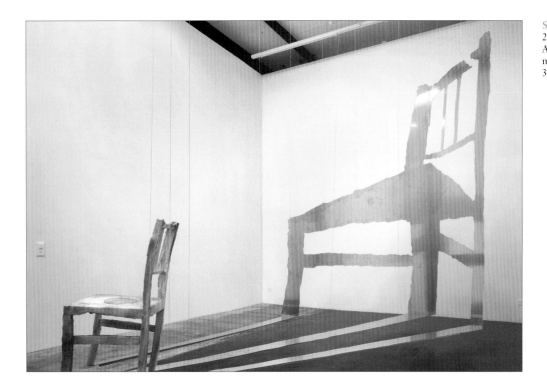

Some Say Kumquat, Others Say Vacuum
2003
Aluminum, polyurethane resin, nylon filament, metal mountings, aircraft cable, acrylic paint, rivets
310 x 200 x 380 cm; 122 x 78 ¼ x 149 ⅝ in.

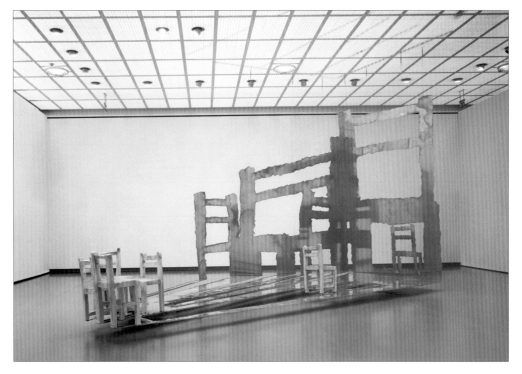

Memories of a Blank Mind
2004
Aluminum, two-component polyurethane foam, wood, aircraft cable, acrylic paint, marker, steel, screws
400 x 600 x 600 cm; 157 ½ x 236 ¼ x 236 ¼ in.
Installation view, "Kir Royal," Kunsthaus Zürich, 2004

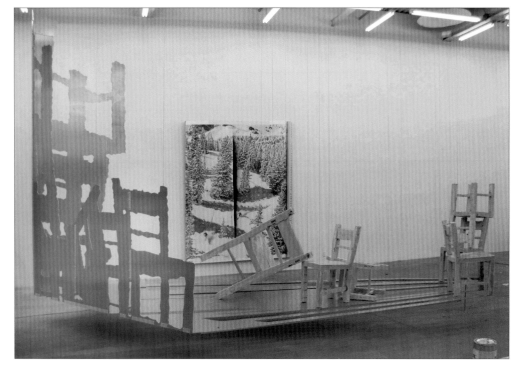

In-progress reconstruction of *Memories of a Blank Mind*
Studio view, Van Brunt Street, Brooklyn

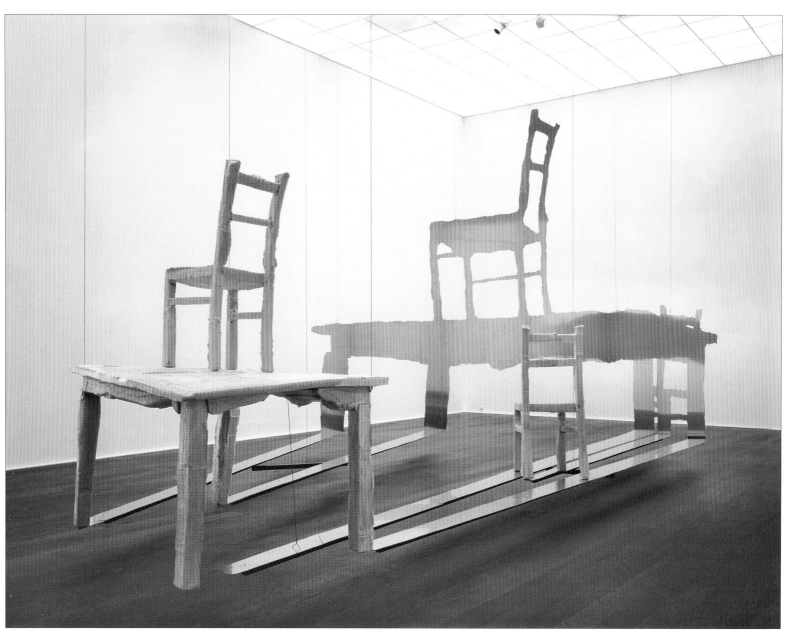

Portrait of a Moment
2003
Aluminum, two-component polyurethane foam, aircraft
cable, steel tubing, acrylic paint, metal fittings
370 x 720 x 380 cm; 145 ⅝ x 283 ½ x 149 ⅝ in.

Youyou
2004–
Work in progress

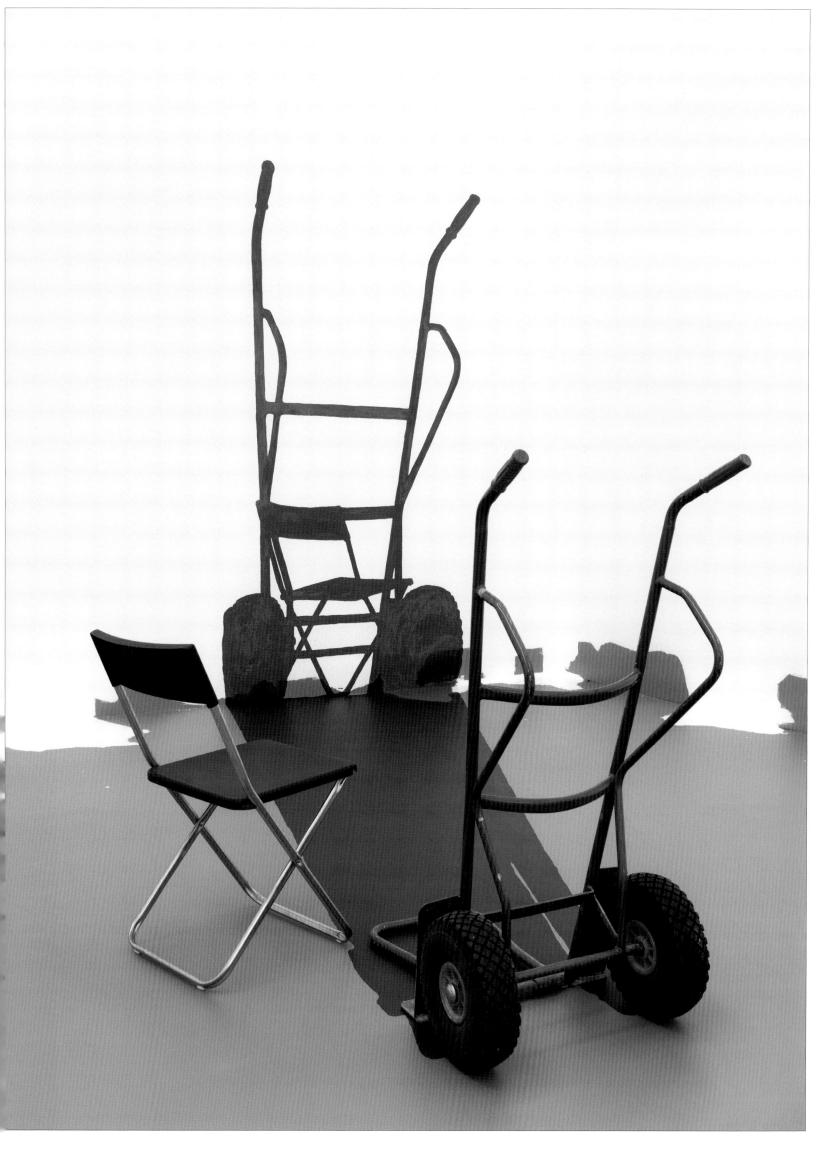

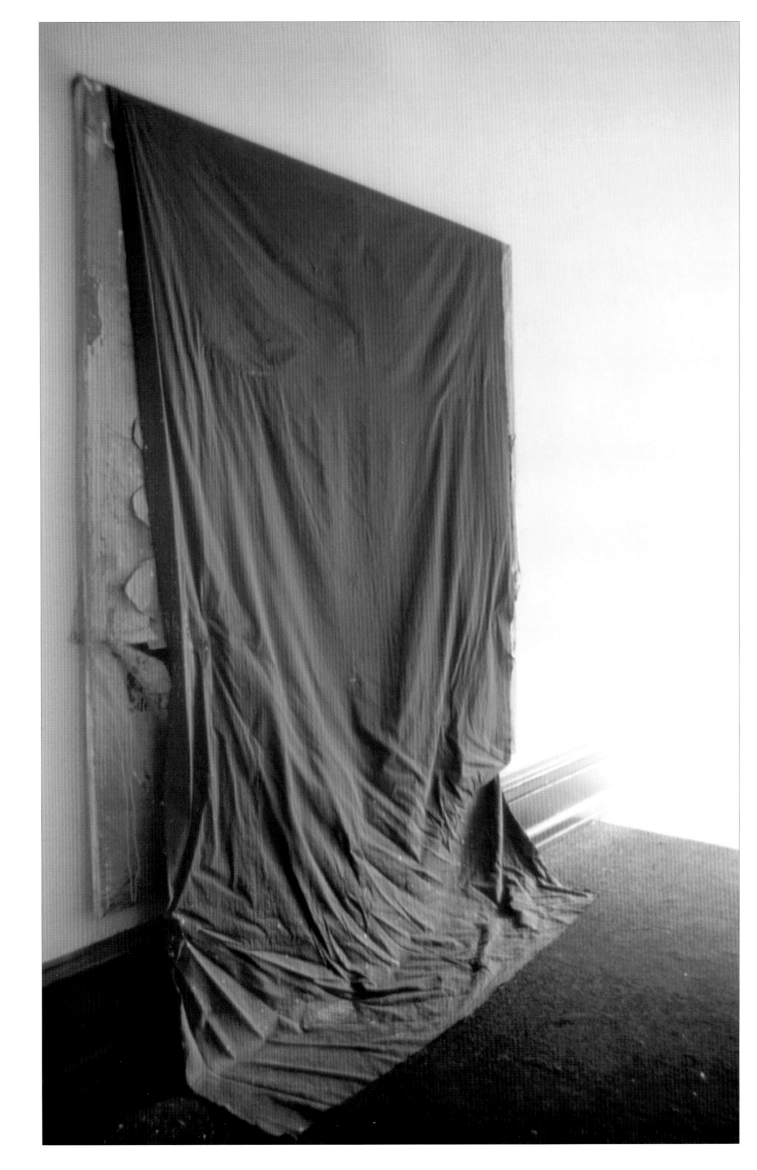

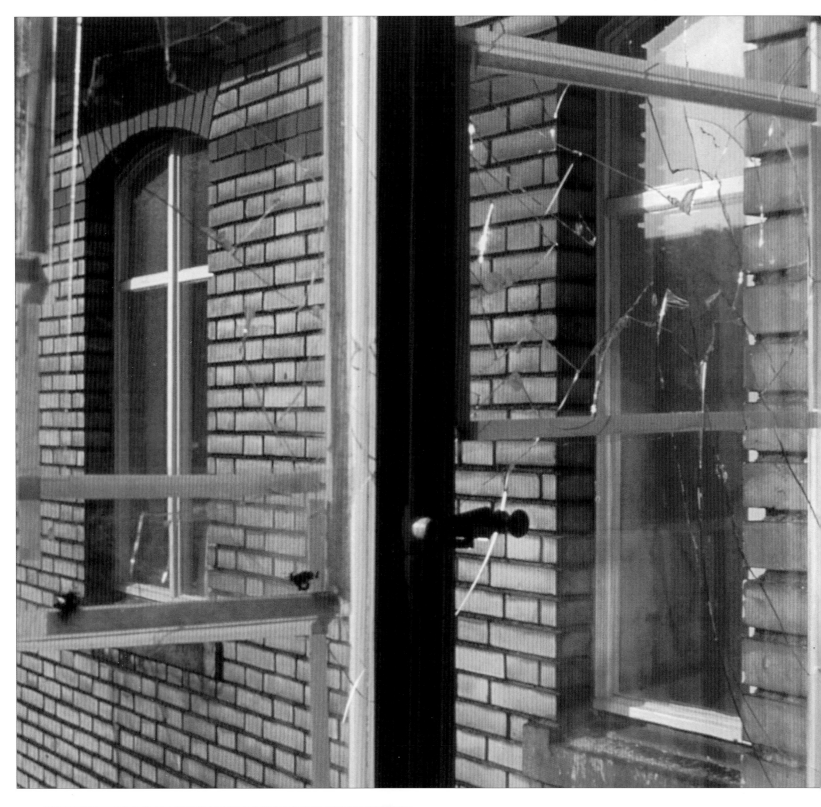

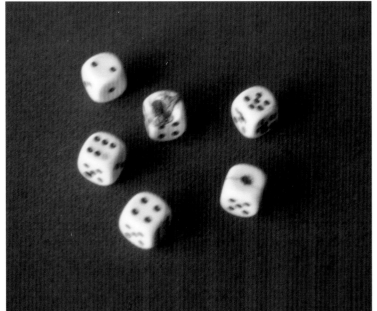

Repaired broken window after window-smashing with
Cyril Kuhn and Akira
Installation view, "Assistent," Stiftung Binz39,
Zurich, 1995

Opposite page:

Window-smashing with Cyril Kuhn and Akira
Installation view, "Assistent," Stiftung Binz39,
Zurich, 1995

Page 29:

Verhängnis
(with Maurus Gmür)
1995
Wood, plastic film, latex paint, acrylic paint, sawdust, fabric
Dimensions unknown

Last Dice Throw Up
1994
Dice, acrylic paint, lead
Dimensions variable

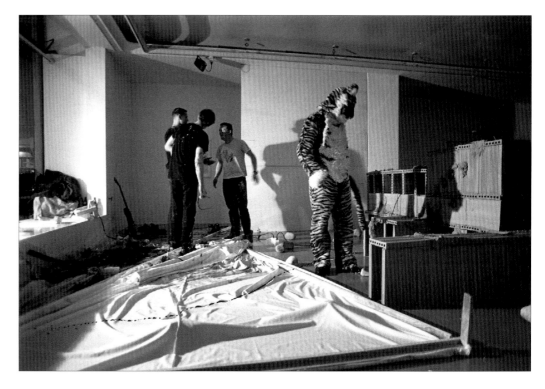

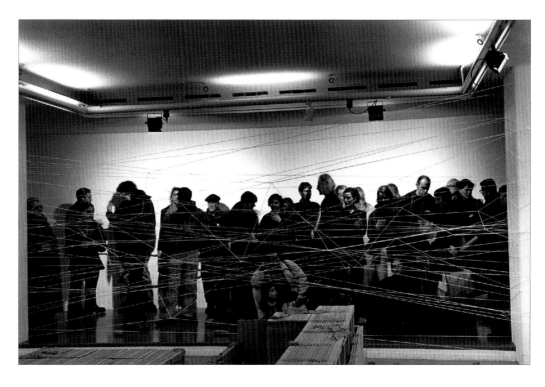

Performance on the occasion of the opening of the
exhibition "Frs Uischer"
Galerie Walcheturm, Zurich, 1996
Co-performers: Kerim Seiler, Cyril Kuhn, and
Maurus Gmür

Spaghetti and Rilke
1999
Wood, unfired clay, wax, makeup, powder,
acrylic paint, car paint
180 x 200 x 100 cm; 70 ⅞ x 78 ¼ x 39 ⅛ in.
Work left outside of group show

Installation view, "Hammer,"
Galerie Walcheturm, Zurich, 1997
Foreground: *Last Chair Standing*, 1997
Background: *Untitled (Wand der Angst)*, 1997

Opposite page:

Last Chair Standing
1997
Wood, clay, silicone, latex paint, string, wire,
caulk, wood glue
64.5 x 79 x 64.5 cm; 25 ⅜ x 31 ⅛ x 25 ⅜ in.
Installation view, "Hammer," Galerie
Walcheturm, Zurich, 1997

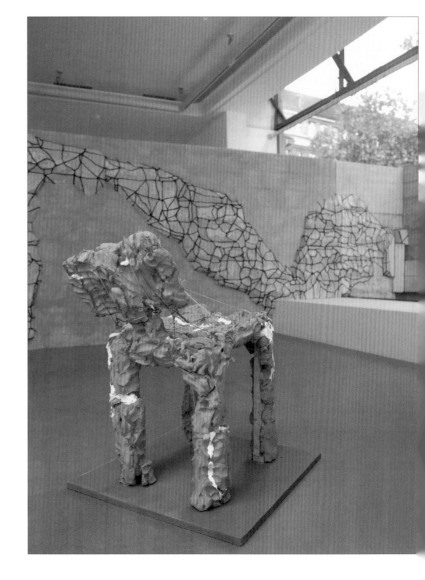

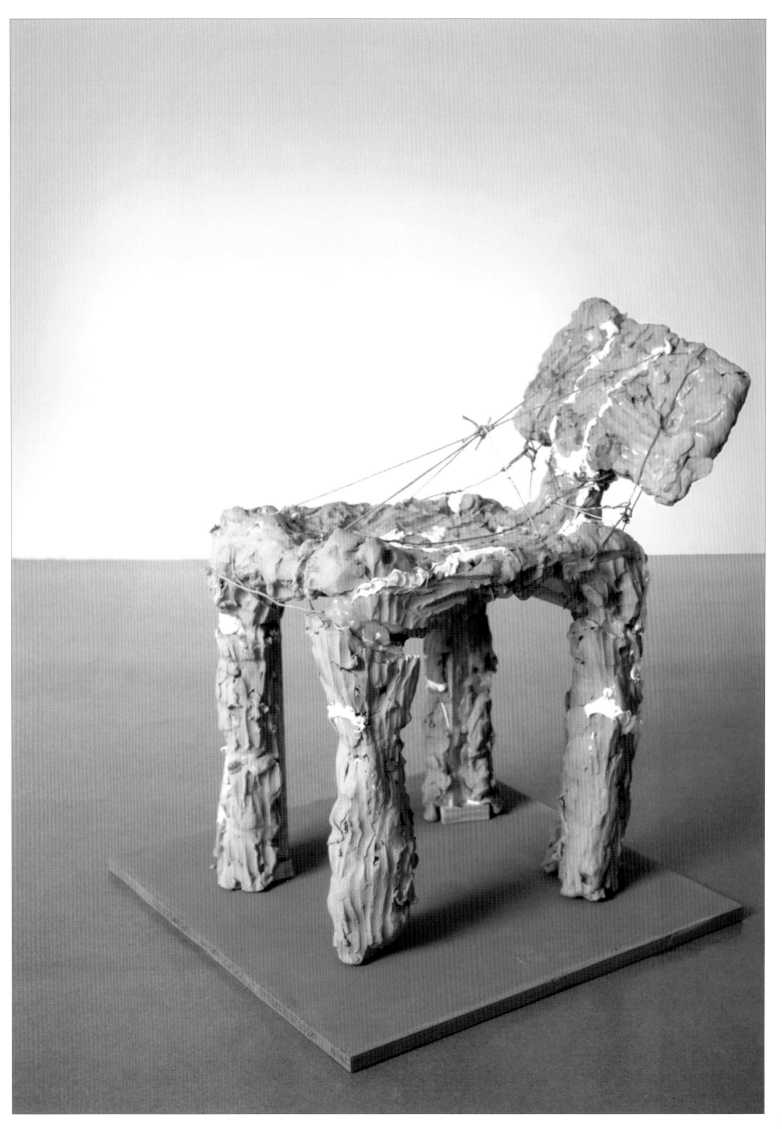

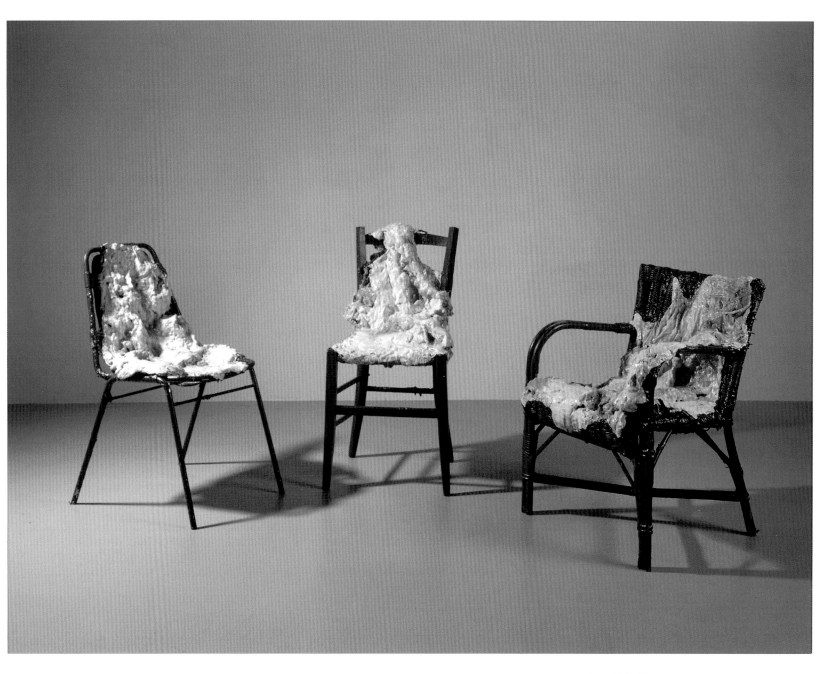

Late Night Show
1997
Found chairs, newspaper, plaster, latex paint,
pigments, glue
Chair 1: 81 x 55 x 65 cm; 31 ⅞ x 21 ⅝ x 25 ⅝ in.
Chair 2: 86 x 45 x 50 cm; 33 ⅞ x 17 ¼ x 19 ¼ in.
Chair 3: 77 x 55 x 65 cm; 30 ¼ x 21 ⅝ x 25 ⅝ in.

Beyond a Step Backwards
1997–2001
Sawdust, polyester resin, plywood, pigments, polyurethane
foam, latex paint, acrylic paint, oil paint, marker, screws
150 x 65 x 50 cm; 59 x 25 ⅝ x 19 ⅝ in.

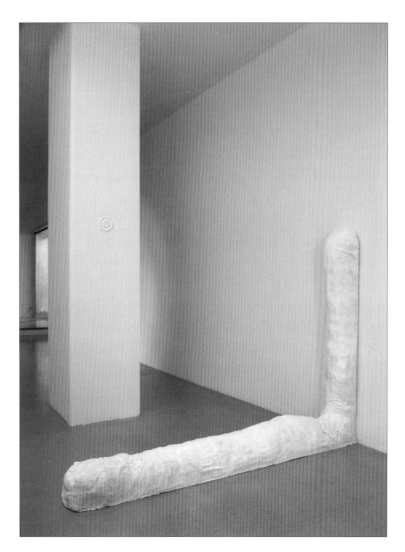

Eckwurst
1997
Wood, plaster, chicken wire, latex paint, acrylic
paint, newspaper, screws
181 x 76 x 67 cm; 71 ¼ x 29 ⅞ x 26 ⅜ in.

Kantenwurst
1997
Wood, plaster, chicken wire, latex paint, acrylic
paint, newspaper, screws
63 x 23 x 182 cm; 24 ¼ x 9 x 71 ⅝ in.

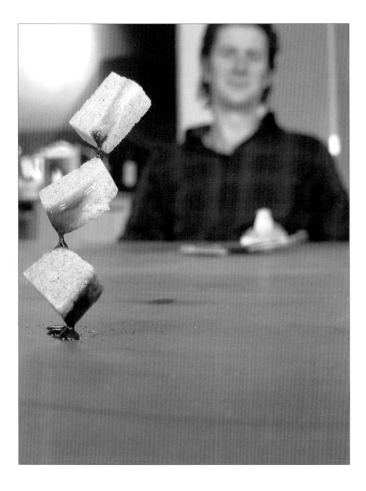

Olé!
2003
Sugar cubes
Dimensions variable

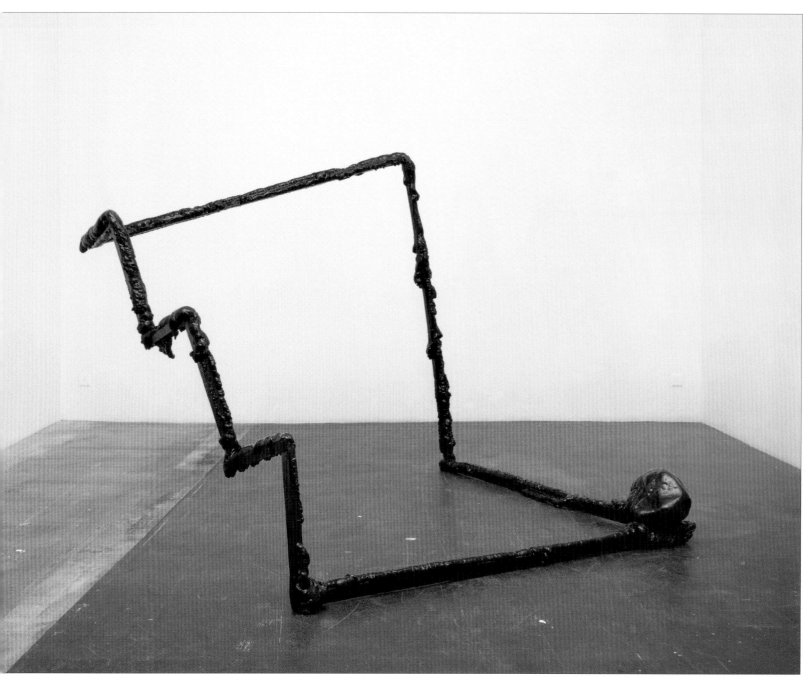

Krise
from *6 ½ Domestic Pairs Project*
2000–2005
Cast aluminum, enamel paint
171 x 190 x 220 cm; 67 ⅜ x 74 ¼ x 86 ⅝ in.

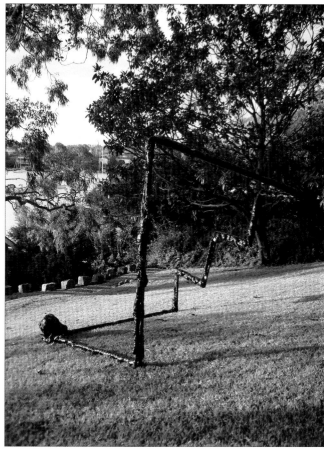

Installation view, *Krise* from *6 ½ Domestic Pairs Project*,
John Kaldor Collection, Sydney, 2005

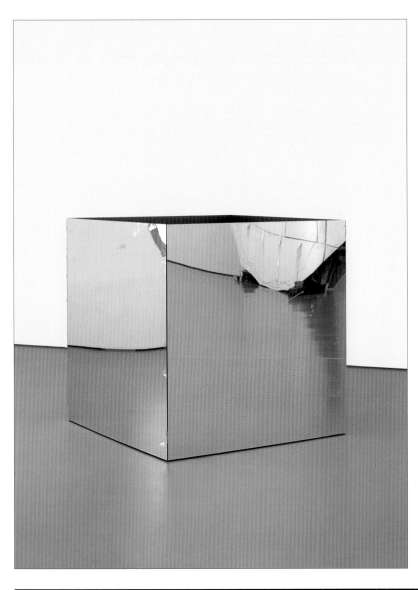

Detail of *Sodbrennen*, 2000–2004

Sodbrennen
2000–2004
Mirrors, aluminum, steel frame, silicone,
orange juice, coffee, cigarettes
155 x 155 x 155 cm; 61 x 61 x 61 in.

A Sigh Is the Sound of My Life
2000–2001
Overlaid by silicone skin, core rotates on a
horizontal axis at a speed of one revolution
every four minutes
Polystyrene, polyurethane foam, wood,
steel axle, electric motor, silicone, gauze,
hairs, wood glue
200 x 200 x 280 cm; 78 ¼ x 78 ¼ x 110 ¼ in.

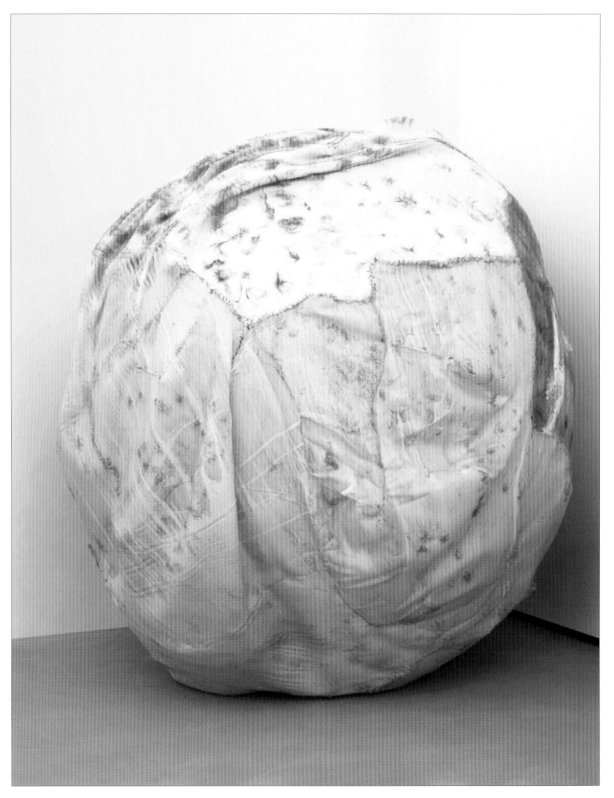

A Sigh Is the Sound of My Life
2000–2001
Overlaid by silicone skin, core rotates on a
horizontal axis at a speed of one revolution
every four minutes
Polystyrene, polyurethane foam, wood,
steel axle, electric motor, silicone, gauze,
hairs, wood glue
200 x 200 x 280 cm; 78 ¼ x 78 ¼ x 110 ¼ in.

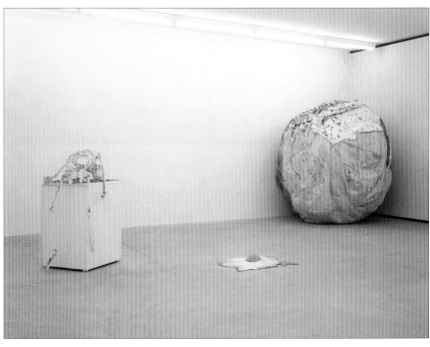

Installation view, "Mastering the Complaint,"
Galerie Hauser & Wirth & Presenhuber, Zurich, 2001
Left to right: *One More Carrot Before I Brush My Teeth*, 2001;
Warum wächst ein Baum / Kann Man zuviel fragen (Nr. 3)
Why does a tree grow / Can one ask too much (No. 3), 2001;
A Sigh Is the Sound of My Life, 2000–2001

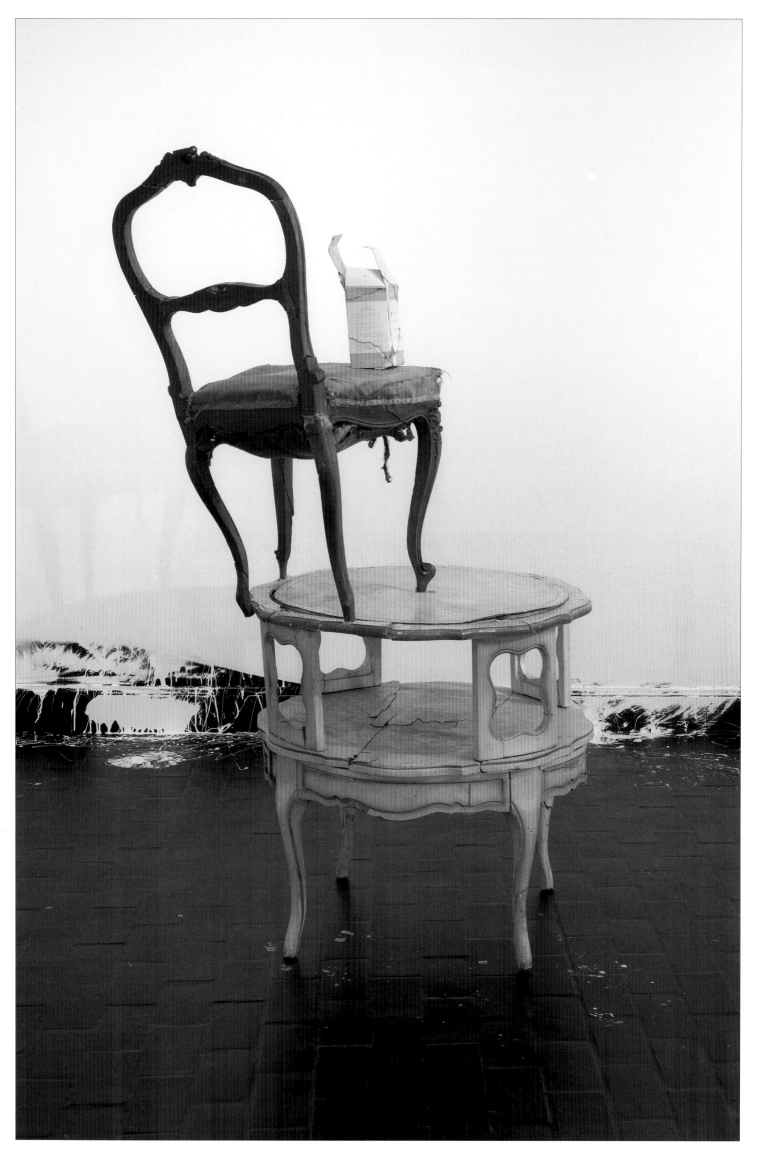

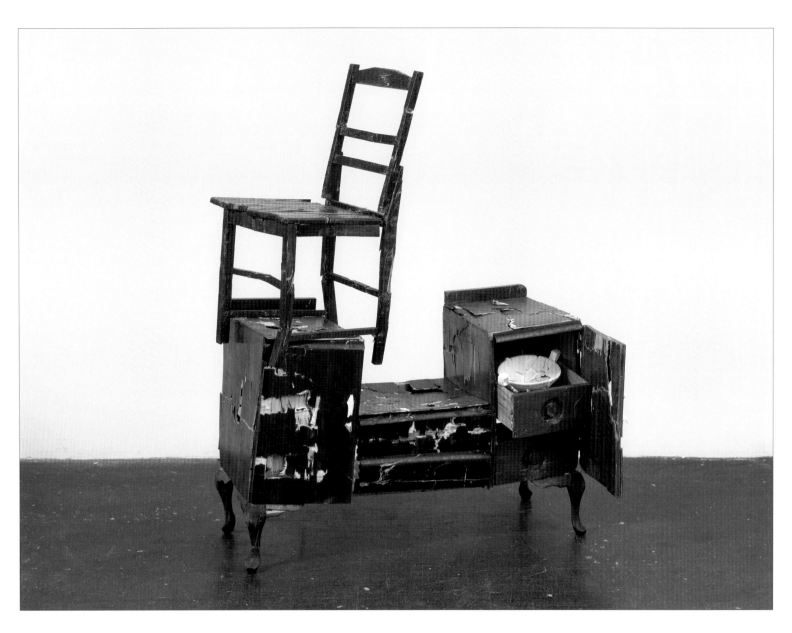

In Dubio Pro Reo
2007
Found cabinet, found stool, found bowl, epoxy glue,
polyurethane glue
155 x 110 x 80 cm; 61 x 43 ¼ x 31 ½ in.

Opposite page:

Addict
2006
Found furniture, cardboard box, epoxy glue
155 x 72.5 x 73 cm; 61 x 28 ½ x 28 ¾ in.
Installation view, "Mary Poppins," Blaffer Gallery,
The Art Museum of the University of Houston,
Texas, 2006
On floor: *Untitled (Floor Piece)*, 2006

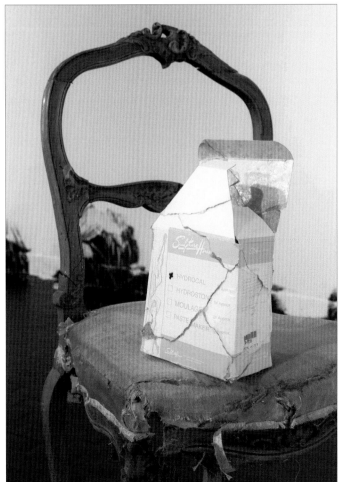

Detail of *Addict*, 2006

IF YOU BUILD YOUR HOUSE ON A BED OF ROTTING VEGETABLES

BY JESSICA MORGAN

*U*rs Fischer's oeuvre is characterized by a morbid glamour. Yet despite being a frequent consumer (or abuser) of sex, the macabre, the violent effects of fracture and collage, and other devices frequently associated with the commercial sphere, his work remains resistant to the popular or iconic status of colleagues with whom he is often associated through exhibition and, especially in recent years, through the private holdings of the West's supercollectors. Fischer is not a purveyor of such memorably succinct images as a dead Pope, a preserved shark, oversize Christmas decorations, or cartoon characters, to mention just a few of the works that have succeeded in firmly imprinting themselves on our overcrowded visual memory. Nor does his work carry an identifiable style, and a common observation on his practice is that it varies so much from exhibition to exhibition that it can be a challenge at times to identify him as the author. Lacking the polished veneer necessary to register in this competitive realm, Fischer's work is rather anachronistically characterized by the vagaries and mistakes of the handcrafted and apparently home-built. But while a first impression of lo-fi techniques may set Fischer's work apart from the expertly fabricated-to-order production of Damien Hirst and Takashi Murakami, for example, in fact almost every gesture of authenticity and semblance of the auratic touch of the artist has been subjected to a digitized and designed process in the artist's studio. The carving, modeling, and draftsmanship that initially appears to connect Fischer to a historical lineage of sculptors, painters, and what we might term a "traditional studio practice" in fact emerges to be something of an illusion, a product of our ongoing fetishism of such attributes. Fischer's manipulation of the aesthetic of the handmade is in fact just one of the many devices put to use in his constantly changing repertoire and has less to do with the didactic implications of his chosen means of production than with the achievement of a desired effect.

A wide array of mediums from painting, sculpture, and installation to photography, drawing, and the production of artist's books are all equally available for use as deemed necessary by Fischer (who is nothing if not astutely aware of the lineage from which each mode or medium emerges). Similarly, the handcrafted or mock-clumsy appearance, the aesthetics of commercial fabrication, or the in situ creation of work with materials available at hand are options to be taken advantage of and returned to as and when desired. Characteristic of all Fischer's work, however, is the tendency to never fully occupy any of the positions implied by this array of artistic choices. But, despite this, his work cannot accurately be described as a postmodern, or Conceptual, or critique. The awareness behind Fischer's work is a direct reflection of his middle-European artistic self-consciousness. It is a state of mind that, while it prevents him from falling into the stylistic camp of a particular ism or fashion, at times perhaps threatens to overdetermine his every move. His outmaneuvering and studious avoidance of falling into the "trap" of an already explored reference, attitude, or gesture to a large extent explains the constant change in appearance of his pieces from show to show, and this vicariousness is another reason for his work's resistance to the arena of media-appealing images. No such anxiety would seem to characterize the work of Jeff Koons or Damien Hirst, for example, both of whom instead persistently continue to pursue ideas, motifs, and series over decades of work resulting in an immediately identifiable production. Fischer's arm's-length exploration of the various possibilities of modern art calls for a comparison with the work of Martin Kippenberger, whose own incessant and expert second-guessing resulted in a similar impression of half-occupied, half-rejected stances in a complex game of art world knowingness. Just as Kippenberger's work embarked on a process of critique through continuation ("Painting is dead. Long live painting.") Fischer's art historical self-consciousness encourages rather than stymies his exploration of the traditional forms of art-making. And while a certain futility is acknowledged, the pleasure of continuing down a path already explored is embraced without irony.

*F*ischer is openly indebted to a wide array of historical sources ranging from the centuries-old tradition of *nature morte*, the nineteenth-century sculptural trope of the partial figure, aspects of Surrealism, and even an engagement with the legacy of institutional critique (ambiguously emptied of politics). In addition he has a clear affinity with the oeuvres of such individual figures as Franz West and Dieter Roth. As ever, however, Fischer employs a distancing effect to these legacies through the use of an "inappropriate" alteration of materials or method of production leaving the odd impression for the viewer of having been seduced by the effect—sexual, beautiful, macabre, or poignant—or referential allure only to have its verity tarnished by the hint of cynicism that appears to be at work refusing us (and him) the pleasure of comfortably settling into a familiar realm. It is as if Fischer applies the principles of the *vanitas* (another frequent theme in his work) to the history of art itself such that as we grasp for the fruit we like it decays before our eyes. We might enjoy the "*rappelle à l'ordre*" but don't be fooled into thinking that it is in any way meaningful.

Franz West, *Lisa de Cohen with Paßstück (Adaptive)*, 1983. Wood, papier mâché, and wall paint, 22 x 36 x 95 cm; 8 ⅝ x 14 ¼ x 37 ½ in. Courtesy Archiv Franz West. Photo: Rudolf Polanszky, Vienna.

West and Roth, arguably Fischer's main influences, also explore the potential of traditional mediums through unconventional thinking. Roth's influence is in evidence in Fischer's fascination with the infra-thin elision between beauty and decay as well as his proclivity to produce works in situ using found and everyday objects—recalling in particular Roth's increasingly elaborate late installations that were constructed by a team of assistants and artist friends in the exhibition space. For Roth materiality and its vast scope for chronology—from the daily process of decay to the history of civilization and the geological time of place—point to a melancholic, perhaps dystopian view of existence as an endless struggle to order the ephemeral debris of the world and thereby attempt to overcome an inevitable slide toward ruin. Suspicious of any pattern for making art, Roth's statement "Formulas work out, bodies go under" underlines the unheroic, unflinching honesty in his self-portrayal and draws a parallel with Fischer's own resistance to routine methodology. Fischer shares an affinity for the tradition of the memento mori, minus the moralizing tone, and works such as *Rotten Foundation* (1998) could be read as a slightly comedic version of organic Roth time. For this work a haphazardly built brick wall rests on an absurdly insecure foundation of a pile of fruit and vegetables. The apples, potatoes, lettuce, and oranges threaten to inevitably rot with the logical consequence that this already badly built structure will collapse. While Roth's infamous installation at Eugenia Butler Gallery in Los Angeles in 1970, *Staple Cheese (A Race)*, for which he filled various found suitcases with cheese and left them to rot over the course of the exhibition, had the additionally aggressive quality of the smell of the decaying cheese in the California heat, Fischer's work further departs from his forebear's use of organic materials through the cartoonlike quality of the gesture of the collapsing wall suggestive of a spoof of some (nonexistent) popular proverb: "If you build your house on a bed of rotting vegetables..." This narrative quality is shared by another organic work, Fischer's *Untitled (Bread House)* (2004–05). Similarly a decidedly health- and safety-averse construction, *Untitled (Bread House)* takes the form of a Swiss chalet, which in this case has a quite expertly achieved form given that instead of bricks and mortar the artist used bread loaves for the walls and roof. Drawing upon our association with the witch's house in the Brothers Grimm story of Hansel and Gretel, Fischer's piece captures this enigmatic childhood fantasy, further

Jessica Morgan

embellished for the installation at Gavin Brown's gallery in New York by the addition of two green parakeets that helped to bring about the crumbling ruin. Quite unlike the physical failing implied by much of Roth's use of organic materials, Fischer's *Untitled (Bread House)* instead draws upon the rich psychological terrain of childhood, the underlying refrain of the Brothers Grimm tales. And in this respect it relates and takes an insouciant twenty-first-century attitude toward other historically familiar motifs similarly updated in Fischer's work, such as the skeletal form of the *danse macabre* or the *vanitas*.

Dieter Roth, *Staple Cheese (A Race)*, 1970. © Dieter Roth Estate.

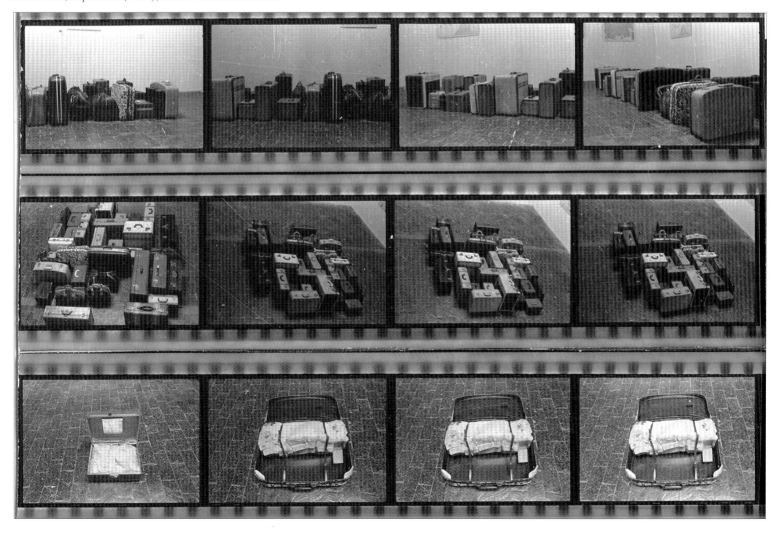

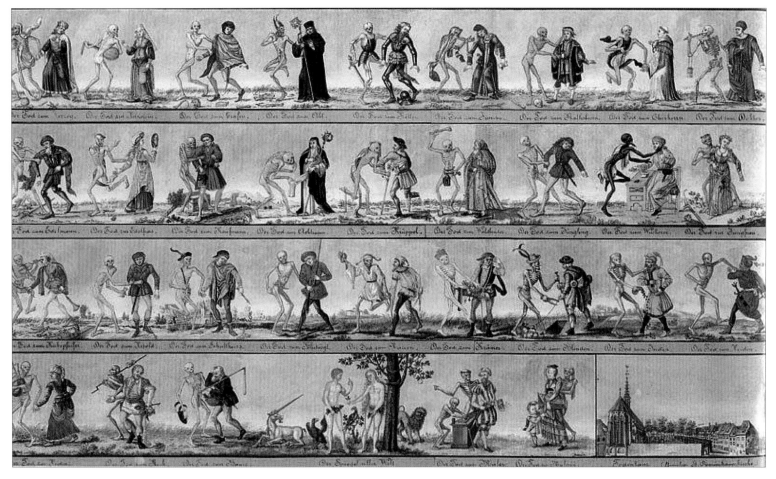

Johann Rudolf Feyerabend, *Der Prediger Totentanz*, 1806. Watercolor copy of a destroyed fresco by Konrad Witz, *Totentanz der Stadt Basel*, 1440. Basel, Switzerland. © Historisches Museum, Basel.

*M*uch of Fischer's work could be said to carry an air of decay and refer to the inevitable failings of the body, suggested as well in much of Roth's concern with time. Fischer explores the subject through the sculptural trope of the chair rather than a conventional representation of the human form. An ongoing feature of Fischer's oeuvre, the chair is a stand-in for the body—its anthropomorphic legs, back, and arms have, after all, been put to use for many years as a form of portraiture or figurative representation in the history of art. Almost without exception Fischer's chairs have been tampered with, combined, deconstructed, or crudely fabricated in some way that mimics the awkwardness, scale, occasional grace, and sexuality of the human body. The use of the chair recalls the work of West, though not his furniture, which tends to take the form of simple welded objects comprising rebars covered in cheap, secondhand "oriental" carpets or African fabric. Fischer's chairs have more in common with West's *Paßstücke* (Fitting Pieces)—ungainly forms usually made from plaster on a metal infrastructure with rough, faux-clumsy surfaces. Visitors are invited to manipulate the *Paßstücke*, adapting their bodies to them but rarely managing anything more than an ungainly union. Handling the objects, one is made eminently aware of the lack of grace in aspects of the human form, and the limbs, obstacles, and protuberances of the *Paßstücke* become apparent as our own faintly laughable characteristics as we wrestle with them as we do with our own physicality. Fischer's chairs are entirely unusable but there is always the implication of the human form through a projected interaction or surrogacy similar to the *Paßstücke*. *Last Chair Standing* (1997), for example, a rough wood and clay construction apparently held together by the string that prevents it from toppling over backwards, suggests the excesses of a late night. The cast aluminum sculptures *Chair for a Ghost: Thomas* and *Chair for a Ghost: Urs* (both 2003) consist of the partially suspended remains of two chairs that appear to have been eaten away by rampant woodworms. The chairs/personae are fragmented skeletal forms—the chair as memento mori—and as such are far uncannier than the limber human skeleton employed by Fischer in works such as *Skinny Afternoon* (2003). For *Late Night Show* (1997), West's *Paßstücke* appear to have collapsed onto three found chairs, their luridly painted plaster and papier mâché forms suggestive of limp bodies—perhaps viewers of the titular performance. Awkwardly copulating, the two conjoined chairs of *Stühle* (2002) are further united by the thick coat of shiny brown paint that covers their entire surface. Their attempt at stacking, despite the fact that they were clearly not designed for such a purpose, brings to mind the contortions

produced by the *Paßstücke* while also embodying Fischer's capacity to combine sex and brute physicality.

*W*hile the chair series may in fact be the most "figurative" body of work Fischer has produced, the human figure makes a frequent appearance in his oeuvre through the aforementioned skeleton and the partial figure. Oddly Fischer's skeletons are in fact some of the least macabre aspects of his work. In *Undigested Sunset* (2001–02), for example, the slacker skeleton collapses on a couch apparently enjoying a break from the stilted movements normally imposed on his bony body. Fischer's pairing of the skeleton with contemporary objects—the park bench of *Skinny Sunrise* (2000), the washing machine of *One More Carrot Before I Brush My Teeth* (2001), or the living room couch of *Undigested Sunset*—places the action in the realm of the everyday, humorously updating the *danse macabre* from drawing-room drama to TV-room joke.

> **The awareness behind Fischer's work is a direct reflection of his middle-European artistic self-consciousness.**

*W*hen flesh is still attached to bone in Fischer's work, the body is placed under attack: it is melting, fractured, decapitated, and penetrated. Fischer's bodies, despite (or perhaps because of) this incompletion and decay are contemporary, sexually charged fragments and, like the cast of skeletons, capture in their pose the artist's eye for the poignant brevity of an everyday gesture or the familiarity of an intuitive placement of arms or legs. With his various disembodied heads, arms, feet, and hands, as well as the extraordinary melting wax females, Fischer plunders the art historical trope of the partial figure, updating this legacy for our own time. Like the work of Medardo Rosso and Edgar Degas, both of whom he seems indebted to, Fischer's own production is clearly influenced by the possibility of cropping the photographic image and the resulting dismemberment of a figure or form caught at the edge of the camera's frame. He uses this abstracted effect to focus attention on momentary effects, and works such as *September Song* (2002) and *Hands* (2002) affirm Fischer's ability to capture a casual yet

expressive pose. Their tension as objects, however, derives from the blunt caesura of the limbs, the un-organic manner in which the Styrofoam from which they have been modeled reverts to a cubic block at the end, and the suspension of the fragmented limbs in space. Fischer places them at the plausible height of their human parallel calling for the optical "completion" of the missing parts of the form. Despite the lack of limbs or torso there is nothing incomplete about the work, recalling the debate in the nineteenth century around Auguste Rodin's "unfinished" figures, about which Charles Baudelaire stated, "There is a great difference between a work that is complete, and a work that is finished … in general that which is complete is not finished, and … a thing that is highly finished may not be complete at all." Fischer's decayed and fragmented forms have more life in them than many a fully representational figure.

*F*ischer's most remarkable figurative works, the self-destructing wax female figures constituting the curiously titled *What if the Phone Rings* (2003), were preceded by works such as *am & pm* (2001), *Napoleon, Is There Something You Didn't Tell Me / Napoleon Misunderstood* (2001), *Untitled (Nude on a Table)* (2002), and *I Can Smell Your Words* (2002), which gave the illusion of melting through the application of wax, paint, and polyurethane to the surface of the sculpture. Mouths open (to emit pleasure or pain?) and covered by or extruding viscous substances, the heads are caught ambiguously between ecstasy and death. Next to these disturbing, semi-submerged busts, the violated forms of the three women in *What if the Phone Rings* seem relatively benign. Two of the figures, one seated and the other reclining, rest on statuary plinths, while the third sits directly on the ground. Wicks have been inserted in their heads, legs, and buttocks such that over the course of an exhibition the women gradually melt, long drips of colored wax resembling stringy hairs cascading down their bodies and large cavities forming at the locus of heat. Sculpturally the works represent a development of the notion of the object in flux, usually achieved through kineticism or the use of organic materials à la Roth. Here the forms begin life "complete" and end in a state of Medardo Rosso-like decomposition. By showing the sculpture one commits to destroying it and this gradual obliteration is largely so compelling due to Fischer's choice of subject: the female form. The classic ideal of beauty—albeit somewhat cartoonishly suggested in the figures' lipstick-red mouths and bluntly graceful attitudes—is subjected to a brutal attack. The effect of which—the melting and consequent gaping holes that appear unexpectedly at the back of an otherwise facially complete head or in the upper leg of a seated figure— invokes the compelling combination of extreme beauty and extreme ugliness, a dualistic trope that Fischer has frequently employed to capture the audience's attention. Lust and disgust, and the surprising proximity of the two, are placed in a dialectical relationship and we move around the decomposing figures transfixed by the two simultaneous readings.

*B*odies are not the only elements in a state of partial ruin in Fischer's work. Architecture suffers a similar process of decay, reduced to a skeletal form in works such as *Glaskatzen—Mülleimer der Hoffnung* (1999), *The Membrane (Half Full, Half Empty)* (2000), and *Mastering the Complaint* (2001). Not strictly a representation of any particular type of building or construction, the broken glass edifice of *Glaskatzen—Mülleimer der Hoffnung* is suggestive of a sequence of rooms on a horizontal plane—perhaps the galleries of a museum, containers, or vitrines now in ruin. This architectural reference is further abbreviated into a series of corner constructions consisting of two simple sheets of board for the work *Mastering the Complaint*. Each ninety-degree angle suggests the limits of the space to be defined, creating a mazelike sequence through the installation. These works lay the ground for the grand gesture of the installation *Portrait of a Single Raindrop* (2003), shown first at Gavin Brown's enterprise in New York, and repeated on a massive scale for Fischer's solo exhibition at Kunsthaus Zürich in 2004. Here Fischer crudely cut through the temporary walls of the exhibition space creating massive punched-out windows with views onto the adjacent gallery. The clumsiness of the cuts suggested a childlike haste (and the illusion of ease), and the roughly hand-drawn lines indicating the circumference of the hole still in evidence on the cutout sections added to this air of casual destruction. The holes themselves reveal the apparent solidity of the dividing wall to be nothing more than the hollow drywall and three-by-fours of a cheaply achieved, temporary spatial solution. The work recalls the circular and conical cuttings of Gordon Matta-Clark but Fischer's gesture is largely drained of the sociopolitical implications of the latter's actions and is perhaps closer to the scale distortion and playfulness of Claes Oldenburg and Coosje van Bruggen's blow-ups—a comparison enhanced

by the enormous plugs that once filled the cutout holes leaning absurdly against the gallery wall, apparently waiting to be popped back in place at any moment. The arid solidity of the white cube is transformed into a flimsy model (perhaps inspired in part by the architectural model in which the exhibition was planned in the artist's studio), and despite the "real" scale of the exhibition, the effect is such that the gallery space appears like a giant dollhouse, filled with sculptural toys.

*T*he deconstruction of the gallery space at Kunsthaus Zürich was preceded by an exploration of the structure of the studio. *Madame Fisscher* (1999–2000) is an installation that consists of the interior skin and contents of the artist's studio at Delfina Studios in London, which was cut up, removed, and reassembled as an artwork. Peering through the open door of what from the outside appears to be a simply fabricated box construction, one discovers the paint-splattered interior and drawing-encrusted walls of the space in which the artist worked for a yearlong residency. Instead of the traditional exhibition of work made while resident on a program, Fischer took the studio space itself, presumably deeming this more emblematic of the work undertaken during this time than any single piece conceived. A crude Styrofoam figure (the artist or an artwork in the making?), a chintz-covered chair, a few worktables, and some half-finished pieces litter the space in addition to numerous graphic works by the artist (drawn or painted directly on the wall and on paper), all of which feature his signature heavily outlined forms, which recall the cartoon-influenced work of Philip Guston as well as urban graffiti. The artist's studio is an ongoing feature of Fischer's work, the chairs and tables that he frequently returns to recalling the self-fabricated or found furniture used in his own studio. In Fischer's work the studio space and its mundane contents become the subject of art rather than remaining merely the surroundings in which art is made. He seems to suggest that it is the time spent sitting, eating, smoking, drinking, talking, and perhaps doing nothing at all that constitutes the artwork and therefore calls for representation over and above any exterior inspiration. Though Fischer's work may seem anachronistically to return to the studio at a time when artists have fully embraced the commercial fabrication of

Medardo Rosso, *Bambino alle cucine economiche*, c. 1911. Close-up of a photograph from the 1904 Salon d'Automne Silver; gelatin print on cardboard paper emulsified by the artist, 16.5 x 13.5 cm; 6 ½ x 5 ⅛ in. © Archivio Medardo Rosso 2009.

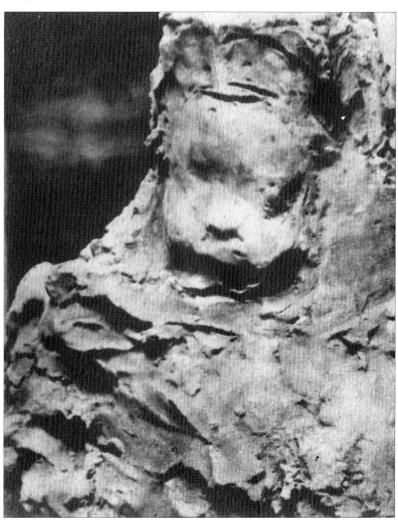

work, pieces such as *Frozen* (1998) and *Madame Fisscher* should be read in dialogue with similarly ambiguous affirmations of the studio such as Roth's studio floor installation *Fussboden* (1975–92), for which the artist lifted up the paint-splattered floor of his studio and presented it as one enormous "found" painting (and a register of time) or Kippenberger's *Spiderman Atelier* (1996), for which the artist created the cliché Paris atelier (in fact copied from Henri Matisse's studio) occupied by the painter/superhero ready to leap to new heights of creative genius. Though it is hard to situate Fischer's work in relationship to the polemical writing of Daniel Buren in his legendary essay "The Function of the Studio" (1971), which questions the relevance of a traditional studio practice in light of the emerging Conceptual art practice that took place in situ in the street or museum, his work nevertheless raises questions in regard to the role of the artist, the institution, and the structures that govern our reading of space and place. Typically for Fischer, this work demonstrates an ambiguous acceptance and rejection of tradition. The studio is at once revered through preservation and simultaneously presented as a dead object rather than an active space of production.

Fischer's gesture is largely drained of sociopolitical implications.

*F*ischer's most recent works have continued to address these concerns and increasingly do so through a simple but radical gesture. Undoubtedly his most significant work to date, *Verbal Asceticism* (2007) was first shown in the glamorous setting of the Palazzo Grassi in the third installment of the collection of François Pinault. Fischer's work was indicated as located on the top floor of Palazzo Grassi but visitors searching there for his signature sculptural works were left at a loss. Wall labels referring to works by Mark Rothko, Brice Marden, and Richard Serra, among others, suggested that the mid- to late twentieth-century collection of Pinault that had been exhibited previously in the show "Where Are We Going?" remained on view. However, instead of the actual artworks, an expertly produced black-and-white photographic illusion of the paintings and sculpture was wallpapered on the surface of the galleries. The shadowy three-dimensional presence of a sepia-toned "prop" sculpture by Serra occupied one wall and on another "hung" the monochrome rectangular floating forms of a Rothko—the illusion was such that it was only after running one's hand across the wall that it became entirely apparent that these works were in fact finely printed reproductions photographed on site and pasted back on the wall to create a perfectly produced memory of what had existed before in the exact same location. Not only were the artworks reproduced in the wallpaper but so was every detail on the wall: from architectural details to wall labels and shadows, such that the work was in fact an entire reproduction of the room as it looked at the time of "Where Are We Going?" For many of the viewers the work was (mis)understood to be a stand-in for the missing works from the collection (assumed to be on loan) that were perhaps considered by the collector to be better shown in reproduction than not at all. For those who realized that this was the work of Fischer, however, the installation raised many questions, remaining however, in typical Fischer fashion, opaquely unclear as to any singular intention. Was it a soft version of institutional critique drawing attention to the significance of the context of art for any reading of the works themselves? Was this a work highlighting the trophy-style presentation of a supercollector? Was it a form of appropriation in which not only the artworks (à la Elaine Sturtevant and Sherrie Levine) but also the surrounding exhibition spaces are reproduced? Was it a romantically or art historically inclined piece designed to recall the presence of works seen previously in the gallery to create an ongoing history of the space? Or was the installation bluntly suggesting the mediated quality of much iconic art of the late twentieth century?

*A*t Palazzo Grassi the wallpaper installation was combined with real works by West, brightly colored abstract sculptures and collages whose messy globular forms contrasted perfectly with the slick neutrality of the walls. Fischer curated past and present exhibitions together, at once deflating the modern masters by reducing them to a "low" art form while simultaneously acknowledging their ability to sustain a presence despite this downgrading. Perhaps it was the potential suggested in this combination of past and present that led Fischer to take the idea further in his 2008 installation

(created with Gavin Brown) at Tony Shafrazi Gallery, titled "Who's Afraid of Jasper Johns?" Here Fischer photographed, this time in color, the installation of Shafrazi's exhibition "Four Friends" (featuring work by the '80s quartet Jean-Michel Basquiat, Donald Baechler, Keith Haring, and Kenny Scharf) and included in the shots, and subsequent wallpaper, details of the architecture and even the guard who typically stood in the gallery space (both real and reproduction guard coexisted during the exhibition). Further compounding the confusion created by this simulacra was the placement of real works on top of the wallpapered art—both framed pieces by artists such as Gilbert & George, Richard Prince, and Malcolm Morley, and flat wall drawings by Lawrence Weiner and Lily van der Stokker—creating a complex collage effect and an uncertainty as to what was real and what reproduction as well as a visual confusion between the different surfaces and grounds. Carpeting this mise-en-scène was a piece by Rudolf Stingel for which the artist used the same photo-print technique to reproduce the paint-splattered floor of his studio on a gray carpet (a work that may well have inspired Fischer's Palazzo Grassi installation given the close proximity of the artist's studios at this time and their various collaborations). The Shafrazi show brought into play Fischer's talent for collage and the casual Surrealism and irreverence he employs in his two-dimensional work, recalling in particular his graphic work on books and publications—an outlet for his ability to combine, overlap, and repeat images both of his own work and that of others. Fischer's curatorial work and sampling of other artists' production can be read as an extension of his own peripatetic travels through the history of art, once again avoiding association with a given language of art, a position achieved here through the various guises of others' work.

*P*erhaps reacting against the profusion of images and objects that has thus far characterized his work, Fischer produced two negative spaces in late 2007 that alongside the Palazzo Grassi and Shafrazi installations signal a new dimension to his critical engagement with exhibition-making. *Untitled (Hole)* at Sadie Coles HQ and *You* at Gavin Brown's enterprise consisted of, in the first case, a cast bronze hole that was suspended between the two floors of the gallery. Only the exterior of the cast cavity was visible from below in the basement while the gravelike depth could be viewed on the ground floor, suggesting a darkly pessimistic state of entropy. The second project consisted of the dramatic excavation of the gallery in New York involving the removal of earth to a depth that meant visitors standing in the enormous hollow could not see over the edge of the cavity. Both works were strikingly experiential: a somber meeting with mortality at the edge of the grave and the unnerving experience of being observed in a vulnerable position from above by those remaining on the circumference of *You*. The latter work suggested a debt to the critical interventions into the exhibition space by Michael Asher as well as the project by Chris Burden, *Exposing the Foundation of the Museum* at the Geffen Contemporary at MOCA (1986/2008), for which the artist dug down to the cement floor of what was intended to be the temporary site of the Los Angeles museum. *Untitled (Hole)* in fact also calls for comparison with a historical precedent, in this case, the somewhat atypical action of Claes Oldenburg in the work *Placid Civic Monument* (1967), for which Oldenburg hired a crew of municipal gravediggers to excavate a hole in the lawn behind New York's Metropolitan Museum of Art. The work made direct reference to the Vietnam War, embodying the inverted opposite of the type of monument that Oldenburg imagined would be erected in honor of the fallen soldiers. In Fischer's work any political dimension relating either to the present state of affairs or to this historical lineage is largely denied. *You* represents one of the most nihilistic statements thus far by Fischer, the very act bringing to mind the popular expression "to dig oneself into a hole."

*F*ischer's work has been characterized by such a furiously astute capacity to absorb and simultaneously resist influence that one wonders if it is possible to keep running at such a pace, and if works such as *You* imply a fatigue with the notion of the never-ending production of objects and works involved in this effort. His increasingly evident engagement with the process of exhibition-making offers a possible form of continuation, however, that allows once again for the artist to remain at a comfortable distance from the subjects and histories that he takes on. Perhaps such a direction would mean that we sadly see less of his endlessly compelling objects, though we would undoubtedly continue to learn from his capacity to breathe new life into the strangely limited arena of exhibition design, pointing ultimately to new ways in which to appreciate (rather than feel overburdened by) the wealth of materiality that surrounds us.

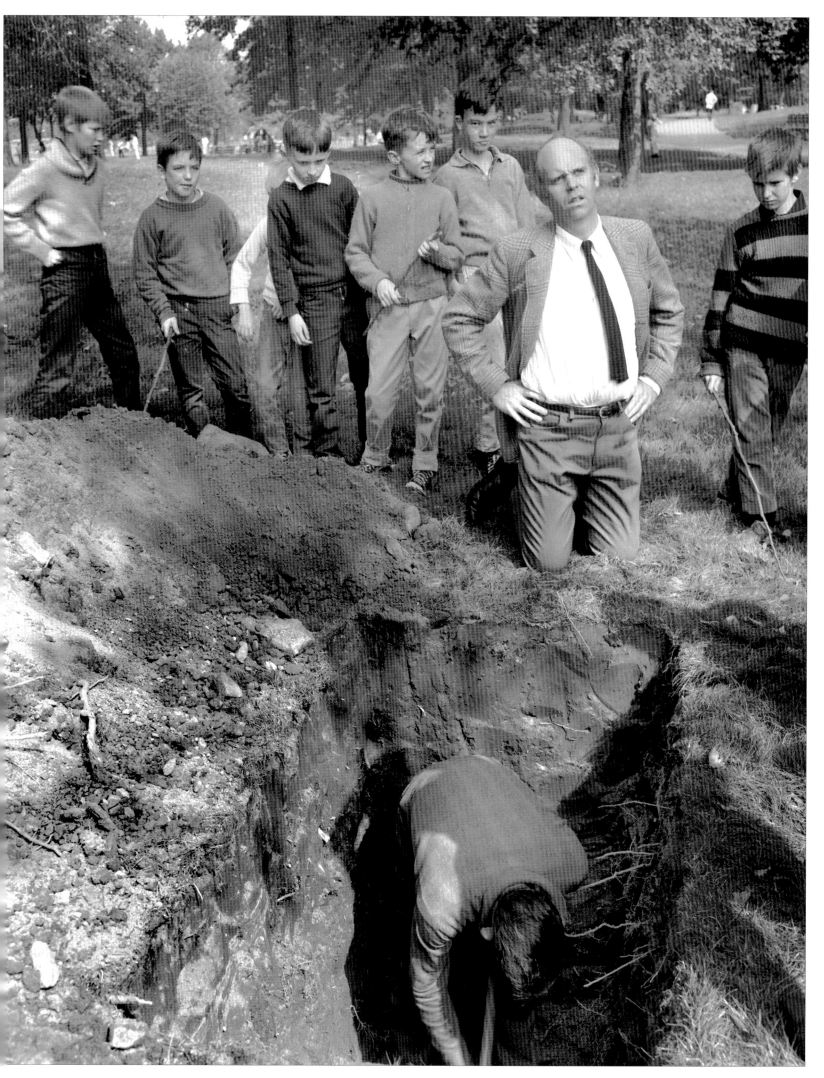

Claes Oldenburg, View of *Placid Civic Monument*, 1967. 108 cubic feet of Central Park surface-excavated and reinserted northwest of "Cleopatra's Needle" and behind the Metropolitan Museum of Art for the exhibition "Sculpture in Environment," October 1–31, 1967. Exhibition sponsored by NYC Administration of Recreation and Cultural Affairs Showcase Festival. Collection Gift to New York City from Claes Oldenburg. Courtesy the Oldenburg van Bruggen Foundation. © 2009 Claes Oldenburg. Image © New York City Parks Photo Archive.

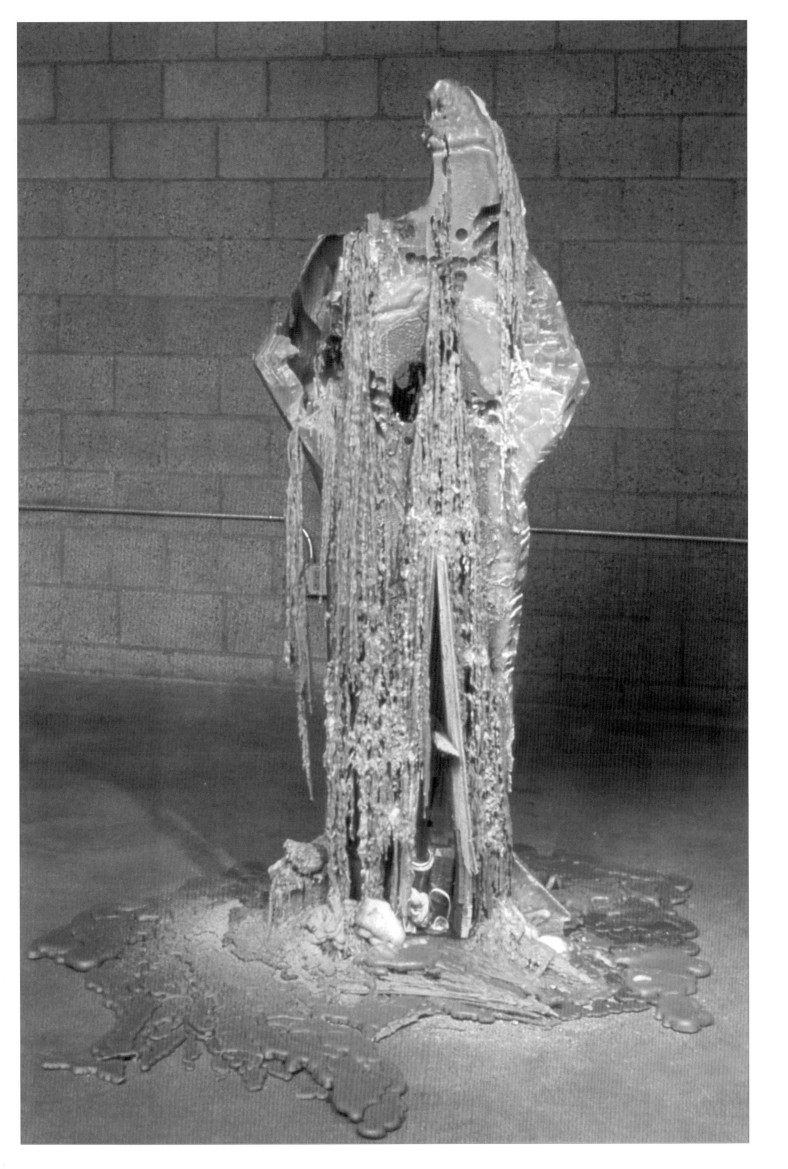

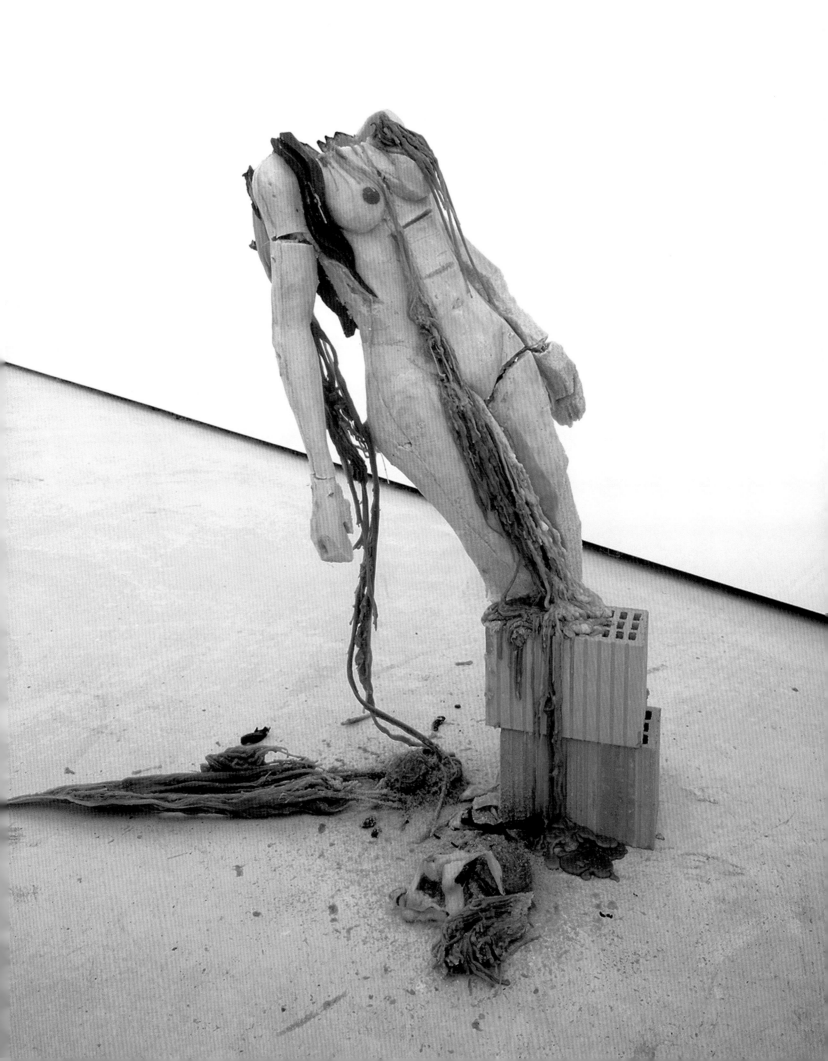

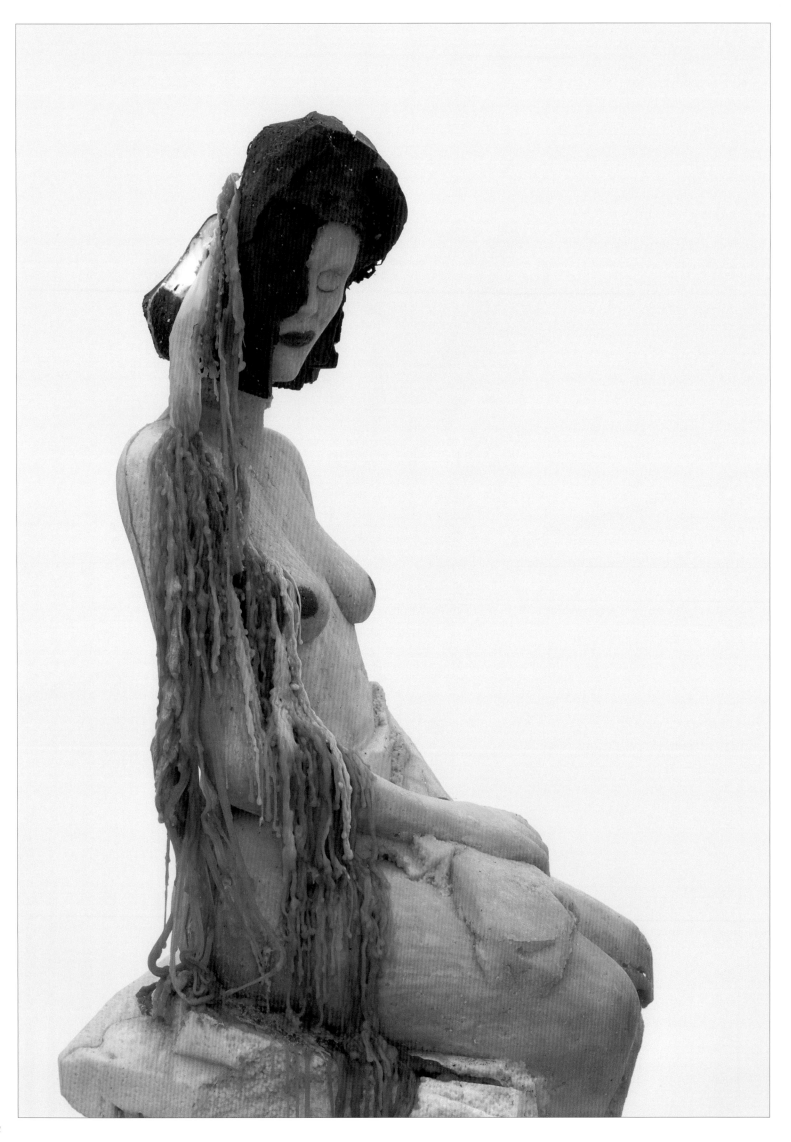

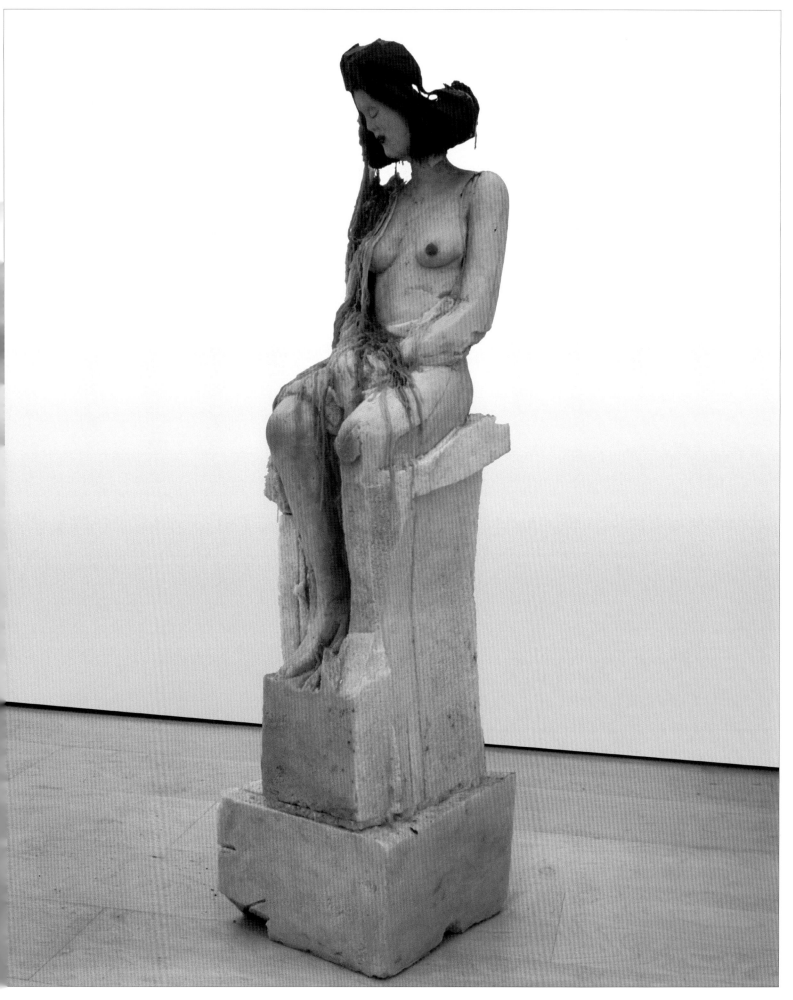

This page and opposite:

What if the Phone Rings
2003
Wax, pigment, wick
Figure 1: 106 x 142 x 46 cm; 41 ¼ x 55 ⅞ x 18 ⅛ in.
Figure 2: 200 x 54 x 46 cm; 78 ¾ x 21 ¼ x 18 ⅛ in.
Figure 3: 94 x 99 x 54 cm; 37 x 39 x 21 ¼ in.
Installation view, "need no chair when walking,"
Sadie Coles HQ, London, 2003

Page 50:

What Should an Owl Do with a Fork
2002
Wax, wick, wood, garbage
178 x 71 x 30.5 cm; 70 ⅛ x 28 x 12 in.
Installation view, "What Should an Owl Do with a
Fork," Santa Monica Museum of Art, California, 2002

Page 51:

Untitled
2001
Wax, pigment, wick, brick, metal rod
170 x 46 x 29 cm; 66 ⅞ x 18 ⅛ x 11 ⅜ in.

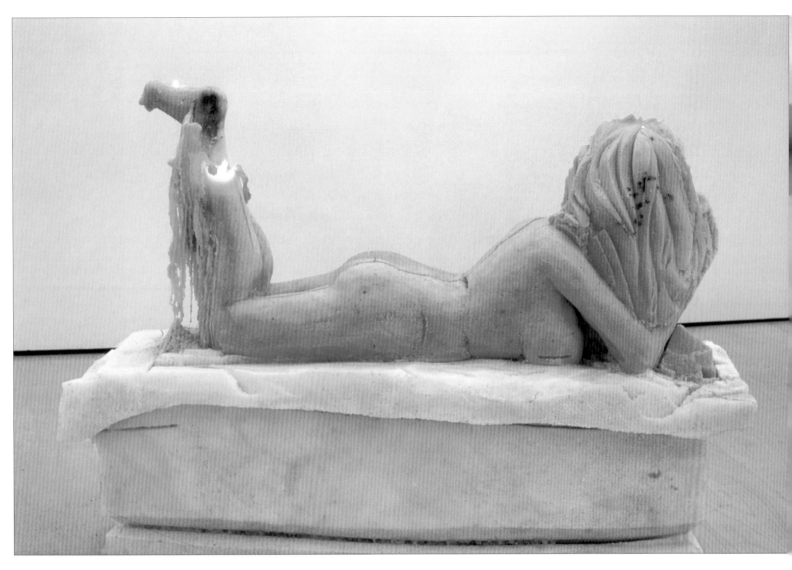

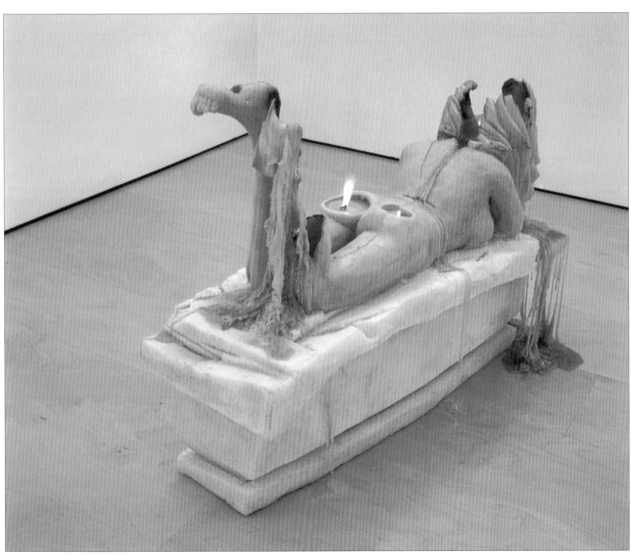

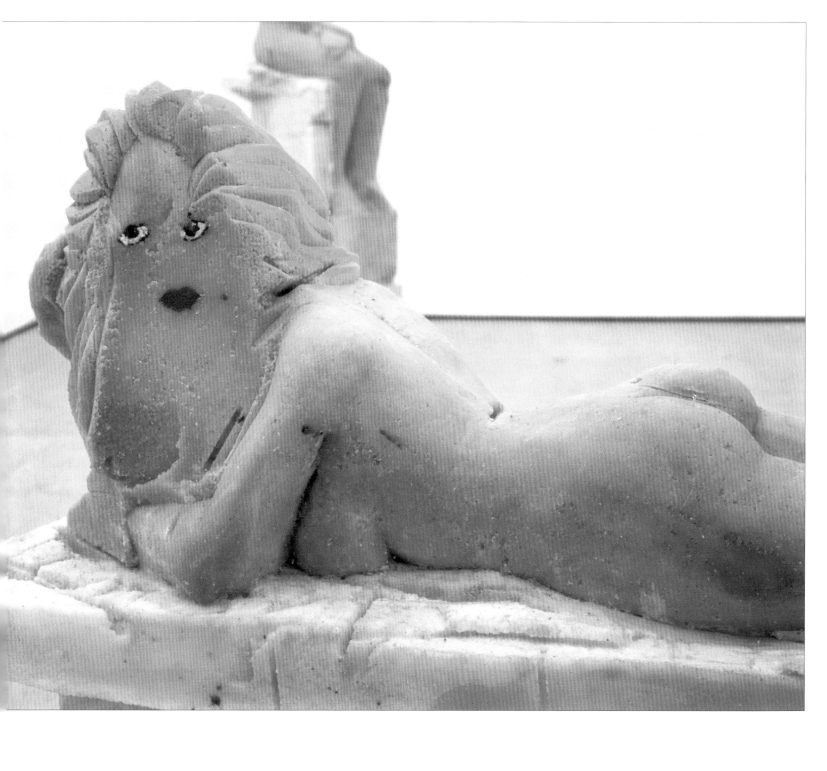

What if the Phone Rings
2003
Wax, pigment, wick
Figure 1: 106 x 142 x 46 cm; 41 ¾ x 55 ⅞ x 18 ⅛ in.
Figure 2: 200 x 54 x 46 cm; 78 ¾ x 21 ¼ x 18 ⅛ in.
Figure 3: 94 x 99 x 54 cm; 37 x 39 x 21 ¼ in.
Installation view, "need no chair when walking,"
Sadie Coles HQ, London, 2003

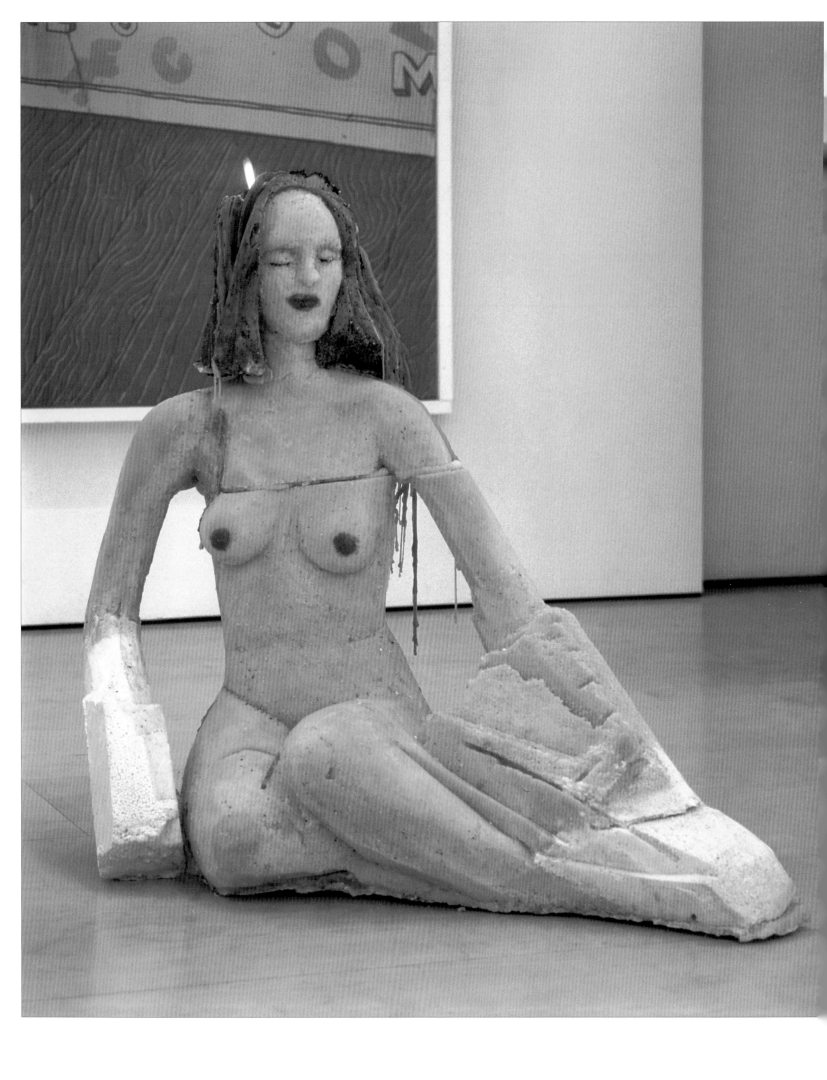

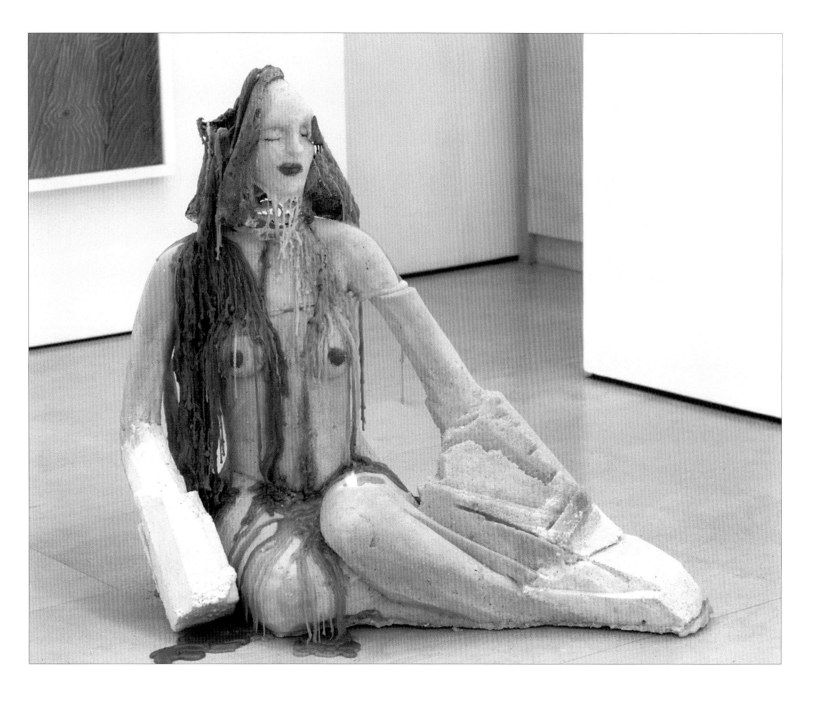

What if the Phone Rings
2003
Wax, pigment, wick
Figure 1: 106 x 142 x 46 cm; 41 ¼ x 55 ⅞ x 18 ⅛ in.
Figure 2: 200 x 54 x 46 cm; 78 ¾ x 21 ¼ x 18 ⅛ in.
Figure 3: 94 x 99 x 54 cm; 37 x 39 x 21 ¼ in.
Installation view, "need no chair when walking,"
Sadie Coles HQ, London, 2003
On wall: *Joe*, 2003

57

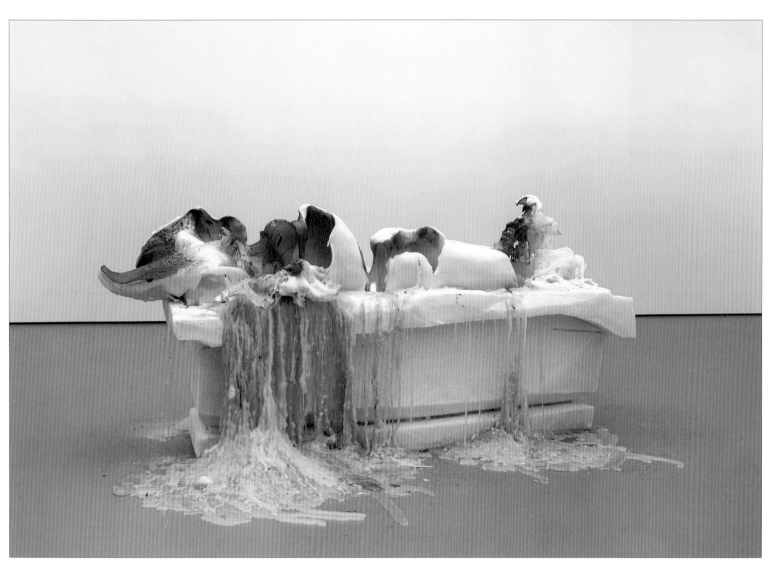

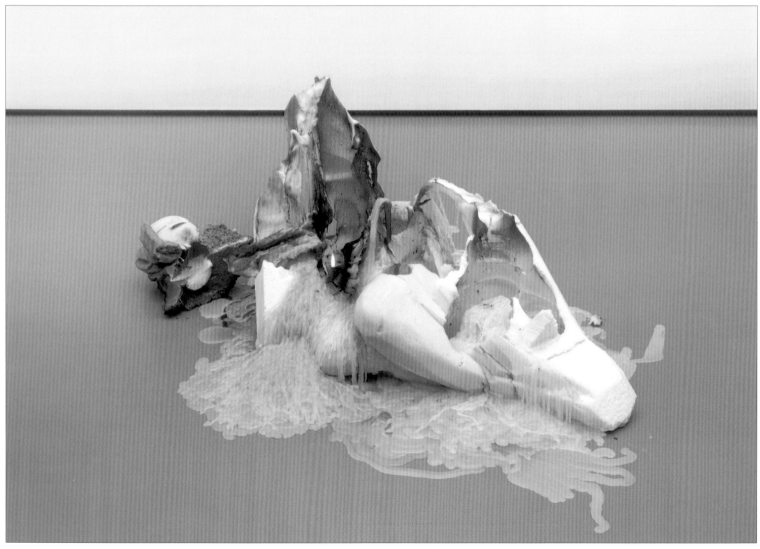

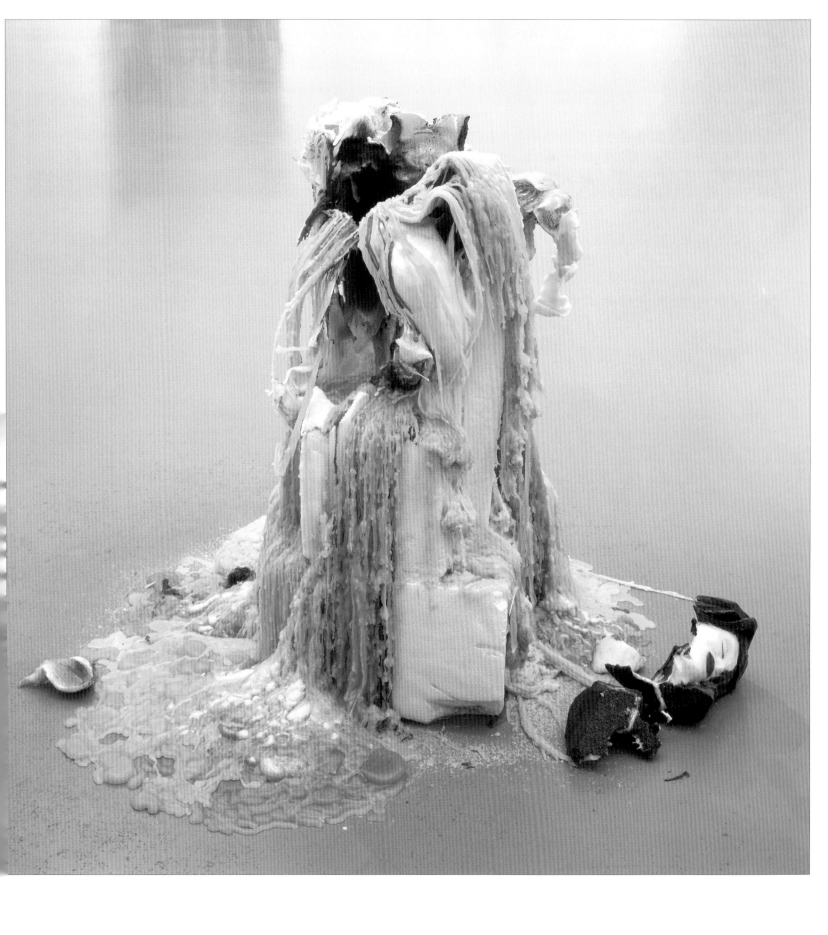

What if the Phone Rings
2003
Wax, pigment, wick
Figure 1: 106 x 142 x 46 cm; 41 ¼ x 55 ⅞ x 18 ⅛ in.
Figure 2: 200 x 54 x 46 cm; 78 ¾ x 21 ¼ x 18 ⅛ in.
Figure 3: 94 x 99 x 54 cm; 37 x 39 x 21 ¼ in.
Installation view, "Kir Royal," Kunsthaus Zürich, 2004

THIS IS MY GRANDMOTHER SHE MAKES REALLY GENIUS CAKES

AN INTERVIEW WITH URS FISCHER
BY MASSIMILIANO GIONI

■ *Massimiliano Gioni: I want to begin with a very practical question: How do you start a work?*

● Urs Fischer: It comes to you. Sometimes you look for it, sometimes you don't. Then you hold on to it.

■ *MG: Let's start with the mirror boxes, for example, the ones you made for the show at the New Museum. For that work, you started from the idea of the mirror, didn't you?*

● UF: The mirror surface is irrelevant. What's interesting to me is the absence of the object. The object is reduced to an image and projected on a rectangular prism. The shape of the rectangular prism creates a clearer order than a cylinder would, let's say. The rectangular shape is basically anonymous: it doesn't have an individual characteristic like the shape of a dog, for example. If you think of anything, really, the rectangle seems to be the most neutral shape. A right angle is almost invisible to us. So if you apply an image to the rectangular form, it really functions as anti-figuration.

■ *MG: Why refuse figuration? What is it that you are reacting against?*

● UF: There's always a moment when things feel obsolete and then it's time for a shave.

■ *MG: So what do you think we need to get over?*

● UF: For example, there's a recent movement of folkish escapism.

■ *MG: Could you elaborate on that?*

● UF: What I mean is that there has been a tendency in culture—white, urban Western culture—to go backwards, into a romantic role-playing. You look at most recent art or music or film: it seems to be that to play the role of the creator has become the actual act of creation. It seems that the artist believes in the genre itself, rather than the genre as a vehicle. It's confusing. Look, basically, you're on duty—every artist is on duty. It's a matter of tempering your self-indulgence: "Don't get high on your own supply." What I hate about doing art is that it never gives me a lasting satisfaction.

■ *MG: Let's go back to the boxes. How did you choose the images to be printed on them?*

UF: I didn't choose them as images, I chose them as objects. I started by writing out lists of objects. Then I started considering their size in space and how to adjust that. It turned out that almost all the objects ended up bigger than they are in real life. If you go smaller, it tends to resemble a model. So, in a sense, it's a reverse of that, even with the models—the skyscraper model, Eiffel Tower souvenir, and phone booth—I used as objects for the mirror boxes. What happens when these things that are so familiar to us—that are made for humans or grown for humans—are blown-up in size is that they somehow appear no bigger than they were before. Yes, they

are larger, but they're still the same: models that are in a 20:1 ratio rather than 1:1. So getting back to the image, the image of these objects has no particular size.

■ *MG: Is there no rule for the size? Obviously not all the images of the objects printed on the boxes are following the same formula: They are not all based on a 20:1 principle.*

● UF: What determines the ultimate size of each object is based on architectural reasoning. There seems to be a certain size that is ideal for each of these objects. It sometimes took a lot of trial and error to find this size. Architecture always takes into consideration the spatial confrontation between you and a thing.

■ *MG: I am particularly interested in the images on the boxes. They compose a sort of encyclopedia of banalities. You are an avid consumer of images, and some of them are quite cheap, trite, or kitsch. Are you interested in bad taste?*

● UF: What do you mean by bad taste?

■ *MG: For example, in some recent paintings, you have inserted materials from B movies and horror flicks. In other works you have used motifs from folk decorations. And there are the Swiss chalets and the Germanic architectures that you have put in some of your sculptures and paintings… Are these images you like or are you using them in a critical manner?*

● UF: I believe images are emotionally charged. Each image has a different kind of charge. You make use of the emotional quality of the image rather than what the image is.

> **It's not what you lie about, it's how you lie—to yourself and to others.**

■ *MG: So you are not choosing them because they question our assumptions of taste?*

● UF: No. I just like them. I think they look good. They are not cheap, nor they are wrong: they're images. I like them, they are nice. Take this image, for example: these buildings, these houses, whatever you want to attach to them—the reference to German architecture or to folklore—to me they are just good images. They are the very basic, simple image of a house. They are archetypes. Also, I'd never reference Germanic architecture.

■ *MG: Where do you find the images you use? I have always been very fascinated by the number of images you have on your computer. Do you mostly work with found images?*

● UF: Not necessarily. Many of the images—like the ones on the boxes—are created by me, they are fabricated.

■ *MG: But in your paintings especially there seems to be a great deal of recycling. It looks like you favor found images.*

● UF: The way I see it, my paintings are more like sculptures. I see them as objects on the wall that have a particular surface. The paint applied is just one possible layer.

■ *MG: These sculpture-paintings, like your sculptures, often seem unfinished: They are so rife with information that they remain somehow open. I think in your work there is almost a cult of the unfinished, a roughness that could be read as a polemic against a certain polished look that has been so fashionable lately.*

● UF: I hope you're not talking about the boxes. They're about as polished as things get. But as far as many of my works go, I don't really ask myself if they are finished or not. There are many different ways of finishing things. This doesn't interest me specifically. It's about how much control you want to apply to something that is matter—something that is the physical material body you work with. And, on the other hand, there is the control exercised by someone's psychology: the things you want to show, the things you

Photo: Selva Barni

Massimiliano Gioni

The Pyramids of Giza, c. 2560 B.C., Egypt.

don't want to show, and the image this creates on the outside. This is the uncontrollable quality of any work. That's what makes it so difficult to lie as an artist in the long run. In the long run, it's not the story you tell, it's how you tell the story. Or better, it's not what you lie about, it's how you lie—to yourself and to others.

■ *MG: Is this why you work with materials that are to a certain extent less controllable? You have made sculptures with melting wax and with other perishable materials. You have used moving objects, unstable components, and even fruits and vegetables that rot in the course of the exhibition.*

● UF: This lack of control you're describing is something entirely different to me. Wax that melts in itself creates a more beautiful perfection than you can create. There is a perfection in the movement. The way food decomposes is predictable. It's a predictable process: it always rots in the same way. You're actually in control when you let nature do its thing. I'm interested in finding different ways of being an author. And I am not talking about delegating part of the production or working with other people. It is more about letting materials and images take on their own life. The work has its own reality, and you are in service of it.

■ *MG: Which makes me want to ask you about illusion. There is a hallucinatory quality to your work, even when you are being hyperrealistic, like, for example, in* Untitled (Bread House) *(2004–05), which is simply what the title says it is: a house made of bread instead of bricks. Even if you use bread itself, the resulting image of the chalet made of bread and inhabited by live birds turns into a mirage, a hallucination. There is an aspect of showmanship, a theatrical talent for staging your work that is quite unique: I always think of Baroque sculpture when looking at your work. It's spectacular but in a very dark way: The illusion is there in service of an obscure force.*

● UF: I don't try to set up an illusion. It's more a consequence of how charged an image or a sculpture can be. The work has to have a life of its own: that's the energy of the piece, and that's what you have to be in service of.

■ *MG: Are sculptures, paintings, collages, and installations all equal? Is that element of control you are talking about equally reachable with any medium?*

● UF: They're interchangeable, but not equally good.

■ *MG: I would say that lately you are concentrating more on sculptures. Did you start as a sculptor?*

● UF: No, I'm a trained photographer. But I do like to build.

■ *MG: You've been making large-scale sculpture since early on in your career. Just as your paintings seem to swallow any image, so your sculptures try to take over any available space.*

● UF: To me, in fact, it's not really about big or small. It's all the same. The scale doesn't matter. Obviously large works allow you to participate in

them: they surround you. But you can just as easily relate to a small piece in a corner. I work on the relation between objects. It's the relations that are important, not the size. For example, the shape of the Pyramids: their size is not just a function of what they needed to represent—they had to be that big. I assume they addressed the Egyptian notion of the universe. They're an idea that's bigger than the mummy inside. An ideal shape. They seem to be about the beauty of the idea. I can get the same sensation from the hands gripping the flesh in a Bernini sculpture or from a good Sol LeWitt—that works too.

■ *MG: What does it mean for you that a sculpture works?*

● UF: I think you cannot answer this question. What works for you about art?

■ *MG: Actually the thing that I like about your art is that, on many levels, it doesn't work. It's not a closed, clear, polished system. There is no recipe or formula. Often your work is something I cannot immediately place. And I found myself asking: Is this actually good?*

● UF: Whatever you'd like.

Sol LeWitt, *Splotch #3*, 2000. Acrylic on fiberglass, 102 x 30 x 112 cm; 40 x 12 x 44 in. The LeWitt Collection, Chester, Connecticut. Exhibition view, "Sol LeWitt on the Roof: Splotches, Whirls and Twirls," April 26–October 30, 2005, The Iris and B. Gerald Cantor Roof Garden, The Metropolitan Museum of Art. © The LeWitt Estate / Artists Rights Society (ARS), New York. Photograph © 2005 The Metropolitan Museum of Art.

Gian Lorenzo Bernini, *Il Ratto di Proserpina* (detail), 1621–22. White marble. Galleria Borghese, Rome.

past or the present—it doesn't matter which because they lead to the same thing—that basically reprocess language: cultural language and personal language. It's about passing things on.

■ *MG: Do you feel anybody is absorbing your own work?*

● UF: That I don't know.

■ *MG: Do you care?*

● UF: How can one care?

■ *MG: Where do you think your work ends?*

● UF: I don't know. I don't think about it. Lots of crates, and lots of storage, unfortunately. That's where the work ends usually.

■ *MG: And what about the viewer? You seem to have a rather hostile relationship to your viewers. I am thinking of some of your most aggressive gestures, like the holes in the walls or the hole in the floor at Gavin Brown's gallery…*

● UF: I am not against the viewer. Why would I be against the viewer?

■ *MG: Would you say those gestures were against the gallery then?*

● UF: I really don't think that way. Institutional critique doesn't do its job well anyway.

■ *MG: Still, I feel your work is pretty aggressive. Some of your images can be very tough or uncomfortable.*

● UF: I don't know what's aggressive about it.

■ *MG: Do you think in ideas or materials? Your work, to me, seems so deeply connected to specific materials. It could even be described as a reflection on certain materials, on their instability, even their ability to perish.*

● UF: Materials are inevitably a means to the end, right?

■ *MG: Some people criticize your work because they say it's not clear what it is really about.*

● UF: People seem to fear art. Art has always been a word for this thing that can't be rationalized when you see or hear something that you struggle to explain. But that's its strength, of course; that's what the word "art" is for. For example, I'm reading about Caspar David Friedrich. In the essays, there are many ideas and interpretations about his intentions, trying to personify him, and his ideas and politics. This might all be true to some degree and have actually factored into his decisions. But even he doesn't know why it's good… There are so many people trying to explain how a certain piece is interesting. And it's so limiting, it's crazy. An artwork is shrunk down to two or three sentences. It's like if you were to say, "This is my grandfather, and he likes leather shoes." Or, "This is my grandmother, she makes really genius cakes." I think art is like people: you cannot reduce them to a couple of sentences. They are much more complex, much richer.

■ *MG: Let's backtrack a little. At the very beginning you were working collaboratively. You were doing things with other people.*

● UF: Yeah, lots.

■ *MG: And, what was that? Did you consider it art?*

● UF: Well, I guess so. I still don't know what art would really mean. But it was also about the joy of doing things, you know? It can be fun to do things together.

■ *MG: And now are you doing things more by yourself?*

● UF: Not necessarily. I was just in Oslo, and I was there with Georg Herold. We had lots of coffee and cigarettes and we hung out. The joy of work isn't always about a finished piece, it's about play. It's very stimulating to throw around ideas with other people. That's the root; there is no plant that grows alone.

■ *MG: You mentioned Herold, who is an artist that I learned to appreciate through your work. That's something that always struck me about your practice: Your work has created its own tradition, it has written its own genealogy. It could be true for every artist, but I see it very clearly in your work. Artists like Herold or Dieter Roth or, more closely, Franz West, they all seem to influence your work but, at the same time, your practice reactivates their legacy.*

● UF: Franz West is super. And Georg is also a fantastic artist. I'm kind of fed up with the emphasis always being on the new, on young artists. One of the things I enjoy most about art is seeing people working more melodiously, using the experience of a lifetime in a fraction of a second. Being with Georg is nice because you can see his way of doing and seeing things: He has his own very personal way of operating and you can recognize it in every choice or move. Franz West is the same: I watched him work a few times, and don't ask me how he does it, but there is something extremely specific about the way he does things. It's a way of touching things, of moving things, of finding his own balance.

■ *MG: Are you and your work concerned with the past? I remember you were talking about Robert Morris recently. Is yours a conscious exploration of an older sculptural tradition?*

● UF: You cannot freeze language. I speak, you speak, and together we keep things alive. Language is not the product of an individual, but individuals drive it forward through living. There are certain triggers from the

Carl Fabergé, *The Imperial Peacock Egg*, 1908. © Collection FEMS, Pully, Switzerland.

■ *MG: Would the same apply to you? Do you have a sense of what's going on in your work? For example, I've always found your work very noisy, disturbed, with so many layers: Your work carries too much information. It made me often think of Albert Oehlen.*

● UF: I prefer to think about Polke. I think a lot about Picabia too, though. Picabia's great.

■ *MG: Speaking of Picabia, how important is technology for your work? Your work is very technological, but you don't push technology into the foreground.*

● UF: I love technology. It's nice. It helps you get stuff done more easily. But it also comes with a specific history. Like silk-screening, for example, which I love: it is a very used-up medium in art. It's a very occupied territory. But I still

like the power of silk-screening. When you have an image that's rasterized, it has a power that you wouldn't have otherwise, that you don't have through photographic techniques. It's a certain hardness. It's nice, very stark.

■ *MG: I want to ask you something about some of the subjects and the objects you have used in your sculptures. There are a lot of very common objects, like lamps, tables, chairs, and cigarette packs. You have used very domestic images, very dull images.*

● UF: I don't find them dull. Maybe it's an obvious choice, but those are the things I relate to. What if I did a Fabergé egg? Would that be better? Even if I have nothing to do with it? I just use stuff that's around me. And those objects, those domestic images, as you call them, are made in human scale, so they can also be related to humans. They're made by humans for humans. They speak about us. And they are things you are bound to deal with.

■ *MG: To me your chairs are still a mystery though. There are so many of them in your work, and most of the time the works with the chairs are also strangely incomprehensible, at least to me. Yes, of course, they might be memories of Bruce Nauman or Joseph Beuys, and even of Van Gogh; there are so many chairs in the history of art, but still I don't get why today an artist would be making chairs.*

● UF: For me it's not about today and it's not about the chair. Some of the objects you are talking about are just good errand boys for things I have in mind. And in most cases, I don't even think about the object, I think about a situation.

■ *MG: What do you mean by "a situation"?*

● UF: What's going on between elements in a work. Not compositionally, but almost politically, and definitely structurally: A chair is never a piece of furniture for me; it is part of a situation that establishes a real clash in space. A situation means that things are forced to occupy a space together or alone.

■ *MG: I feel that many of the situations you create are also quite unstable. You have made sculptures that melt, sculptures broken into pieces, crippled walls erected on shaky foundations. In other cases you have created a disturbance of perception, as with the mirrors oscillating and giving the viewer the impression that the whole room is swinging.*

Franz West is super. And Georg Herold is also a fantastic artist.

● UF: The moving mirrors took me a few years to figure out. I started by looking in a coffee cup, seeing how the reflections of the sky moved in the liquid. Then I was in Venice, on one of the vaporetto stands, and noticed how the tide and the waves would make the whole experience of standing in one place particularly uncomfortable. So first I started thinking of how to create a floor that could give that sense of imbalance. But there was something too gimmicky in the idea of a floor that moves: it looks like a trick. So eventually I had to understand that in order to shift our sense of balance I had to move the walls: that's how I got the idea of the mirrors installed on

Georg Herold, *Lost in Tolerance*, 2006. Laths, glass, boxing gloves, and screw clamp, 259.7 x 275 x 49.5 cm; 102 ¼ x 108 ¼ x 19 ½ in. Courtesy of the artist and Friedrich Petzel Gallery, New York. Photo: Larry Lamay.

the hydraulic pumps attached to the wall. This way I think it's even more interesting because you lose your equilibrium and it gets quite disturbing. But in fact nothing is really happening to you: it's just the way you relate yourself to your own image in the mirror.

■ *MG: Is* You *(2007), the hole at Gavin Brown's gallery, also a piece about perceptual distortion?*

● UF: No, not really. In a way I don't even care if it's an actual hole; it could be fictional. And it's not about exposing the foundation of a gallery either. I like the thought of making a piece based on subtracting something. And the byproduct of descending below the floor line was very tempting.

■ *MG: You also did another hole, the one that is now installed in Athens at the Dakis Joannou Collection and that was first presented at Sadie Coles HQ in London in 2007. Was that a precedent for* You?

● UF: They are similar, because they are both holes, but the aluminum one came out of a series of weird incidents. I was once in a friend's garden, and I was thinking of making a solid hole. Initially it was meant as a grave, a contemporary grave. The dead person would be buried underneath the hole. At a later point, I changed the work so that the part you see from underneath is the cast of the air in the hole above, as if the air had solidified.

■ *MG: So this work is actually a grave?*

● UF: No. But, when I was working on this piece, I started looking at a lot of funerary sculptures. There are some very strange examples of graves, like the one of Philippe Pot, who spent years thinking about how his grave would look. Now his grave is at the Louvre: It's eight sculptures of monks carrying the body of a knight on their shoulders. It's a very beautiful piece: the procession to the grave becomes the grave itself. Funerary sculpture replaces something that was alive with still matter. In many ways that's what sculpture is ultimately about: it stands for something that was alive. It might not be a grave for someone, but a tombstone for a thought.

Francis Picabia, *Ninie (Selfportrait)*, 1942. Oil on cardboard, 55 x 46 cm; 21 ⅝ x 18 ⅛ in. Courtesy Galerie Bruno Bischofberger, Zurich. ©2009 Artists Rights Society (ARS), New York / ADAGP, Paris.

Antoine Le Moiturier, Tomb of Philippe Pot, end of 15th century. Limestone, later polychromed, 180 x 265 x 170 cm; 70 ⅞ x 104 ⅜ x 67 in.

Robert Morris, *Untitled*, 1978. Carved oak and mirror, 180 cm; 71 in. high. Courtesy Sonnabend Gallery, New York. Photo: Robert Morris. © 2009 Robert Morris / Artists Rights Society (ARS), New York.

■ *MG: I always thought of that sculpture as a strange self-portrait of yours. Maybe I'm too romantic, but there is something also in its size… Do you have works that you identify with? Even just on a sort of physical level.*

● UF: Most of them, yes. Sure. But then again I am the author of those works, so what else would you expect?

■ *MG: What about the new ones, the large aluminum sculptures? Those were actually born as tiny clay sculptures, weren't they?*

● UF: Yes, they began as tiny clay models. But it's not about their size. Certain things have an innate bruteness. Like a wave. There is a brute force to waves. And to clouds—their monumentality. There is always something brutal in monumentality. I'm using examples from nature here, but we're talking about something fundamental to human psychology. That power can be overwhelming, but on an emotional level, there's an element of comfort to it.

■ *MG: How did you make the aluminum sculptures? They started as clay, correct? You just took a bit of clay in your hand and you squeezed it, right?*

● UF: You just apply force. There is hardly any composition to it. This work is more about selection than composition.

■ *MG: They actually made me think of people who are afraid of flying. They clench their fists. Did you try out different sizes when you decided to enlarge them?*

● UF: I always knew I wanted to make them bigger. The sculptures as you see them now are much smaller than I originally thought they should have been. I actually wanted them to be much much larger. They were meant to stand outside. But then when I started working on them I made these paper

and cardboard mock-ups and had them freestanding in the studio, and I really liked what they did at that size, indoors. They were totally different from what I had originally thought, so I decided to make them at that scale.

"This is my grandfather, and he likes leather shoes."

■ *MG: What about the hanging one?*

● UF: That's slightly different because it is the sculpture of a negative space. It's not a cast of the clay that I have squeezed in my hands. It's actually the inside space of a hole I made in the clay. I squeezed the clay, and then X-rayed the object so I could see its inside, and then turned that inside space into a positive.

■ *MG: You are still thinking of doing them as very large outdoor sculptures, aren't you?*

● UF: Yes, I'm working on these now.

■ *MG: Would you say your work is about destruction?*

● UF: No, it's all construction, but sometimes things just don't want to be.

Installation view, "Frs Uischer," Galerie Walcheturm, Zurich, 1996
Left to right: Various drawings; *Skelett*, 1996; *Untitled (50 Rocks)*, 1996

Performance on the occasion of the opening of the exhibition
"Frs Uischer," Galerie Walcheturm, Zurich, 1996
Co-performers: Kerim Seiler, Cyril Kuhn, and Maurus Gmür

Skelett
1996
Bricks, cement, unfired clay
Dimensions variable
Installation view, "Frs Uischer,"
Galerie Walcheturm, Zurich, 1996
Foreground: *Untitled (50 Rocks)*, 1996

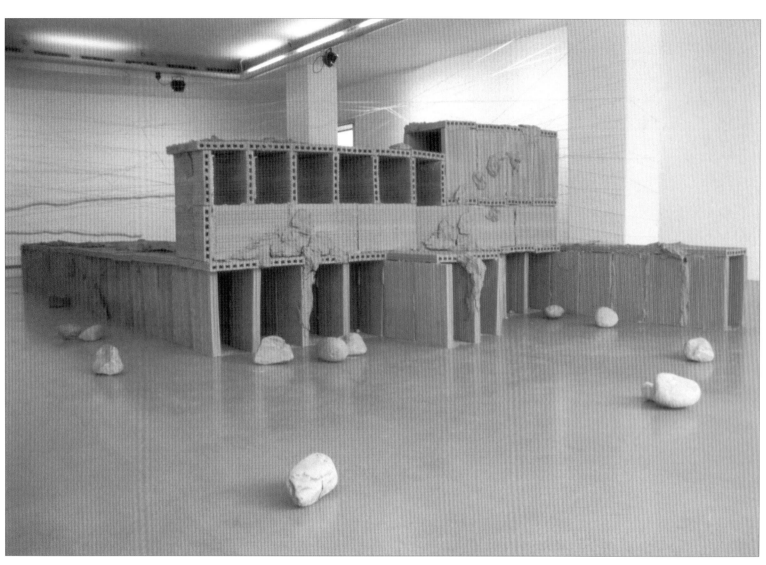

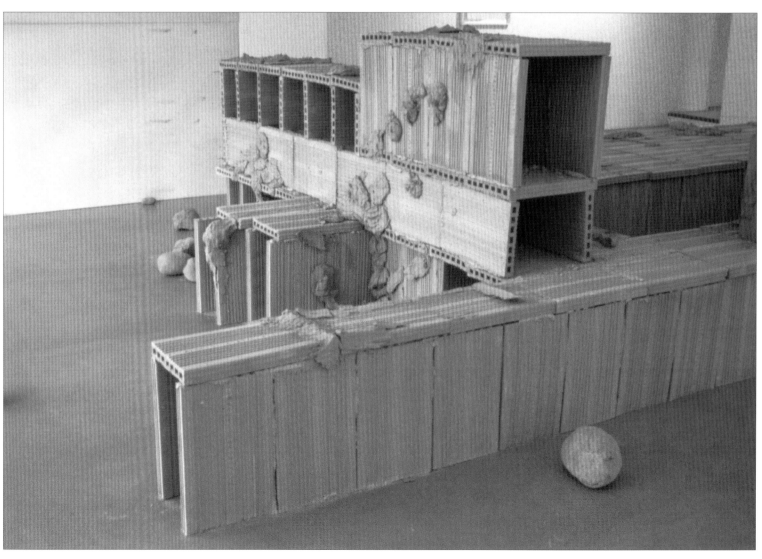

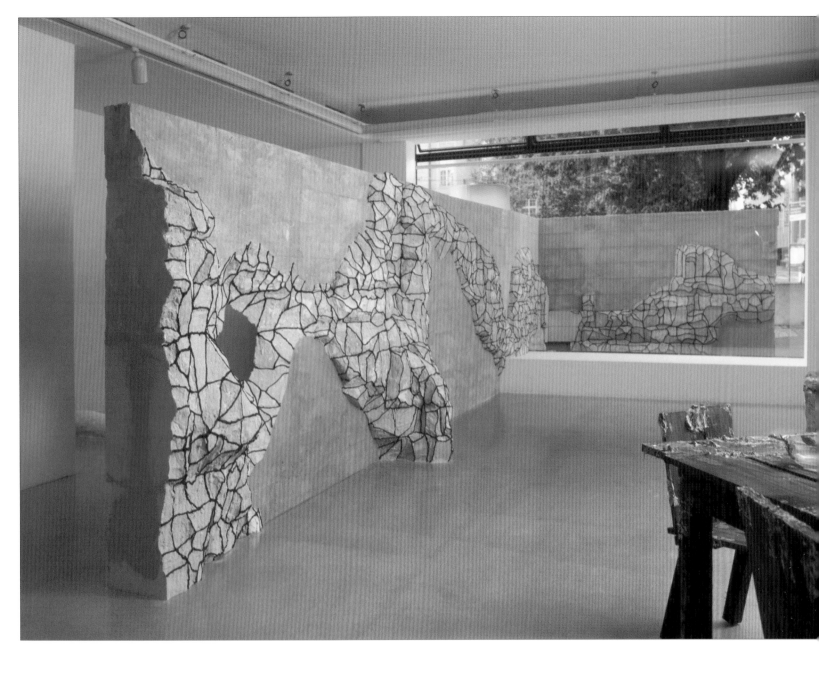

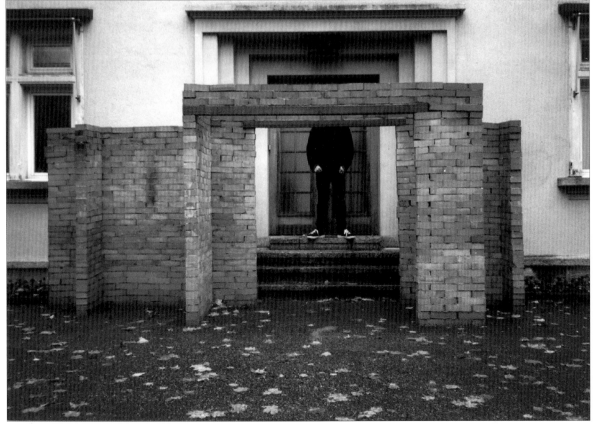

Untitled
1997
Bricks, mortar, wooden beams
Dimensions unknown
Installation view, "été 97," Centre d'édition
contemporaine (formerly Centre Genevois
de Gravure Contemporain), Geneva, 1997

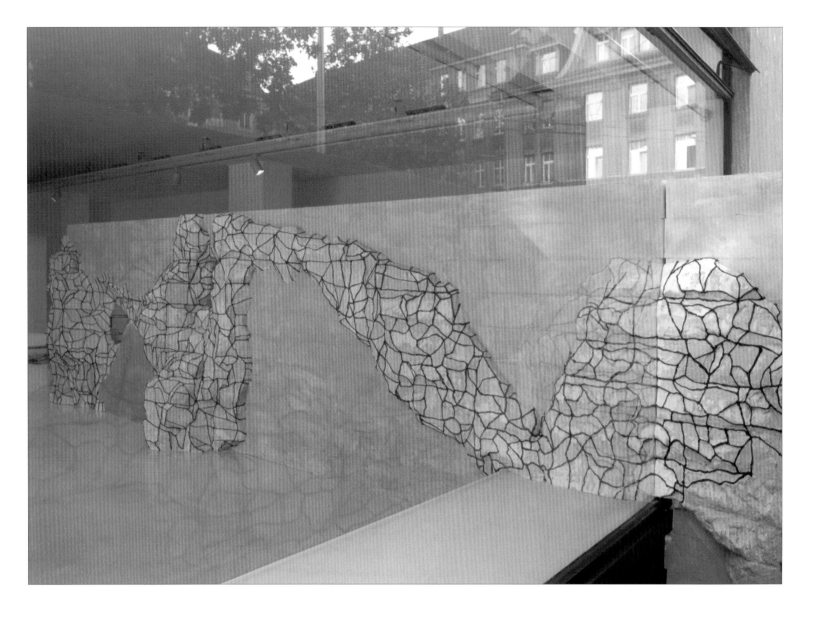

This page and opposite top:

Untitled (Wand der Angst)
1997
Aerated concrete, mortar, silicone, coffee
320 x 830 x 203 cm; 126 x 326 ¾ x 79 ⅞ in.
Installation view, "Hammer," Galerie
Walcheturm, Zurich, 1997

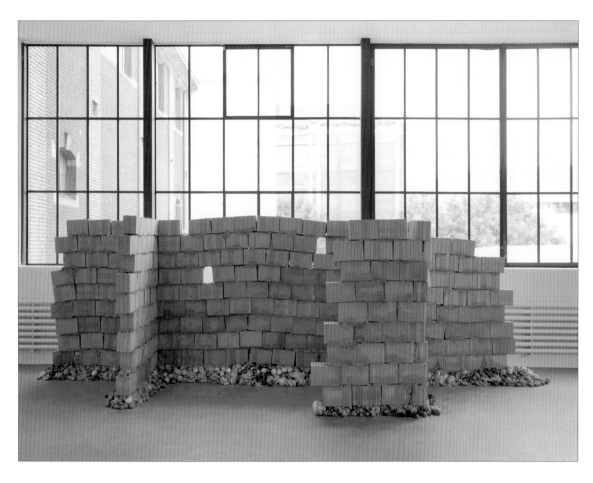

Rotten Foundation
1998
Bricks, mortar, fruits, vegetables
Dimensions variable
Installation view, "ironisch / ironic:
maurizio cattelan, urs fischer, alicia
framis, steve mcqueen, aernout mik /
marjoleine boonstra," Migros Museum für
Gegenwartskunst, Zurich, 1998

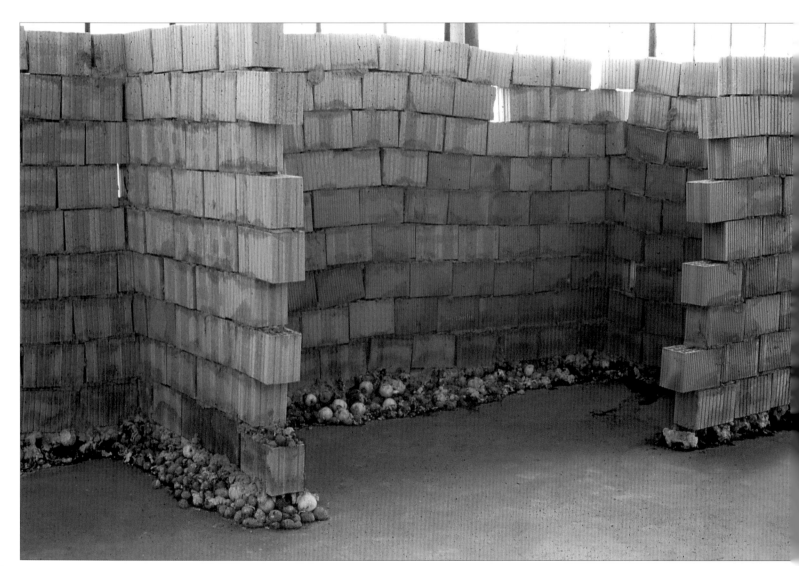

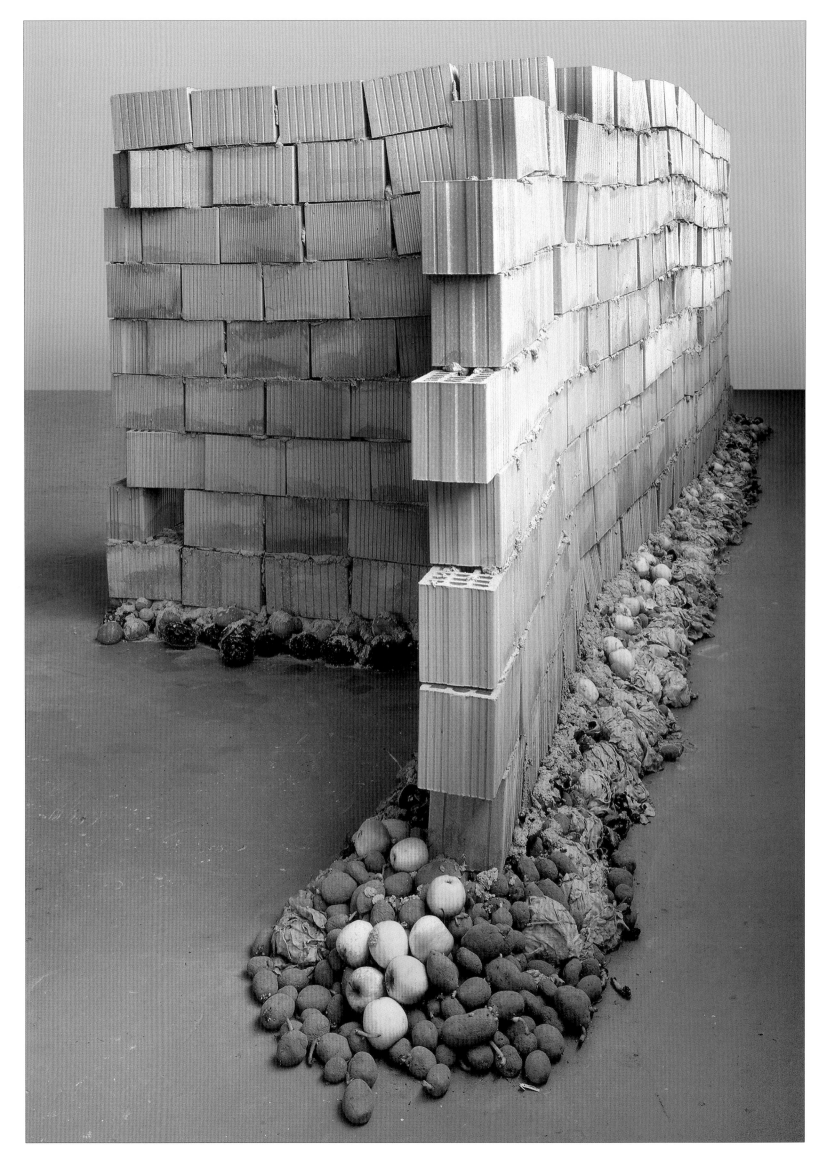

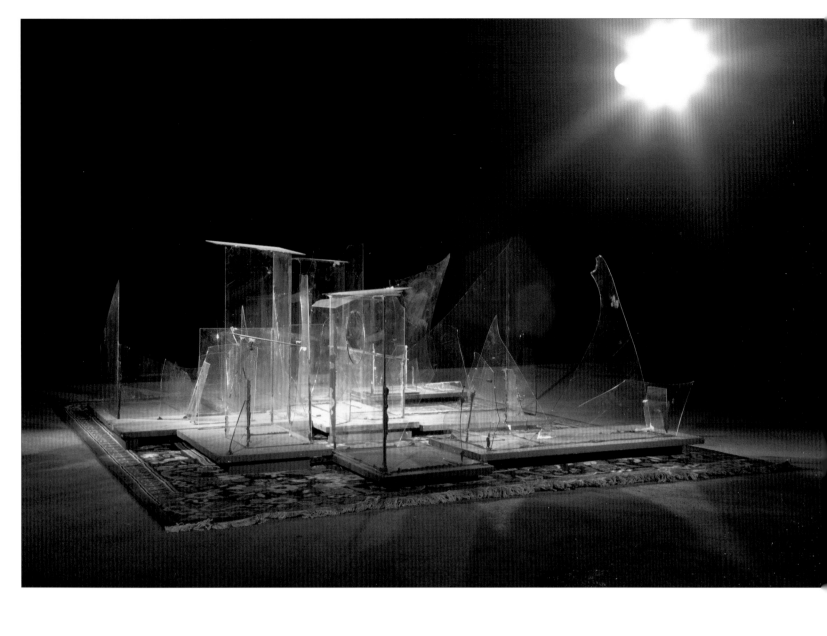

Glaskatzen—Mülleimer der Hoffnung
1999
Carpet, wood, glass, silicone (casts of room corners),
acrylic paint
Approx. 100 x 385 x 270 cm; 39 ⅛ x 151 ⅝ x 106 ¼ in.

Opposite page:

Installation view, "Espressoqueen—Worries and other
stuff you have to think about before you get ready for
the big easy," Galerie Hauser & Wirth & Presenhuber,
Zurich, 1999
Bottom, foreground to background: *Glaskatzen—Mülleimer
der Hoffnung*, 1999; *Stormy Weather*, 1999; *Köpfe (Heads)*,
1997–1999; *Schwerelosigkeit*, 1998–1999

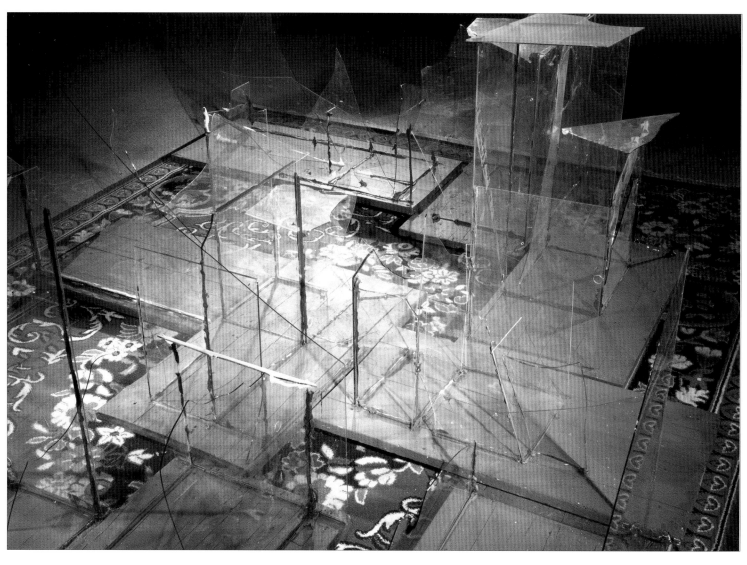

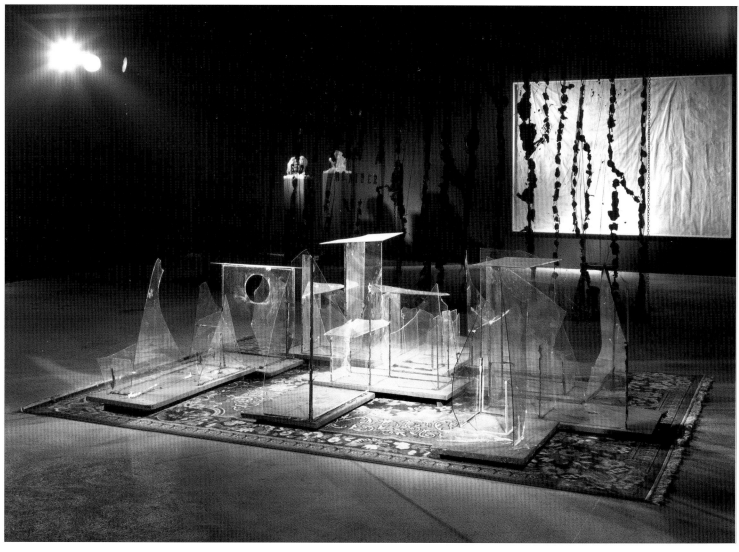

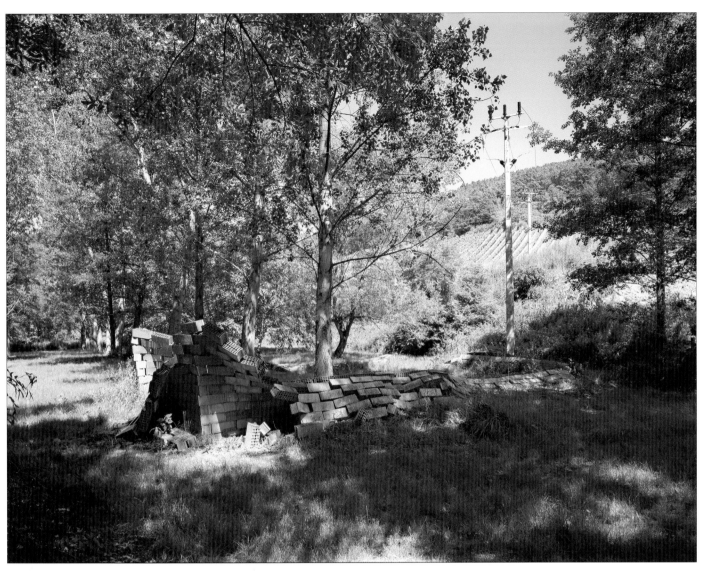
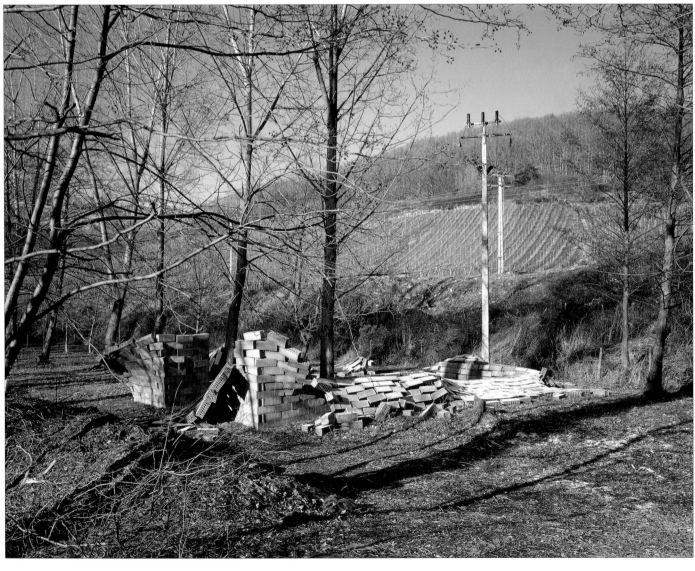

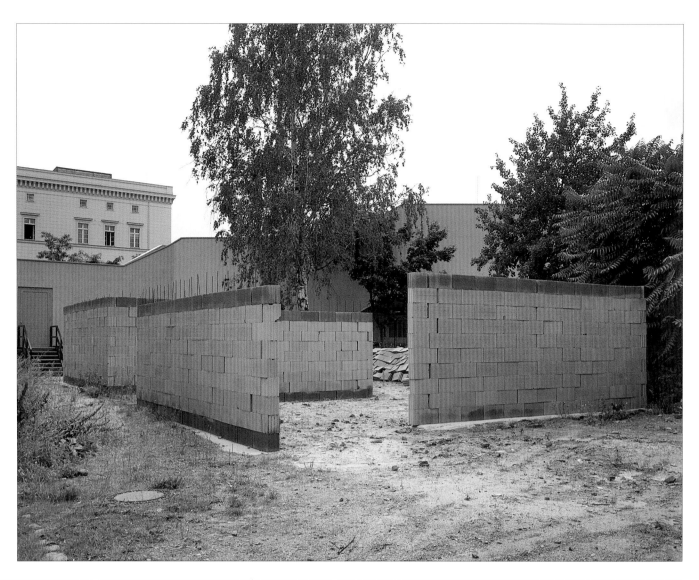

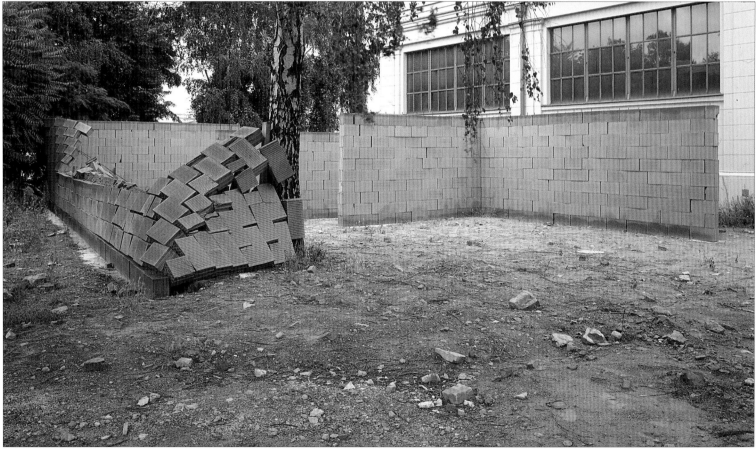

Opposite page:

Installation view, *Baked Master's Basket*
Private Collection, Alsace, France, 1999

Baked Master's Basket
1999
Concrete foundation, rebar, bricks
Dimensions variable
Installation view, "Urs Fischer. Werke aus der Friedrich Christian Flick Collection im
Hamburger Bahnhof," Hamburger Bahnhof, Museum für Gegenwart, Berlin, 2005

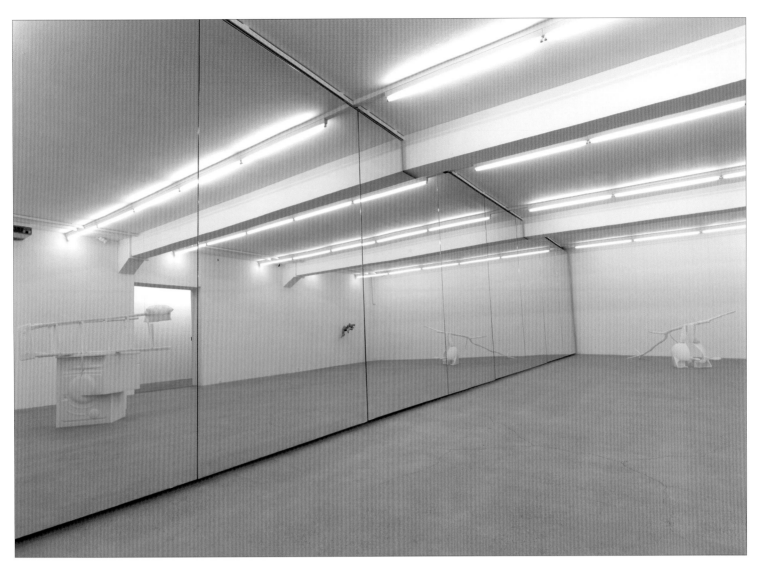

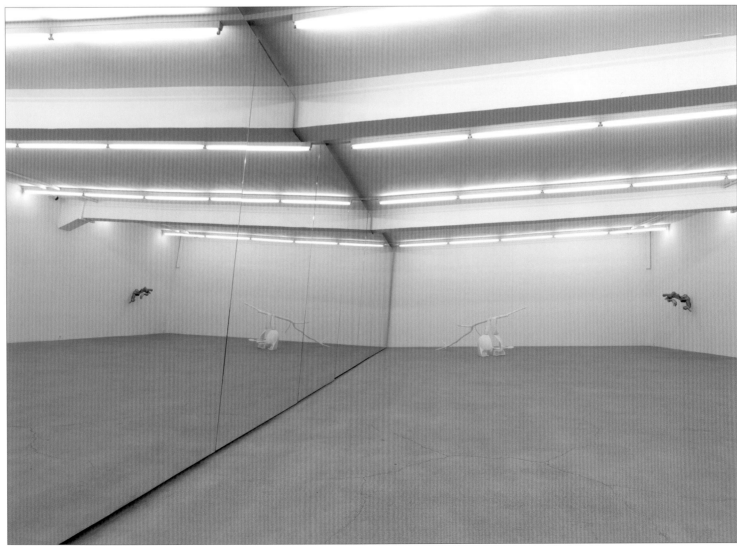

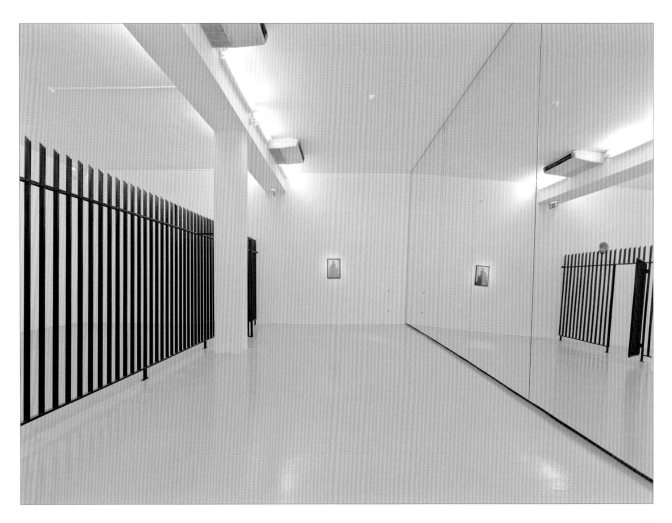

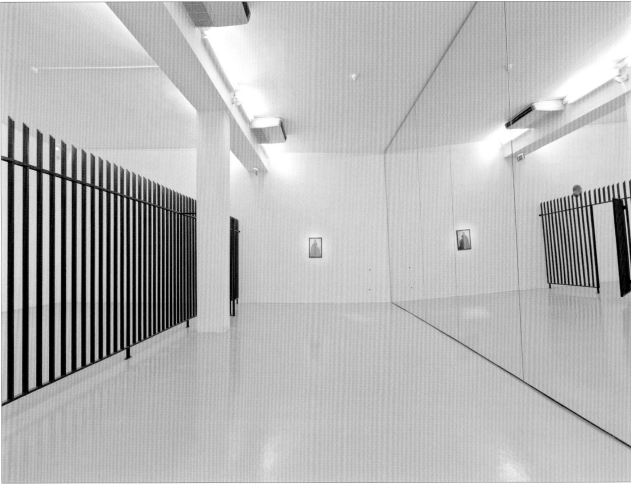

Death of a Moment
2007
Mirrors tilt back and forth in a wavelike pattern
Mirrors, aluminum, hydraulics, control unit
Dimensions variable
Installation view, "large, dark & empty," Galerie Eva Presenhuber, Zurich, 2007
Top, reflected in mirror: *Thank You Fuck You*, 2007
Bottom, left to right: *Fuck You Thank You*, 2007; *The Grass Munchers*, 2007

This page and following:

Installation view, "Fractured Figure: Works from the
Dakis Joannou Collection," Deste Foundation Centre for
Contemporary Art, Athens, 2007–2008
Death of a Moment, 2007
This page, left to right: Poka-Yio, *Self-Decapitated*, 2005;
Roberto Cuoghi, *Untitled (Lady Godzilla)*, 2004

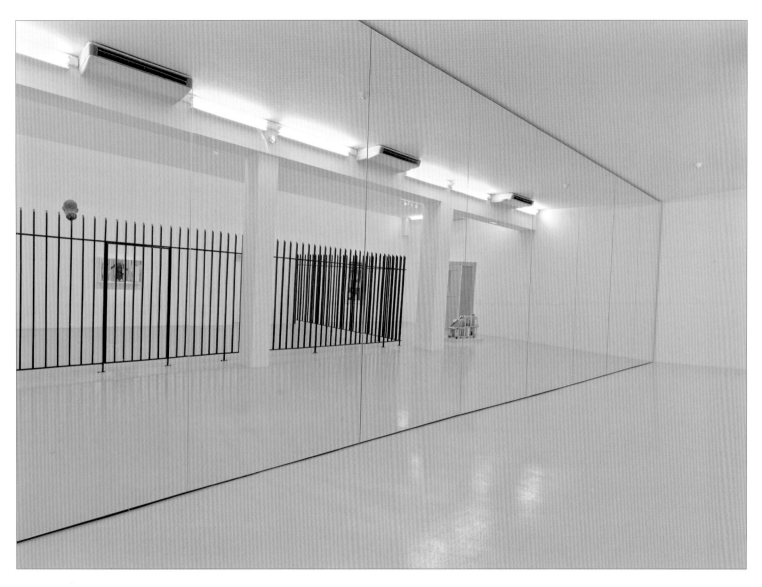

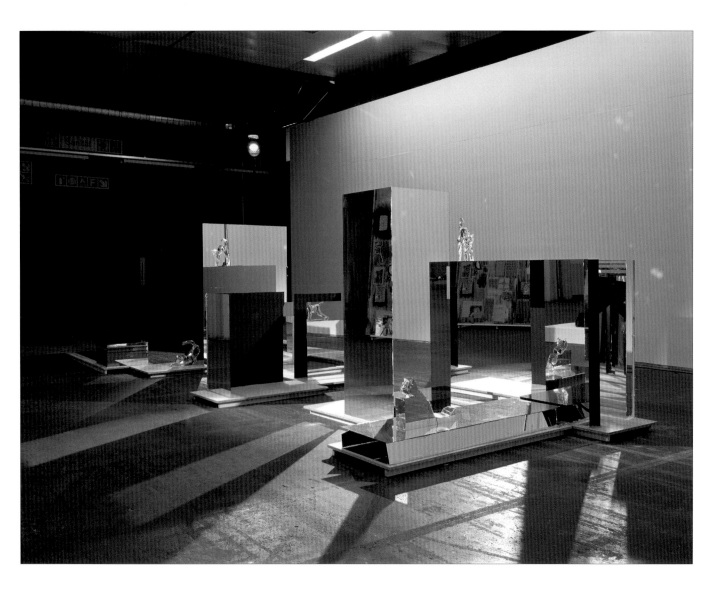

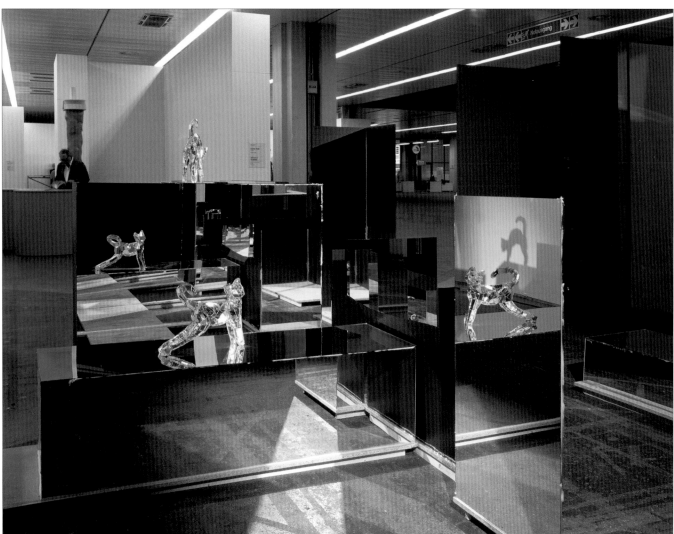

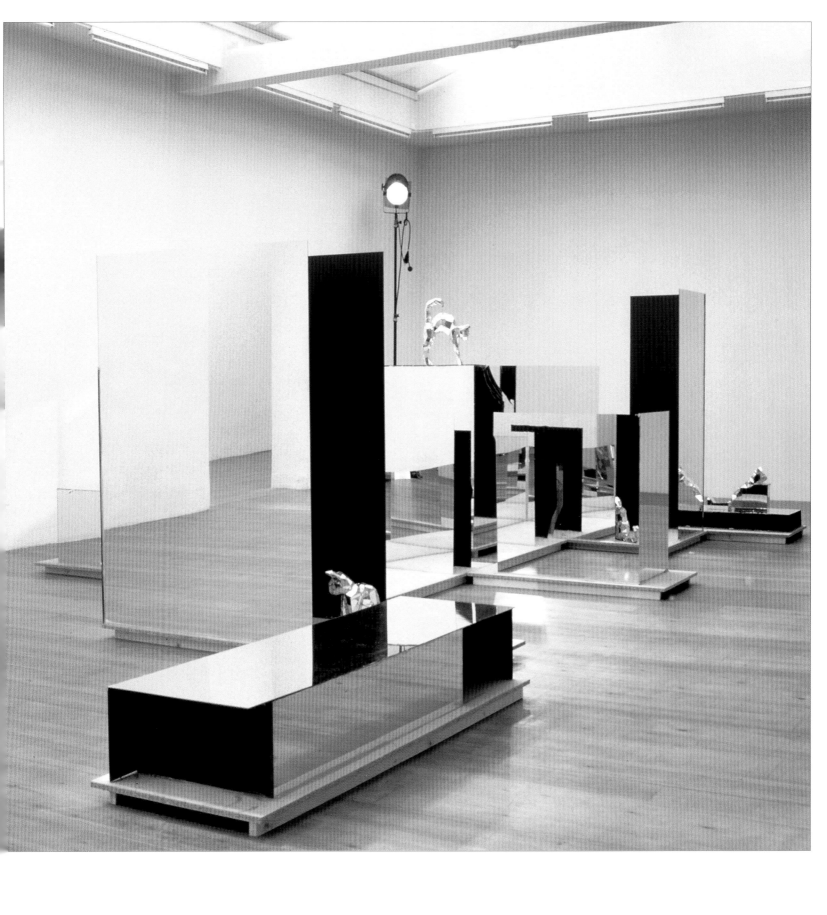

Installation view, Art Unlimited, Art Basel, 1999
Dr. Katzelberg (Zivilisationsruine), 1999

Dr. Katzelberg (Zivilisationsruine)
1999
Mirrors, wood, polystyrene, silicone, three theatrical
spotlights on tripods
210 x 500 x 350; 82 ⅝ x 196 ⅞ x 137 ¼ in.
Installation view, "The Membrane—and why I don't
mind bad-mooded People," Stedelijk Museum Bureau
Amsterdam, 2000

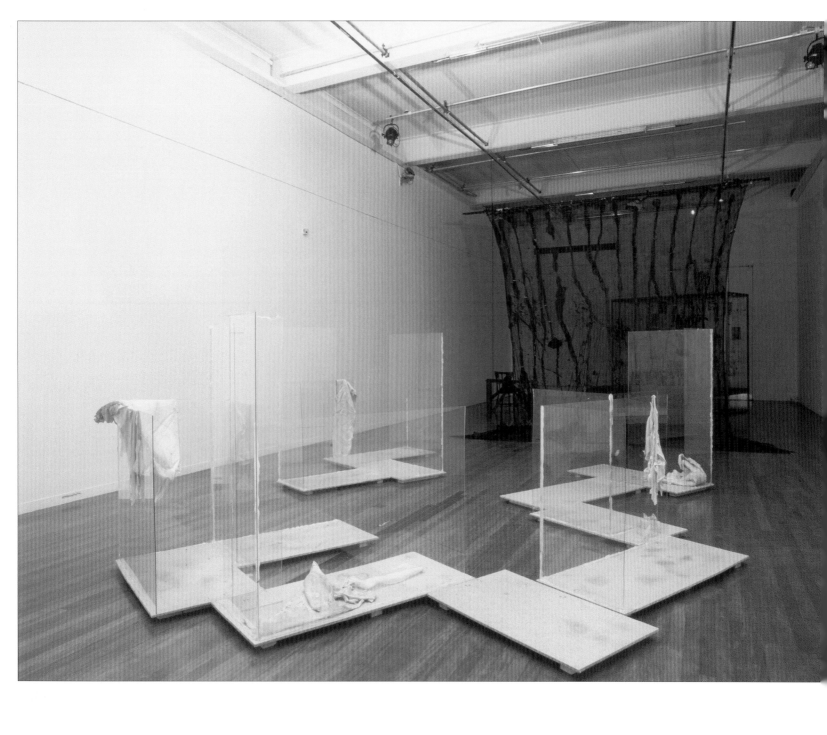

Glaskatzensex / Transparent Tale
2000
Particleboard, wood, silicone (casts of room corners),
glass, acrylic paint, marker
158 x 560 x 600 cm; 62 ¼ x 220 ½ x 236 ¼ in.
Installation view, "Without a Fist—Like a Bird,"
Institute of Contemporary Arts, London, 2000
Background: *Remembering the Polyester Pirate (Instant
Apathy)*, 2000

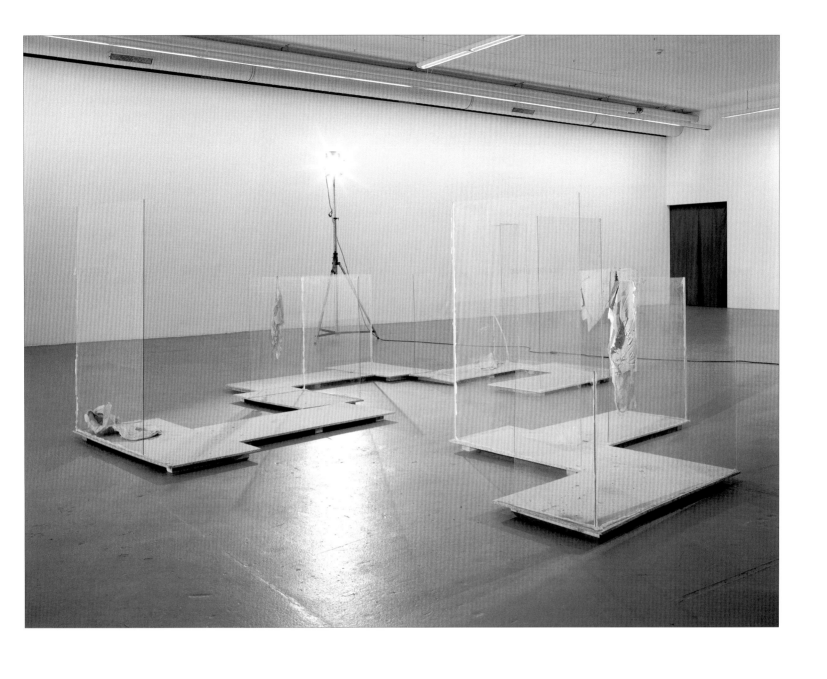

Installation view, "Bewitched, Bothered and Bewildered:
Spatial Emotion in Contemporary Art and Architecture,"
Migros Museum für Gegenwartskunst, Zurich, 2003
Glaskatzensex / Transparent Tale, 2000

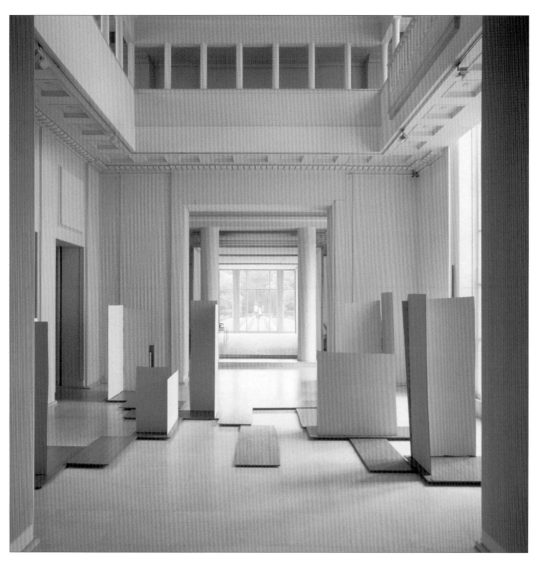

Almonds in Comparison
2001
Mixed media
Dimensions variable
Installation view, "Squatters,"
Museu Serralves, Porto, Portugal, 2001

Opposite page:

Mastering the Corner
from the portfolio *Thinking about Störtebeker*
2005

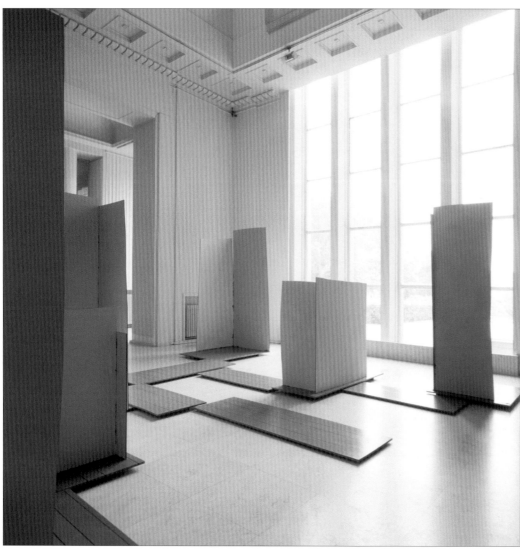

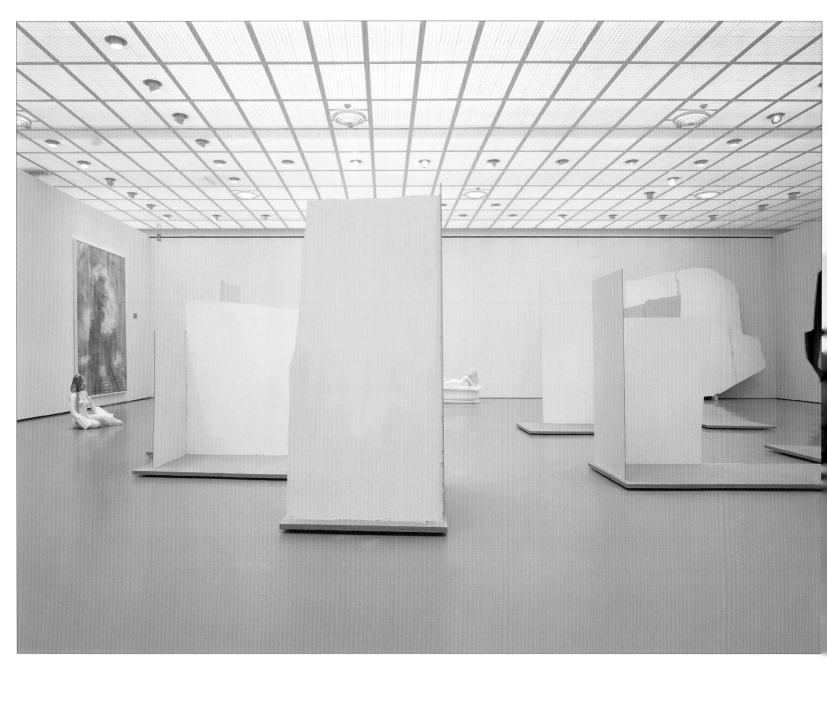

Peanuts in Comparison (Erdnüsse im Vergleich)
2004
MDF, aluminum, construction adhesive, acrylic paint,
acrylic lacquer
11 parts: 265 x 1000 x 900 cm; 104 ⅜ x 393 ¼ x 354 ⅜ in.
Installation view, "Kir Royal," Kunsthaus Zürich, 2004

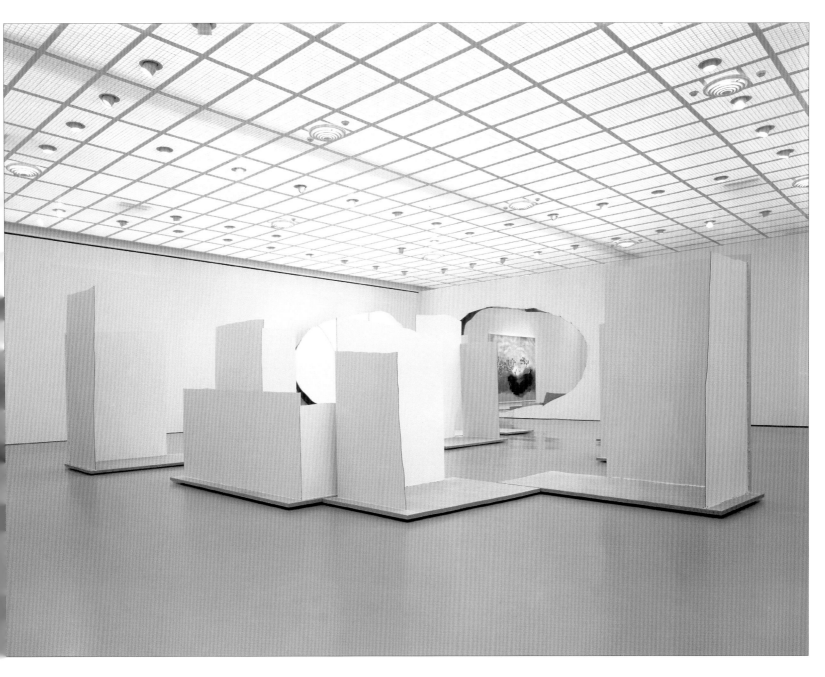
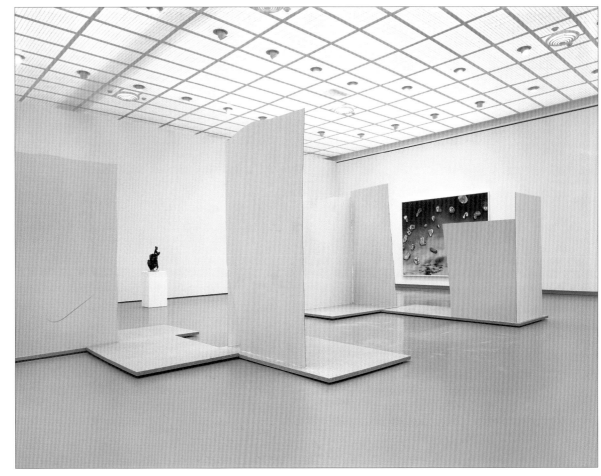

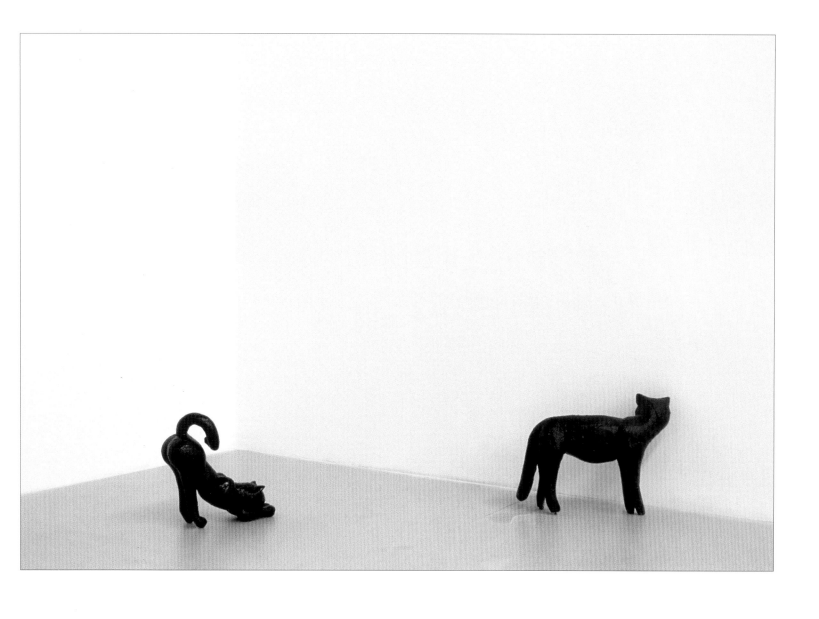

The Cat with the Broken Leg or The Cat Who Laid the Golden Egg
2000
Polystyrene, plaster, oil paint, acrylic paint, filler, screws
Dimensions variable

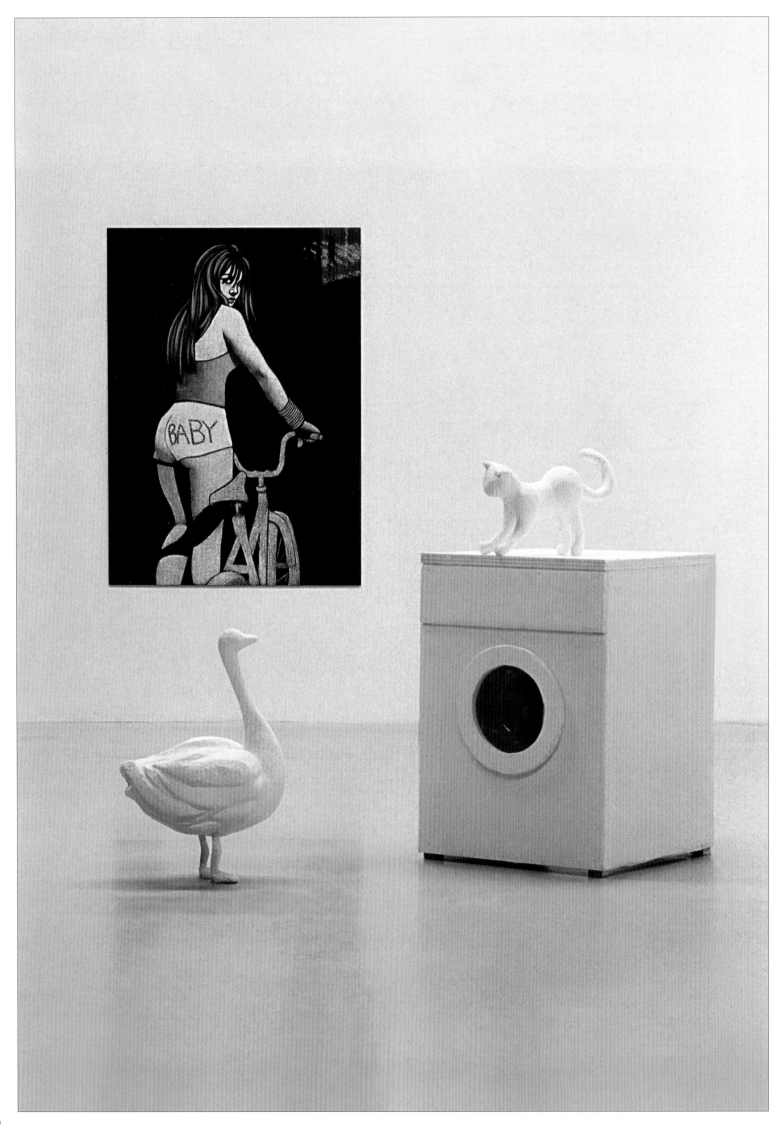

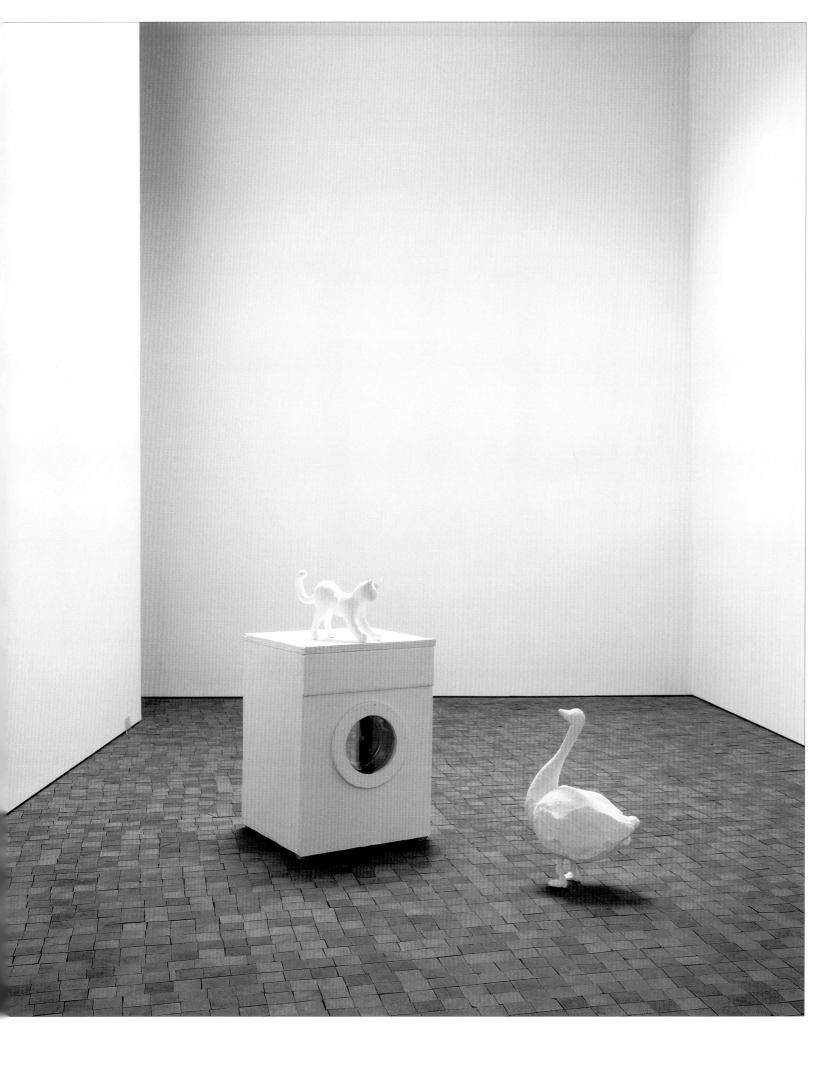

Installation view, "Cappillon—Urs just does it for the girls"
(with Amy Adler), Delfina, London, 2000
Foreground: *Cappillon*, 2000
Background: Amy Adler, *Different Girls*, 2000

Cappillon
2000
Wood, plaster, polystyrene, filler, latex paint, glass, cast tin
115 x 90 x 172 cm; 45 ¼ x 35 ⅛ x 67 ¼

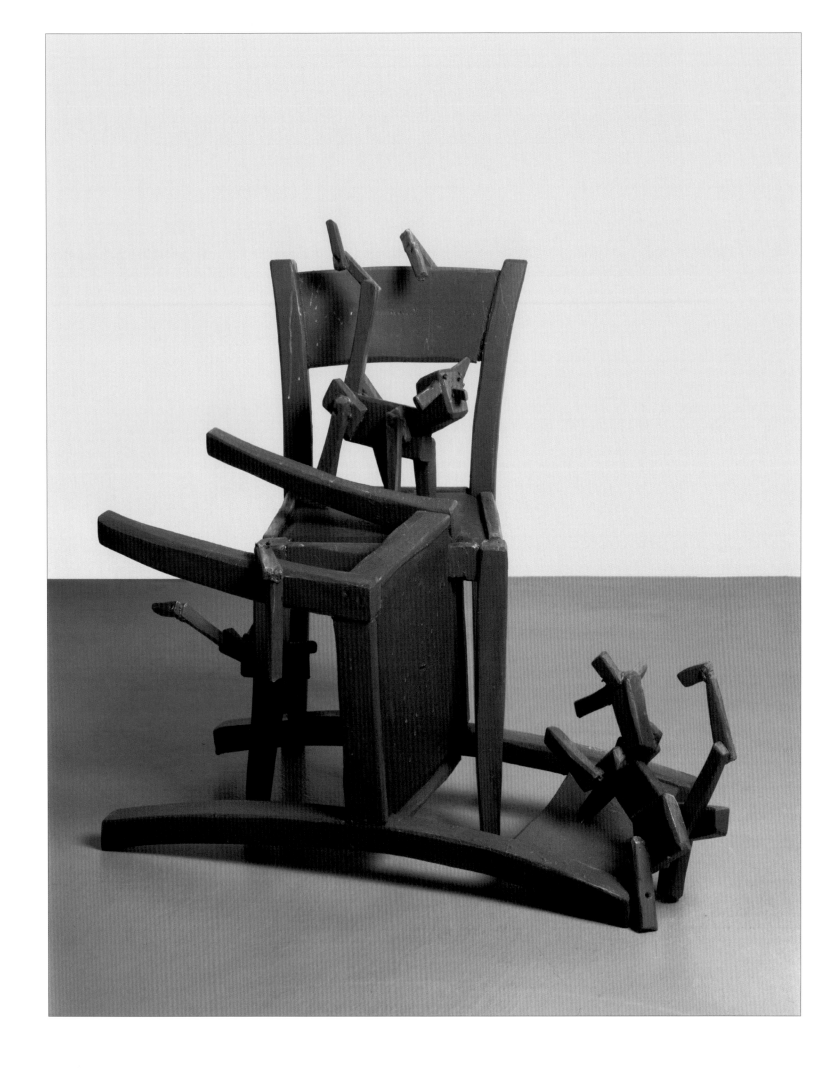

Hotel
2001
Polyurethane foam, acrylic foam, wood,
nails, screws
85 x 45 x 85 cm; 33 ½ x 17 ¼ x 33 ½ in.

Cutting a Cake with a Hammer
2000
Wood, polystyrene, latex paint, spotlight,
enamel paint, filler, nails, screws
110 x 70 x 70 cm; 43 ¼ x 27 ½ x 27 ½ in.

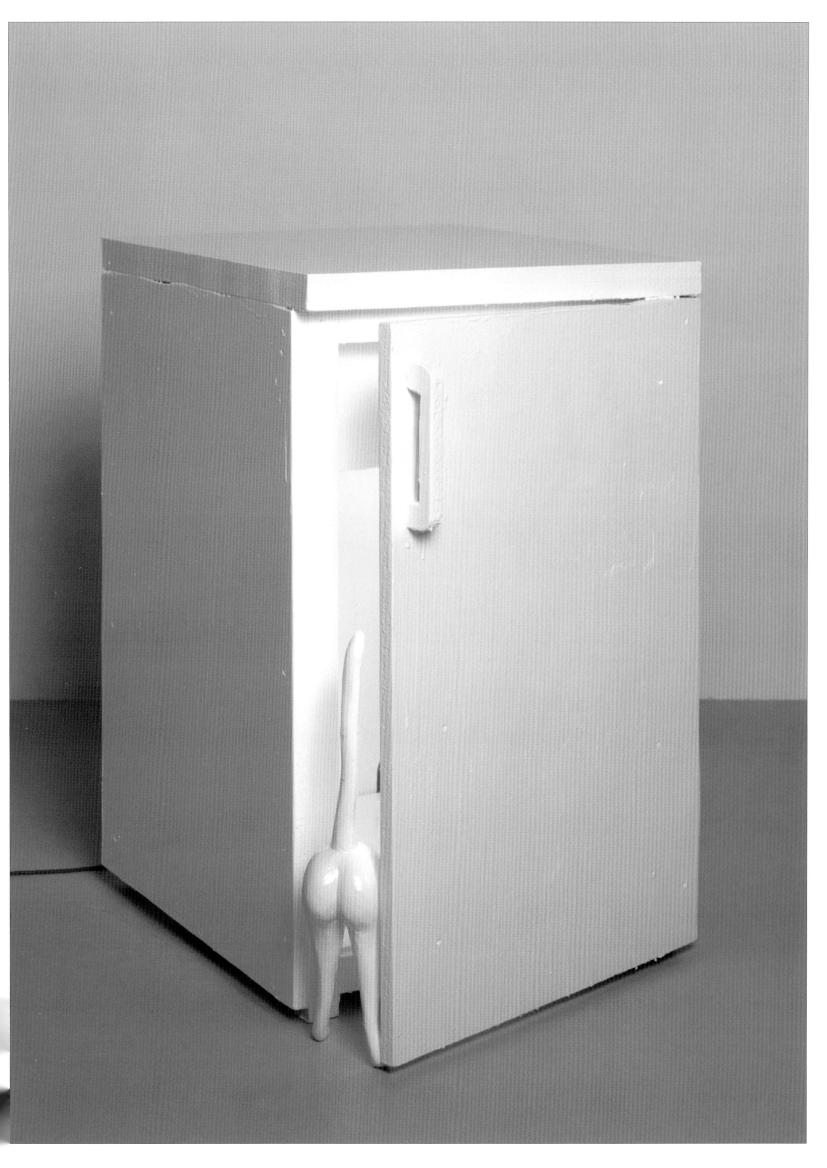

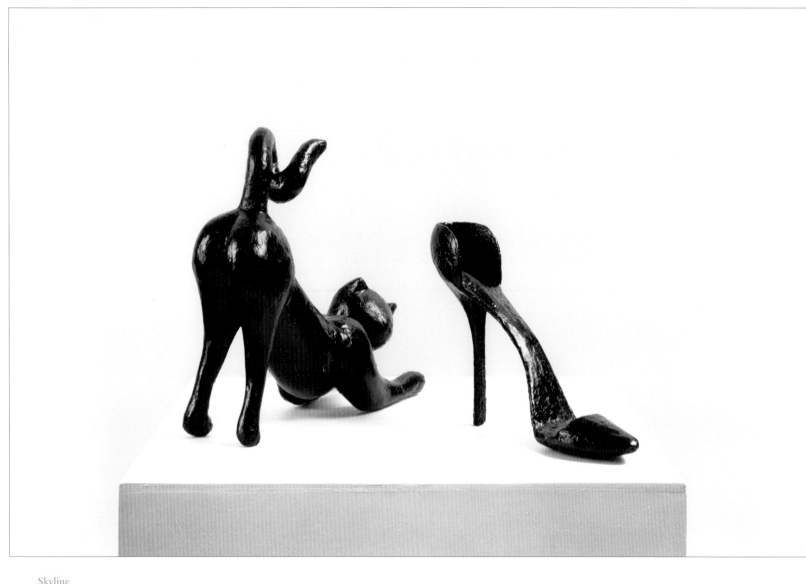

Skyline
2002
Cast bronze, acrylic paint
28 x 44.5 x 49 cm; 11 x 17 ½ x 19 ¼ in.

Walking Heads / Thinking Feet
2002
Polystyrene, polyurethane foam, acrylic paint, latex paint, screws
56 x 19 x 15 cm; 22 x 7 ½ x 5 ⅞ in.
Installation view, "Lowland Lullaby: Ugo Rondinone with John
Giorno and Urs Fischer," Swiss Institute, New York, 2002
On wall, left to right: drawing from *Scenes from the Internal
Backdrops*, 2000; drawing from *I Get a Heater*, 2001; drawing from
Geige, 2001
On floor: Ugo Rondinone, *Lowland Lullaby*, 2002

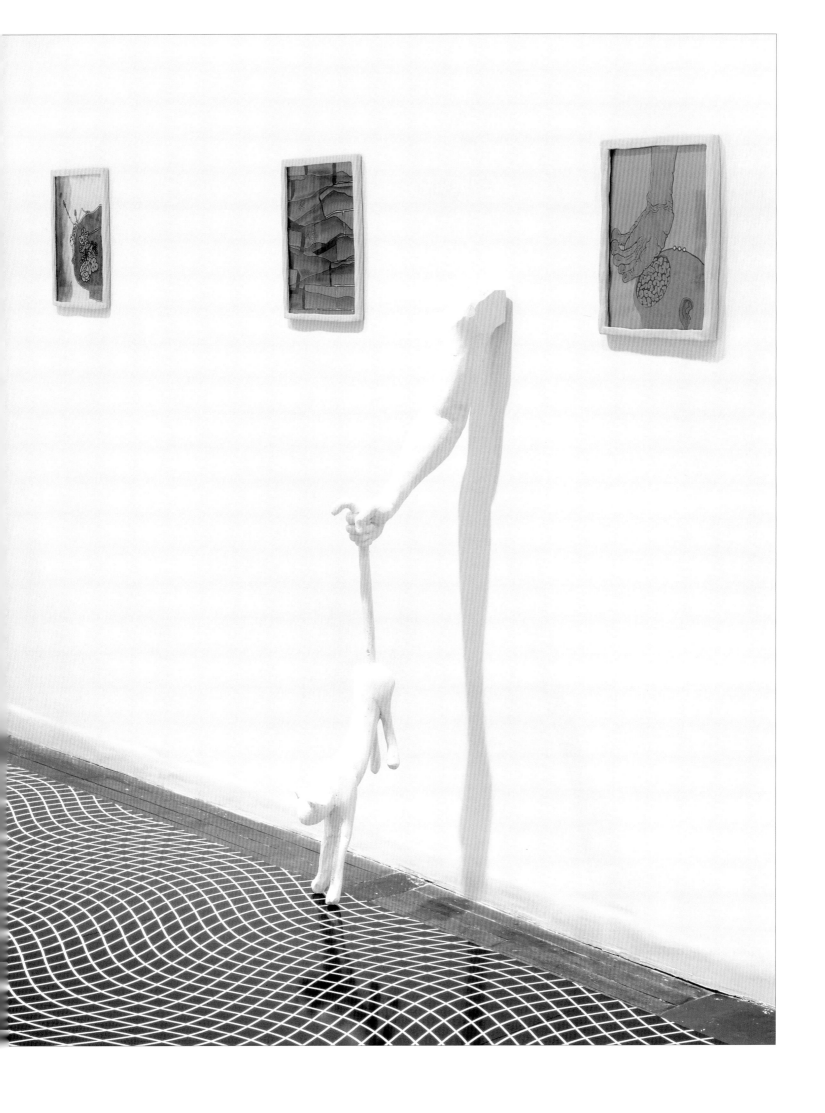

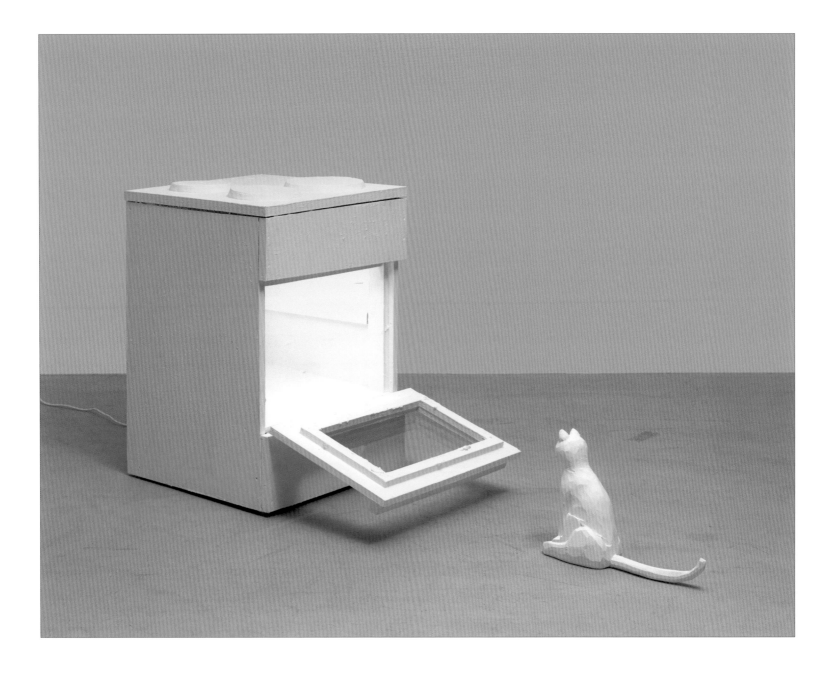

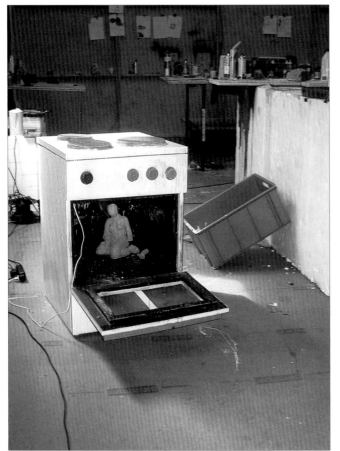

Mr. Flosky
2001–2002
Wood, latex paint, lamp, cable, plaster, polystyrene, glass, glue, screws
Stove: 98.5 x 105 x 59 cm; 38 ¼ x 41 ⅜ x 23 ¼ in.
Cat: 33.5 x 46 x 14.5 cm; 13 ¼ x 18 ⅛ 5 ¼ in.

Studio view, *Mr. Flosky*, Hardturmstrasse, Zurich, 2001

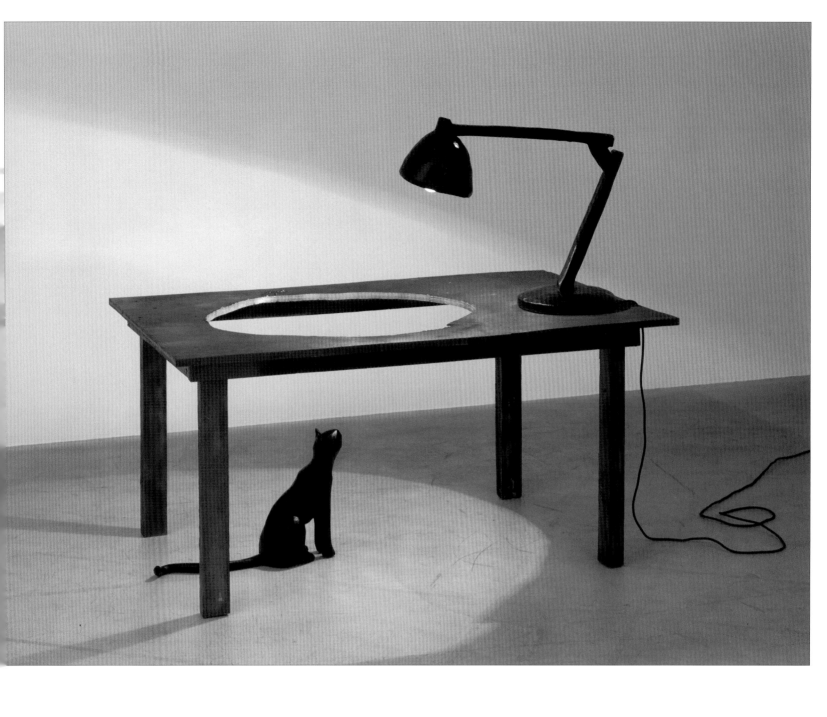

Daylight Pillow
2004
Aluminum, acrylic paint, light bulb,
socket, electric cable
125 x 140 x 94 cm; 49 ¼ x 55 ⅛ x 37 in.

Page 98:

Untitled (Self-destroying Cat)
2009
Unfired clay
Dimensions variable
Installation view, Slottsparken, Oslo, 2009

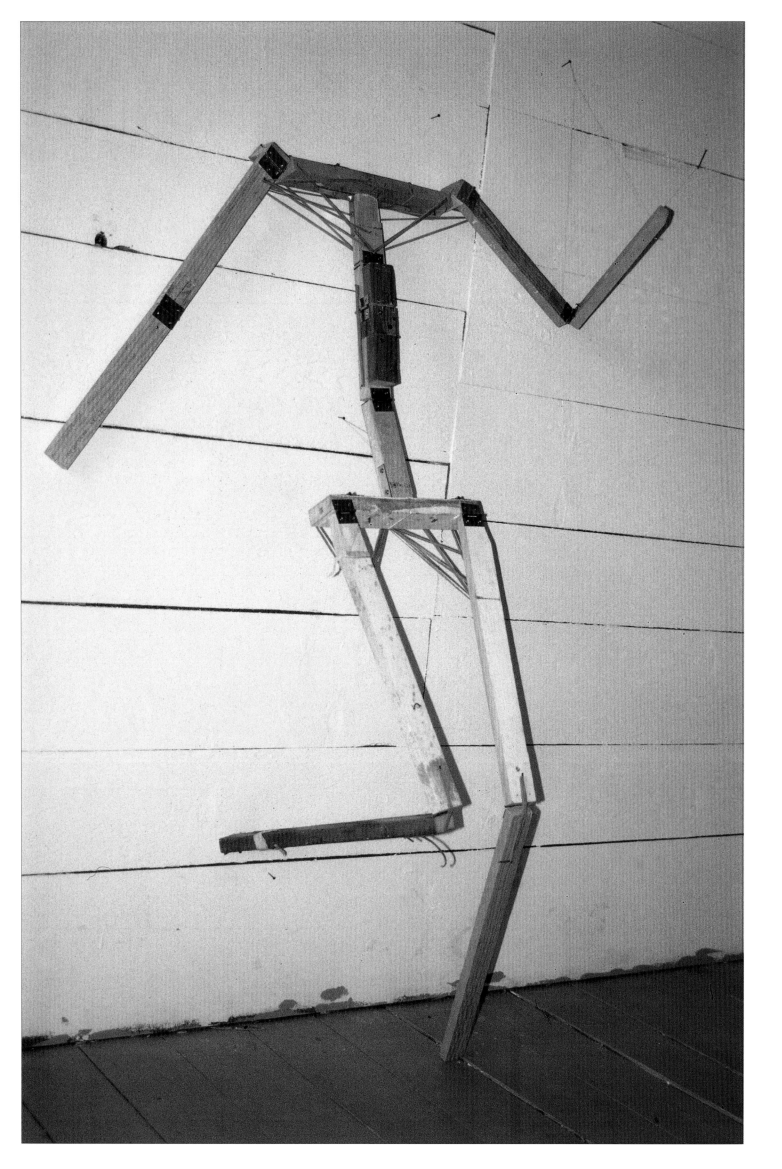

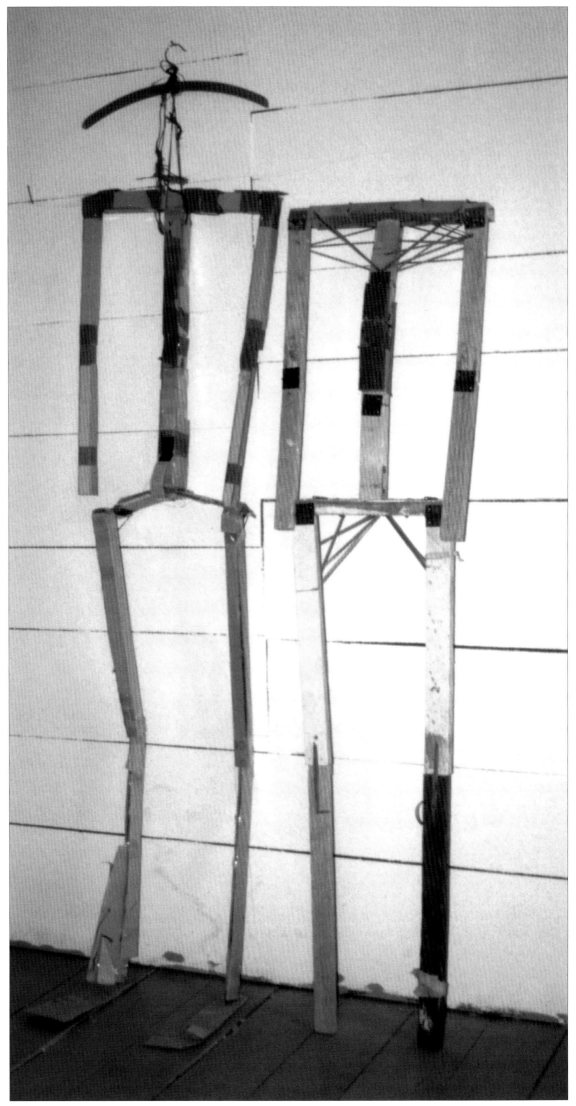

Untitled
1995
Cardboard, wood, rubber bands, hinges, coat
hanger, string, screws, tape
Dimensions unknown
Studio view of destroyed works

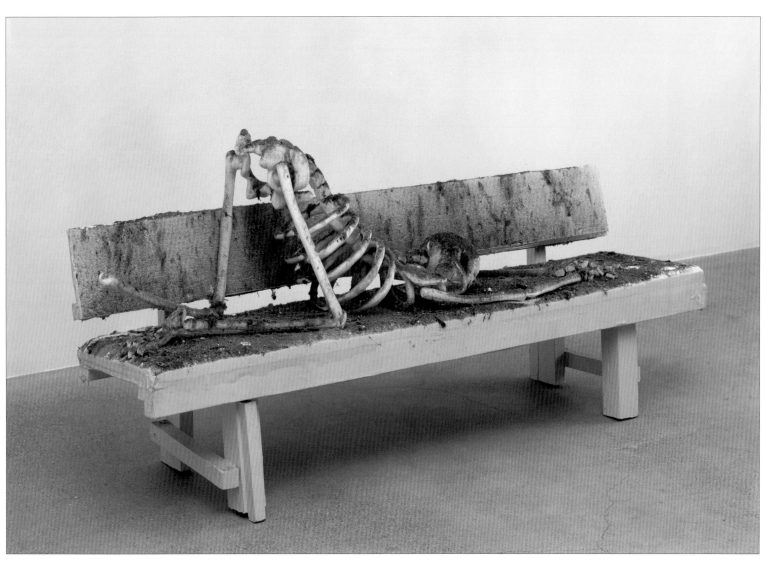

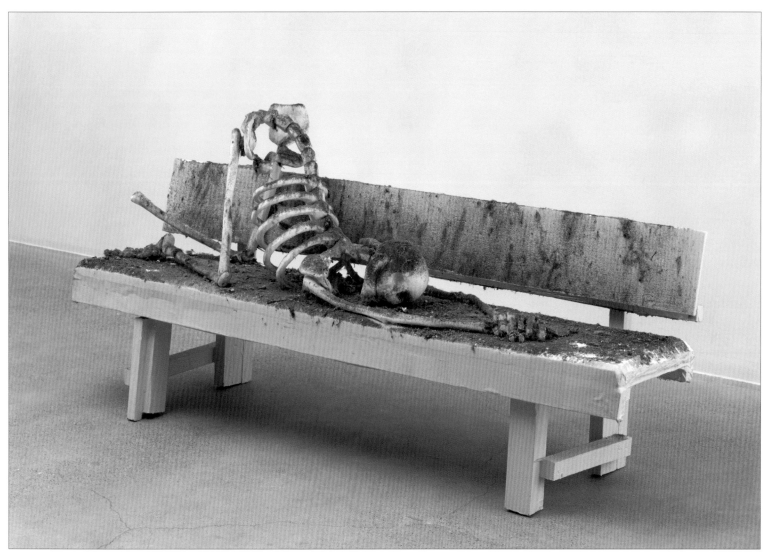

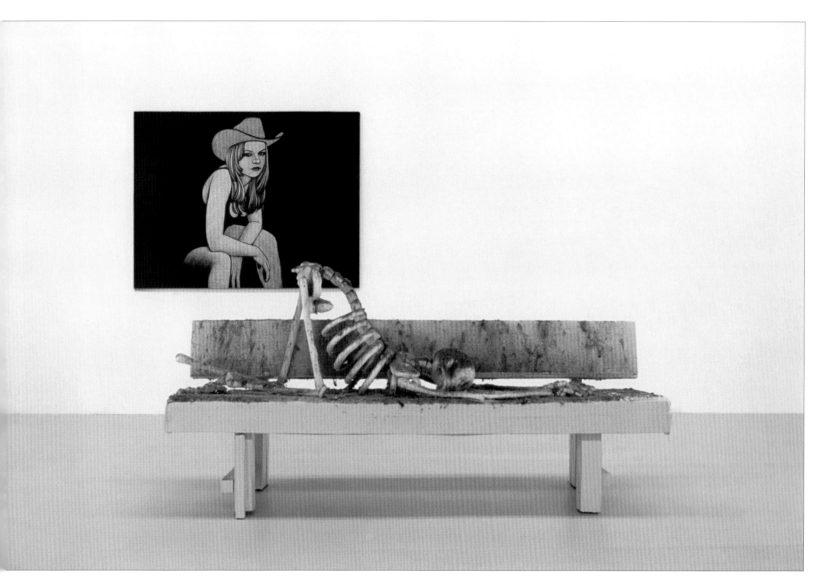

Installation view, "Cappillon—Urs just does it for the girls"
(with Amy Adler), Delfina, London, 2000
Foreground: *Skinny Sunrise*, 2000
Background: Amy Adler, *Different Girls*, 2000

Skinny Sunrise
2000
Polystyrene, wood, wood glue, dust, spray adhesive, flour,
acrylic paint, silicone, screws, fabric
70 x 120 x 70 cm; 27 ½ x 47 ¼ x 27 ½ in.

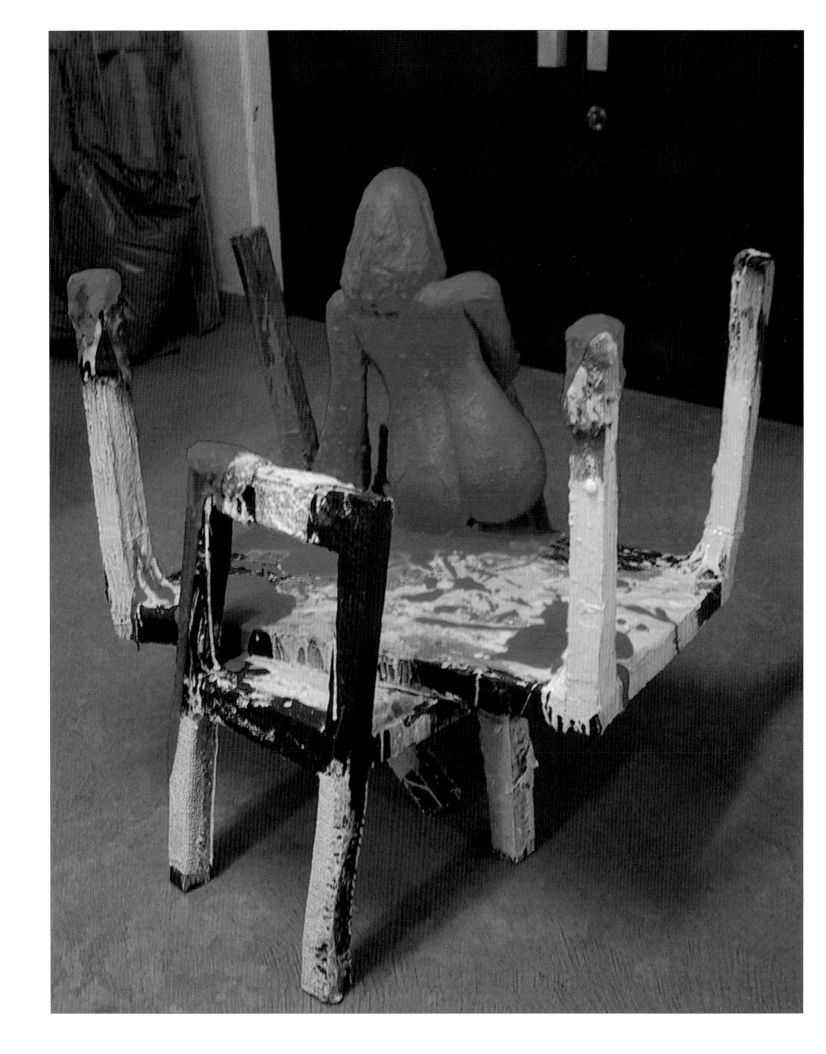

Untitled (Pink Lady)
2001
Polystyrene, polyurethane resin, polyurethane foam, oil paint,
acrylic paint, fluorescent pigments, sugar, egg whites, screws
100 x 100 x 150 cm; 39 ⅜ x 39 ⅜ x 59 in.
View at shipping company

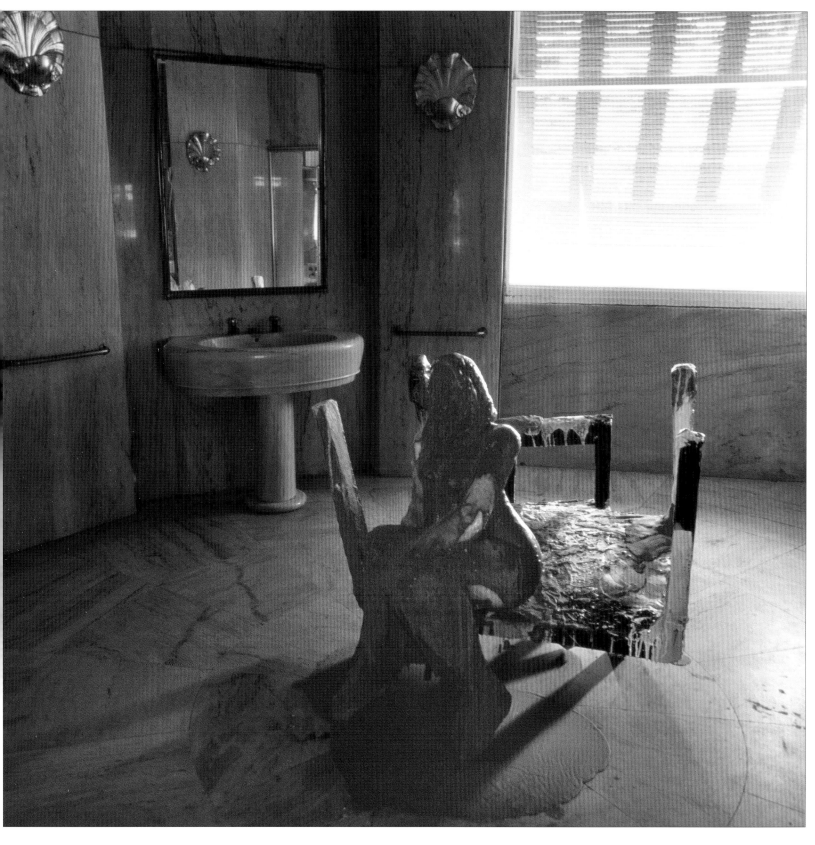

Installation view, "Squatters," Museu Serralves, Porto,
Portugal, 2001
Untitled (Pink Lady), 2001

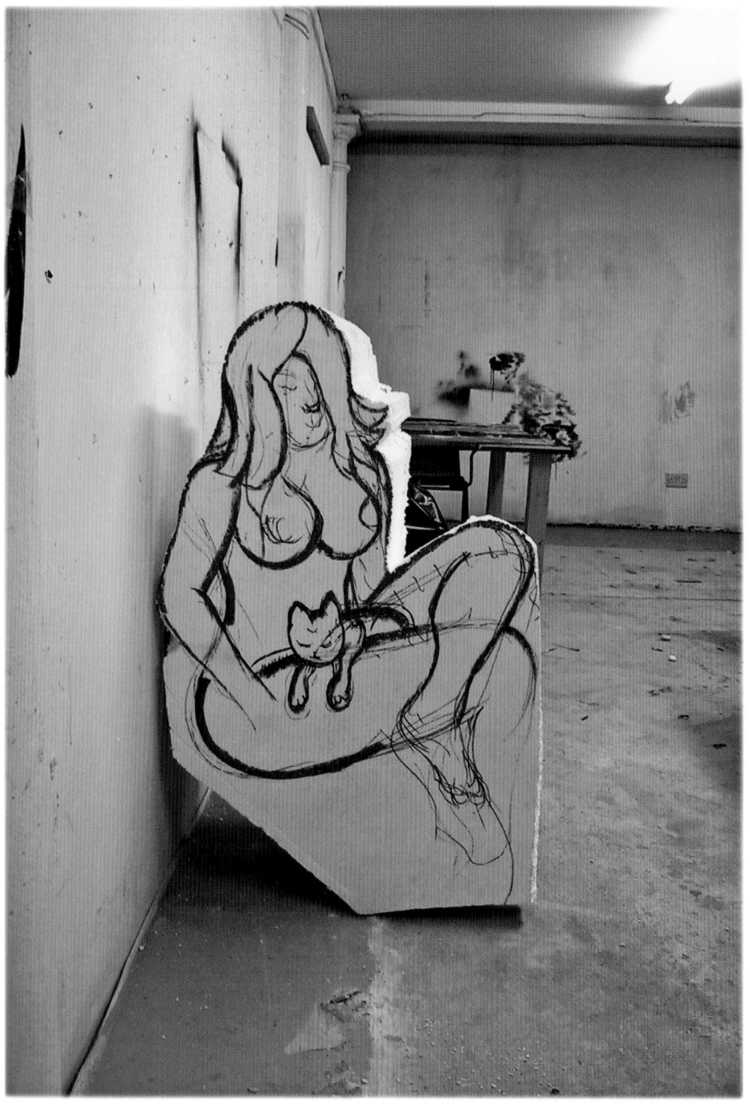

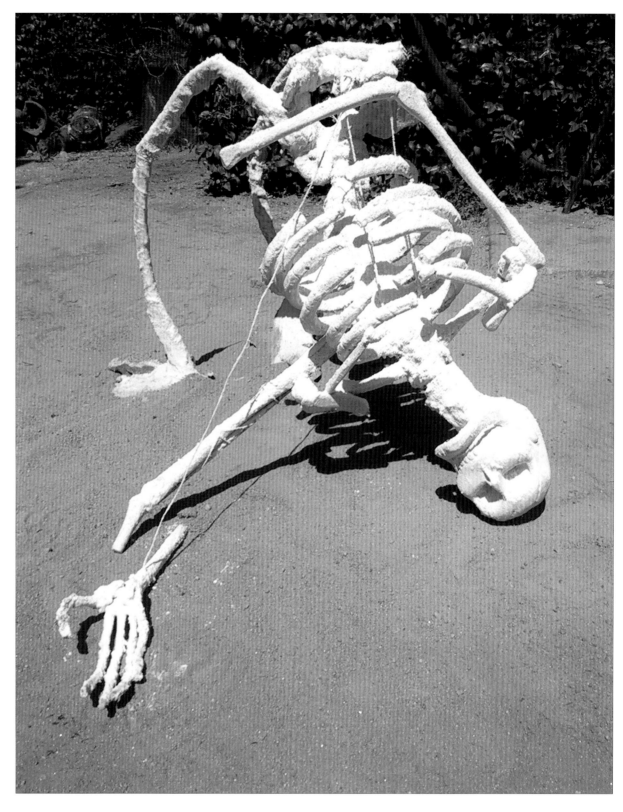

Untitled (Skinny)
2001
Polystyrene, epoxy, strings, screws
Dimensions unknown
Installation view, "Squatters,"
Museu Serralves, Porto, 2001

Installation view, "Squatters,"
Museu Serralves, Porto, 2001
Untitled (Skinny), 2001

Girl Foam Studio
from the portfolio *Thinking about Störtebeker*
2005

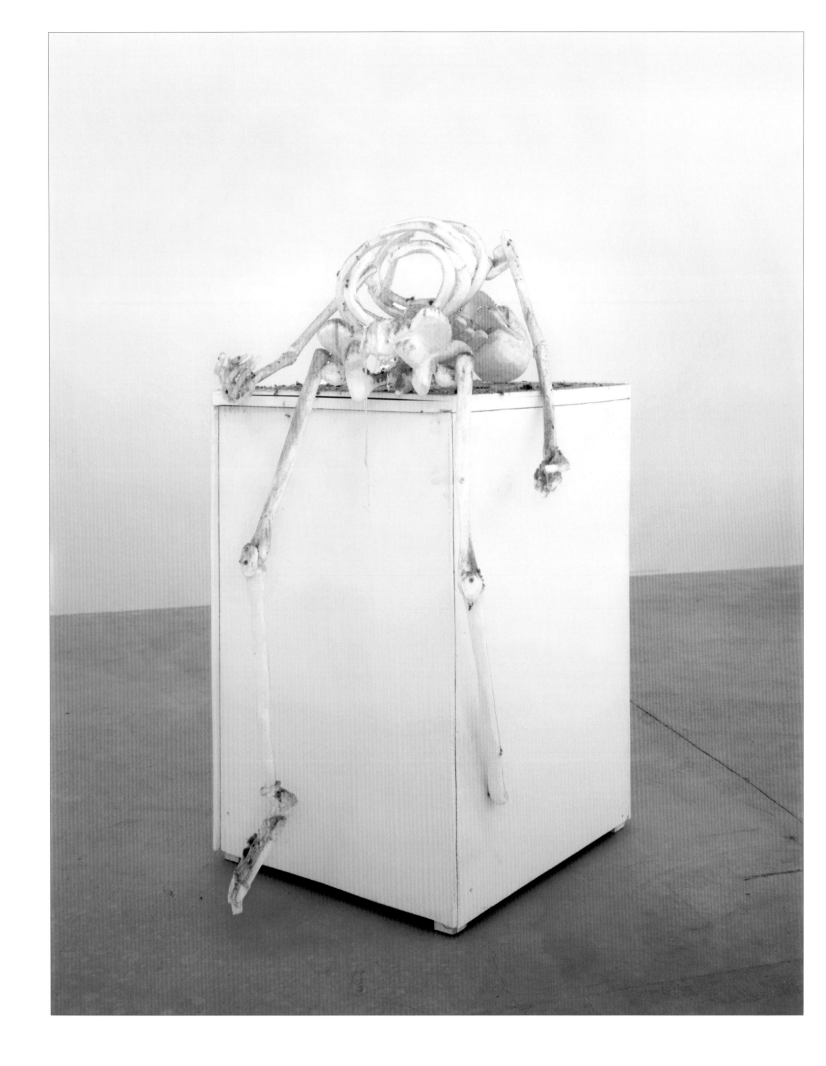

One More Carrot Before I Brush My Teeth
2001
Wood, polystyrene, polyurethane foam, particleboard, glass,
latex paint, silicone, pencil, spray adhesive, screws, dust, glue
131 x 81 x 97 cm; 51 ⅝ x 31 ⅞ x 38 ¼ in.

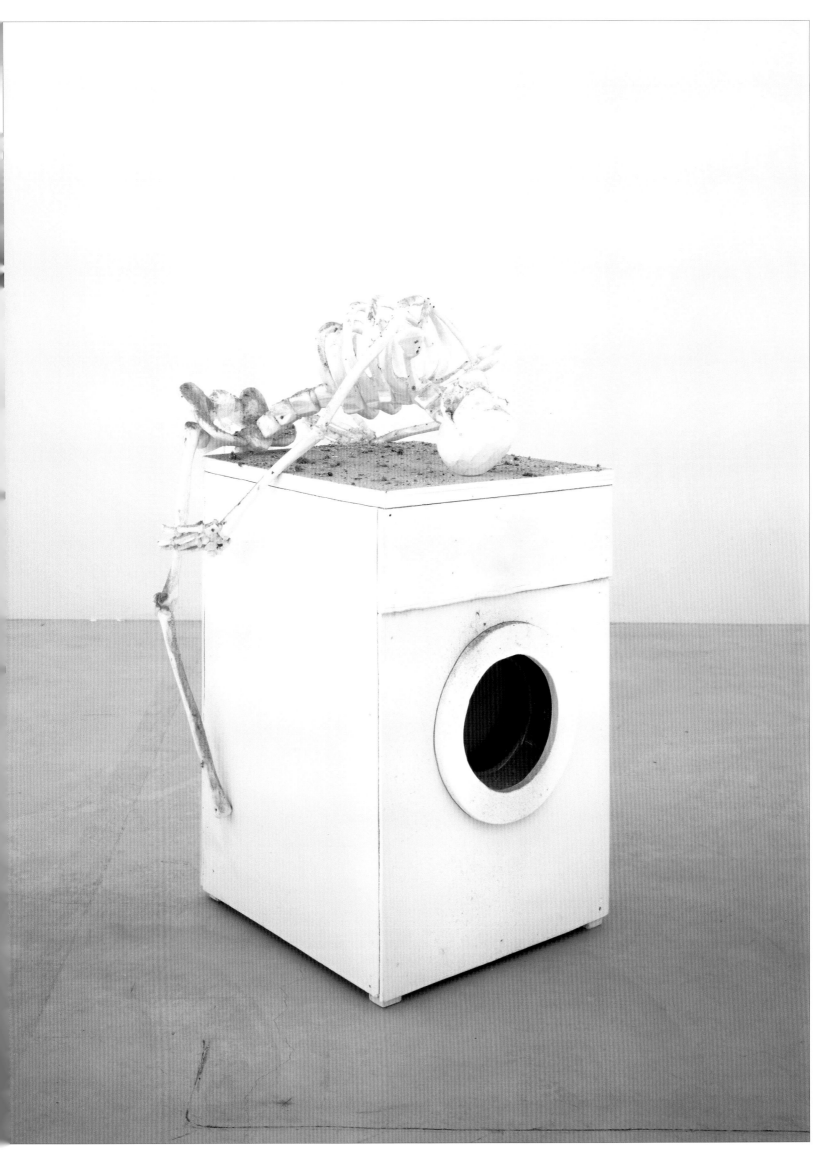

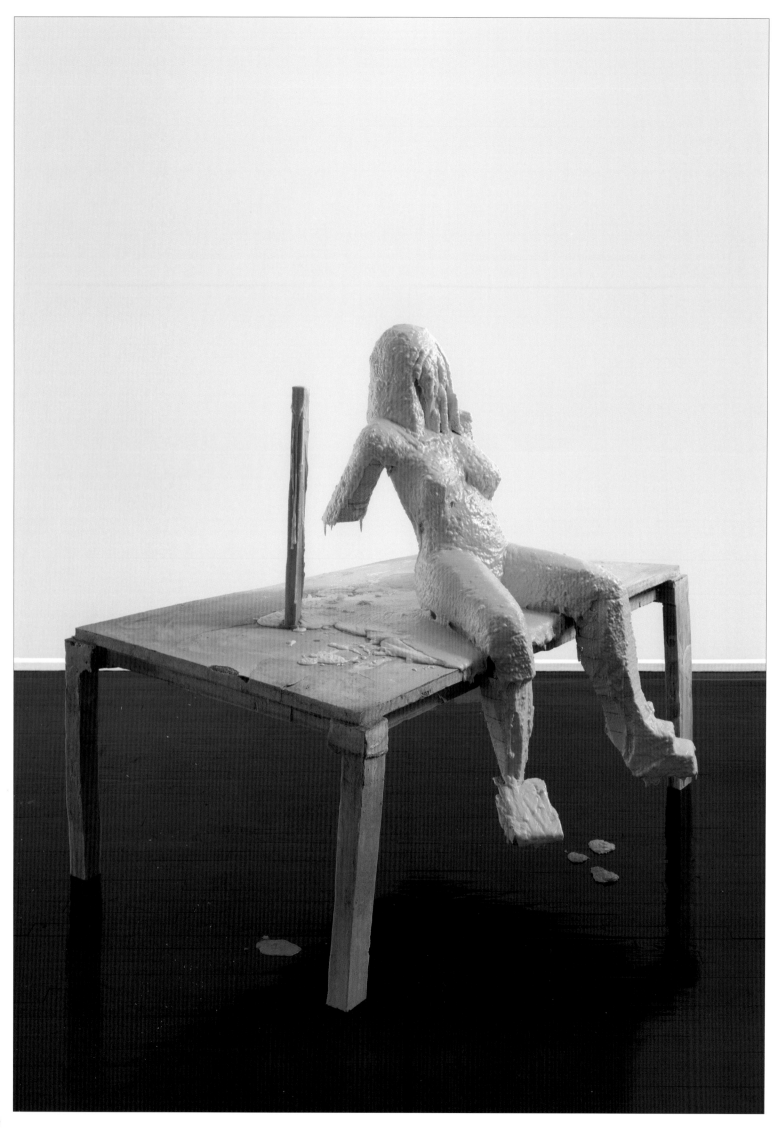

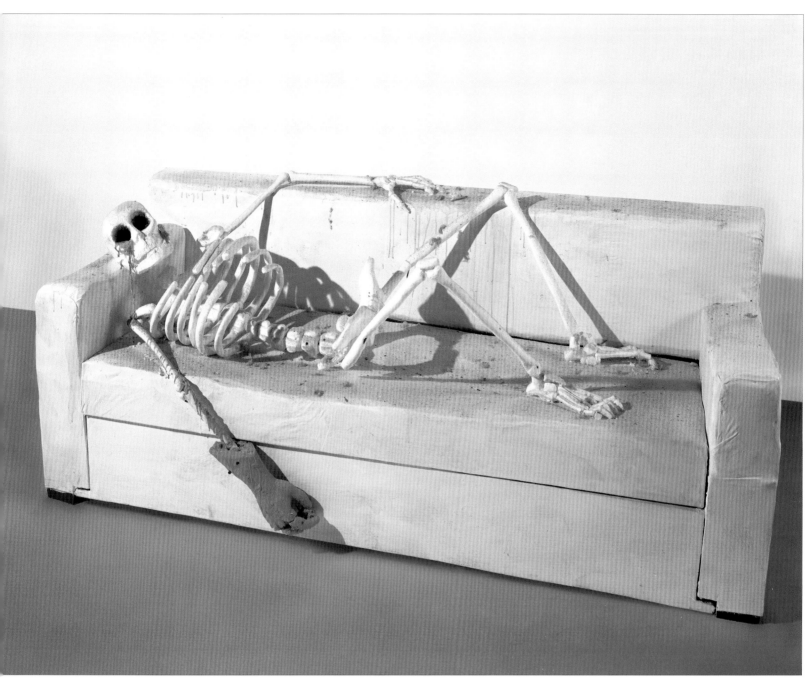

Undigested Sunset
2001–2002
Cast aluminum, wax, wood, acrylic paint, pigments,
fabric, silicone, wood glue, screws
77.5 x 183 x 72.5 cm; 30 ½ x 72 x 28 ½ in.

Untitled (Nude on a Table)
2002
Two-component polyurethane foam, cardboard,
polystyrene, polyurethane foam, tape, screws,
powdered sugar, egg whites, pigments, acrylic paint
141 x 157 x 126 cm; 55 ½ x 61 ¼ x 49 ⅝ in.

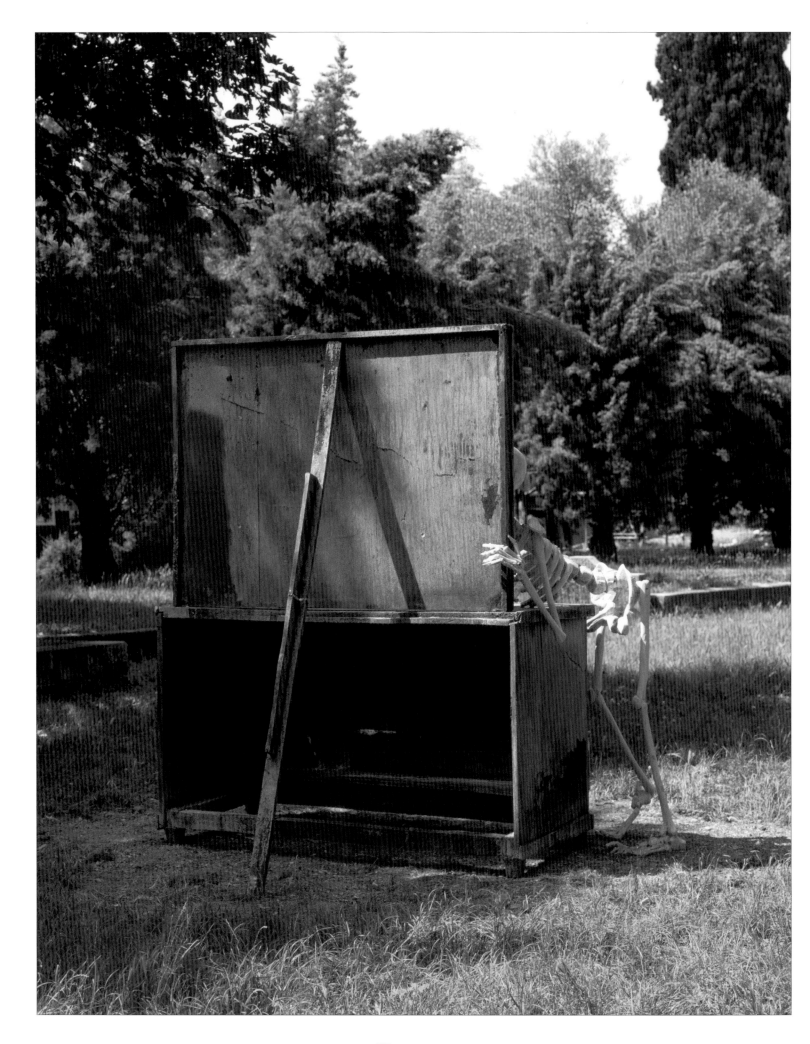

Skinny Afternoon
2003
Cast aluminum, mirror, lacquer paint, acrylic
paint, polyurethane foam, screws
200 x 160 x 120 cm; 78 ¼ x 63 x 47 ¼ in.
Installation view, "Dreams and Conflicts: The
Viewer's Dictatorship," Venice Biennale, 2003

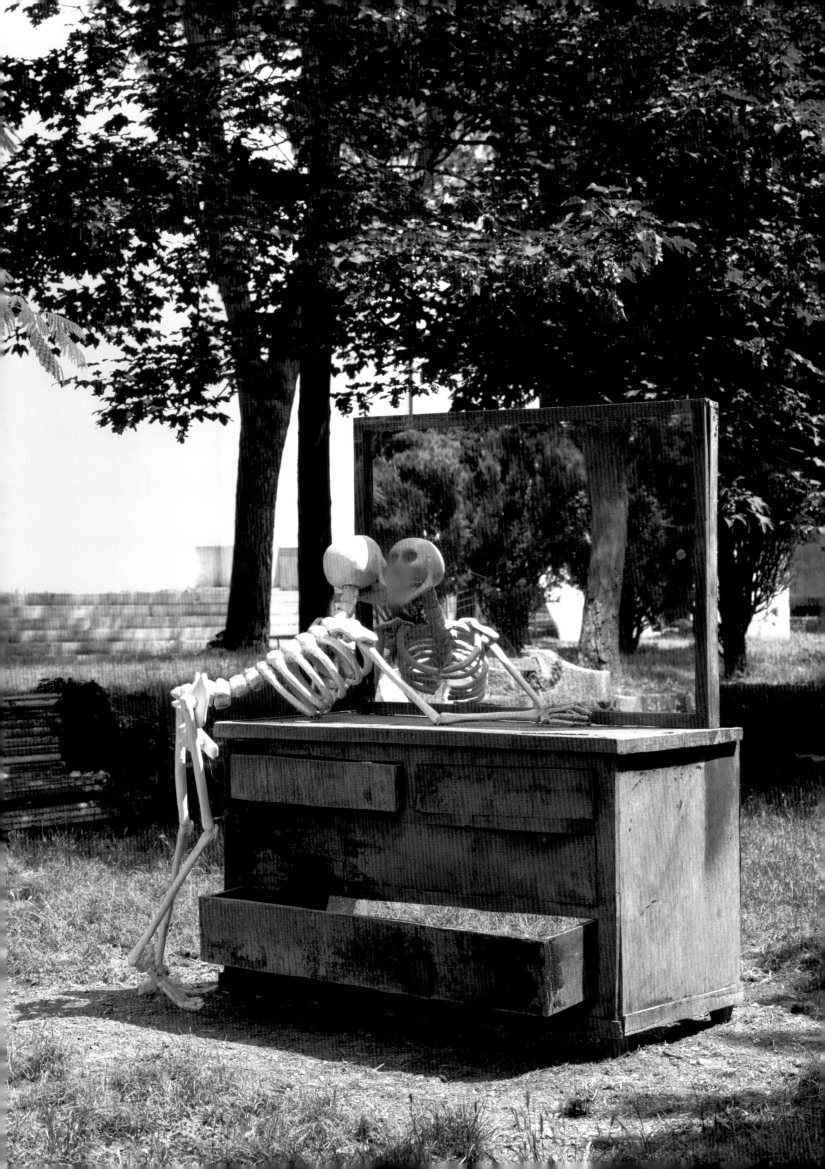

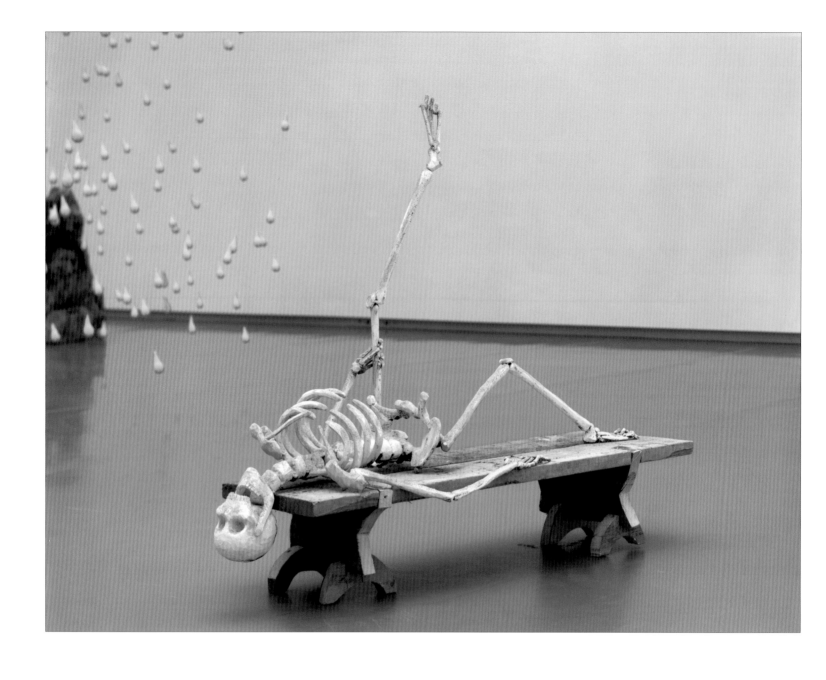

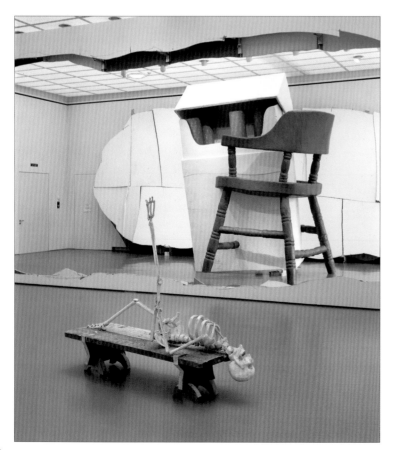

Kuckuck Backwards
2004
Wood, aluminum, cement, sawdust, enamel paint
162 x 200 x 64 cm; 63 ¼ x 78 ¾ x 25 ¼ in.
Installation view, "Kir Royal," Kunsthaus Zürich, 2004
Background: *Horses Dream of Horses*, 2004

Installation view, "Kir Royal," Kunsthaus Zürich, 2004
Left to right: *Middleclass Heroes*, 2004; *Kuckuck Backwards*,
2004; Prototype of *Bad Timing, Lamb Chop!*, 2004

Paris 1919
2006
Tar, plaster, iron, aluminum, rubber
340 x 85 x 85 cm; 133 ⅞ x 33 ½ x 33 ½ in.
Installation view, "Paris 1919," Museum
Boijmans Van Beuningen, Rotterdam, 2006

Page 116:

Violent Cappuccino
2007
Cast aluminum, lacquer, motor oil, glue, dust
202.5 x 130 x 73 cm; 79 ¾ x 51 ⅛ x 28 ¾ in.

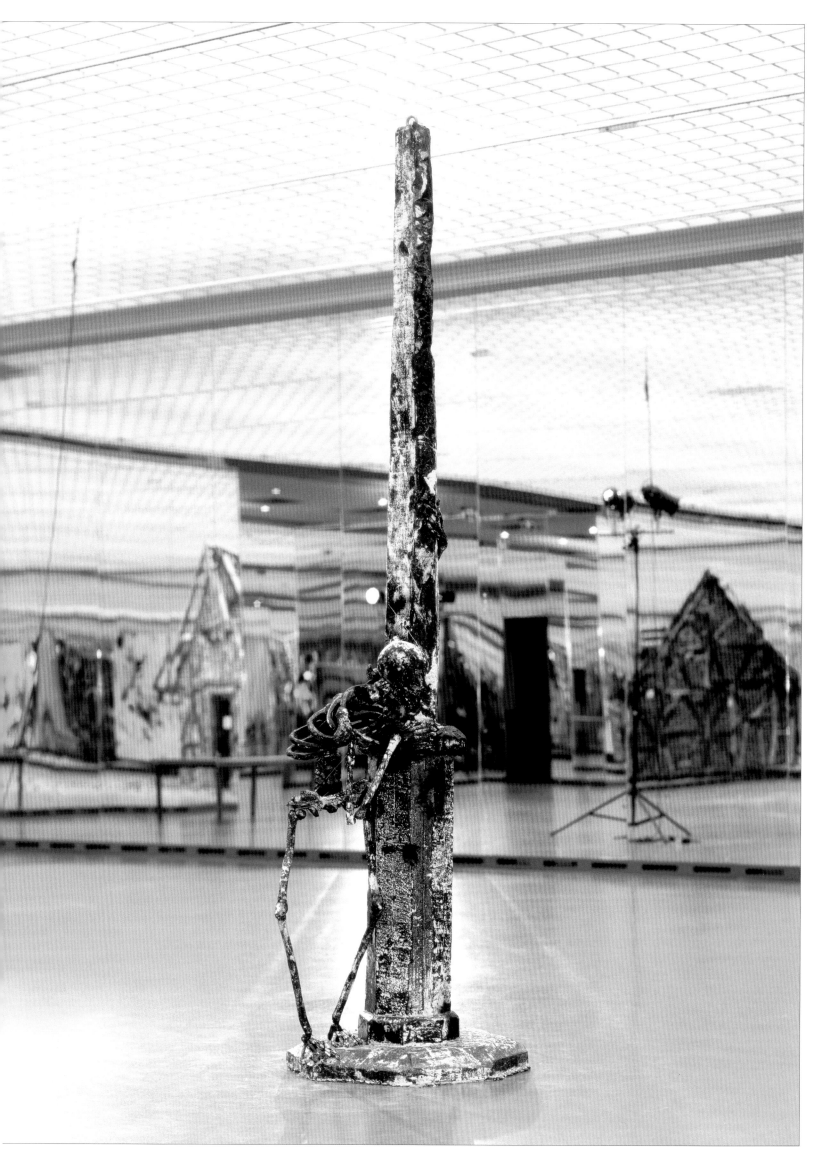

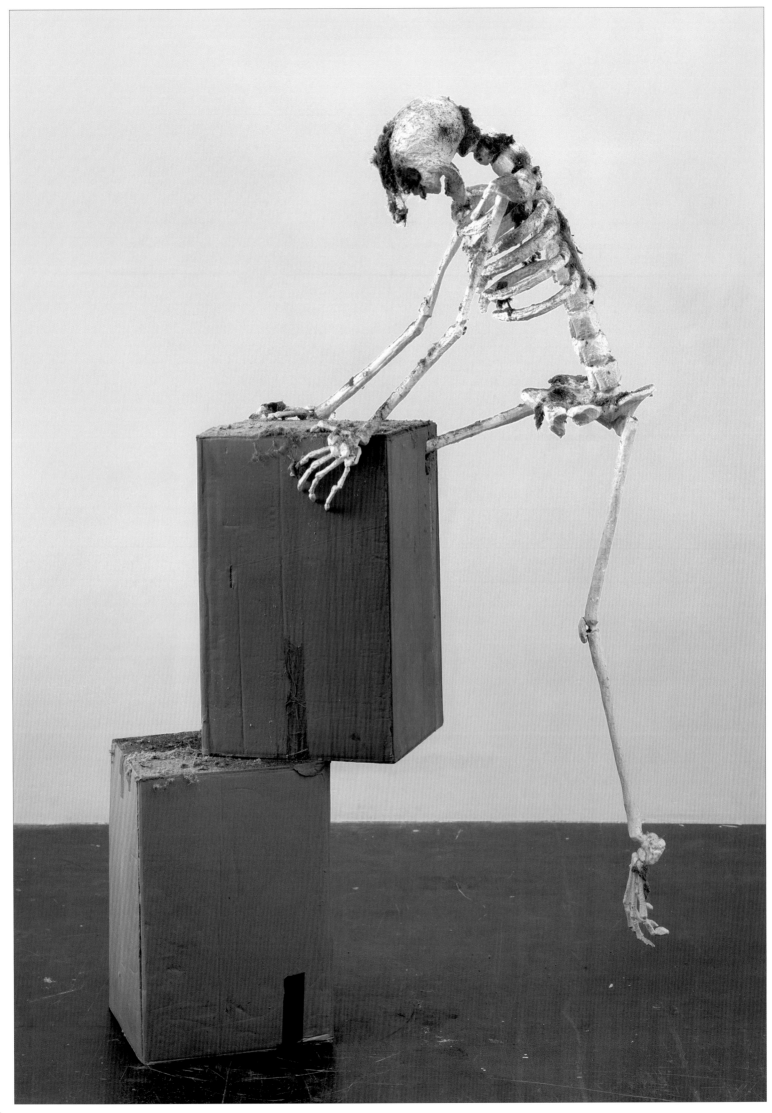

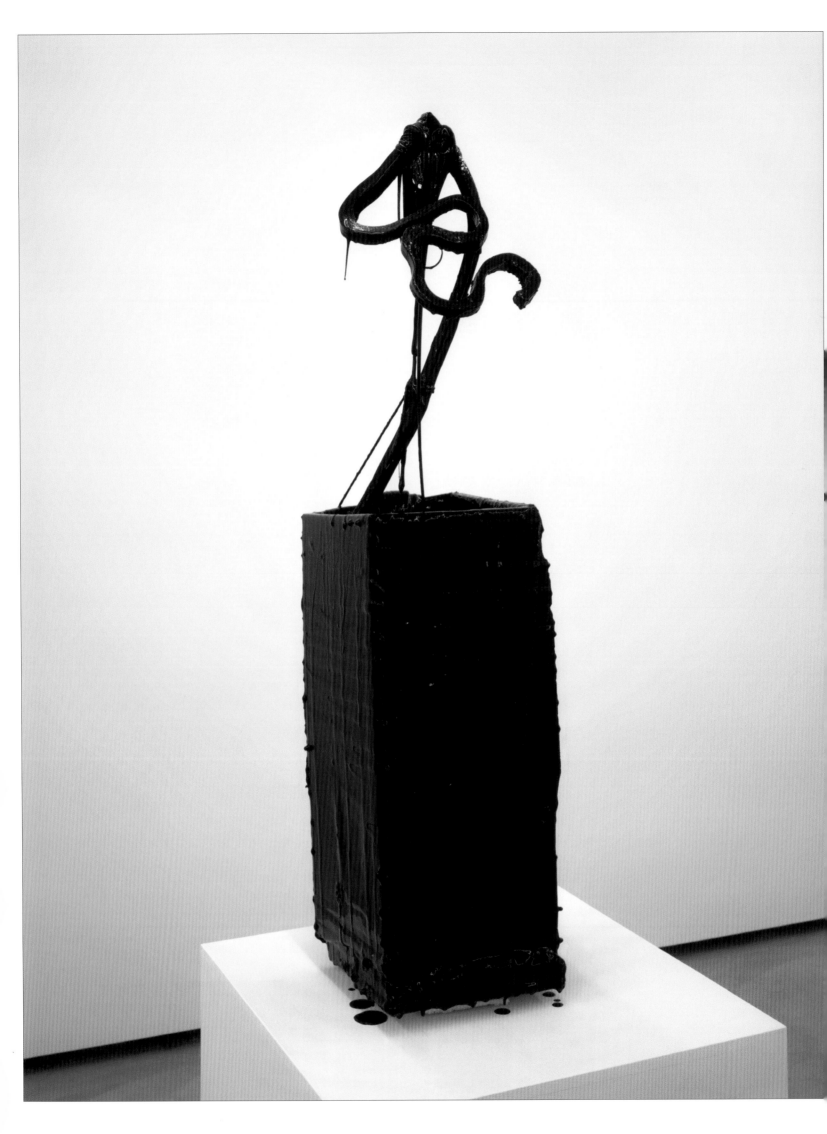

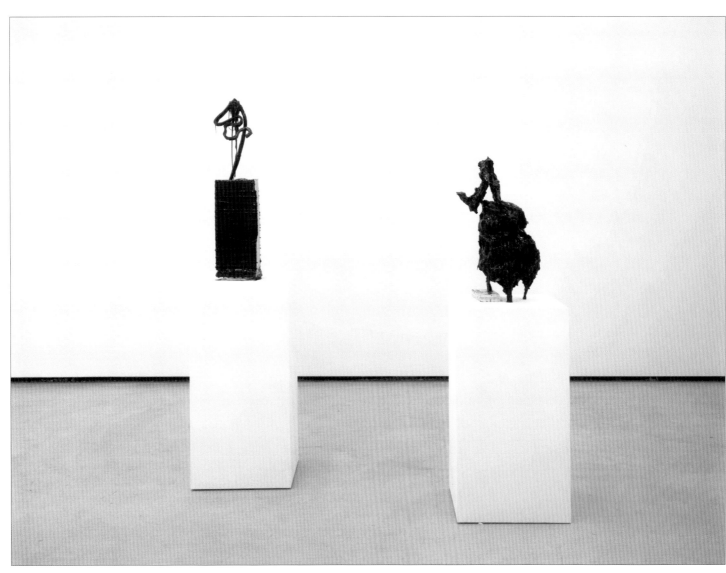

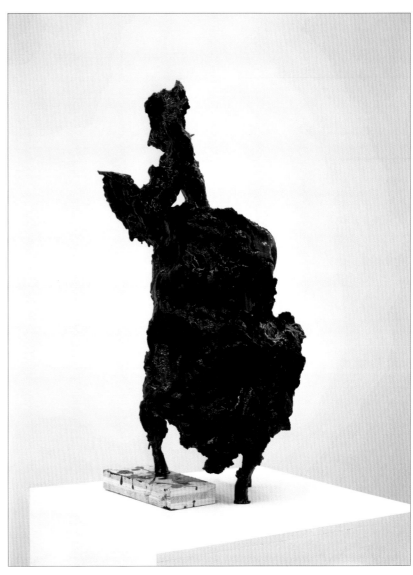

Servile Serenade / Servile Symphony
2001
Epoxy, lacquer, wood, MDF
Part 1: 21 x 25 x 83 cm; 8 ¼ x 9 ⅞ x 32 ⅝ in.
Part 2: 39 x 31 x 61 cm; 15 ⅜ x 12 ¼ x 24 in.

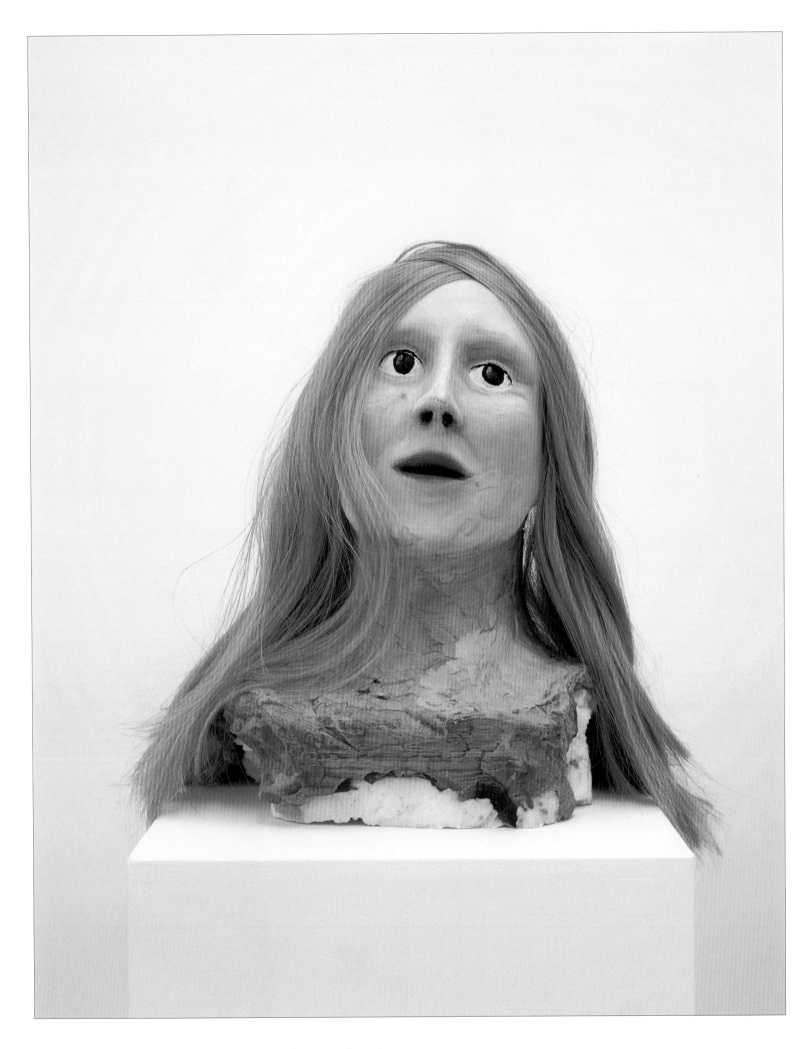

Napoleon, Is There Something You Didn't Tell Me / Napoleon, Misunderstood
2001
Polyurethane resin, stearin, oil paint, synthetic hair, pigments, marker
Part 1: 31 x 27 x 23 cm; 12 ¼ x 10 ⅝ x 9 in.
with pedestal: 26 x 26 x 116 cm; 10 ¼ x 10 ¼ x 45 ⅝ in.
Part 2: 24 x 27 x 30 cm; 9 ½ x 10 ⅝ x 11 ¾ in.
with pedestal: 28 x 27.5 x 119 cm; 11 x 10 ⅞ x 46 ⅞ in.

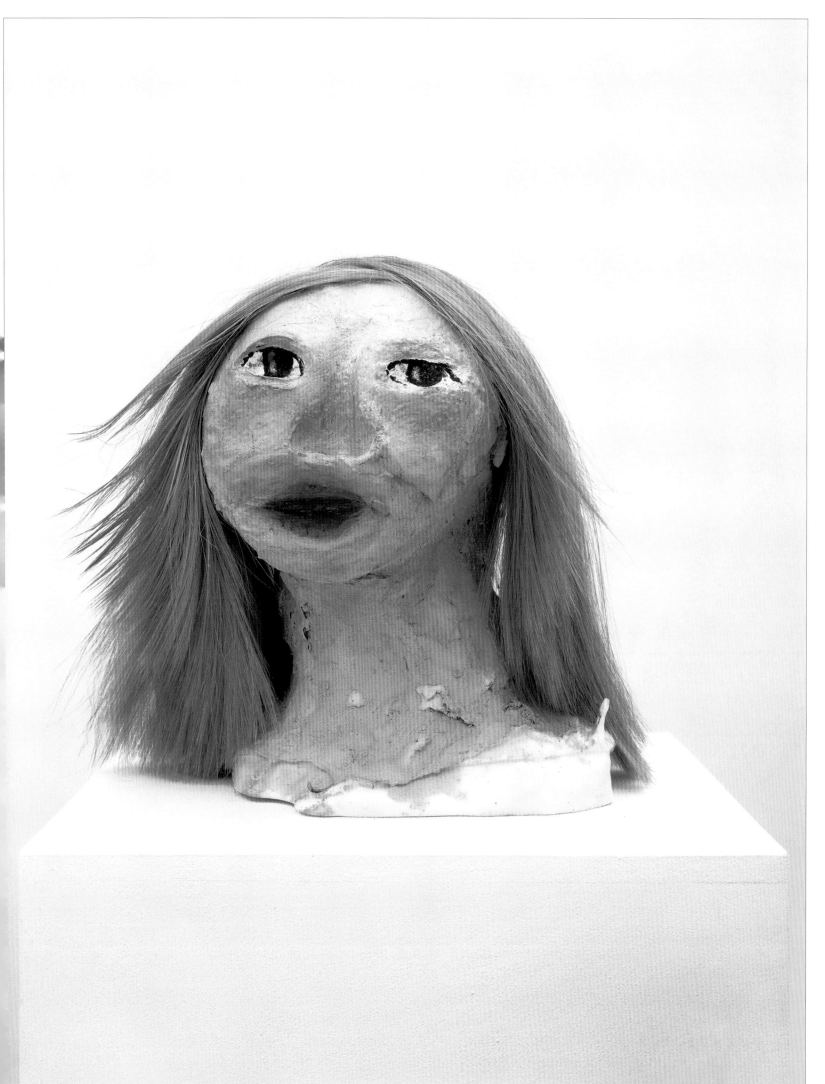

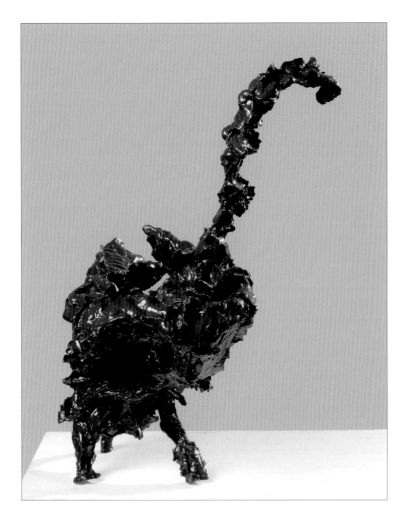

Good Good Breath / Good Bad Breath
2002
Polyurethane resin, wire, enamel, varnish, primer
Dimensions unknown

Installation view, "What Should an Owl Do with a Fork,"
Santa Monica Museum of Art, California, 2002
Good Good Breath / Good Bad Breath, 2002

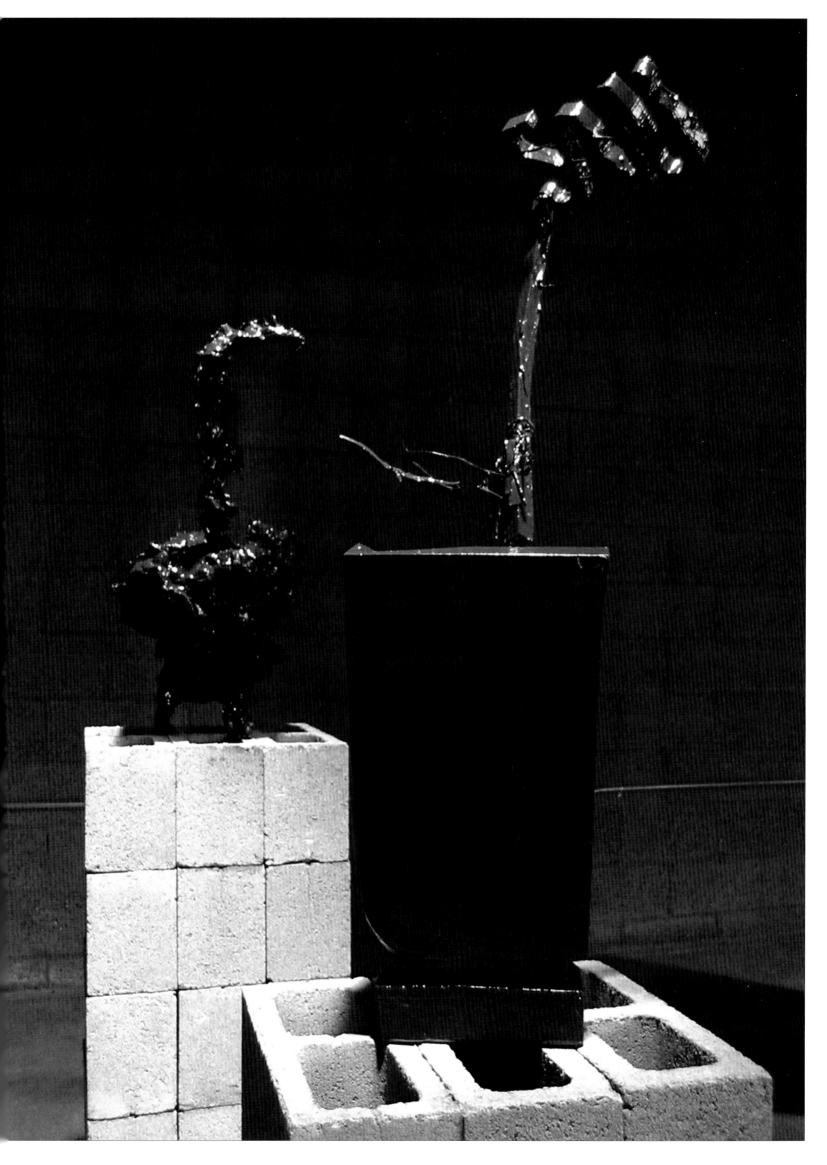

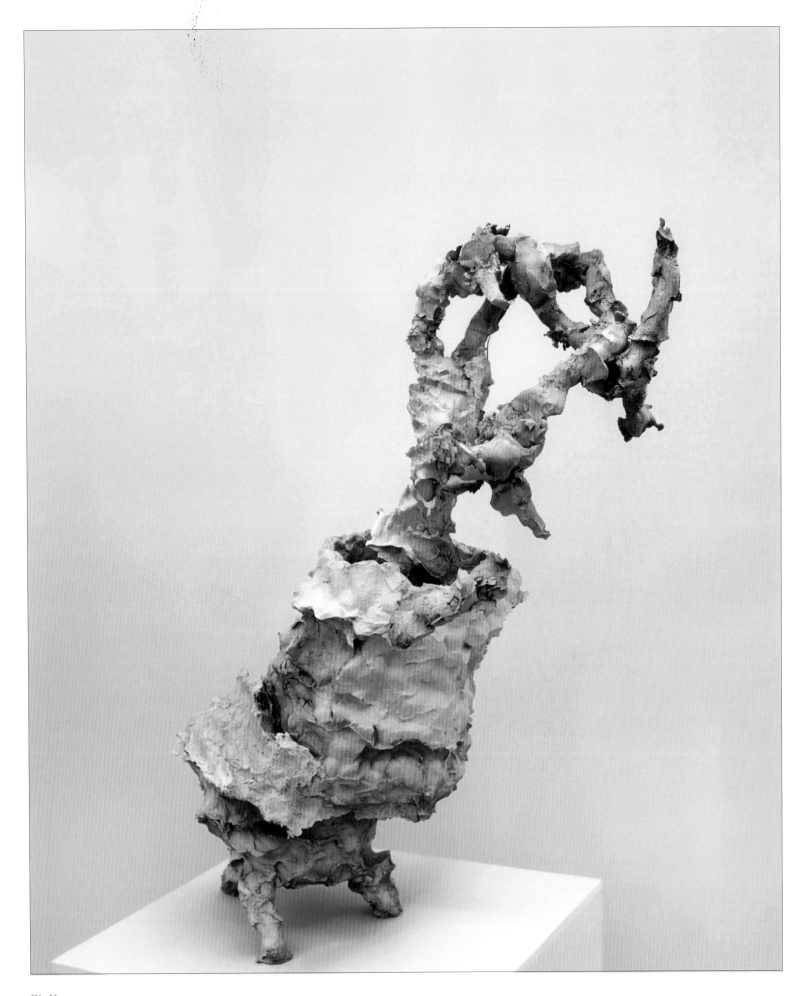

Die Hungry
2003
Polyurethane resin, acrylic paint, clay, screws
70 x 50 x 38 cm; 27 ½ x 19 ¼ x 15 in.

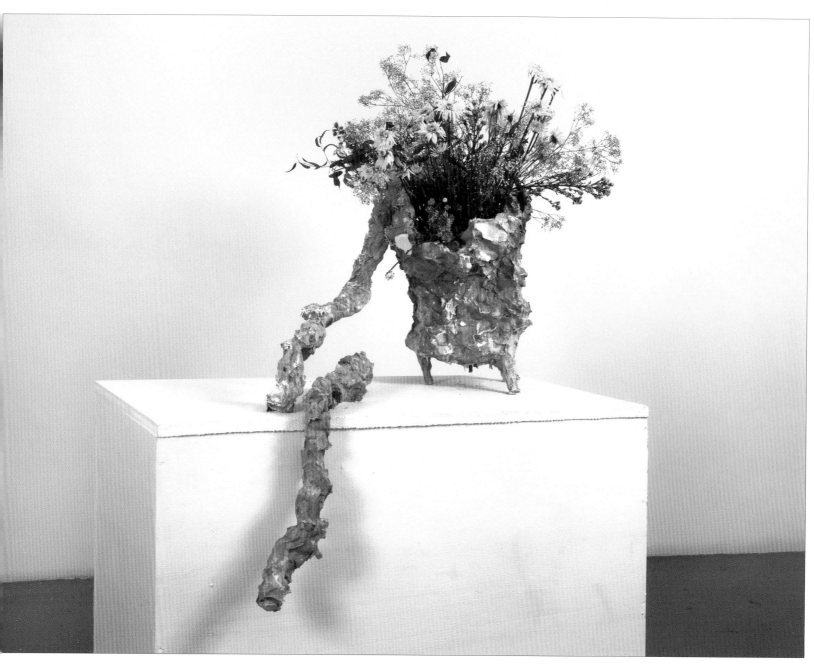

Say Hello / Say Good Bye
2003
Dried white flowers, polyurethane resin,
acrylic paint, screws
76.2 x 73.8 x 48.3 cm; 30 x 29 x 19 in.

Installation view, "Mr. Watson—Come Here—I
Want to See You," Hydra Workshop, Greece, 2005
Die Hungry, 2003

125

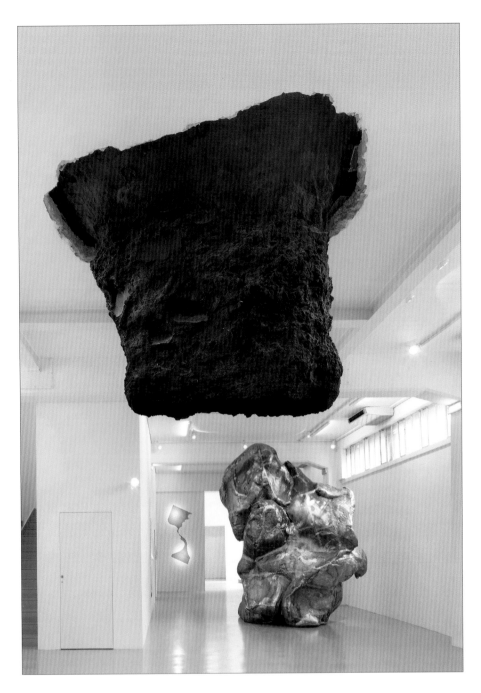

Installation view, "A Guest + A Host = A Ghost: Works
from the Dakis Joannou Collection," Deste Foundation
Centre for Contemporary Art, Athens, 2009
Untitled (Hole), 2007, *Marguerite de Ponty*, 2006–2008
On wall: Seth Price, *Untitled*, 2008

Untitled (Hole)
2007
Cast aluminum, aluminum
540 x 340 x 270 cm; 212 ½ x 133 ⅞ x 106 ¼ in.
Installation view, "Uh...," Sadie Coles HQ, London, 2007

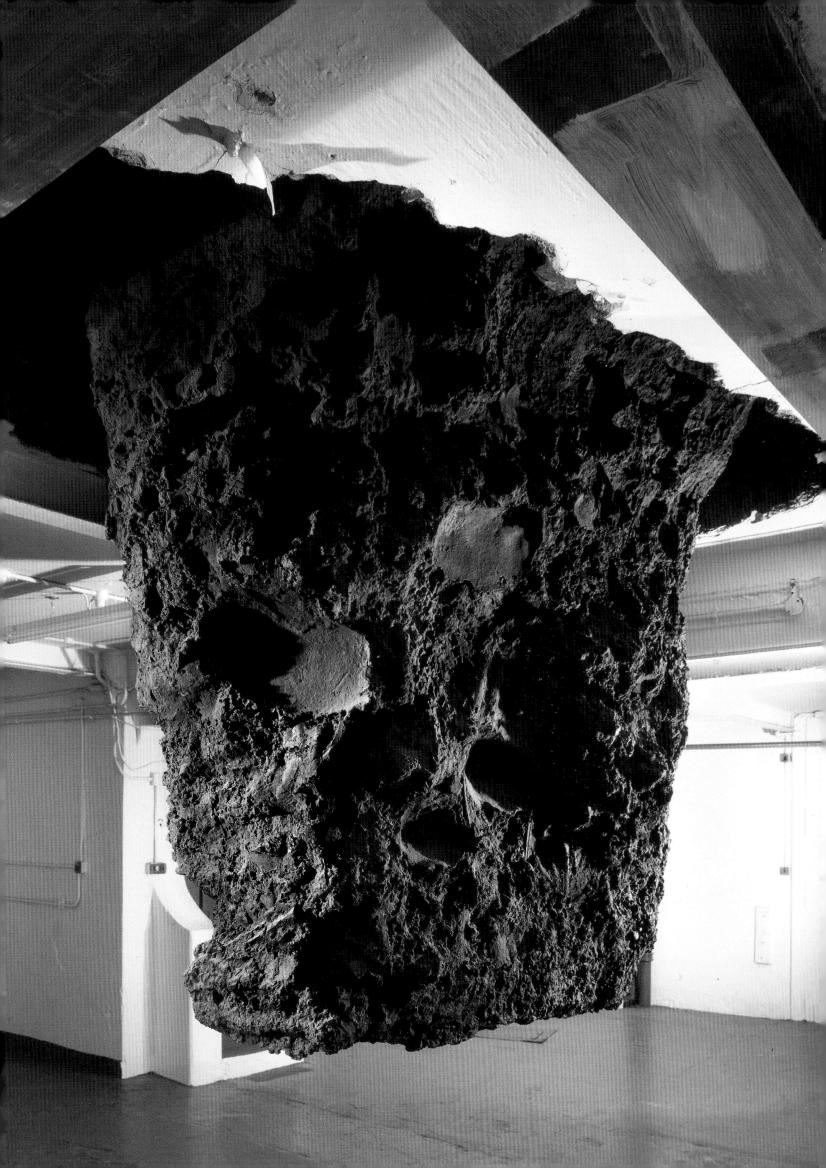

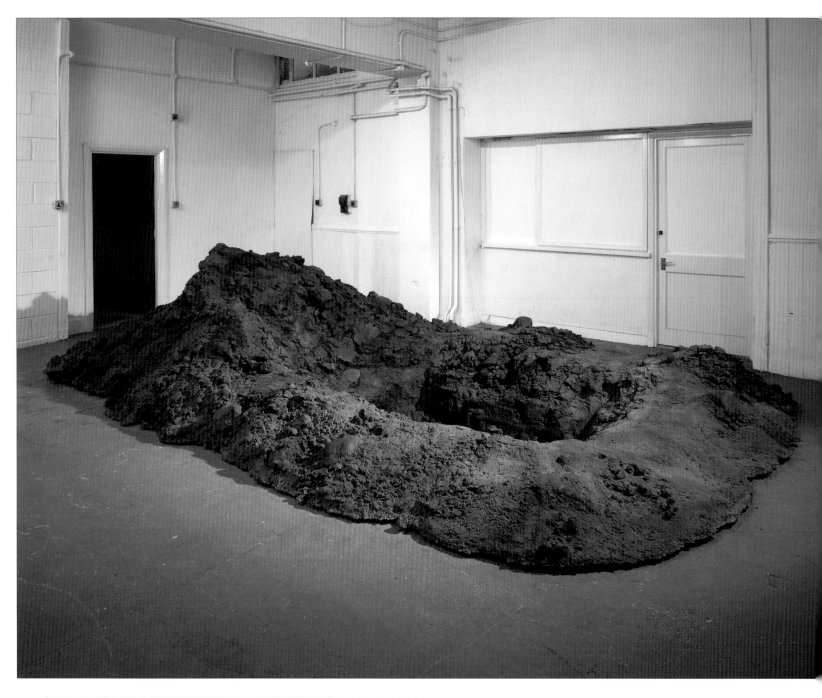

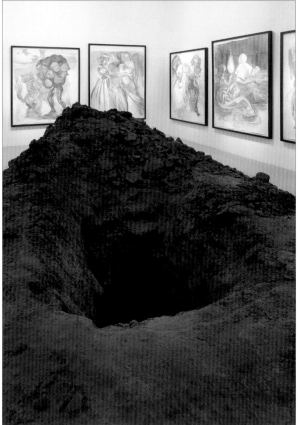

Untitled (Hole)
2007
Cast aluminum, aluminum
540 x 340 x 270 cm; 212 ½ x 133 ⅞ x 106 ¼ in.
Installation view, "Uh...," Sadie Coles HQ, London, 2007

Installation view, "A Guest + A Host = A Ghost: Works from the Dakis Joannou Collection," Deste Foundation Centre for Contemporary Art, Athens, 2009
Untitled (Hole), 2007
Background: Kara Walker, *Br'er*, *John Brown*, *Pegged*, and *Allegory*, all 1996

Detail of *Untitled (Hole)*, 2007

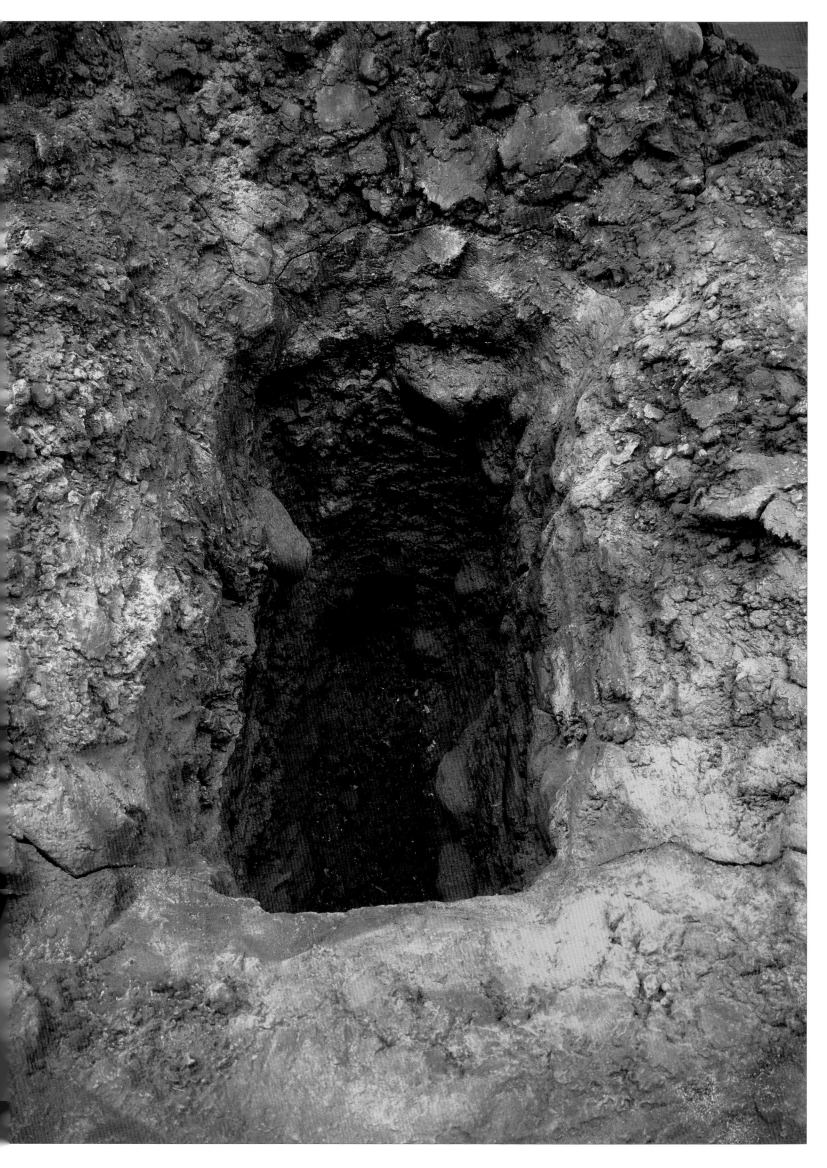

Untitled (Step Piece)
1995
Intervention activated by visitor's entrance
into gallery; when stepped on, slightly
elevated wooden board slaps the floor,
producing a loud noise
MDF, aluminum trim, bungee cord, hooks
Dimensions variable
Installation view, "Karaoke 444&222 too,"
South London Gallery, London, 1995

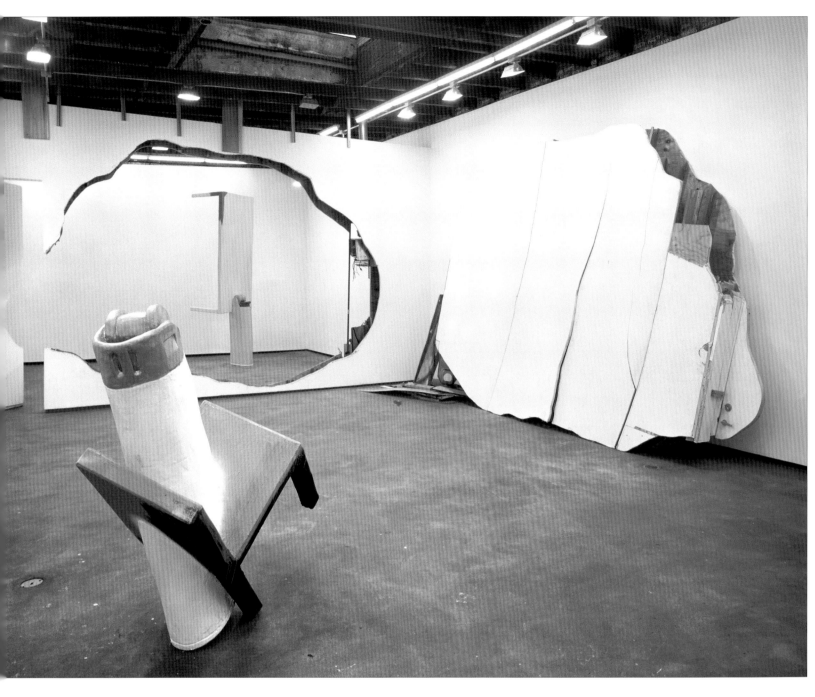

Portrait of a Single Raindrop
2003
Cuts in wall with relocated cutouts
Dimensions variable
Installation view, "Portrait of a Single Raindrop,"
Gavin Brown's enterprise, New York, 2003
Left to right: *You Can Not Win*, 2003; *You Can
Only Lose*, 2003

Formenscheisser
1998
Ballpoint pen, marker, chalk pastel, and fixative on paper
29.7 x 21 cm; 8 ¼ x 11 ¼ in.

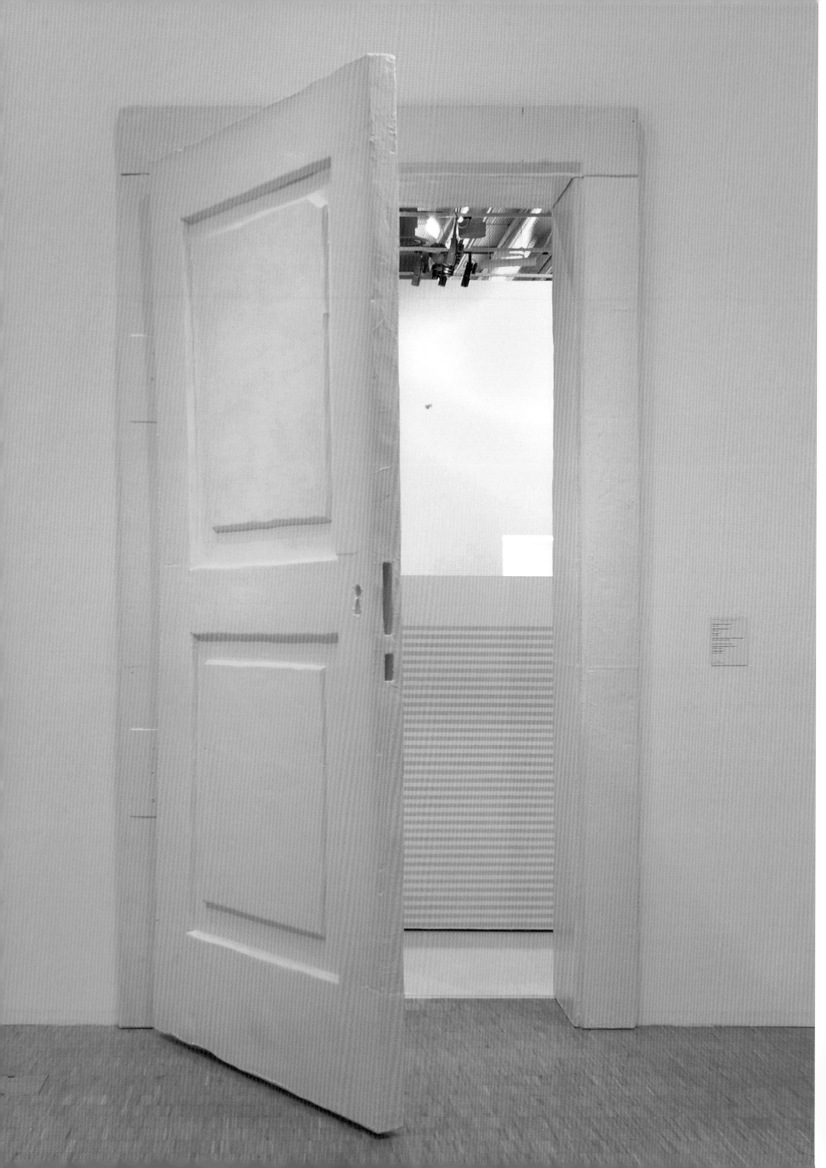

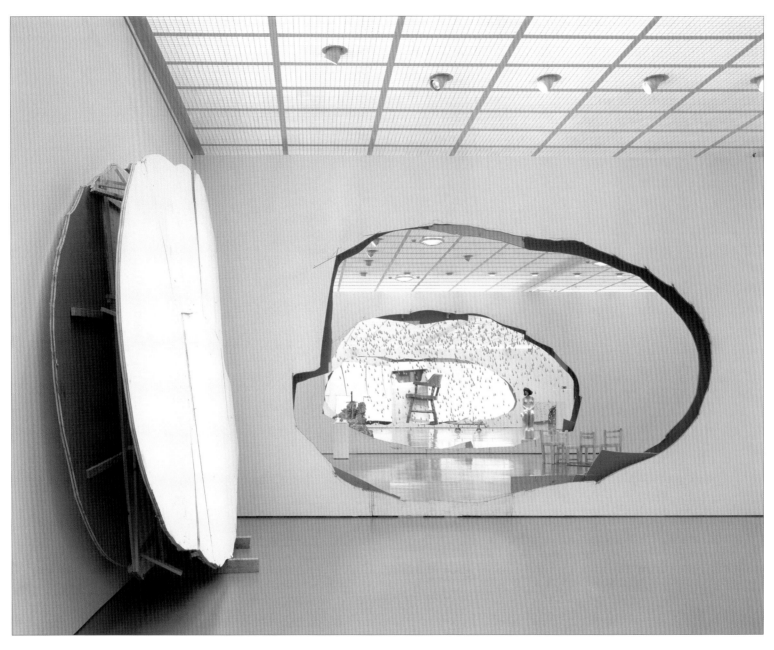

Middleclass Heroes
2004
Cuts in wall with relocated cutouts
Dimensions variable
Installation view, "Kir Royal," Kunsthaus Zürich, 2004

Not My House, Not My Fire
2004
Polyester resin, polyurethane resin, polystyrene, epoxy glue, acrylic
paint, acrylic primer, steel hinges, screws, wood glue
323 x 186 x 56 cm; 127 ⅛ x 73 ¼ x 22 in.
Installation view, "Not My House, Not My Fire," Espace 315,
Centre Georges Pompidou, Paris, 2004

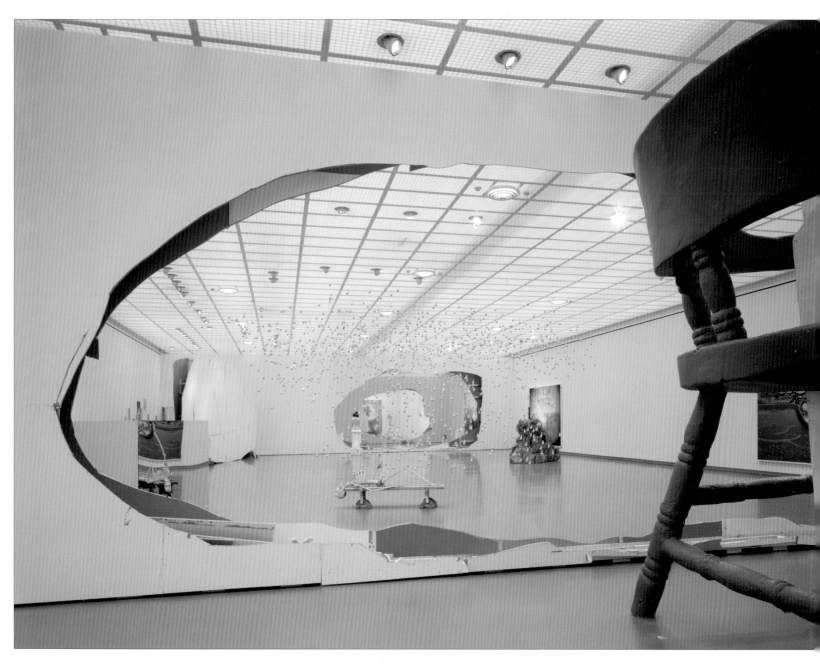

Middleclass Heroes
2004
Cuts in wall with relocated cutouts
Dimensions variable
Installation view, "Kir Royal," Kunsthaus Zürich, 2004

Installation view, "Kir Royal," Kunsthaus Zürich, 2004
Left to right: *Middleclass Heroes*, 2004; *Peanuts in Comparison (Erdnüsse im Vergleich)*, 2004; *Your Deaths Your Births*, 2004; *What if the Phone Rings*, 2004

Installation view, "Kir Royal," Kunsthaus Zürich, 2004
Horses Dream of Horses, 2004; *Middleclass Heroes*, 2004; *What if the Phone Rings*, 2004; *Untitled*, 2004; *Stalagmites of Love*, 2004

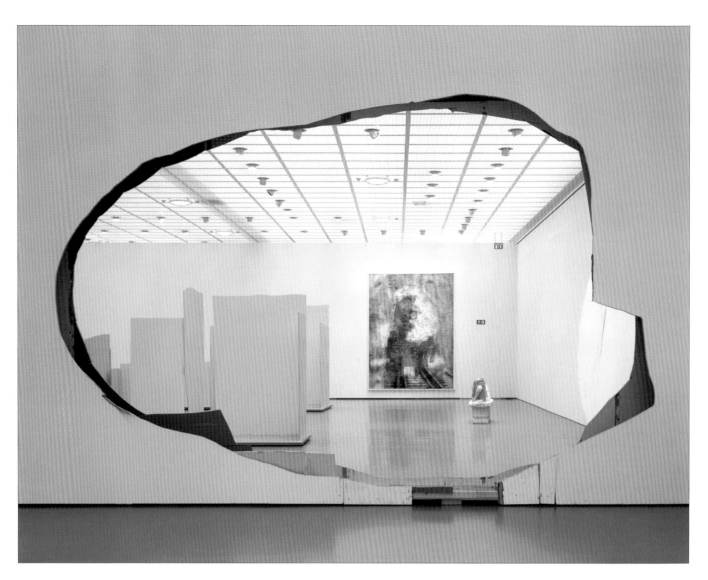

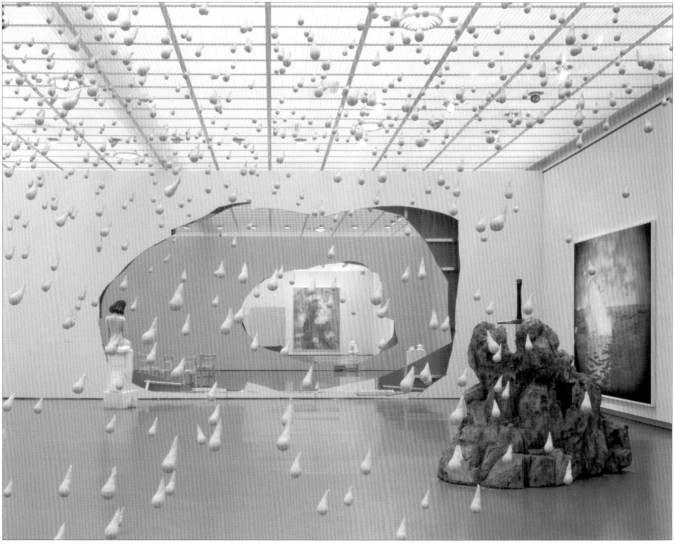

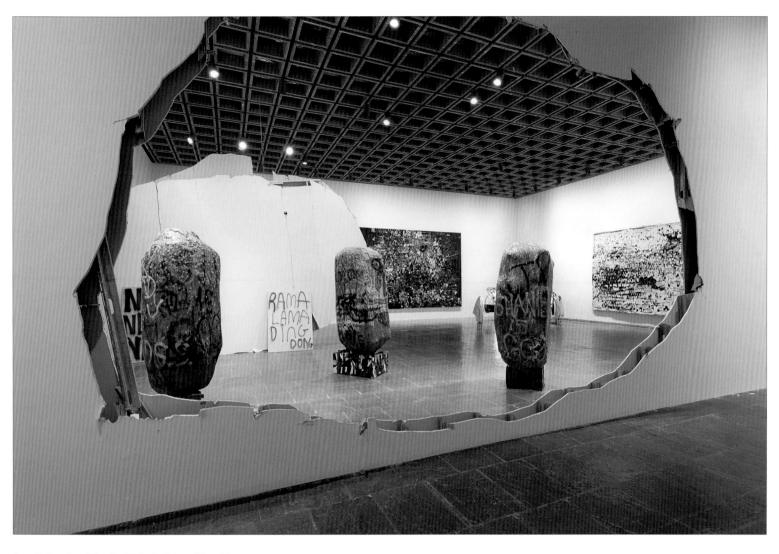

Installation view, "Day for Night," Whitney Biennial,
Whitney Museum of American Art, New York, 2006
The Intelligence of Flowers, 2005
Background, left to right: Dan Colen, *Untitled (Zippideedoodah)*,
2006; Mark Bradford, *Los Moscos*, 2004; Mark Bradford,
Untitled, 2005–2006

The Intelligence of Flowers
2005
Cuts in wall with relocated cutouts
Dimensions variable
Installation view, Frieze Art Fair,
Galerie Eva Presenhuber booth, London, 2005

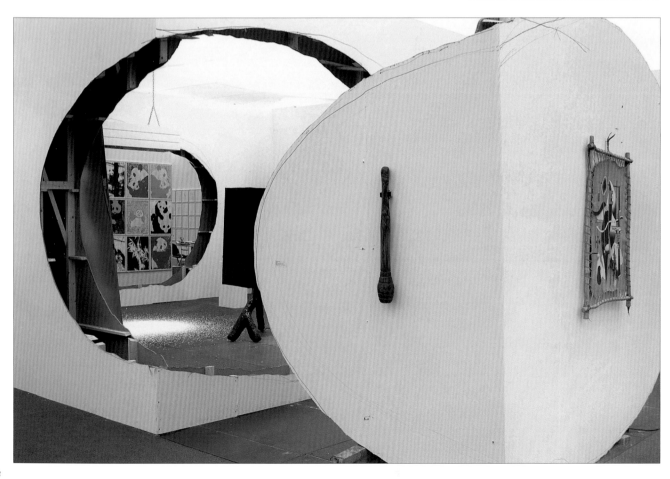

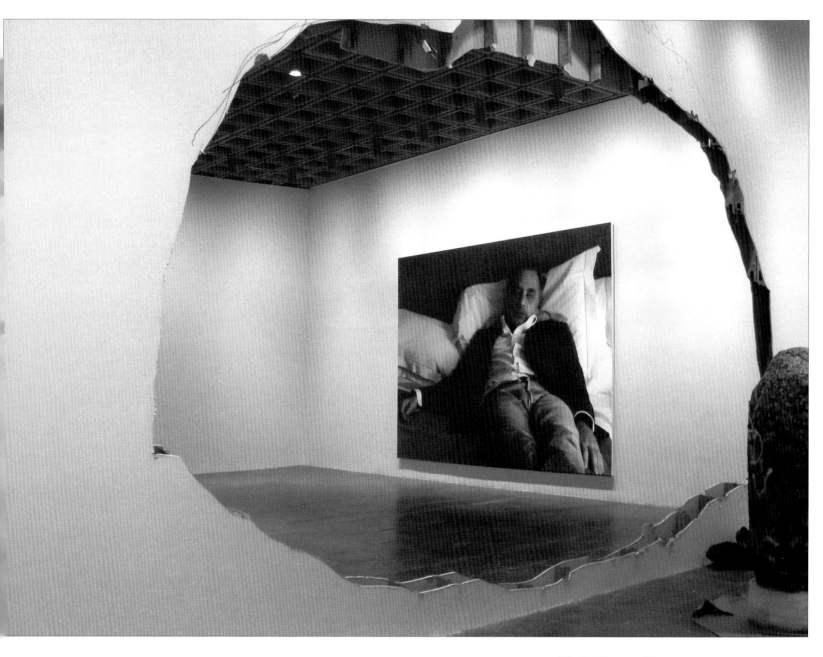

The Intelligence of Flowers
2005
Cuts in wall with relocated cutouts
Dimensions variable
Installation view, "Day for Night," Whitney Biennial,
Whitney Museum of American Art, New York, 2006
Left to right: Rudolf Stingel, *Untitled (After Sam)*,
2005–2006; Dan Colen, *Untitled (Zippideedoodah)*,
2006

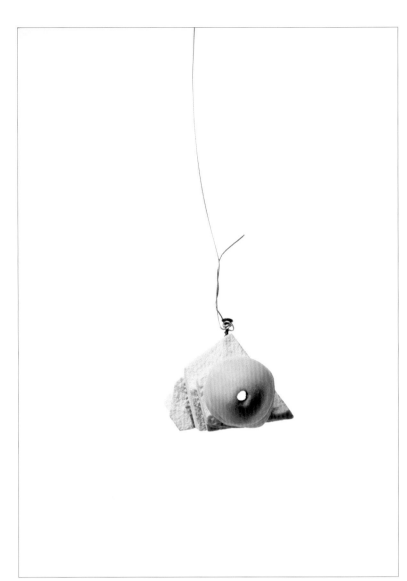

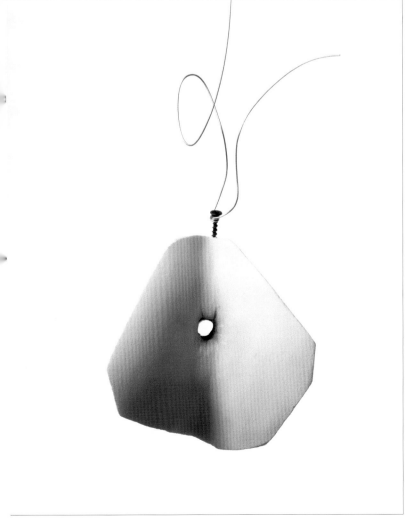

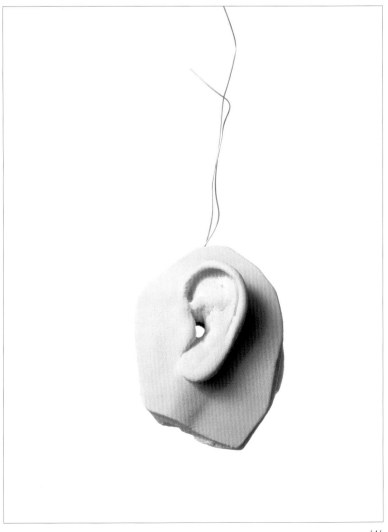

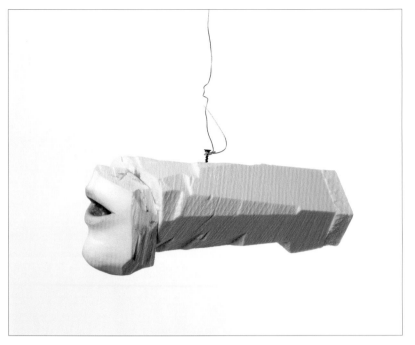

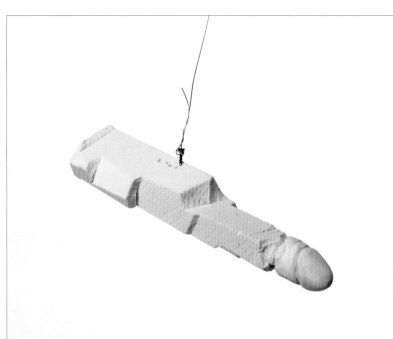

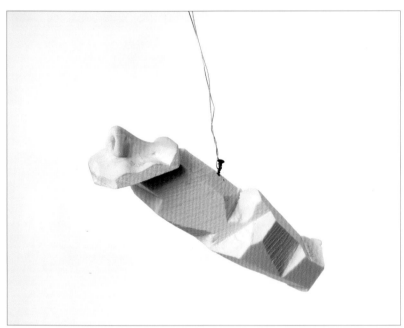

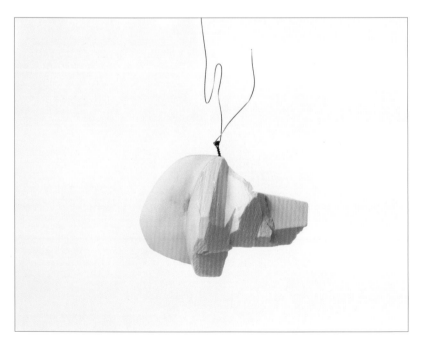

Previous spread, this page, and opposite page, bottom:

Untitled (Holes)
2006
Carved polyurethane, plaster, acrylic paint, screws, wire
Ear: 13 x 34 x 9 cm; 5 ⅛ x 13 ⅜ x 3 ½ in.
Nose: 8 x 31 x 8 cm; 3 ⅛ x 12 ¼ x 3 ⅛ in.
Arse: 15 x 19 x 13 cm; 5 ⅞ x 7 ½ x 5 ⅛ in.
Willy: 7 x 34 x 9 cm; 2 ¾ x 13 ⅜ x 3 ½ in.
Mouth: 15 x 33 x 14 cm; 5 ⅞ x 13 x 5 ½ in.

Installation view, Galerie Eva Presenhuber, Zurich, 2006
Untitled (Holes), 2006; *Paris 2006*, 2006;
"Mr. Watson—come here—I want to see you.," 2005

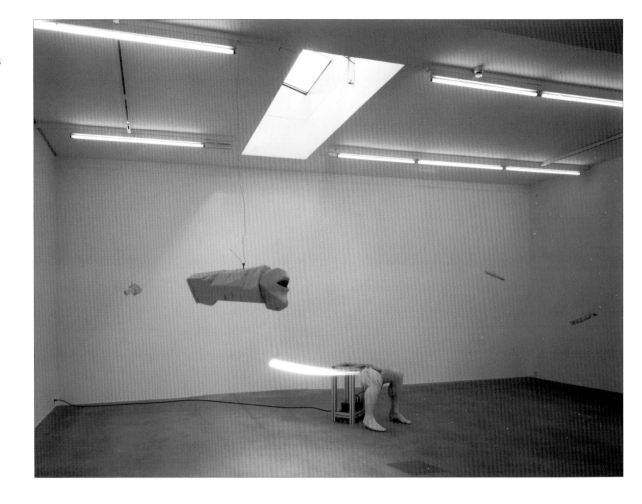

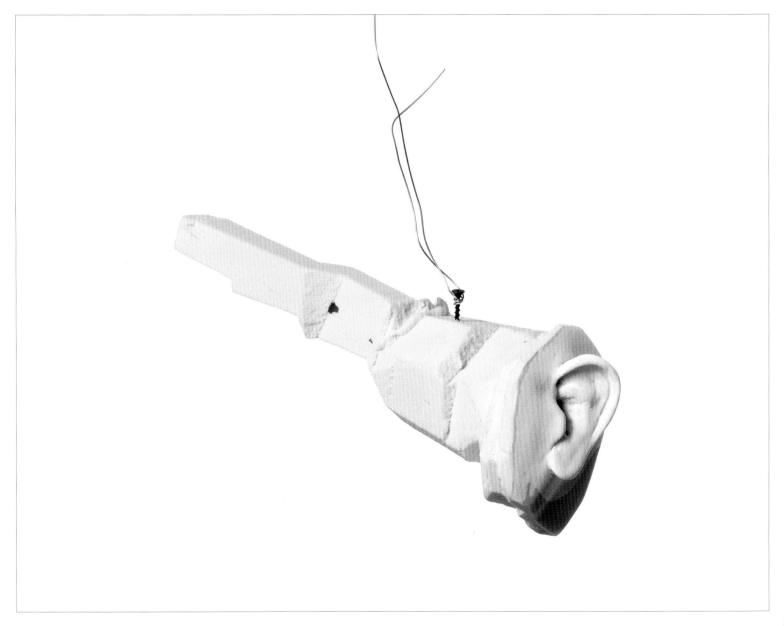

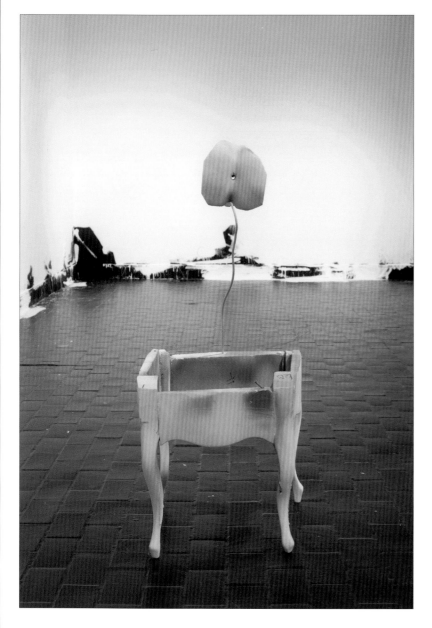
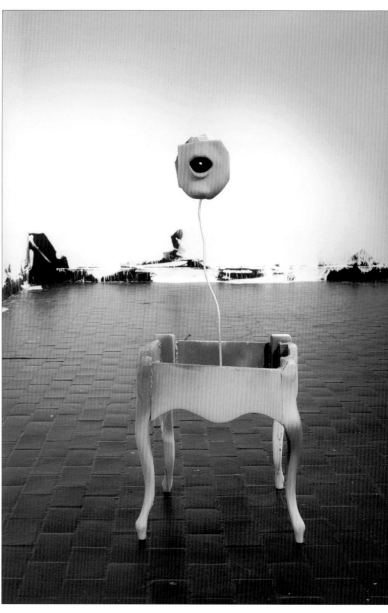

Untitled
2006
Polyurethane foam, spray enamel, aluminum rod, screws
106 x 42.5 x 76.5 cm; 41 ¼ x 16 ¼ x 30 ⅛ in.
Installation view, "Mary Poppins," Blaffer Gallery,
The Art Museum of the University of Houston, Texas, 2006
On floor: *Untitled (Floor Piece)*, 2006

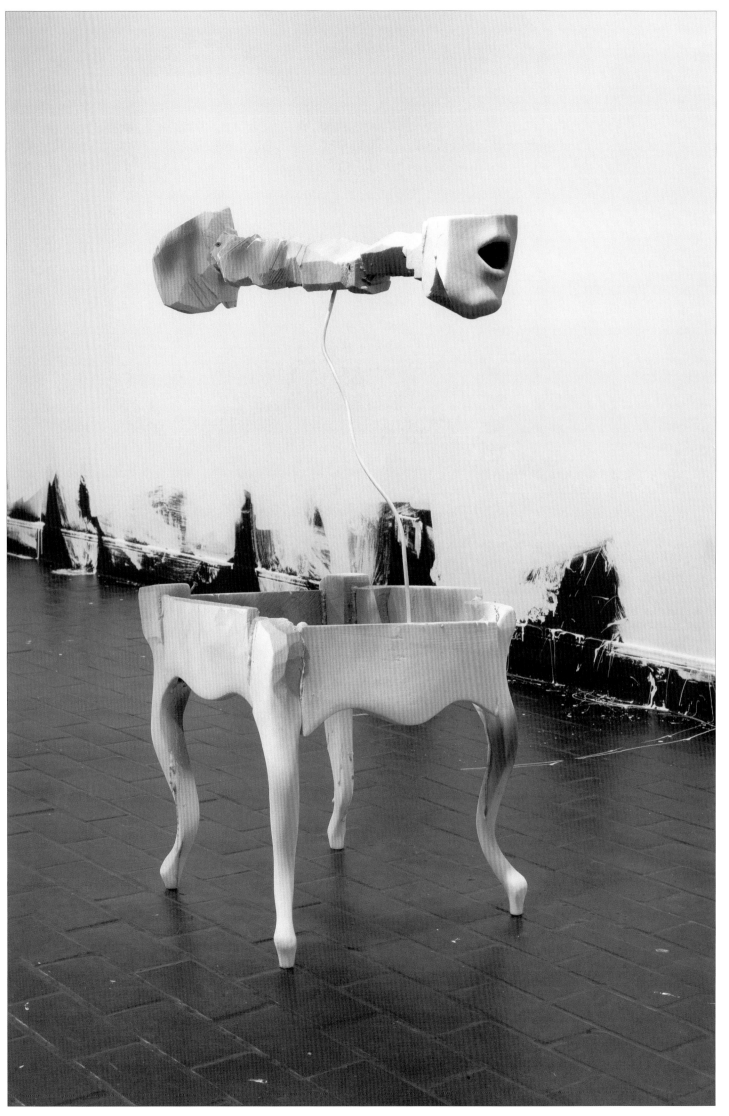

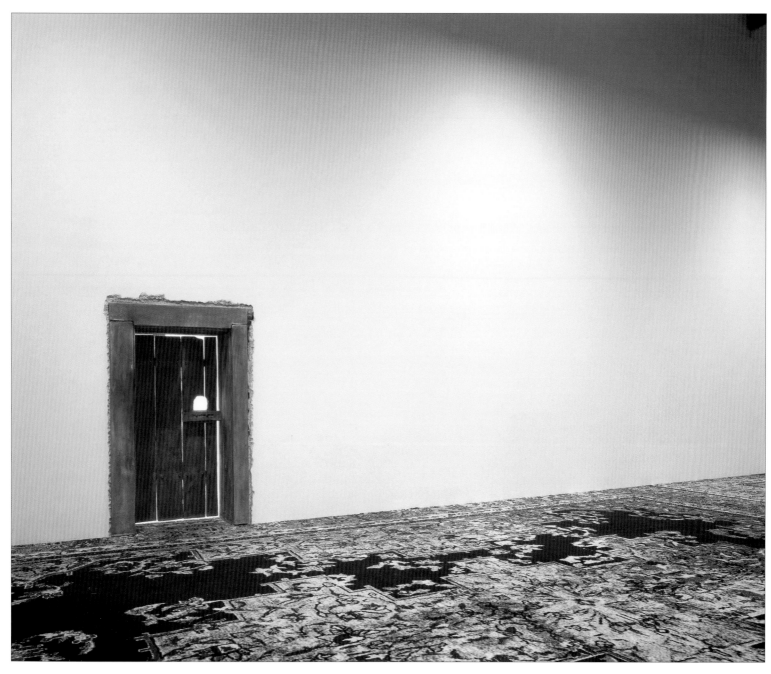

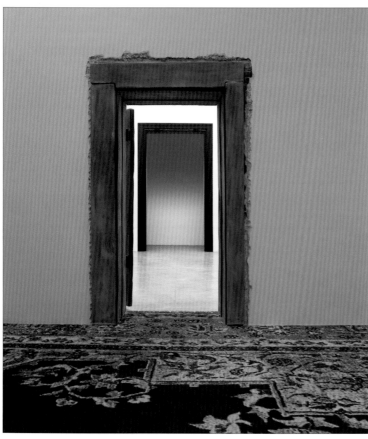

Untitled (Door)
2006
Cast aluminum, enamel paint, steel hinges
215 x 136 x 51 cm; 84 ⅝ x 53 ½ x 20 ⅛ in.
Installation view, "Urs Fischer e Rudolf Stingel,"
Galleria Massimo de Carlo, Milan, 2006–07
On floor: Rudolf Stingel, *Untitled (Sarouk)*, 2006

Untitled (Door)
2006
Cast aluminum, enamel paint, steel hinges
215 x 136 x 51 cm; 84 ⅝ x 53 ½ x 20 ⅛ in.
Installation view, "Urs Fischer e Rudolf Stingel,"
Galleria Massimo de Carlo, Milan, 2006–07

Bottom right:

Installation view, "Urs Fischer e Rudolf Stingel,"
Galleria Massimo de Carlo, Milan, 2006–07
Rudolf Stingel, *Untitled*, 2006

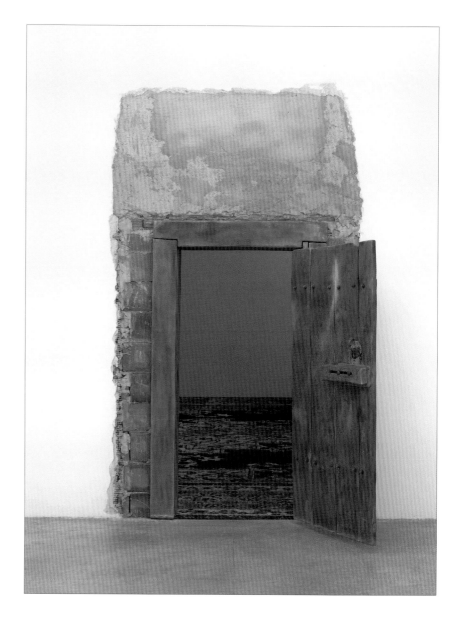

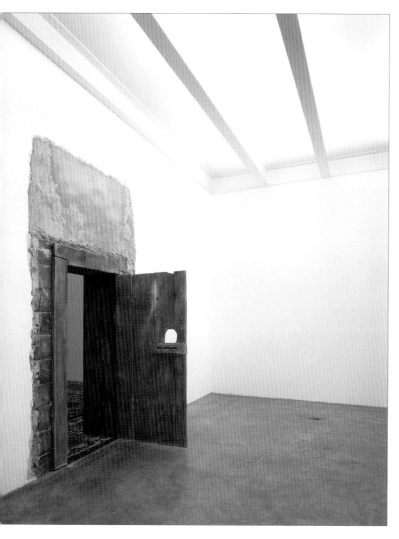

Untitled (Door)
2006
Cast aluminum, enamel paint, steel hinges
256 x 172 x 27 cm; 100 ¼ x 67 ¼ x 10 ⅝ in.
Installation view, "Urs Fischer e Rudolf Stingel,"
Galleria Massimo de Carlo, Milan, 2006–07
On wall: Rudolf Stingel, *Untitled (Bolego)*, 2006

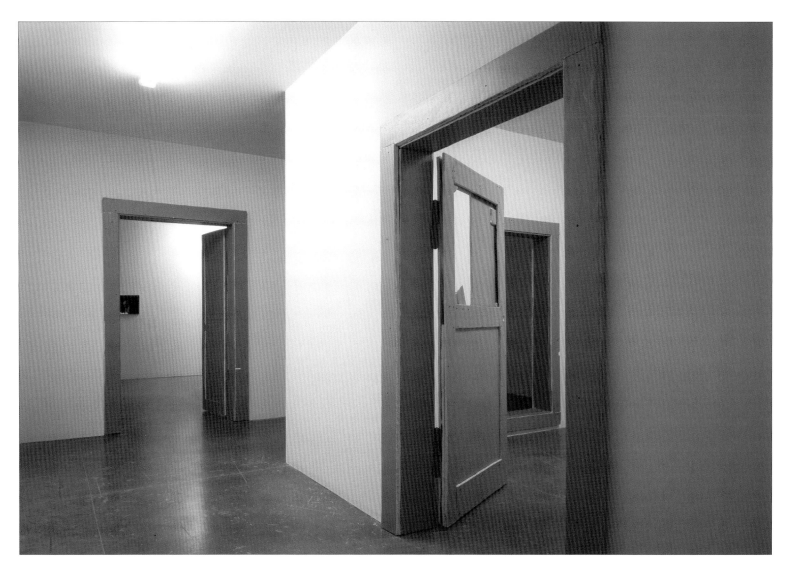

Installation view, "Urs Fischer e Rudolf Stingel,"
Galleria Massimo de Carlo, Milan, 2006–07
Untitled (Door), 2006; *Untitled (Door)*, 2006;
Untitled (Door), 2006
On wall: Rudolf Stingel, *Untitled (Bolego)*, 2006

Untitled (Door)
2006
Cast aluminum, enamel paint, steel hinges
281 x 183 x 27 cm; 110 ⅝ x 72 x 10 ⅝ in
Installation view, "Urs Fischer e Rudolf Stingel,"
Galleria Massimo de Carlo, Milan, 2006–07
On wall: Rudolf Stingel, *Untitled (Bolego)*, 2006

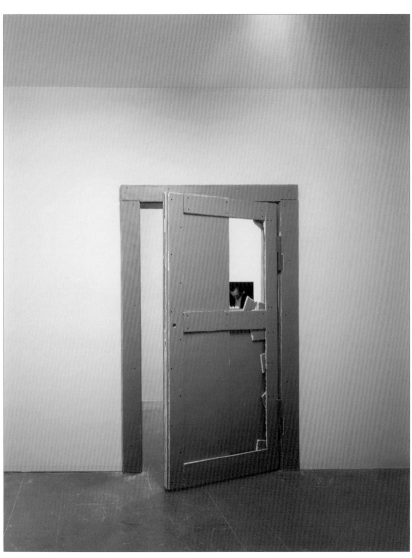

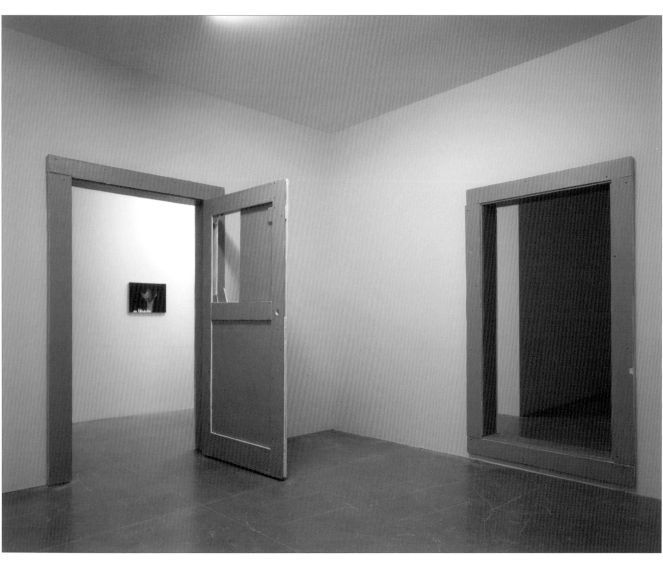

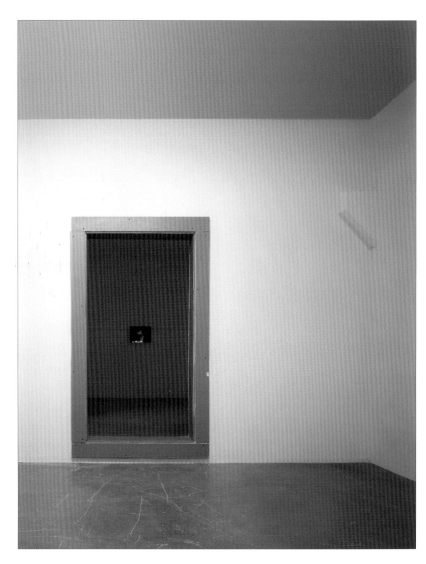

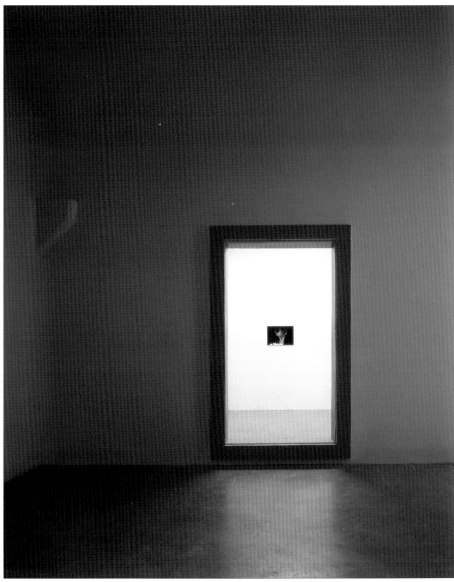

Untitled (Door)
2006
Cast aluminum, enamel paint, steel hinges
247 x 156 x 27 cm; 97 ¼ x 61 ⅛ x 10 ⅝ in
Installation view, "Urs Fischer e Rudolf Stingel,"
Galleria Massimo de Carlo, Milan, 2006–07
On wall: Rudolf Stingel, *Untitled (Bolego)*, 2006

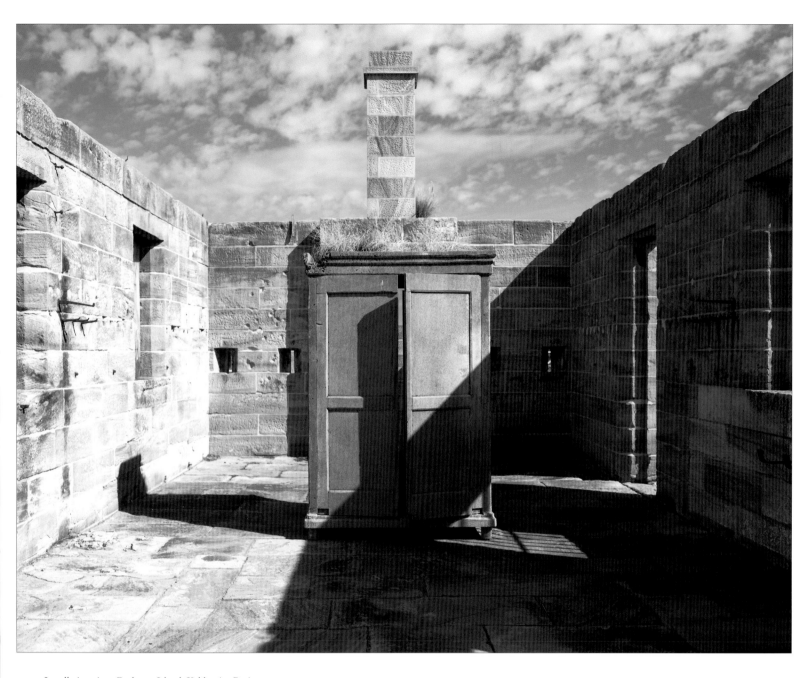

Installation view, Cockatoo Island, Kaldor Art Projects
and the Sydney Harbour Federation Trust, Sydney, 2007
Untitled (Cabinet), 2007

Untitled (Cabinet)
2007
Cast aluminum, mirror, local plants
261 x 188 x 155 cm; 102 ¼ x 74 x 61 in.

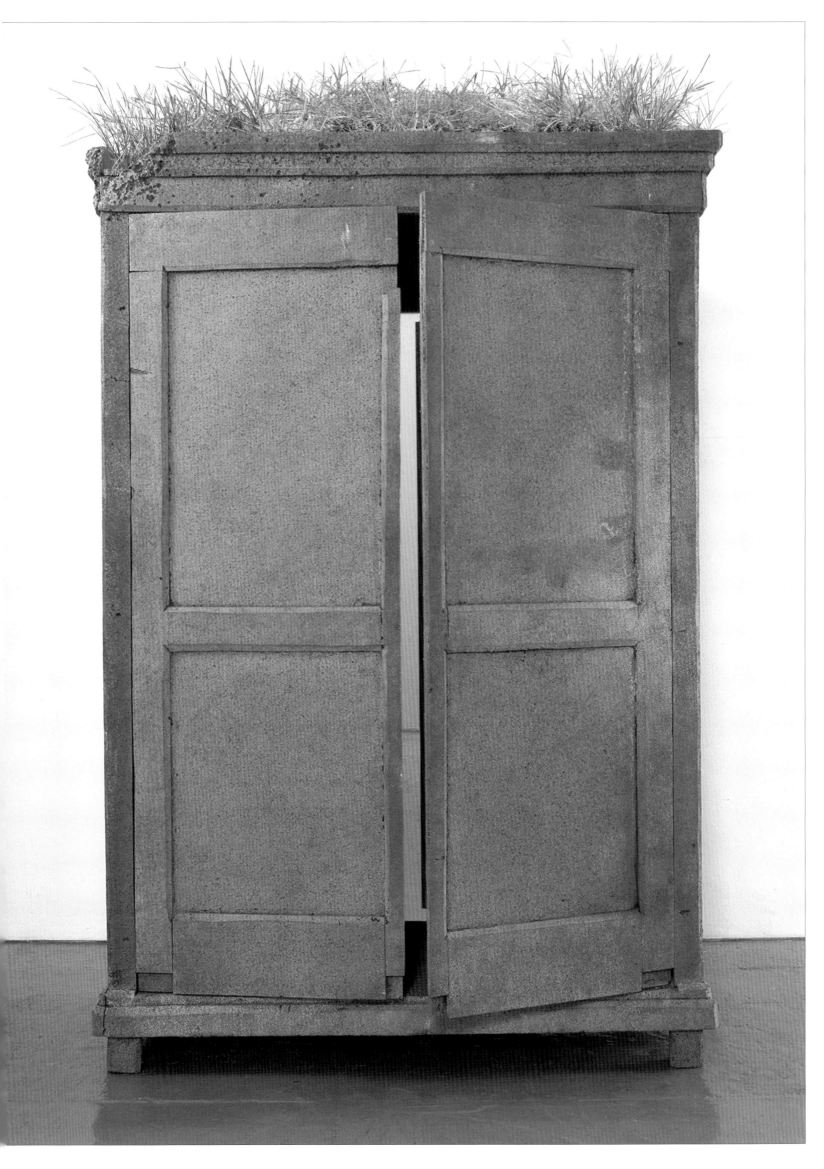

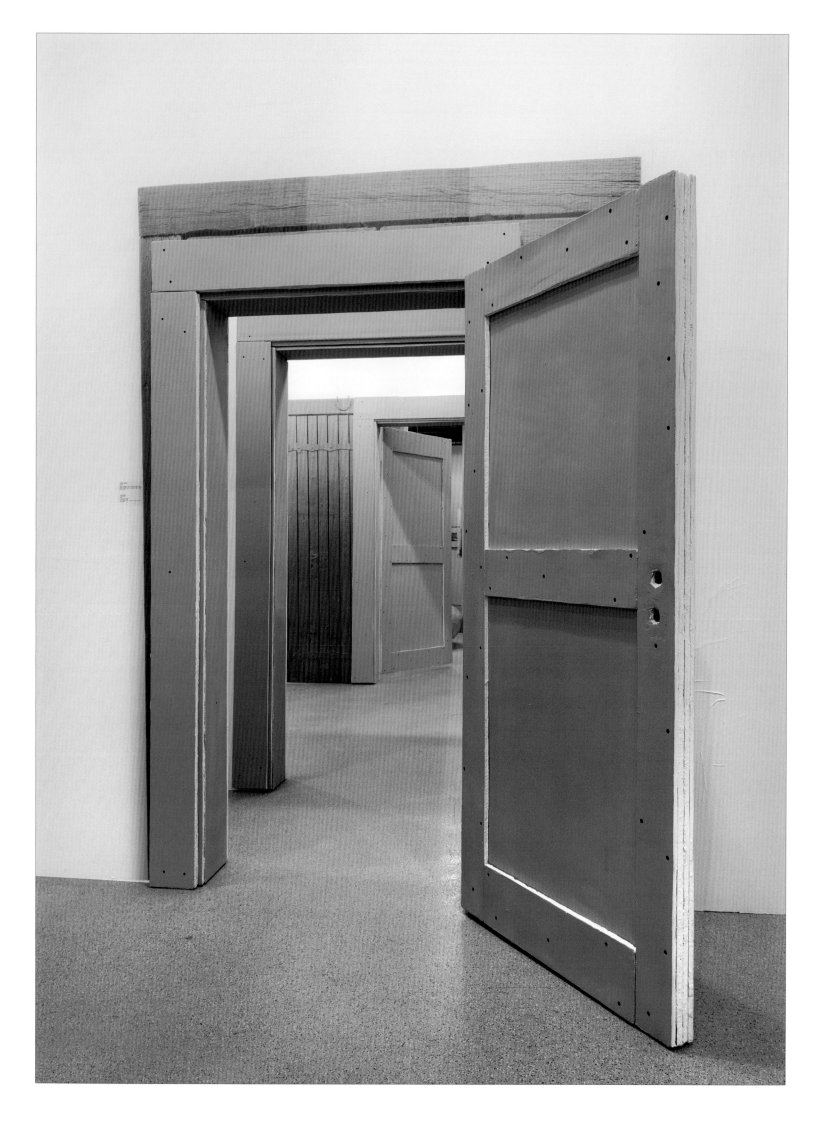

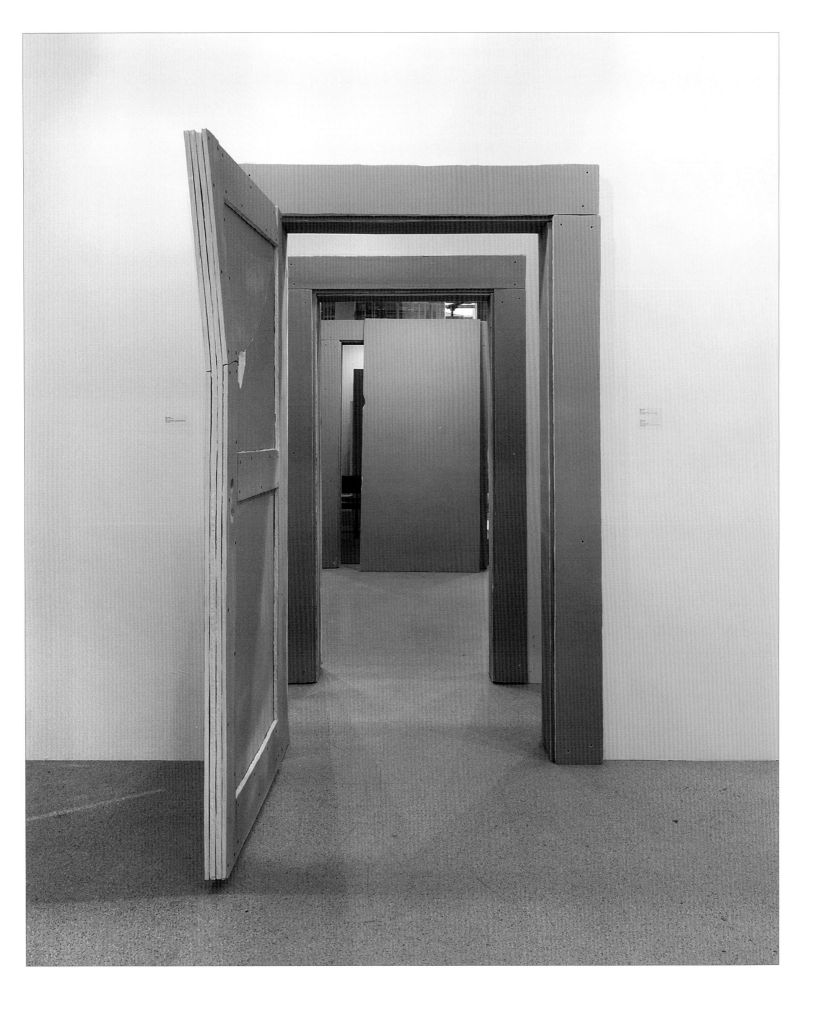

Untitled (Doors)
2007
Two doors installed in wall
Cast aluminum, enamel paint, steel hinges
Door 1: 250 x 185 x 33 cm; 98 ⅜ x 72 ⅞ x 13 in.
Door 2: 242 x 175 x 32 cm; 95 ¼ x 68 ⅞ x 13 in.
Installation view, Art Basel, Galerie Eva Presenhuber booth, 2007
Background: *Untitled (Doors)*, 2007;
On wall: *Last Call, Lascaux*, 2007

Untitled (Doors)
2007
Two doors installed in wall
Cast aluminum, enamel paint, steel hinges
Door 1: 235 x 155 x 33 cm; 92 ½ x 61 x 13 in.
Door 2: 220 x 135 x 33 cm; 86 ⅝ x 53 ⅛ x 13 in.
Installation view, Art Basel, Galerie Eva Presenhuber booth, 2007
Background: *Untitled (Doors)*, 2007

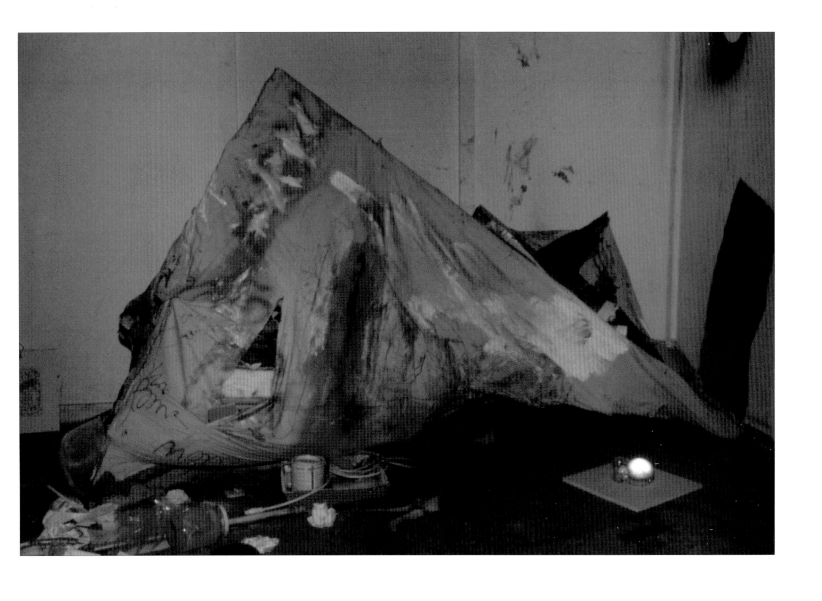

Ali
(with Maurus Gmür)
1994
Mixed media
Dimensions unknown
Studio view, Zurich, 1994

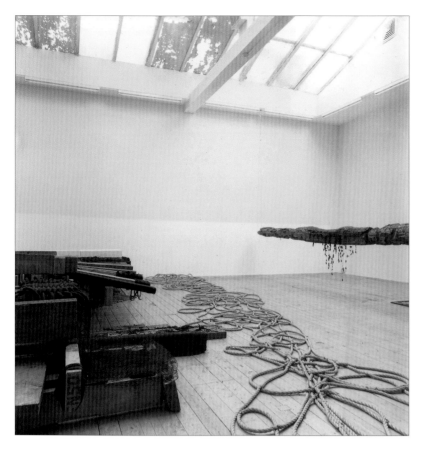
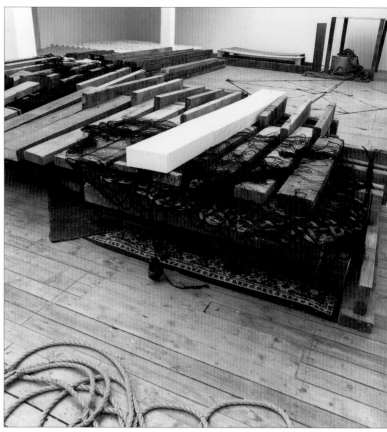
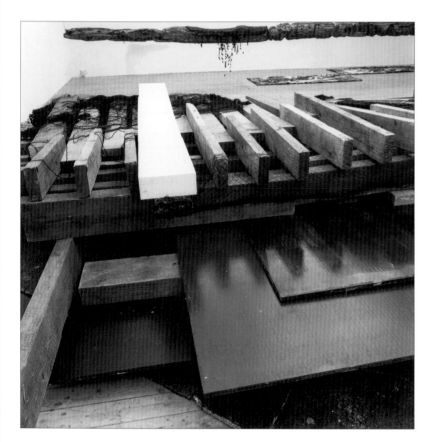
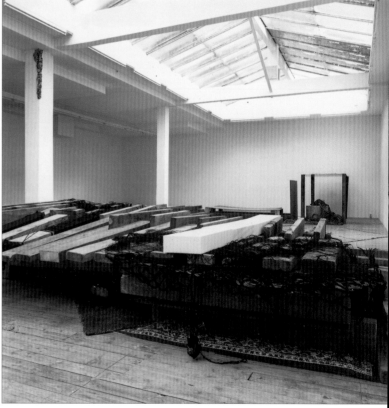

Installation view, "Calypso" (with Antonietta Peeters and
Avery Preesman), Stedelijk Museum Bureau, Amsterdam, 1995

Untitled (Garbage Pile)
1995
Garbage and latex
Dimensions unknown

Living on the Phone
1998
Wood, glass, paper, resin, acrylic paint, latex paint, ink,
pencil, marker, coffee, sugar, tape, screws
174 x 232.5 x 7.5 cm; 68 ½ x 91 ½ x 3 in.

Pages 162–163:

Installation view, "Frs Uischer," Galerie Walcheturm,
Zurich, 1996
Various drawings, 1995

Personal Titanic
1998
Glass, wood, paper, plastic, acrylic paint, felt, ink, pencil,
marker, ballpoint pen, tape
174.5 x 233.5 x 7.5 cm; 68 ¼ x 91 ⅞ x 3 in.

Studio view, *Personal Titanic* in progress, Switzerland, 1998

The Big Easy alias The Alternative Problem
1998–2000
Wood, glass, paper, bark, photographs, latex paint, acrylic
paint, marker, spray enamel, wood glue, wax, sawdust
182 x 252 x 16 cm; 71 ⅝ x 99 ¼ x 6 ¼ in.

More Sweet Feelings, Worries and Other Stuff
1998–1999
Wood, tinted glass, paper, marker, ink, latex paint,
acrylic paint, spray enamel, staples
181 x 250 x 9.5 cm; 71 ¼ x 98 ⅛ x 3 ¼ in.

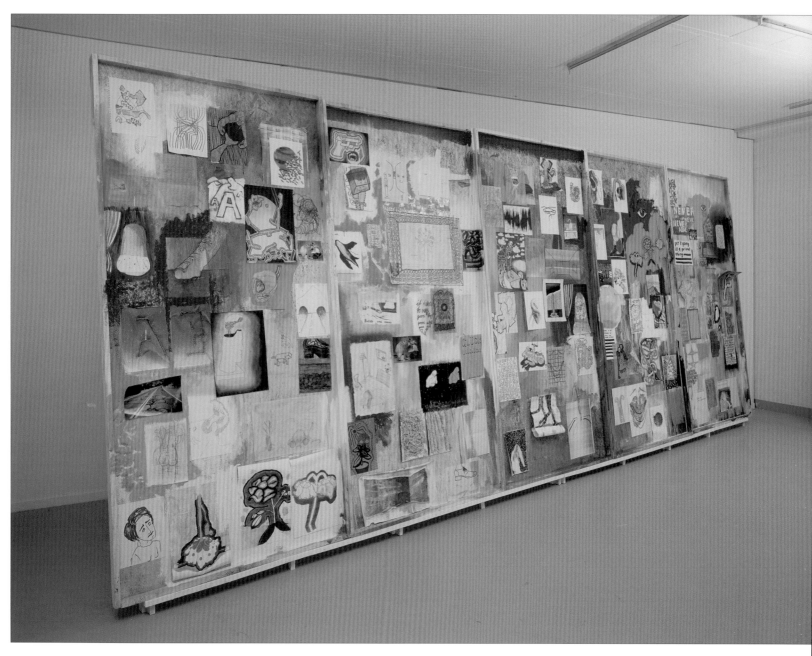

Kommt Zeit, Kommt Unrat
1999
Wood, glass, paper, photocopies, acrylic paint, latex paint,
marker, ink, pastel, spray enamel, fixative, wood glue
250 x 625 x 40 cm; 98 ⅜ x 246 x 15 ¼ in.

Studio view, Wallisellen, Switzerland, 1998

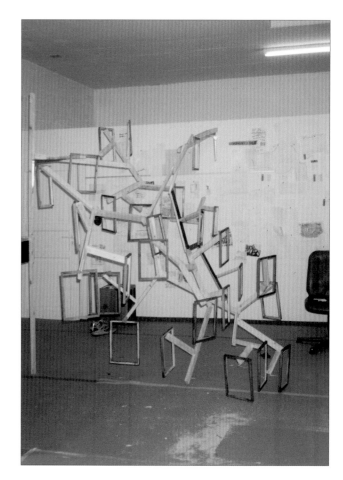

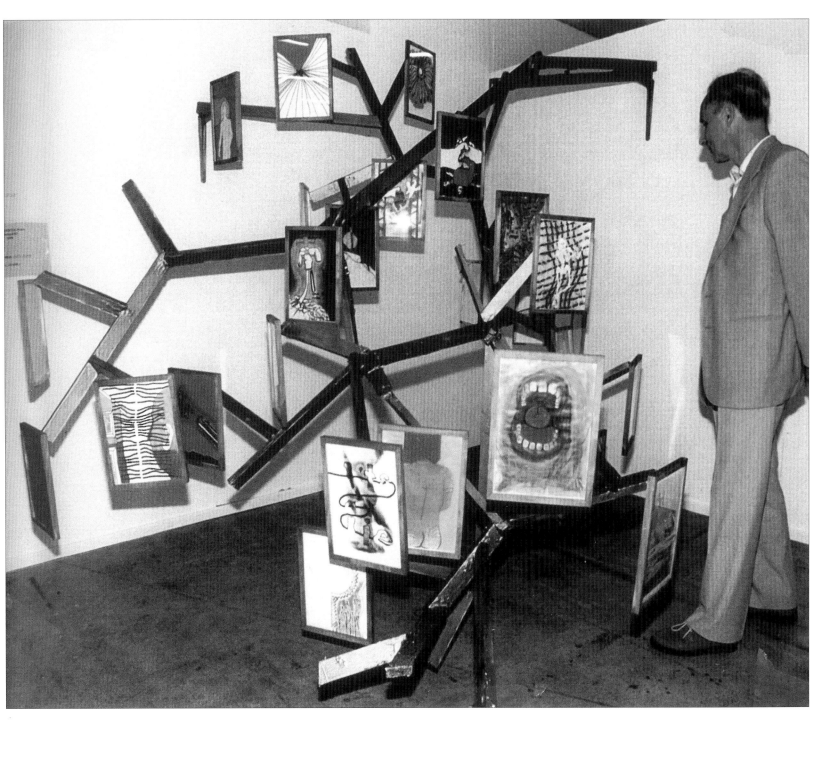

Untitled
1999
Mixed media
Dimensions unknown

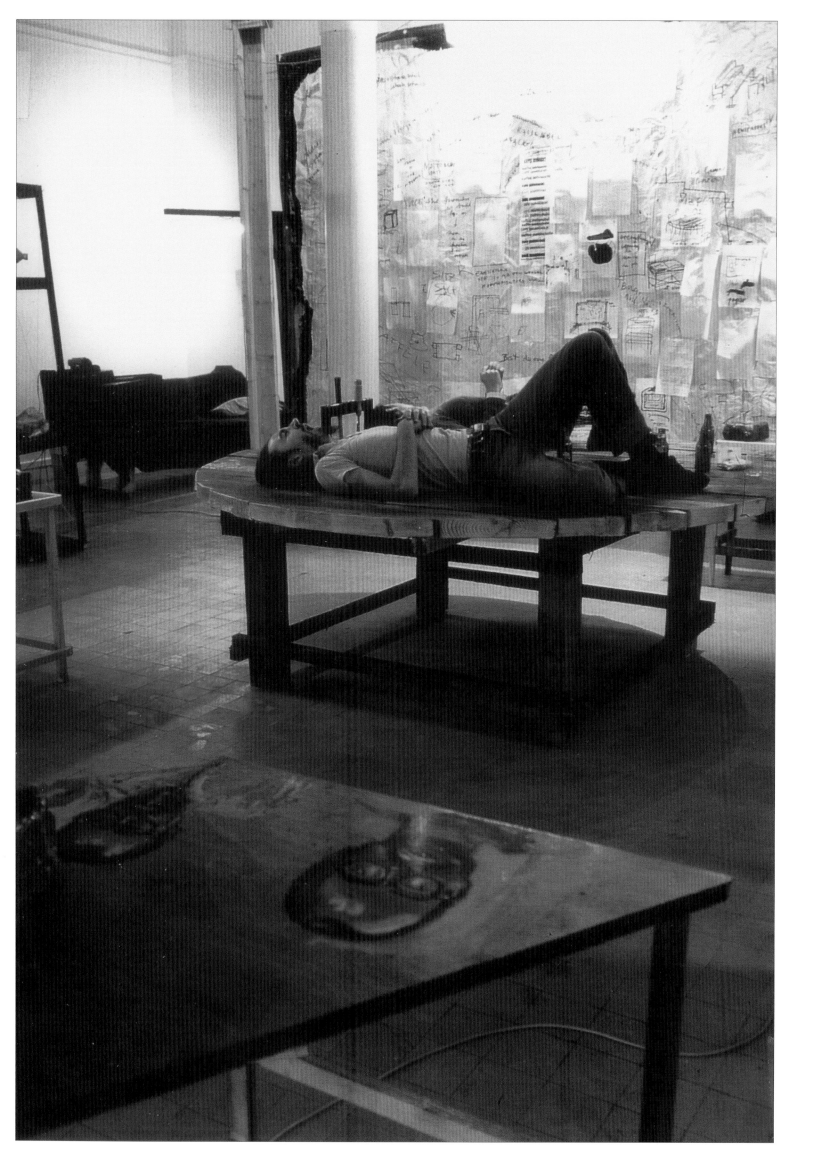

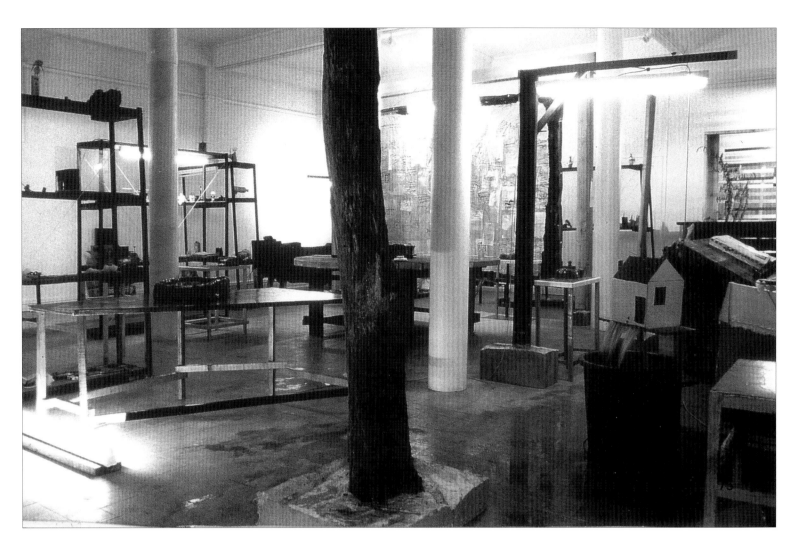

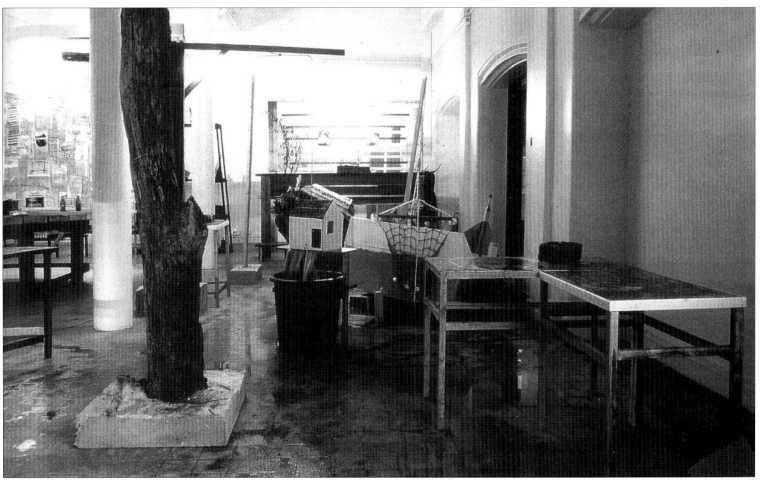

Installation view, "Pizzeria Sehnsucht"
(with Marko Lehanka), Ateliers du
FRAC des Pays de la Loire,
Saint-Nazaire, France, 1999

A Man and His Head Like a Hand with a Bread
Unfiltered Summer / Autumn 99 Poetry and Brain Waste
1999
Iron, glass, zinc phosphate paint, photocopies on polyester film,
adhesive tape
234 x 273 x 101 cm; 92 ⅛ x 107 ½ x 39 ¾ in.

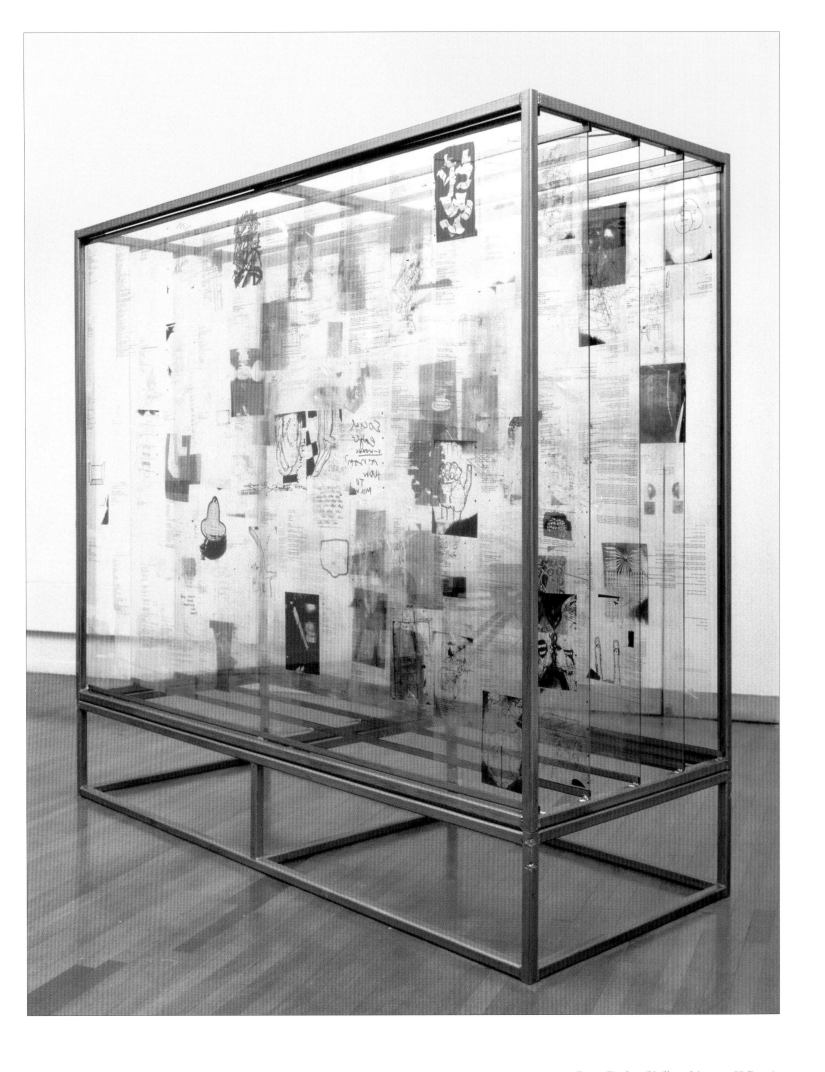

Poem-Donkey (Unfiltered Autumn 99 Poem)
2000
Iron, glass, zinc phosphate paint, photocopies on
polyester film, adhesive tape
195 x 280 x 120 cm; 76 ¾ x 110 ¼ x 47 ¼ in.

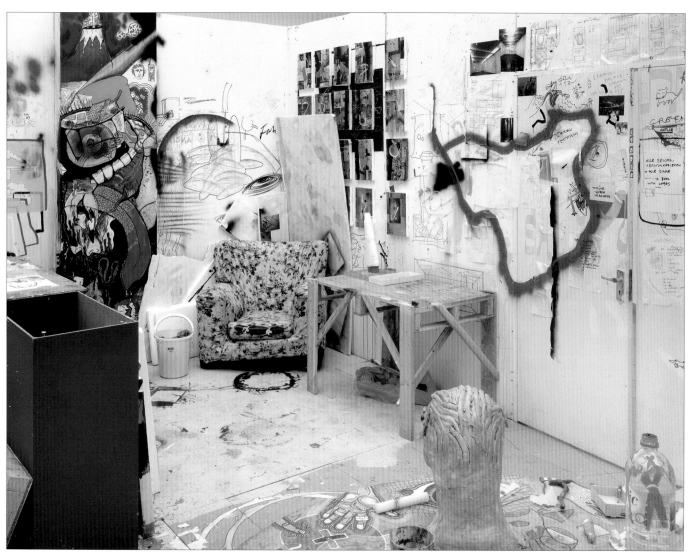

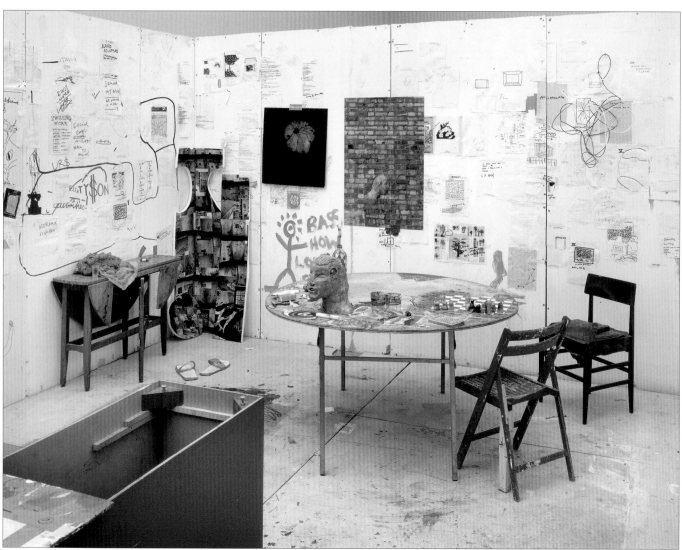

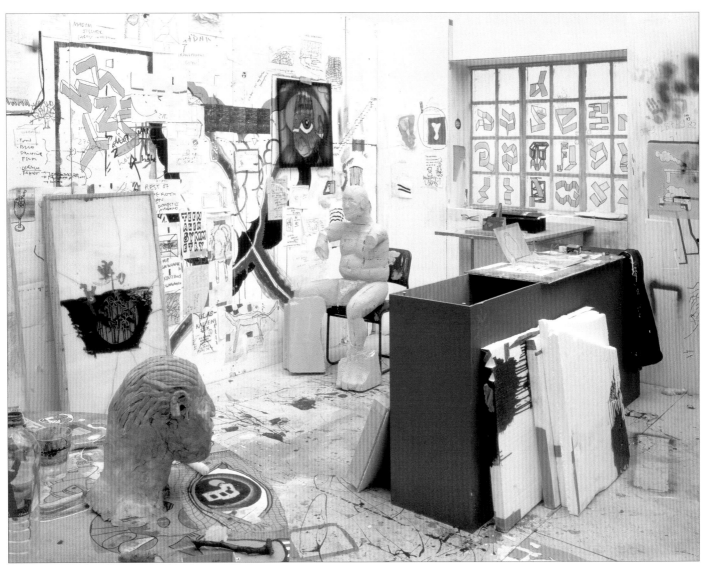

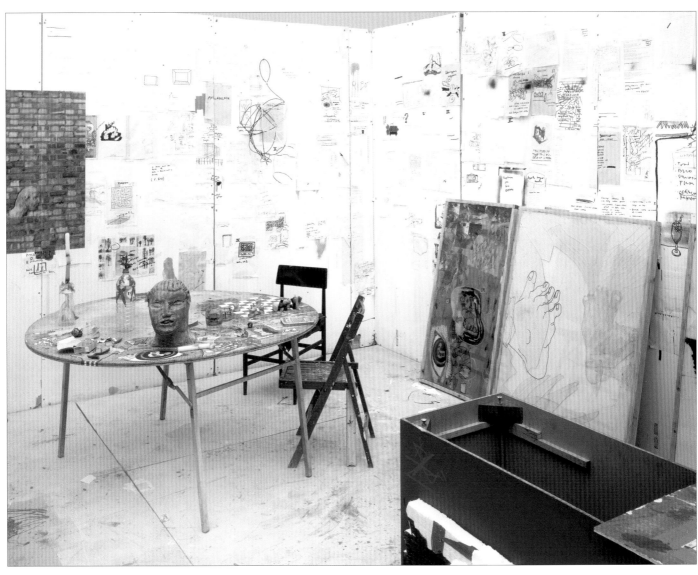

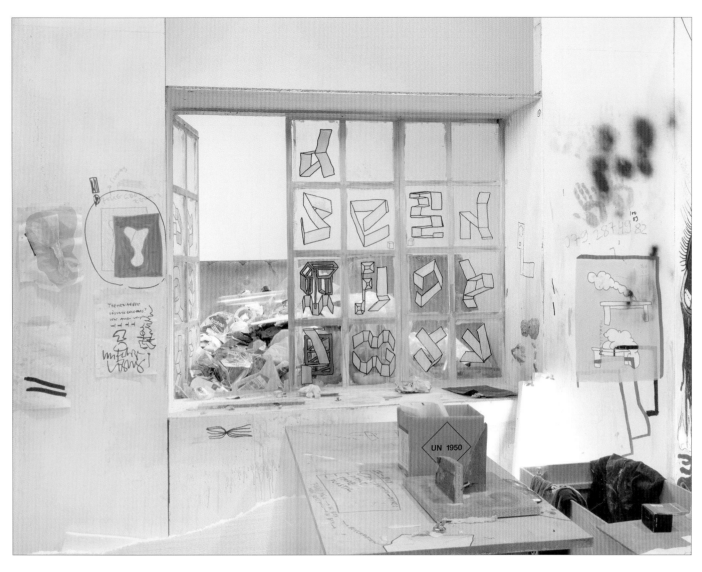

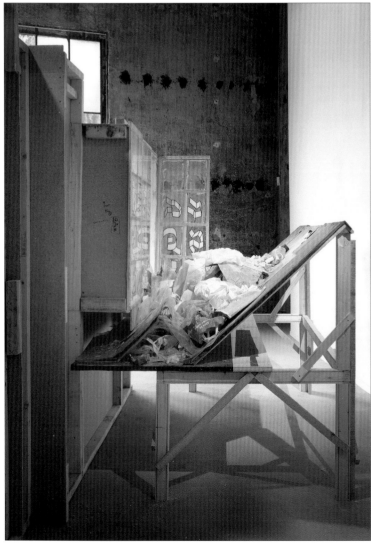

This and previous pages:

Madame Fisscher
1999–2000
Mixed media
Dimensions variable
Installation view, "The House of Fiction," Sammlung
Hauser & Wirth, Lokremise, St. Gallen, Switzerland, 2002

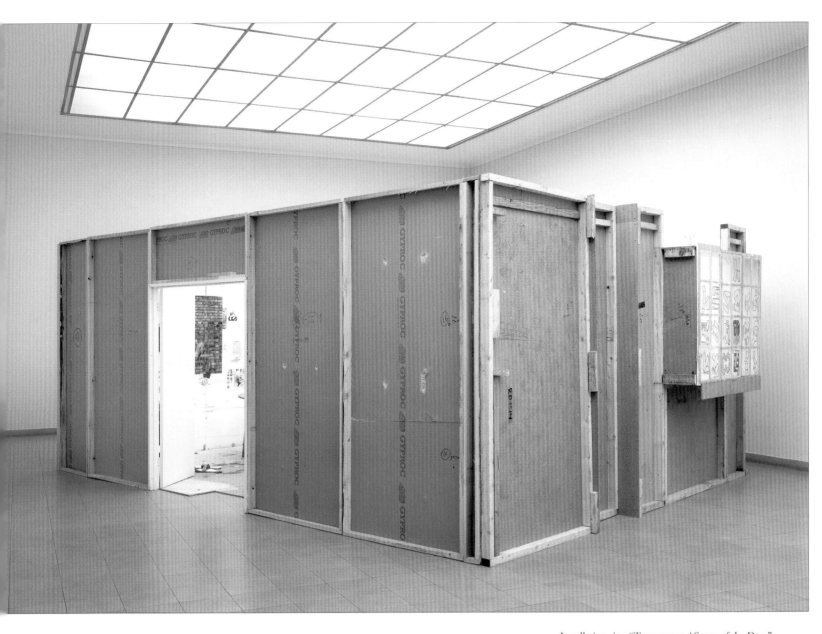

Installation view "Tagessuppen / Soups of the Days"
and "6 ½ Domestic Pairs Project" (with Keith Tyson),
Kunsthaus Glarus, Switzerland, 2000
Madame Fisscher, 1999–2000

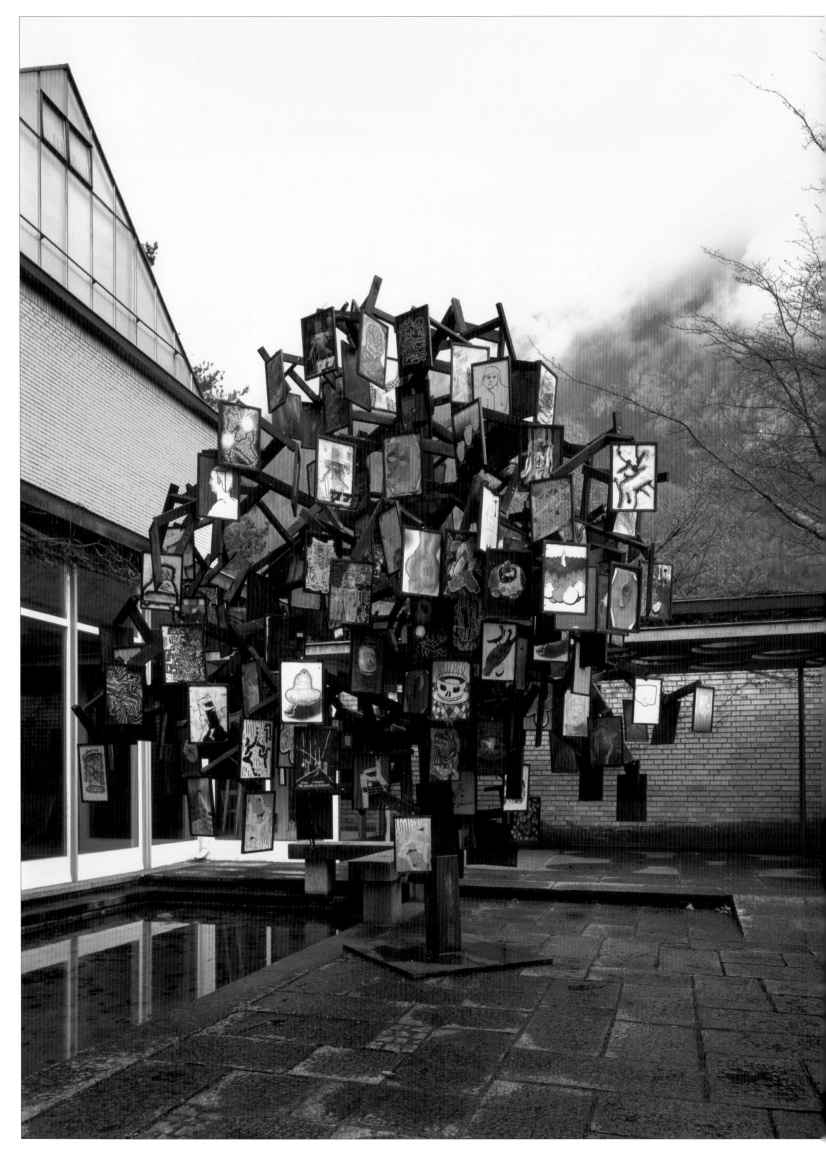

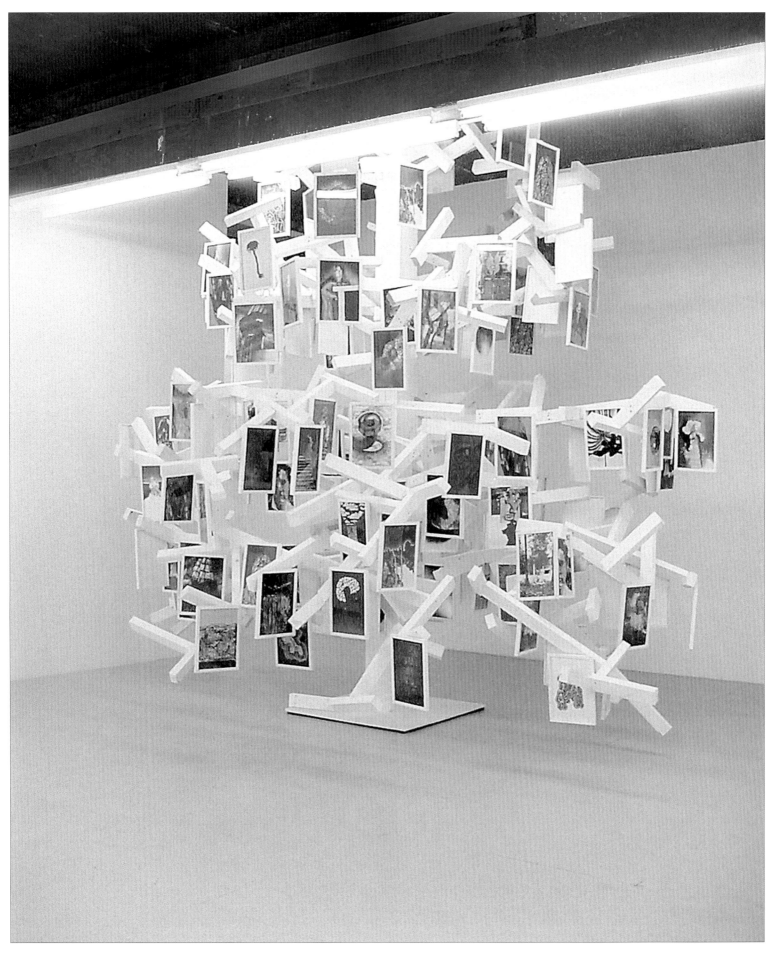

Jet Set Lady
2000
Color copies, wooden frames, wood, iron base, acrylic
glass, wood stain, acrylic lacquer, wood glue, screws
450 x 450 x 420 cm; 177 ⅛ x 177 ⅛ x 165 ⅛ in.
Installation view "Tagessuppen / Soups of the Days"
and "6 ½ Domestic Pairs Project" (with Keith Tyson),
Kunsthaus Glarus, Switzerland, 2000

The Lady
2000
Laser prints, wooden frames, wood, iron base,
silicone, wood glue, screws
Dimensions unknown
Installation view, "Cappillon—Urs just does it for
the girls" (with Amy Adler), Delfina, London, 2000

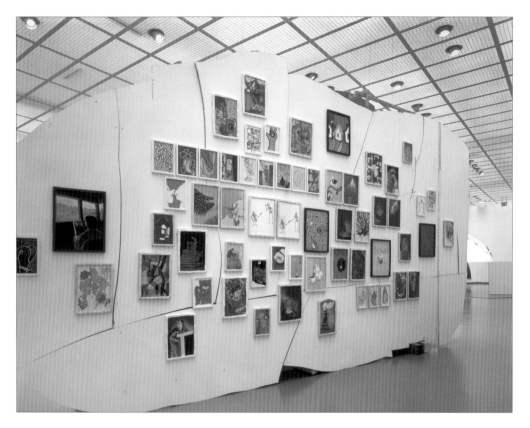

Installation view, "Kir Royal," Kunsthaus Zürich, 2004
Various drawings

Jet Set Lady
2000–2005
2,000 framed color prints of drawings, 24 fluorescent tubes,
wooden frames, iron, metal primer, UV-protective lacquer
900 x 700 x 700 cm; 354 ⅜ x 275 ⅝ x 275 ⅝ in.
Installation view, "Jet Set Lady," Fondazione Nicola Trussardi,
Milan, 2005

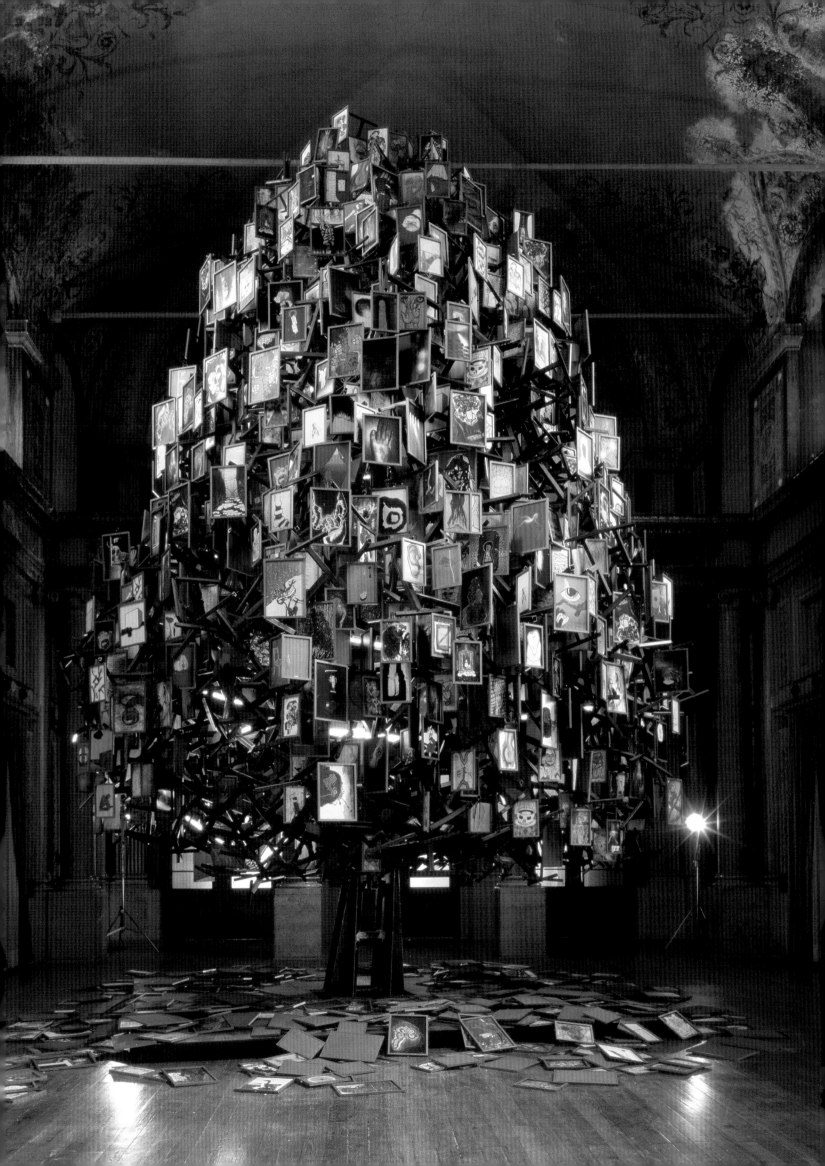

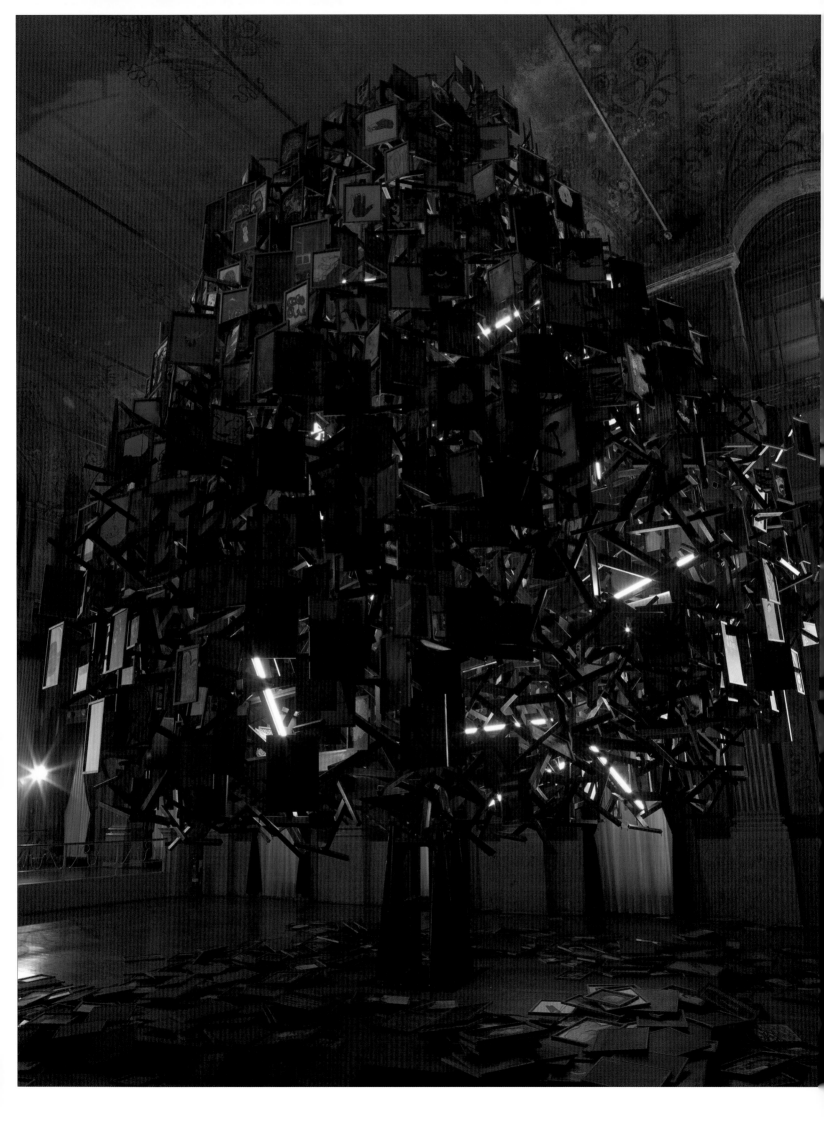

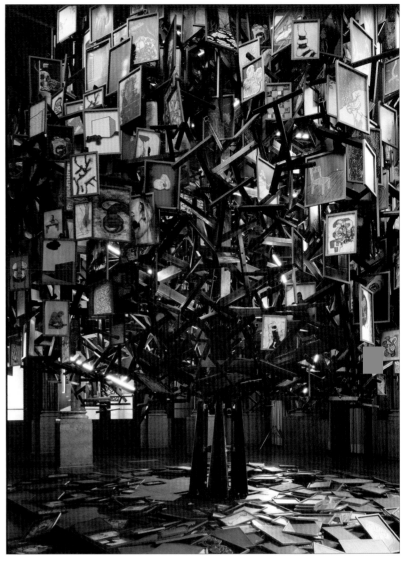

Jet Set Lady
2000–2005
2,000 framed color prints of drawings, 24 fluorescent tubes,
wooden frames, iron, metal primer, UV-protective lacquer
900 x 700 x 700 cm; 354 ⅜ x 275 ⅝ x 275 ⅝ in.
Installation view, "Jet Set Lady," Fondazione Nicola Trussardi,
Milan, 2005

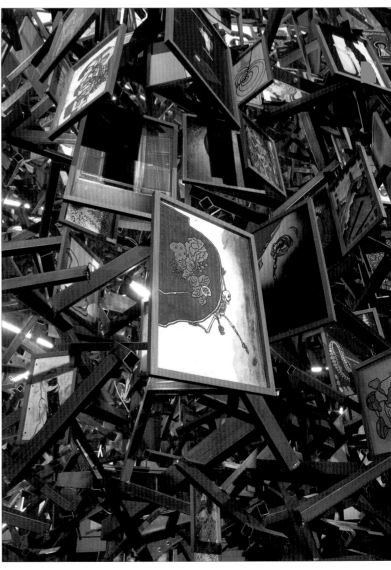

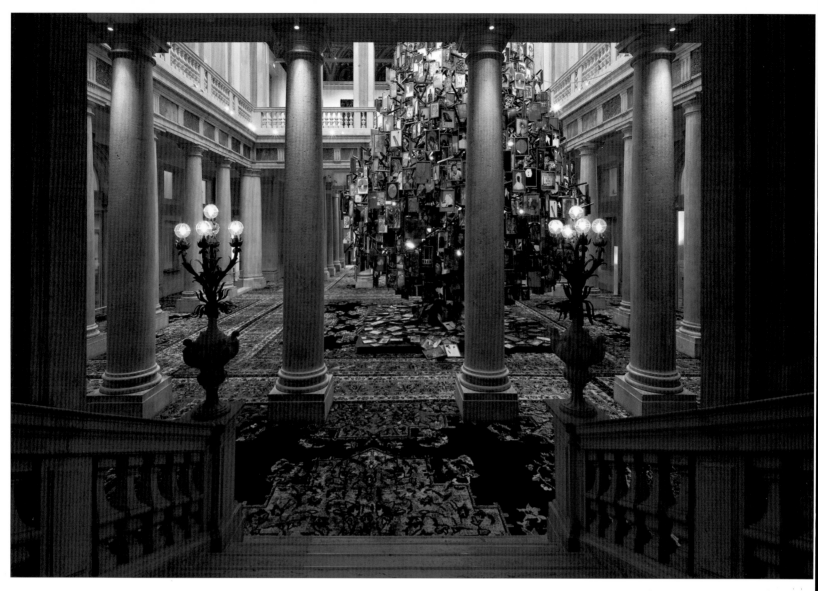

Jet Set Lady
2000–2005
2,000 framed color prints of drawings, 24 fluorescent tubes,
wooden frames, iron, metal primer, UV-protective lacquer
900 x 700 x 700 cm; 354 ⅛ x 275 ⅝ x 275 ⅝ in.
Installation view, "Sequence 1: Painting and Sculpture in the
François Pinault Collection," Palazzo Grassi, Venice, 2007
On floor: Rudolf Stingel, *Untitled (Sarouk)*, 2006

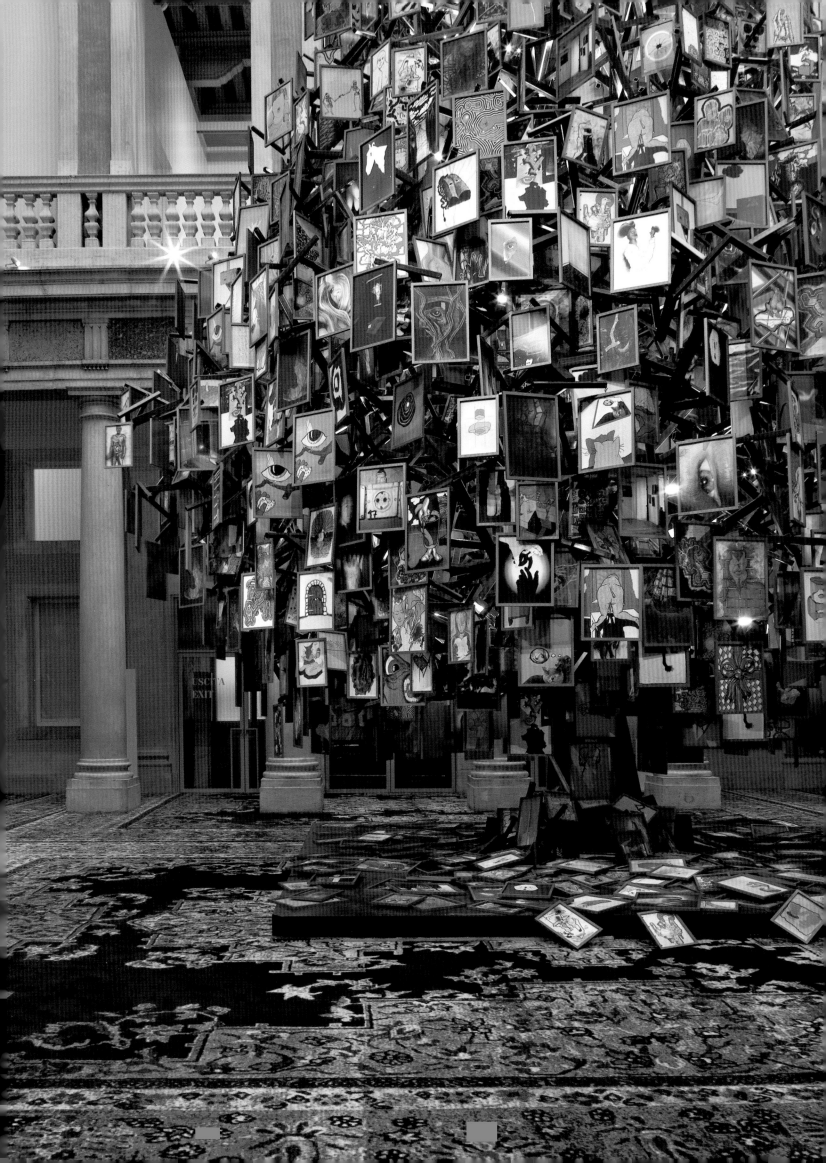

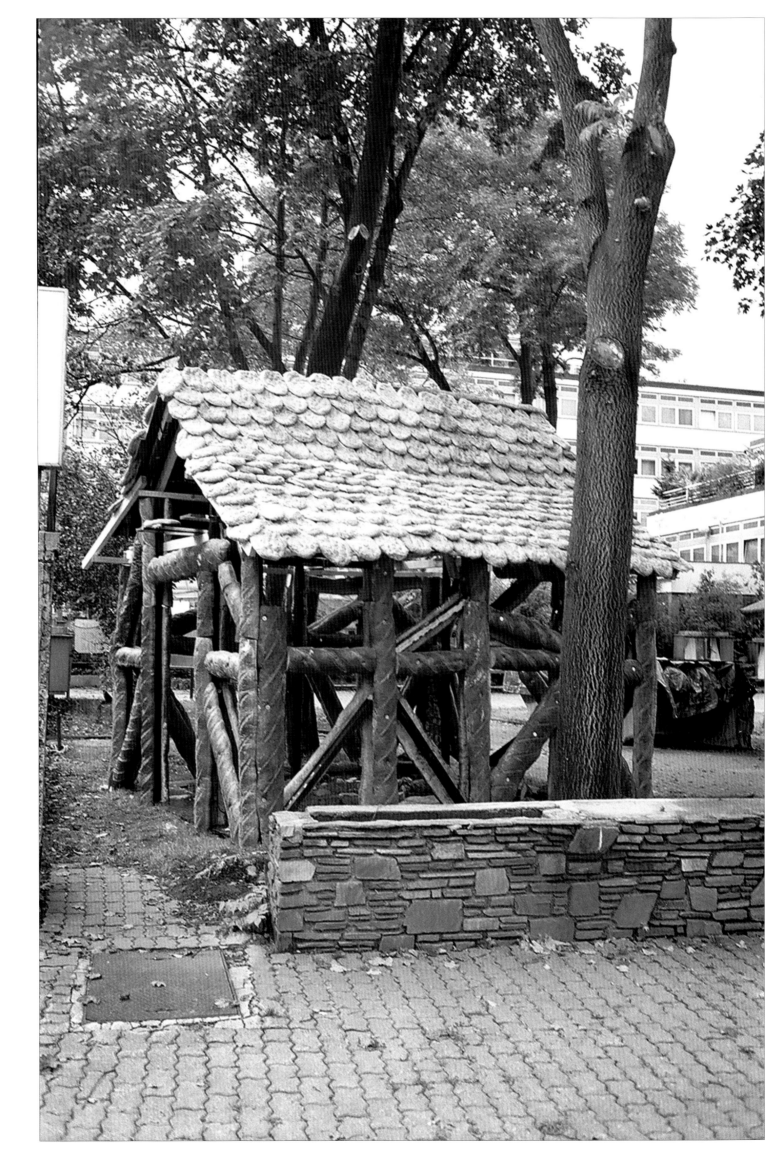

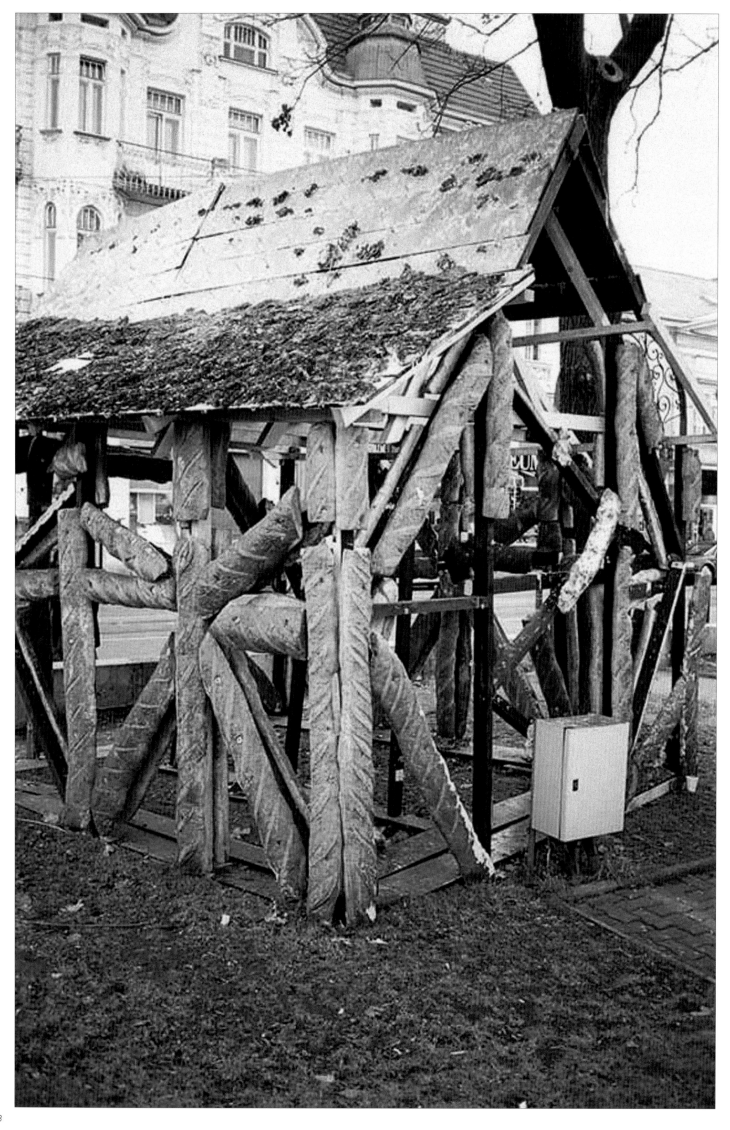

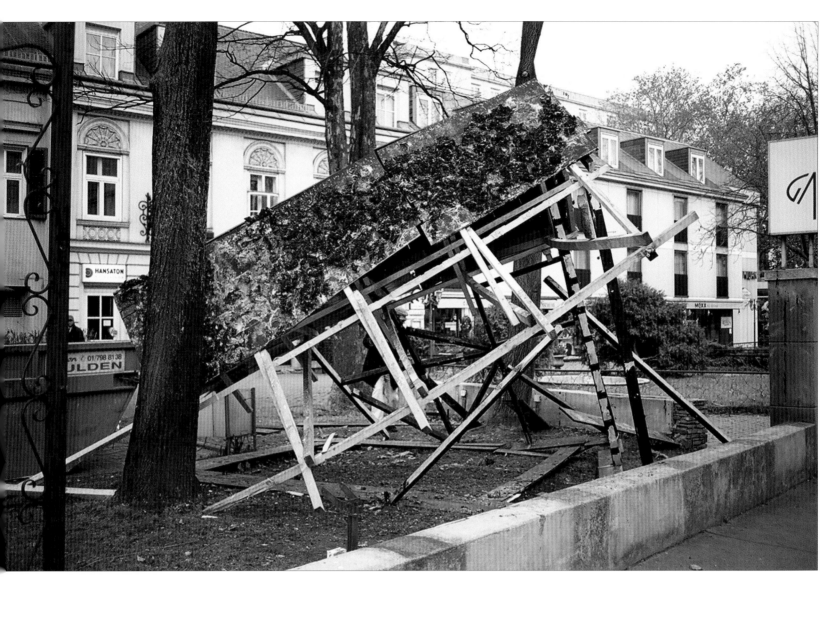

This spread and previous:

Untitled (Bread House)
2004
Bread, wood, marzipan, screws
400 x 400 x 430 cm; 157 ½ x 157 ½ x 169 ¼ in.
Prototype
Installation view, "Feige, Nuss, und Birne,"
Gruppe Österreichische Guggenheim, Vienna, 2004

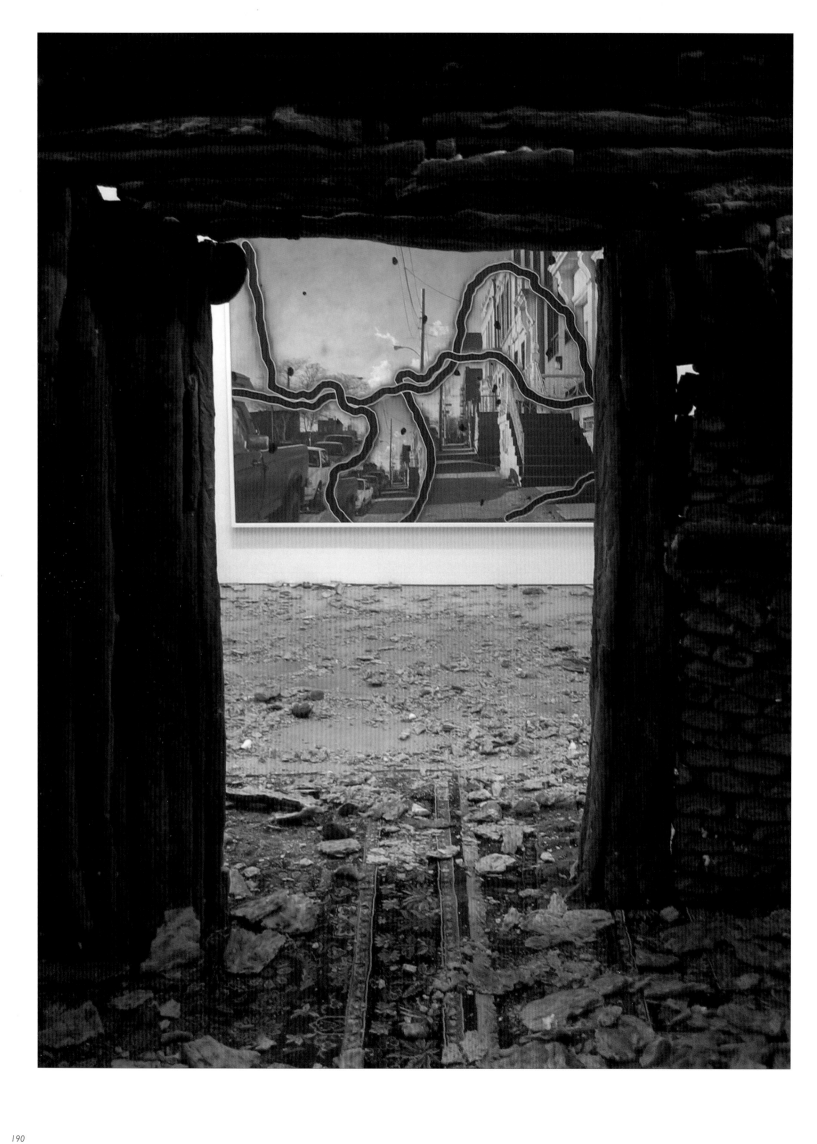

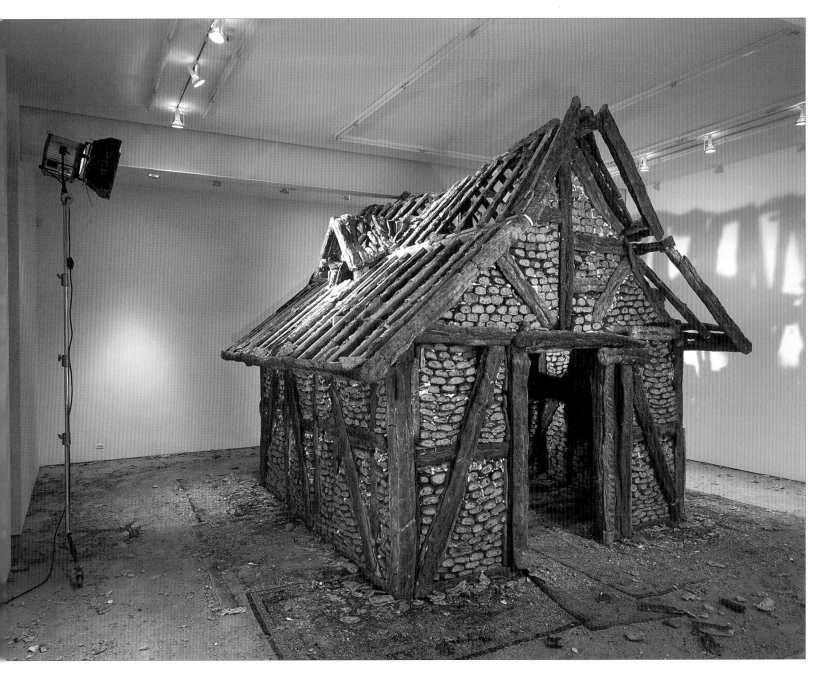

Untitled (Bread House)
2004–2005
Bread, bread crumbs, wood, polyurethane foam, silicone,
acrylic paint, screws, tape, rugs, theater spotlights
406 x 372 x 421 cm; 159 ⅞ x 146 ½ x 165 ¾ in.
Installation view, "Fig, Nut & Pear,"
Gavin Brown's enterprise, New York, 2005

Installation view, "Fig, Nut & Pear," Gavin Brown's enterprise,
New York, 2005
Untitled (Bread House), 2004–2005; *A Novel and Its Novelist*, 2005

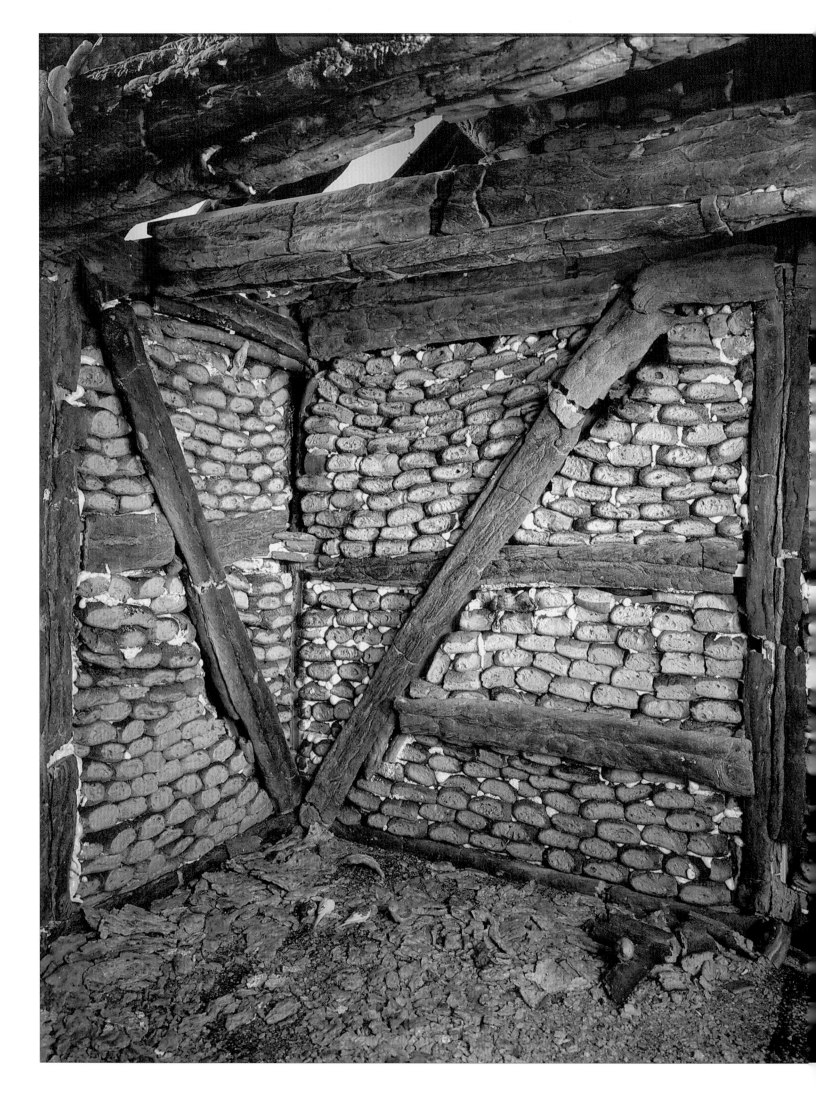

Installation view, "Fig, Nut & Pear,"
Gavin Brown's enterprise, New York, 2005
Untitled (Bread House), 2004–2005

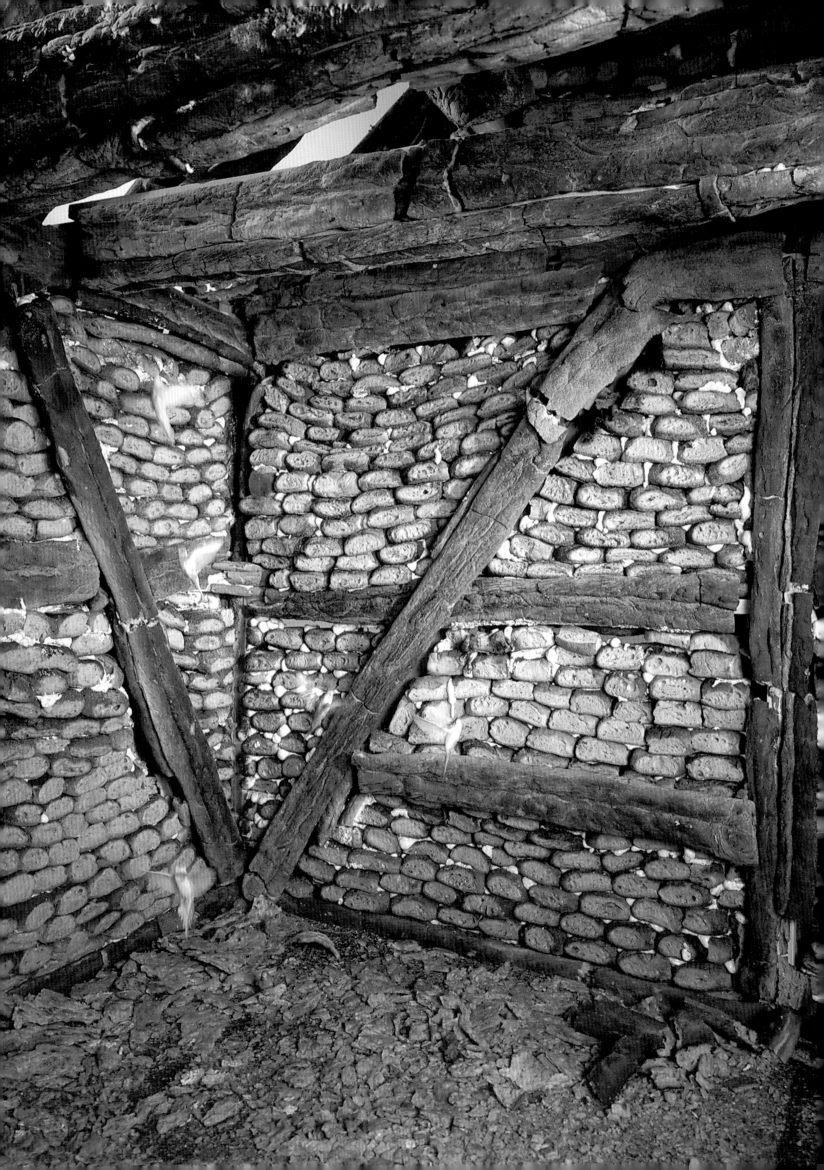

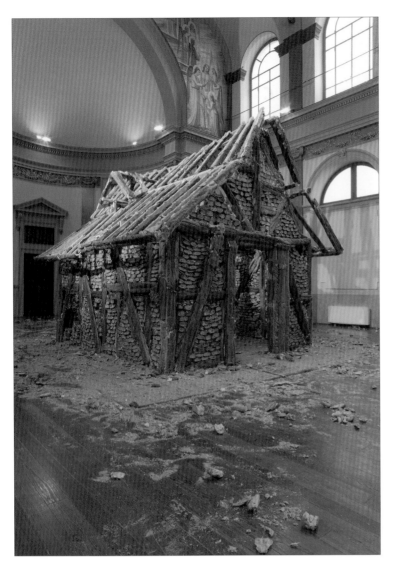

Untitled (Bread House)
2004–2005
Bread, bread crumbs, wood, polyurethane foam, silicone,
acrylic paint, screws, tape, rugs, theater spotlights
406 x 372 x 421 cm; 159 ⅞ x 146 ½ x 165 ¼ in.
Installation view, "Jet Set Lady," Fondazione Nicola
Trussardi, Milan, 2005

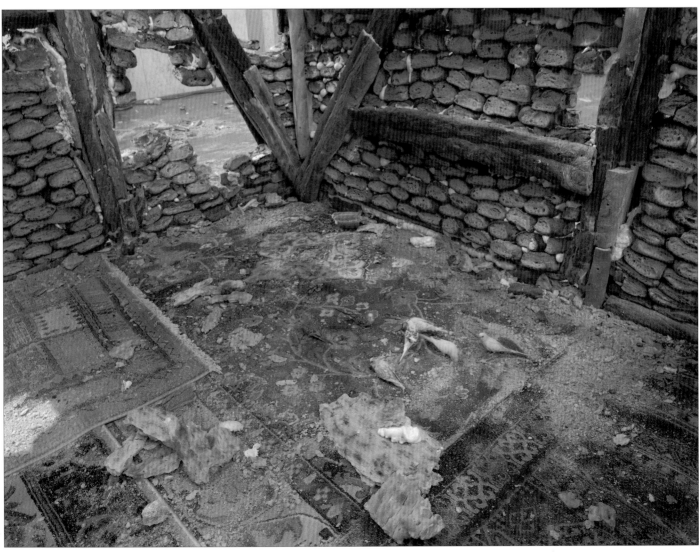

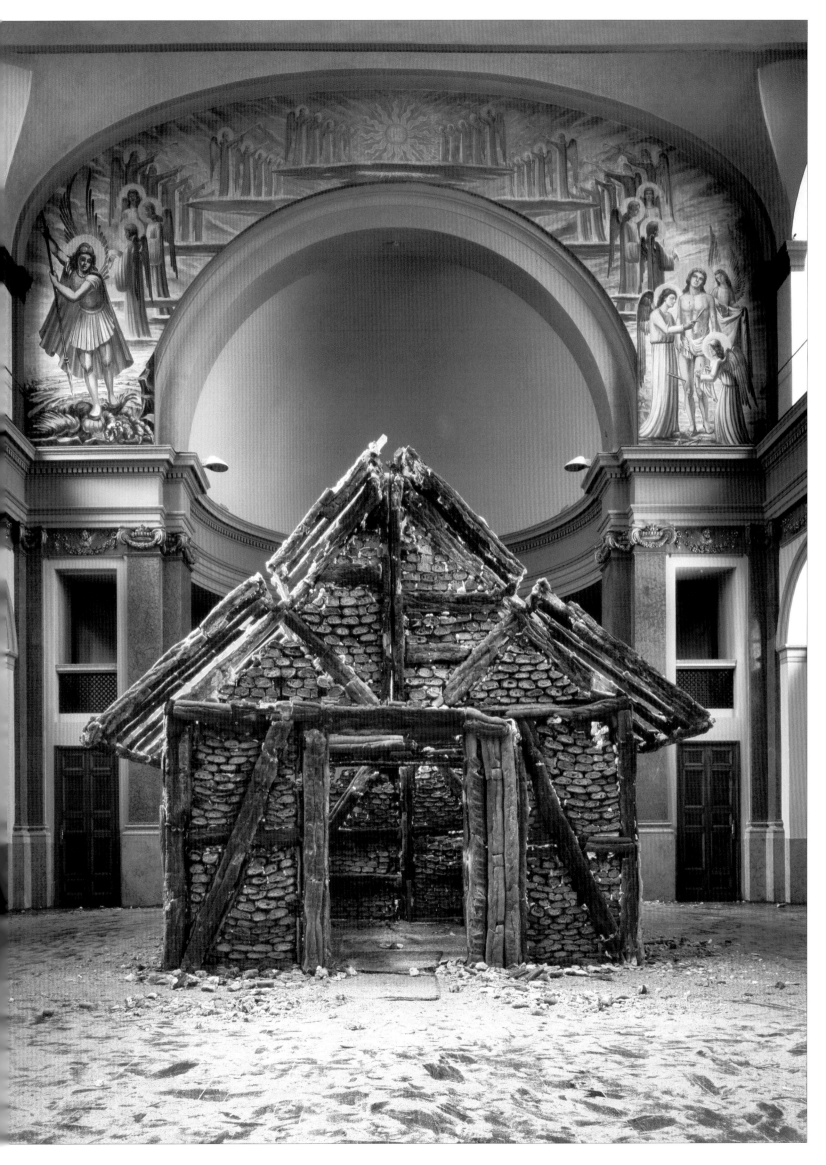

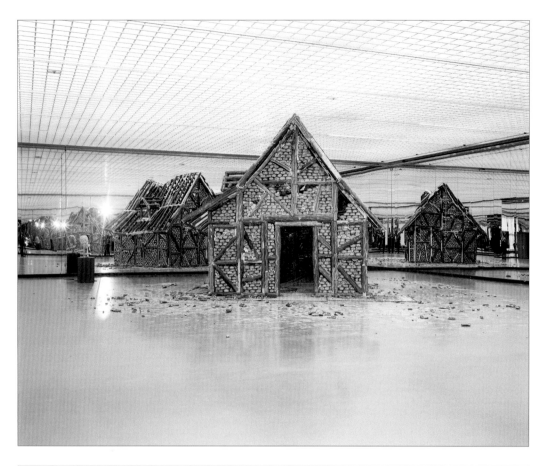

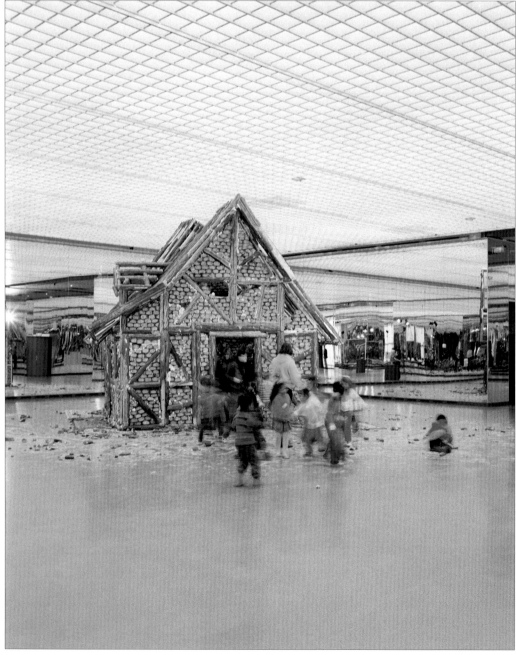

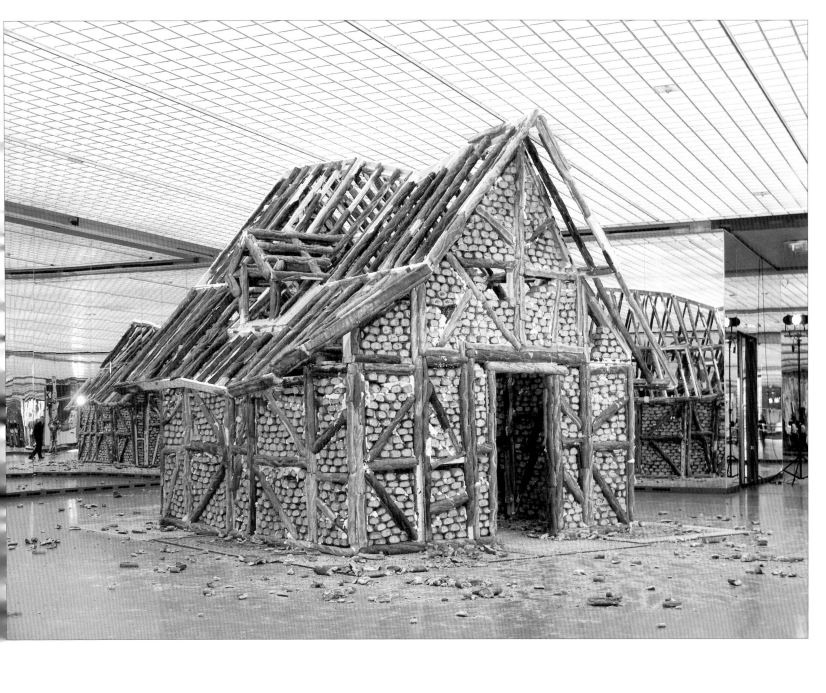

This page and following:

Untitled (Bread House)
2004–2006
Bread, bread crumbs, wood, polyurethane foam, silicone,
acrylic paint, screws, tape, rugs, theater spotlights
500 x 400 x 500 cm; 196 ⅞ x 157 ½ x 196 ⅞ in.
Installation view, "Paris 1919," Museum Boijmans Van
Beuningen, Rotterdam, 2006

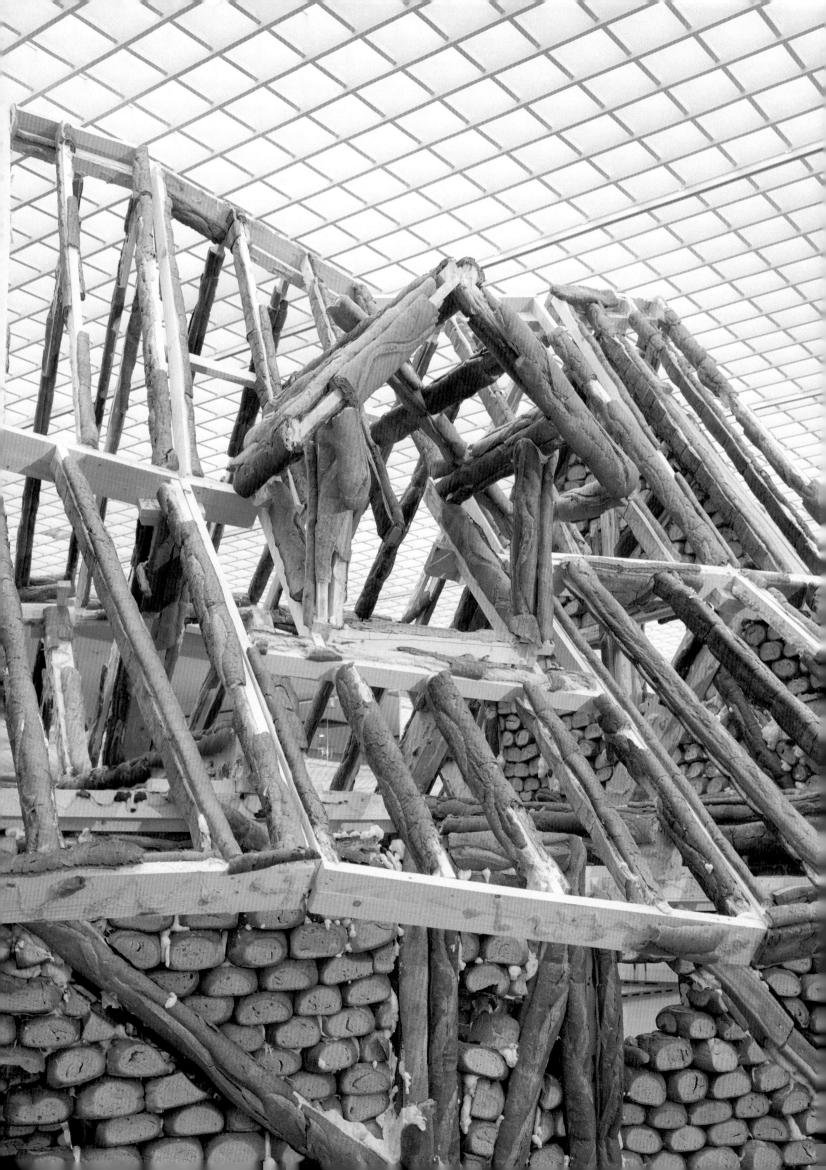

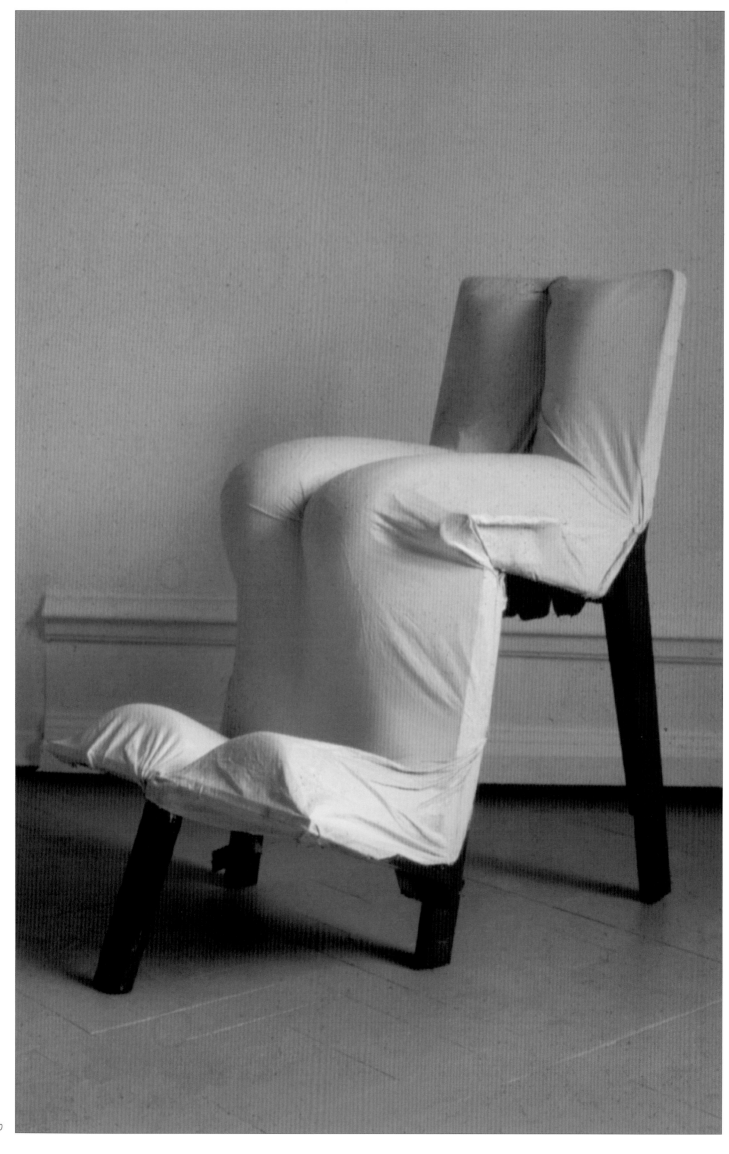

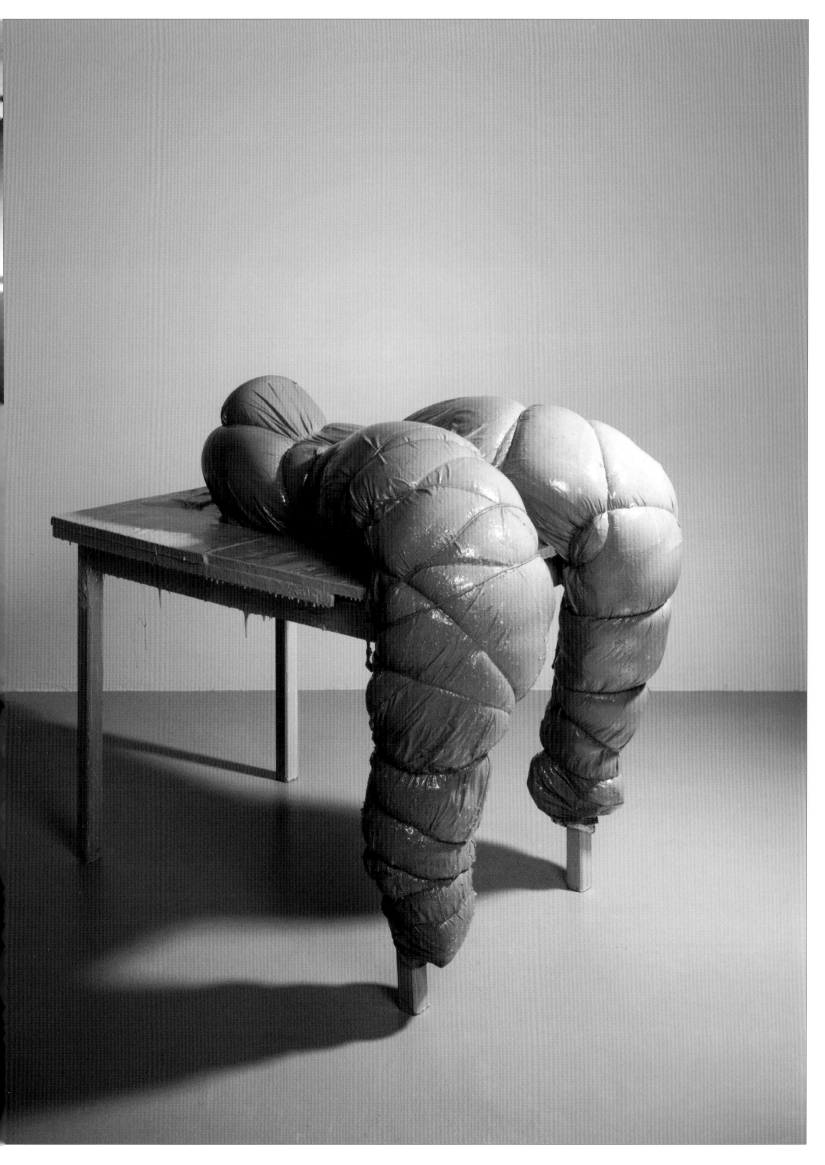

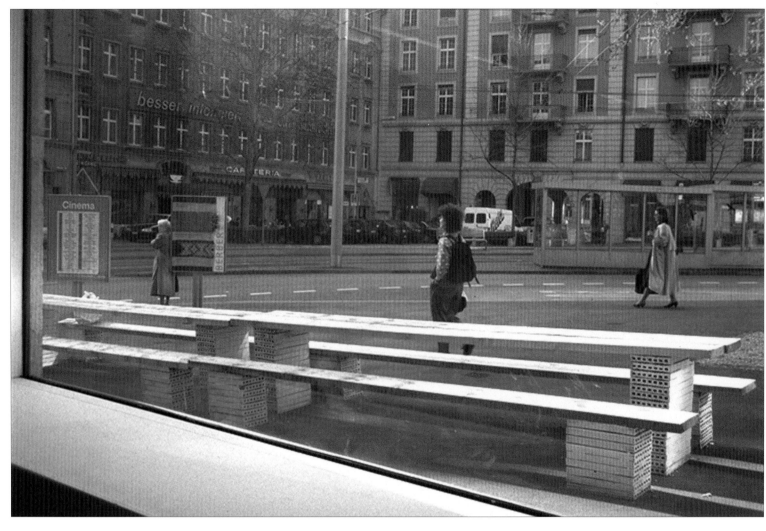

Untitled
1996
Wood, lime, bricks, mortar
Dimensions variable
Installation view, "Frs Uischer,"
Galerie Walcheturm, Zurich, 1996

Page 200:

Stuhl mit (Chair with)
1995–2001
Wood, foam, latex paint, acrylic paint, fabric, screws
100 x 65 x 100 cm; 39 ⅜ x 25 ⅝ x 39 ⅜ in.

Page 201:

Tisch mit (Table with)
1995–2001
Wood, mattress, lacquer, acrylic paint, string, fabric,
two-component epoxy
106 x 123 x 98 cm; 41 ¼ x 48 ⅛ x 38 ⅝ in.

Untitled
1997
Cut-up pallet, household candles
104 x 100 x 23 cm; 41 x 39 ⅜ x 9 in.

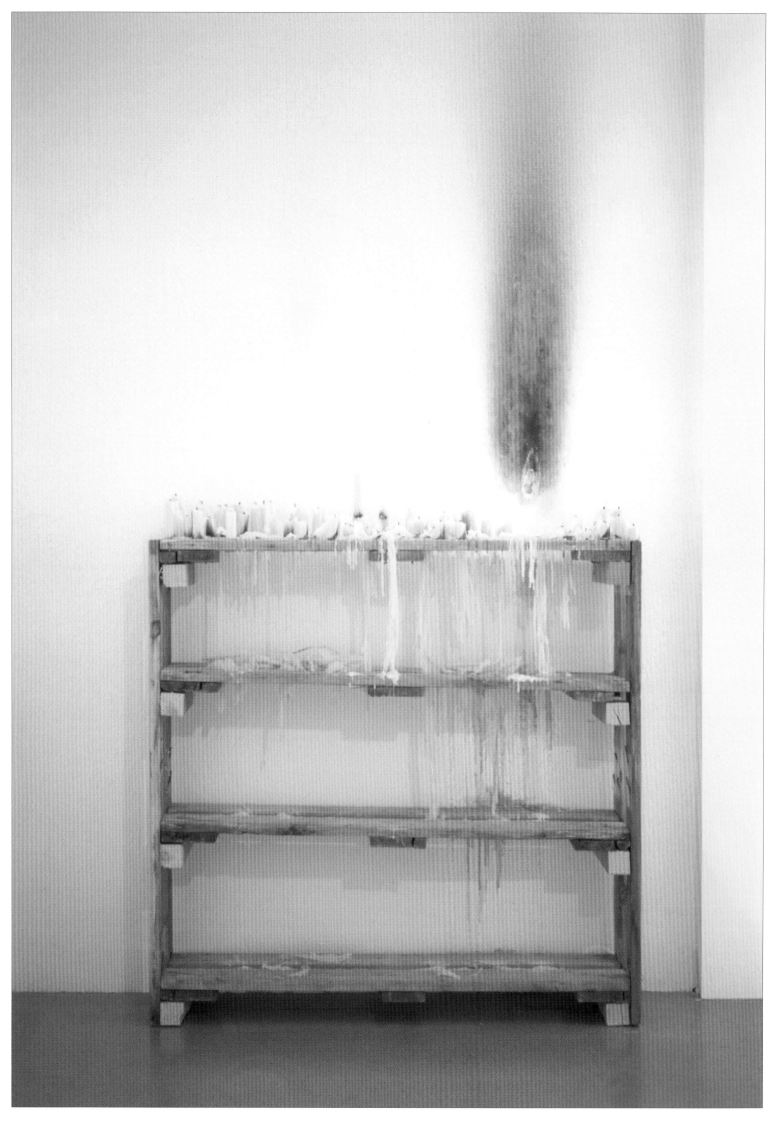

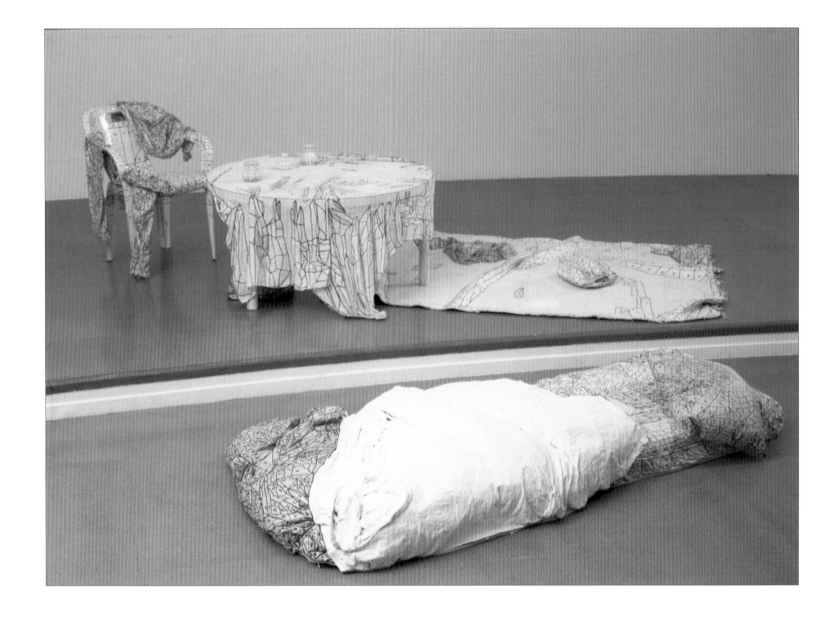

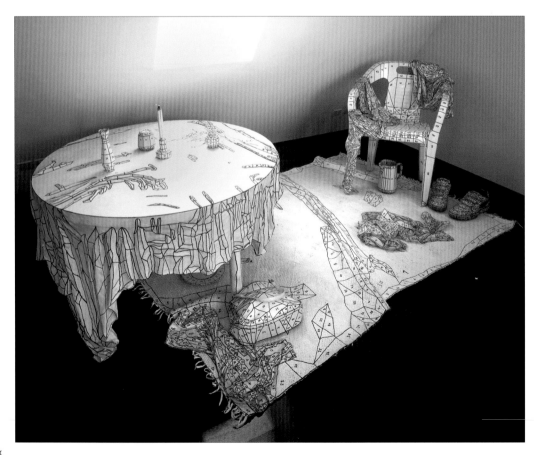

Untitled
1997
Found furnishings, found clothes, latex paint,
acrylic binder, marker, wood glue, silicone
Dimensions variable

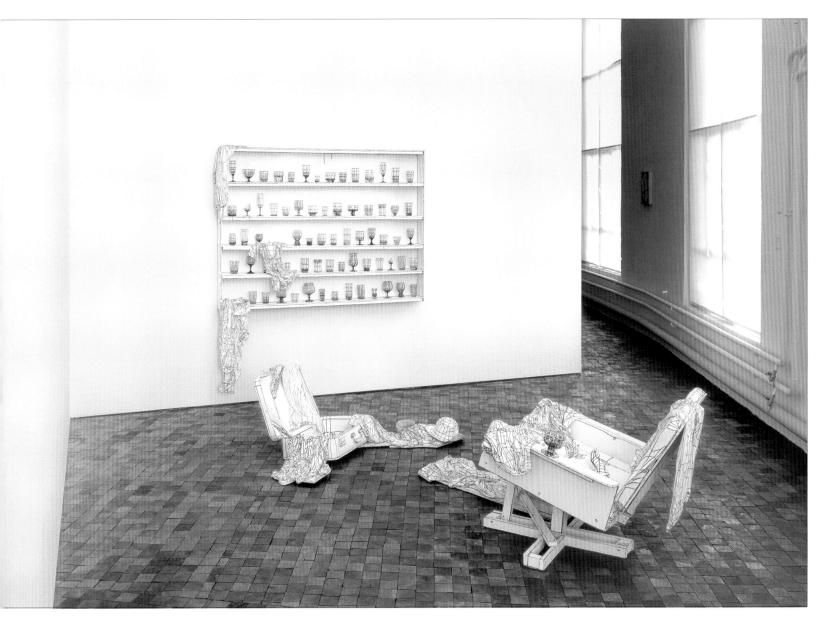

The Art of Falling Apart
1998
Wood, latex paint, acrylic paint, marker, found
clothes, found glasses, found suitcase, found hat
Chair: 180 x 200 x 151 cm; 70 ⅞ x 78 ¾ x 59 ½ in.
Suitcase: 120 x 200 x 80 cm; 47 ¼ x 78 ¾ x 31 ½ in.
Shelf: 140 x 150 x 60 cm; 55 ⅛ x 59 x 23 ⅝ in.

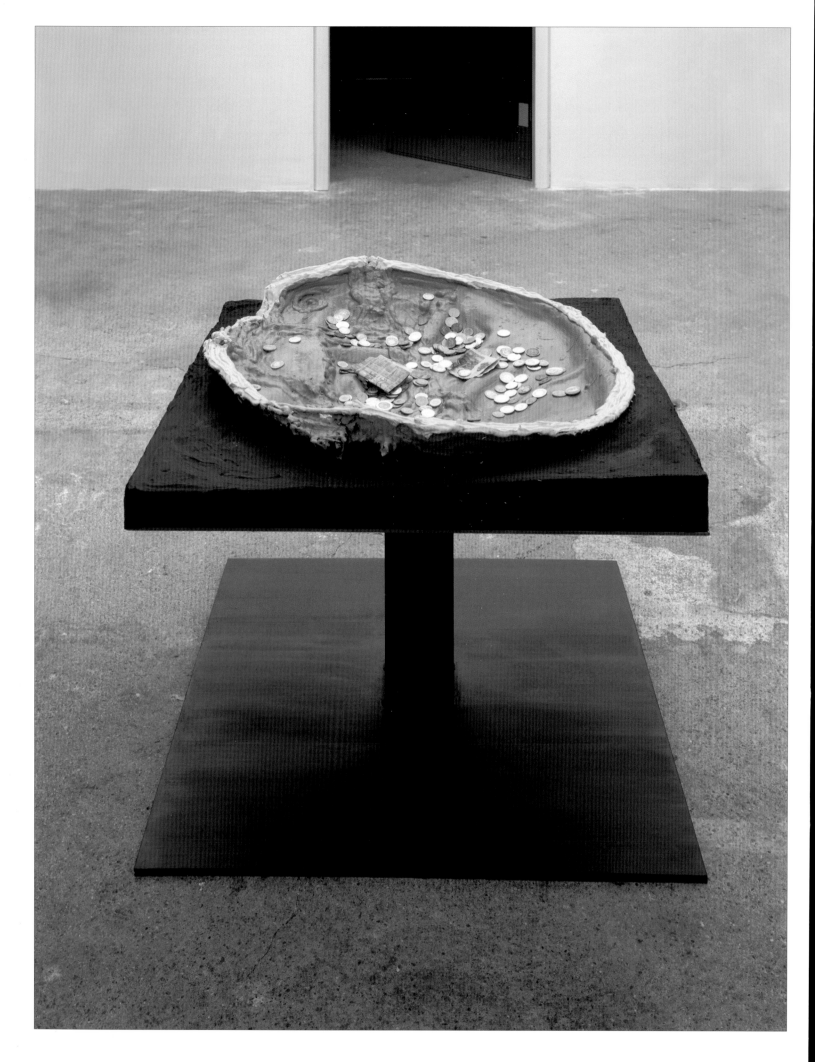

Money Bowl
1999
Iron, metal primer, plaster, acrylic paint, caulk, wax, coins, bills
Bowl: 70 x 70 x 14 cm; 27 ½ x 27 ½ x 5 ½ in.
Pedestal: 70 x 70 x 46 cm; 27 ½ x 27 ½ x 18 ⅛ in.

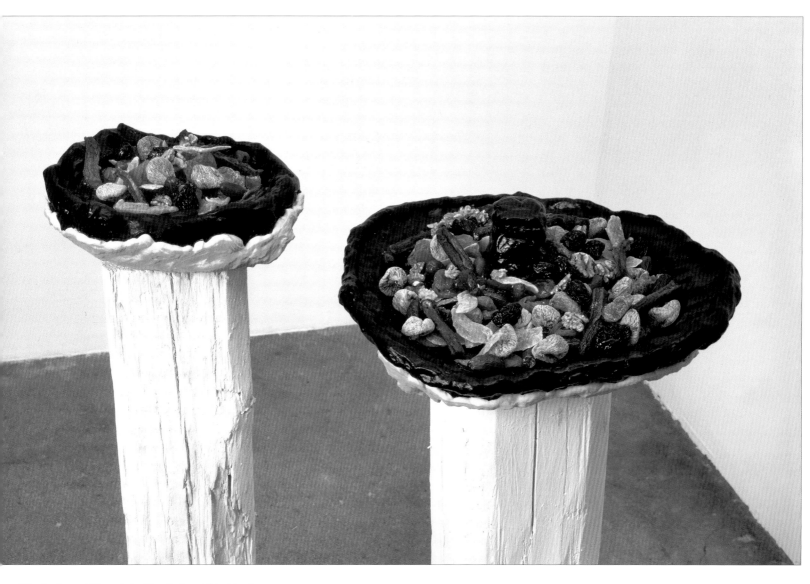

Dörrfrucht und Nussschale (Dry Fruit and Nut Bowl)
1999
Plaster, clay, wood glue, acrylic paint, dried fruit, nuts,
wooden beams, latex paint
Bowl 1: diameter 50 x 20 cm; 19 ⅝ x 7 ⅞ in.
Pedestal: 100 x 22 x 20 cm; 39 ⅜ x 8 ⅝ 7 ⅞ in.
Bowl 2: diameter 35 x 12 cm; 13 ¾ x 4 ¼ in.
Pedestal: 110 x 24 x 20 cm; 43 ¼ x 9 ½ x 7 ⅞ in.

Pages 208–209:

Untitled (Candle)
1999
Fiber cement, candles, screws
Base: 100 x 100 cm; 39 ⅜ x 39 ⅜ in.
Pedestal: 125 x 20 x 20 cm; 49 ¼ x 7 ⅞ x 7 ⅞ in.
Wax: 70 x 85 x 70 cm; 27 ½ x 33 ½ x 27 ½ in., growing

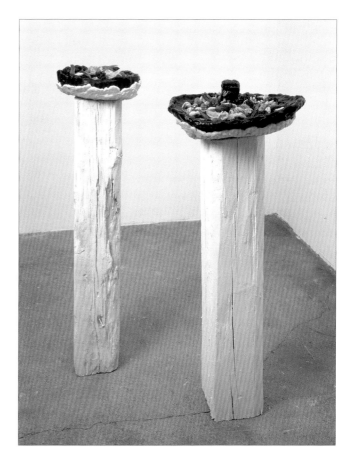

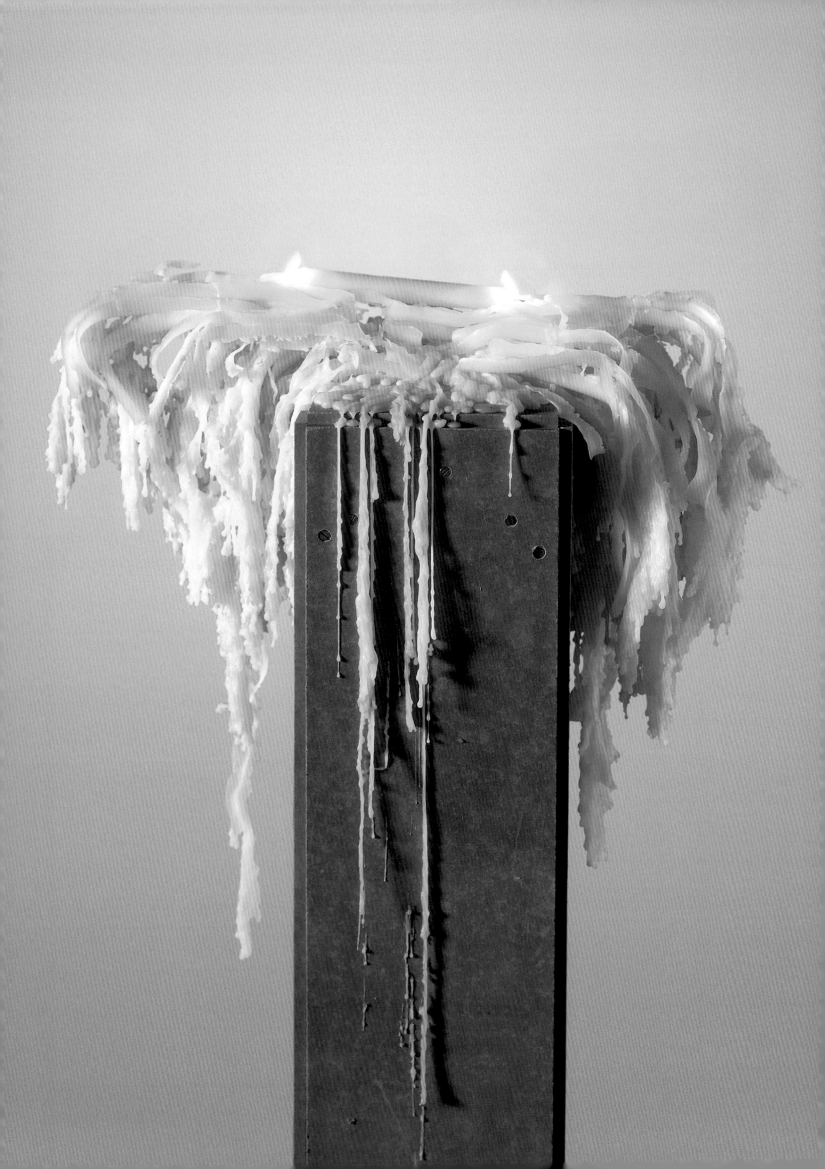

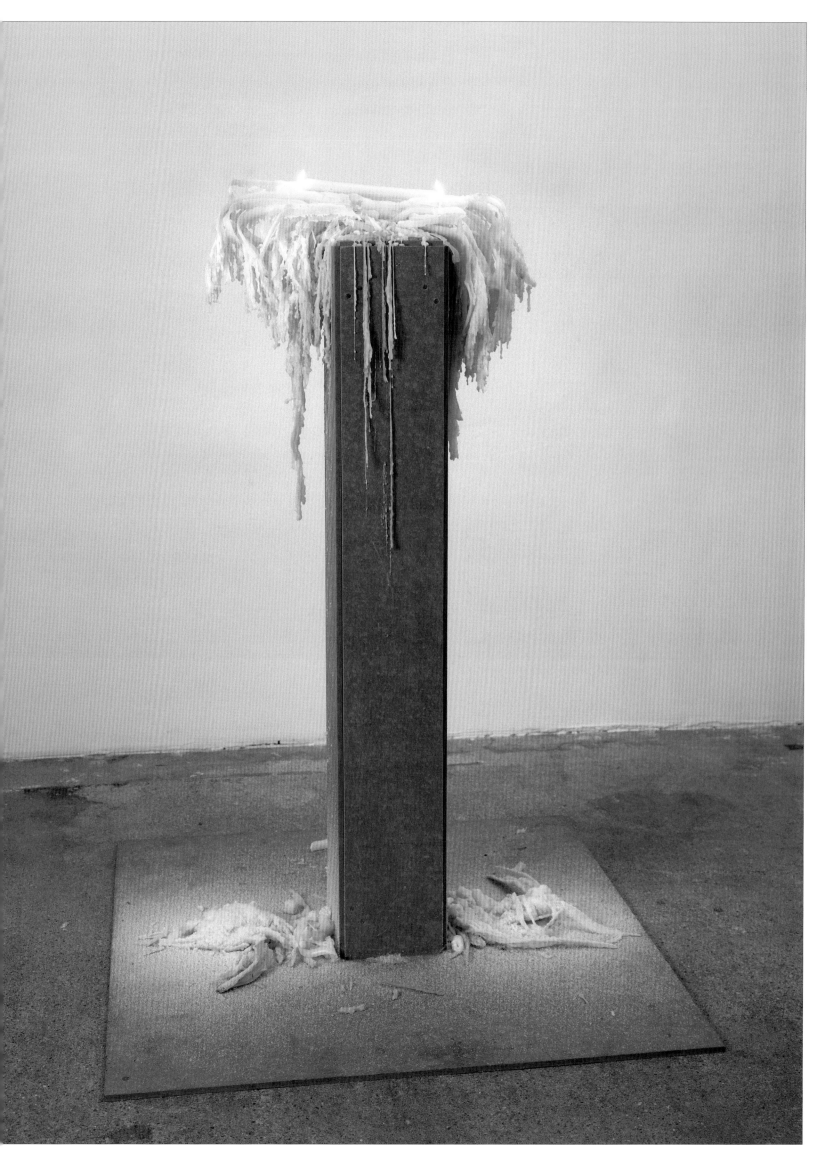

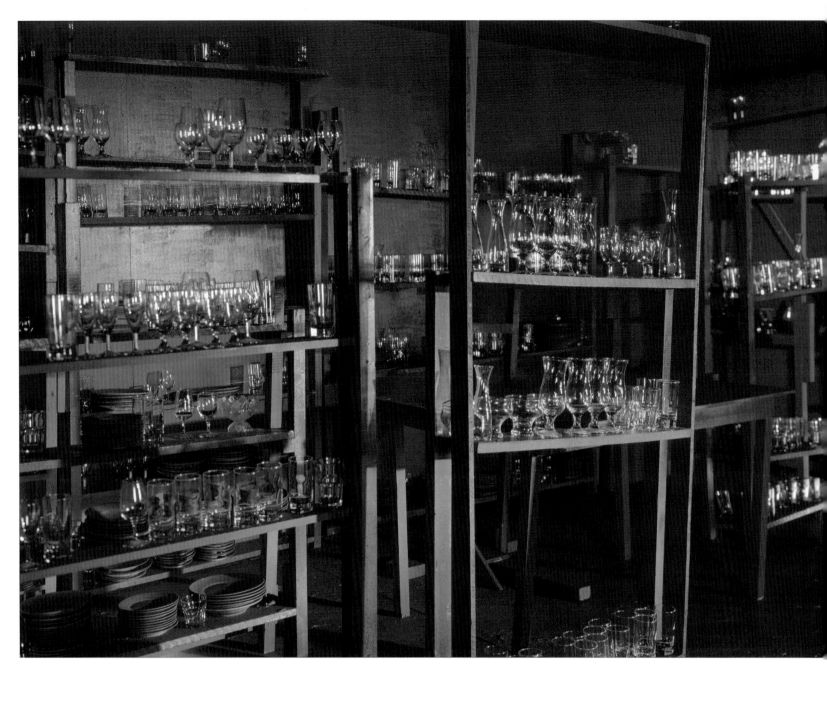

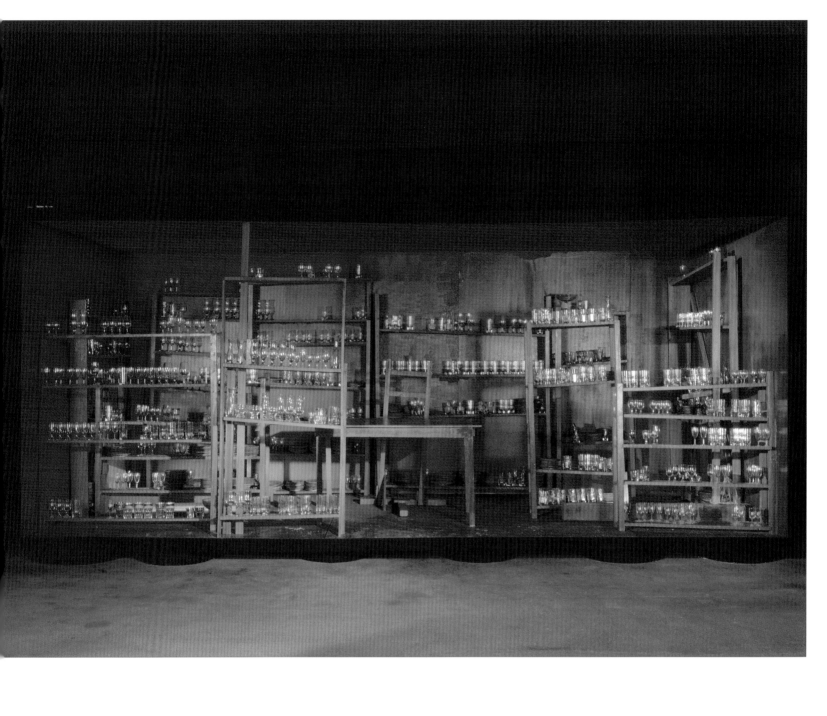

ESPRESSOQUEEN
1998
Wood, glass, tires, silicone, latex paint, acrylic paint,
neon light, sound
284 x 628 x 254 cm; 111 ¼ x 247 ¼ x 100 in.
"Espressoqueen—Worries and other stuff you have to
think about before you get ready for the big easy,"
Galerie Hauser & Wirth & Presenhuber, Zurich, 1999

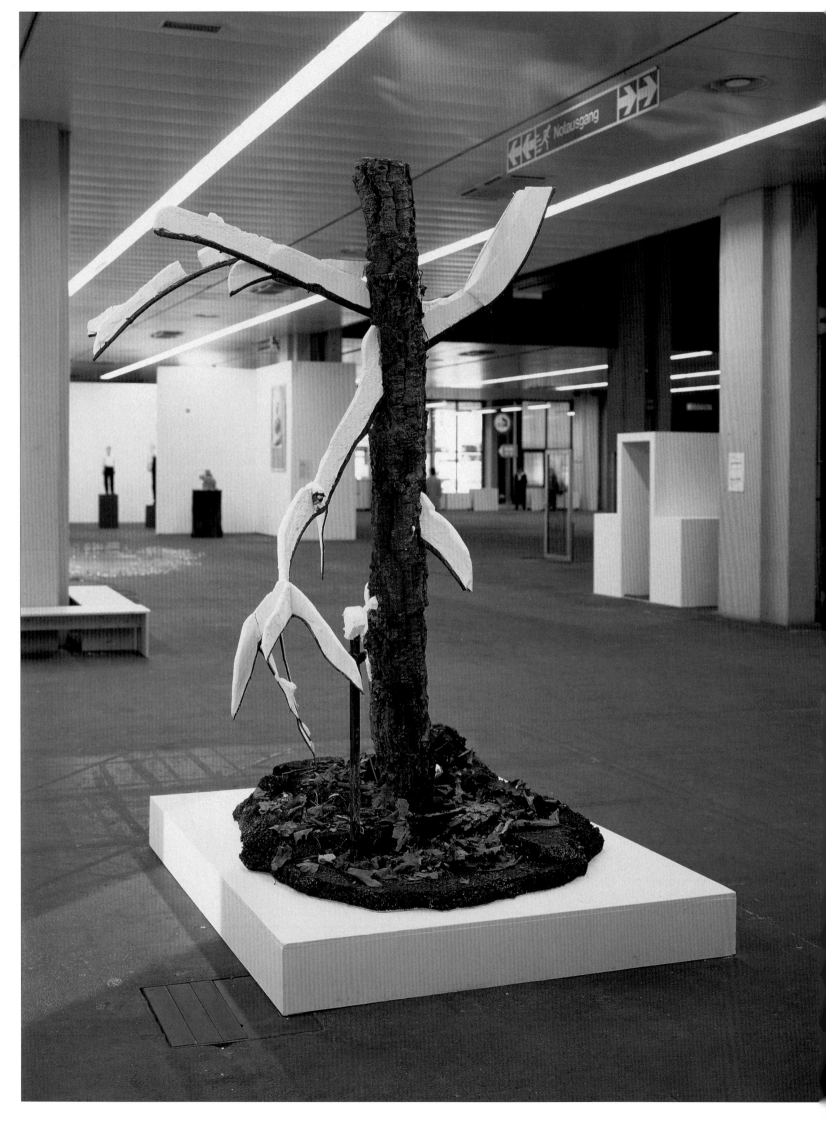

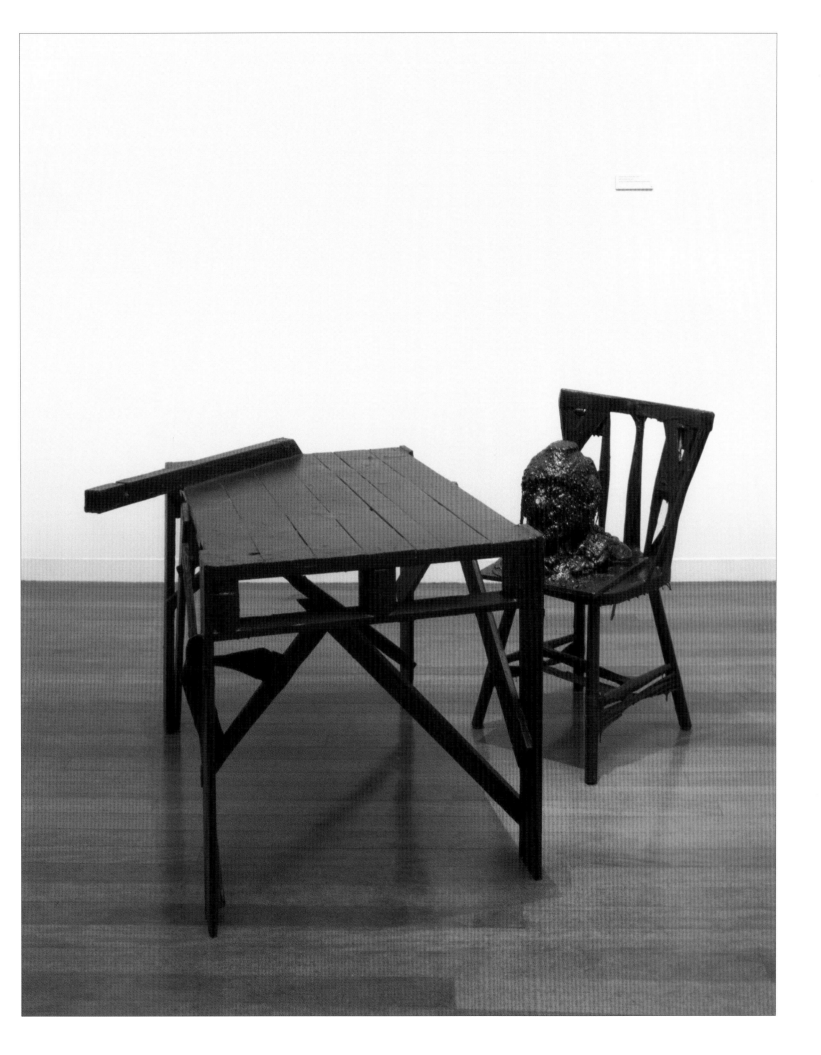

Untitled (Baum)
1999
Cork, wood, silicone, acrylic paint, moss, glue, wire,
wooden bird model, dried leaves
280 x 150 x 200 cm; 110 ¼ x 59 x 78 ¾ in.
Installation view, Art Unlimited, Art Basel, 1999

Gedanken kommen zurück 'bitte'
2000
Wood, wax, silicone, clay, spray enamel
80 x 160 x 120 cm; 31 ½ x 63 x 47 ¼ in.

Speedy, Smokey, Peegee, Charly, Mungo
2000
Fruits, vegetables, nylon filament, screws
Dimensions variable
Installation view, "Tagessuppen / Soups of the Days"
and "6 ½ Domestic Pairs Project" (with Keith Tyson),
Kunsthaus Glarus, Switzerland, 2000

Untitled
2000
Apple, pear, nylon filament, screws
Dimensions variable

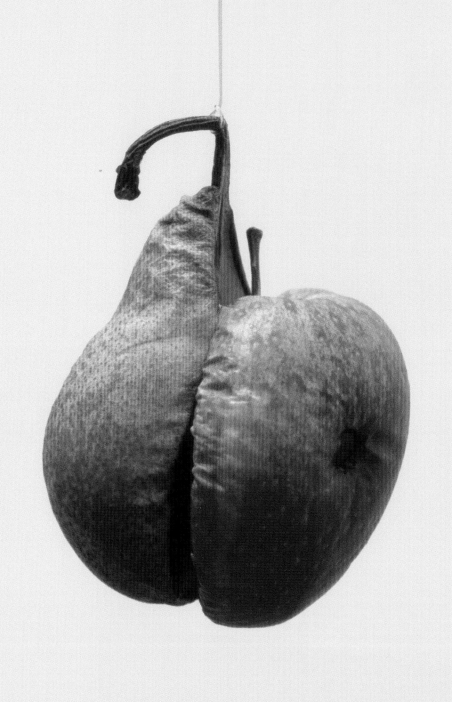

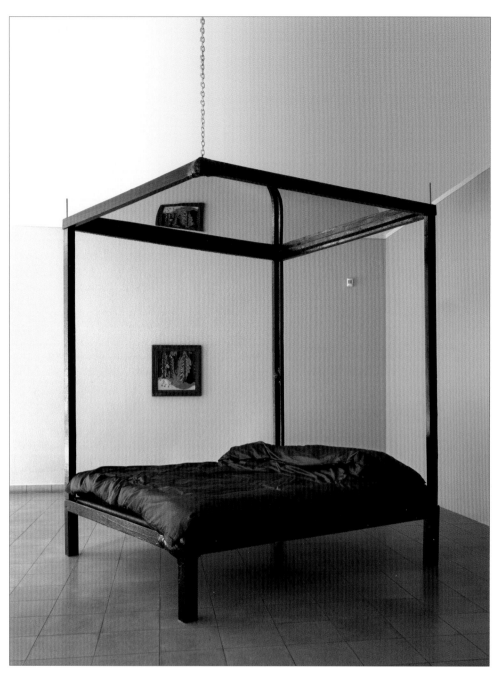

Bed
from *6 ½ Domestic Pairs Project*
2000
Wood, zinc phosphate paint, clay, acrylic glass mirror,
mattress, bedding, canvas, wood glue, screws
212 x 190 x 212 cm; 83 ½ x 74 ¼ x 83 ½ in.
Installation view, "Tagessuppen / Soups of the Days"
and "6 ½ Domestic Pairs Project" (with Keith Tyson),
Kunsthaus Glarus, Switzerland, 2000
On wall: Ernst Ludwig Kirchner, *Am Waldrand*,
1935–1936

Keith Tyson, *Relaxing Possibility, Applied Art Machine: "A
bed that does the worrying for you"* (from *6 ½ Domestic Pairs
Project*), 2000
Installation view, "Tagessuppen / Soups of the Days"
and "6 ½ Domestic Pairs Project" (with Keith Tyson),
Kunsthaus Glarus, Switzerland, 2000

Lamp
from *6 ½ Domestic Pairs Project*
2000–2005
Cast aluminum, enamel paint, light bulb,
electric cable
200 x 75 x 130 cm; 78 ¾ x 29 ½ x 51 ⅛ in.

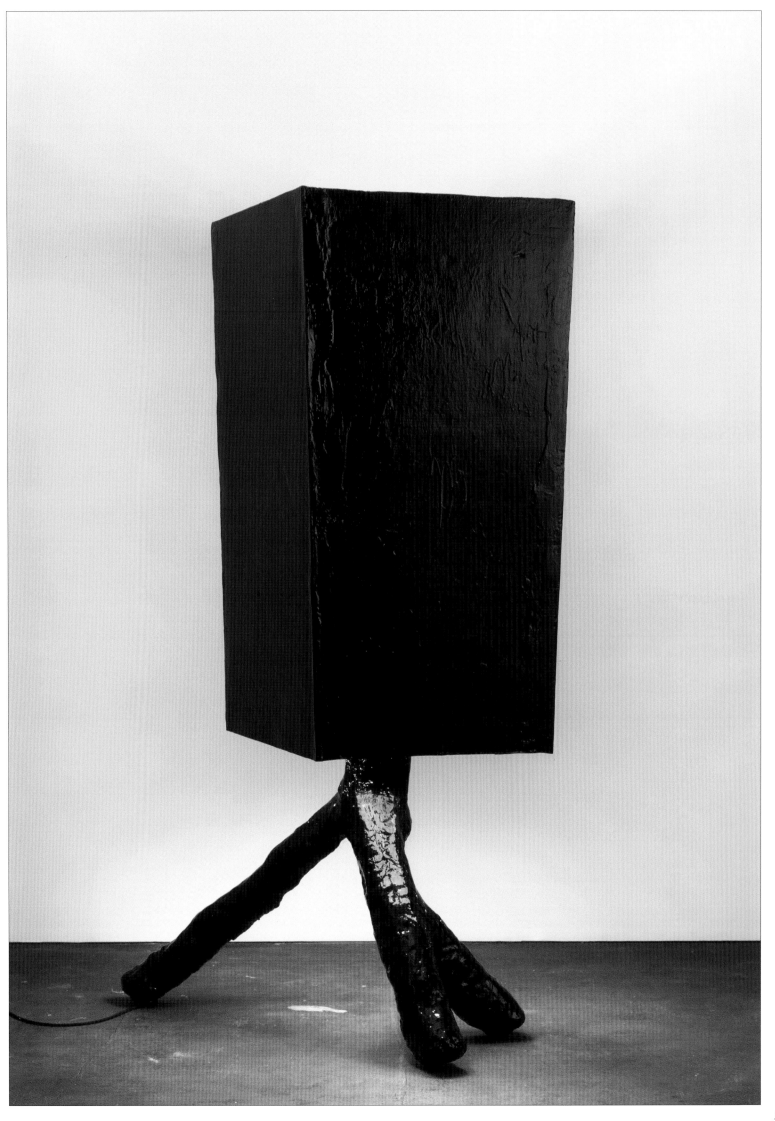

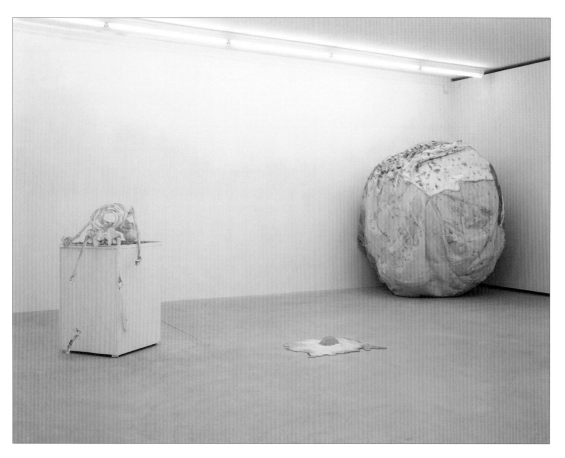

Installation view, "Mastering the Complaint,"
Galerie Hauser & Wirth & Presenhuber,
Zurich, 2001
One More Carrot Before I Brush My Teeth, 2001;
*Warum wächst ein Baum / Kann Man zuviel
fragen (Nr. 3) Why does a tree grow / Can one ask
too much (No. 3)*, 2001; *A Sigh Is the Sound of
My Life*, 2000–2001

Opposite page:
Keep It Going Is a Private Thing
2001
Mechanical robot half-dog wags its tail
Synthetic fur, polystyrene, electric motor,
control unit, acrylic paint, polyurethane foam,
wood glue
70 x 30 x 79 cm; 27 ½ x 11 ¾ x 31 ⅛ in.
Installation view, "Mastering the Complaint,"
Galerie Hauser & Wirth & Presenhuber,
Zurich

Warum wächst ein Baum / Kann man zuviel Fragen (Nr. 3)
Why does a tree grow / Can one ask too much (No. 3)
2001
Polyurethane resin, UV-protective varnish, acrylic paint,
polystyrene
13 x 86 x 73 cm; 5 ⅛ x 33 ⅞ x 28 ¾ in.

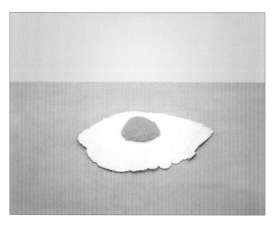

Warum wächst ein Baum / Kann man zuviel Fragen (Nr. 2)
Why does a tree grow / Can one ask too much (No. 2)
2001
Polyurethane resin, UV-protective varnish, acrylic paint,
polystyrene
13 x 80 x 70 cm; 5 ⅛ x 31 ½ x 27 ½ in.

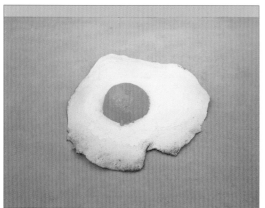

Warum wächst ein Baum / Kann man zuviel Fragen (Nr. 1)
Why does a tree grow / Can one ask too much (No. 1)
2001
Polyurethane resin, UV-protective varnish, acrylic paint,
polystyrene
13 x 100 x 93 cm; 5 ⅛ x 39 ⅜ x 36 ⅝ in.

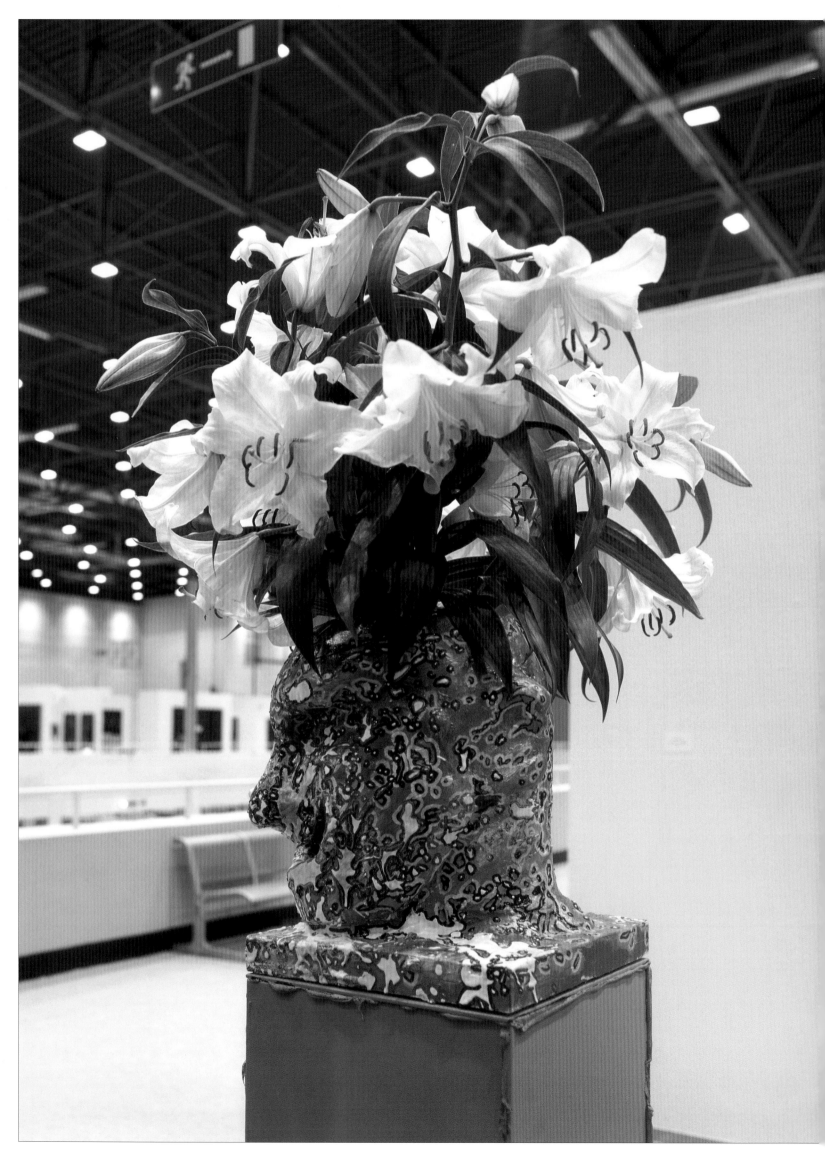

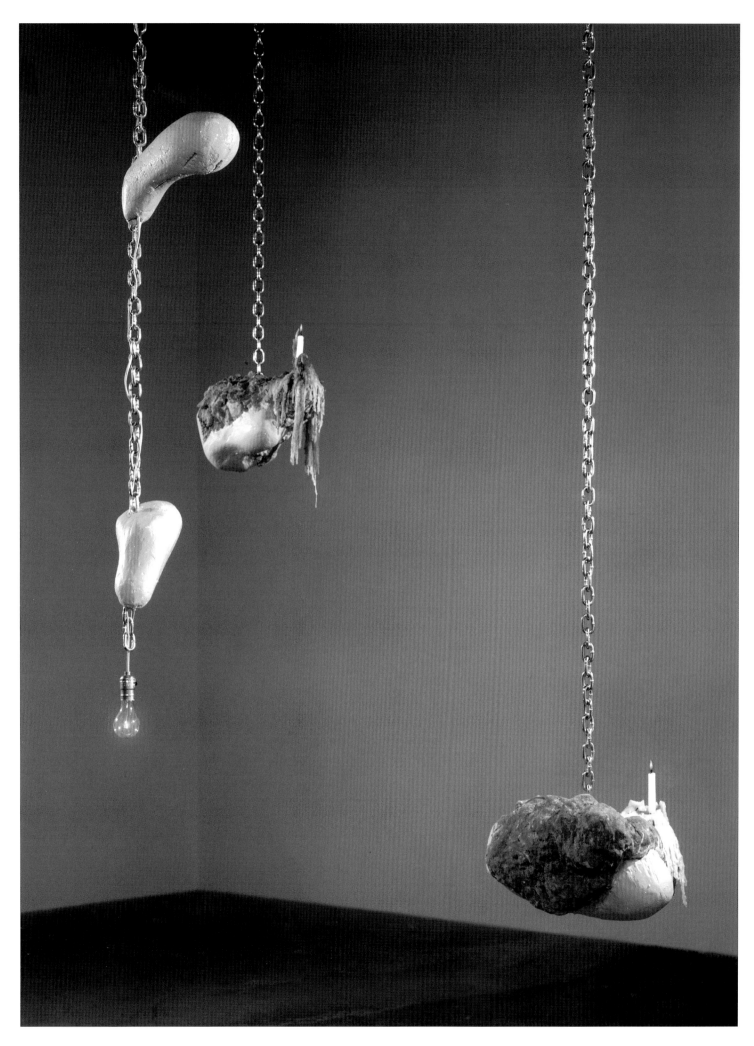

That's the Way It Is with the Magic. Sometimes It
Works and Sometimes It Doesn't
2000
Plaster, silicone, marker, acrylic paint, spray enamel, glass
vase, polyurethane foam, fresh white lilies
200 x 40 x 40 cm; 78 ¾ x 15 ¾ x 15 ¾ in.

Internal Backdrop (Jealous House Blends & Airports)
2001
Cement, sand, iron, steel chains, polystyrene, polyurethane
foam, polyurethane resin, acrylic filler, acrylic paint, candles,
cables, light bulb, socket
Dimensions variable

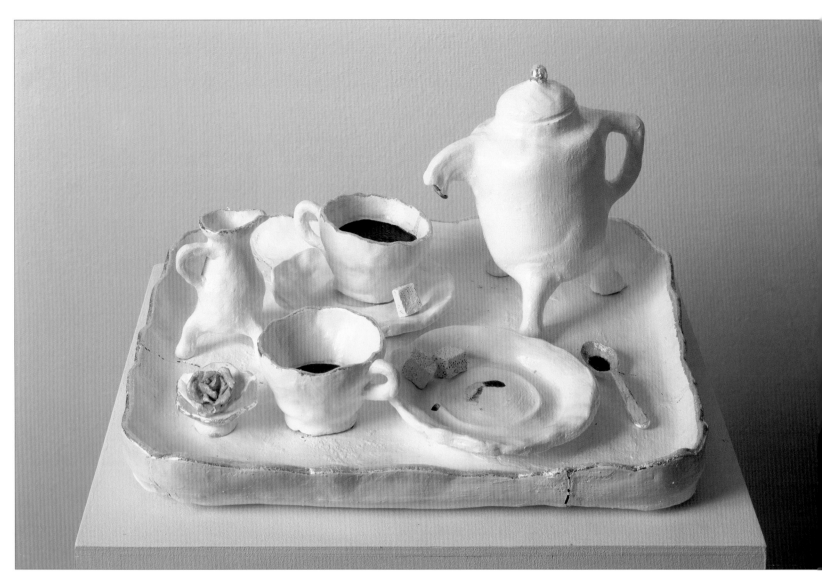

Tea Set
2002
Clay, wood, glue, acrylic paint, silver leaf
23 x 45 x 39 cm; 9 x 17 ¼ x 15 ⅜ in.

Telephone
2002
Polyurethane resin, oil paint
12 x 20 x 11 cm; 4 ¼ x 7 ⅞ x 4 ⅜ in.

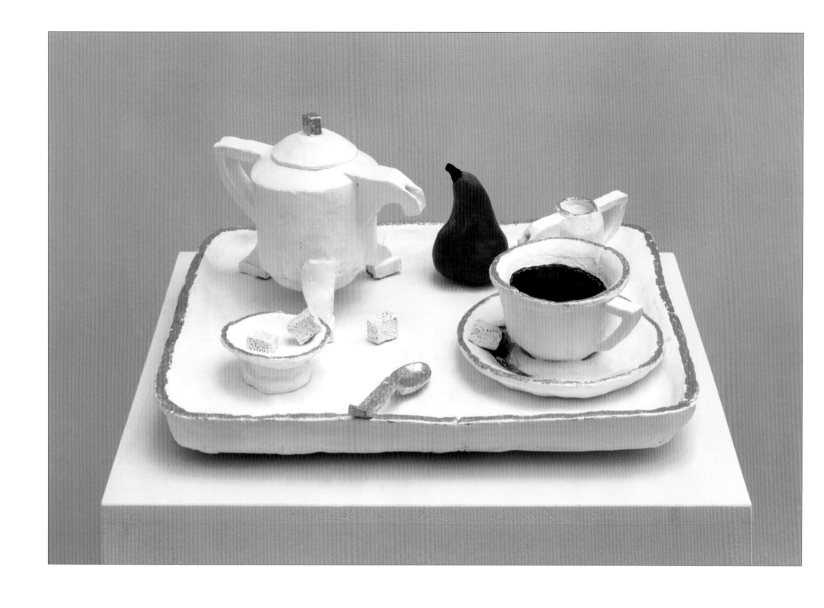

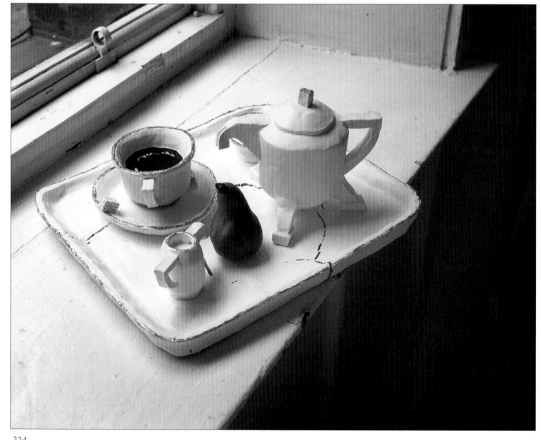

Tea Set
2002
Clay, acrylic paint, plywood, copper leaf
20 x 38 x 32 cm; 7 ⅞ x 15 x 12 ⅝ in.

Installation view, "Mystique Mistake,"
The Modern Institute, Glasgow, 2002
Tea Set, 2002

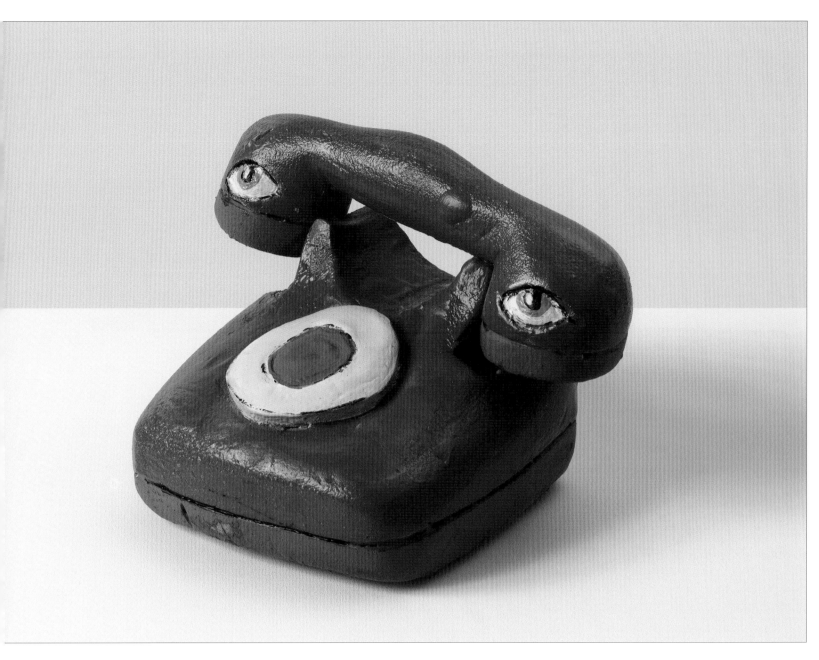

Telefon
2003
Polystyrene, acrylic paint, marker, filler
Dimensions unknown

Watching a Three-legged Cat Cross a Street
2005
Cast aluminum, acrylic paint
20 x 200 x 6 cm; 7 ⅞ x 78 ¾ x 2 ⅜ in.

Hear an Old Lady Laugh Out Loud
2005
Cast aluminum, acrylic paint
15 x 150 x 6 cm; 5 ⅞ x 59 x 2 ⅜ in.

Hear a Junkie Say Thank You
2005
Cast aluminum, acrylic paint
15 x 150 x 6 cm; 5 ⅞ x 59 x 2 ⅜ in.

Untitled
2004
Polyurethane resin, acrylic paint, metal pin
15 x 12 x 5 cm; 5 ⅞ x 4 ¾ x 2 in.

227

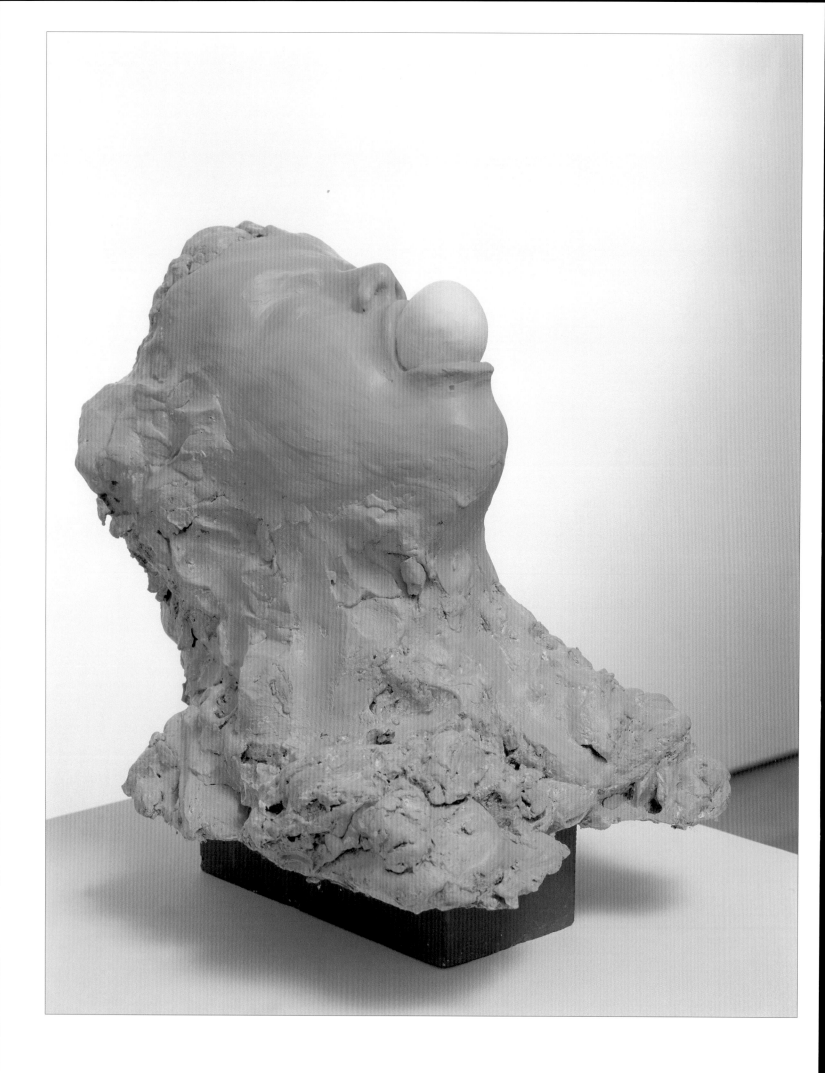

Thinking About Gandhi
2004
Polyurethane resin, acrylic paint, brick
31.8 x 28 x 36.2 cm; 12 ½ x 11 x 14 ¼ in.

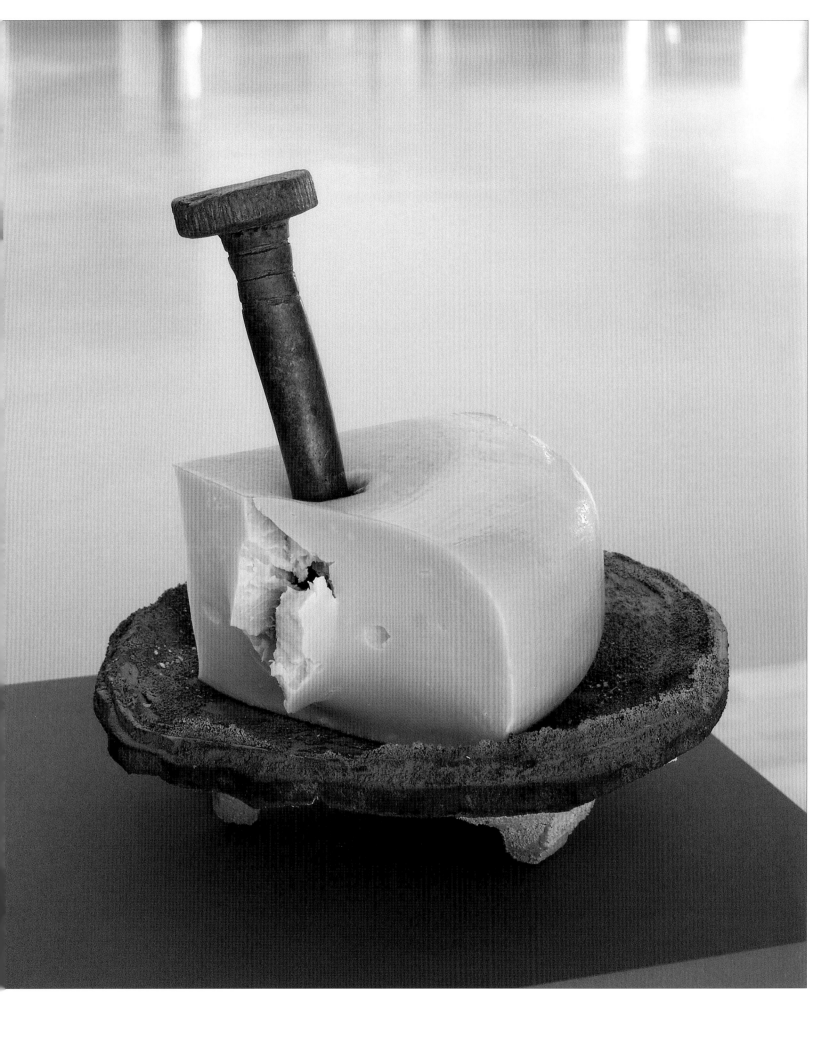

Lie to a Dog
2005
Cast nickel silver, acrylic paint, cheese
53 x 45 x 21 cm; 20 ⅞ x 17 ¼ x 8 ¼ in.

229

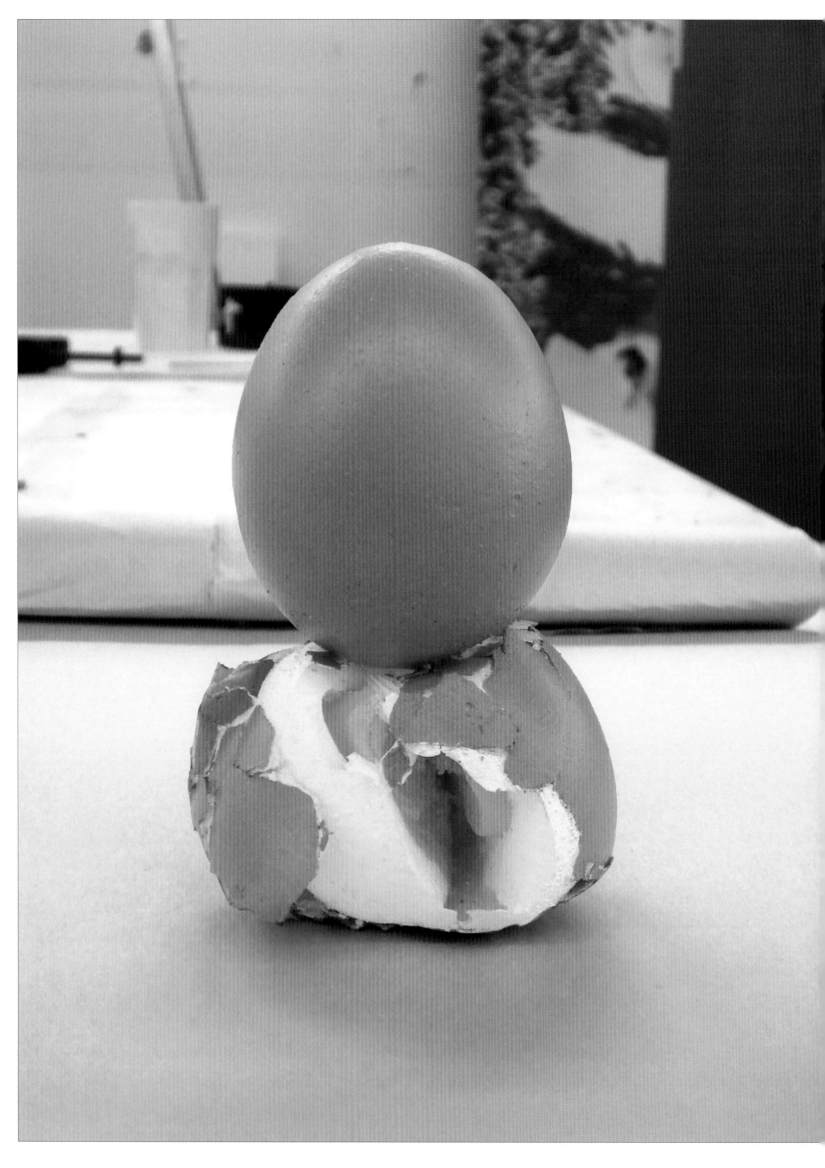

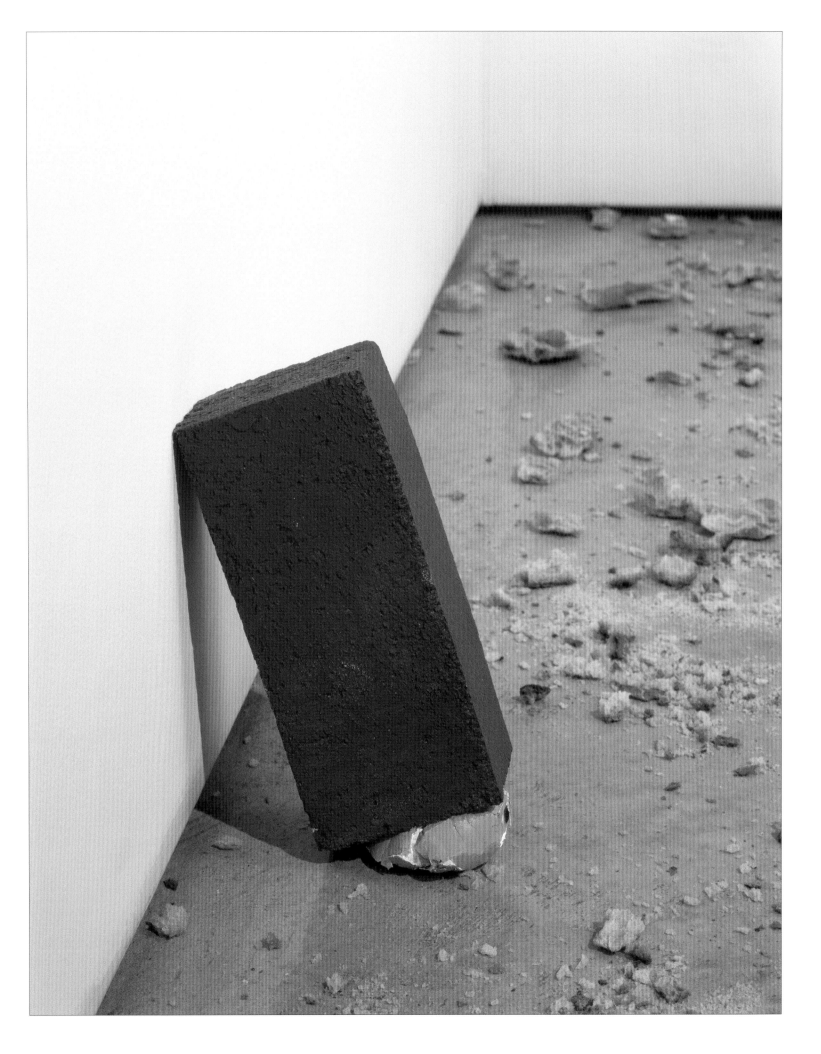

Untitled
2006
Polyurethane resin, acrylic paint
Dimensions unknown
Studio view, 54th Avenue, Long Island City, 2006

Untitled (Brick)
2005
Polyurethane resin, acrylic paint
22.9 x 7.6 x 8.9 cm; 9 x 3 x 3 ½ in.
Installation view, "Fig, Nut & Pear,"
Gavin Brown's enterprise, New York, 2005

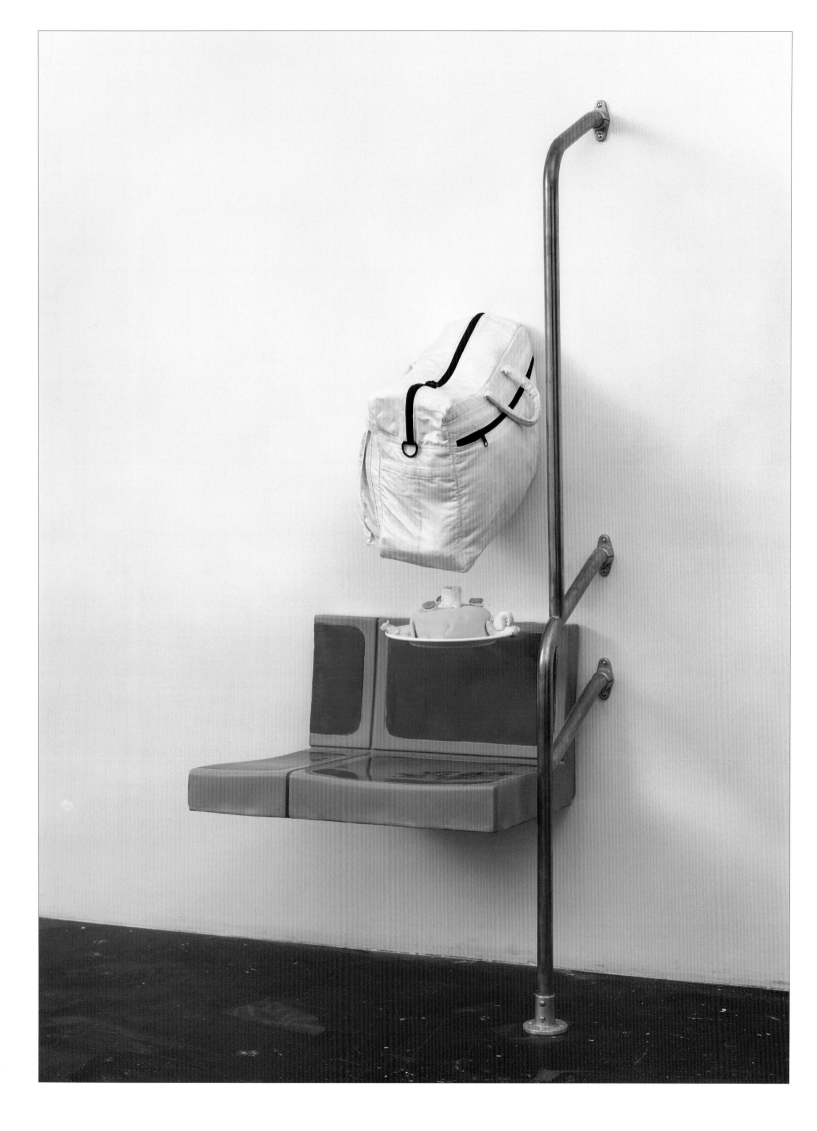

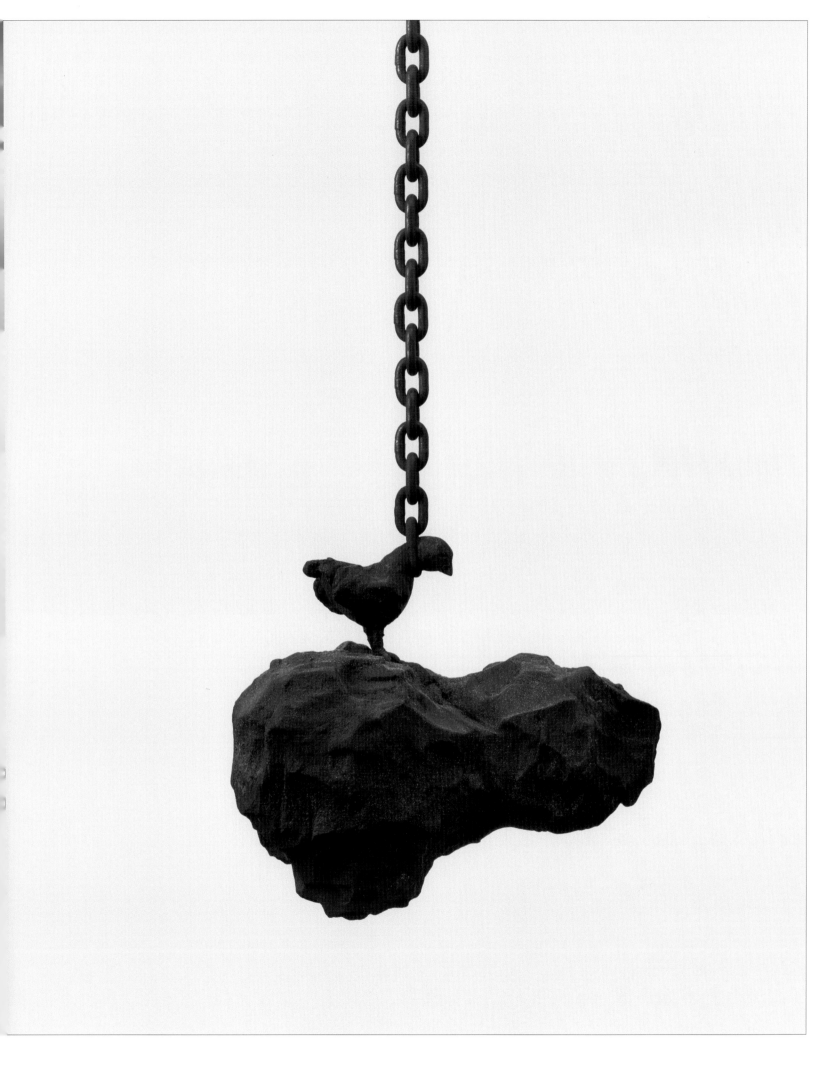

The Lock
2007
Cast polyurethane, steel pipes, electromagnets
184 x 75.5 x 55 cm; 72 ½ x 29 ¼ x 21 ⅝ in.

abC
2007
Cast aluminum, iron particles, steel chain
29 x 32 x 23 cm; 11 ⅜ x 12 ⅝ x 9 in.
Chain: 350 cm; 137 ¼ in.

233

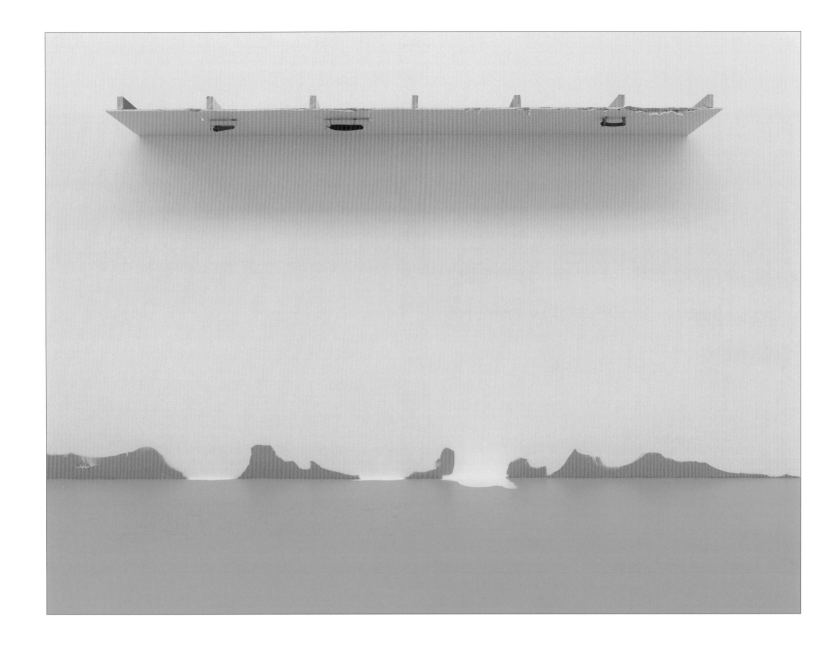

Neon
(with Georg Herold)
2009
Modified fluorescent light fixtures, carrot, cucumber,
sausage, plaster, acrylic paint
Carrot: 8 x 24 x 4 cm; 3 ⅛ x 9 ½ x 1 ⅝ in.
Cucumber: 8 x 38 x 4 cm; 3 ⅛ x 15 x 1 ⅝ in.
Sausage, fingers: 7 x 23 x 9 cm; 2 ¾ x 9 x 3 ½ in.
Installation view, "Dear _____! We _____ on
_____, hysterically. It has to be _____ that _____. No?
It is now _____ and the whole _____ has changed
_____. all the _____, _____" (with Mark Handforth
and Georg Herold), Kunstnernes Hus, Oslo, 2009
On floor: *Barfood with Erich Muehsam / Langweile mit
Richard Wagner*, 2006–2009

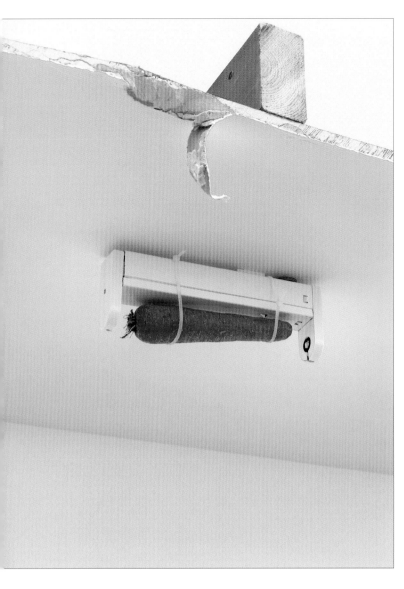
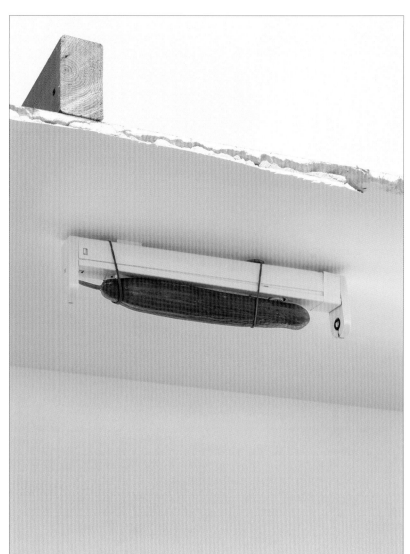

Nickname
2009
Nylon filament, preserved croissant, preserved butterfly, steel
Dimensions variable

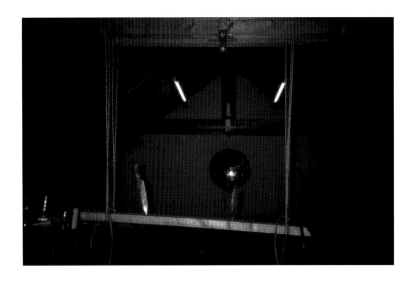

Untitled (Swings)
1995
Rope, wood, knives
Dimensions unknown

Opposite page:

Drip of Thought
1994
Wax
Dimensions unknown

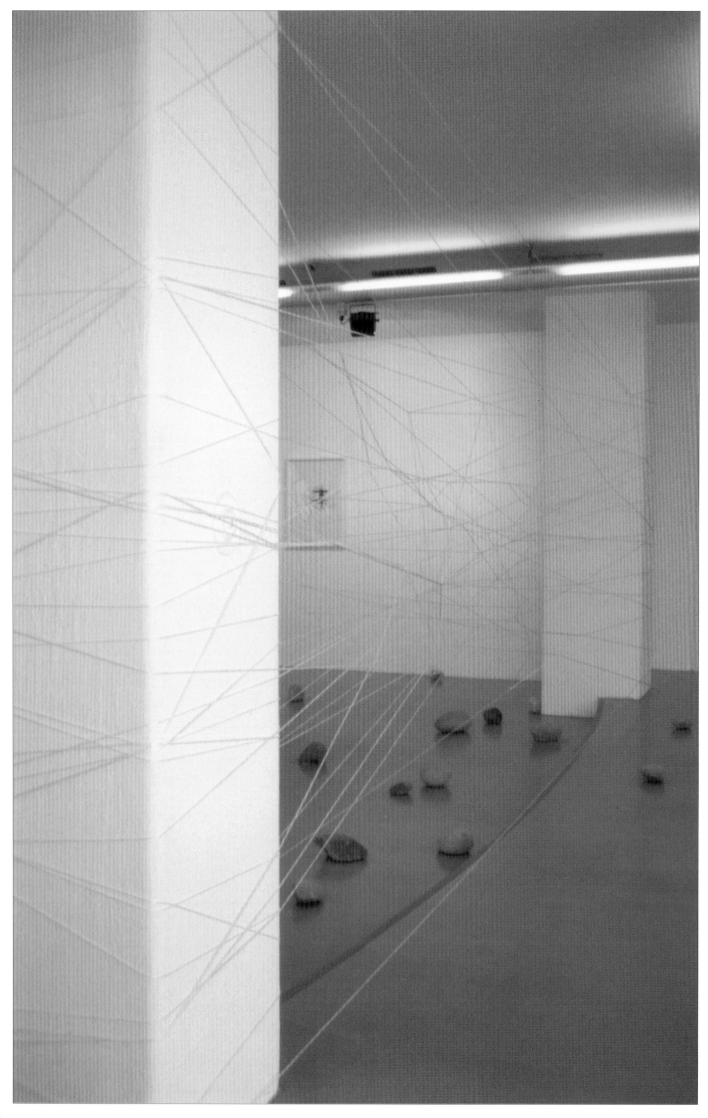

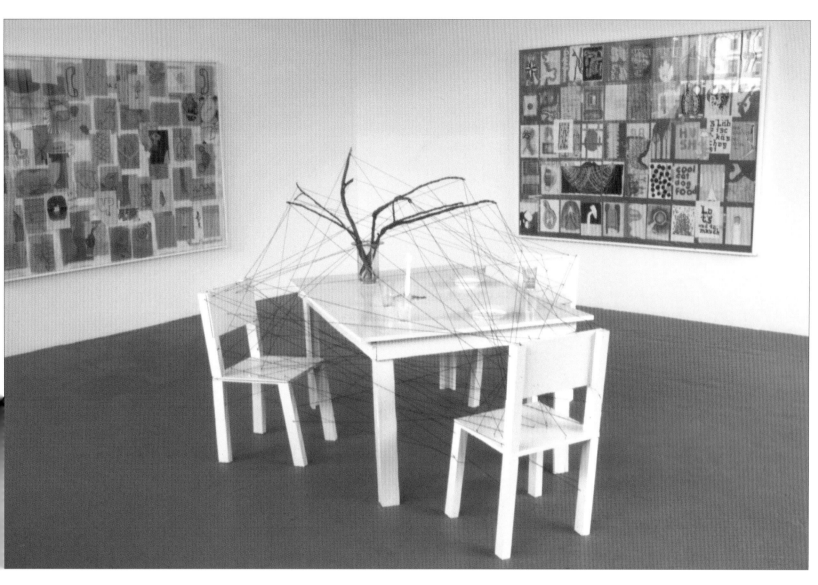

Frozen
1998
Wood, particleboard, latex paint, enamel paint,
candle, vase, dishes, glasses, branches, wool yarn,
wood glue, nails, silicone
220 x 230 x 160 cm; 86 ⅝ x 90 ½ x 63 in.
Installation view, "ironisch / ironic: maurizio
cattelan, urs fischer, alicia framis, steve mcqueen,
aernout mik / marjoleine boonstra," Migros
Museum für Gegenwartskunst, Zurich, 1998
On wall, left to right: *Living on the Phone*, 1998;
Personal Titanic, 1998

Hormonparty
1996
String, assorted colored thread
Dimensions variable
Installation view, "Frs Uischer,"
Galerie Walcheturm, Zurich, 1996
Untitled (50 Rocks), 1996

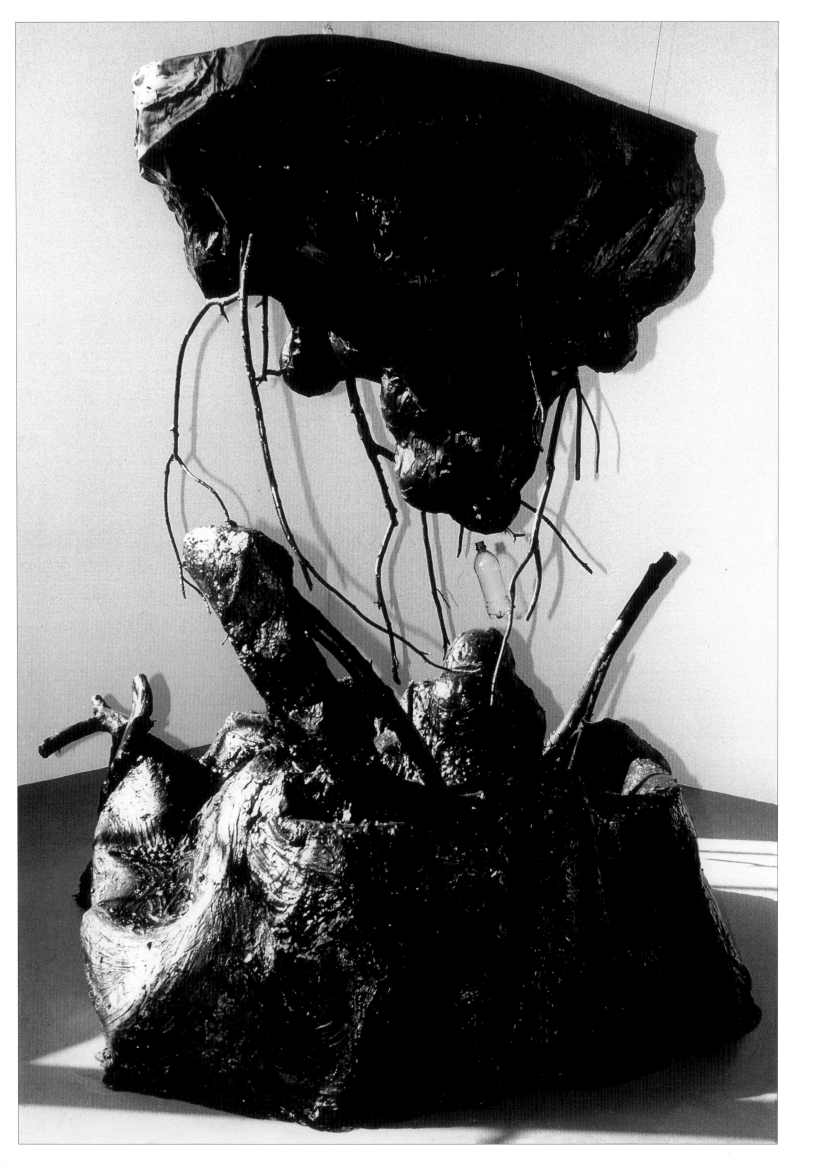

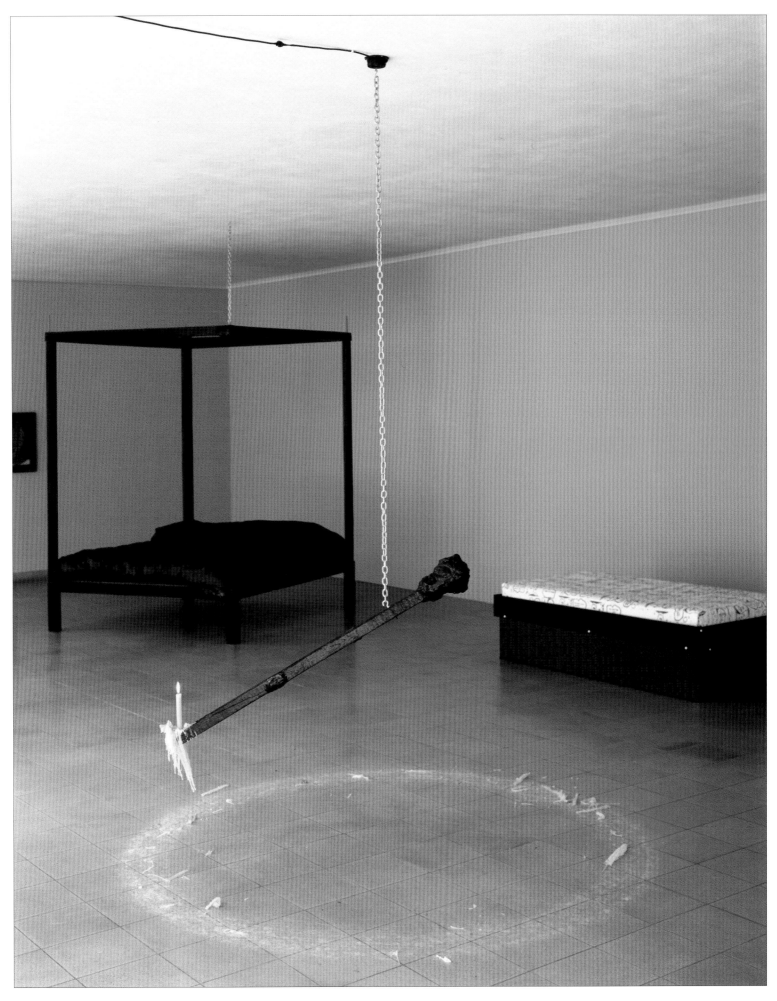

Untitled (Landscape)
1998
Mixed media, plastic bottle, magnets
Dimensions unknown
Installation view, "ironisch / ironic: maurizio
cattelan, urs fischer, alicia framis, steve mcqueen,
aernout mik / marjoleine boonstra," Migros
Museum für Gegenwartskunst, Zurich, 1998

Kerzenständer (Candlestick)
from *6 ½ Domestic Pairs Project*
2000
Wood, clay, enamel paint, chain, electric motor, candle, wood glue
Dimensions variable
Installation view, "Tagessuppen / Soups of the Days" and "6 ½ Domestic
Pairs Project" (with Keith Tyson), Kunsthaus Glarus, Switzerland, 2000
Bed, 2000; Keith Tyson, *Relaxing Possibility, Applied Art Machine: "A bed
that does the worrying for you"* (from *6 ½ Domestic Pairs Project*), 2000

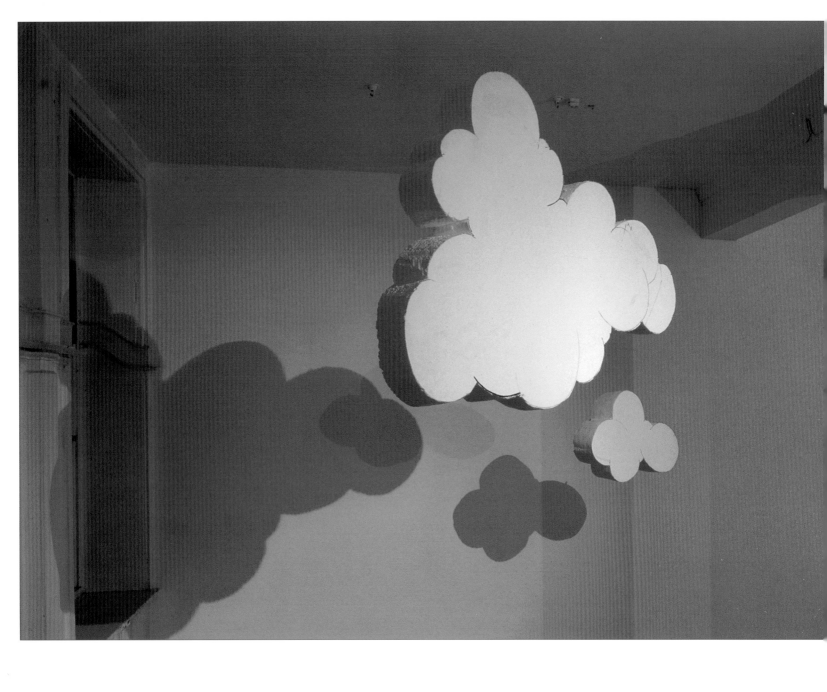

Clouds
2002
Polystyrene, wire, theater spotlight with pink gel
Cloud 1: 100 x 150 x 16 cm; 39 ⅜ x 59 x 6 ¼ in.
Cloud 2: 45 x 63 x 16 cm; 17 ¾ x 24 ¾ x 6 ¼ in.

Installation view, "Mystique Mistake,"
The Modern Institute, Glasgow, 2002
Chair, 2002; *Light*, 2002; *Clouds*, 2002; *Hands*, 2002

Opposite page:

Chair
2002
Chair vibrates at a high frequency, appearing blurry
Wood, oil paint, electric motor, mechanism, glue,
silicone, battery
82 x 42 x 42 cm; 32 ¼ x 16 ½ x 16 ½ in.

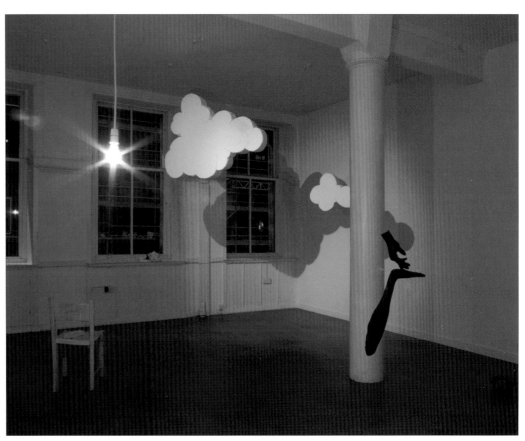

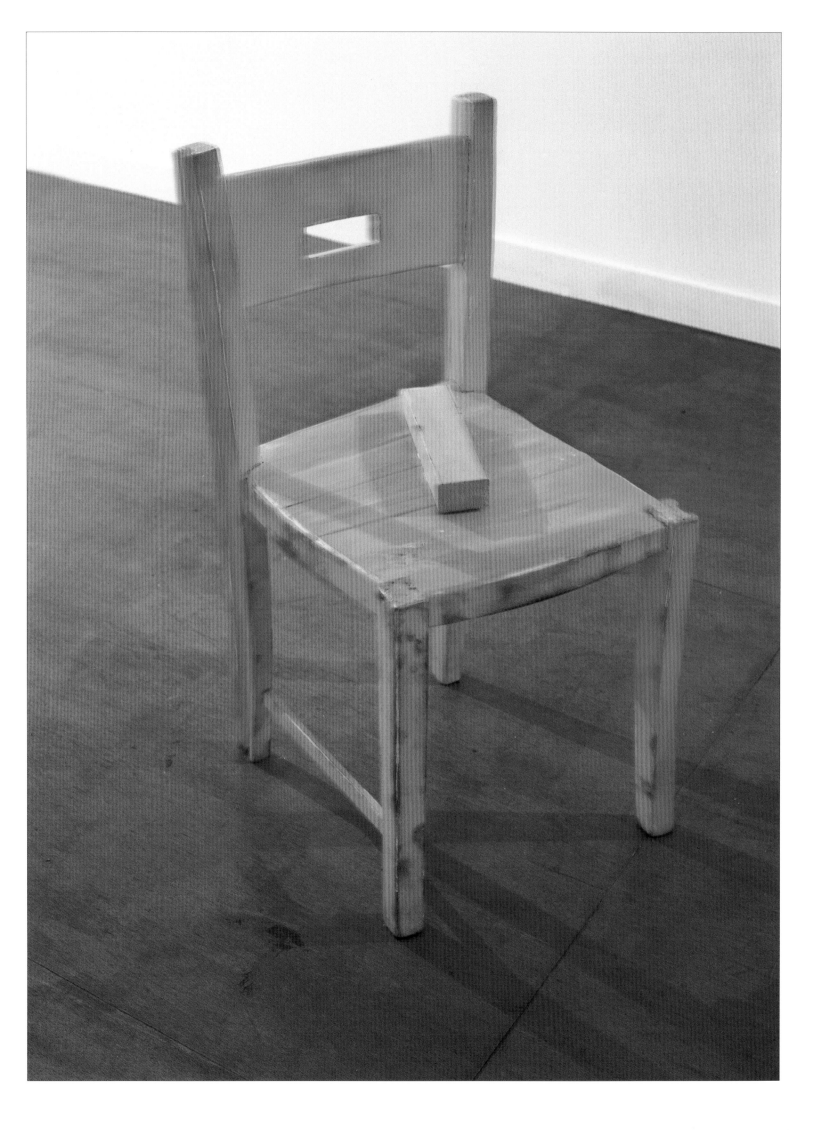

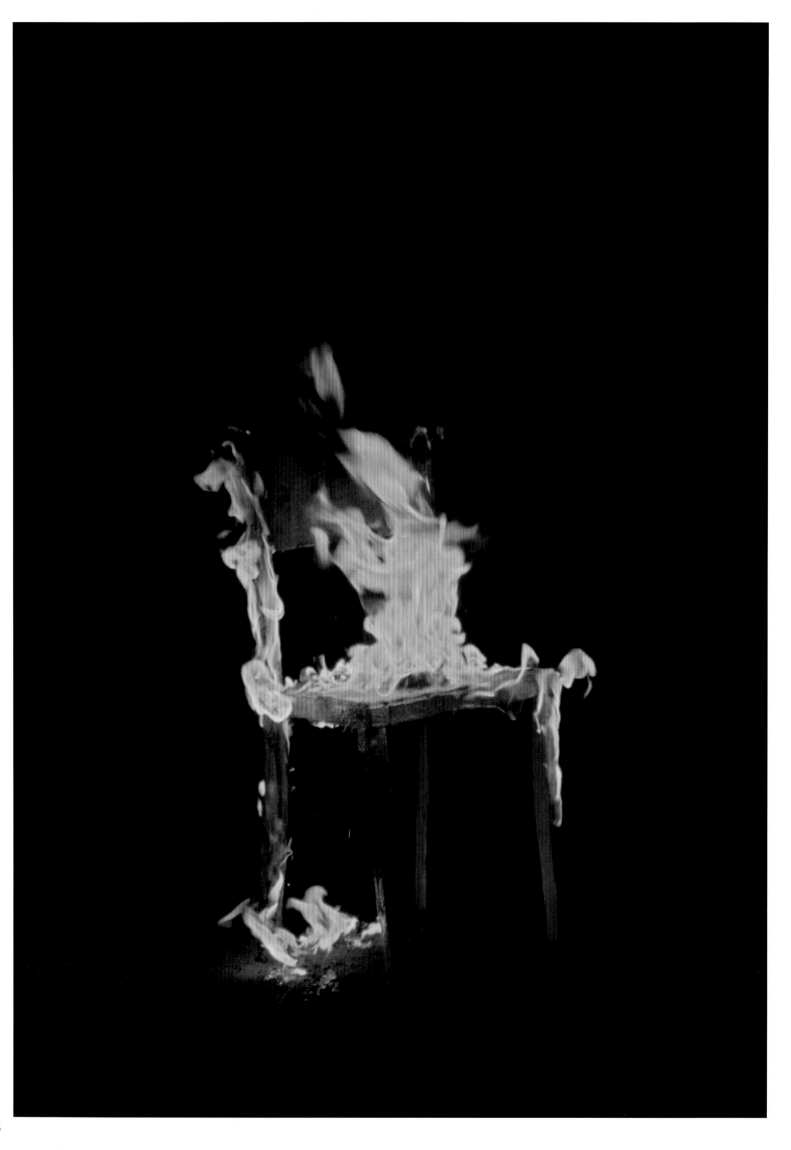

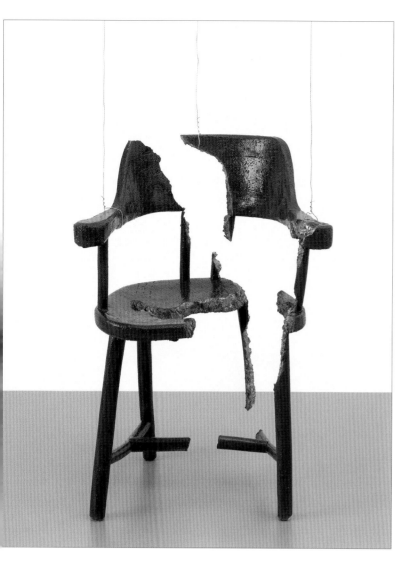

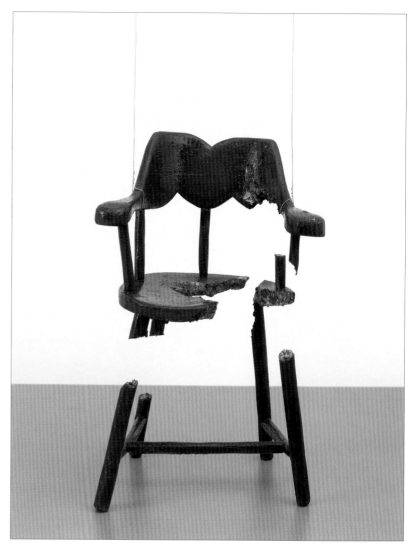

Chair for a Ghost: Urs
2003
Cast aluminum, enamel paint, wire
95 x 62 x 52 cm; 37 ⅜ x 24 ⅜ x 20 ½ in.

Chair for a Ghost: Thomas
2003
Cast aluminum, enamel paint, wire
95 x 62 x 52 cm; 37 ⅜ x 24 ⅜ x 20 ½ in.

Prototype for burning chair
2002

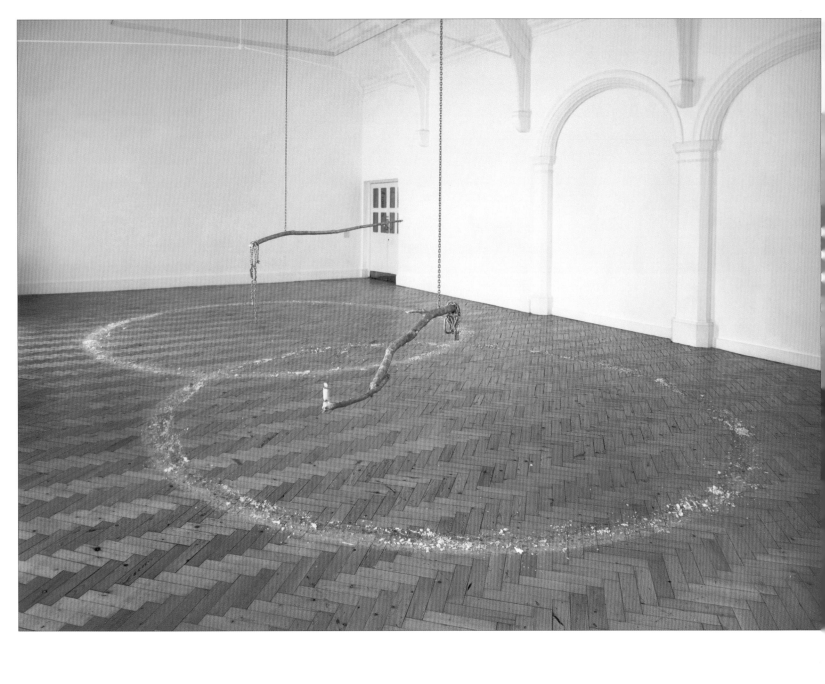

Untitled (Branches)
2005
Cast aluminum, chains, candles, low-speed electric motors, control units
Branch 1: 50 x 320 x 40 cm; 19 ⅝ x 126 x 15 ¼ in.
Branch 2: 50 x 310 x 40 cm; 19 ⅝ x 122 x 15 ¼ in.
Installation dimensions variable
Installation view, Camden Arts Centre, London, 2005

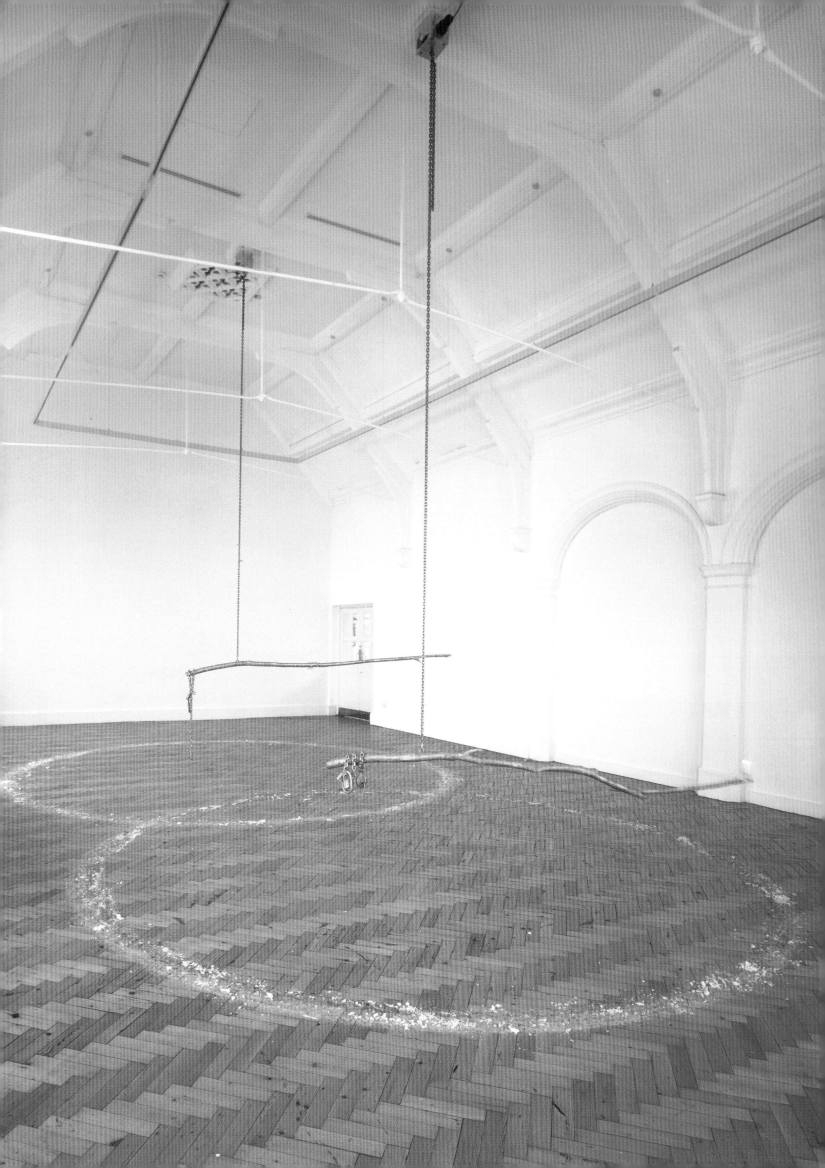

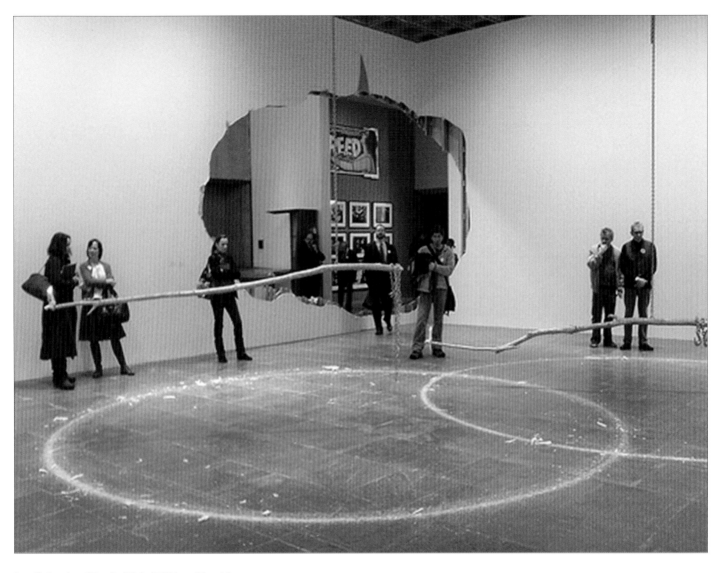

Installation view, "Day for Night," Whitney Biennial,
Whitney Museum of American Art, New York, 2006
Untitled (Branches), 2005; *The Intelligence of Flowers*, 2005

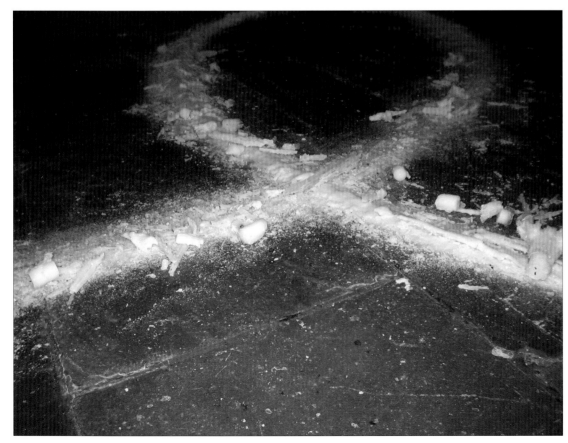

Detail of *Untitled (Branches)*, 2005
Installation view, "Day for Night,"
Whitney Biennial, Whitney Museum
of American Art, New York, 2006

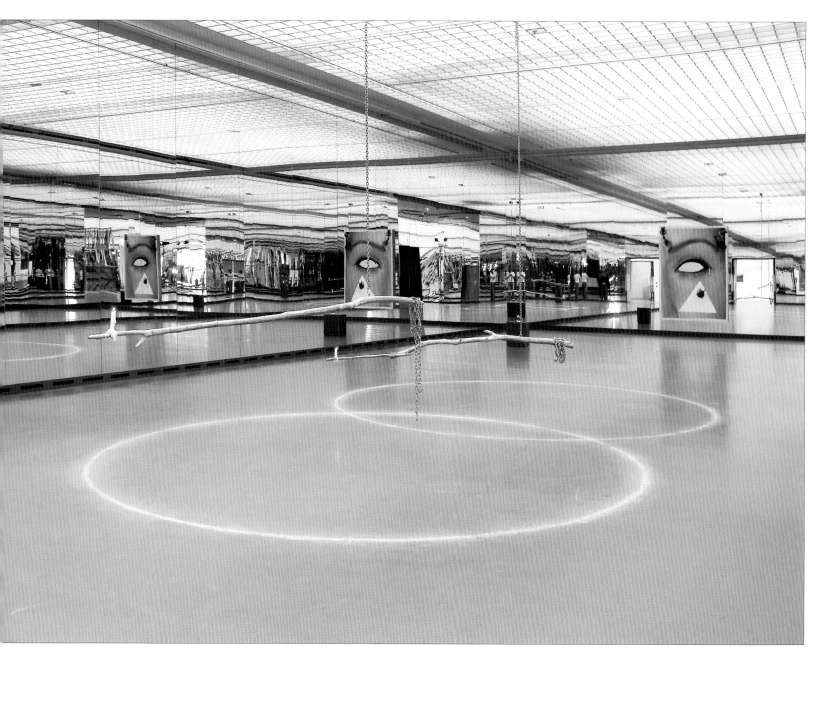

Installation view,"Paris 1919," Museum Boijmans Van Beuningen,
Rotterdam, 2006
Untitled (Branches), 2005; *office theme / addiction / mmmh camera*, 2006

Fiction
2006–
Table vibrates at a high frequency, appearing blurry
Work in progress
Installation view, "Paris 1919," Museum Boijmans Van
Beuningen, Rotterdam, 2006

Installation view, "Mary Poppins," Blaffer Gallery,
The Art Museum of the University of Houston, Texas, 2006
Left to right: *Untitled (Floor Piece)*, 2006; *Addict*, 2006;
Chagall, 2006

Opposite page:

Chagall
2006
Sculpture vibrates at a high frequency, appearing blurry
Polyurethane foam, nails, spray enamel, acrylic paint,
expanding polyurethane foam, filler, polyurethane glue,
electric motor, aluminum, control unit, battery, cables
225 x 61 x 104 cm; 88 ⅝ x 24 x 41 in.
Addict, 2006; *Untitled (Floor Piece)*, 2006

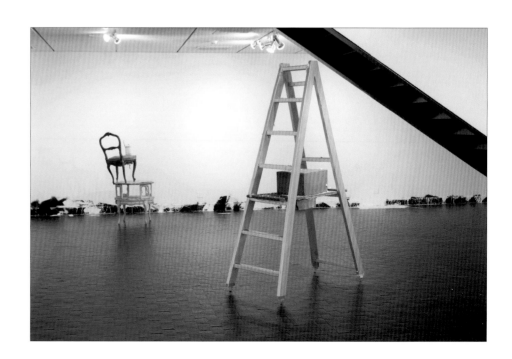

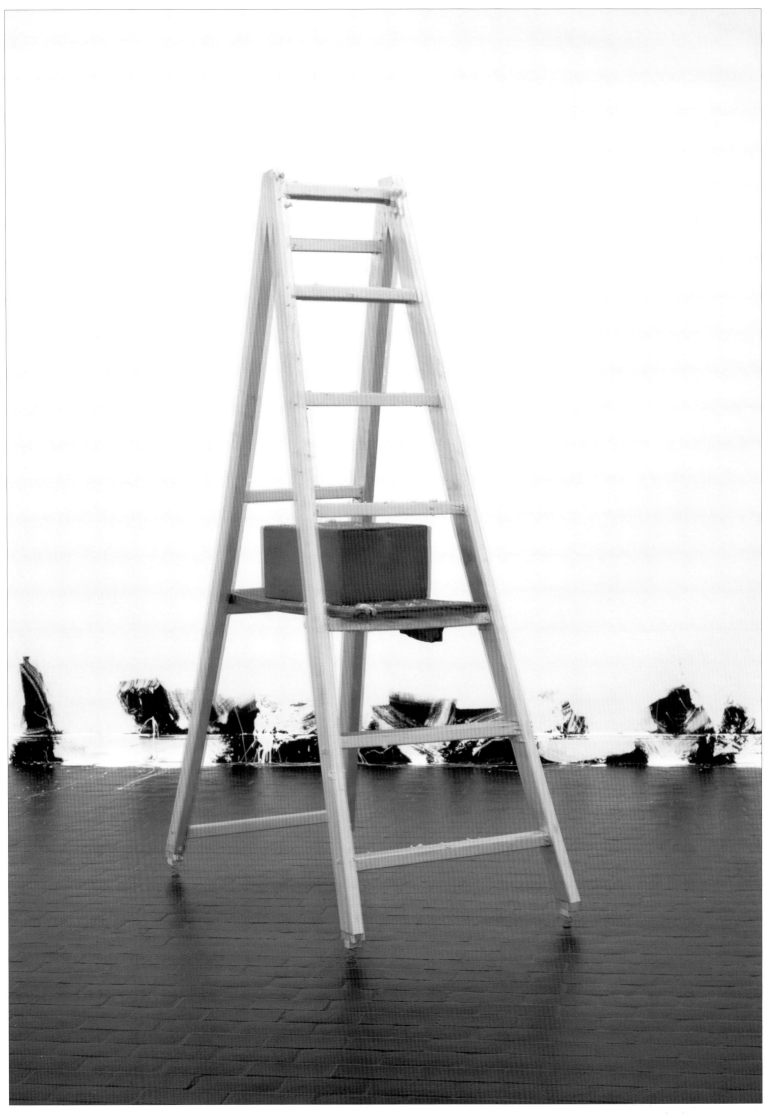

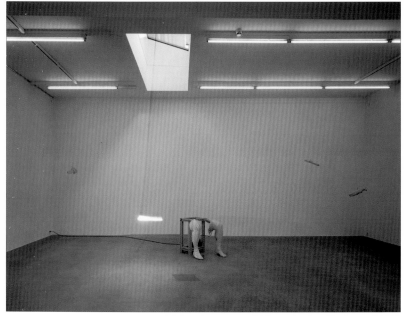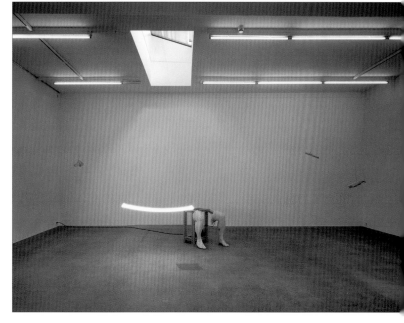

Installation view, Galerie Eva Presenhuber, 2006
"Mr. Watson—come here—I want to see you.," 2005;
Paris 2006, 2006

This page and opposite page, top:

"Mr. Watson—come here—I want to see you."
2005
Light swings back and forth, accelerating and decelerating in a 12-minute cycle
Electric motor, control unit, electric cable, light bulb, wire
Dimensions variable
Installation view, "Mr. Watson—Come Here—I Want to See You," Hydra Workshop, Greece, 2005

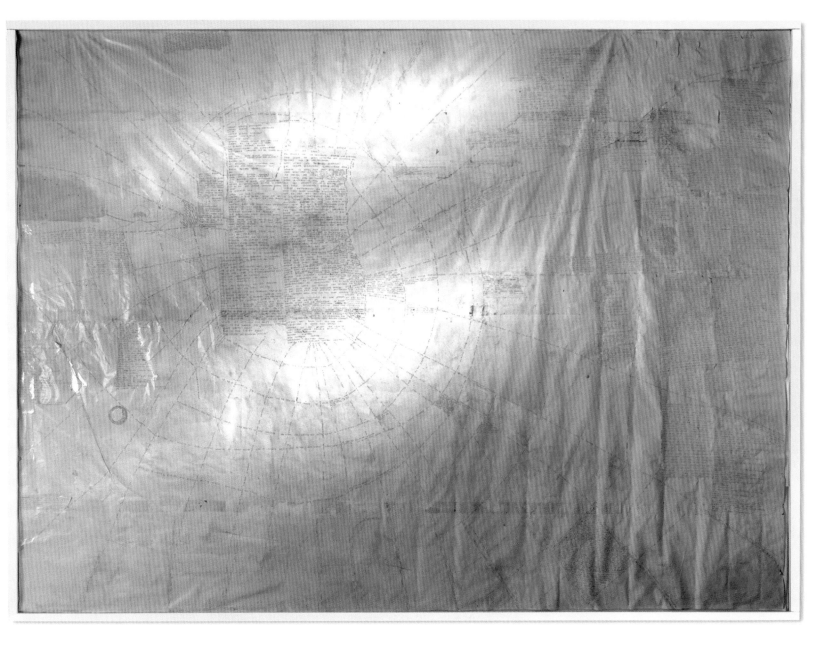

Schwerelosigkeit
1998–1999
Wood, glass, paper, latex paint, acrylic paint,
ballpoint pen, acrylic binder, screws
204 x 284 x 9.5 cm; 80 ¼ x 111 ¼ x 3 ¾ in.

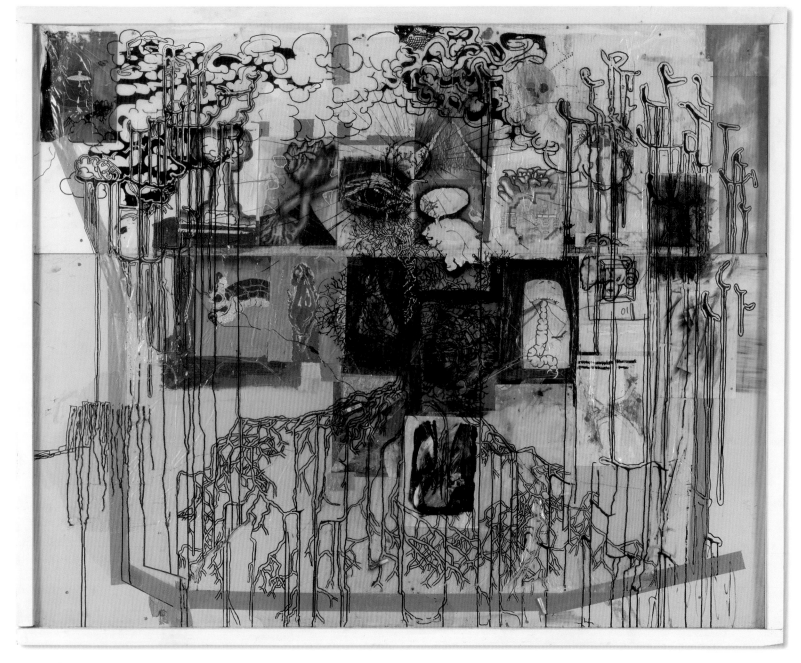

Eternal Soup of the Day
1999
Wood, glass, MDF, plastic film, acrylic paint, marker, ink,
chalk pastel, duct tape, wood glue
161 x 201 cm; 63 ⅜ x 79 ⅛ in.

Installation view, "Without a Fist—Like a Bird,"
Institute of Contemporary Arts, London, 2000

Foreground:

Untitled
2000
Particleboard, wood, unfired clay, candle, wire
Dimensions unknown

On wall:

The Temple of BlaBla Technique
2000
Wood, glass, paper, acrylic paint, marker, wood glue
246 x 306 cm; 96 ⅞ x 120 ½ in.

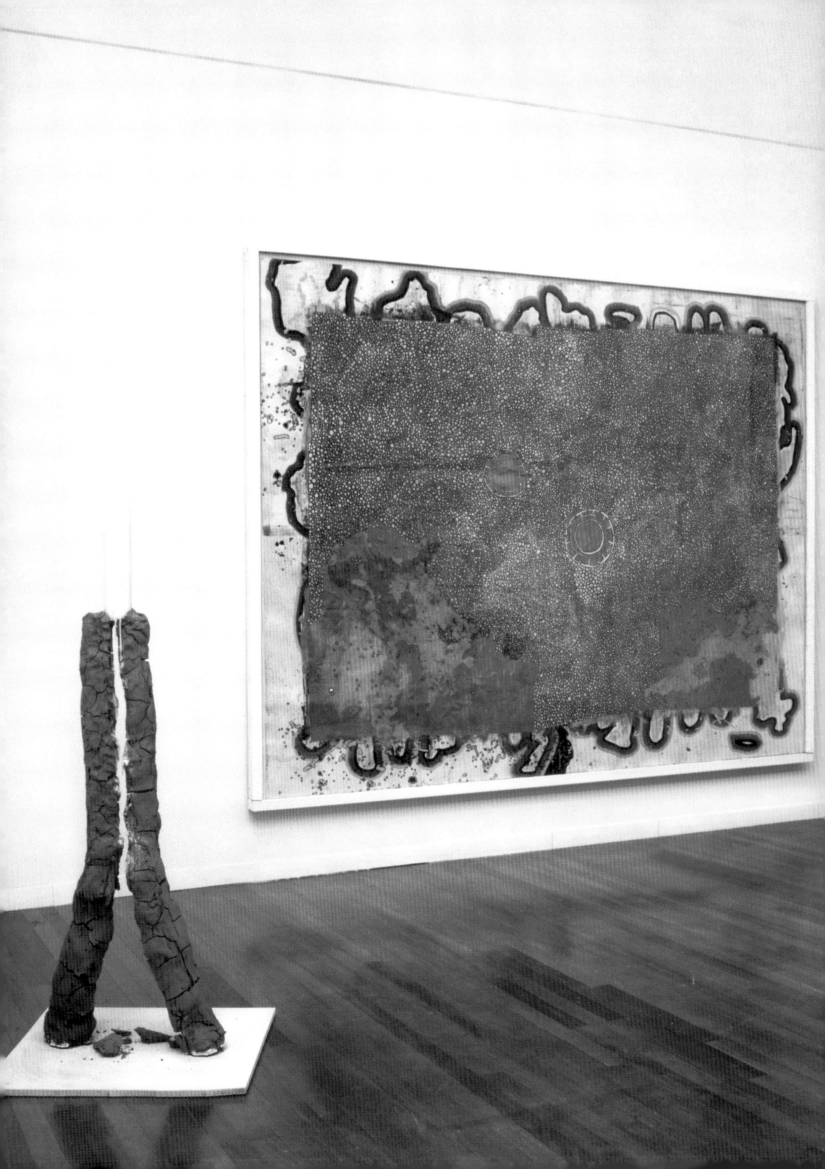

Partisan Hangover
2000
Wood, glass, particleboard, photocopies on clear polyester
film, acrylic paint, oil paint, marker, wood glue, spray
adhesive, plaster, screws, metal brackets, tape
188.3 x 215.5 x 12 cm; 74 ⅛ x 84 ⅞ x 4 ¼ in.

Nurse Random (Hymn to the Self-declared Sane)
2000
Wood, glass, particleboard, photocopies on polyester film,
latex paint, acrylic paint, oil paint, marker, wood glue,
spray adhesive, plaster, screws, metal brackets, tape
190.3 x 237.2 x 12 cm; 74 ⅞ x 93 ⅜ x 4 ¼ in.

Personal Weather
2000
Wood, glass, paper, photocopies on polyester film, acrylic
paint, marker, spray adhesive
189 x 277 cm; 74 ⅛ x 109 in.

Vain Whining
2001
Wood, glass, paper, photocopies on polyester film,
slide film, latex paint, acrylic paint, marker, wood glue,
wallpaper paste, spray adhesive, screws, laminate
186.2 x 238 x 12 cm; 73 ¼ x 93 ¼ x 3 ¼ in.

Whiny Vanity
2001
Wood, glass, paper, photocopies on polyester
film, slide film, latex paint, acrylic paint, marker,
wood glue, spray adhesive, screws, laminate
186.2 x 238 cm x 12 cm; 73 ¼ x 93 ¼ x 3 ¼ in.

Soulkebabish Nosyness
2001
Wood, glass, particleboard, paper, photocopies on
polyester film, photocopies, slide film, latex paint, oil
paint, acrylic paint, marker, wood glue, spray adhesive,
UV-protective lacquer, staples
212 x 266.5 x 12.5 cm; 83 ½ x 104 ⅞ x 4 ⅞ in.

Cape Carneval
2000–2001
Wood, glass, particleboard, paper, photocopies on
polyester film, slide film, latex paint, oil paint, acrylic
paint, marker, wood glue, spray adhesive, UV-protective
lacquer, staples
266 x 194.5 x 12.5 cm; 104 ¾ x 76 ⅝ x 4 ⅞ in.

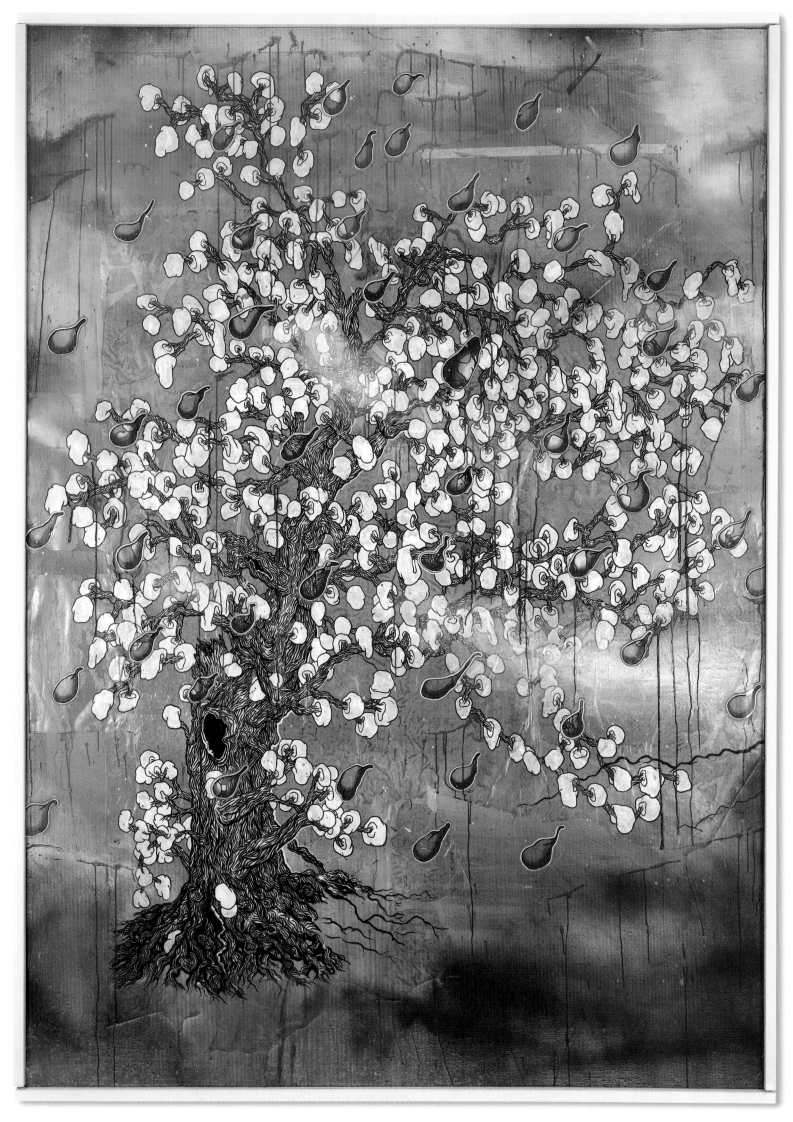

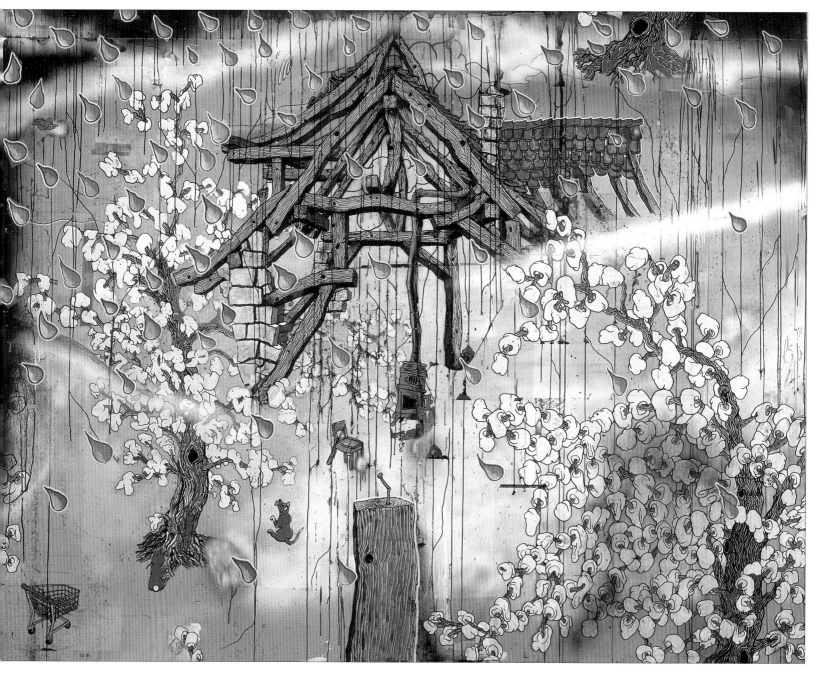

The Trick Is to Keep Breathing
2001
Wood, glass, particleboard, photocopies on
polyester film, latex paint, acrylic paint, marker,
acrylic glue, tape, screws
219.5 x 281 cm; 86 ⅛ x 110 ⅝ in.

Baum
2002
Wood, glass, particleboard, photocopies on polyester film,
acrylic paint, latex paint, marker, staples, screws
212 x 290 x 8.5 cm; 83 ½ x 114 ⅛ x 3 ⅜ in.

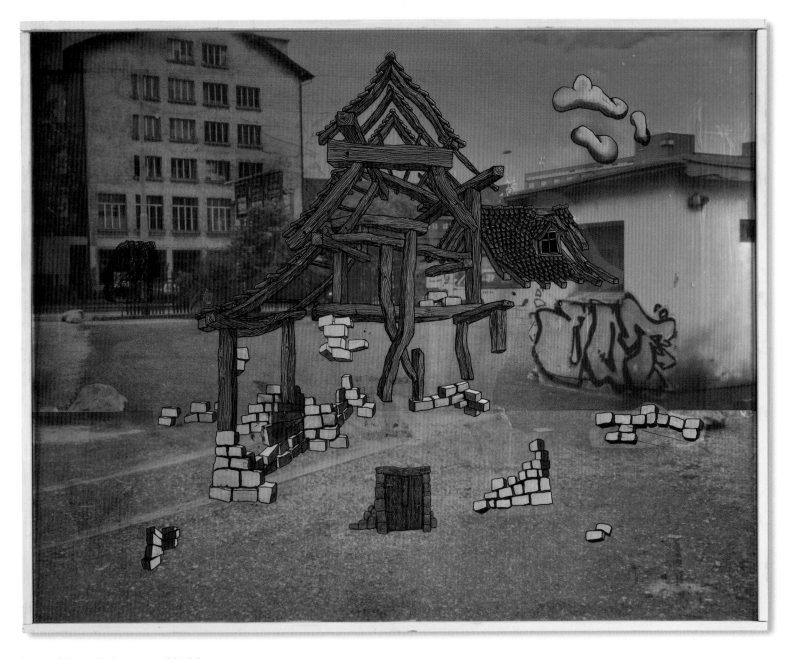

Reversed Scene of a Lost Internal Backdrop
2002
Wood, acrylic paint, glue, marker, acrylic glass,
slide film, tape, glass, particleboard
200 x 250 cm; 78 ¼ x 98 ⅜ in.

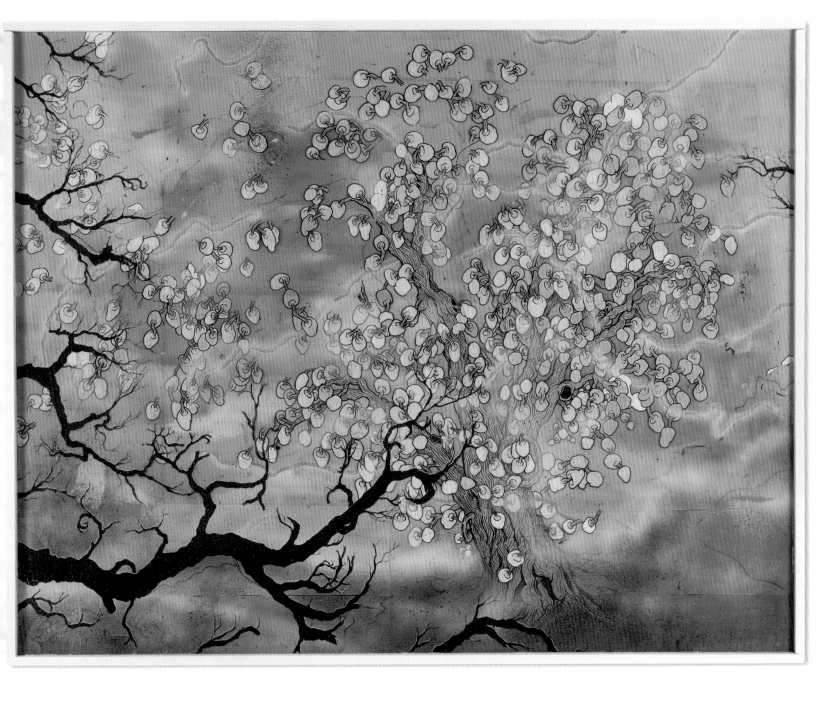

Mr. Toobad
2003
Wood, plywood, glue, acrylic paint, polyester film,
paint marker, tape, staples, screws, fittings, glass,
latex paint, UV-protective lacquer
210 x 268 x 10 cm; 82 ⅝ x 105 ½ x 4 in.

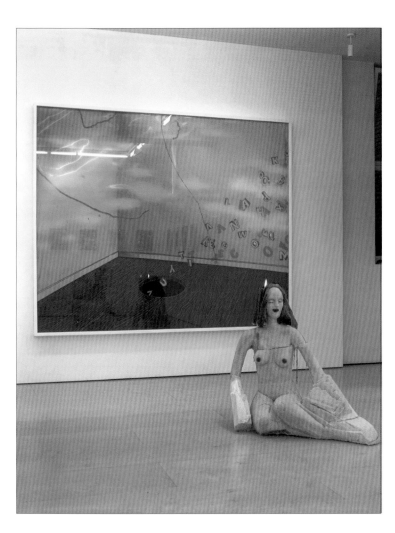

Joe
2003
Wood, glass, slide film, acrylic paint, marker,
glue, screws, staples
201.2 x 250.5 cm; 79 ¼ x 98 ⅝ in.
Installation view, "need no chair when walking,"
Sadie Coles HQ, London, 2003
Foreground: *What if the Phone Rings*, 2003

Pick a Moment You Don't Pick
2003
Wood, acrylic glass, inkjet print on film, acrylic
paint, marker, glue, spray adhesive, varnish,
screws
231 x 310 x 7.5 cm; 91 x 122 x 3 in.

Pick a Moment You Don't Pick
2003
Wood, acrylic glass, inkjet print on film, acrylic
paint, marker, glue, spray adhesive, varnish,
screws
231 x 310 x 7.5 cm; 91 x 122 x 3 in.

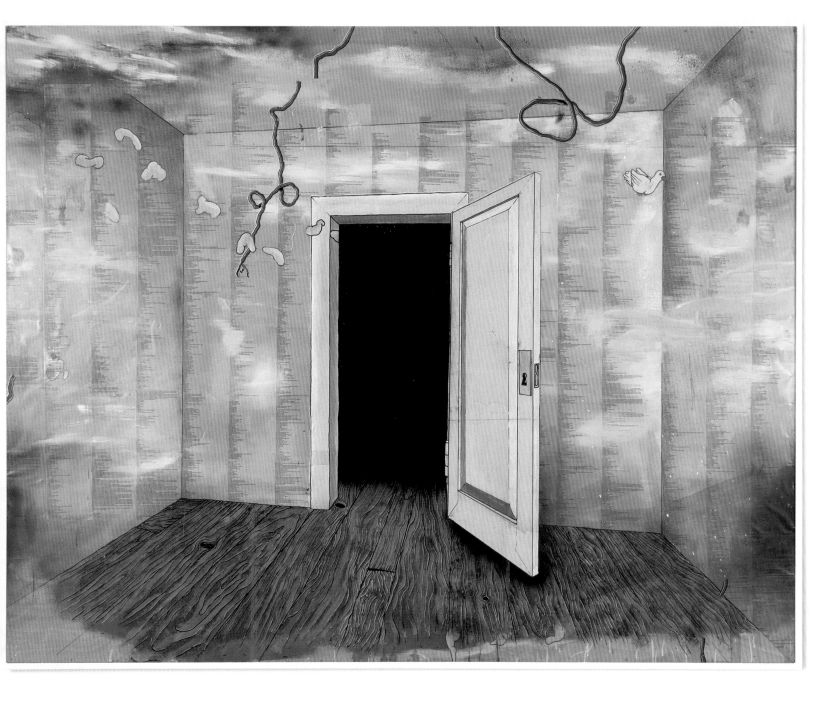

50 / 50
2002
Wood, glass, particleboard, photocopies
on polyester film, acrylic paint, oil paint,
marker, glue, staples
228 x 314 cm; 89 ¼ x 123 ⅝ in.

No Need for Ketchup with the Ice Cream
2004
Aluminum, ACM panels, acrylic paint, latex
paint, marker, UV acrylic varnish
308 x 398 x 6 cm; 121 ¼ x 156 ¼ x 2 ⅜ in.

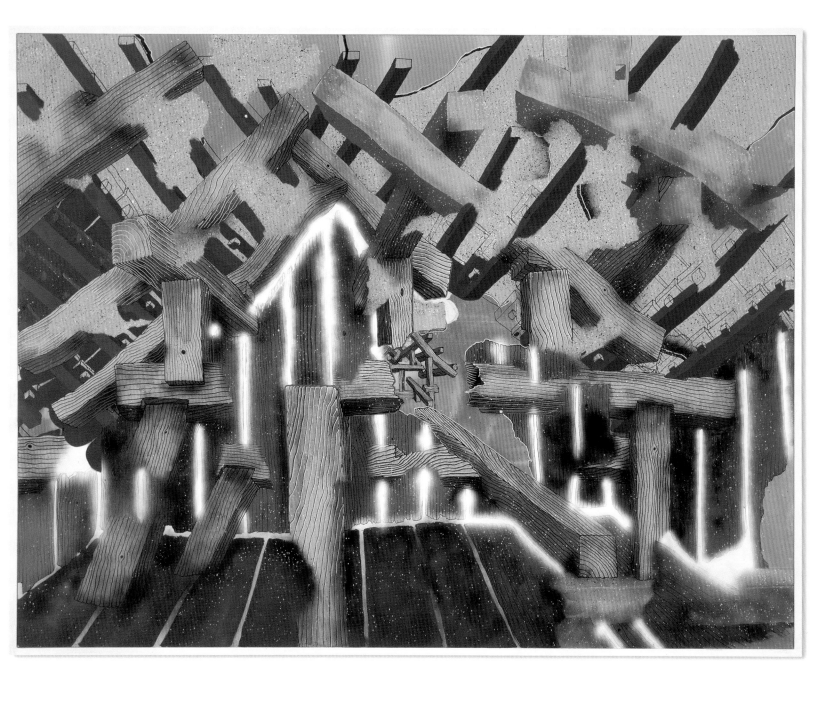

She Called Her "Taxi"
2004
Aluminum, ACM panels, acrylic paint,
latex paint, marker, UV-protective lacquer
308 x 398 x 6 cm; 121 ¼ x 156 ¼ x 2 ⅜ in.

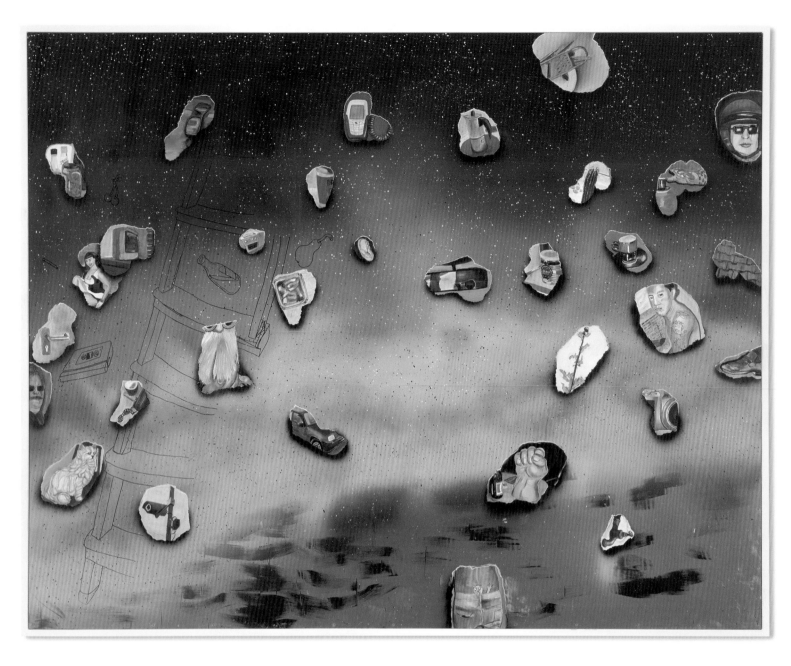

Call Cranach
2004
Aluminum, ACM panels, UV inkjet print, acrylic
paint, marker, UV-protective lacquer
251 x 316 x 6 cm; 98 ⅞ x 124 ⅜ x 2 ⅜ in.

Installation view, *Your Deaths, Your Births*
Private Collection, London

Opposite page:

Your Deaths Your Births
2004
Aluminum, ACM panels, UV inkjet print, acrylic
paint, marker, UV-protective lacquer
356 x 276 x 6 cm; 140 ⅛ x 108 ⅝ x 2 ⅜ in.

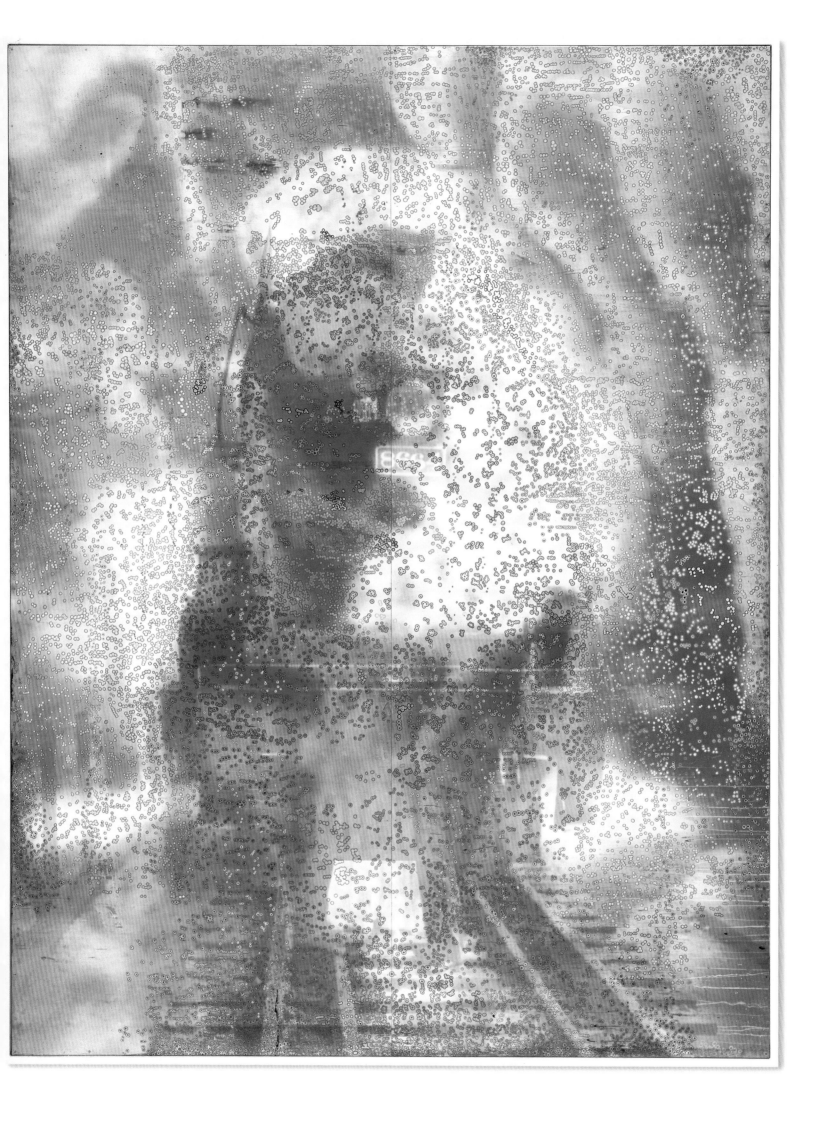

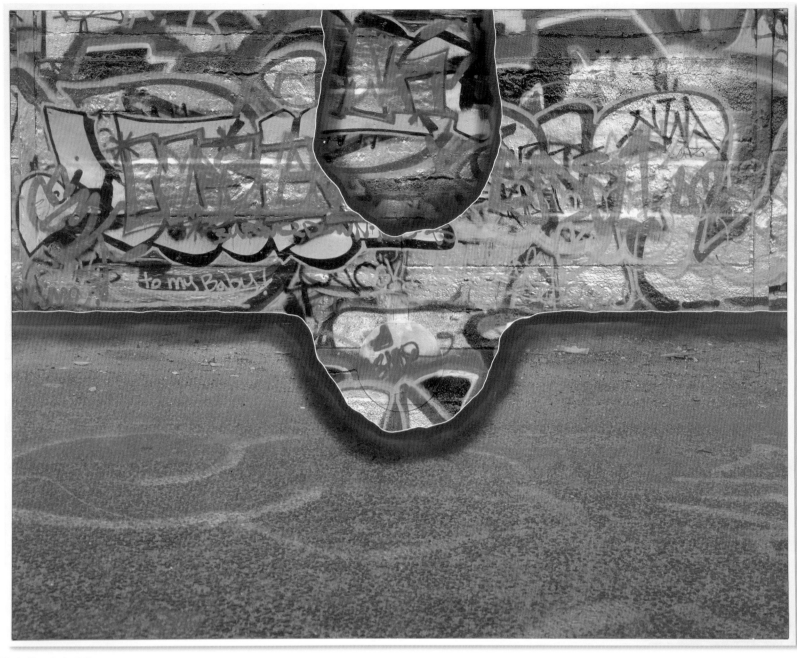

Birds Sing, Rain Falls
2004
Aluminum, ACM panels, UV inkjet print,
acrylic paint, marker, UV-protective lacquer
276 x 356 x 6 cm; 108 ⅜ x 140 ⅛ x 2 ⅜ in.

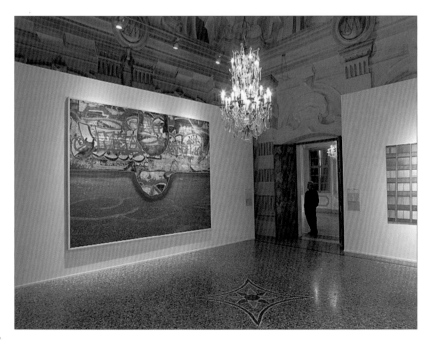

Installation view, "Infinite Painting—Contemporary
Painting and Global Realism," Villa Manin Centre
for Contemporary Art, Codroipo, Italy, 2006
Birds Sing, Rain Falls, 2004

Stalagmites of Love
2004
Aluminum, ACM panels, UV inkjet print,
acrylic paint, marker, UV-protective lacquer
276 x 356 x 6 cm; 108 ⅝ x 140 ⅛ x 2 ⅛ in.

office theme / the nineties / blah is the new bushwa
2006
Wood, ACM panels, Epson ultrachrome inkjet print on
canvas and Somerset velvet fine art paper, primer, oil paint,
acrylic paint, paper cement, epoxy polymer, varnish
305.5 x 245 x 8 cm; 120 ¼ x 96 ½ x 3 ⅛ in.

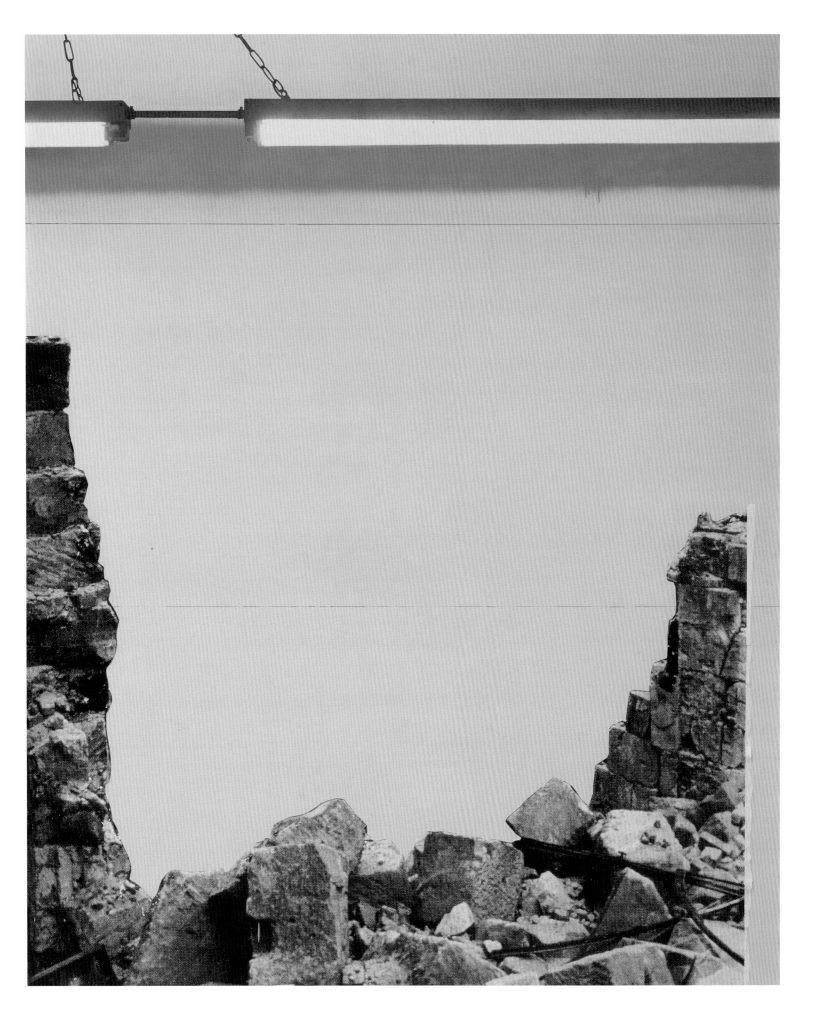

Page 280:

office theme / addiction / mmmh camera
2006
Wood, ACM panels, Epson ultrachrome inkjet
print on canvas and Somerset velvet fine art paper,
cardboard, primer, oil paint, acrylic paint, paper
cement, epoxy polymer, varnish
245.3 x 183 x 8.3 cm; 96 ⅝ x 72 x 3 ¼ in.

Page 281:

Installation view, office theme / addiction / mmmh camera,
"Paris 1919," Museum Boijmans Van Beuningen,
Rotterdam, 2006

Untitled (Nürnberg)
2006
Wood, ACM panels, Epson ultrachrome
inkjet print on Somerset velvet fine art
paper, primer, oil paint, acrylic paint,
paper cement, paint marker, varnish
305.5 x 245 x 8 cm; 120 ¼ x 96 ½ x 3 ⅛ in.

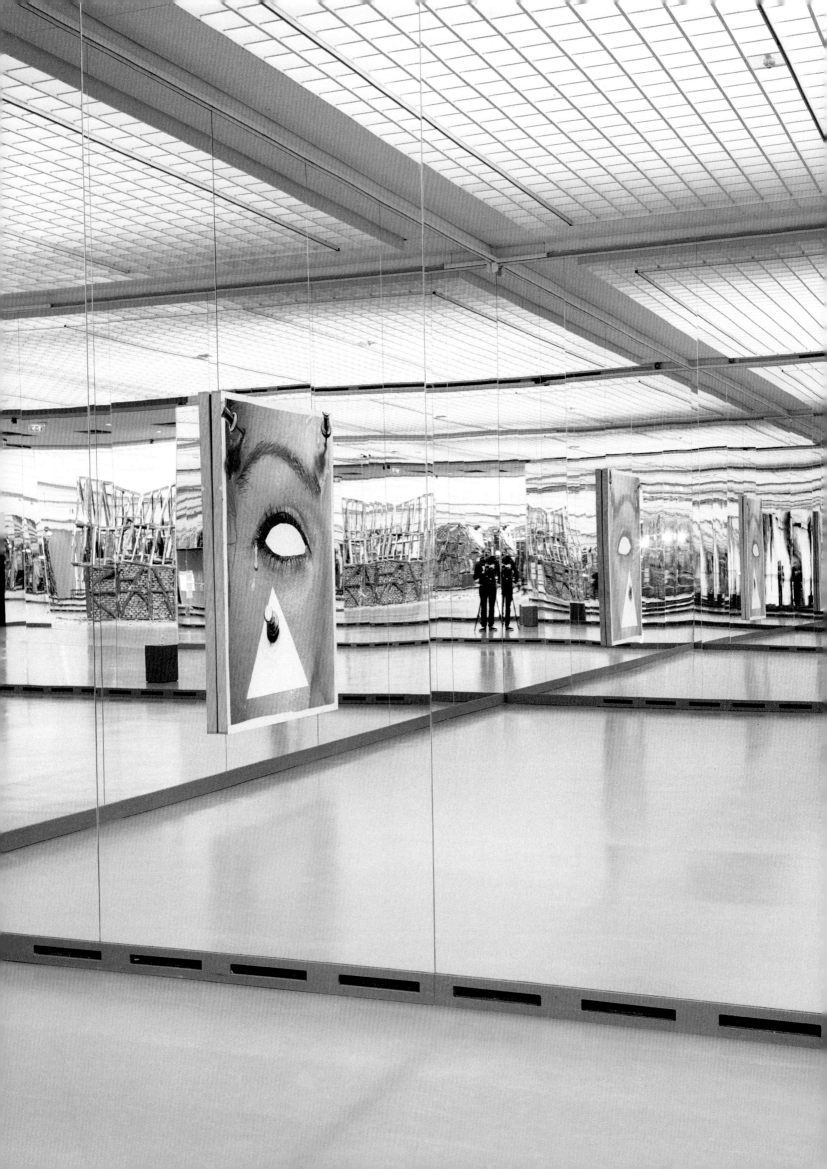

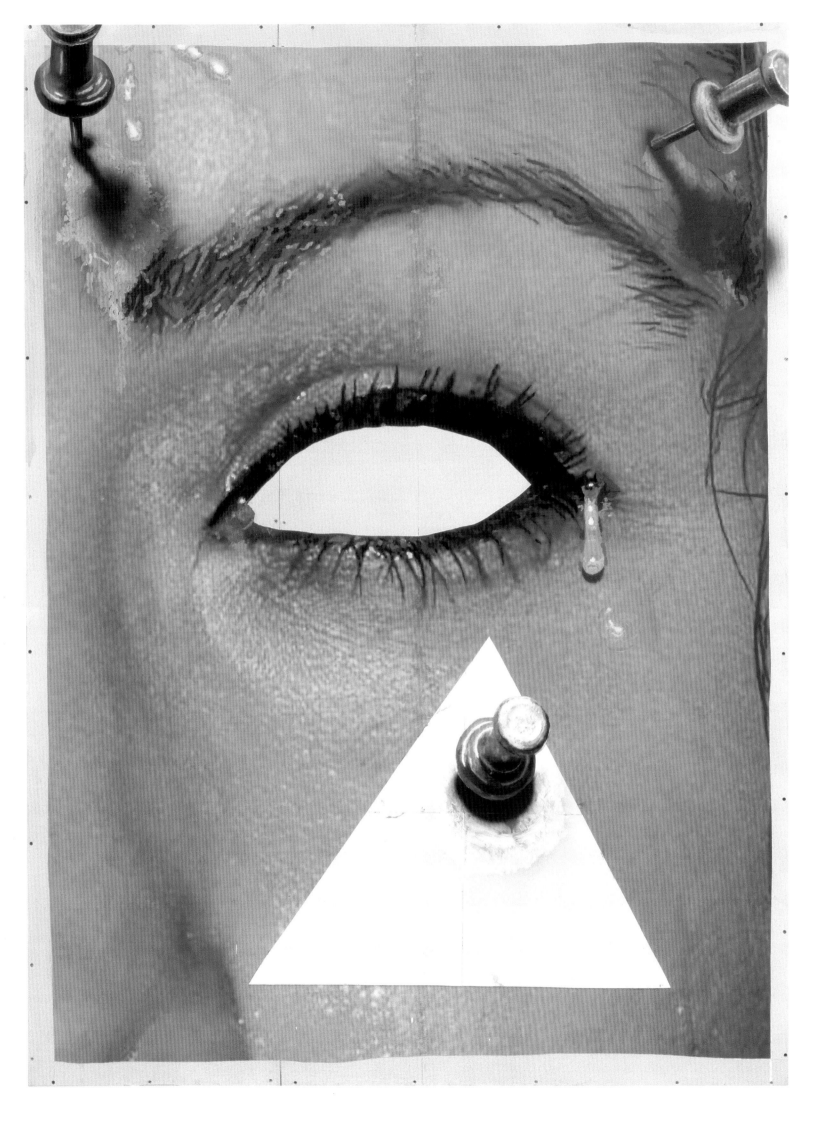

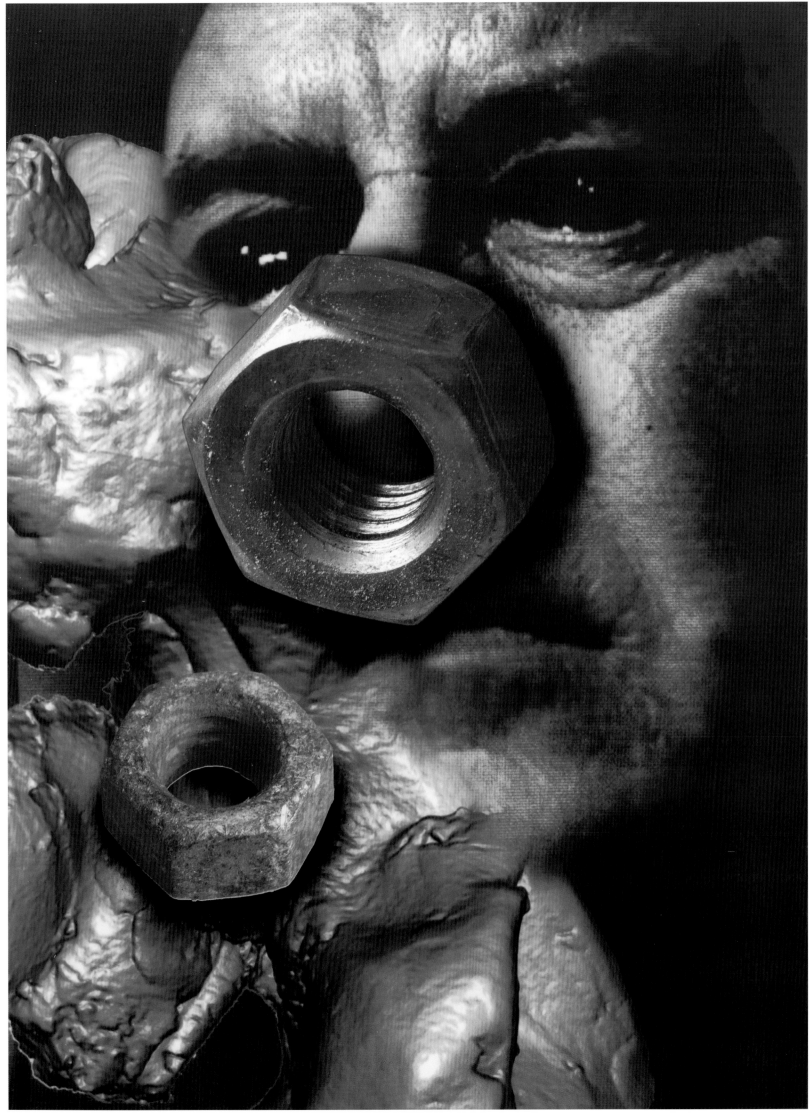

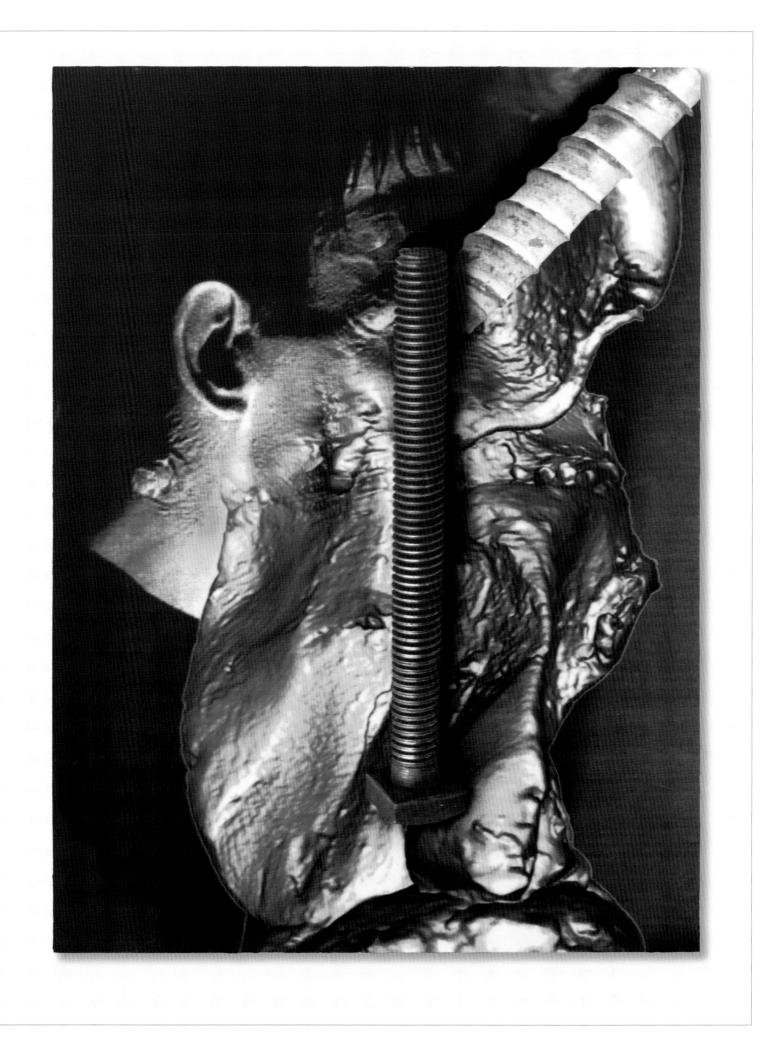

Guerkli
2009
Oak, ACM panels, gesso, ink, acrylic paint,
polyurethane glue, screws
243.8 x 182.9 x 3.8 cm; 96 x 72 x 1 ½ in.

Salami
2009
Oak, ACM panels, gesso, ink, acrylic paint,
polyurethane glue, screws
243.8 x 182.9 x 3.8 cm; 96 x 72 x 1 ½ in.

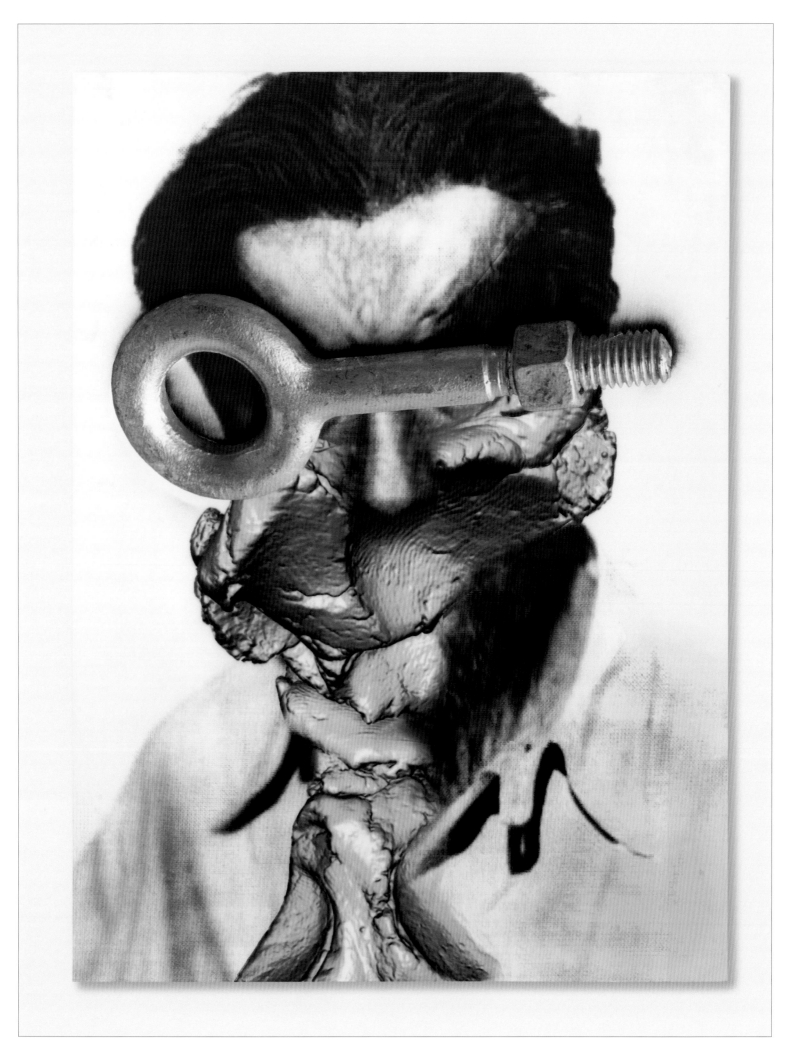

Noodles
2009
Oak, ACM panels, gesso, ink, acrylic paint,
polyurethane glue, screws
243.8 x 182.9 x 3.8 cm; 96 x 72 x 1 ½ in.

Meatloaf
2009
Oak, ACM panels, gesso, ink, acrylic paint,
polyurethane glue, screws
243.8 x 182.9 x 3.8 cm; 96 x 72 x 1 ½ in.

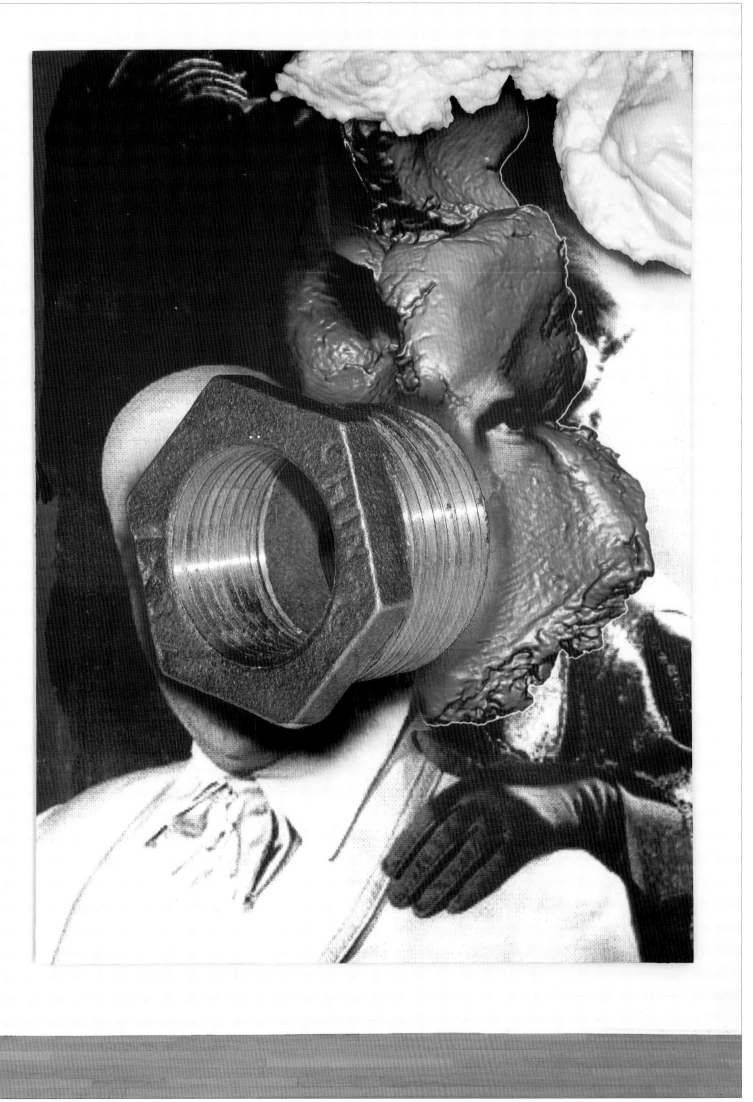

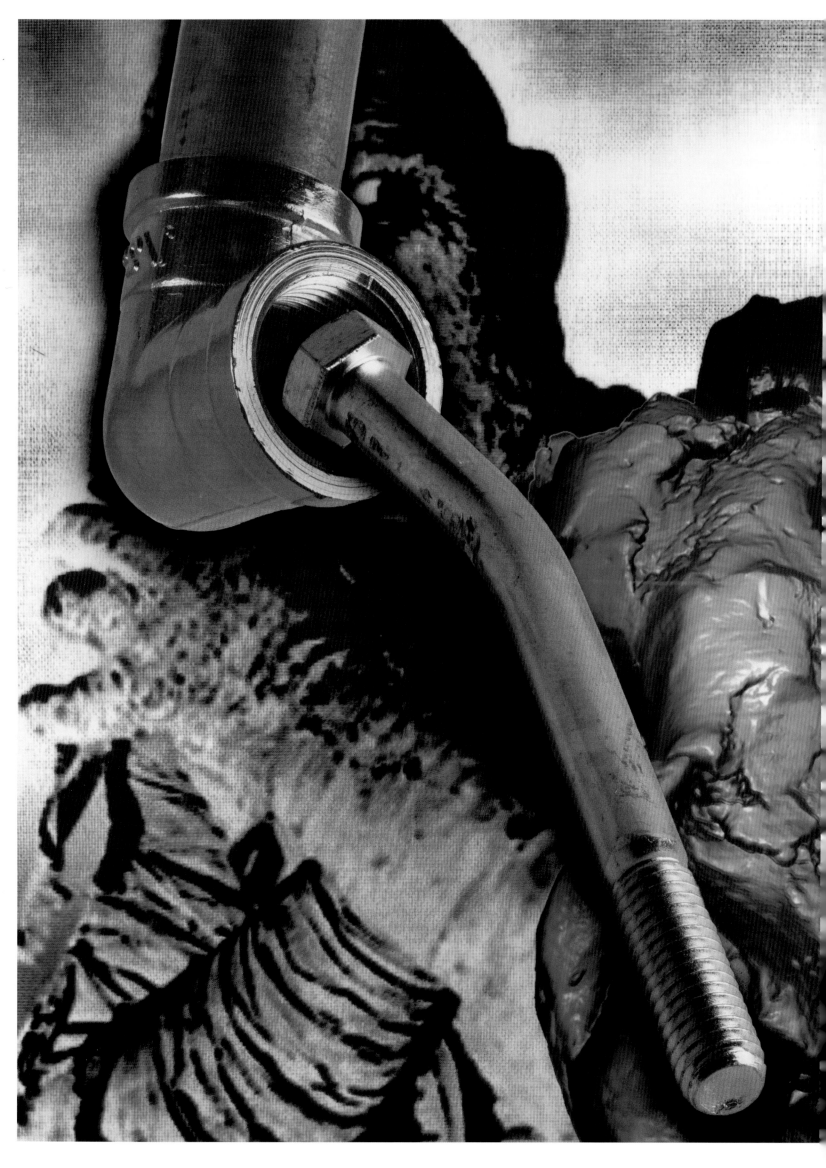

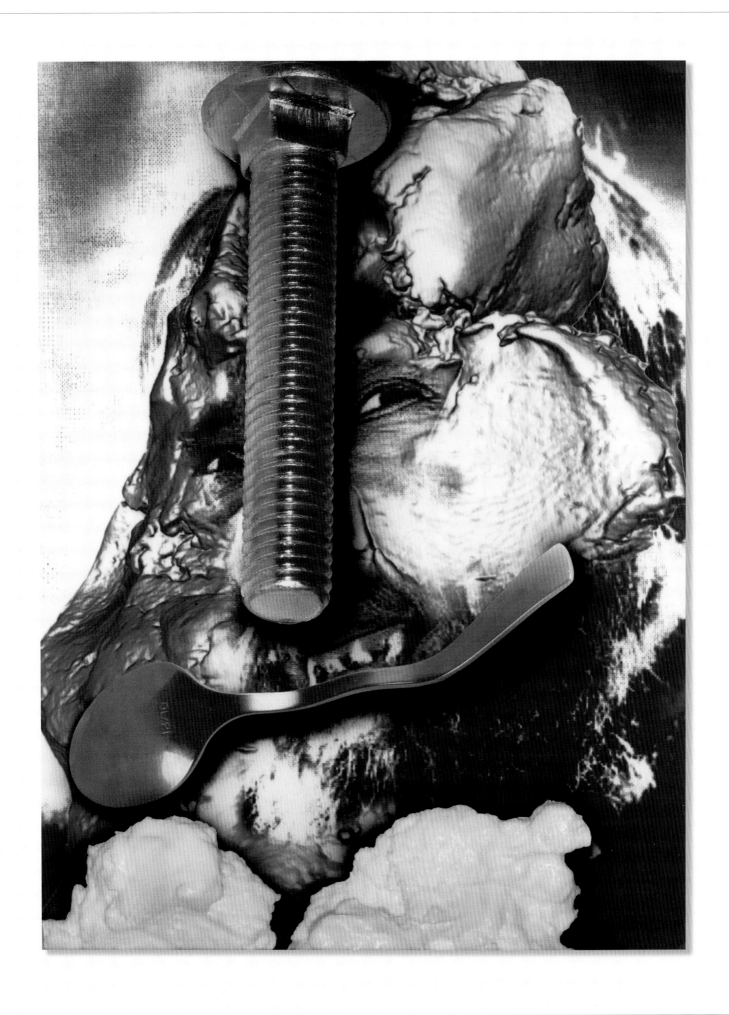

Tuxedo
2009
Pine, MDF, ACM panels, acrylic adhesive, gesso, ink,
acrylic paint, screws
243.8 x 181.6 x 4.1 cm; 96 x 71 ½ x 1 ⅝ in.

Poultry
2009
Pine, MDF, ACM panels, acrylic adhesive, gesso, ink,
acrylic paint, polyurethane glue, screws
243.8 x 181.6 x 4.1 cm; 96 x 71 ½ x 1 ⅝ in.

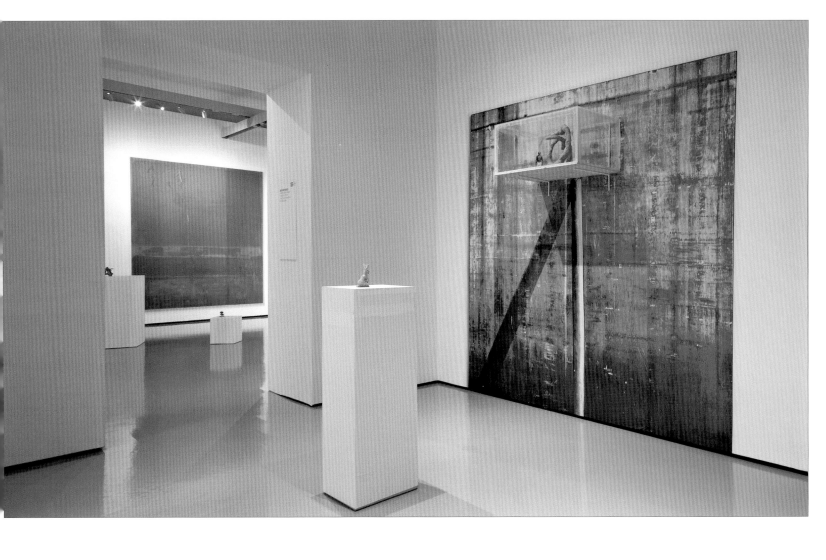

Verbal Asceticism
2007
Wallpaper prints of black-and-white reproductions of artworks exhibited in
these rooms in the previous exhibition, "Where Are We Going?"
Dimensions variable
Installation view, "Sequence 1: Painting and Sculpture in the François Pinault
Collection," Palazzo Grassi, Venice, 2007
Top, foreground: *Pop the Glock*, 2006
On wall: Franz West, *Flora (Model)*, 2006; vitrine by Rudolf Polanszky

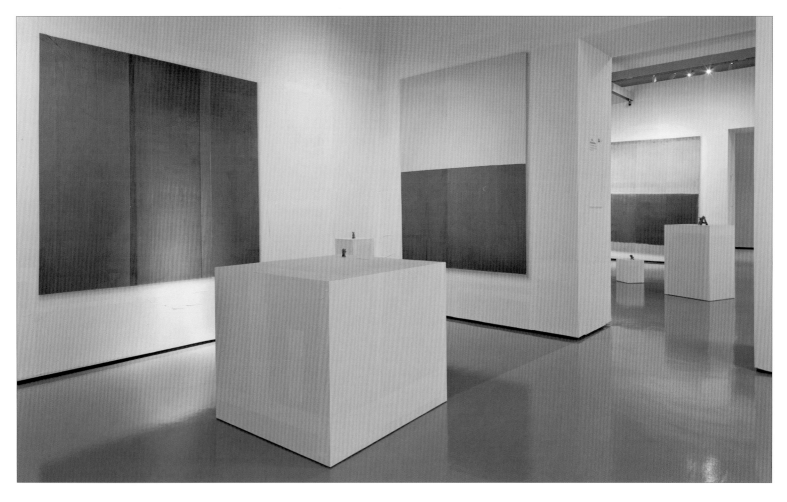

Installation view, "Sequence 1: Painting and Sculpture in the
François Pinault Collection," Palazzo Grassi, Venice, 2007
Foreground: *Untitled*, 2007
On wall: *Verbal Asceticism*, 2007

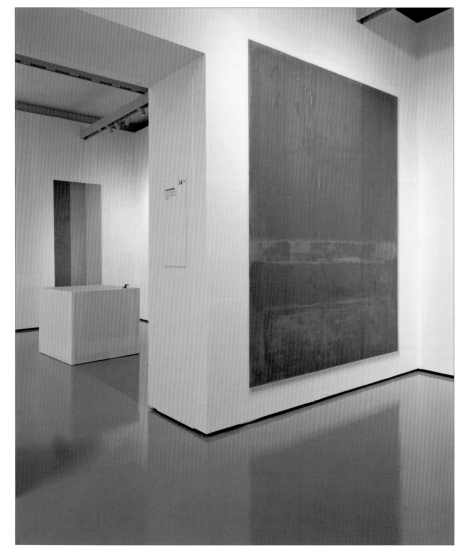

Untitled
2007
Cast nickel silver, gesso, oil paint
Mouse 1: 6 x 12.5 x 4 cm; 2 ⅜ x 4 ⅞ x 1 ⅝ in.
Mouse 2: 6 x 3.5 x 5 cm; 2 ⅜ x 1 ⅜ x 2 in.

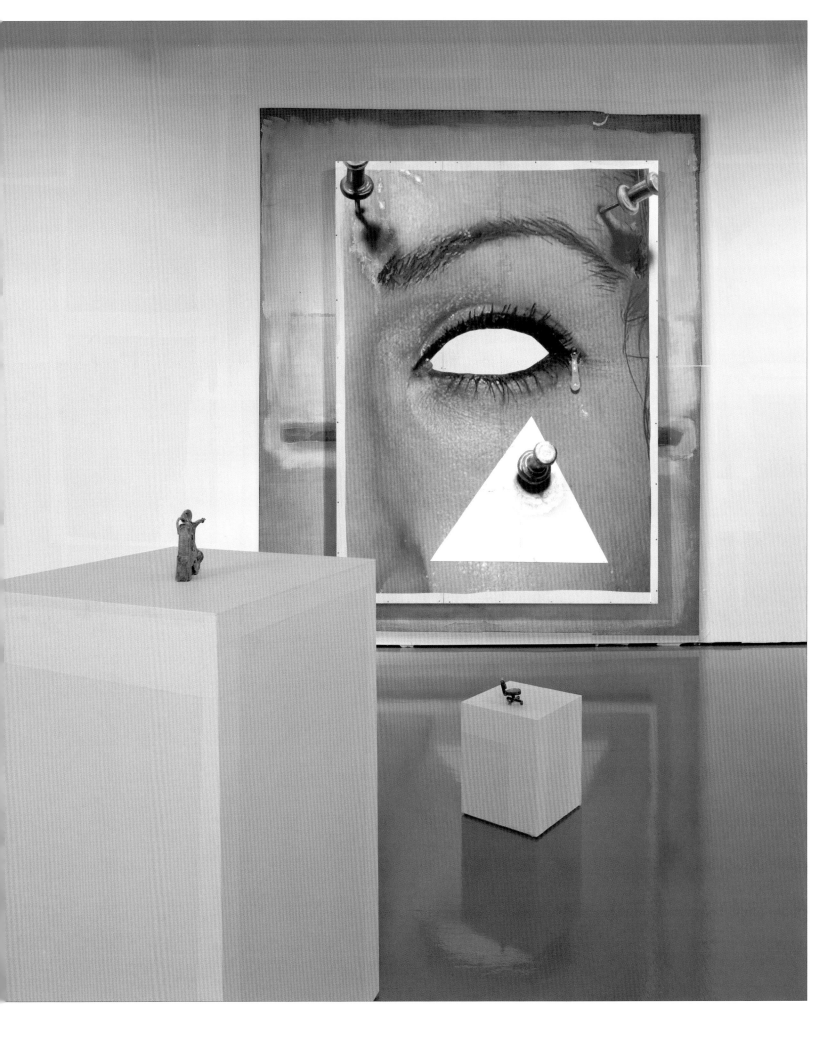

Installation view, "Sequence 1: Painting and Sculpture in the
François Pinault Collection," Palazzo Grassi, Venice, 2007
Foreground to background: *Untitled*, 2007; *Untitled*, 2007; *office
theme / addiction / mmmh camera*, 2006; *Verbal Asceticism*, 2007

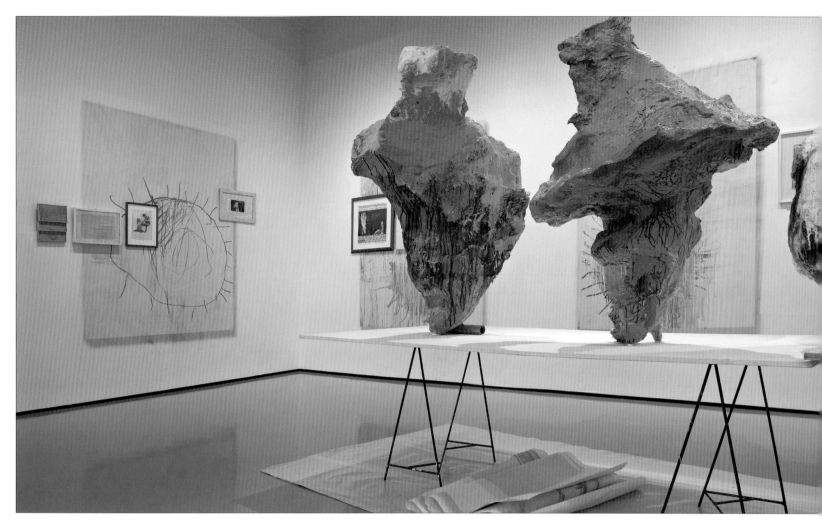

Verbal Asceticism
2007
Wallpaper prints of black-and-white reproductions of artworks exhibited in these rooms in the previous exhibition
"Where Are We Going?"
Dimensions variable
Installation view, "Sequence 1: Painting and Sculpture in the François Pinault Collection," Palazzo Grassi, Venice, 2007
Foreground: Franz West, *Worktable and Workbench*, 2006
On wall: Franz West, *Collecting Wall*, 2007

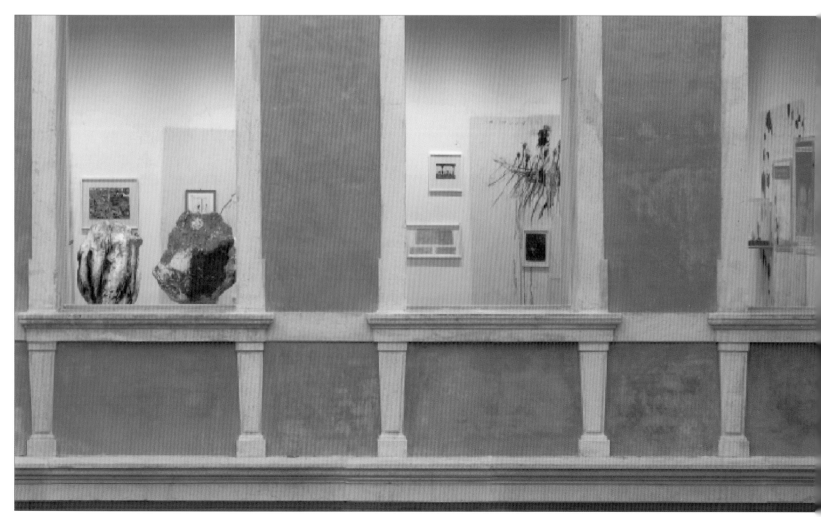

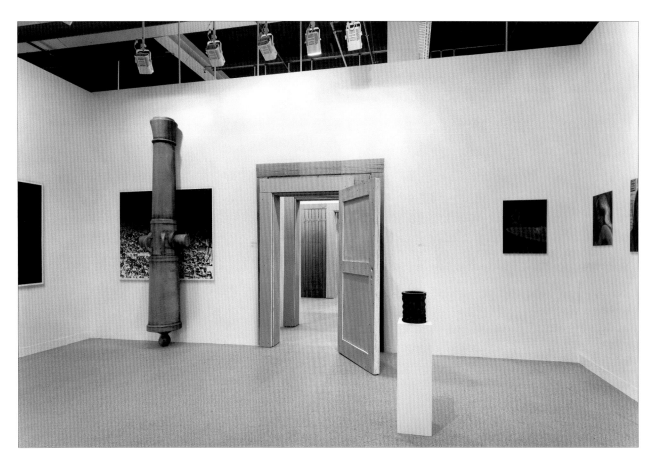

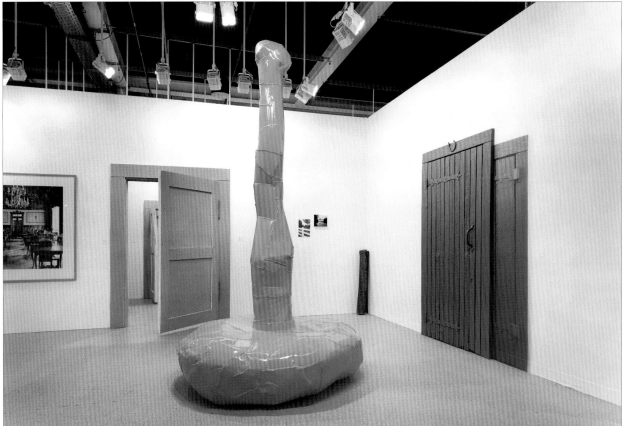

2007
Wallpaper prints of black-and-white reproductions of individual artworks exhibited in the
Galerie Eva Presenhuber booth at the Armory Show in New York in 2007
Dimensions variable
Installation view, Art Basel, Galerie Eva Presenhuber booth, 2007
Untitled (Doors), 2007
Top, left to right: Valentin Carron, *L'Hostile*, 2005; Peter Fischli / David Weiss, *Pot*, 2005
Bottom, left to right: Candida Höfer, *Arquivo Distrital De Braga II 2006*, 2006; Franz
West, *Gartenpouf (blue)*, 2006; Karen Kilimnik, *the chateau of glass in the pond*, 2007; Tim
Rollins and K.O.S., *Pinocchio #14 (After Carlo Collodi)*, 1992; Ugo Rondinone, *City Circus
Cemetary*, 2007

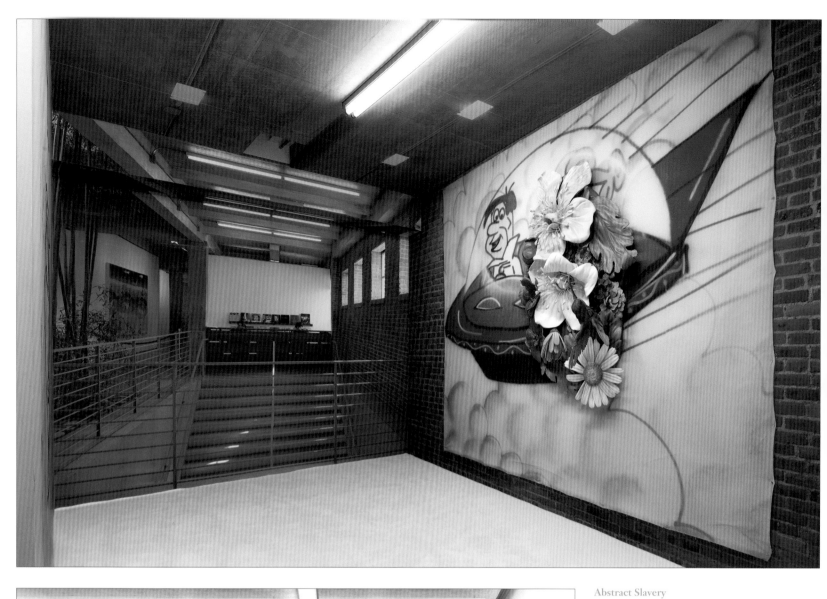

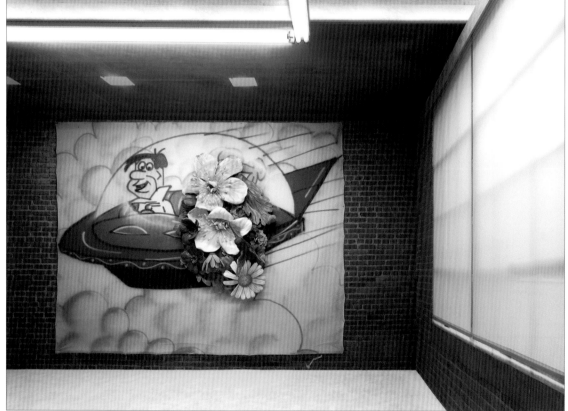

Abstract Slavery
2008
Wallpaper prints of 1:1 scale color reproduction
of the gallery space during the previous
exhibition "Four Friends"
Dimensions variable
Installation view, "Who's Afraid of Jasper Johns?"
Tony Shafrazi Gallery, New York, 2008
Jeff Koons, *Wall Relief with Bird*, 1991

Opposite page:

Installation view, "Who's Afraid of Jasper Johns?"
Tony Shafrazi Gallery, New York, 2008
Wallpaper: *Abstract Slavery*, 2008
Left to right: Francis Picabia, *Portrait Einer
Schauspielerin, Suzanne Romain*, 1943; Georg
Herold, *Eimer Neben Sockel*, 1987; Lily van der
Stokker, *Pink Blubber*, 2008; Francis Bacon,
Untitled (Head), 1949

Installation view, "Who's Afraid of Jasper Johns?"
Tony Shafrazi Gallery, New York, 2008
Wallpaper: *Abstract Slavery*, 2008
Left to right: Georg Herold, *Holz Ohne Raum
(No Room for Wood)*, 1988; Malcolm Morley, *Age
of Catastrophe*, 1976

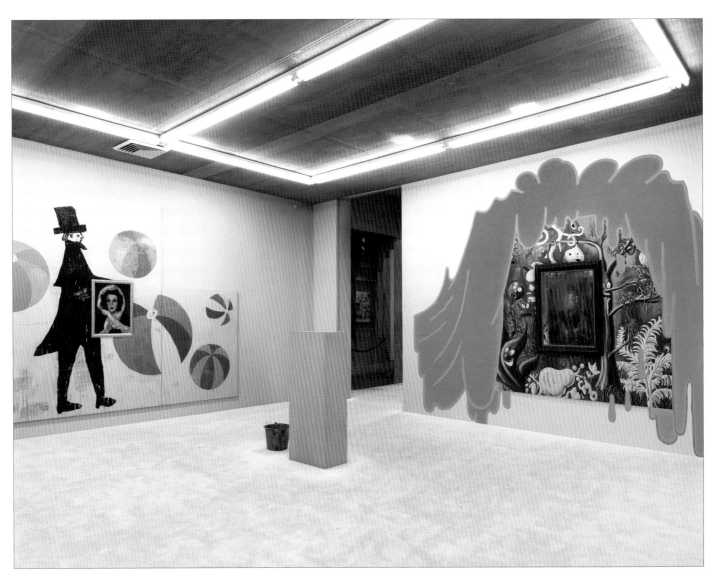

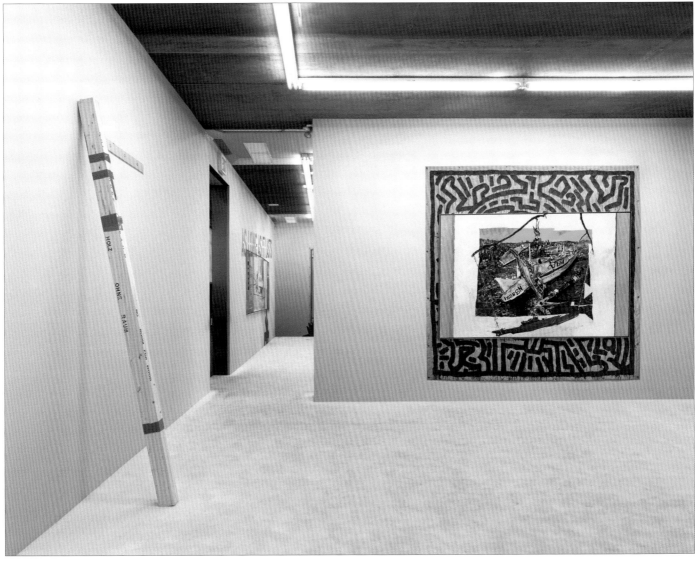

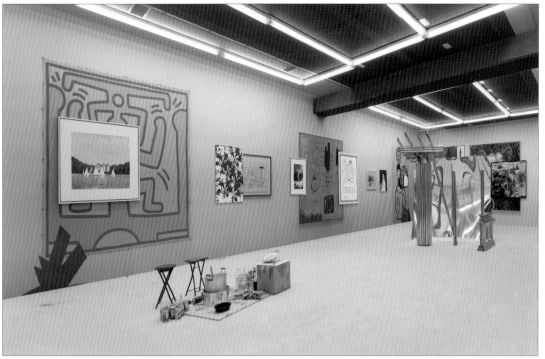

Abstract Slavery
2008
Wallpaper prints of 1:1 scale color reproduction
of the gallery space during the previous
exhibition "Four Friends"
Dimensions variable
Installation view, "Who's Afraid of Jasper
Johns?" Tony Shafrazi Gallery, New York, 2008
Left to right: Malcolm Morley, *Castle with
Sailboats*, 1969; Rirkrit Tiravanija, *Untitled (tom
ka soup)*, 1991; Christopher Wool, *Untitled
S116*, 1993; Richard Prince, *Spiritual America*,
1983; Sue Williams, *Dessert*, 1990; Mike Bidlo,
Not Picasso (Self-Portrait: Yo Picasso, 1901), 1986;
Robert Ryman, *Series #33 (White)*, 2004; Robert
Morris, *Untitled*, 1978; Cindy Sherman, *Untitled
#175*, 1987

Installation view, "Who's Afraid of Jasper
Johns?" Tony Shafrazi Gallery, New York, 2008
Wallpaper: *Abstract Slavery*, 2008
Left to right: Gilbert & George, *MENTAL NO.
4*, 1976; Robert Morris, *Untitled*, 1978; Cady
Noland, *SLA group shot #1*, 1991

Installation view, "Who's Afraid of Jasper
Johns?" Tony Shafrazi Gallery, New York, 2008
Wallpaper: *Abstract Slavery*, 2008
Left to right: Robert Morris, *Untitled*, 1978;
Cady Noland, *SLA group shot #1*, 1991

Opposte page:

Installation view, "Who's Afraid of Jasper
Johns?" Tony Shafrazi Gallery, New York, 2008
Wallpaper: *Abstract Slavery*, 2008
Left to right: Gilbert & George, *MENTAL NO.
4*, 1976; Cindy Sherman, *Untitled #175*, 1987

Installation view, "Who's Afraid of Jasper
Johns?" Tony Shafrazi Gallery, New York, 2008
Wallpaper: *Abstract Slavery*, 2008
Left to right: Cady Noland, *SLA group shot #1*,
1991

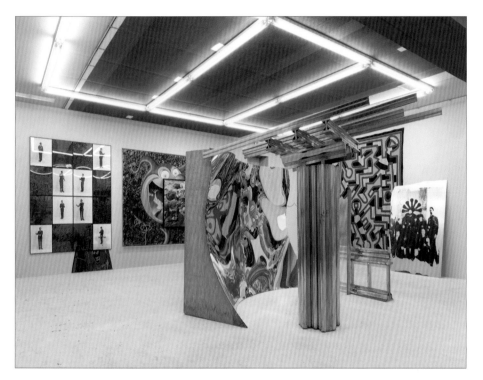

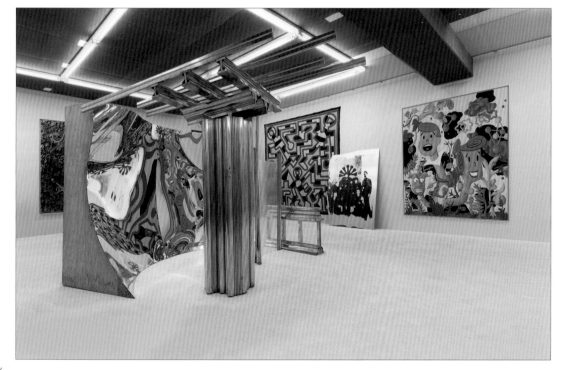

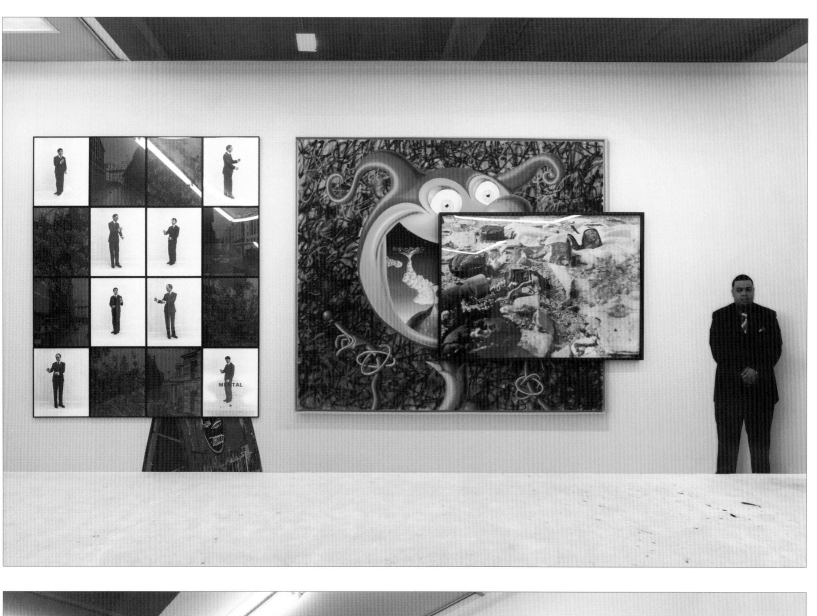

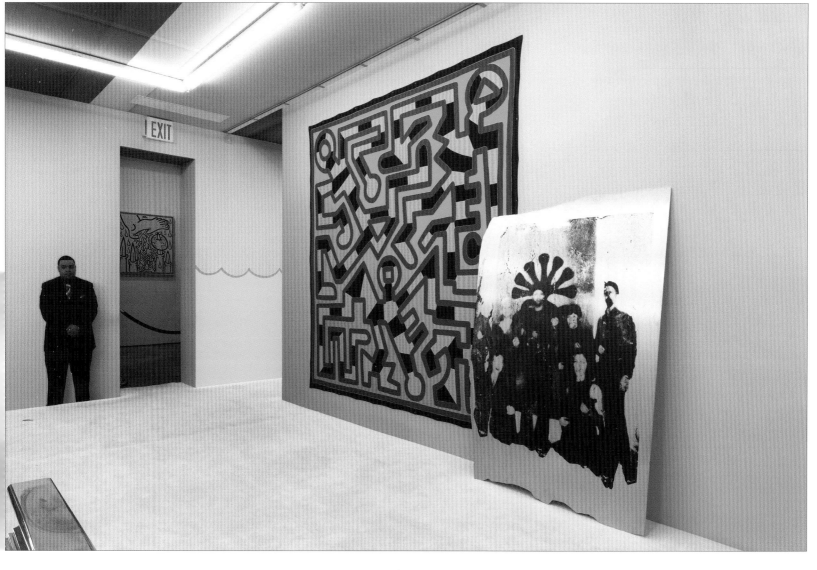

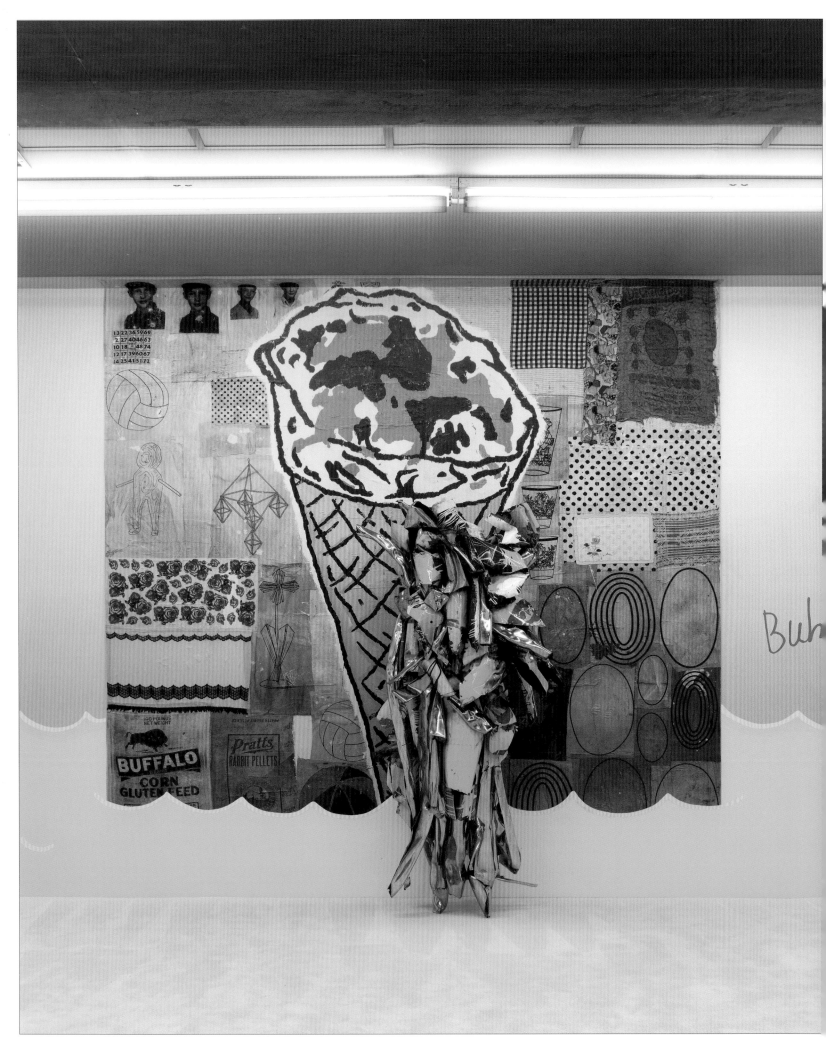

Abstract Slavery
2008
Wallpaper prints of 1:1 scale color reproduction of the gallery space during the previous exhibition "Four Friends"
Dimensions variable
Installation view, "Who's Afraid of Jasper Johns?" Tony Shafrazi Gallery, New York, 2008
Foreground to background: John Chamberlain, *Carmen Miranda's Shoes*, 1989; Lily van der Stokker, *Water Buh*, 2008

Meer
2002
Wood, glass, particleboard, slide film, polyester film, latex
paint, acrylic paint, marker, screws
238 x 310 x 8.5 cm; 93 ¼ x 122 x 3 ⅛ in.

Make a Duck Out of a Cow
2003
Wood, acrylic glass, plywood, inkjet print on film, latex paint
acrylic paint, marker, spray adhesive, glue, screws, varnish
231 x 309.9 x 7.6 cm; 91 x 122 x 3 in.

Untitled (Floor Piece)
2006
Black adhesive vinyl, latex paint
Dimensions variable

Opposite page:

Installation view, "Mary Poppins," Blaffer Gallery, The Art
Museum of the University of Houston, Texas, 2006
Left to right: *Untitled (Floor Piece)*, 2006; *Nach Jugendstiel
kam Roccoko*, 2006; *Addict*, 2006

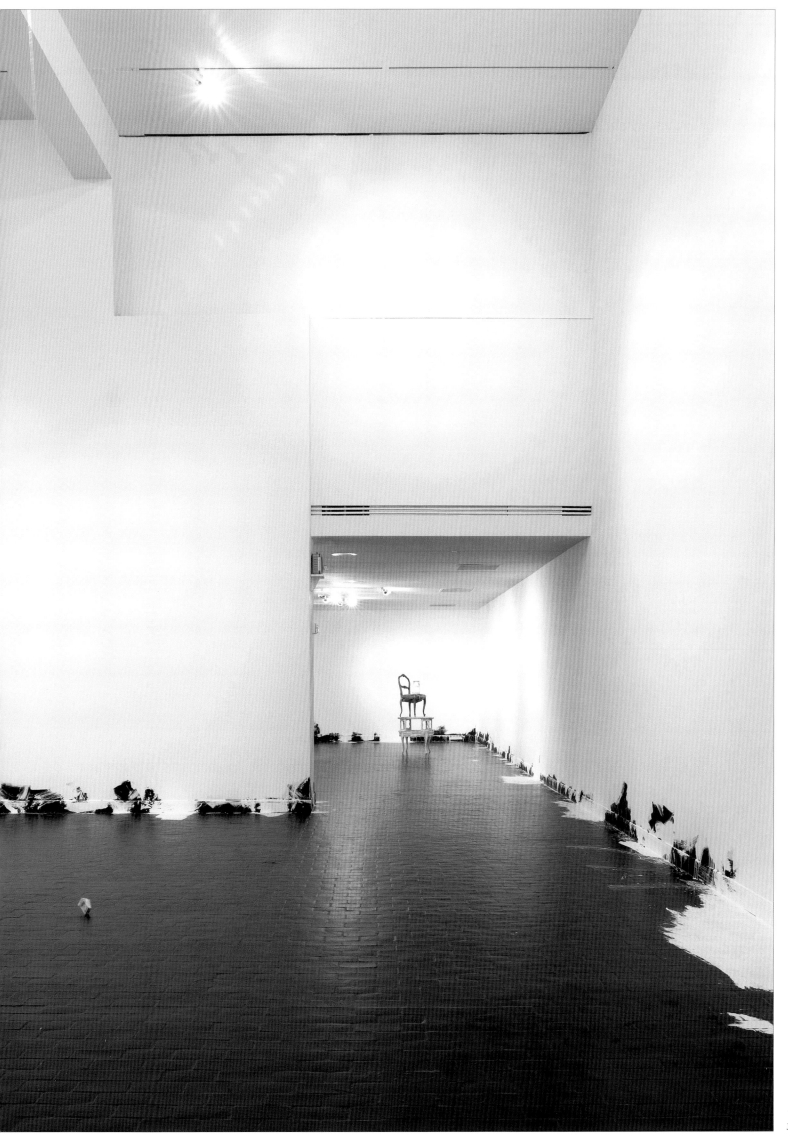

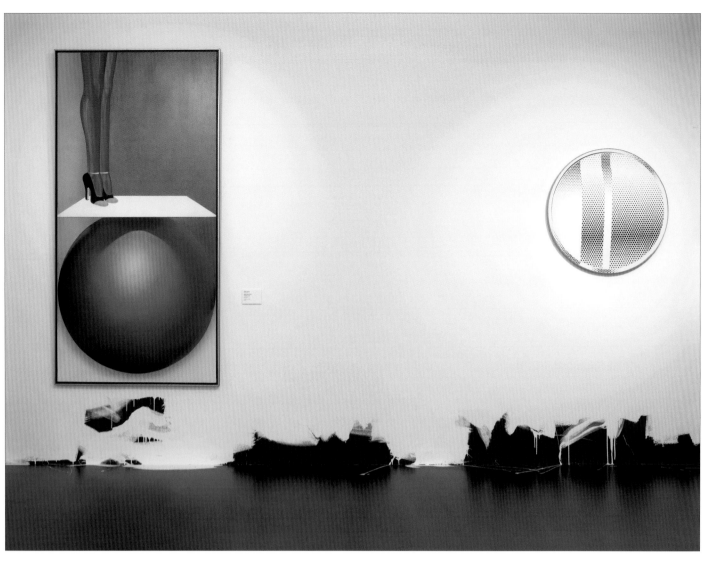

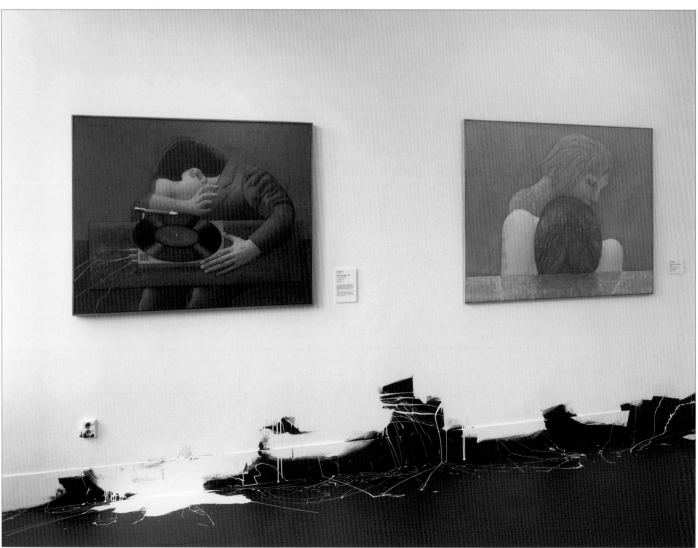

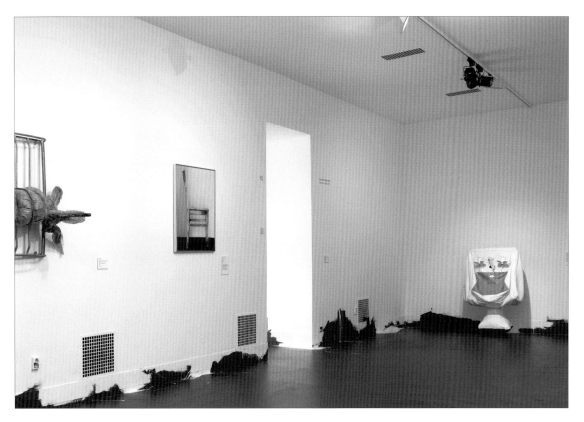

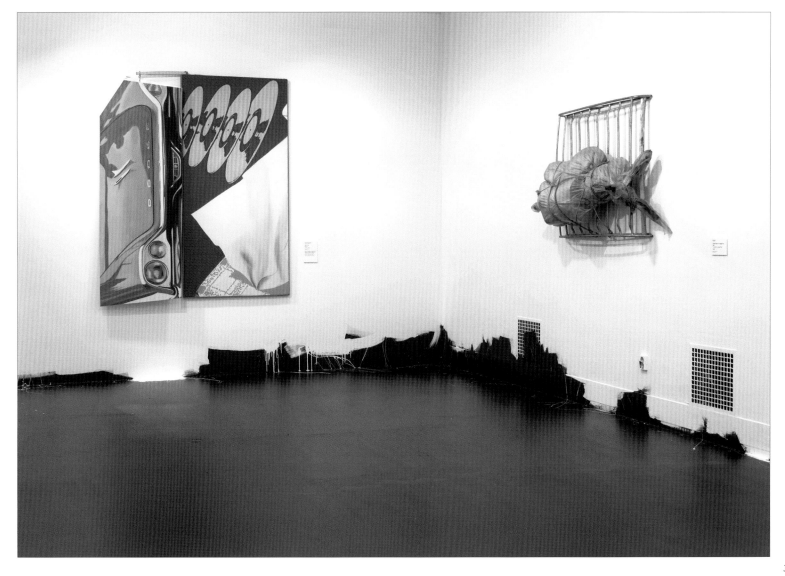

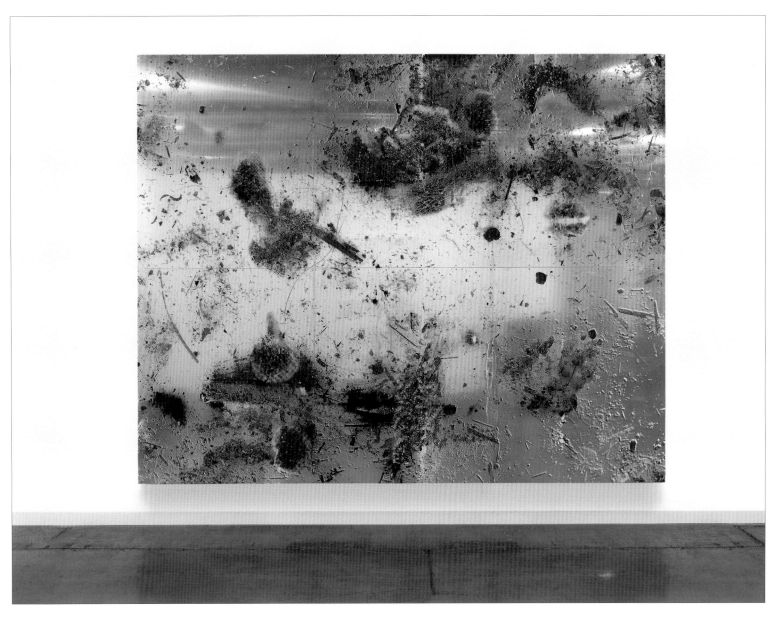

Untitled
2007
Aluminum, transparent primer, vinyl paint,
pigments, silicone, screws
284.5 x 362 cm; 112 x 142 ½ in.

Untitled
2007
Aluminum, transparent primer, vinyl paint,
pigments, silicone, screws
284.5 x 362 cm; 112 x 142 ½ in.

Untitled
2007
Aluminum, transparent primer, vinyl paint,
pigments, silicone, screws
274 x 351 cm; 108 x 138 ⅛ in.

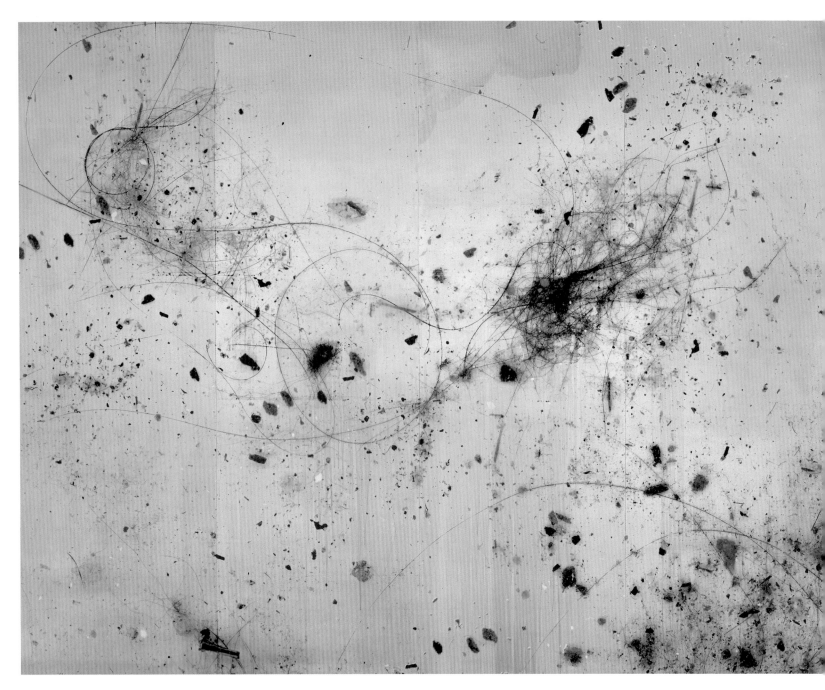

Untitled
2007
Aluminum, transparent primer, vinyl paint,
pigments, silicone, screws
Panel 3 of 3
Panel 1: 336 x 450 x 8 cm; 132 ⅛ x 177 x 3 ⅛ in.
Panel 2: 343 x 445 x 8 cm; 135 x 175 x 3 ⅛ in.
Panel 3: 361 x 465 x 8 cm; 142 x 183 x 3 ⅛ in.

Installation view, "get up girl a sun is running the world"
(with Ugo Rondinone), Church San Stae, Venice
Biennale, 2007
On wall: *Untitled*, 2007
Left to right: all Ugo Rondinone, *wisdom? peace? blank? all
of this?*, 2007; *get up girl a sun is running the world*, 2006;
air gets into everything even nothing, 2006

Installation view, "get up girl a sun is running the
world" (with Ugo Rondinone), Church San Stae, Venice
Biennale, 2007
On wall: *Untitled*, 2007
Left to right: all Ugo Rondinone, *air gets into everything
even nothing*, 2006; *wisdom? peace? blank? all of this?*, 2007

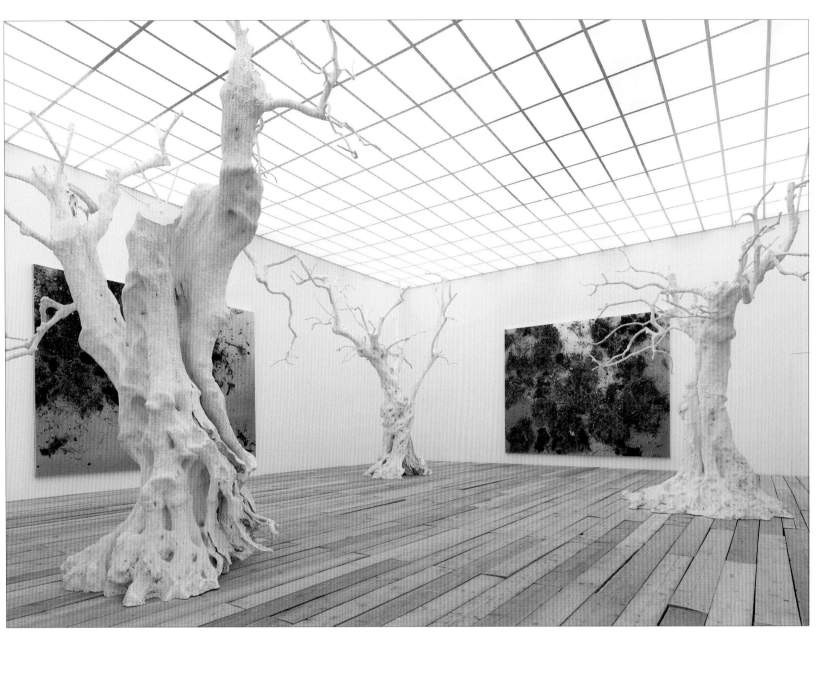

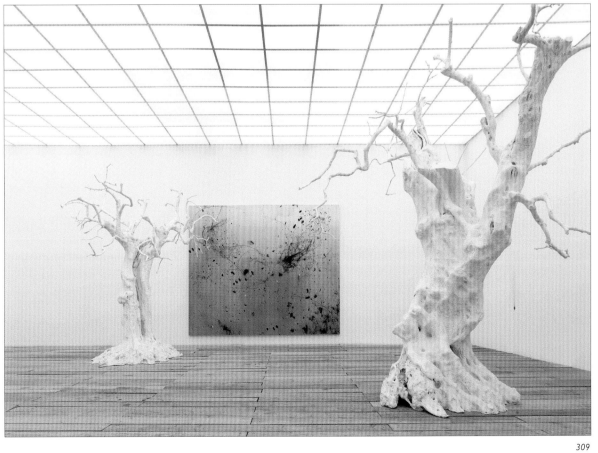

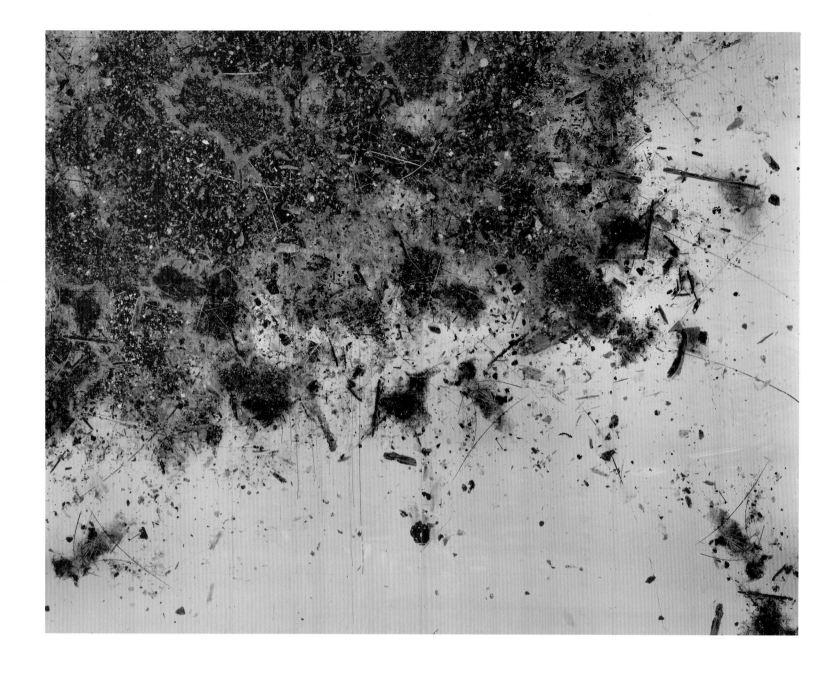

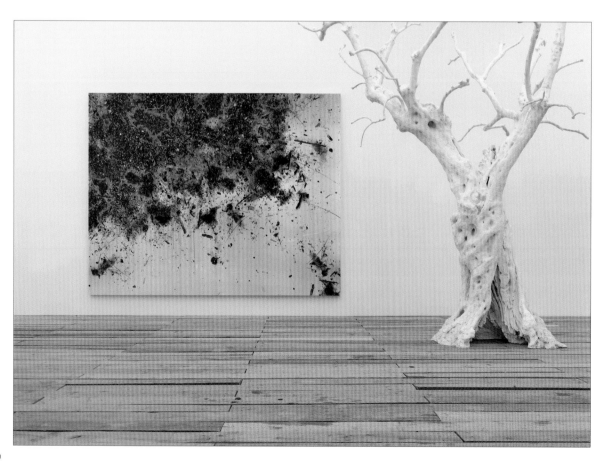

Untitled
2007
Aluminum, transparent primer, vinyl paint,
pigments, silicone, screws
Panel 1 of 3
Panel 1: 336 x 450 x 8 cm; 132 ⅛ x 177 x 3 ⅛ in.
Panel 2: 343 x 445 x 8 cm; 135 x 175 x 3 ⅛ in.
Panel 3: 361 x 465 x 8 cm; 142 x 183 x 3 ⅛ in.

Untitled
2007
Aluminum, transparent primer, vinyl paint, pigments,
silicone, screws
Panel 2 of 3
Panel 1: 336 x 450 x 8 cm; 132 ⅛ x 177 x 3 ⅛ in.
Panel 2: 343 x 445 x 8 cm; 135 x 175 x 3 ⅛ in.
Panel 3: 361 x 465 x 8 cm; 142 x 183 x 3 ⅛ in.

Installation view, "get up girl a sun is running the world"
(with Ugo Rondinone), Church San Stae, Venice
Biennale, 2007
On wall: *Untitled*, 2007
Left to right: Ugo Rondinone, *get up girl a sun is running
the world*, 2006

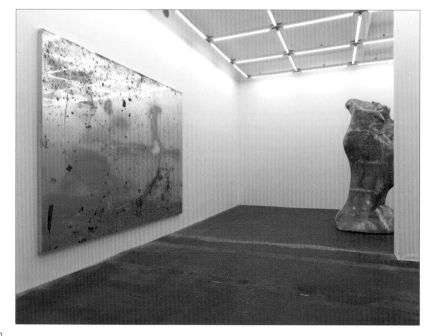

Blurry Hesse
2008
Aluminum, transparent primer, vinyl paint,
pigments, spray enamel, silicone, screws
275 x 355 x 8 cm; 108 ¼ x 139 ¾ x 3 ⅛ in.

Installation view, "Blurry Renoir Debussy,"
Galerie Eva Presenhuber, Zurich, 2008
Blurry Hesse, 2008; *Ix*, 2006–08

Opposite page:
Blurry Renoir
2008
Aluminum, transparent primer, vinyl paint,
pigments, spray enamel, silicone, screws
284 x 363 x 8 cm; 111 ¾ x 142 ⅞ x 3 ⅛ in.

Blurry Debussy
2008
Aluminum, transparent primer, vinyl paint,
pigments, spray enamel, silicone, screws
275 x 351 x 8 cm; 108 ¼ x 138 ¼ x 3 ⅛ in.

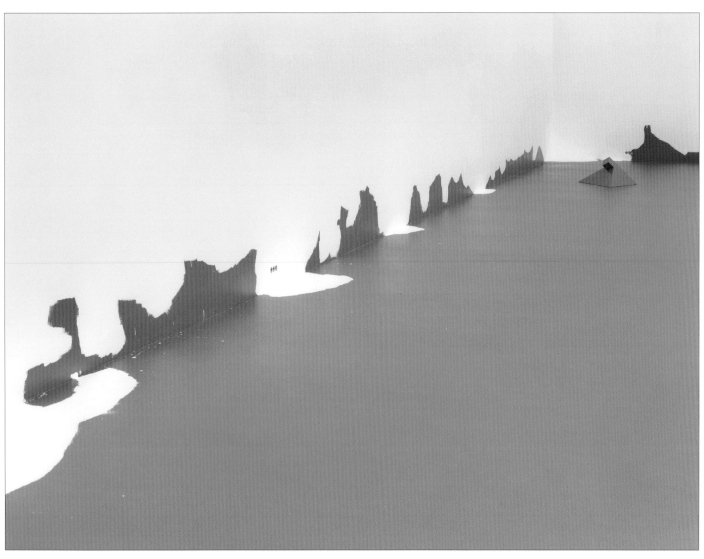

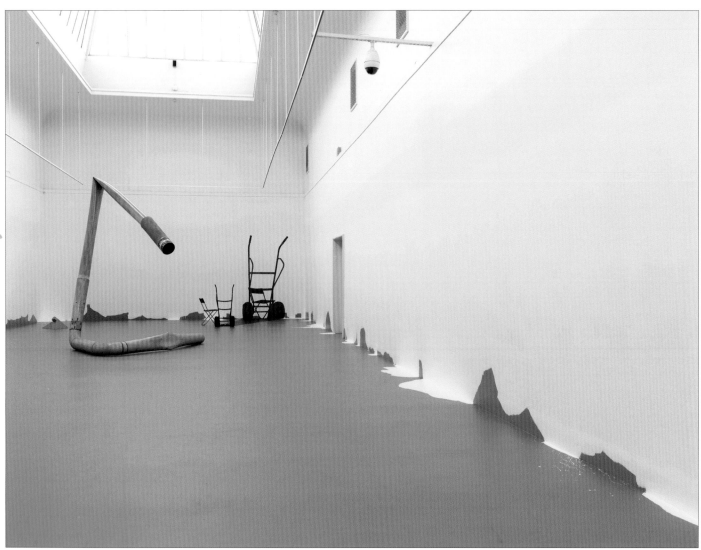

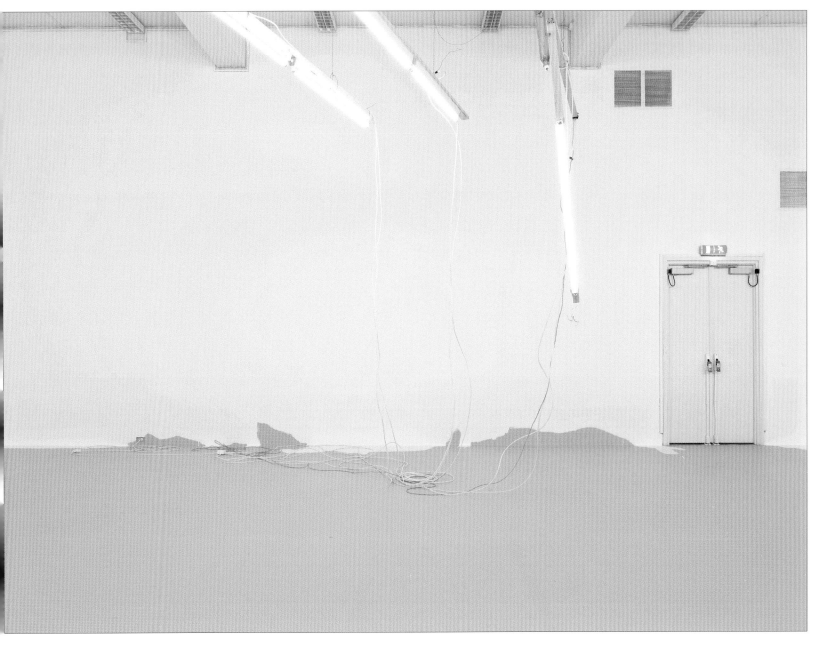

Barfood with Erich Muehsam / Langweile mit Richard Wagner
2006–2009
Colored adhesive vinyl, latex paint
Dimensions variable
Installation view, "Dear _____! We _____ on _____,
hysterically. It has to be _____ that _____. No? It is now _____ and
the whole _____ has changed _____. all the _____, _____" (with
Mark Handforth and Georg Herold), Kunstnernes Hus, Oslo, 2009
On ceiling: Georg Herold, *Poetry Electrique*, 2009

Installation view, "Dear _____! We _____ on
_____, hysterically. It has to be _____ that _____. No?
It is now _____ and the whole _____ has changed
_____. all the _____, _____" (with Mark Handforth and
Georg Herold), Kunstnernes Hus, Oslo, 2009
Barfood with Erich Muehsam / Langweile mit Richard Wagner,
2006–2009
In corner: Georg Herold, *Event*, 2009

Installation view, "Dear _____! We _____ on
_____, hysterically. It has to be _____ that _____. No?
It is now _____ and the whole _____ has changed
_____. all the _____, _____" (with Mark Handforth and
Georg Herold), Kunstnernes Hus, Oslo, 2009
Barfood with Erich Muehsam / Langweile mit Richard Wagner,
2006–2009; *Untitled*, 2009
On left: Mark Handforth, *Mr. Maccarone*, 2008

Barfood with Erich Muehsam / Langweile mit Richard Wagner
2006–2009
Colored adhesive vinyl, latex paint
Dimensions variable
Installation view, "Dear _____! We _____ on _____,
hysterically. It has to be _____ that _____. No? It is now _____ and
the whole _____ has changed _____. all the _____, _____" (with
Mark Handforth and Georg Herold), Kunstnernes Hus, Oslo, 2009

Installation view, "Dear _____! We _____ on
_____, hysterically. It has to be _____ that _____. No?
It is now _____ and the whole _____ has changed
_____. all the _____, _____" (with Mark Handforth and
Georg Herold), Kunstnernes Hus, Oslo, 2009
Barfood with Erich Muehsam / Langweile mit Richard Wagner,
2006–2009
On wall: Georg Herold, *L'après-midi d'un faune*, 2009

Installation view, "Dear _____! We _____ on
_____, hysterically. It has to be _____ that _____. No?
It is now _____ and the whole _____ has changed
_____. all the _____, _____" (with Mark Handforth and
Georg Herold), Kunstnernes Hus, Oslo, 2009
Barfood with Erich Muehsam / Langweile mit Richard Wagner,
2006–2009; *Kratz*, 2009

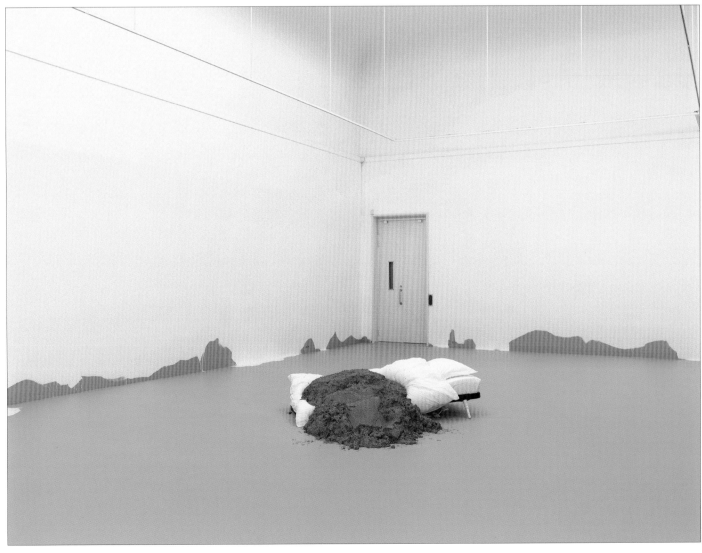

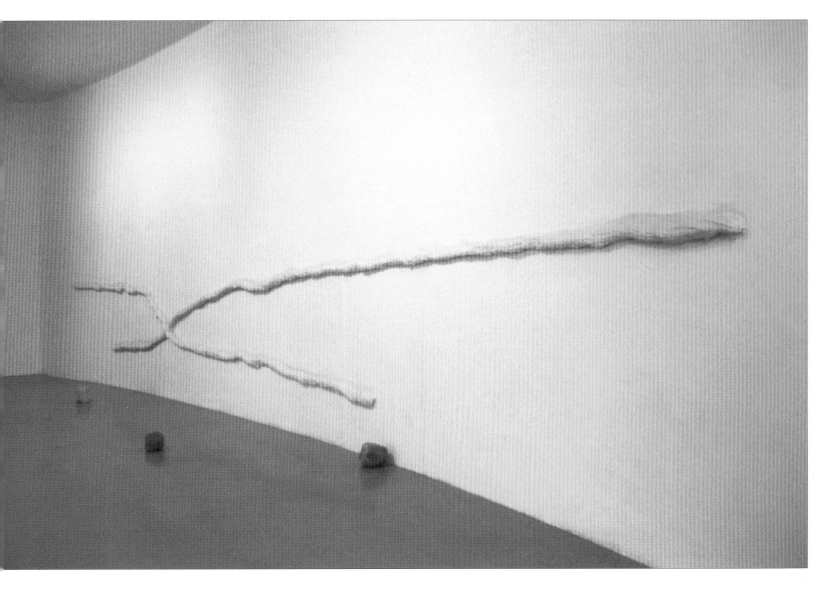

Wandnarbe (Wall Scar)
1996
Plaster, newspaper, wire, latex paint
Dimensions variable
Installation view, "Frs Uischer,"
Galerie Walcheturm, Zurich, 1996
Untitled (50 Rocks), 1996; *Hormonparty*, 1996

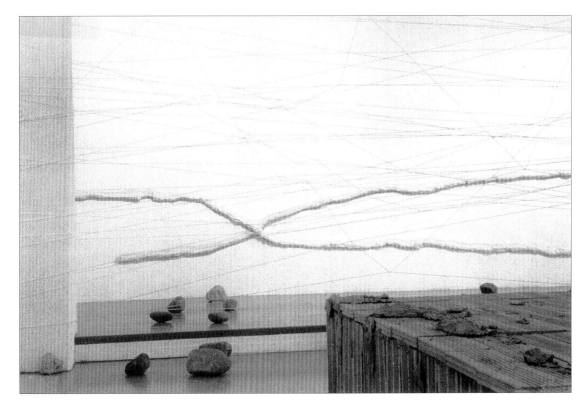

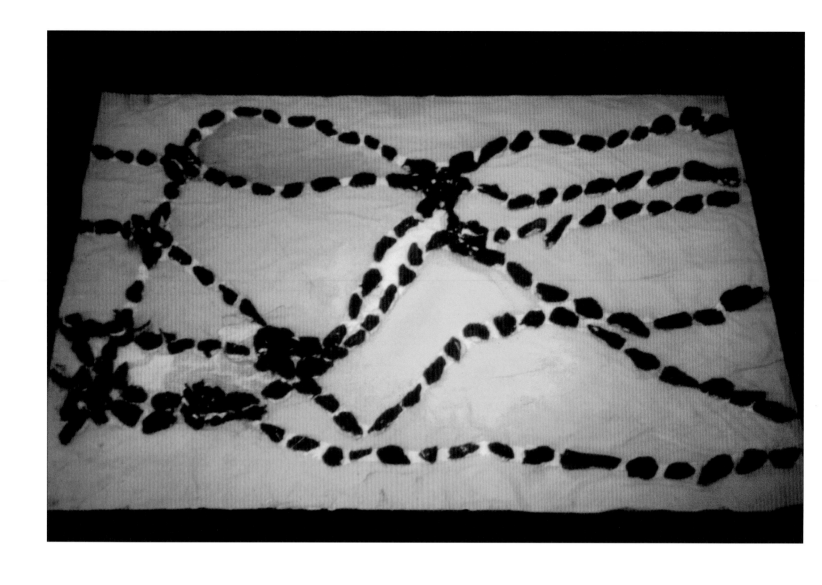

Untitled
1997
Bark, caulk, latex paint, and acrylic paint on paper
Dimensions unknown

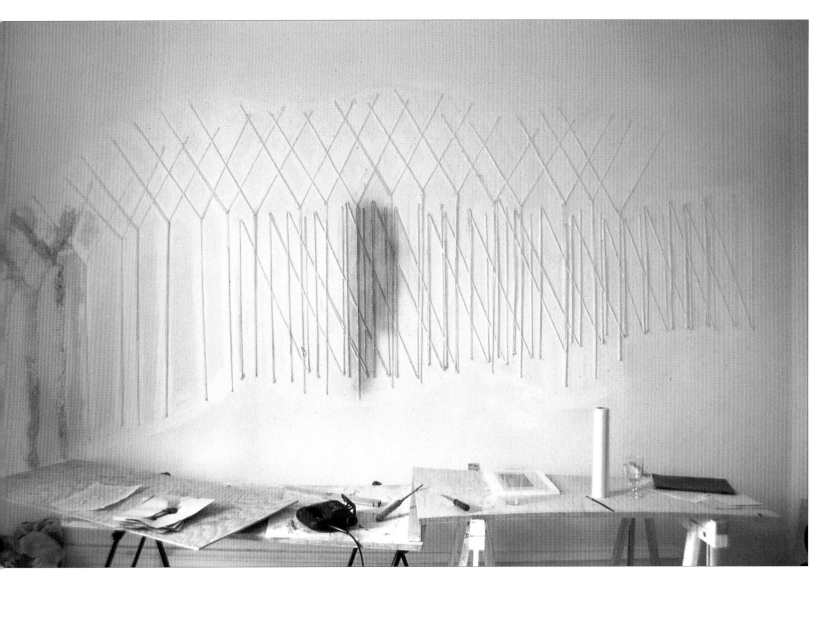

Study for *Yes / No Crossfade*
Studio view, Schweizergasse, Zurich, 1996

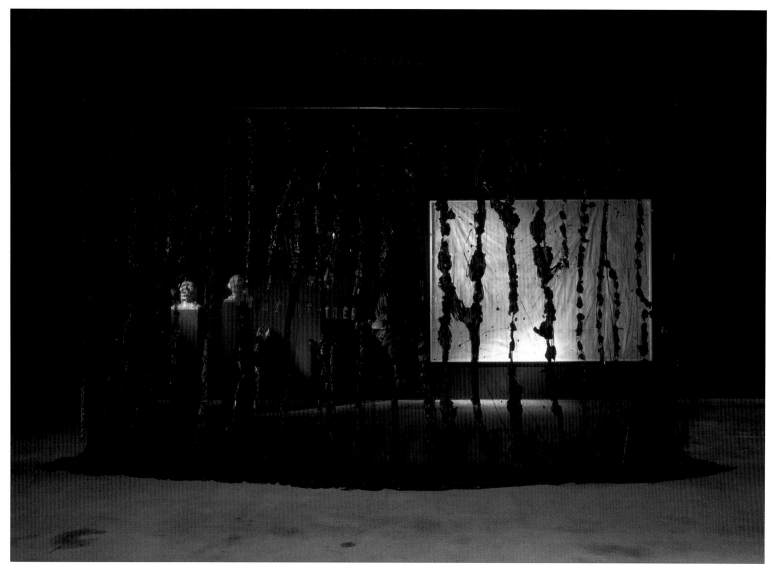

Stormy Weather
1999
Bark, acrylic paint, tulle, chains, aluminum tube, plastic letters, wood, wood glue
Curtain: 600 x 400 cm; 236 ¼ x 157 ½ in.
Stool: 55 x 48 cm; 21 ⅝ x 18 ⅞ in.
Installation view, "Espressoqueen—Worries and other stuff you have to think about before you get ready for the big easy," Galerie Hauser & Wirth & Presenhuber, Zurich, 1999
Background, left to right: *Köpfe (Heads)*, 1997–1999; *Schwerelosigkeit*; 1998–1999

Remembering the Polyester Pirate (Instant Apathy)
2000
Tulle, rocks, lacquer, acrylic paint, chain, aluminum pipe, wood, wood glue
Curtain: 400 x 400 cm; 157 ½ x 157 ½ in.
Bench: 80 x 200 x 50 cm; 31 ½ x 78 ¾ x 19 ⅝ in.
Installation view, "Without a Fist—Like a Bird," Institute of Contemporary Arts, London, 2000
Background: *Poem-Donkey (Unfiltered Autumn 99 Poem)*, 2000

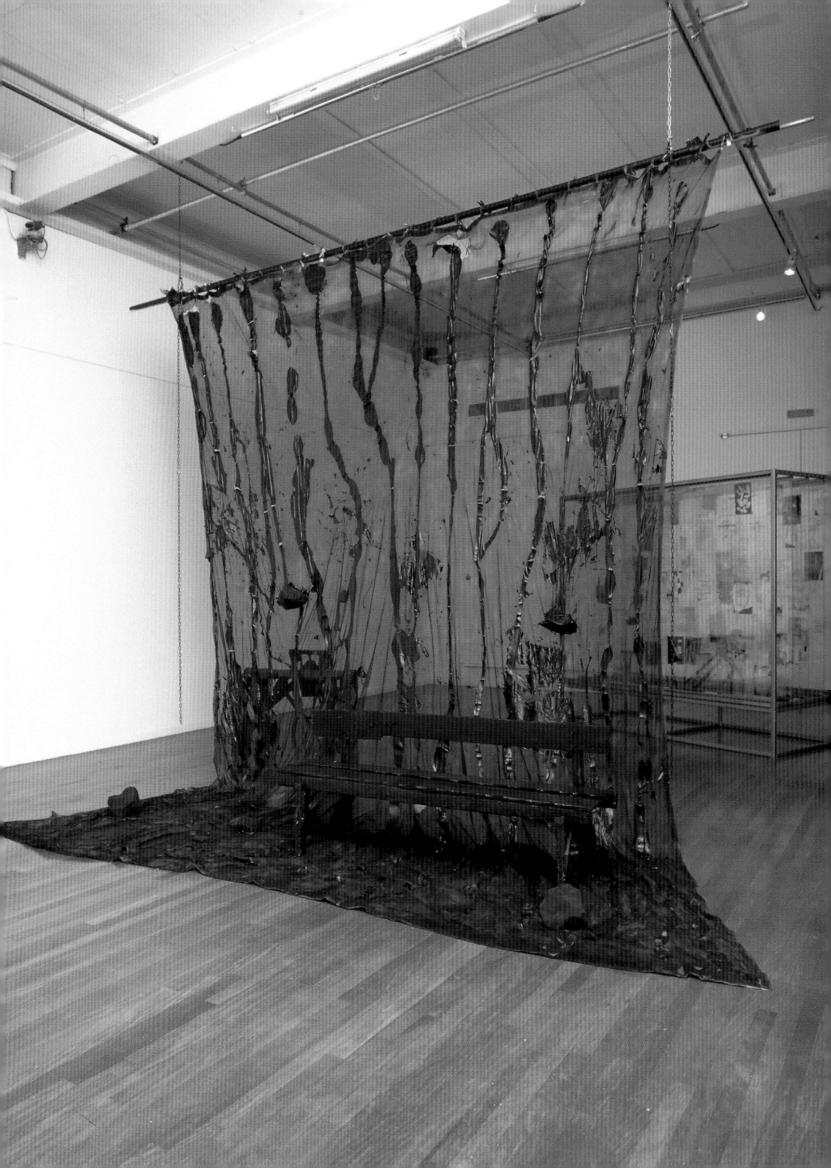

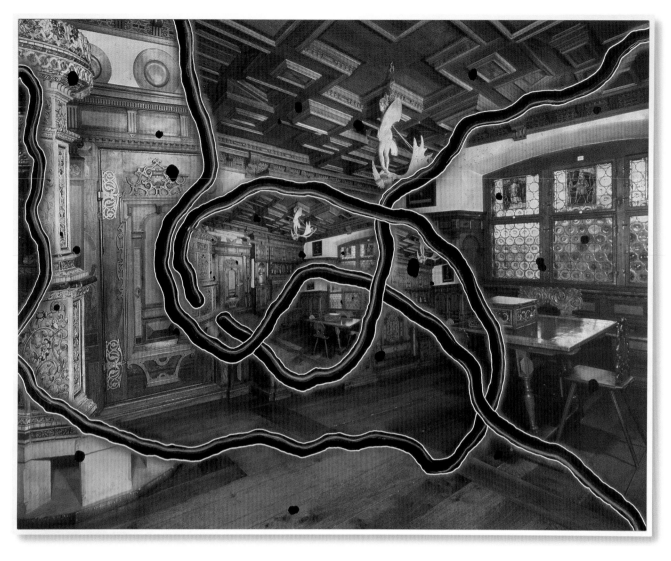

Dead Pigeon on Beethoven Street
2005
Aluminum, ACM panels, UV inkjet print, acrylic paint,
marker, UV-protective lacquer
208 x 273 x 6 cm; 81 ⅞ x 107 ½ x 2 ⅜ in.

A Shovel and a Hole
2005
Aluminum, ACM panels, UV inkjet print, latex paint,
acrylic paint, marker, UV-protective lacquer
208 x 273 x 6 cm; 81 ⅞ x 107 ½ x 2 ⅜ in.

A Novel and Its Novelist
2005
Aluminum, ACM panels, gesso, UV inkjet print, latex
paint, acrylic paint, marker, UV-protective lacquer
208 x 273 x 6 cm; 81 ⅞ x 107 ½ x 2 ⅜ in.

Spinoza Rhapsody
2006
Epoxy resin, pigment, enamel paint, wire, aluminum
Approx. 340 x 905 1360 cm; 133 ⅞ x 356 ¼ x 535 ⅜ in.
Installation view, "The Vincent Award 2006," Stedelijk
Museum, Amsterdam, 2006

Mackintosh Staccato
2006
Epoxy resin, pigment, enamel paint, wire, aluminum
Approx. 250 x 904 x 248 cm; 98 ⅜ x 355 ⅞ x 97 ⅝ in.
Installation view, "Oh. Sad. I see.," The Modern Institute,
Glasgow, 2006
Cup / Cigarettes / Skid, 2006; *Oh, Sad, I See*, 2006

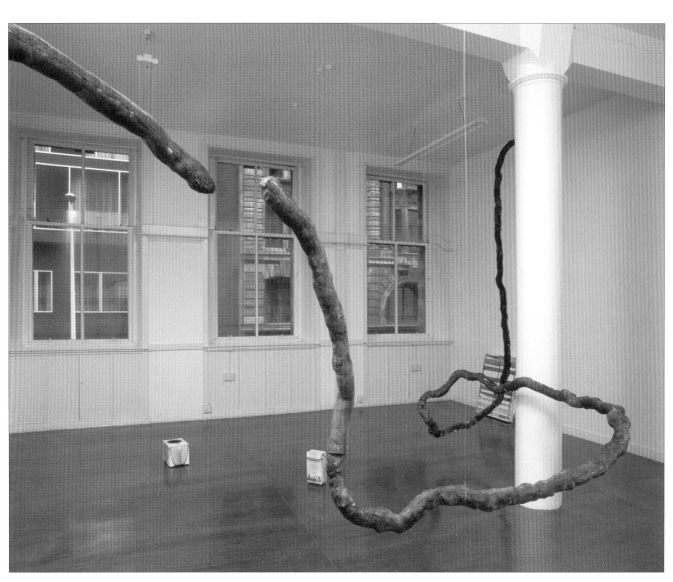

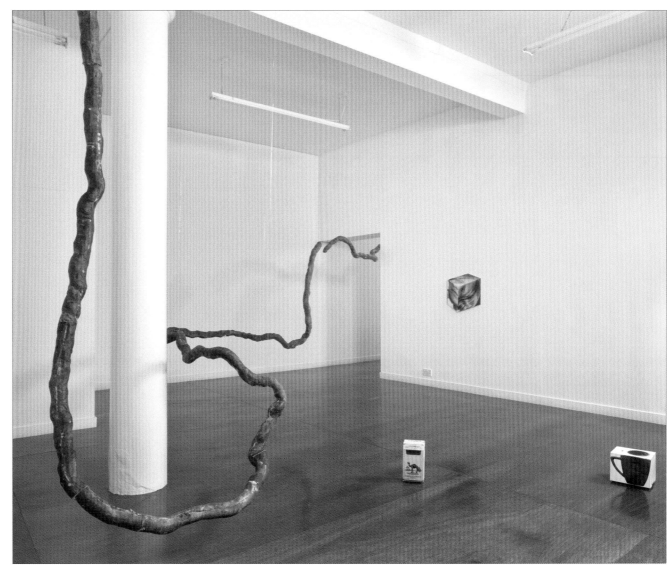

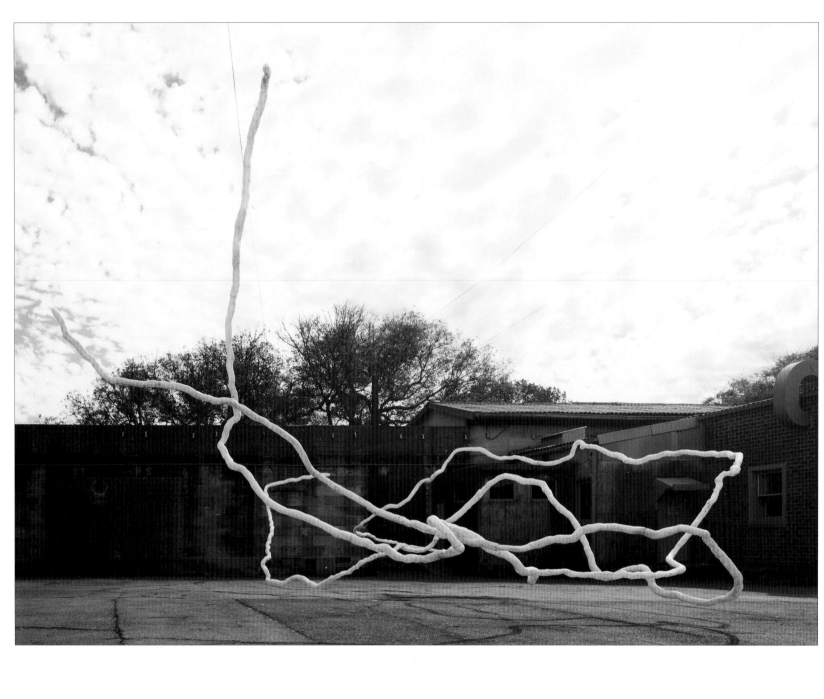

abyss / debauched oratorio / roadshow / abyss
2007
Epoxy resin, pigment, enamel paint, wire, aluminum
Approx. 416 x 1090 x 795 cm; 163 ¼ x 429 ⅛ x 313 in.
Installation view, Cockatoo Island, Kaldor Art Projects and
the Sydney Harbour Federation Trust, Sydney, 2007

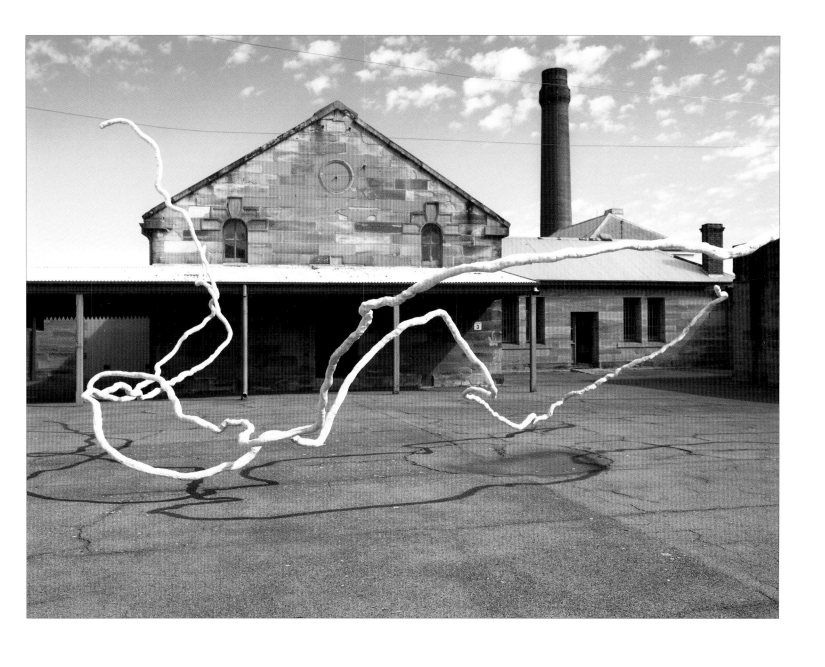

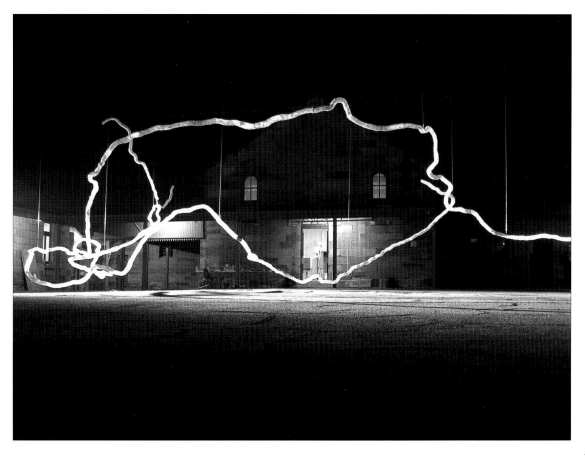

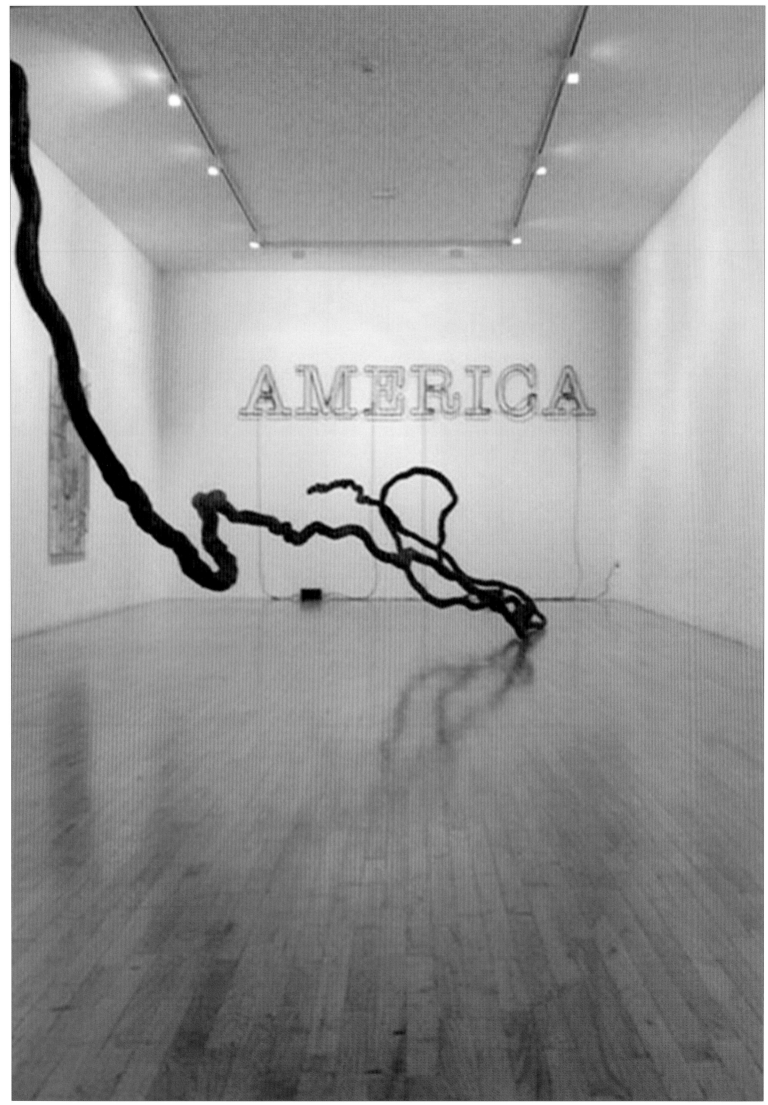

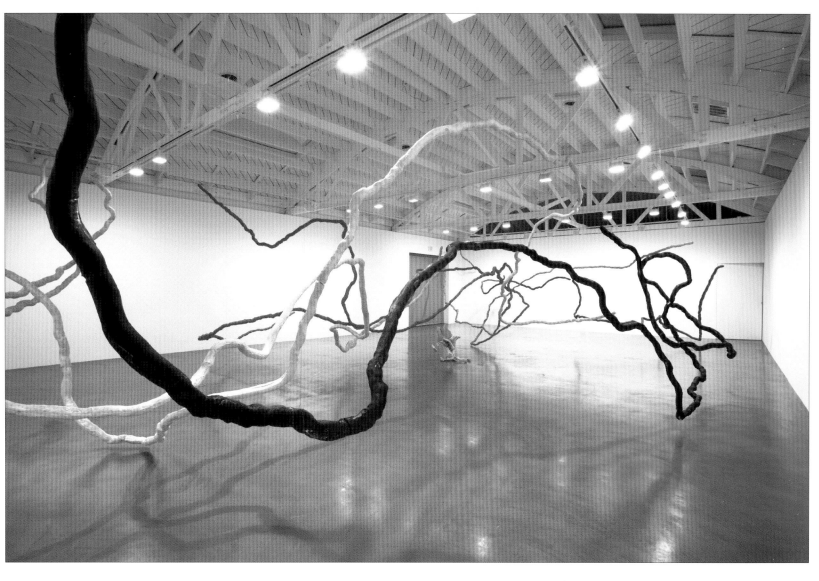

Installation view, "Agnes Martin," Regen Projects, Los Angeles, 2007
Foreground to background: *Cioran Handrail*, 2006; *abyss / debauched oratorio / roadshow / abyss*; 2007; *Spinoza Rhapsody*, 2006; *Mackintosh Staccato*, 2006
Center: *To be titled (Y-Chair)*, 2007

Cioran Handrail
2006
Epoxy resin, pigment, enamel paint, wire, aluminum
Approx. 350 x 860 x 125 cm; 137 ¼ x 338 ⅝ x 49 ¼ in.
Installation view, "Defamation of Character," P.S.1.
Contemporary Art Center, New York, 2006
On back wall: Glenn Ligon, *Untitled*, 2005

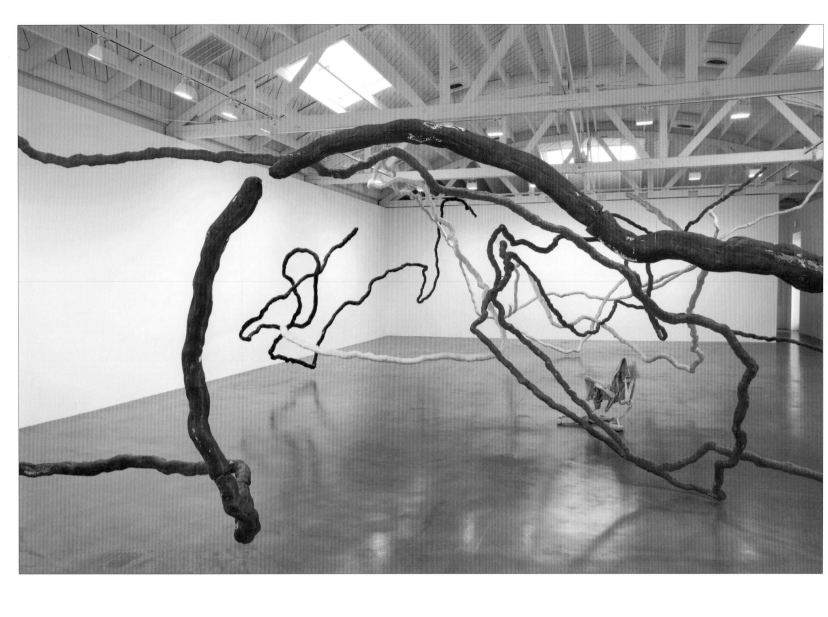

This page and opposite:

Installation view, "Agnes Martin," Regen Projects, Los
Angeles, 2007
Foreground to background: *Mackintosh Staccato*, 2006;
Spinoza Rhapsody, 2006; *abyss / debauched oratorio / roadshow
/ abyss*; 2007; *Cioran Handrail*, 2006
Center: *To be titled (Y-Chair)*, 2007

Page 334:

Spinoza Rhapsody
2006
Epoxy resin, pigment, enamel paint, wire, aluminum
Approx. 340 x 905 x 1360 cm; 133 ⅞ x 356 ¼ x 535 ⅛ in.
Installation view, "A Guest + A Host = A Ghost: Works
from the Dakis Joannou Collection," Deste Foundation
Centre for Contemporary Art, Athens, 2009
Background: *Thank You Fuck You*, 2007; *Death of a Moment*,
2007

Installation view, "A Guest + A Host = A Ghost: Works
from the Dakis Joannou Collection," Deste Foundation
Centre for Contemporary Art, Athens, 2009
Left to right: *Spinoza Rhapsody*, 2006; *Cioran Handrail*,
2006; *A Place Called Novosibirsk*, 2004; *The Lock*, 2006

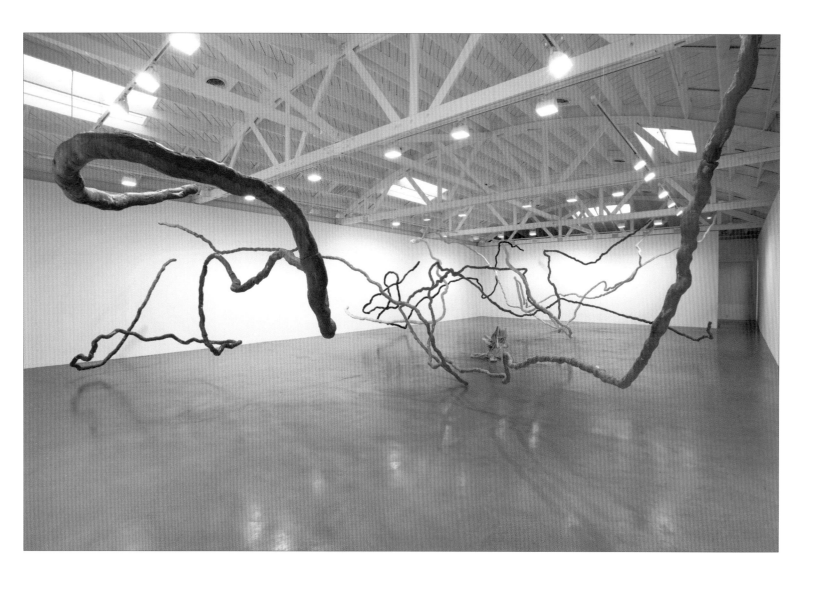

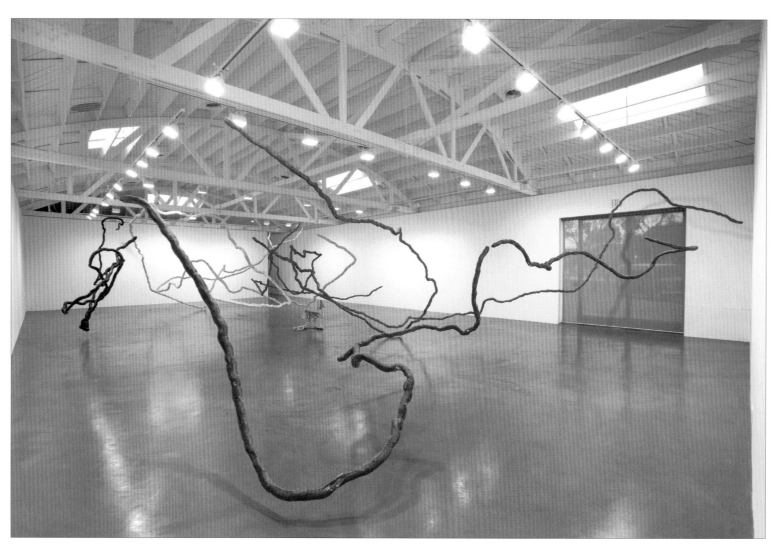

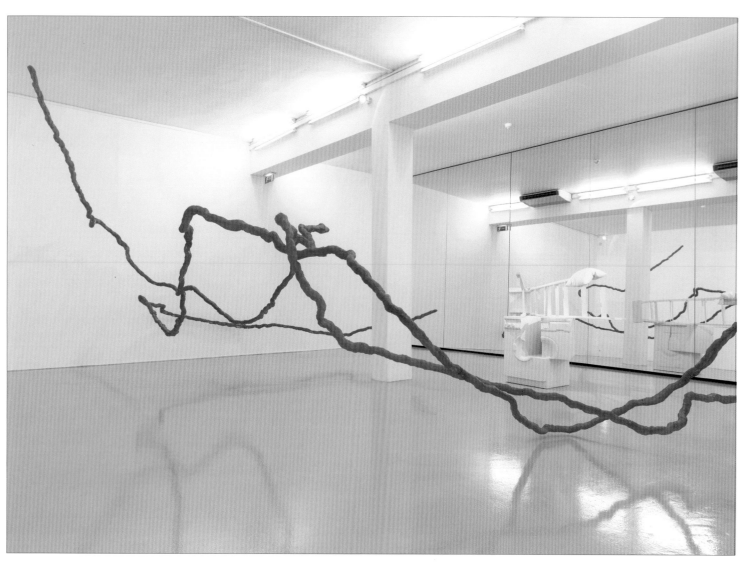

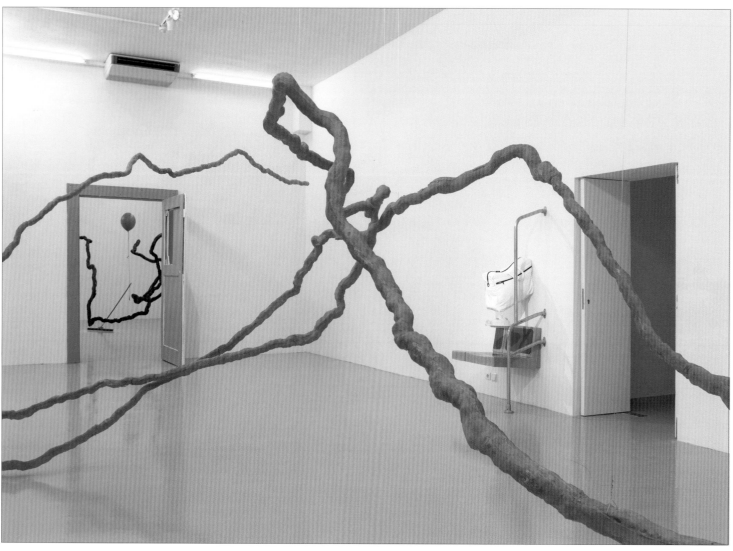

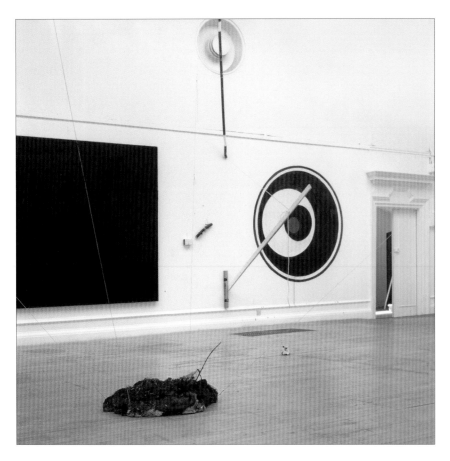
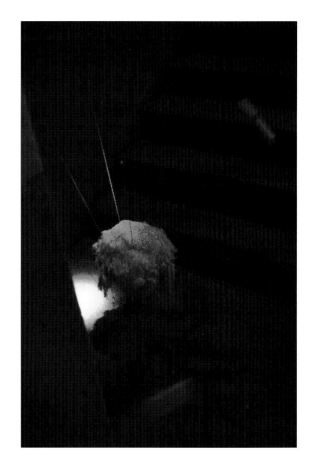
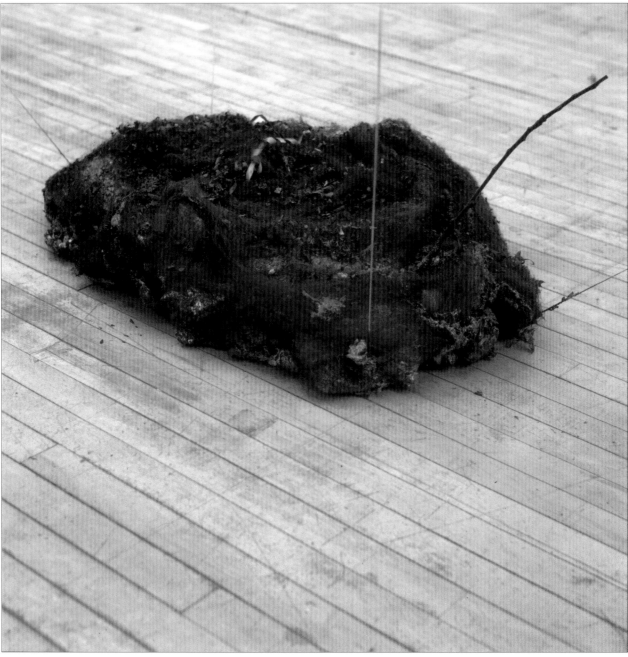

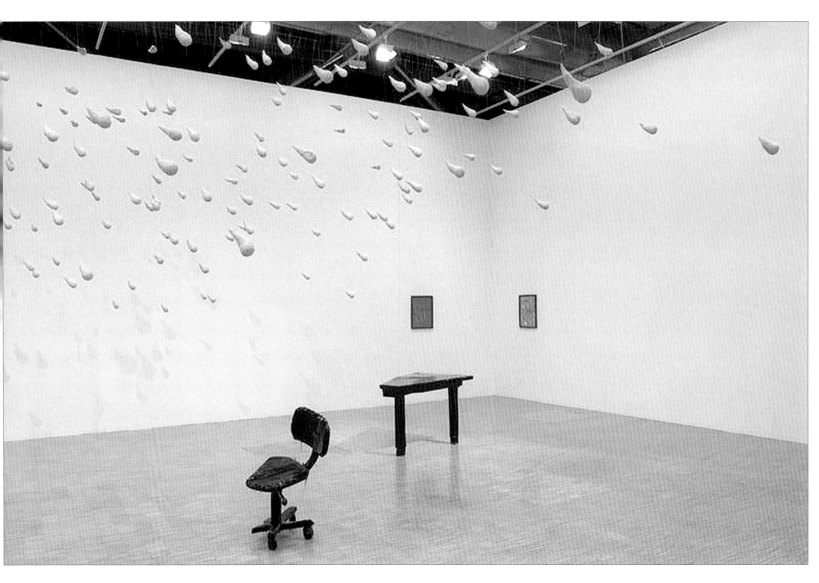

Opposite page, top left:

Untitled
1995
Sculpture can be lifted when viewers pull on levers
Concrete, wood, expanding foam, steel wool,
metallic car paint, string, levers
Dimensions unknown
Installation view, "Karaoke 444&222 too,"
South London Gallery, London, 1995
On wall: Twin Gabriel, *Anti-Climb Painting*, 1994

Opposite page, top right:

Untitled
1995
Cotton fibers, string, polyurethane foam, wood
Dimensions unknown

Detail of *Untitled*
Installation view, "Karaoke 444&222 too,"
South London Gallery, London, 1995

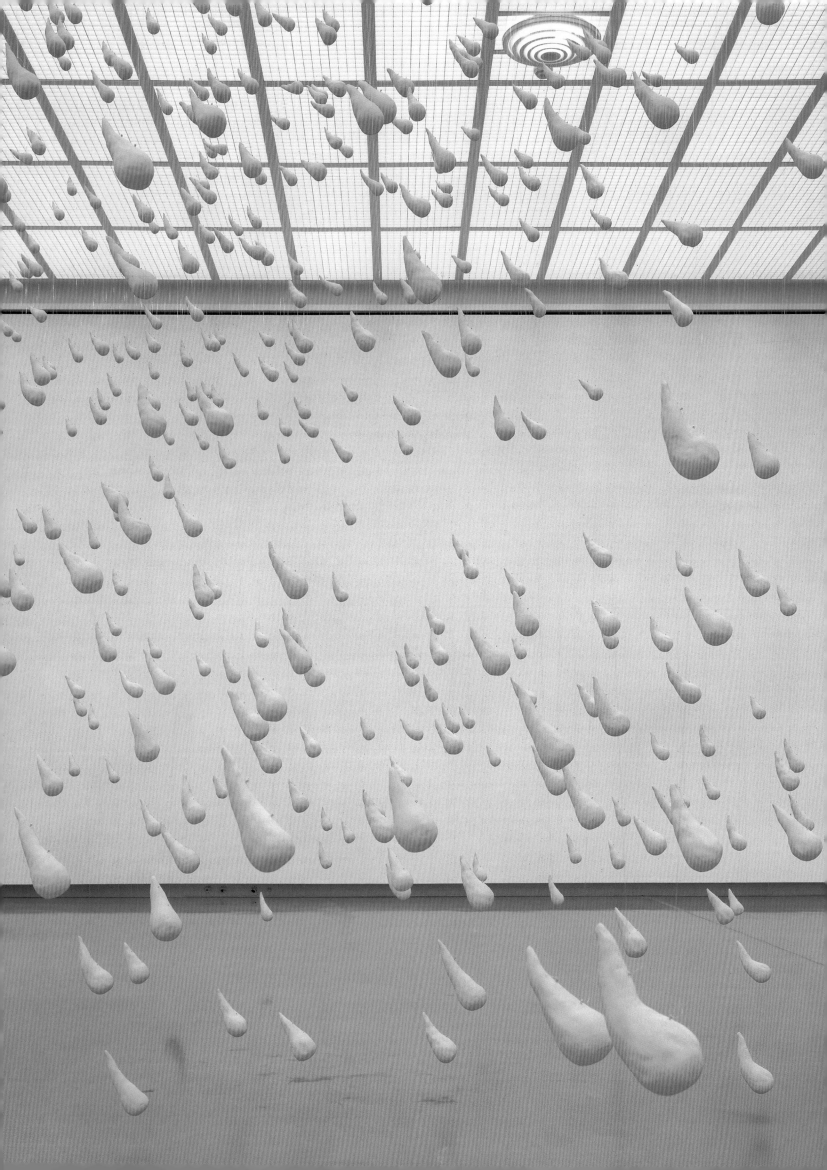

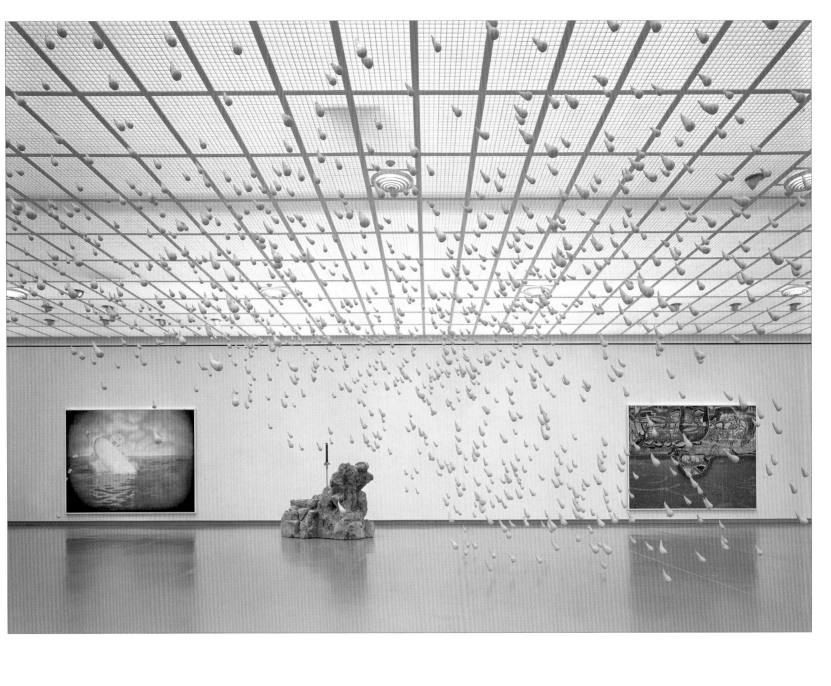

Horses Dream of Horses
2004
Plaster, resin paint, steel, nylon filament
Dimensions variable: 1,500 raindrops, each
up to 17 x 7 x 7 cm; 6 ¼ x 2 ¾ x 2 ¾ in.
Installation view, "Kir Royal," Kunsthaus
Zürich, 2004
Left to right: *Stalagmites of Love*, 2004;
Untitled, 2004; *Birds Sing, Rain Falls*, 2004

Installation view, "Kir Royal," Kunsthaus
Zürich, 2004
Left to right: *Horses Dream of Horses*, 2004;
Middleclass Heroes, 2004; Prototype of *Bad
Timing, Lamb Chop!*, 2004; *Sodbrennen*,
2000–2004; *What if the Phone Rings*, 2003;
She Called Her "Taxi," 2004

Opposite page:

Installation view, "Kir Royal," Kunsthaus
Zürich, 2004
Horses Dream of Horses, 2004

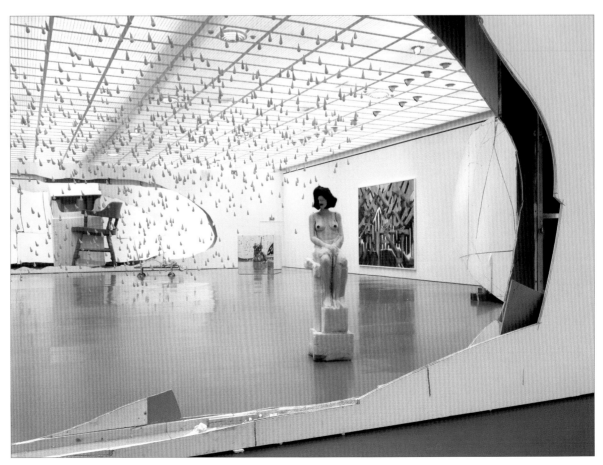

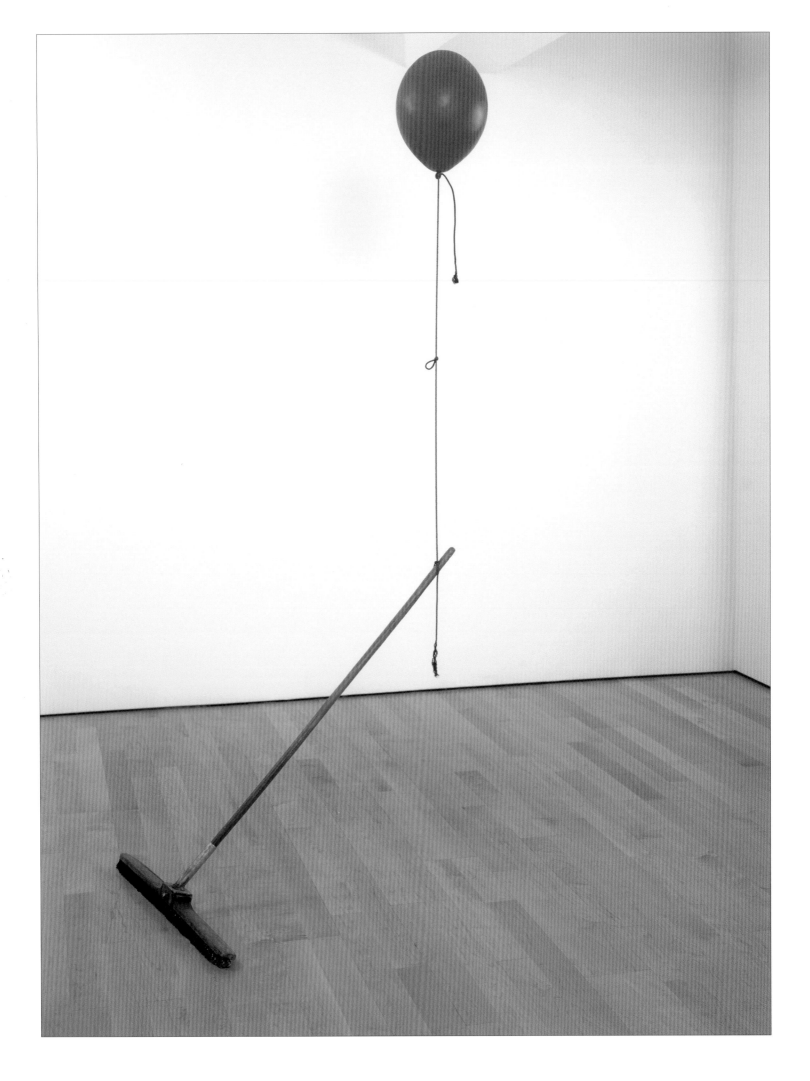

A Place Called Novosibirsk
2004
Cast aluminum, epoxy resin, iron rod, string, acrylic paint
249 x 77.5 x 105 cm; 98 x 30 ½ x 41 ⅜ in.

A Thing Called Gearbox
2004
Cast aluminum, copper, iron rod, string, acrylic paint
231 x 68 x 67.5 cm; 91 x 26 ¾ x 26 ½ in.

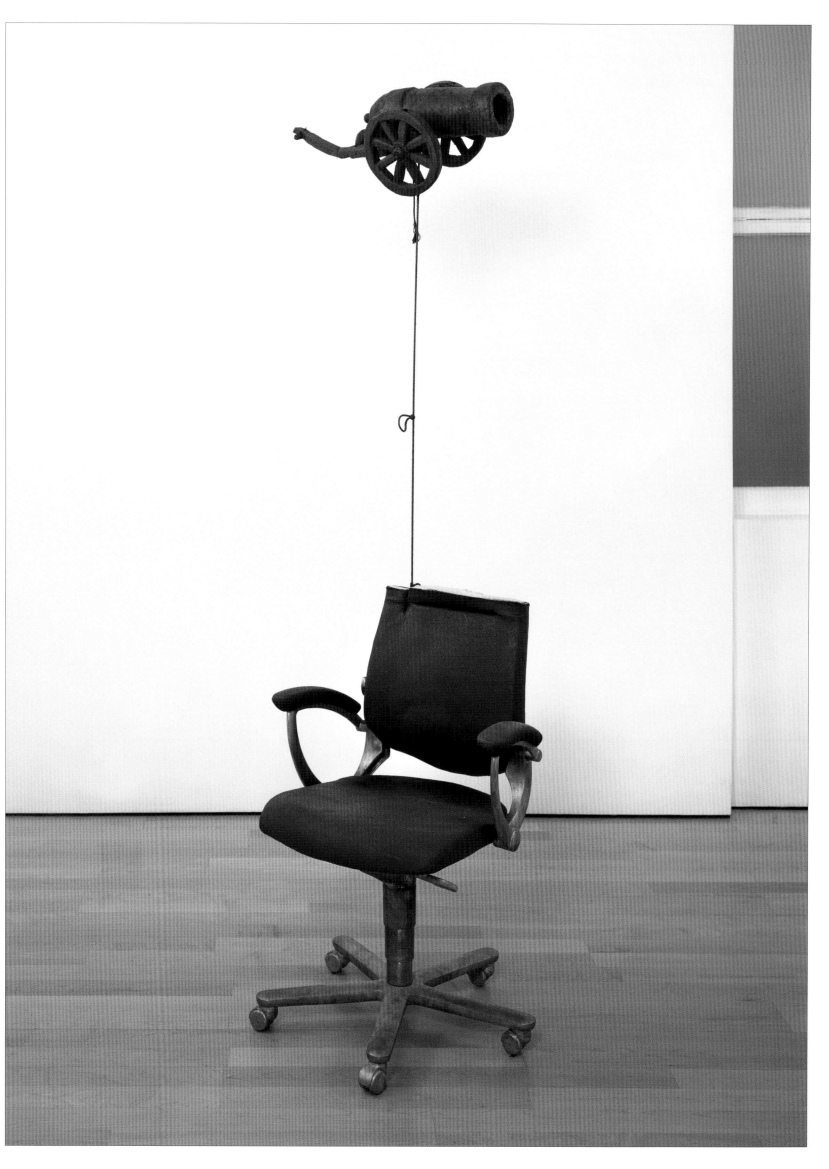

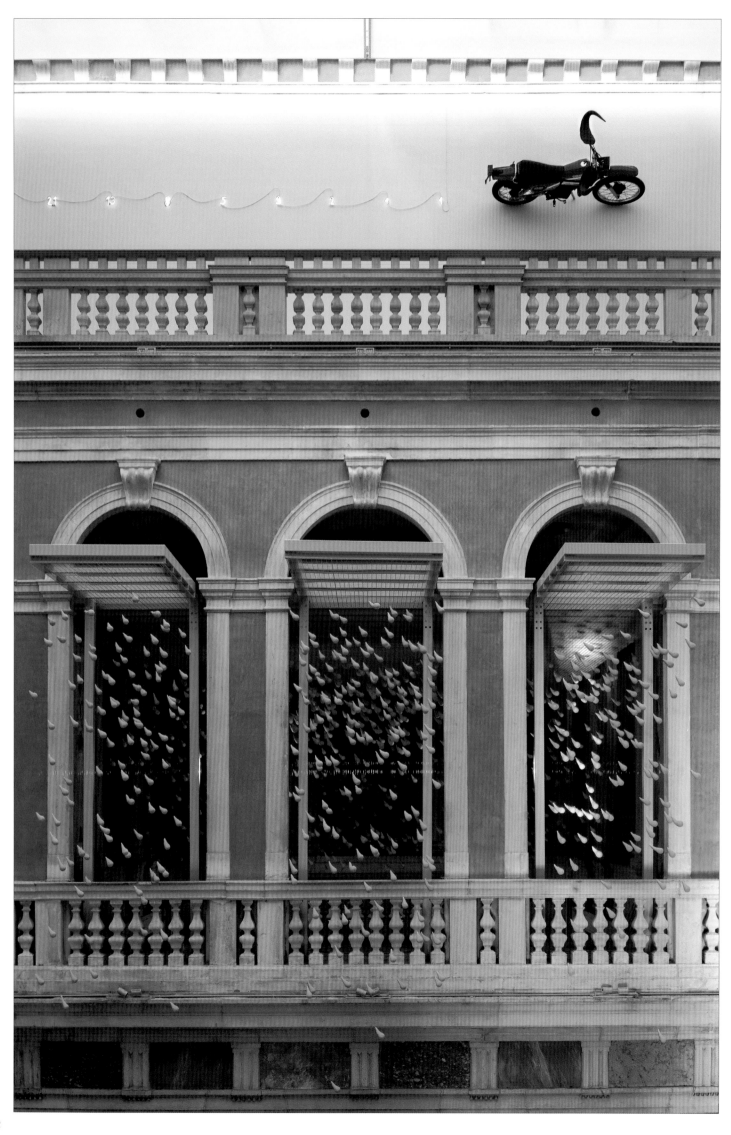

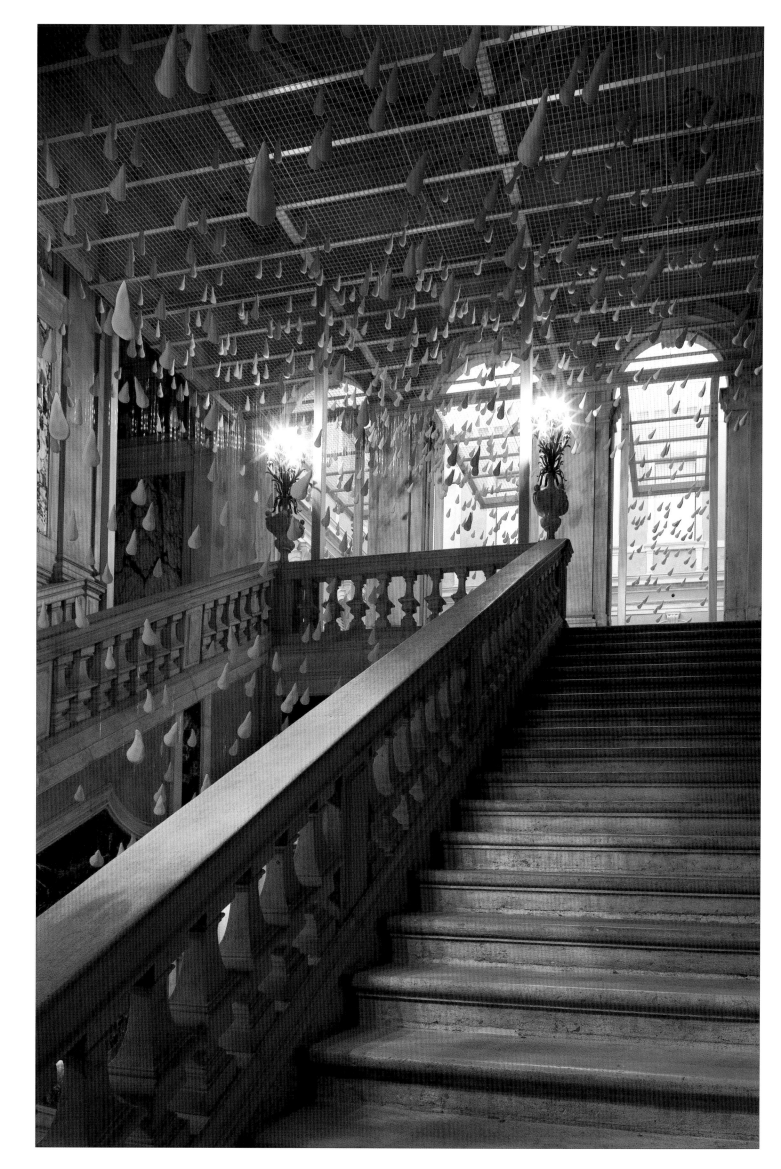

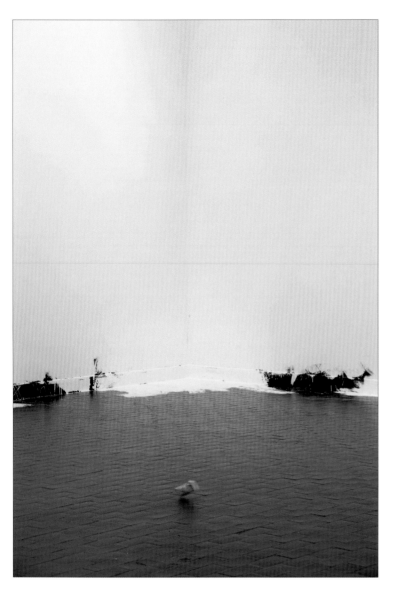
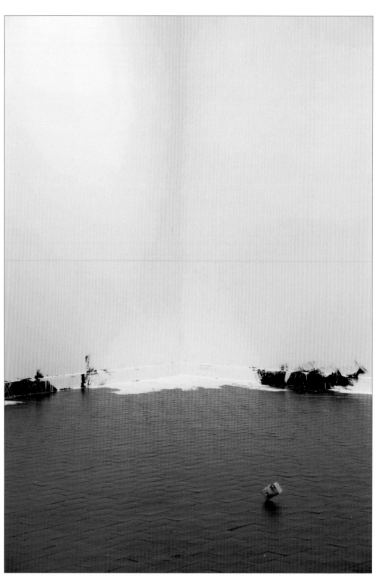
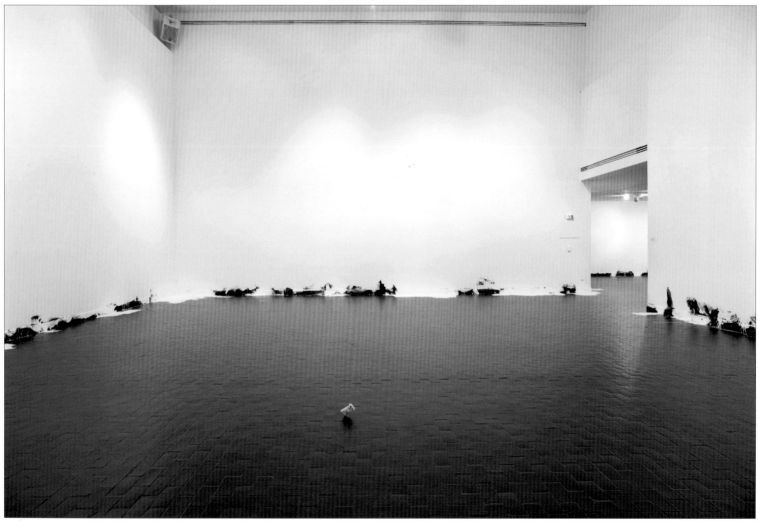

Nach Jugendstiel kam Roccoko
2006
Empty cigarette pack moves erratically along floor,
occasionally flying up into the air
Electric motor, wire, carbon rod, elastic band, nylon filament,
empty cigarette pack, control unit
Installation radius 400 cm; 157 ½ in.; height variable
Installation view, "Mary Poppins," Blaffer Gallery, The Art
Museum of the University of Houston, Texas, 2006
Untitled (Floor Piece), 2006

Pages 342–343:
Vintage Violence
2004–2005
Plaster, resin paint, steel, nylon filament
Dimensions variable: 1,700 raindrops, each up to 19 x 9 x 8
cm; 7 ½ x 3 ½ x 3 ⅛ in.
Installation view, "Where Are We Going? Selections from the
François Pinault Collection," Palazzo Grassi, Venice, 2006
At top: Mario Merz, *Accelerazione = sogno, tubi di Fibonacci al
neon e motocicletta fantasma*, 1972–1986

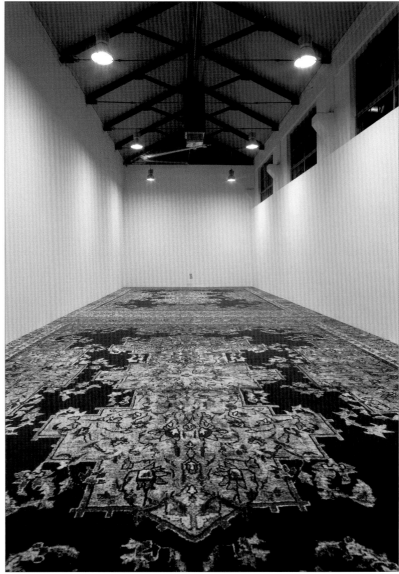

Installation view, "Urs Fischer e Rudolf Stingel,"
Galleria Massimo de Carlo, Milan, 2006–07
Nach Jugendstiel kam Roccoko, 2006
On floor: Rudolf Stingel, *Untitled (Sarouk)*, 2006

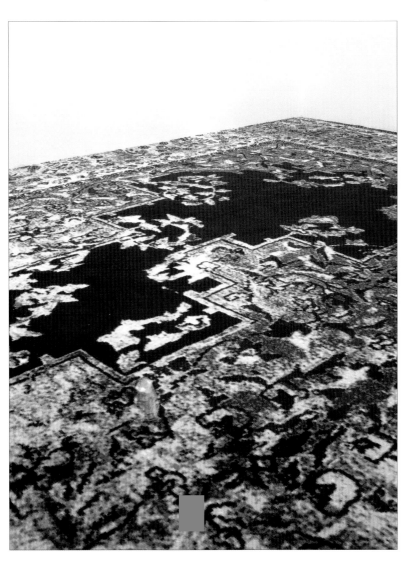

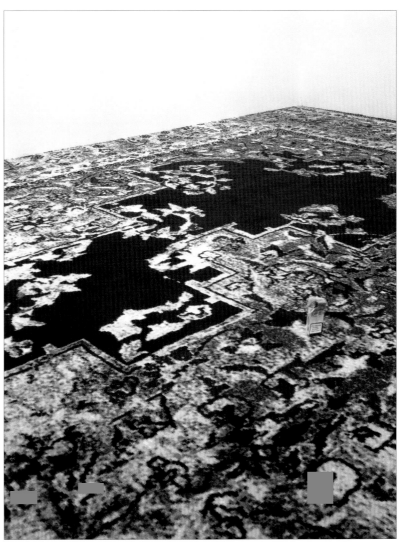

Nach Jugendstiel kam Roccoko
2006
Empty cigarette pack moves erratically along floor,
occasionally flying up into the air
Electric motor, wire, carbon rod, elastic band, thread, empty
cigarette pack, control unit
Installation radius 400 cm; 157 ½ in.; height variable
Installation view, "Sequence 1: Painting and Sculpture in the
François Pinault Collection," Palazzo Grassi, Venice, 2007
On wall: École Bourguignonne, *Philippe Pot priant la Vierge
et l'Enfant*, c. 1480

École Bourguignonne
Philippe Perpet et la Vierge et l'Enfant, XVIe siècle

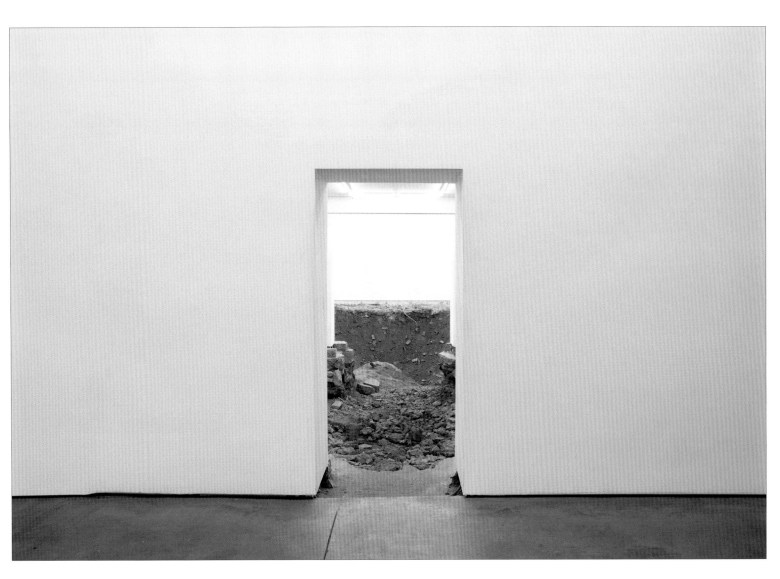

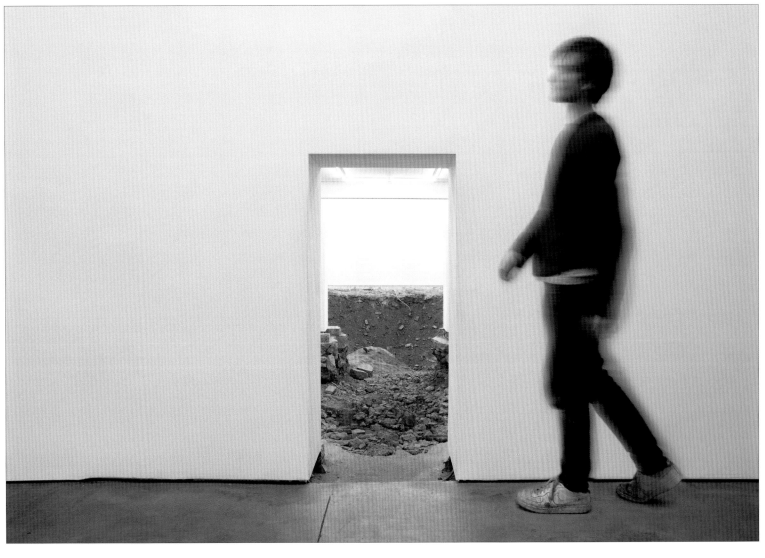

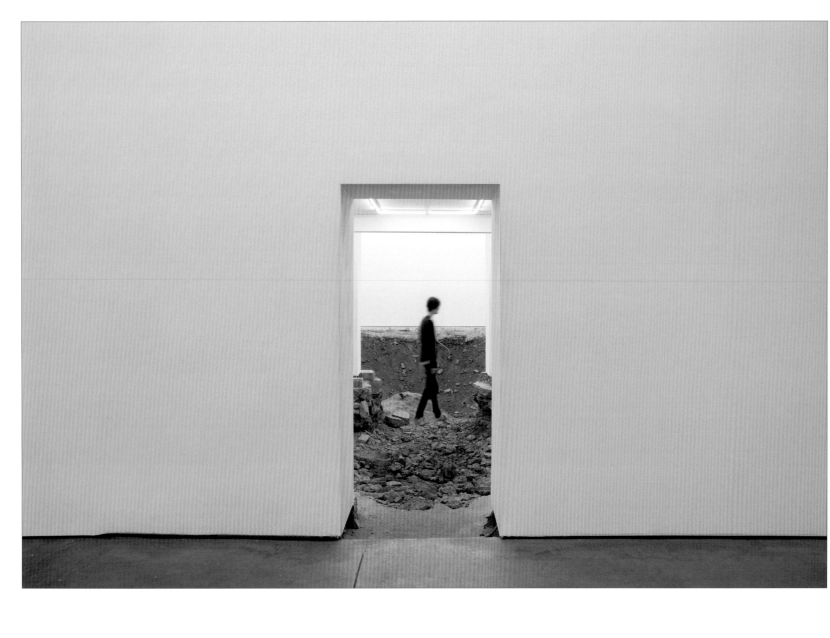

You
2007
Excavation, gallery space, 1:3 scale replica of gallery space
Dimensions variable
Installation view, "you," Gavin Brown's enterprise, New York, 2007

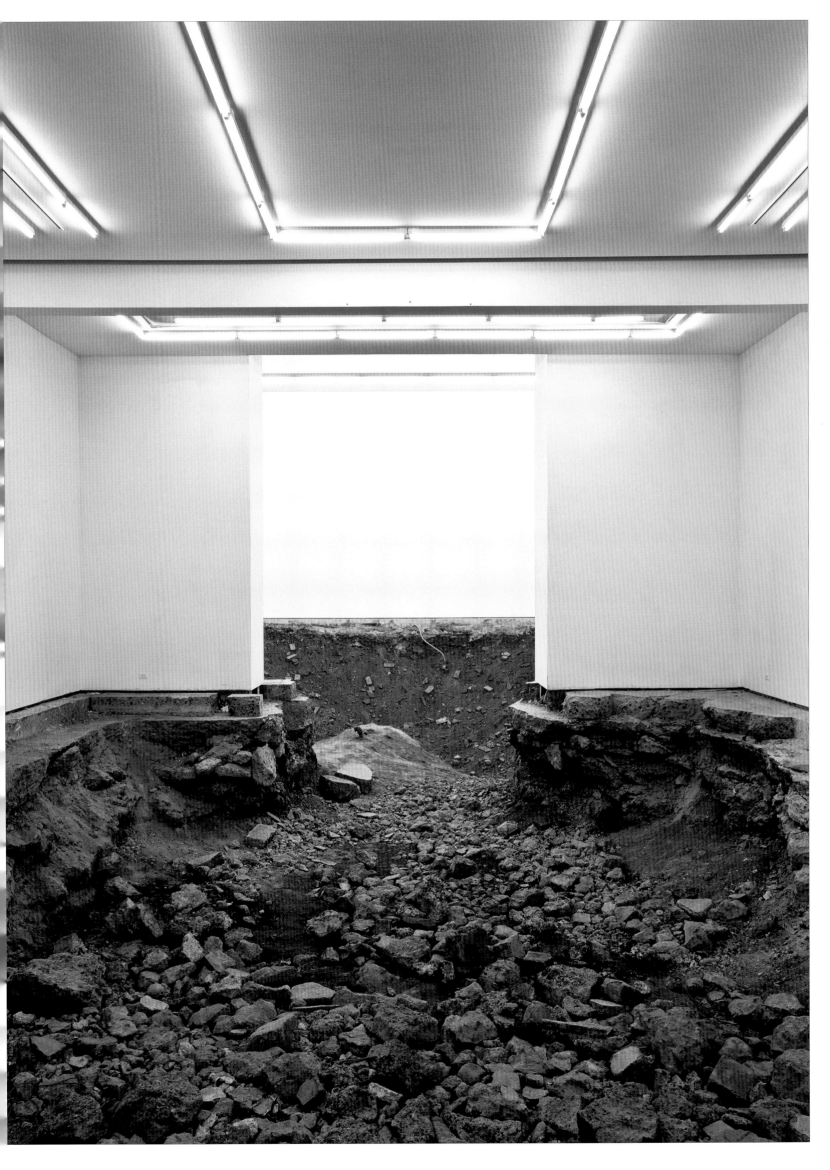

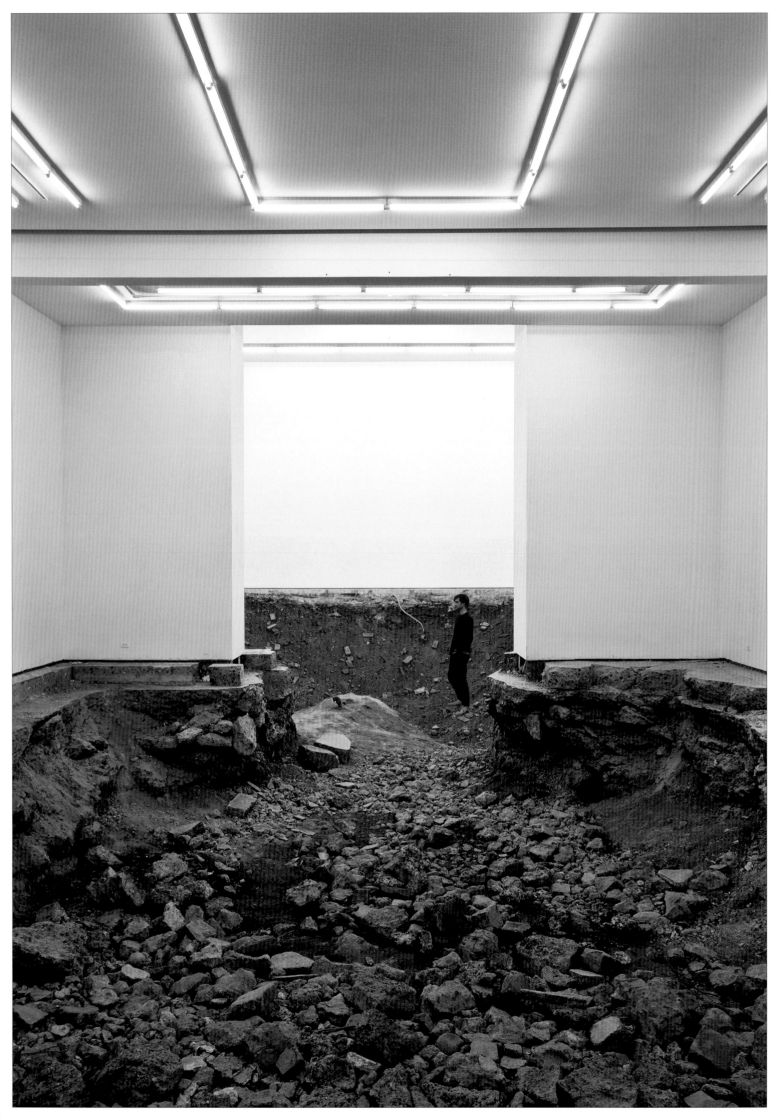

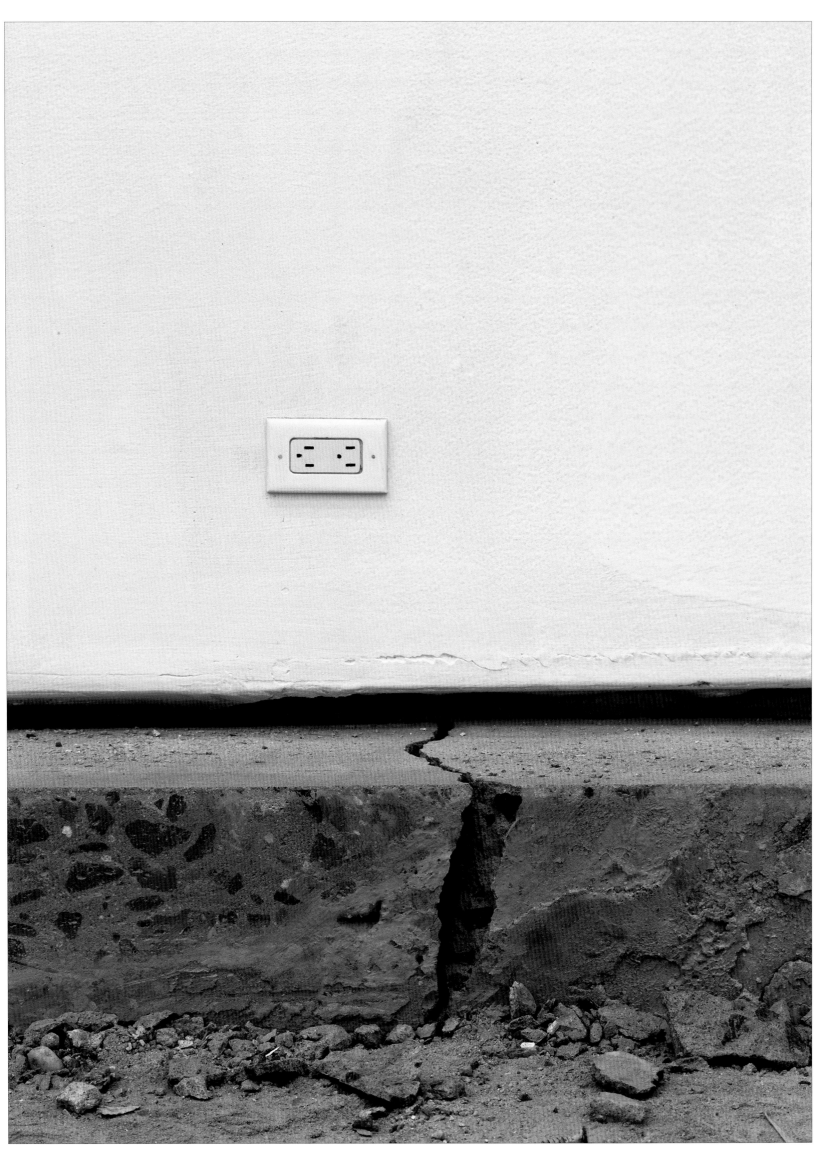

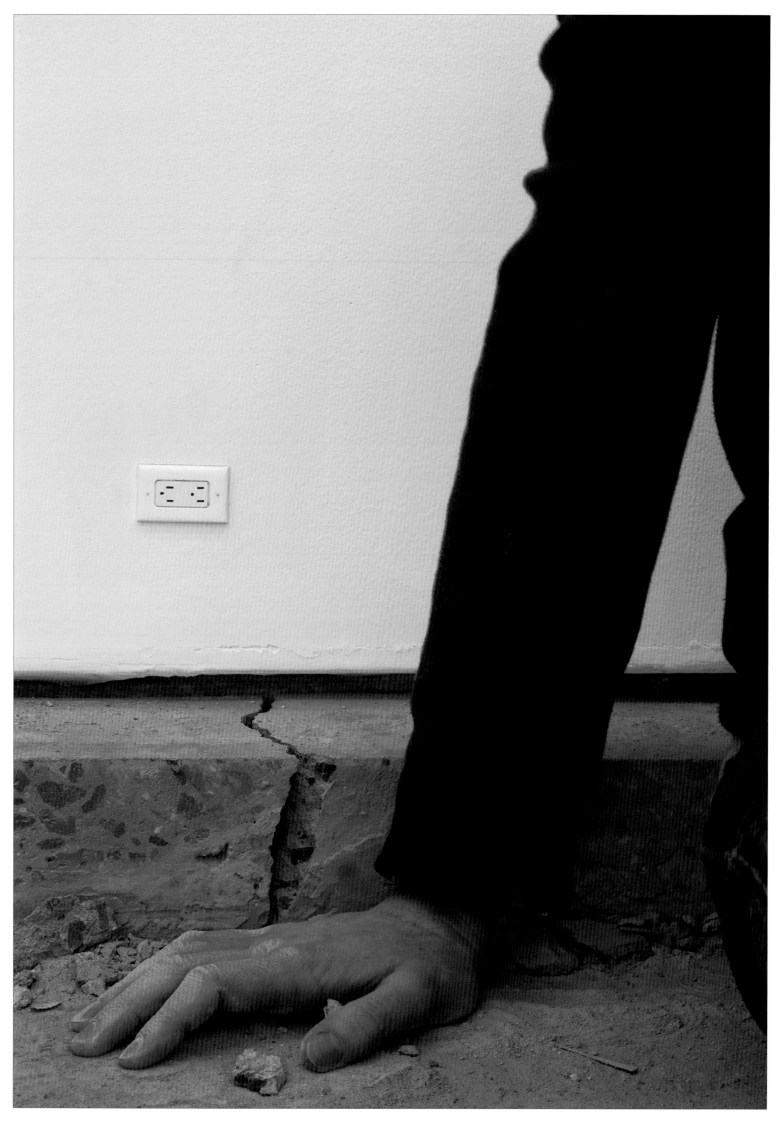

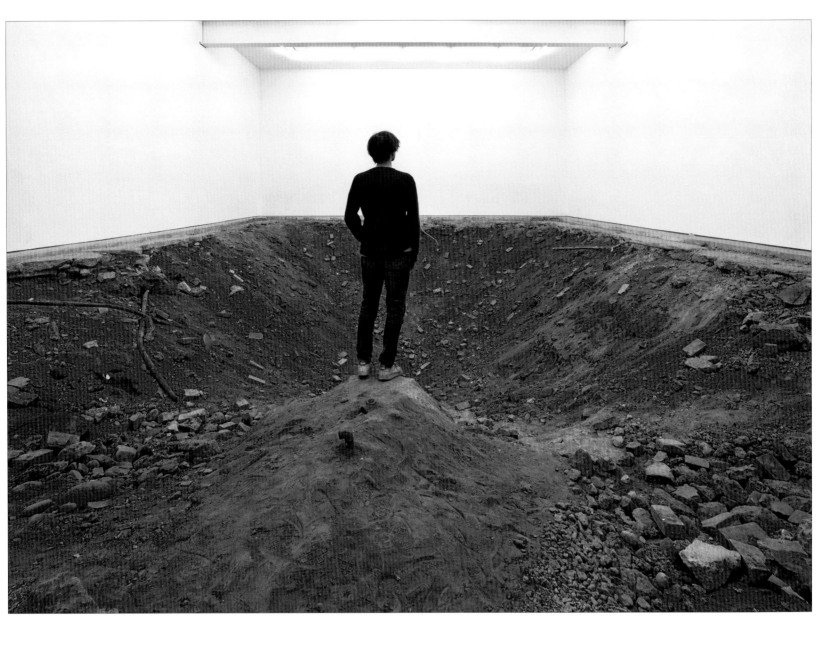

You
2007
Excavation, gallery space, 1:3 scale replica of gallery space
Dimensions variable
Installation view, "you," Gavin Brown's enterprise, New York, 2007

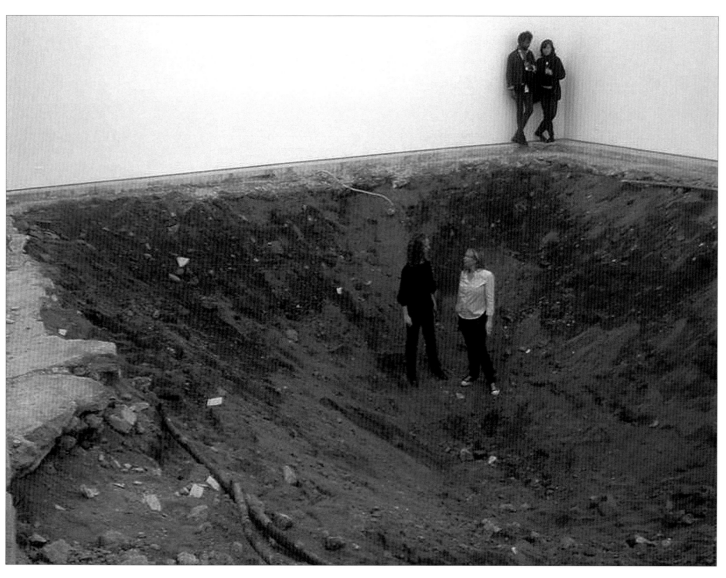

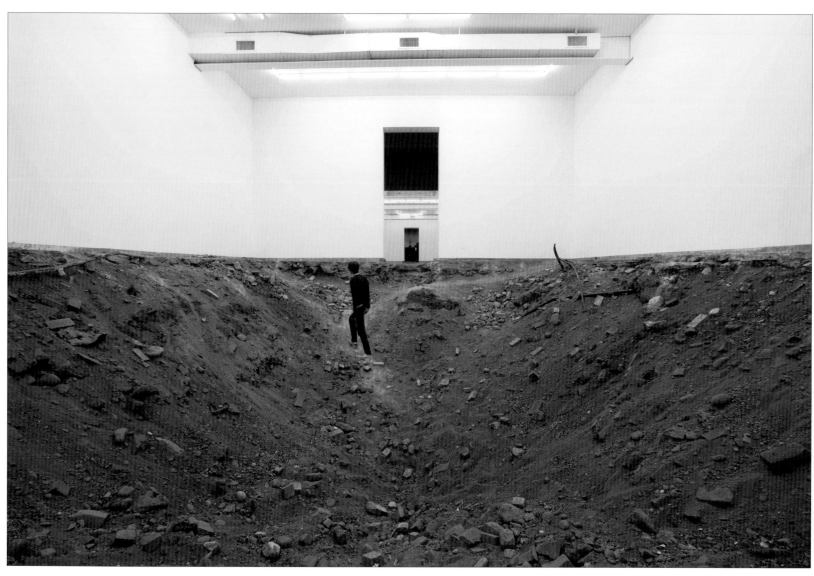

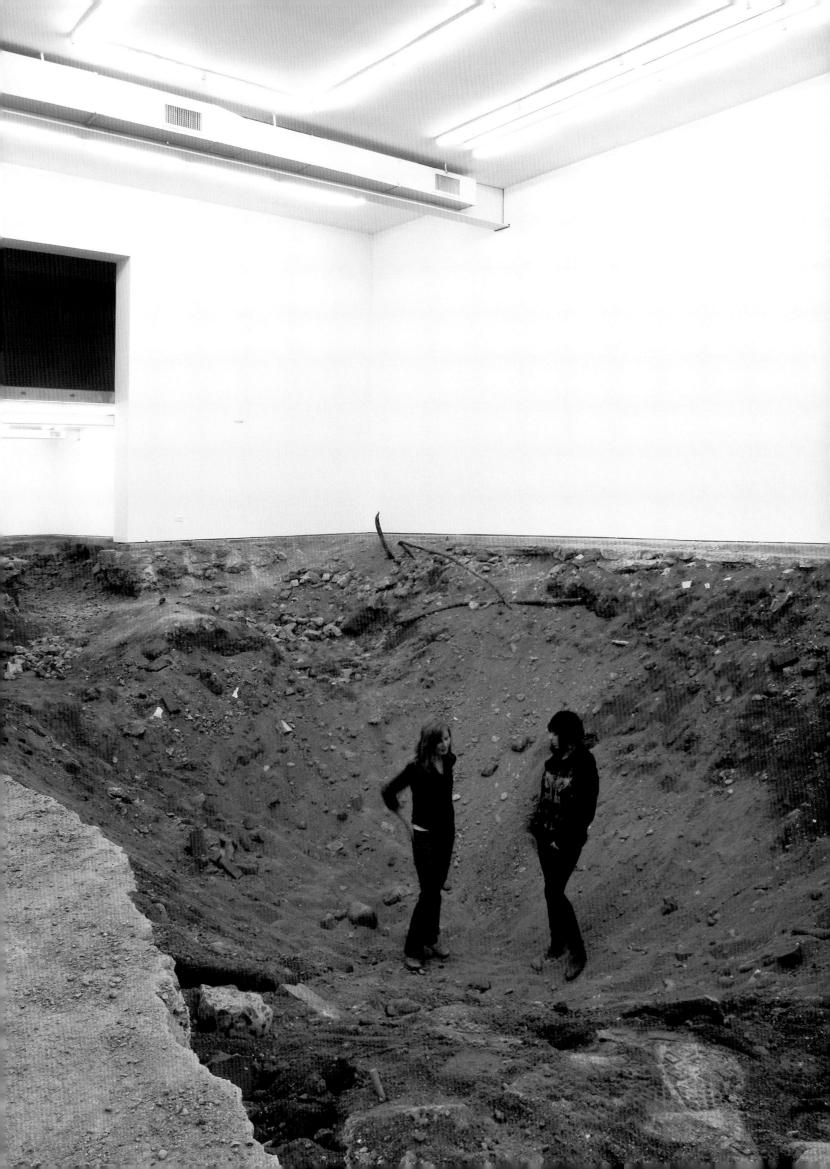

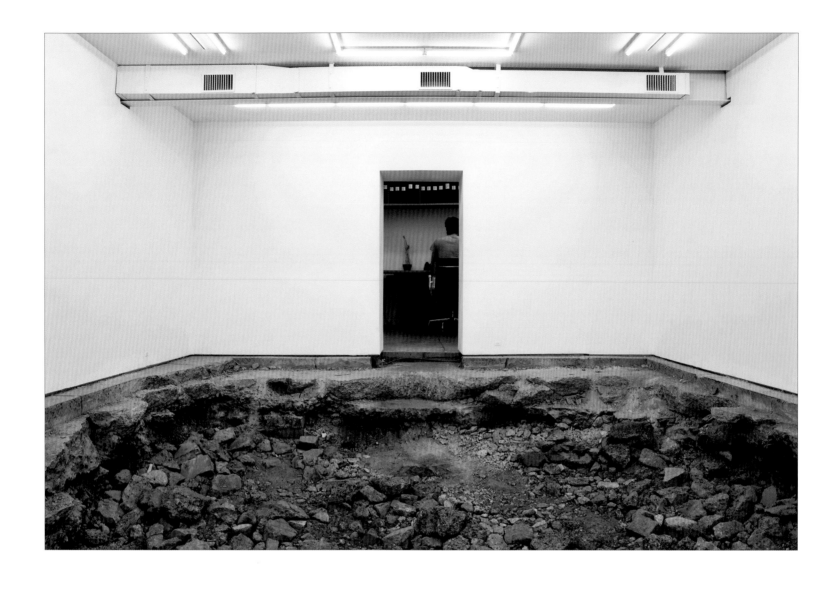

You
2007
Excavation, gallery space, 1:3 scale replica of gallery space
Dimensions variable
Installation view, "you," Gavin Brown's enterprise, New York, 2007

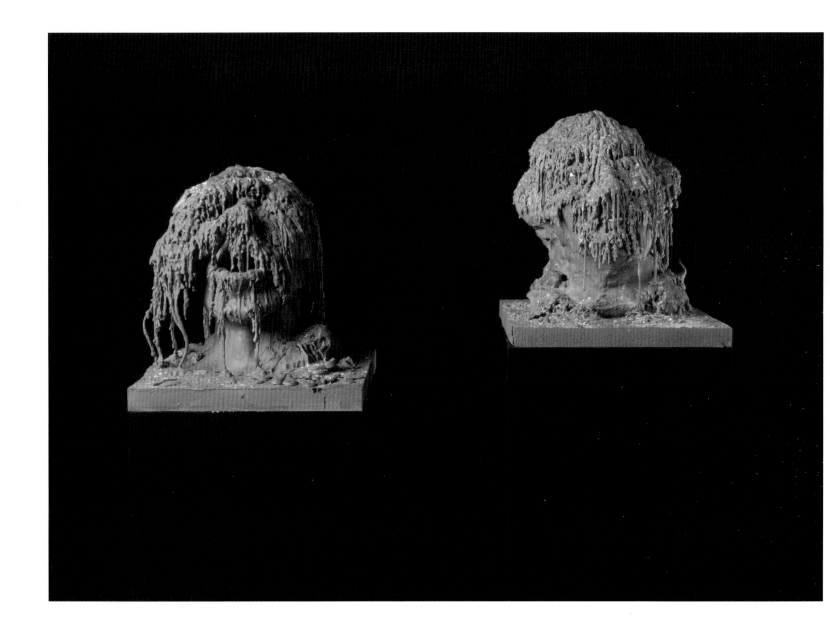

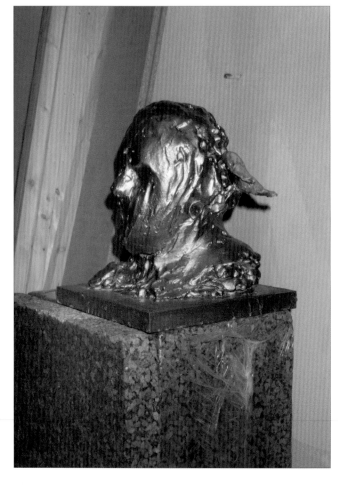

Köpfe (Heads)
1997–1999
Wood, clay, acrylic paint, wax
Head 1: 30 x 30 cm; 11 ¾ x 11 ¾ in.
Pedestal: 130 x 33 x 30 cm; 51 ⅛ x 13 x 11 ¾ in.
Head 2: 30 x 30 cm; 11 ¾ x 11 ¾ in.
Pedestal: 122 x 32 x 32 cm; 48 x 12 ⅝ x 12 ⅝ in.

Untitled
1999
Particleboard, clay, screws, wood glue, acrylic paint,
spray enamel
Dimensions unknown

Untitled (Chair)
1997–2000
Found chair, clay, oil paint, acrylic paint, wax, spray
adhesive, matte varnish, silicone
84 x 51 x 48 cm; 33 x 20 x 18 ⅞ in.
Installed on: Franz West (with Heimo Zobernig), table
from *Heimo West Bar: 10 Spiegeltische, 40 Stühle*, 1998

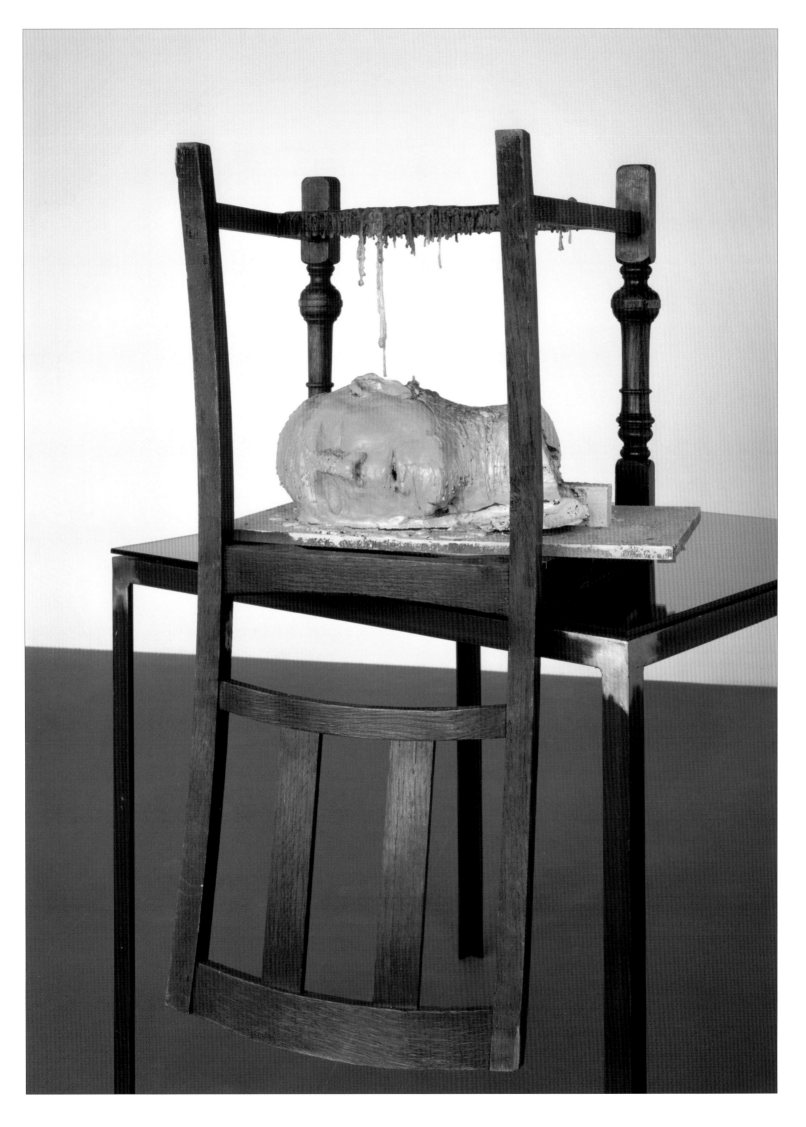

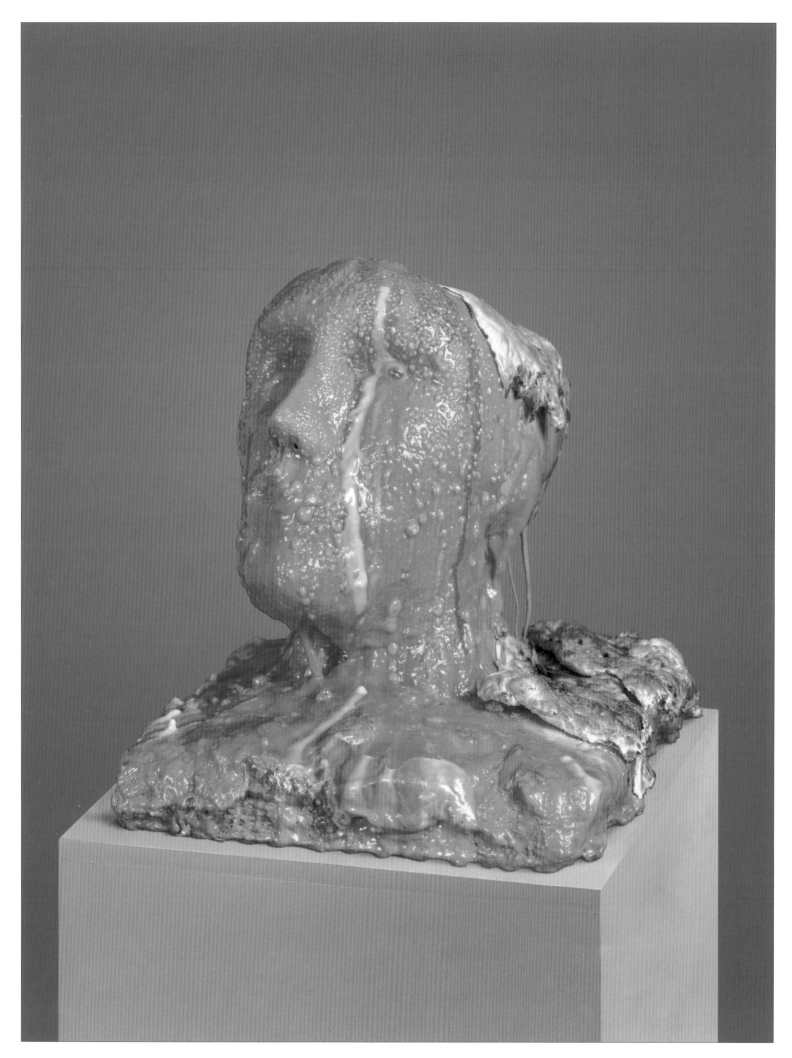

am & pm
2001
Wood, clay, polyurethane resin, pigments, bread, glue, mold
Head 1: 30 x 30.5 x 31 cm; 11 ¾ x 12 x 12 ¼ in.
Head 2: 32 x 40 x 37 cm; 12 ⅝ x 15 ¾ x 14 ⅝ in.

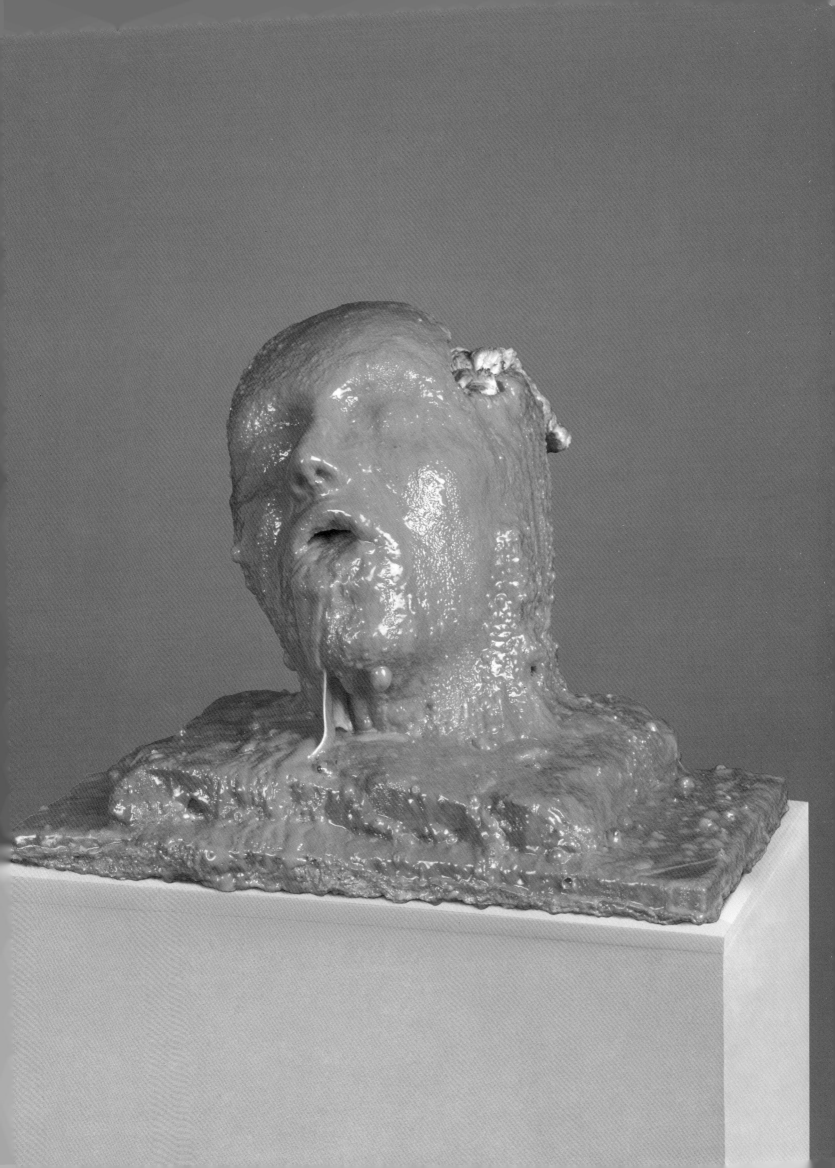

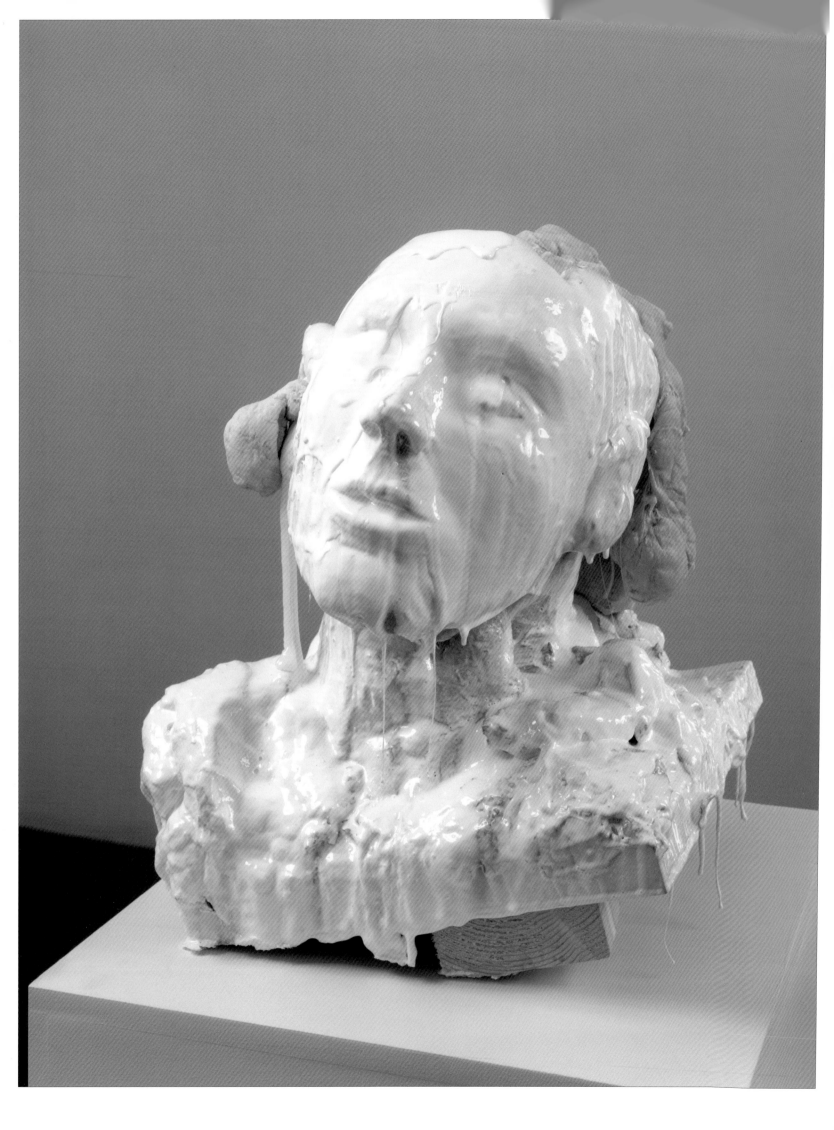

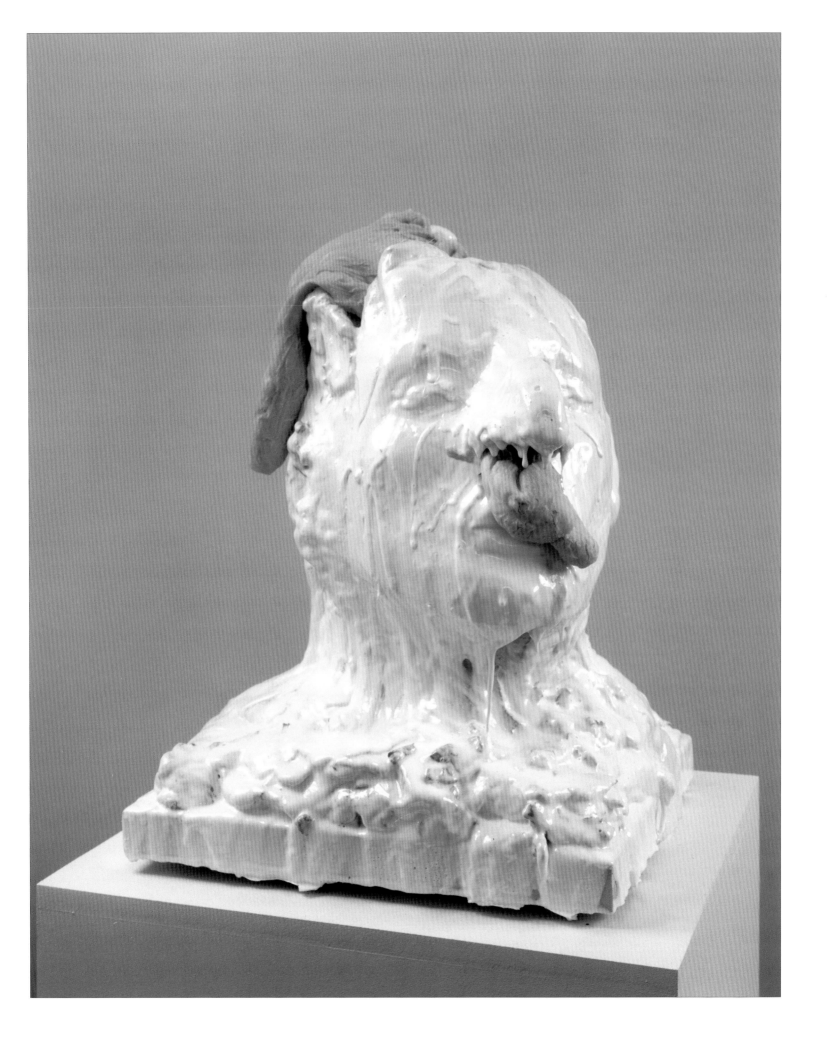

Moody Moments
2003
Clay, polyurethane resin, wood, dough
Head 1: 38 x 33 x 30.5 cm; 15 x 13 x 12 in.
Head 2: 38 x 30.5 x 30 cm; 15 x 12 x 11 ½ in.

I Can Smell Your Words
2002
Polyurethane resin, synthetic hair, acrylic paint, particleboard, marker, fake eyelashes, powdered sugar, egg whites
Dimensions unknown
Studio view, Hardturmstrasse, Zurich, 2002

Installation view, "Not My House, Not My Fire," Espace 315, Centre Georges Pompidou, Paris, 2004
Kir Royal, 2004; *Horses Dream of Horses*, 2004

Kir Royal
2004
Plaster, polyurethane resin, acrylic paint, gauze
45 x 30 x 35 cm; 17 ¾ x 11 ¾ x 13 ¾ in.

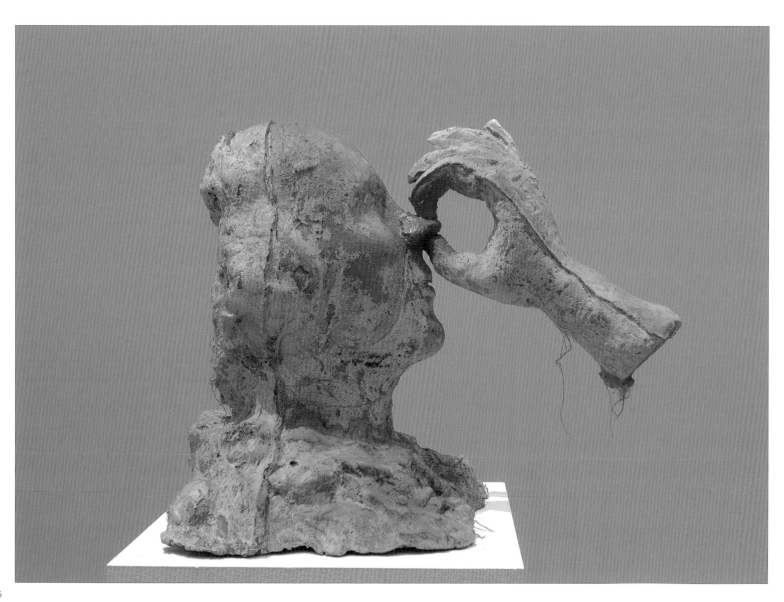

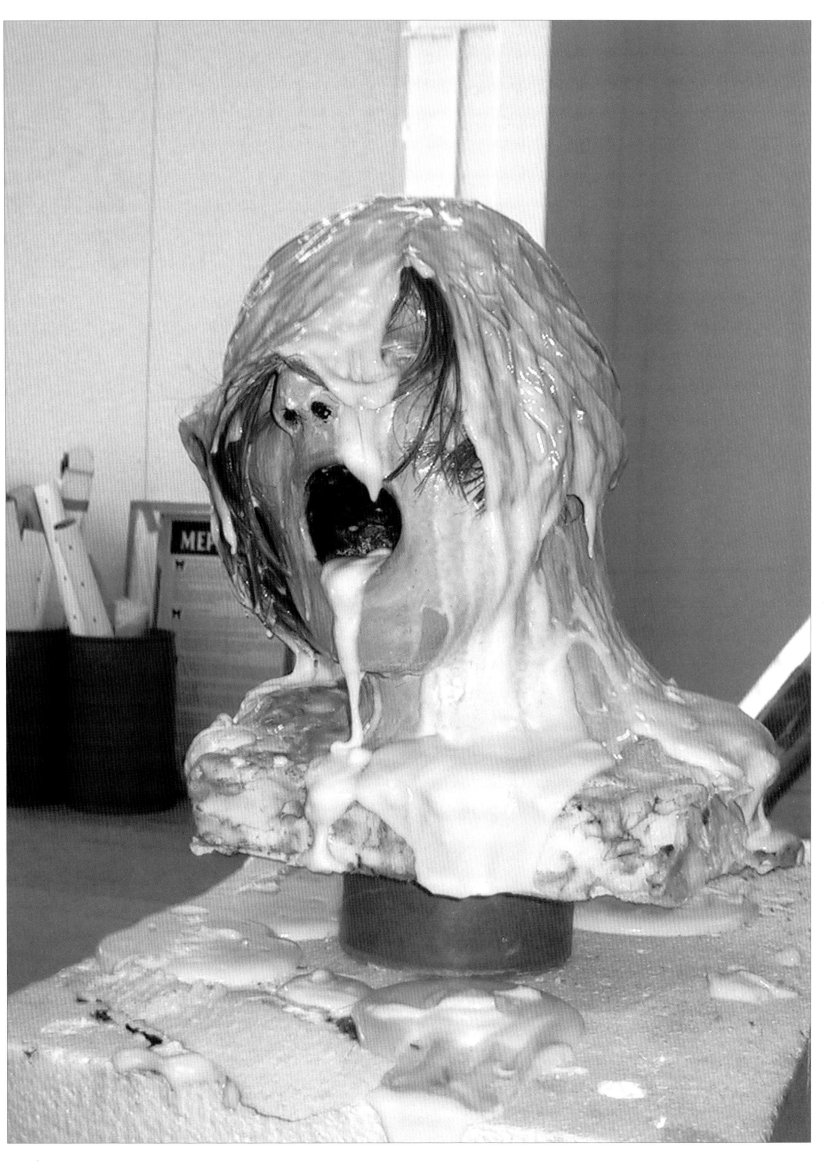

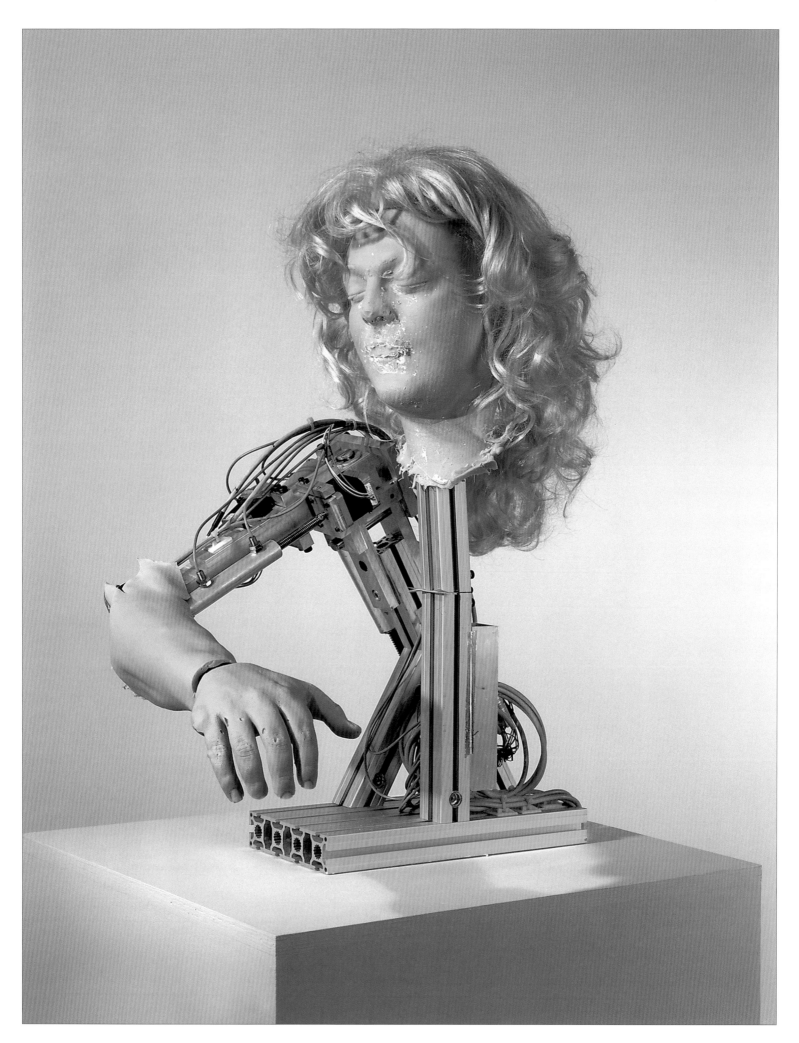

Airports Are Like Nightclubs
2004
Figure runs its fingers through its hair every few minutes
Mechanical robot, silicone, pigment, wig
Sculpture: 66 x 35.5 x 78.7 cm; 26 x 14 x 31 in.
Pedestal: 84 x 63.5 x 53.3 cm; 33 x 25 x 21 in.

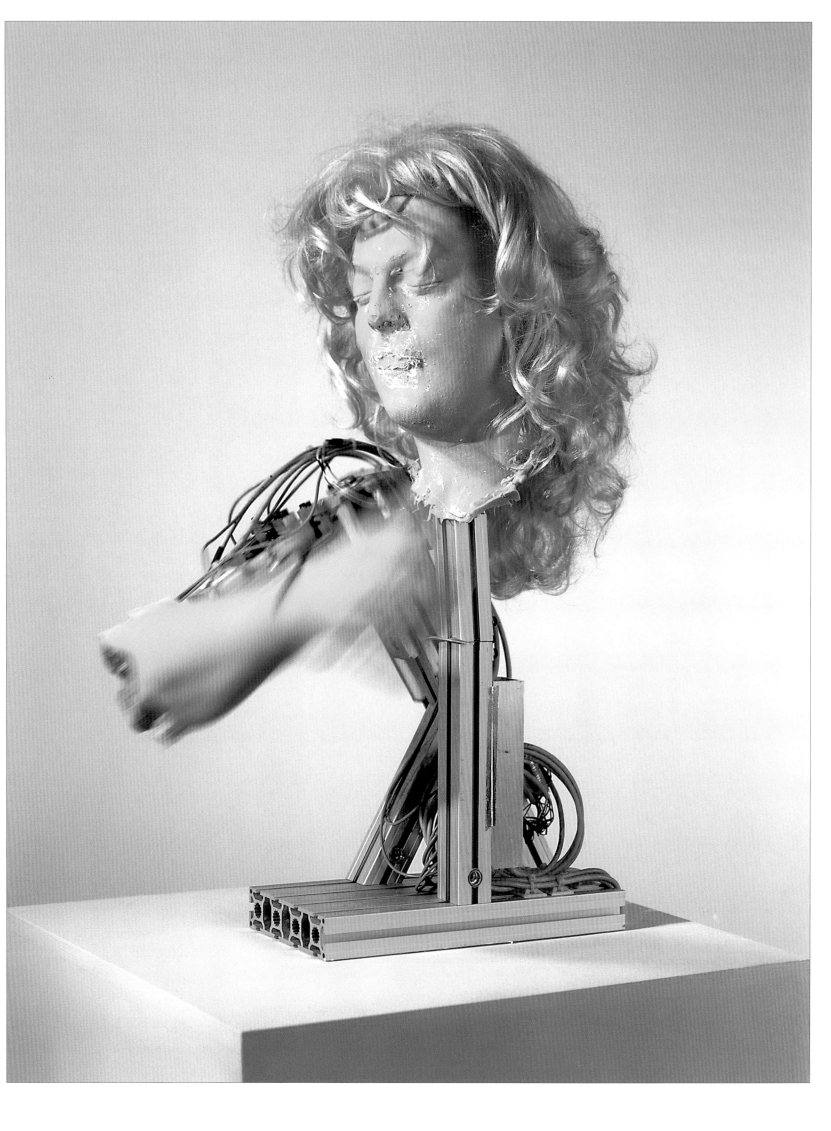

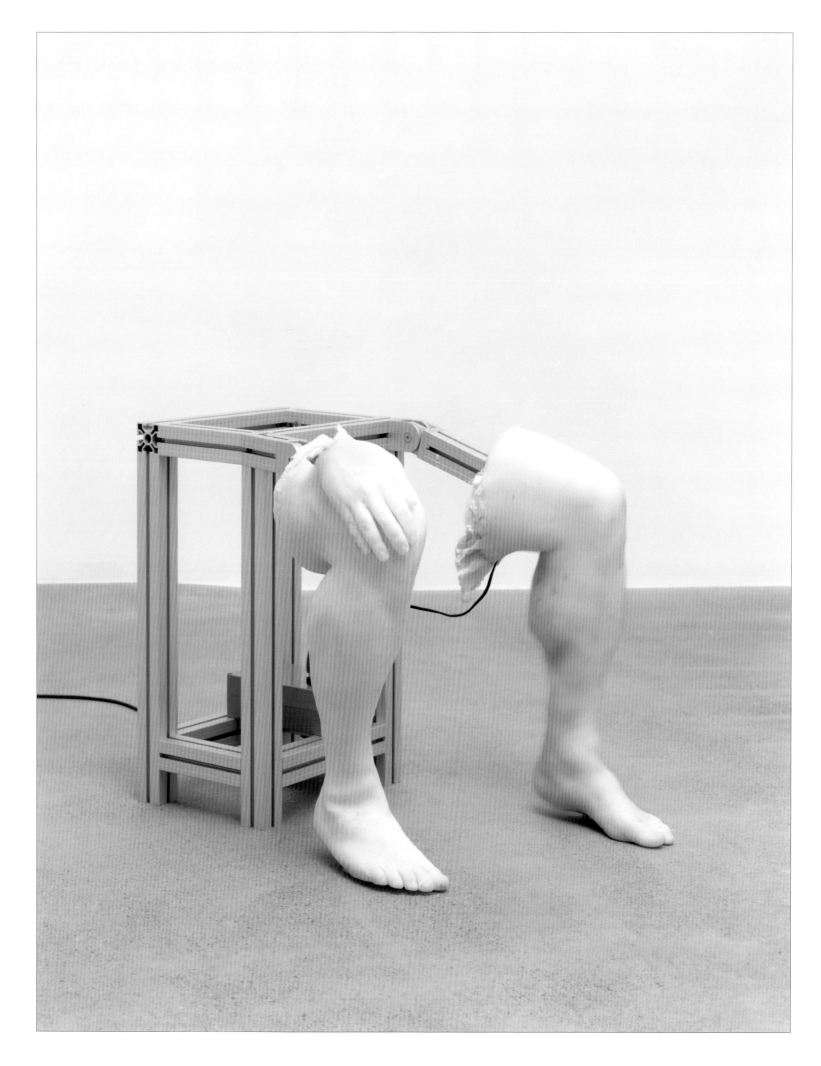

Paris 2006
2006
Left leg jitters impatiently
Electric motor, aluminum tracks, silicone, pigment, cable
85 x 63 x 68 cm; 33 ½ x 24 ¼ x 26 ¼ in.

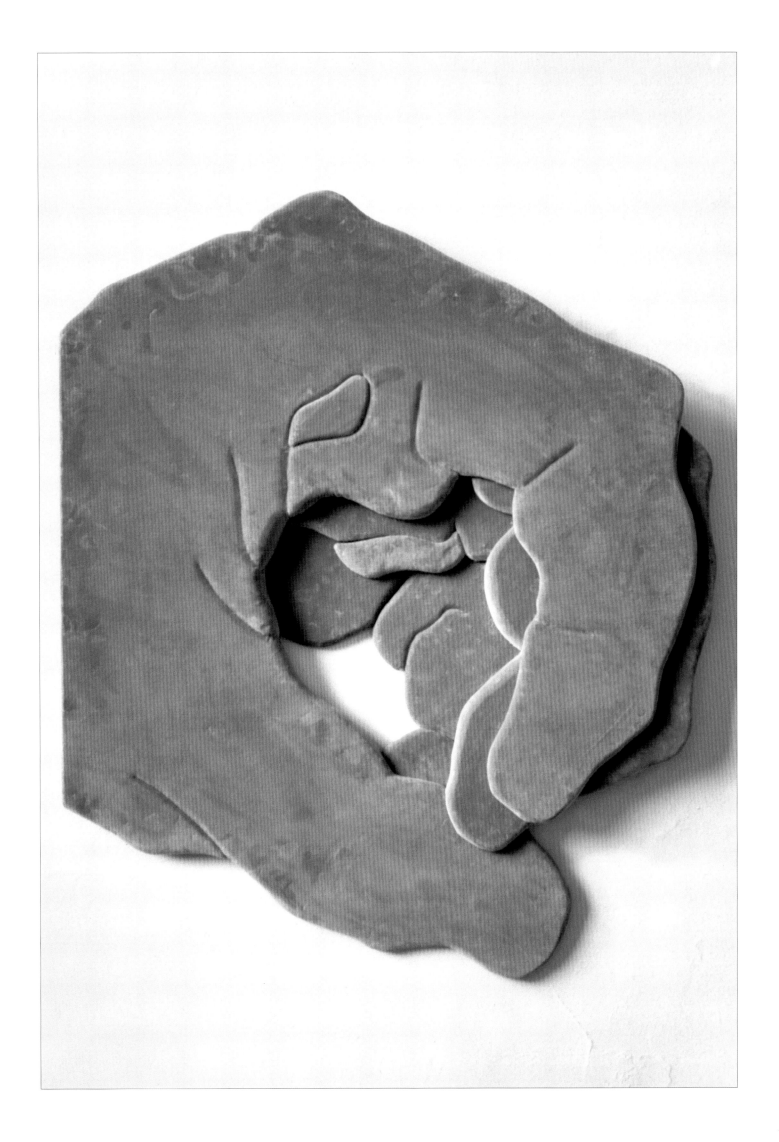

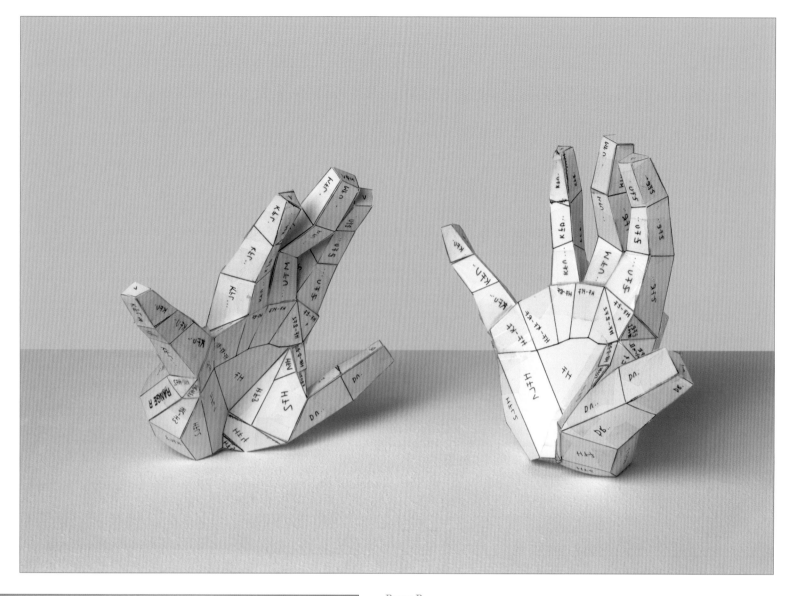

Range R
from *Range R / Range L*
1996
Photocopy, tape, stamp
Edition of 60 (30 right, 30 left)
22 x 18 x 7.5 cm; 8 ⅝ x 7 ⅛ x 3 in.

Untitled (Paper Hand)
1993
Worn by a kid
Photocopy, tape, stamp
Dimensions unknown

Page 373:

Untitled
1993
Particleboard, velour, staples, screws, contact cement
120 x 155 cm; 47 ¼ x 61 in.

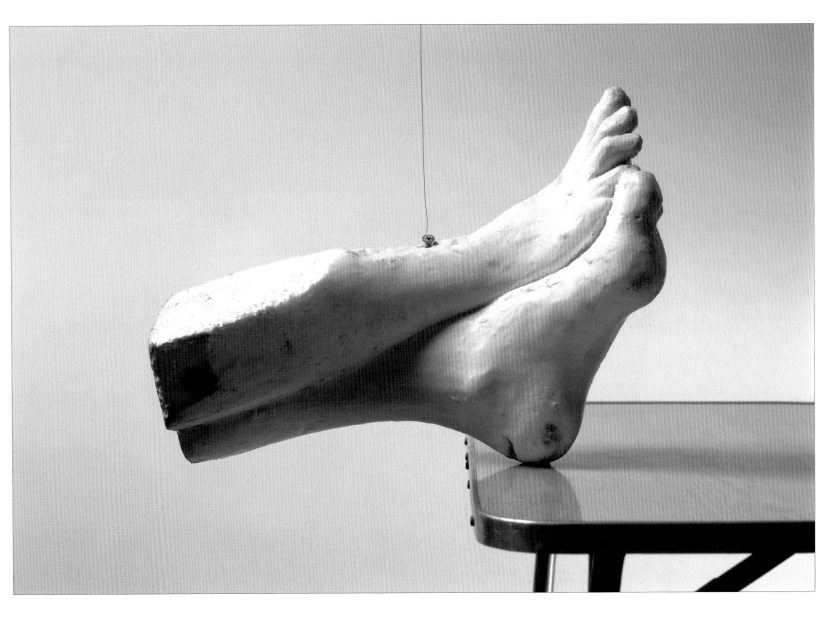

September Song
2002
Polystyrene, glue, paint, wire, screw, marker
23 x 60 x 10 cm; 9 x 23 ⅝ x 4 in.

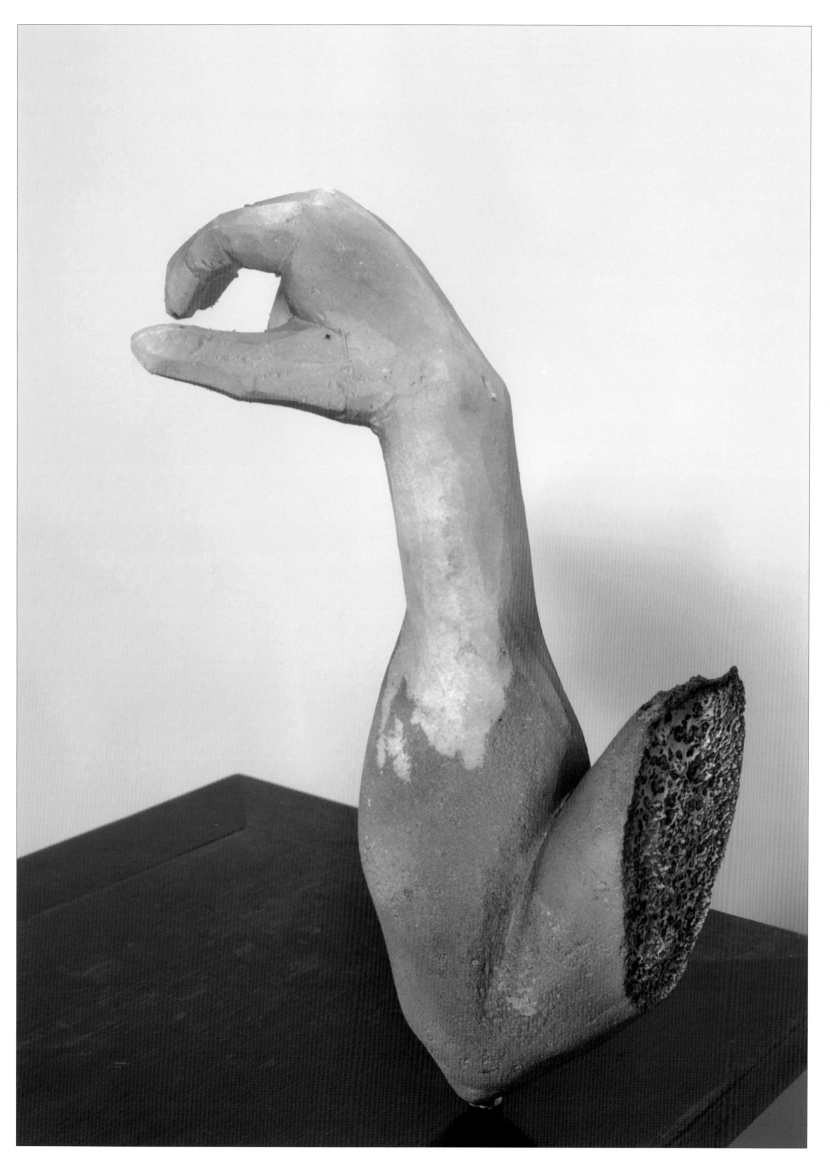

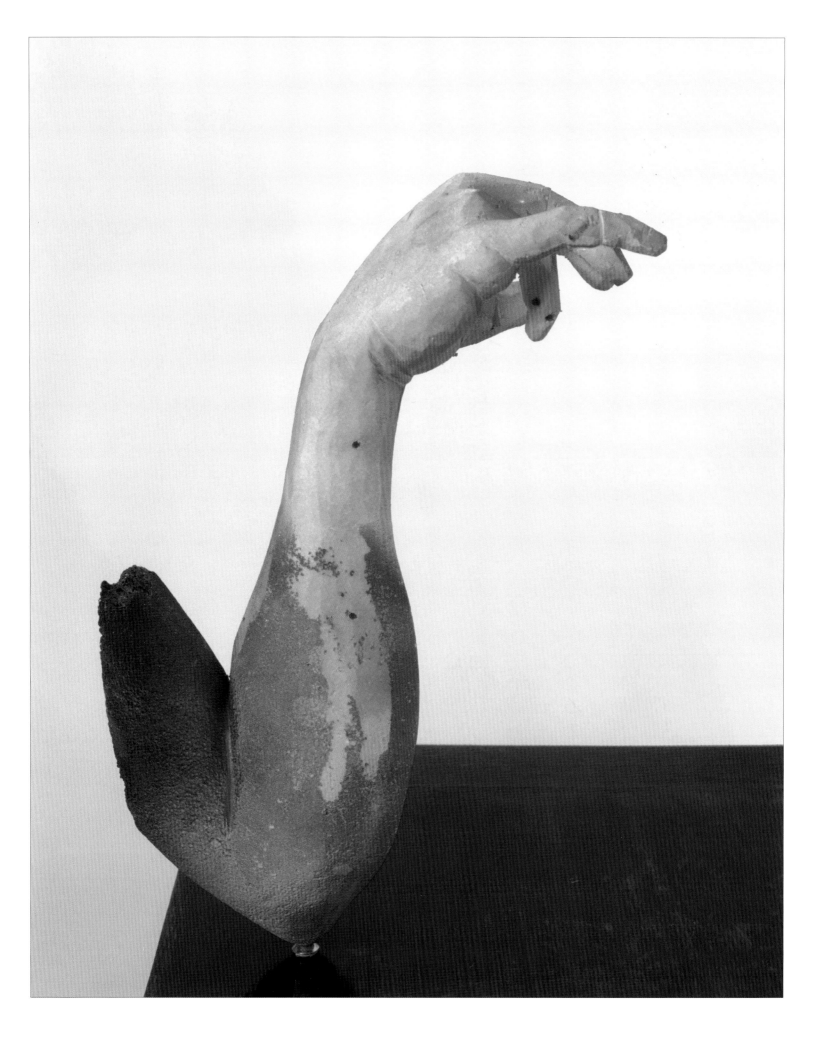

Picky Eater
2003
Polystyrene, polyurethane foam, acrylic paint,
spray enamel, screws, polyurethane glue
41 x 15 x 29 cm; 16 ⅛ x 5 ⅞ x 11 ⅜ in.

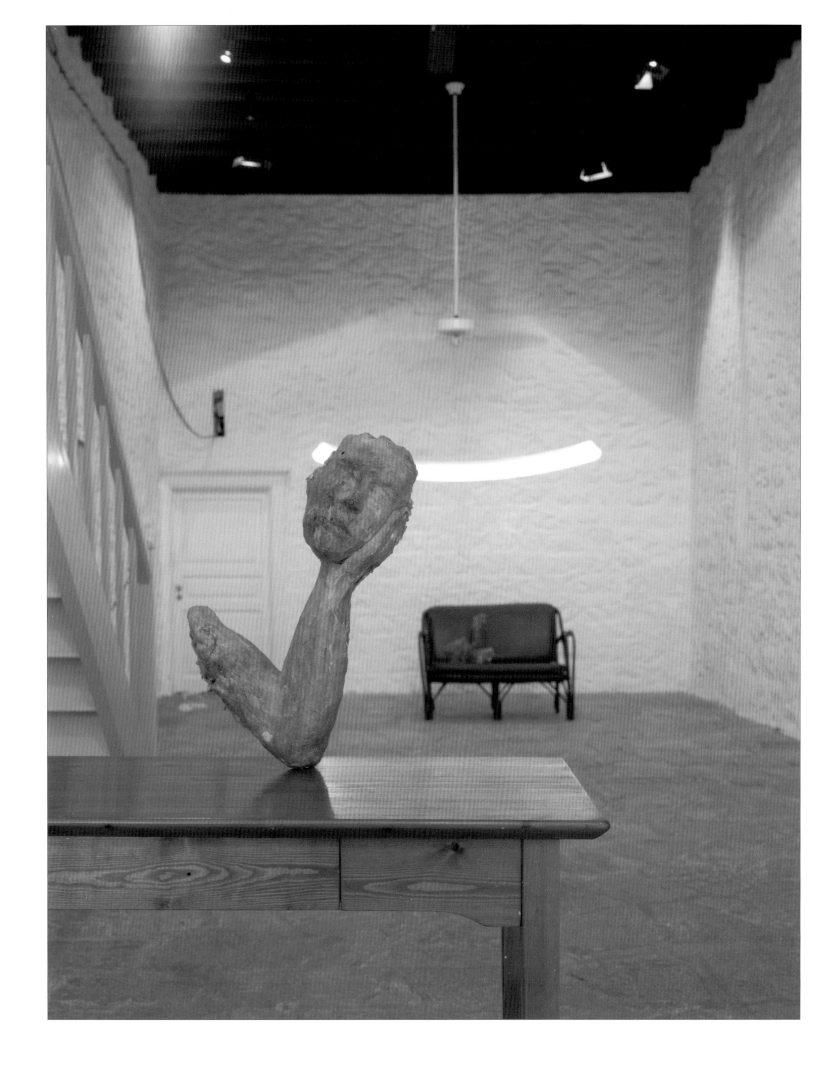

Installation view, "Mr. Watson—Come Here—I Want to See
You," Hydra Workshop, Greece, 2005
Left to right: *Vieille Prune*, 2005; *"Mr. Watson—come here—I
want to see you.,"* 2005; *Tea Time with Miss Cocktail*, 2005

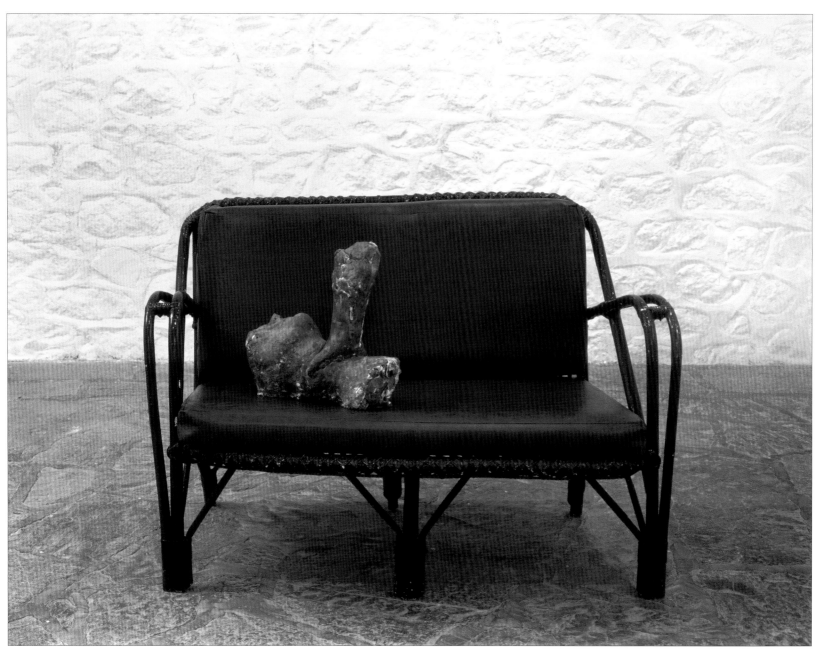

Tea Time with Miss Cocktail
2005
Found couch, two-component
polyurethane foam, pigments, screws
37 x 37 x 17 cm; 14 ⅝ x 14 ⅝ x 6 ¼ in.
Installation dimensions variable

Vieille Prune
2005
Two-component polyurethane foam,
pigments, screws, epoxy glue
53 x 45 x 21 cm; 20 ⅞ x 17 ¾ x 8 ¼ in.

Change of Taste for Miss Cocktail
2005
Cast nickel silver, acrylic paint, gesso
15 x 20.5 x 6 cm; 5 ⅞ x 8 ⅛ x 2 ⅜ in.

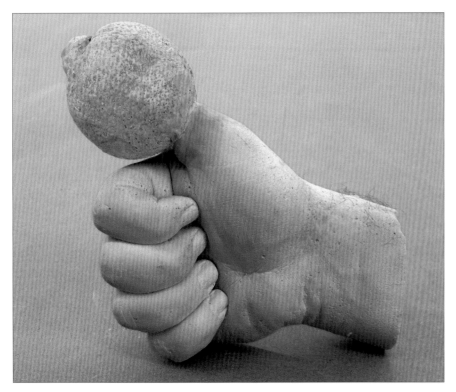

Lemon Hand
2006
Hydrocal, acrylic paint, polyurethane glue, hair
8 x 23 x 14 cm; 3 ⅛ x 9 x 5 ½ in.

Hand Lemon
2006
Hydrocal, acrylic paint, polyurethane glue, hair
18.4 x 18.4 x 18.1 cm; 7 ¼ x 7 ¼ x 7 ⅛ in.

100 Years
2006
Plaster, acrylic paint, glue
10 x 17.8 x 9.5 cm; 4 x 7 x 3 ¾ in.

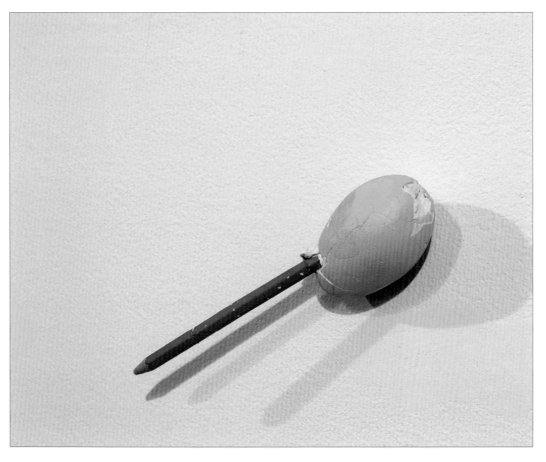

?
2005
Polyurethane resin, two-component
polyurethane foam, acrylic paint, wire,
string, plaster, wood
175.3 x 50.8 x 36.8 cm; 69 x 20 x 14 ½ in.

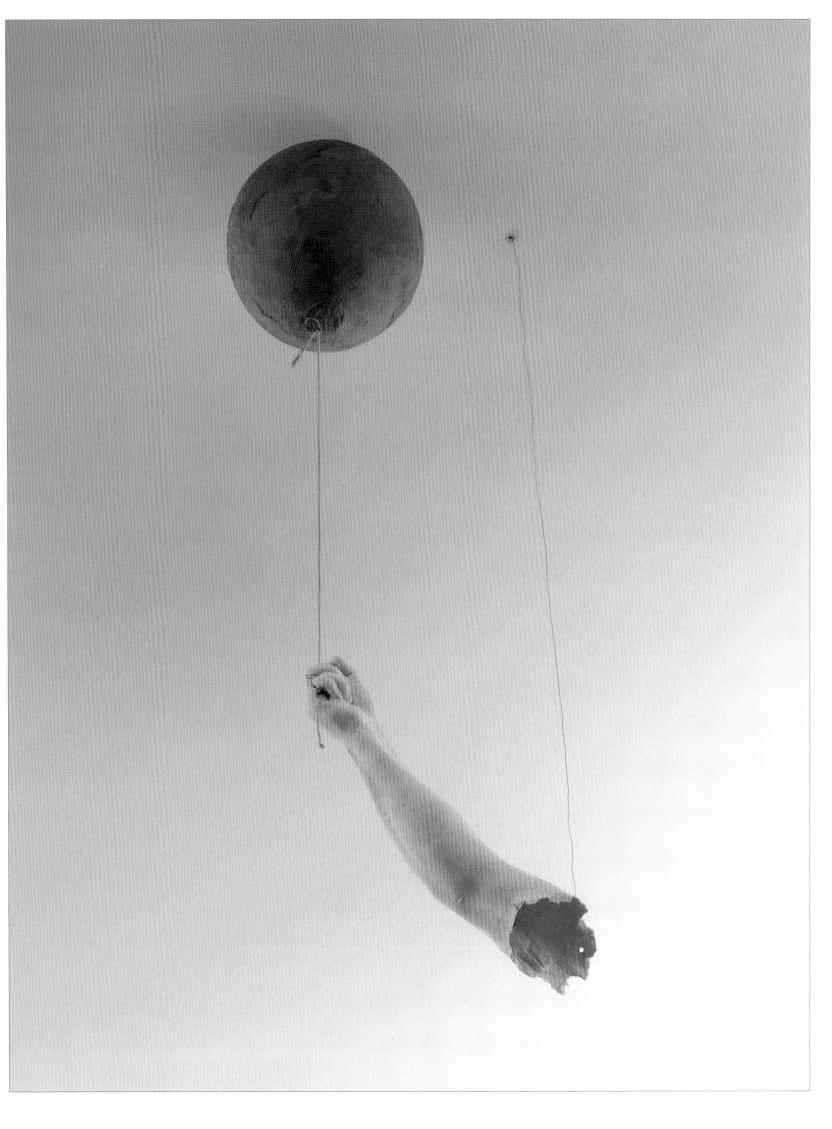

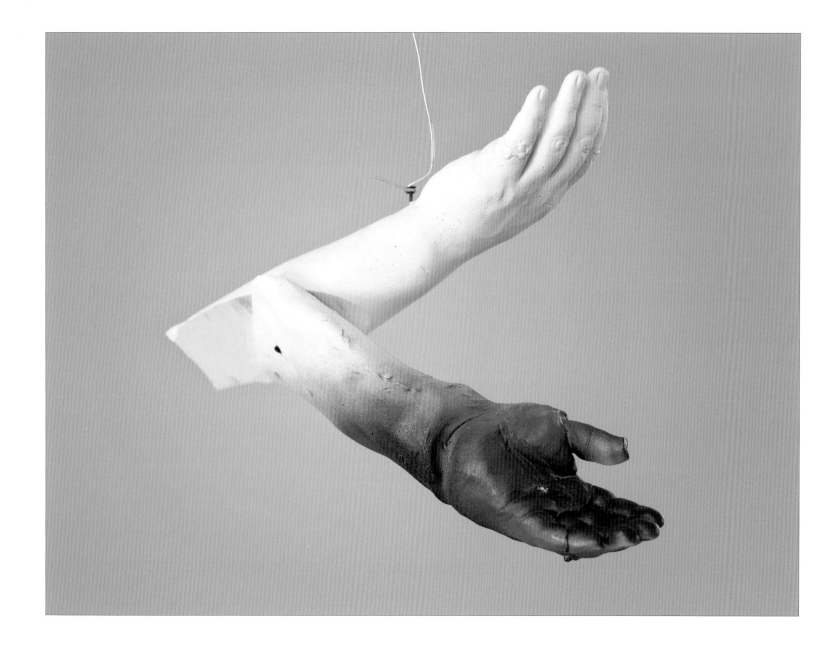

Imaginary Pain
2007
Cast plaster, screws, enamel paint
60 x 60 x 20 cm; 23 ⅝ x 23 ⅝ x 7 ⅞ in.

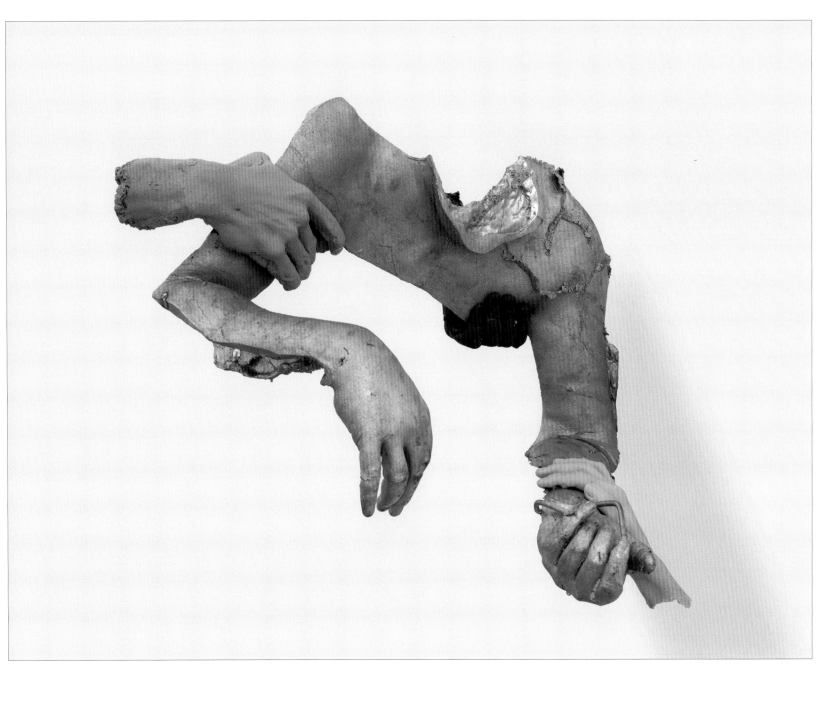

The Grass Munchers
2007
Cast aluminum, pigments, wax
56 x 62 x 44 cm; 22 x 24 ⅛ x 17 ⅜ in.

Untitled
2009
Plaster, acrylic paint, bread
10 x 21 x 15 cm; 3 ⅞ x 8 ¼ x 5 ⅞ in.
Installation view, "Dear _____! We _____ on
_____, hysterically. It has to be _____ that _____. No?
It is now _____ and the whole _____ has changed
_____. all the _____, _____" (with Mark Handforth and
Georg Herold), Kunstnernes Hus, Oslo, 2009
On floor: *Barfood with Erich Muehsam / Langweile mit
Richard Wagner*, 2006–2009

Pages 385–386:

Noisette
2009
Viewer's approach triggers tongue to emerge from hole
Hole in wall, silicone, motion sensor, electric motor,
mechanism
13 x 14 x 50 cm; 5 ⅛ x 5 ½ x 19 ⅝ in.

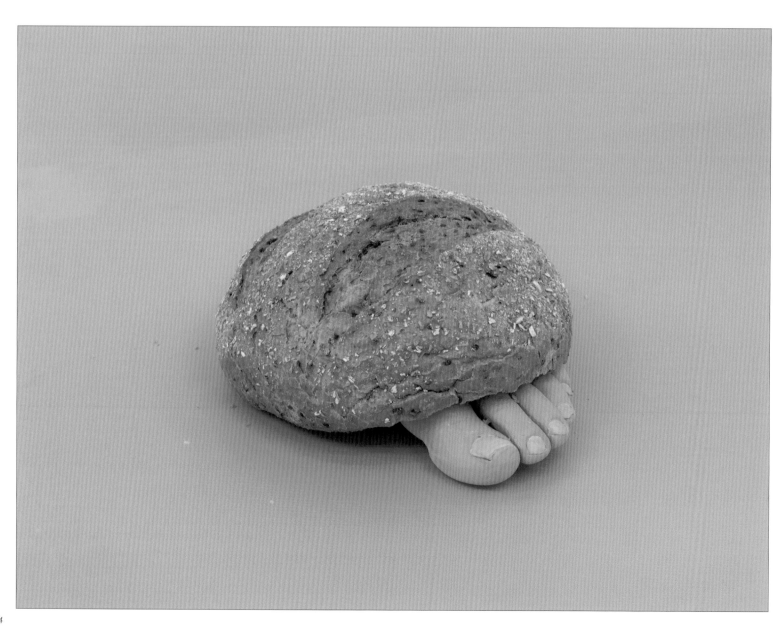

Untitled (Tongue / Léger Shift / Cookie Cutter)
1993
Marker and pencil on paper; framed
25.5 x 34.2 x 2.8 cm; 10 x 13 ½ x 1 ⅛ in.

Untitled
1993
Marker and pencil on paper
2 drawings, each 29.7 x 21 cm; 11 ¾ x 8 ¼ in.

Léger Joke
1993
Marker and pencil on paper
29.7 x 21 cm; 11 ¾ x 8 ¼ in.

389

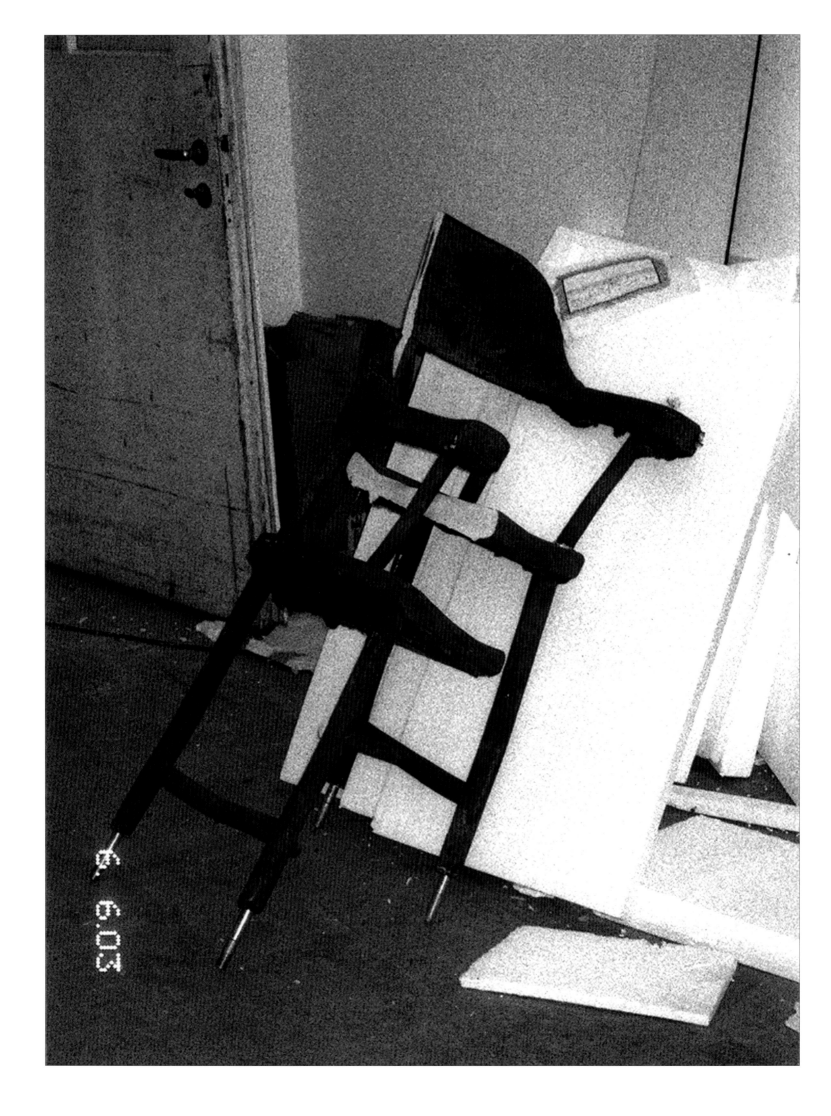

Studio view, Hardturmstrasse, Zurich, 2003

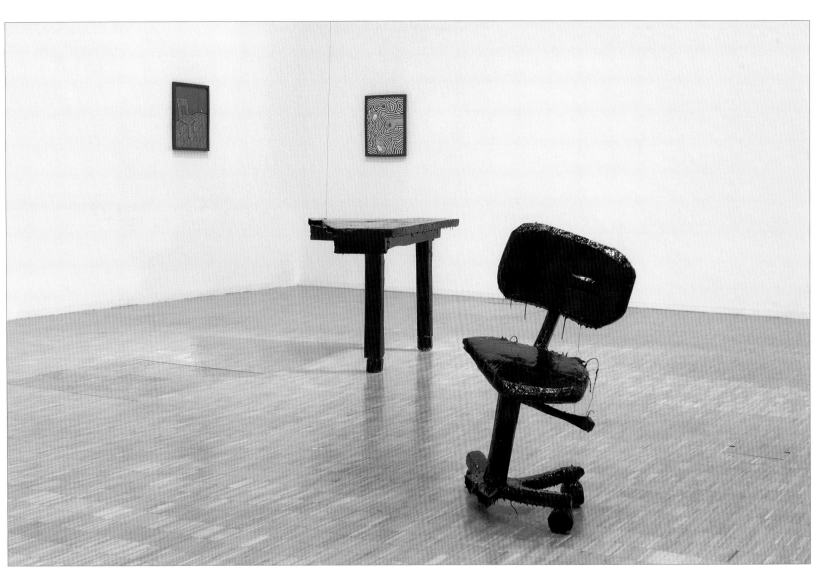

Next Time I Break an Egg, I Will Think of You
2004
Polystyrene, polyurethane resin, car paint, duct
tape, screws, steel wire
Table: 120 x 100 x 80 cm; 47 ¼ x 39 ⅜ x 31 ½ in.
Chair: 70 x 70 x 70 cm; 27 ½ x 27 ½ x 27 ½ in.
Installation view, "Not My House, Not My Fire,"
Espace 315, Centre Georges Pompidou, Paris, 2004
On wall: drawing from *Rainbow Cookie*, 2003;
drawing from *I Hope the Kitten Finds a Mouse*, 2004

Untitled (Cut) / Untitled (Cut)
1991
Acrylic and pencil on paper; framed
2 drawings, each 34.2 x 25.5 x 2.8 cm;
13 ½ x 10 x 1 ⅛ in.

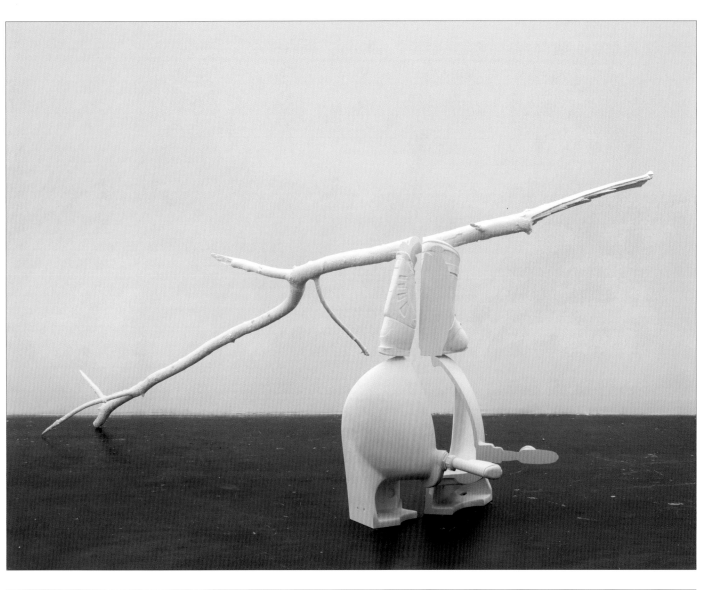

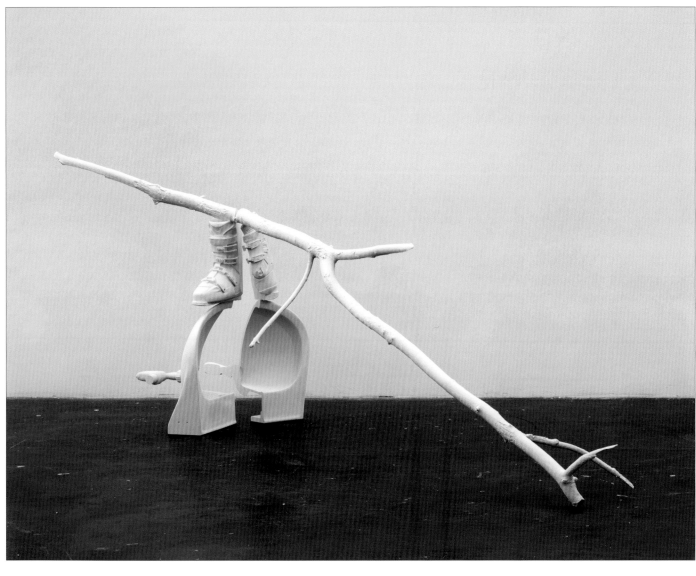

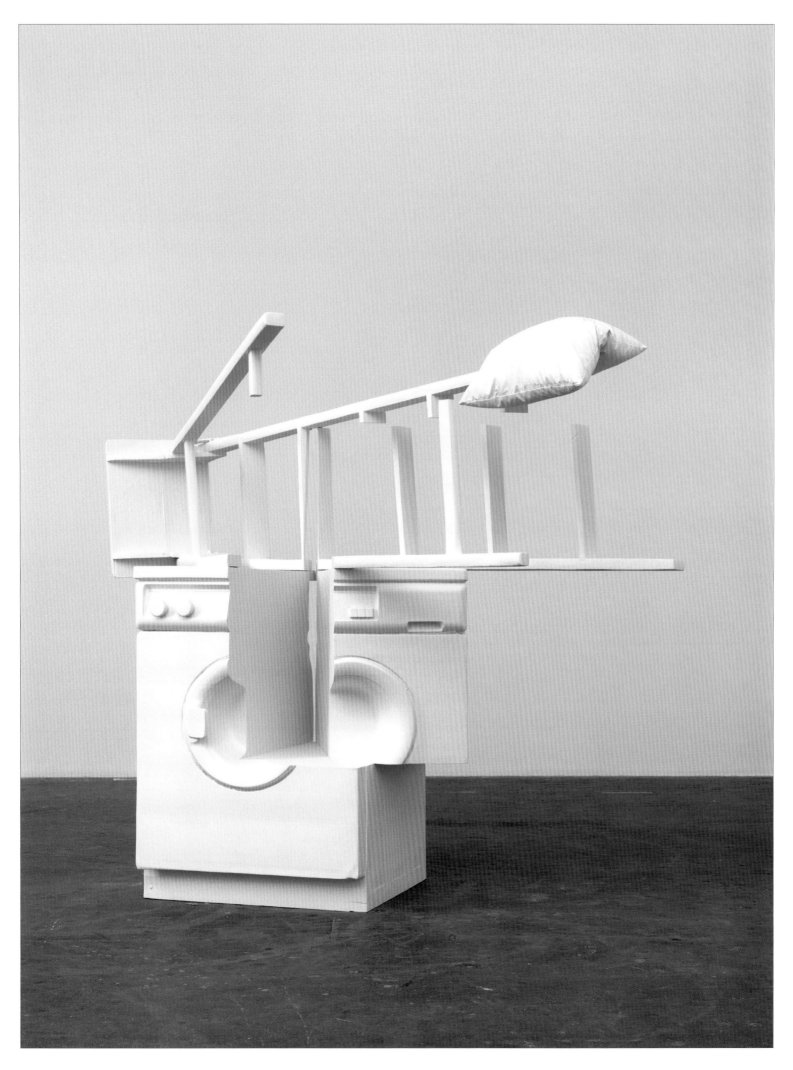

Fuck You Thank You
2007
Cast aluminum, acrylic paint
172 x 305 x 97 cm; 67 ¼ x 120 ⅛ x 38 ¼ in.

Thank You Fuck You
2007
Cast aluminum, acrylic paint
153 x 185 x 141 cm; 60 ¼ x 72 ⅞ x 55 ½ in.

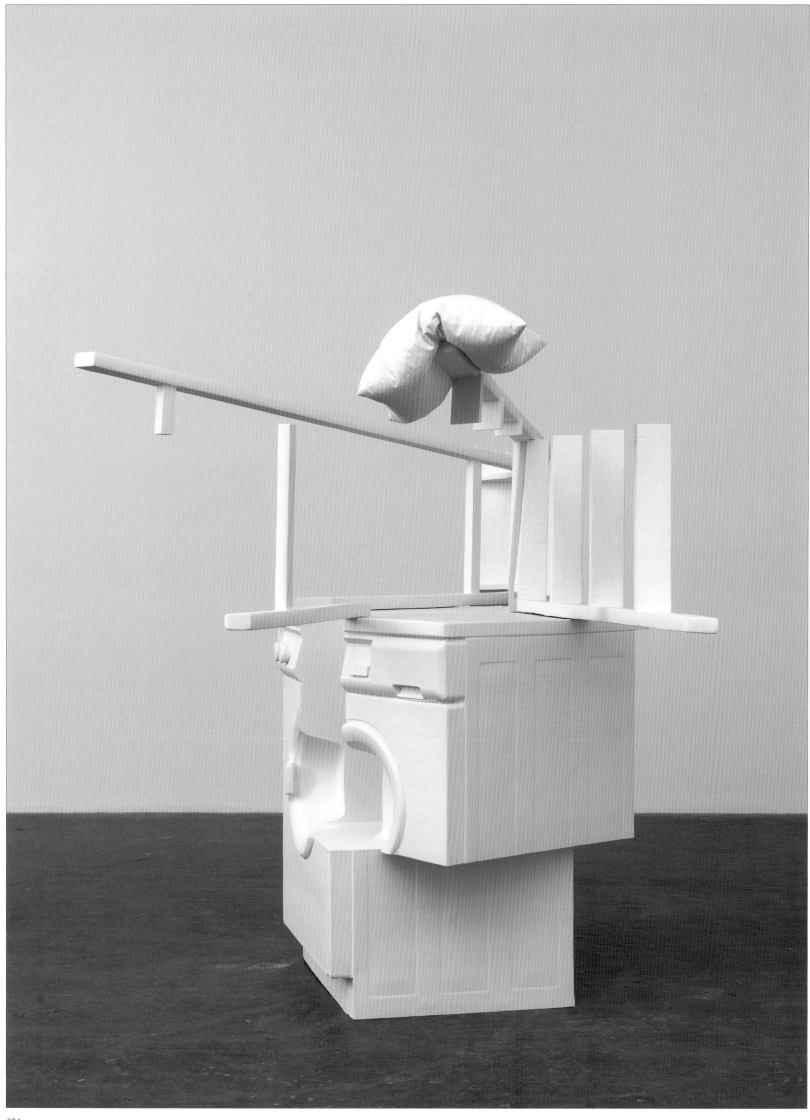

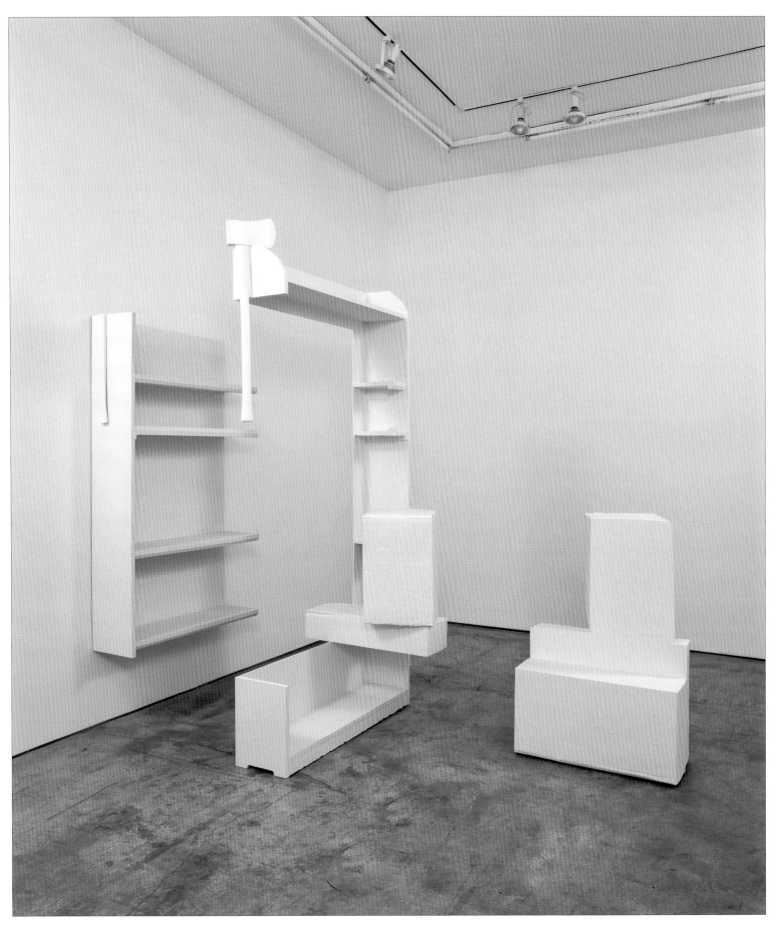

Saggy Tit / Stiff Cock
2008
Cast aluminum, acrylic paint
Left to right:
Shelf: 176 x 107 x 30 cm; 69 ¼ x 42 ⅛ x 11 ¼ in.
Shelf: 257 x 131 x 81 cm; 101 ⅛ x 51 ⅝ x 31 ⅞ in.
Box: 117 x 80 x 99 cm; 46 x 31 ½ x 39 in.

Thank You Fuck You
2007
Cast aluminum, acrylic paint
153 x 185 x 141 cm; 60 ¼ x 72 ⅞ x 55 ½ in.

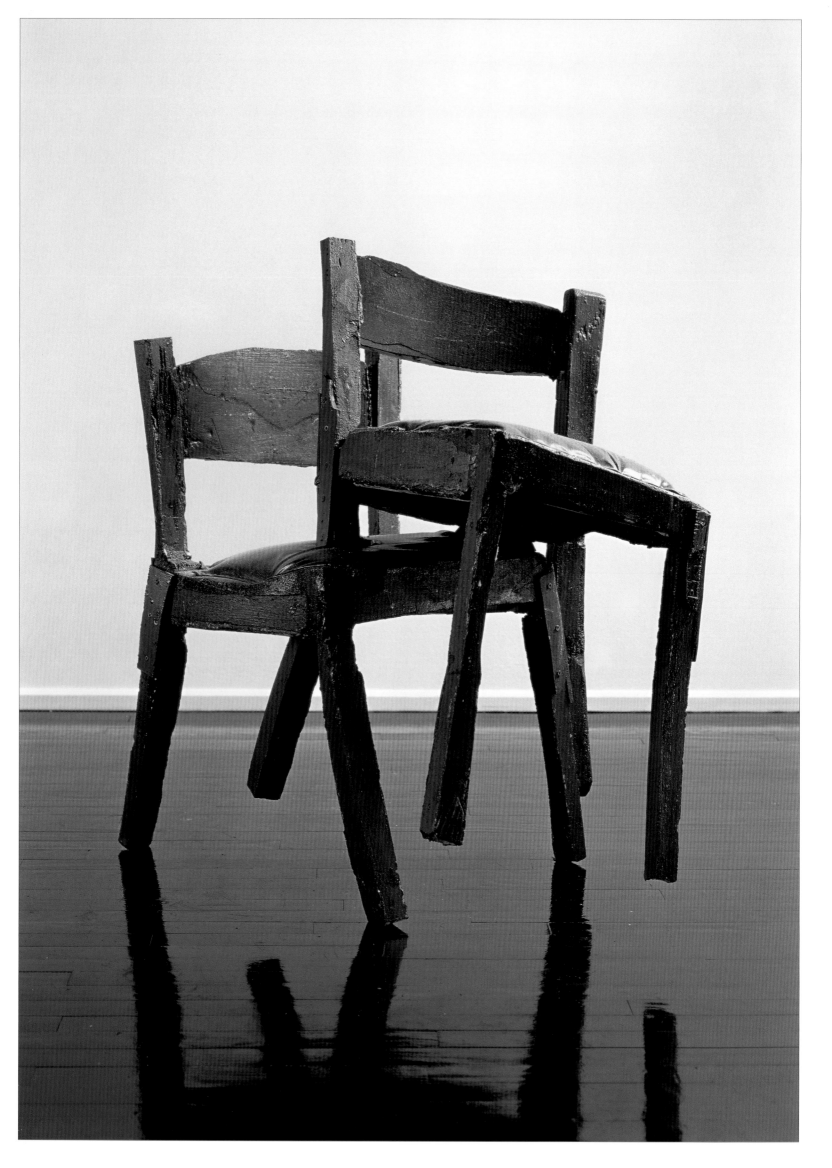

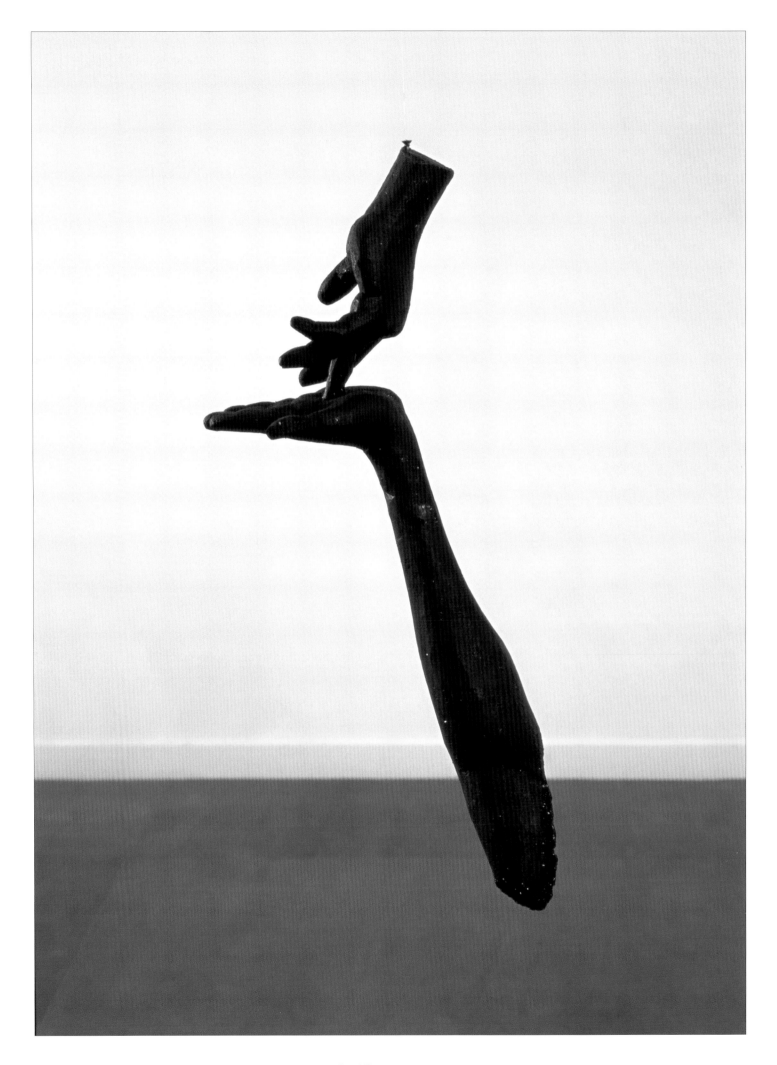

Stühle
2002
Two-component polyurethane foam, polyurethane foam,
cardboard, tape, acrylic paint, imitation leather, brass pins
97 x 85 x 91 cm; 38 ¼ x 33 ½ x 35 ⅞ in.

Page 397:
Hudson
1995
Particleboard, latex paint, screws
Dimensions unknown

Hands
2002
Cast aluminum, wire, enamel paint
73 x 30 cm; 28 ¼ x 11 ¼ in.

A Ruin Looking Good in Dawn
2003
Iris print in frame of polyurethane resin, acrylic
paint, glass, cardboard
46 x 38.3 cm; 18 ⅛ x 15 ⅛ in.

Cold Coffee Waits
2003
Iris print in frame of polyurethane resin, acrylic paint,
glass, cardboard
46 x 38.3 cm; 18 ⅛ x 15 ⅛ in.

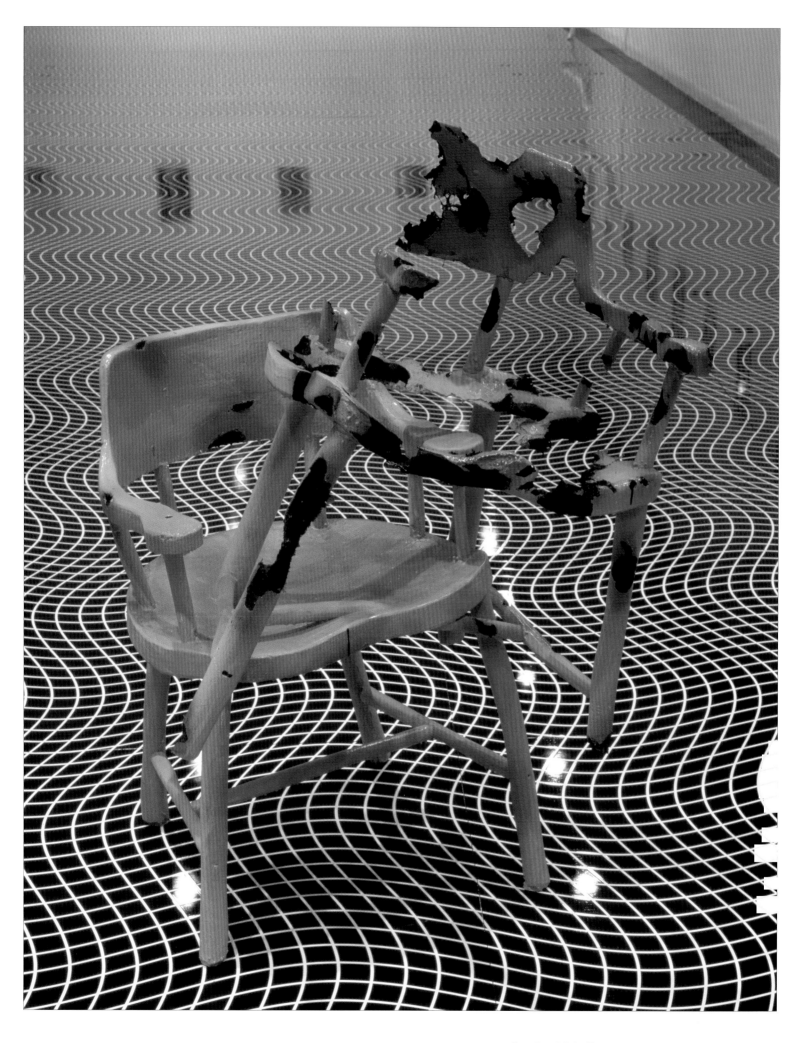

Late Late Night Show
2002
Polystyrene, acrylic paint, wood glue, polyurethane foam, screws
117 x 97 x 66 cm; 46 x 38 ¼ x 26 in.
Installation view, "Lowland Lullaby: Ugo Rondinone with John
Giorno and Urs Fischer," Swiss Institute, New York, 2002
On floor: Ugo Rondinone, *Lowland Lullaby*, 2002

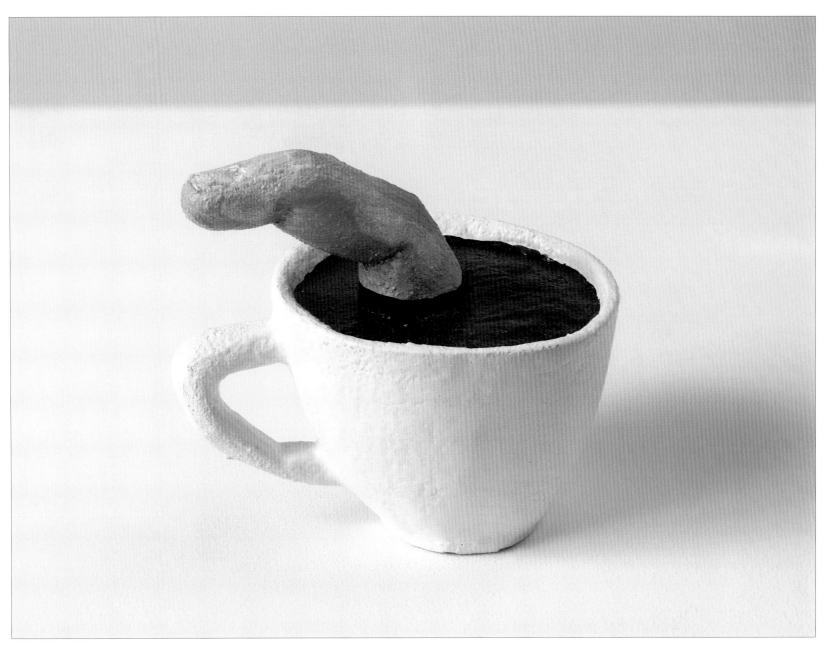

The Way You Move
2003
Polystyrene, polyurethane glue, acrylic paint, marker
12 x 9 x 13 cm; 4 ¾ x 3 ½ x 5 ⅛ in.

Opposite page, clockwise from top right:

Head Side Frontal
from the portfolio *Thinking about Störtebeker*
2005

Digital Sperm 1
Digital image
2002

Digital Sperm 2
Digital image
2002

Digital Sperm 3
Digital image
2002

Page 404:

You Can Not Win
2003
Polystyrene, acrylic paint, Aqua-Resin, screws,
fiberglass
137.2 x 76.2 x 129.5 cm; 54 x 30 x 51 in.

Page 405:

You Can Only Lose
2003
Polystyrene, acrylic paint, Aqua-Resin, screws,
fiberglass
312.4 x 111.8 x 106.7 cm; 123 x 44 x 42 in.

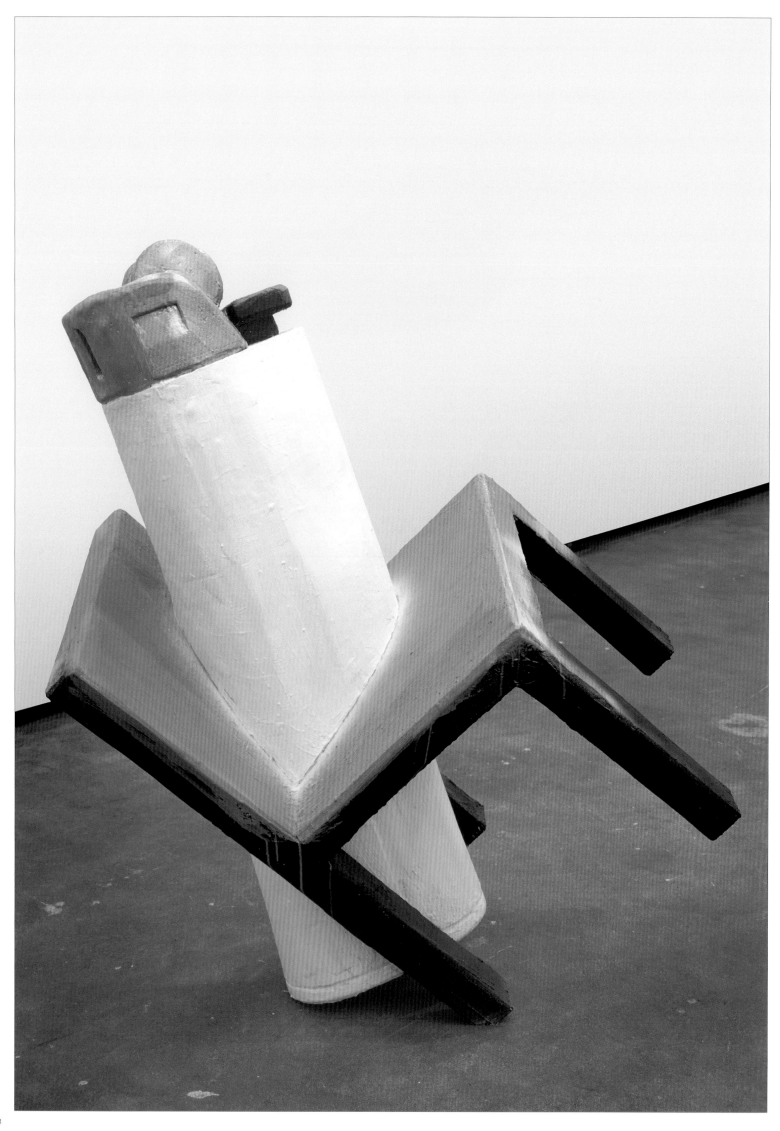

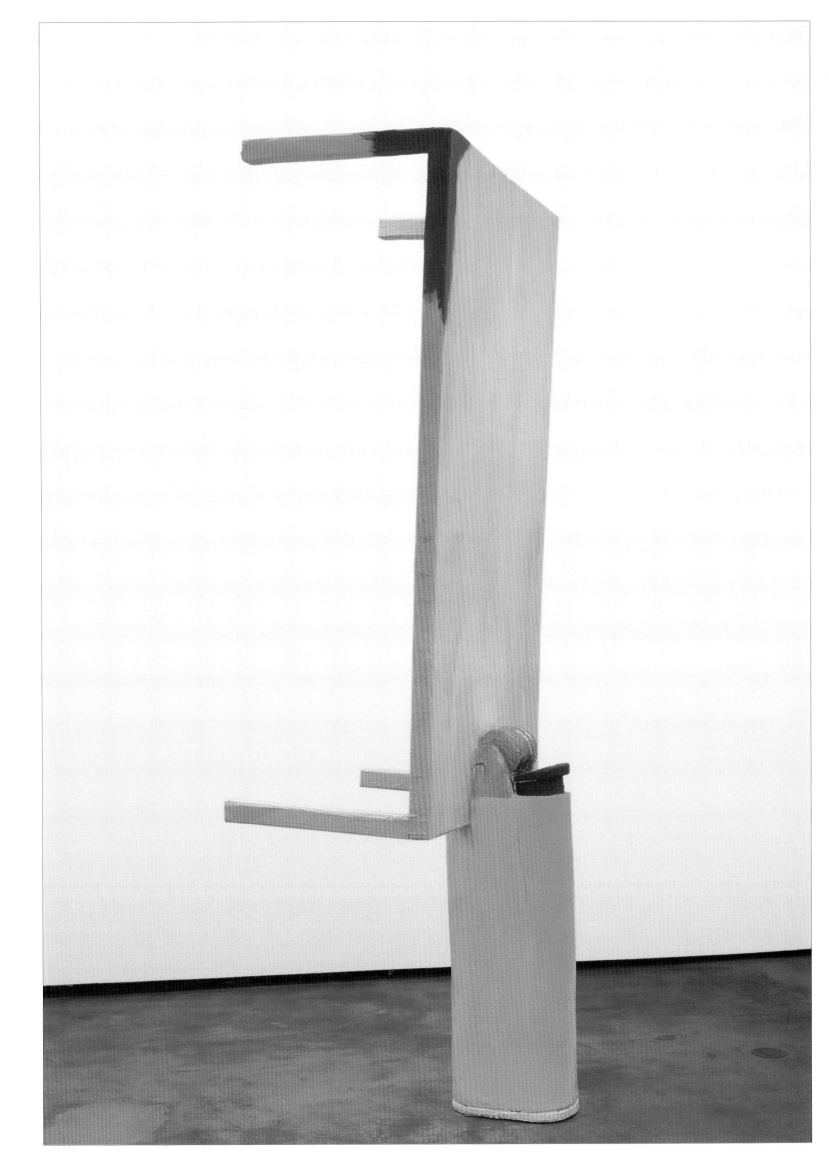

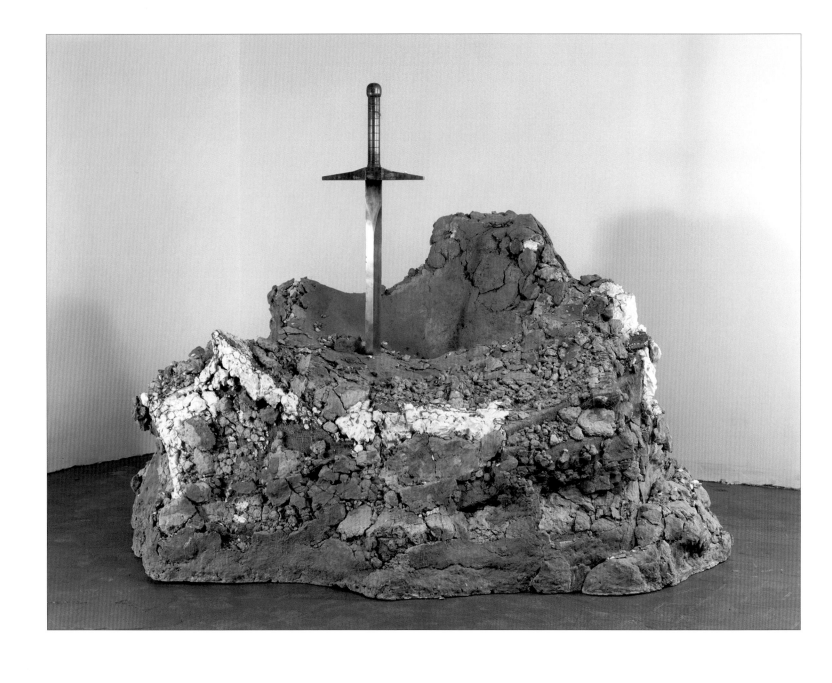

Untitled
2003
Steel, concrete, screws, hair, glue, plastic,
burlap, wood, chicken wire
193 x 243.8 x 162.6 cm; 76 x 96 x 64 in.

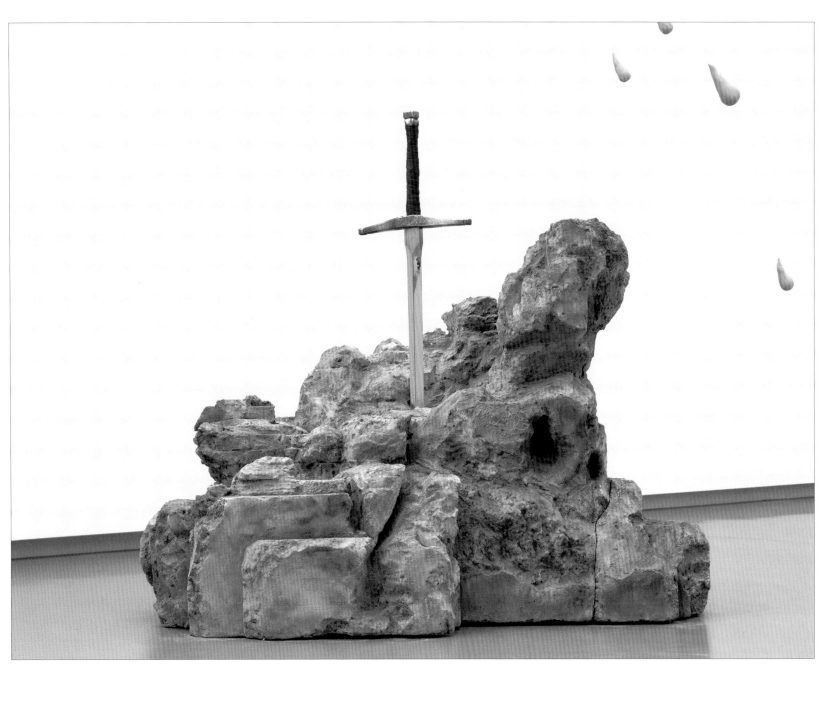

Untitled
2004
Concrete, iron, steel, wax, cement, soot, pigments,
hair, polyurethane resin, acrylic paint
200 x 227 x 170 cm; 78 ¼ x 89 ⅛ x 66 ⅞ in.
Installation view, "Kir Royal," Kunsthaus Zürich, 2004
Horses Dream of Horses, 2004

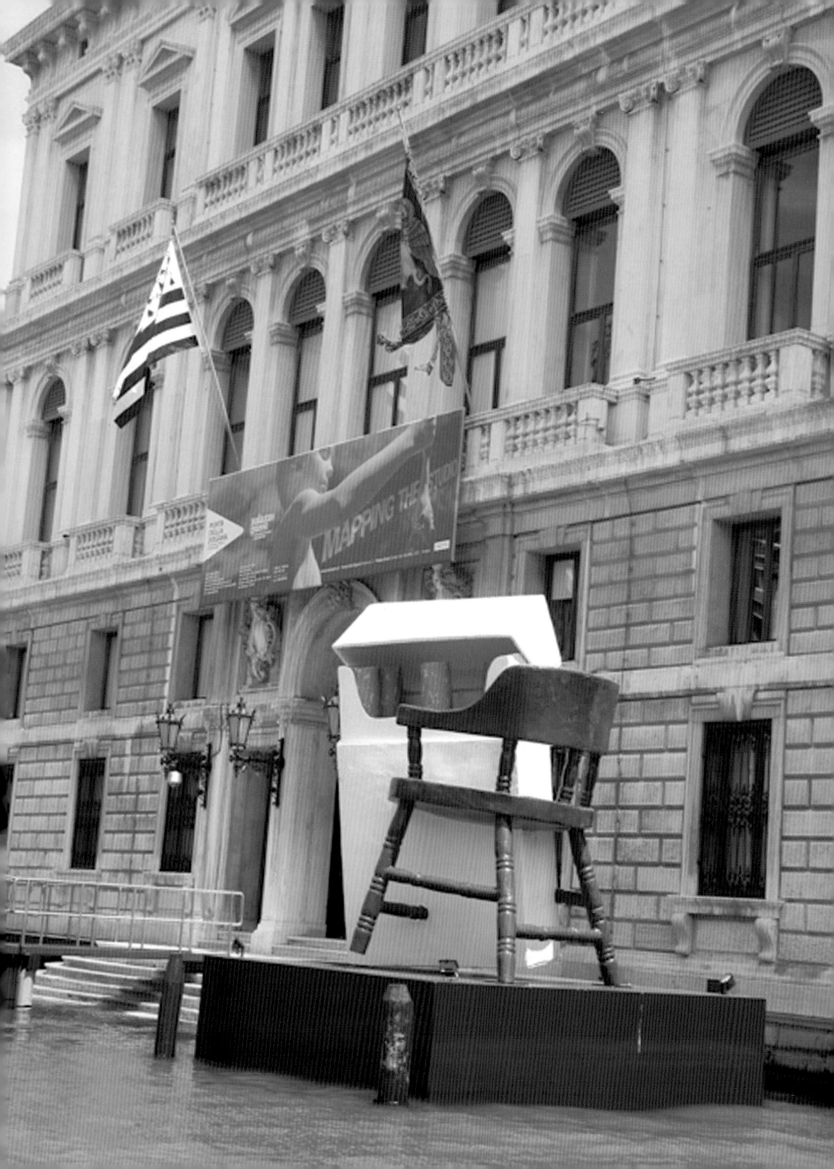

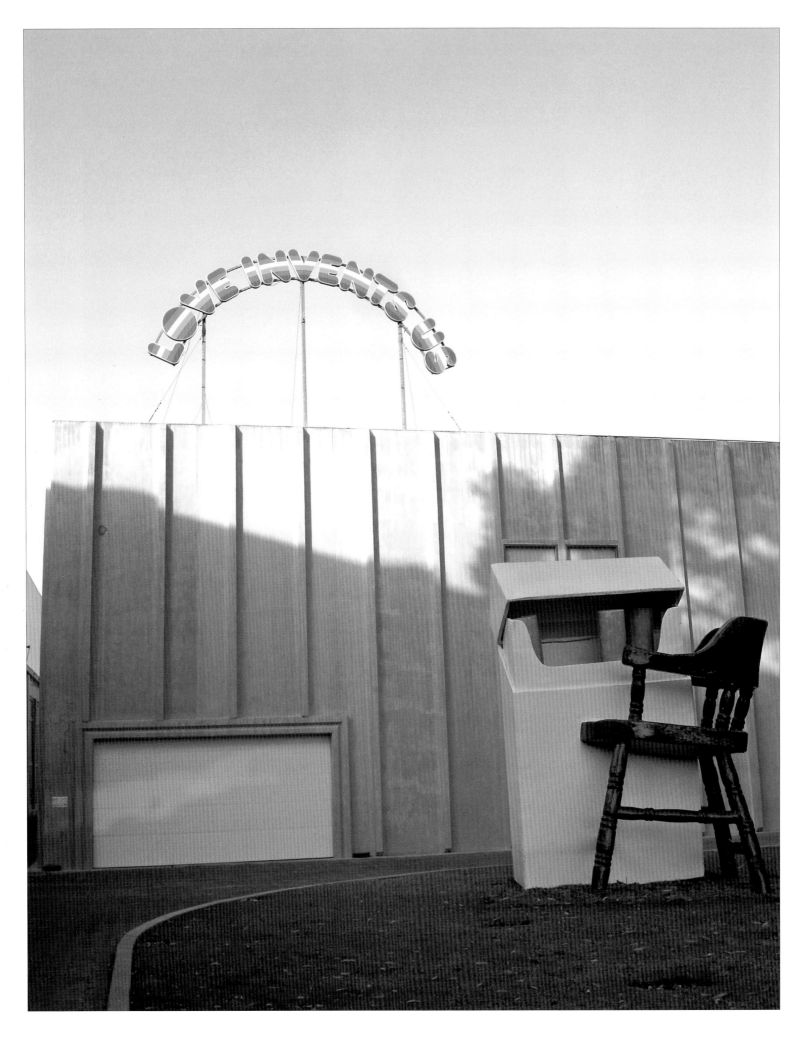

Installation view, "Mapping the Studio: Artists from the
François Pinault Collection," Palazzo Grassi and Punta della
Dogana, Venice, 2009
Bad Timing, Lamb Chop!, 2004–2005

Bad Timing, Lamb Chop!
2004–2005
Cast aluminum, polyurethane resin, enamel paint
450 x 230 x 330 cm; 177 ⅛ x 90 ½ x 129 ⅞ in.
Installation view, "Schweiz über alles," La Colección
Jumex, Ecatepec, Mexico, 2008
Top: Ugo Rondinone, *Love invents us*, 1999

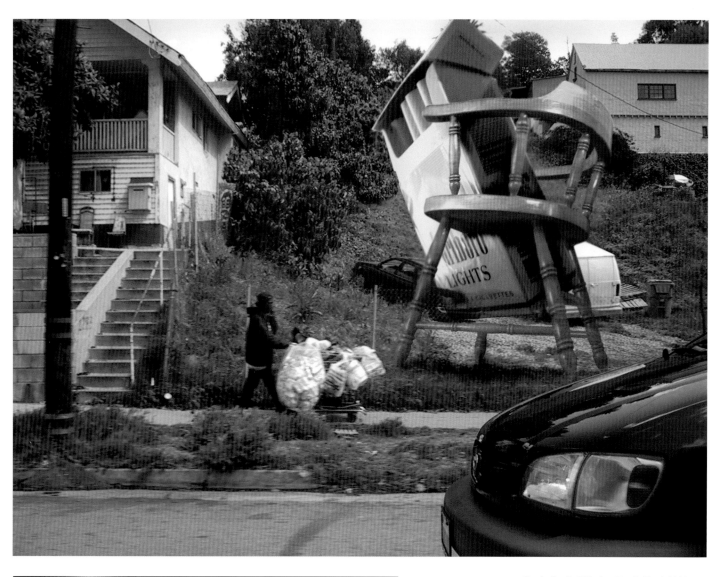

Study for *Bad Timing, Lamb Chop!*, 2001

Study for *Untitled (Lamp / Bear)*, 2004

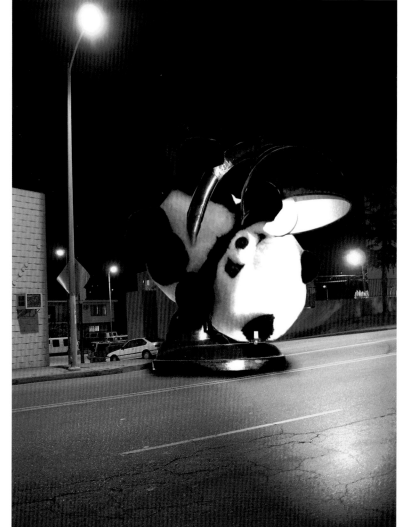

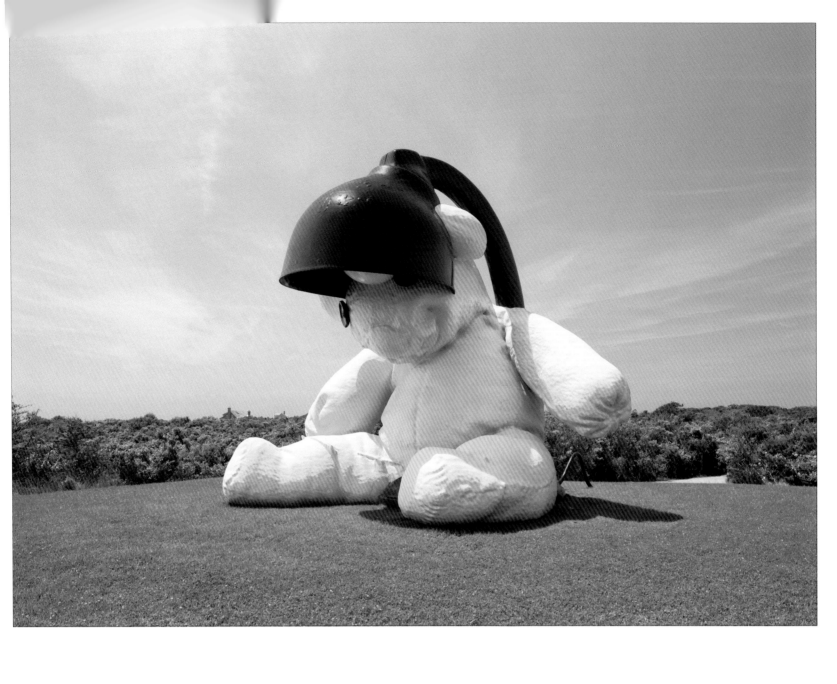

Untitled (Lamp / Bear)
2005–2006
Cast bronze, lacquer, acrylic glass, gas discharge lamp,
stainless steel framework
700 x 650 x 750 cm; 275 ⅝ x 255 ⅞ x 295 ¼ in.
Installation view, home of Amalia Dayan and Adam
Lindemann, Montauk, New York, 2009

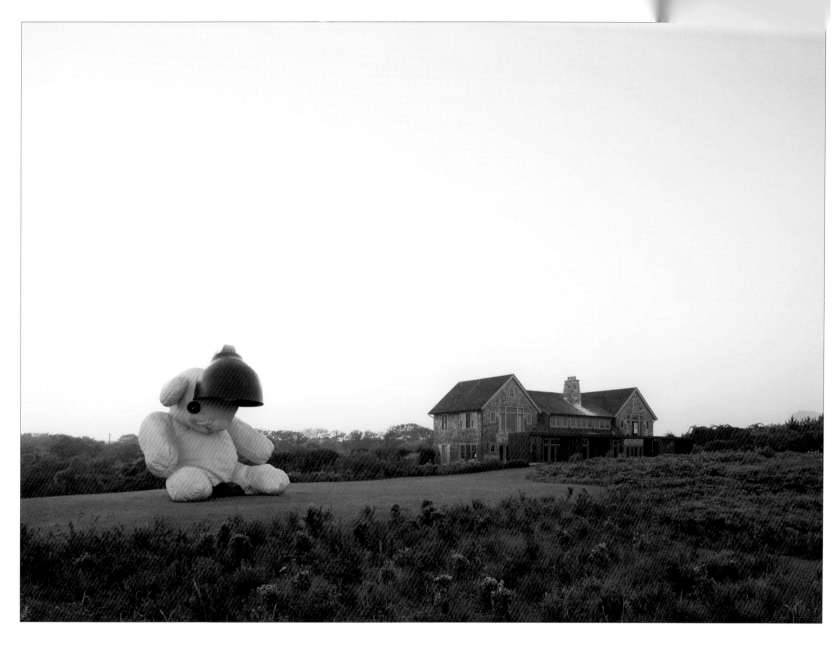

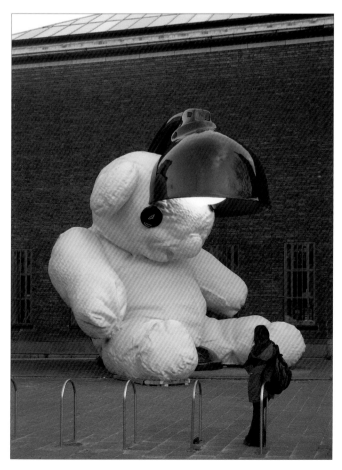

Installation view, "Paris 1919," Museum Boijmans Van
Beuningen, Rotterdam, 2006
Prototype for *Untitled (Lamp / Bear)*, 2005–2006

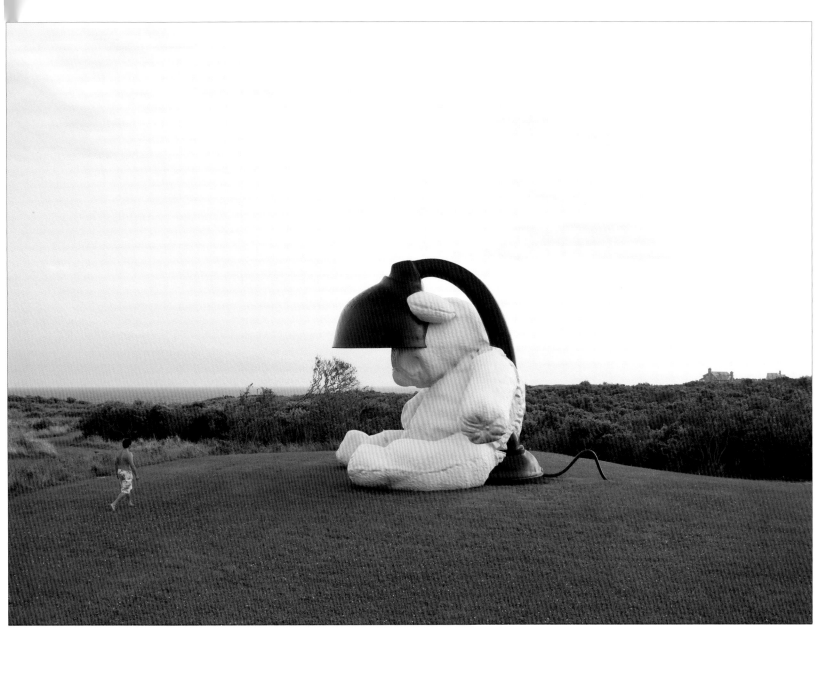

Untitled (Lamp / Bear)
2005–2006
Cast bronze, lacquer, acrylic glass, gas discharge lamp,
stainless steel framework
700 x 650 x 750 cm; 275 ⅝ x 255 ⅞ x 295 ¼ in.
Installation view, home of Amalia Dayan and Adam
Lindemann, Montauk, New York, 2009

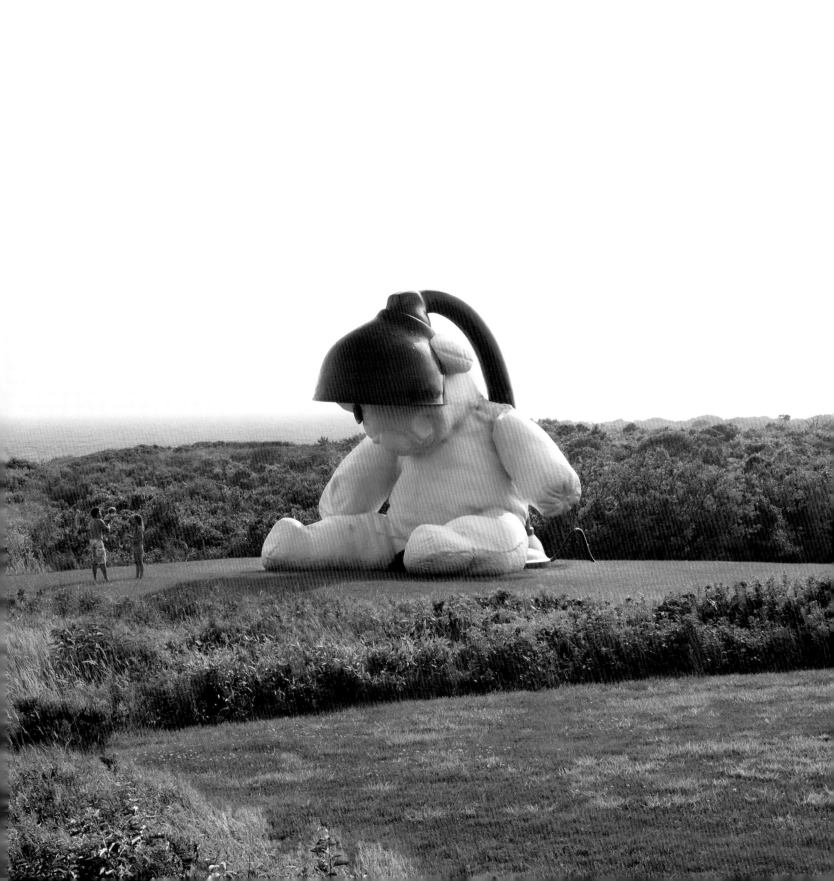

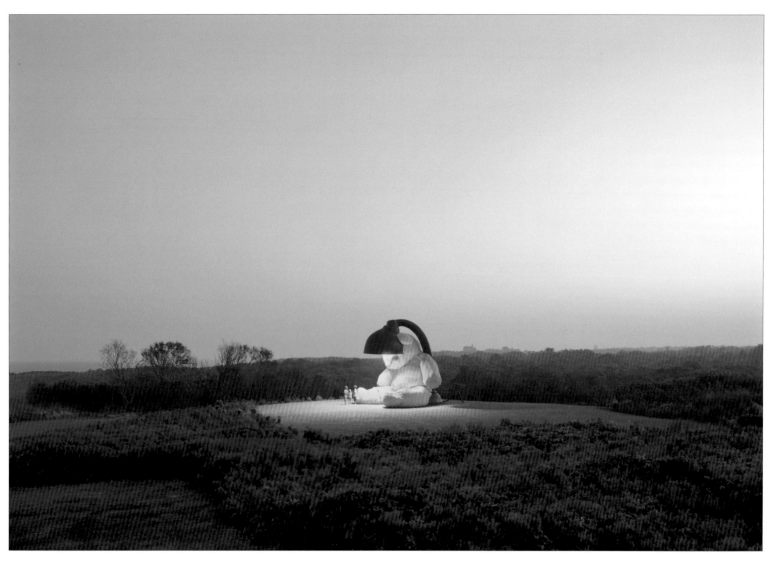

Untitled (Lamp / Bear)
2005–2006
Cast bronze, lacquer, acrylic glass, gas discharge lamp,
stainless steel framework
700 x 650 x 750 cm; 275 ⅝ x 255 ⅞ x 295 ¼ in.
Installation view, home of Amalia Dayan and Adam
Lindemann, Montauk, New York, 2009

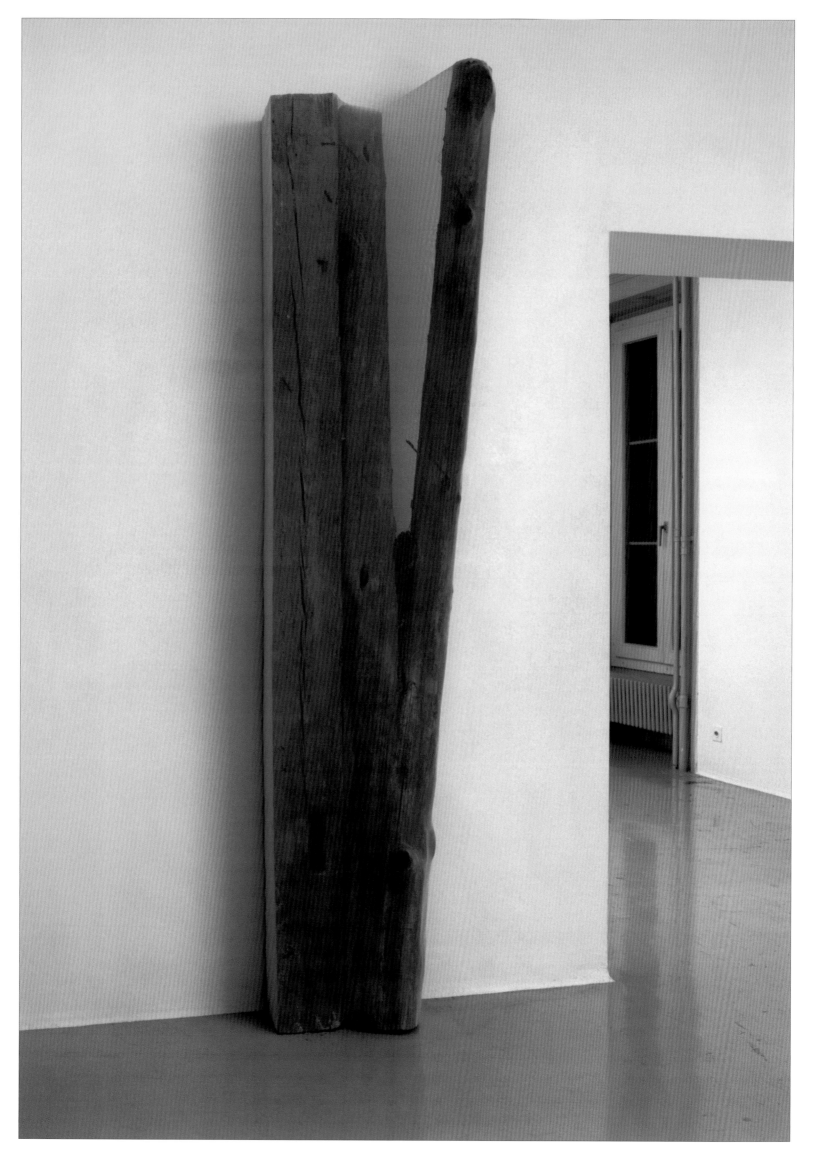

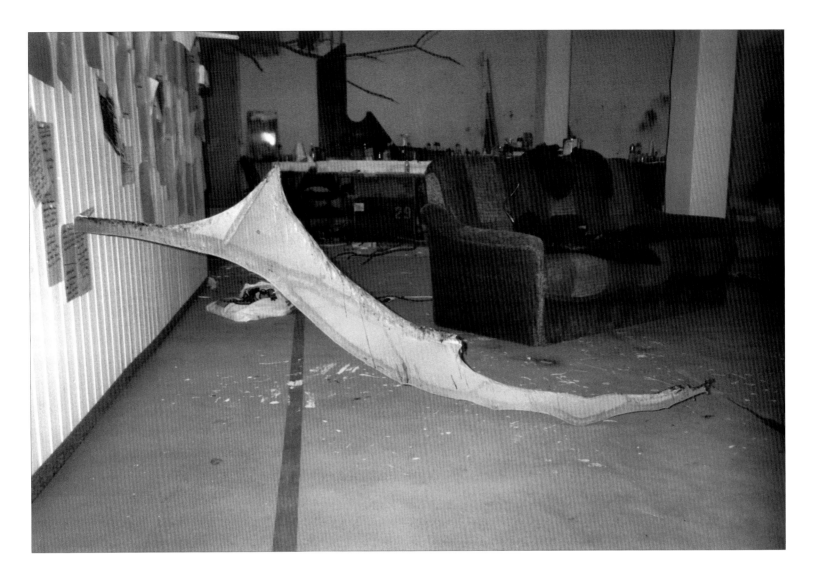

Untitled
1999
Branch, tulle, wax, glue, staples
Dimensions unknown

Untitled
1993
Ink and marker on paper; framed
34.2 x 25.5 x 2.8 cm; 13 ½ x 10 x 1 ⅛ in.

Opposite page:
Untitled
1997
Beam, log, gauze, staples
Dimensions unknown

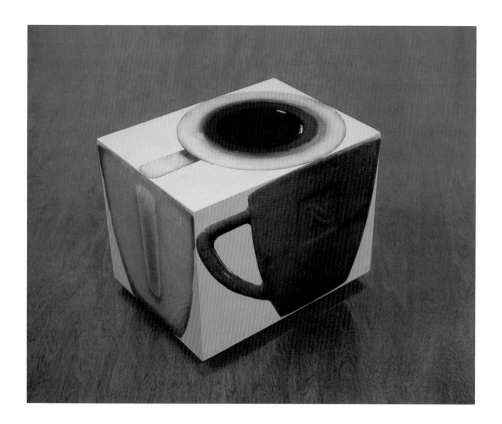

Cup / Cigarettes / Skid
2006
Wood, polyurethane glue, acrylic paint, nails
Coffee cup: 19 x 24.3 x 18 cm; 7 ½ x 9 ⅝ x 7 ⅛ in.
Cigarettes: 26 x 13.8 x 8.9 cm; 10 ¼ x 5 ⅛ x 3 ½ in.
Pallet: 81.1 x 67.8 x 8.9 cm; 31 ⅞ x 26 ¼ x 3 ½ in.
Installation view, "Oh. Sad. I see.,"
The Modern Institute, Glasgow, 2006

Opposite page:

Installation view, "Oh. Sad. I see.,"
The Modern Institute, Glasgow, 2006
Left to right: *Cup / Cigarettes / Skid*, 2006;
Mackintosh Staccato, 2006; *Oh, Sad, I See*, 2006

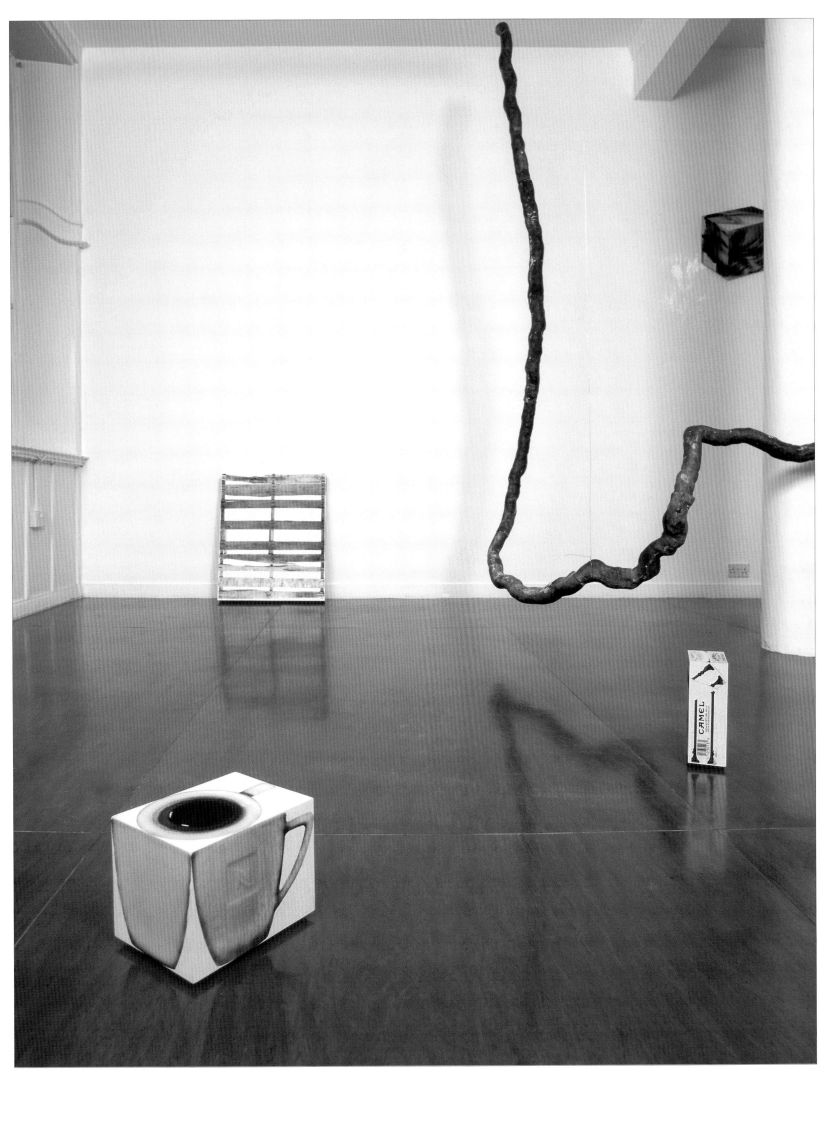

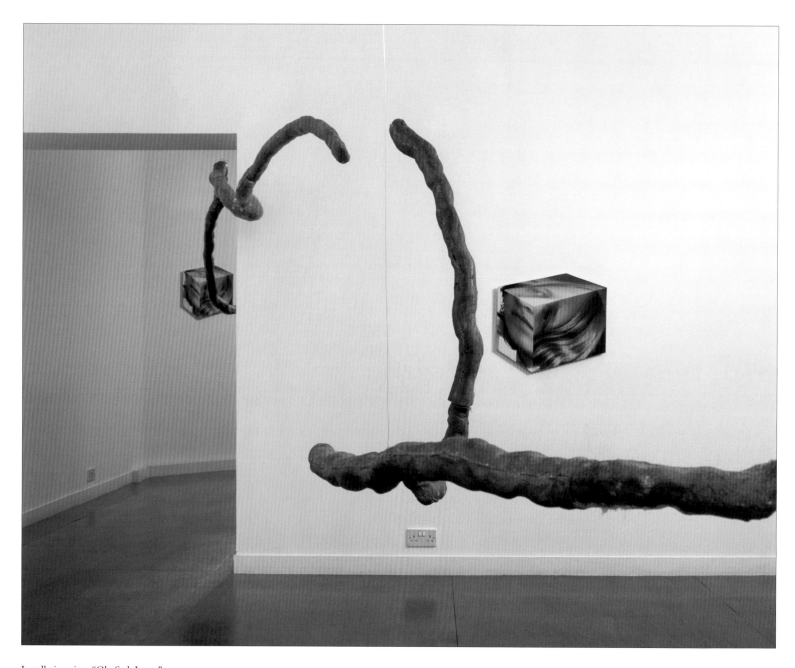

Installation view, "Oh. Sad. I see.,"
The Modern Institute, Glasgow, 2006
Left to right: *Oh, Sad, I See*, 2006;
Mackintosh Staccato, 2006

Oh, Sad, I See
2006
ACM panels, wood, acrylic paint, gesso, epoxy glue
Each 48 x 54.5 x 2.2 cm; 18 ⅞ x 21 ½ x 1 in.

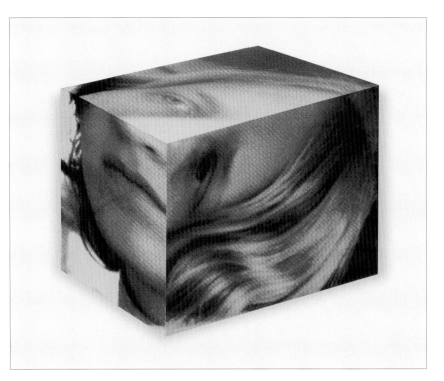

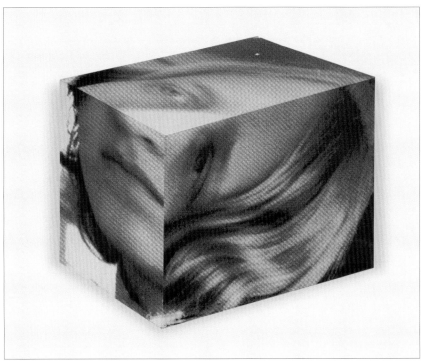

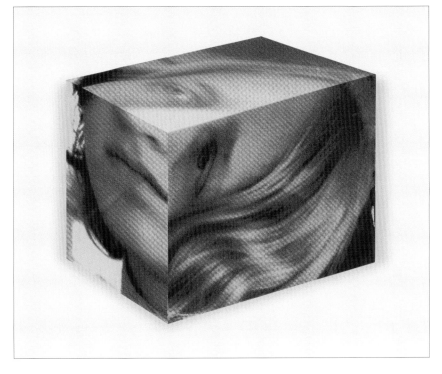

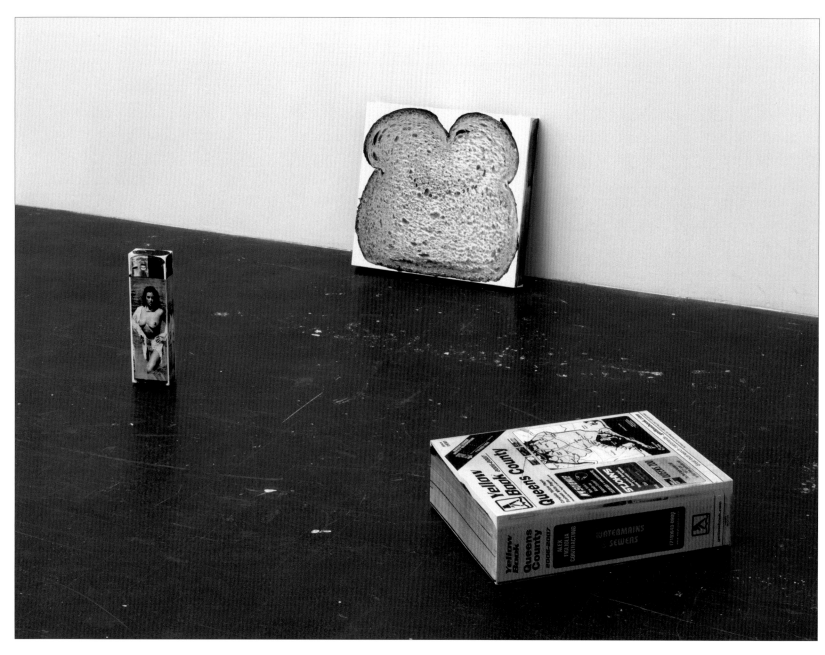

Untitled
2006
MDF, gesso, acrylic paint, wood, wood glue, screws
Lighter: 36.6 x 11 x 5.2 cm; 14 ⅜ x 4 ⅛ x 2 in.
Book: 15.8 x 55 x 41.5 cm; 6 ¼ x 21 ⅝ x 16 ⅜ in.
Toast: 54 x 58.8 x 7.8 cm; 21 ¼ x 23 ⅛ x 3 ⅛ in.

Broom
2007
Polished stainless steel, gesso, inkjet print,
polyurethane foam, glue
137 x 68 x 9 cm; 54 x 26 ¼ x 3 ½ in.

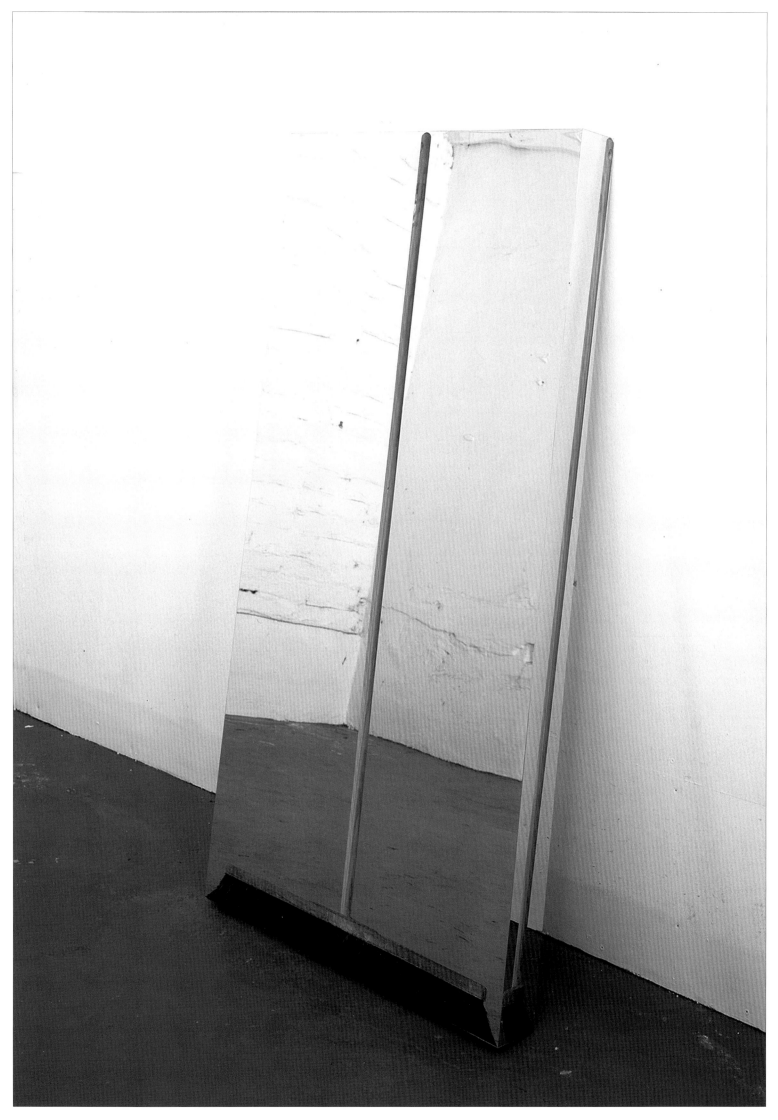

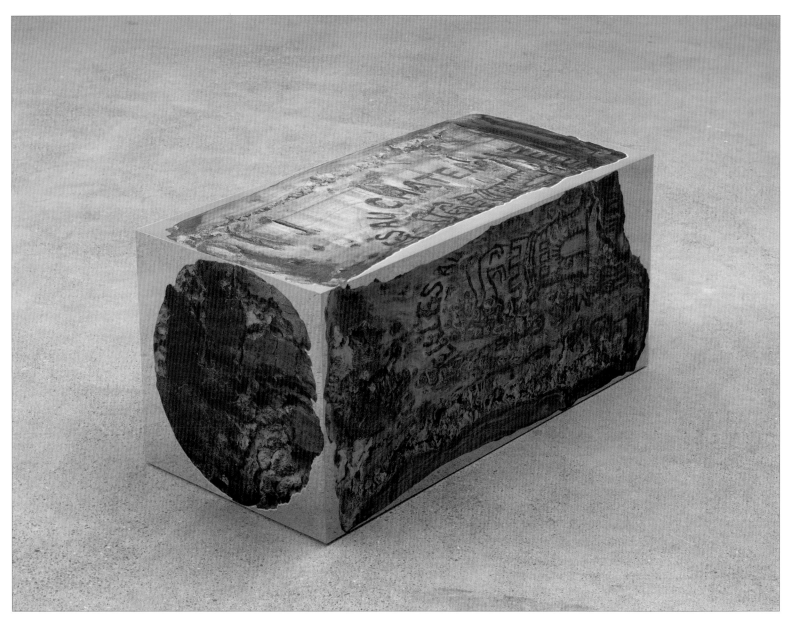

Cork
2009
Silkscreen print on mirror-polished stainless steel sheets, aluminum,
Alucore, two-component epoxy, stainless steel screws
45.2 x 98 x 45.5 cm; 17 ¼ x 38 ⅝ x 17 ⅞ in.

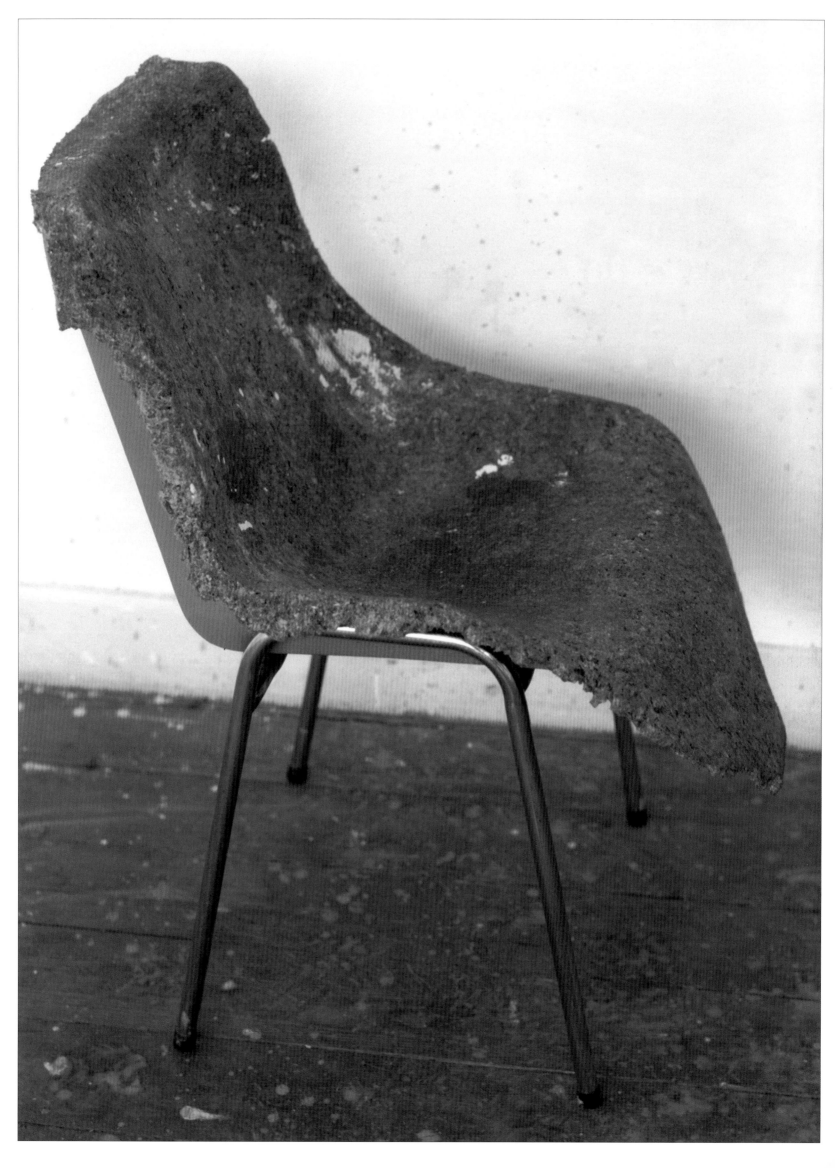

Schimmelteppich (Mold Rug)
1994
Rubber, foam
Dimensions unknown

Studio view, Leland Hotel, San Francisco,
1995

Studies for chairs for individual seating positions
Part 1 of 3
1993
Sawdust, rubber
Dimensions unknown

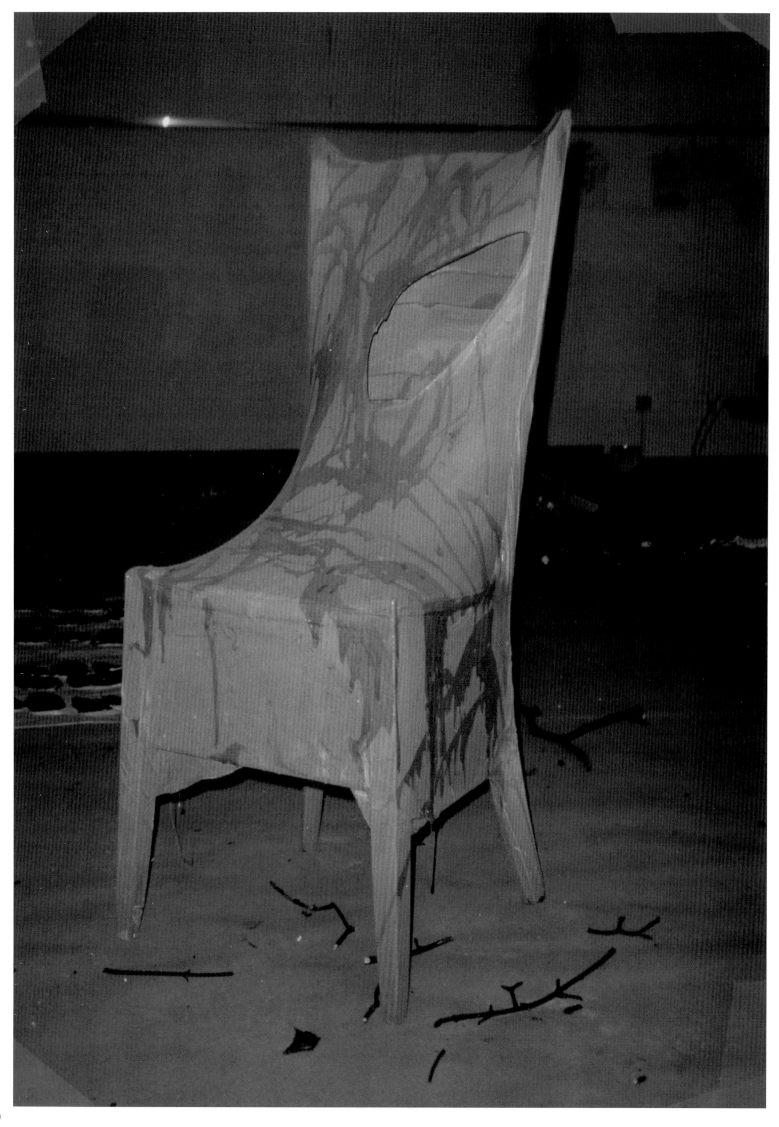

Untitled (Pink Chair)
1996
Found chair, gauze, acrylic paint, glue, staples,
lacquer
103 x 41 x 50 cm; 40 ½ x 16 ⅛ x 19 ¼ in.
Studio view, Wallisellen, Switzerland, 1998

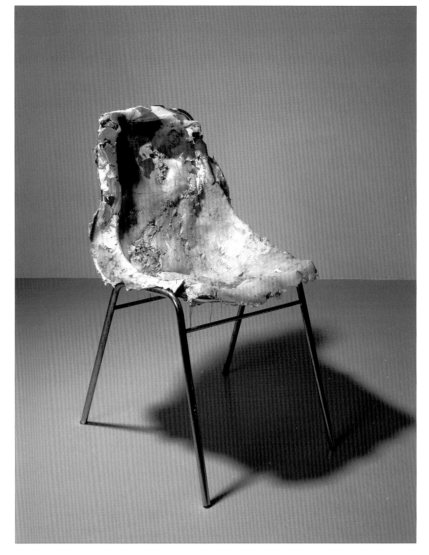

Chair (Sewn)
1999
Found chair frame, silicone, thread, acrylic paint
82 x 52 x 57 cm; 32 ¼ x 20 ½ x 22 ½ in.

Chairs
1998–1999
Silicone, sawdust, plastic, found chairs, spray
enamel, metal
75 x 153 x 57 cm; 29 ½ x 60 ¼ x 22 ½ in.

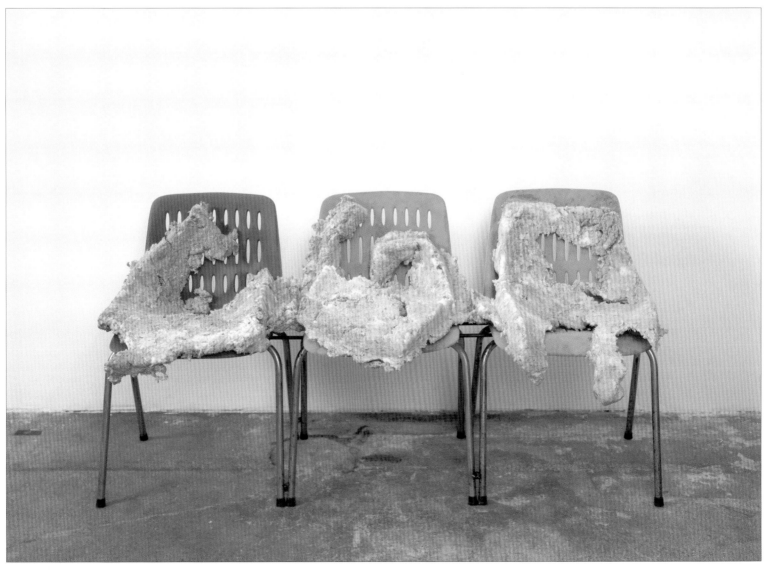

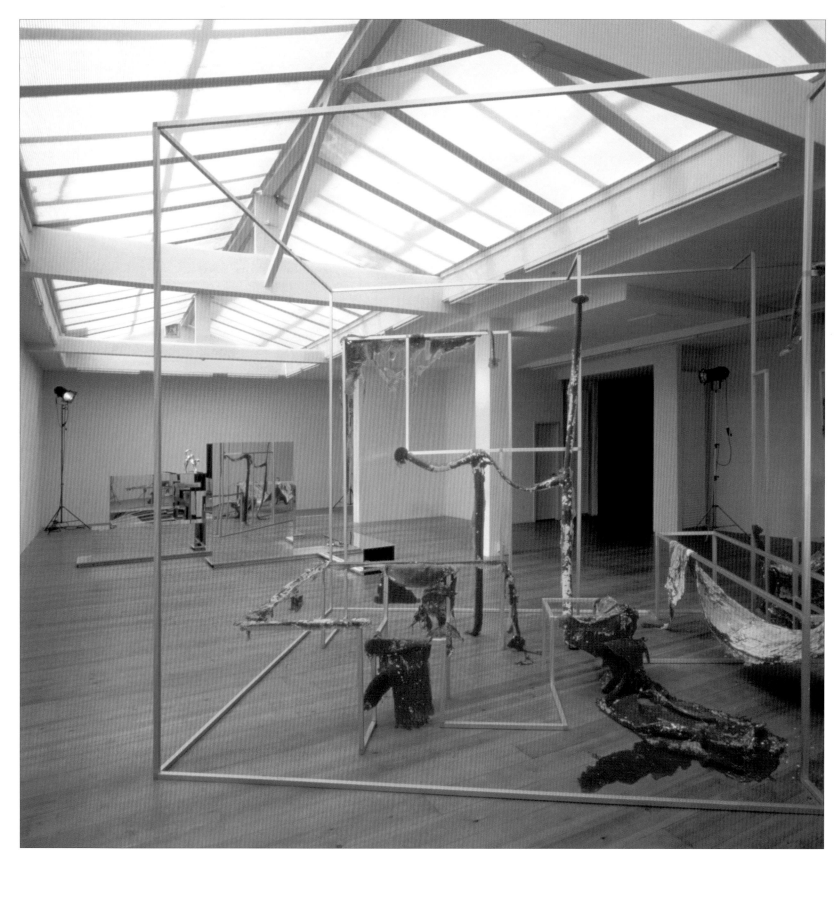

Installation view, "The Membrane—and why I don't
mind bad-mooded People," Stedelijk Museum Bureau
Amsterdam, 2000
Foreground to background: *The Membrane (Half Full, Half
Empty)*, 2000; *Dr. Katzelberg (Zivilisationsruine)*, 1999

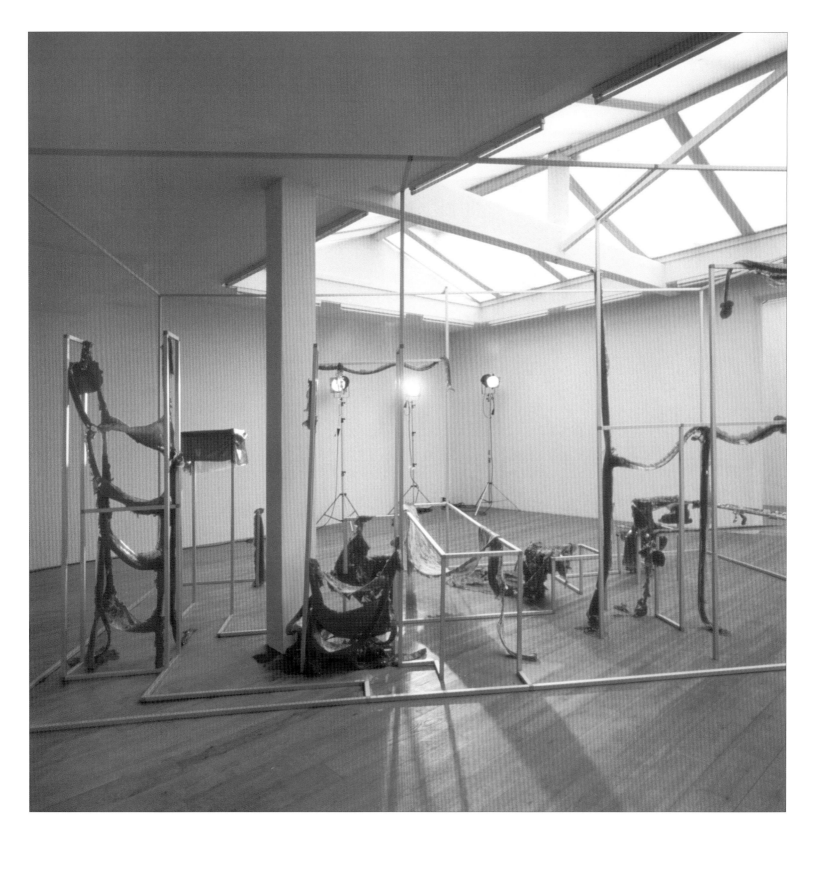

The Membrane (Half Full, Half Empty)
2000
Polyurethane rubber (casts of furniture), pigments,
aluminum tubes with plastic connectors, theater spotlights
on tripods
300 x 600 x 300 cm; 118 ⅛ x 236 ¼ x 118 ⅛ in.
Installation view, "The Membrane—and why I don't
mind bad-mooded People," Stedelijk Museum Bureau
Amsterdam, 2000

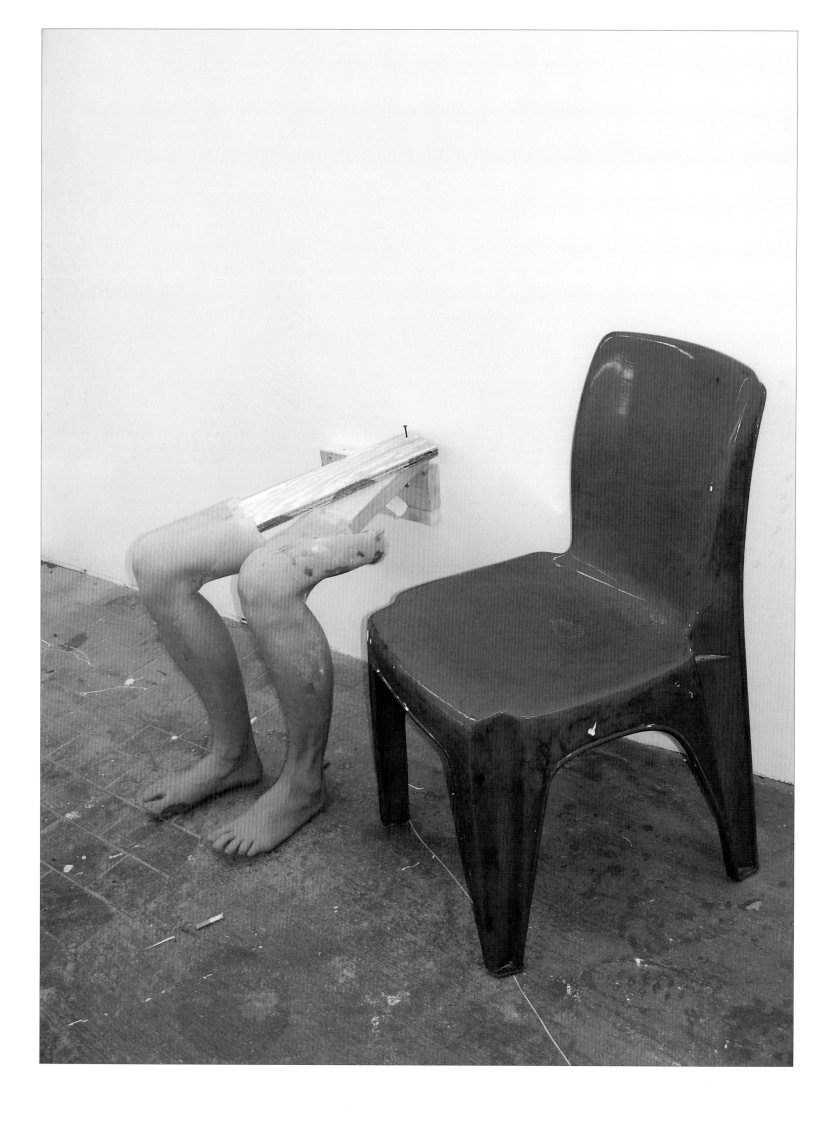

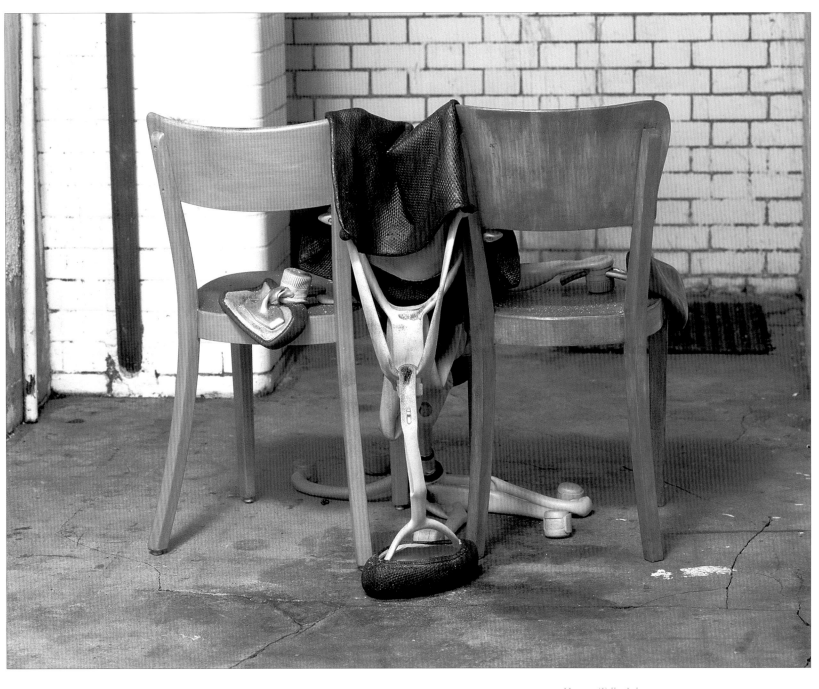

How to Tell a Joke
2007
Polyurethane resin, polymeric plaster, steel, pigments,
acrylic paint, matte varnish, dust
100 x 95 x 100 cm; 39 ⅜ x 37 ⅛ x 39 ⅜ in.

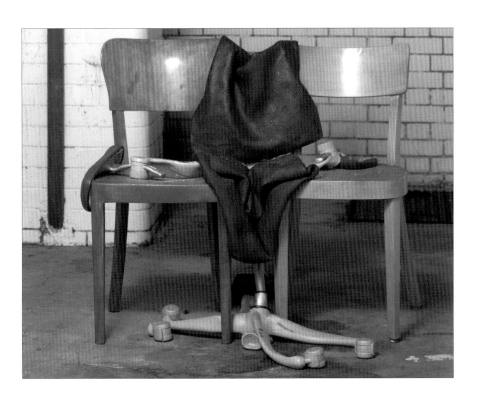

Opposite page:

Untitled
2006
Silicone, wood, found chair, shellac
Dimensions variable

Pages 436–437:

To be titled (Y-Chair)
2007
Polyurethane resin, polymeric plaster, steel, pigments
100 x 95 x 90 cm; 39 ⅜ x 37 ⅛ x 35 ⅜ in.

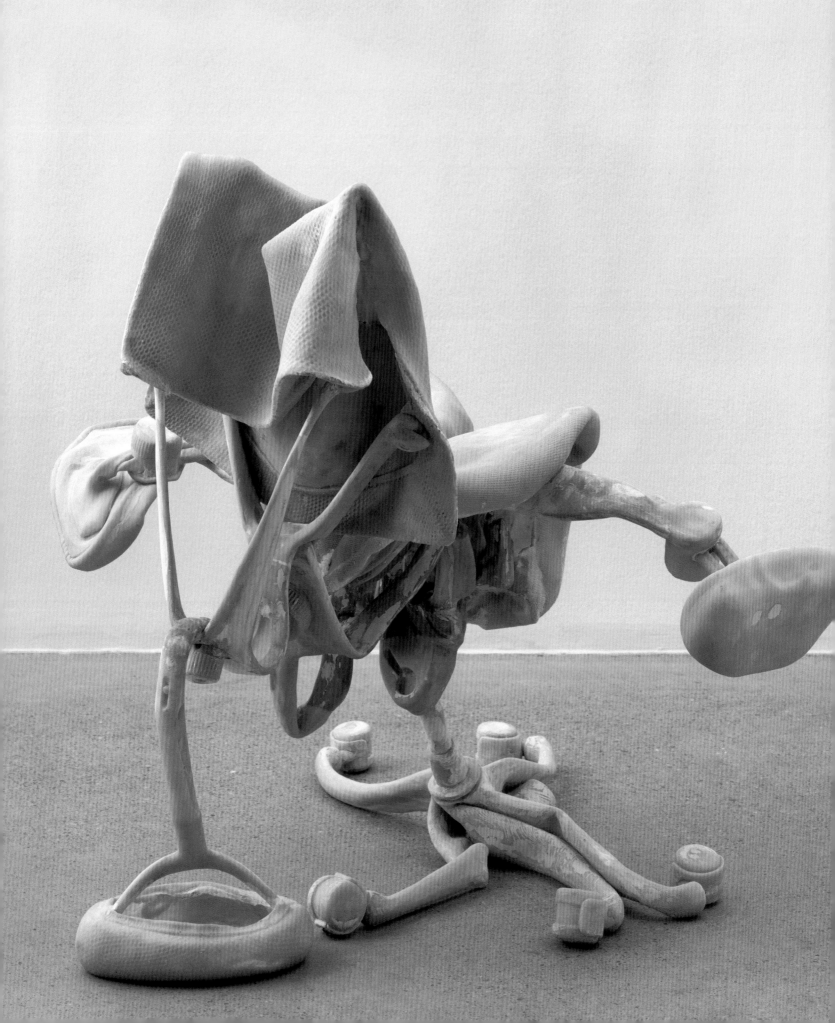

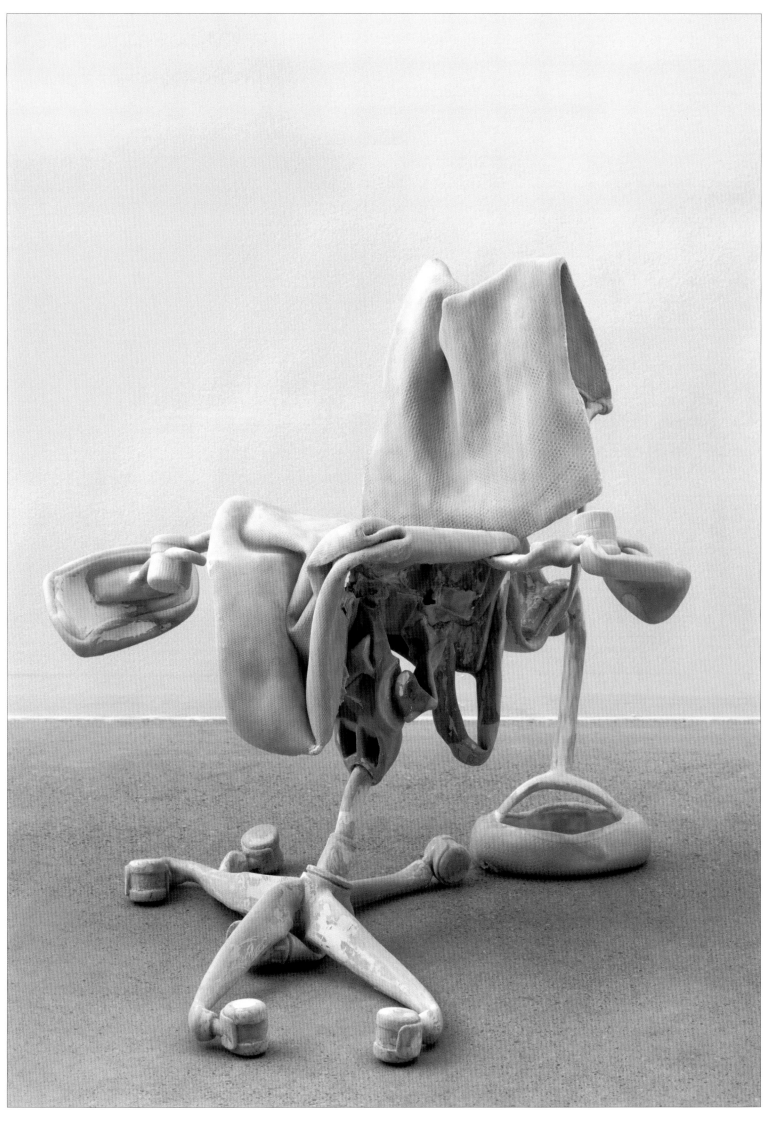

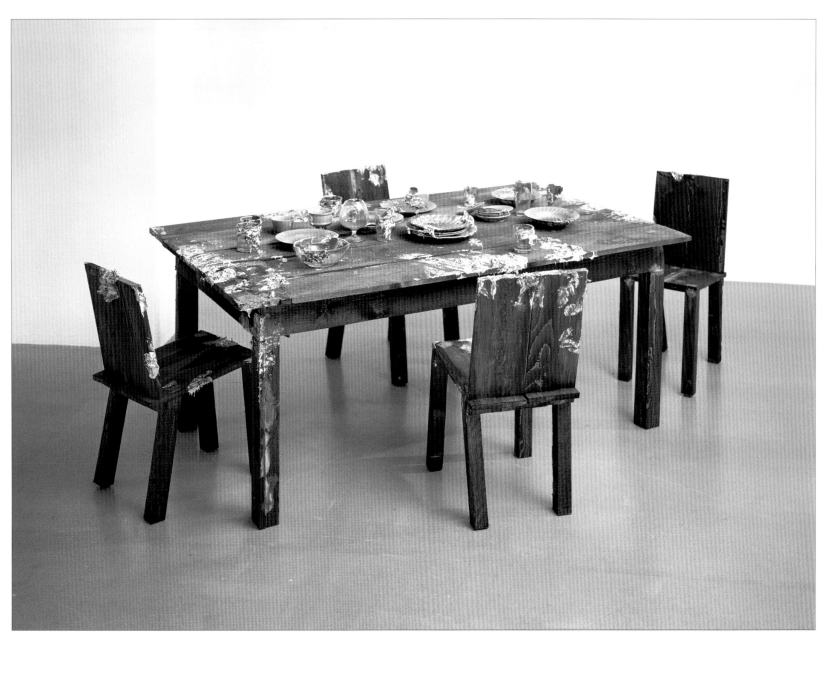

Untitled
1997
Wood, wood glue, stain, dishes, glasses, epoxy adhesive,
silicone, acrylic paint
Table: 105 x 184 x 78 cm; 41 ⅛ x 72 ½ x 30 ¾ in.
4 chairs, each 80 x 34 x 40 cm; 31 ½ x 13 ⅜ x 15 ¼ x in.

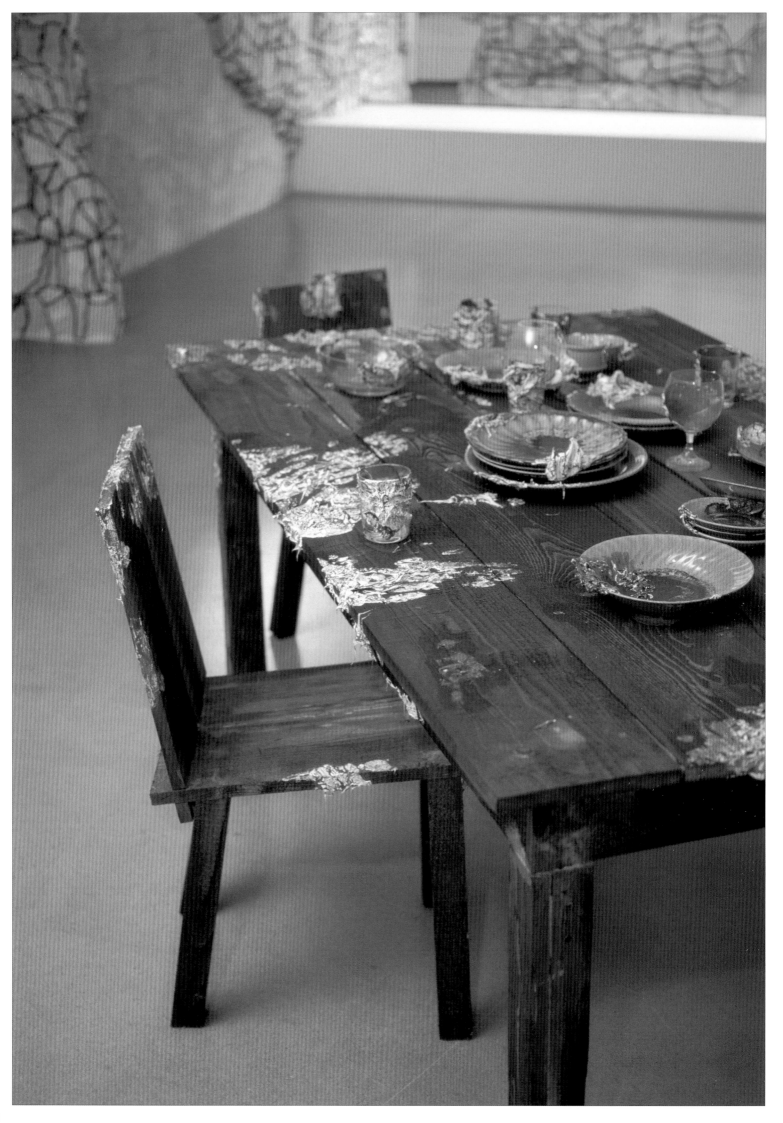

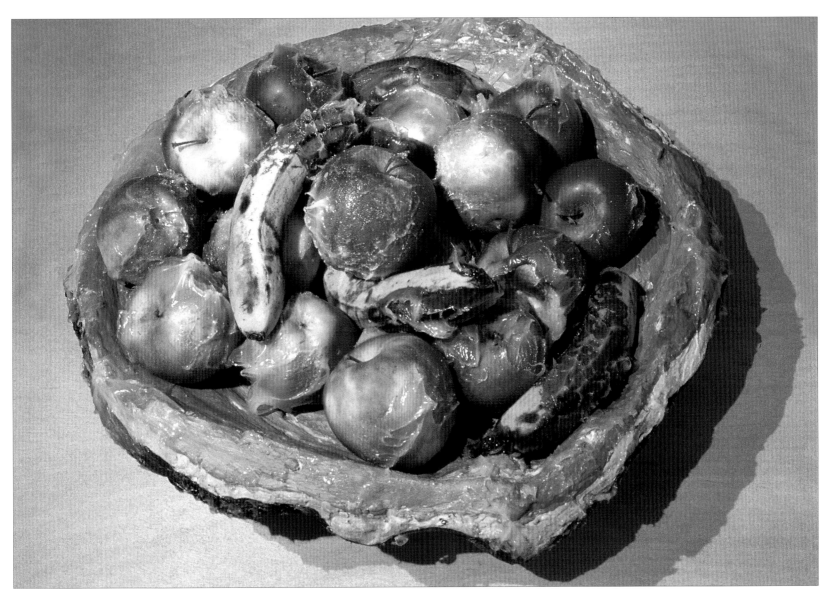

The Human Layer
1999
Plaster, clay, acrylic paint, silicone, fruits
20 x 50 x 50 cm; 7 ⅞ x 19 ¼ x 19 ¼ in.

Untitled
1997
Wood, wood glue, stain, dishes, glasses, epoxy adhesive, silicone, acrylic paint
Table: 105 x 184 x 78 cm; 41 ⅜ x 72 ½ x 30 ¼ in.
4 chairs, each 80 x 34 x 40 cm; 31 ½ x 13 ⅜ x 15 ¼ x in.
Installation view, "Hammer," Galerie Walcheturm, Zurich, 1997
Background: *Untitled (Wand der Angst)*, 1997

Opposite page:

Installation view, "Blurry Renoir
Debussy," Galerie Eva Presenhuber,
Zurich, 2008
Zizi, 2006–2008; *Marguerite de Ponty*,
2006–2008; *Miss Satin*, 2006–2008

Installation view, "Blurry Renoir
Debussy," Galerie Eva Presenhuber,
Zurich, 2008
Ix, 2006–2008; *Zizi*, 2006–2008;
Marguerite de Ponty, 2006–2008

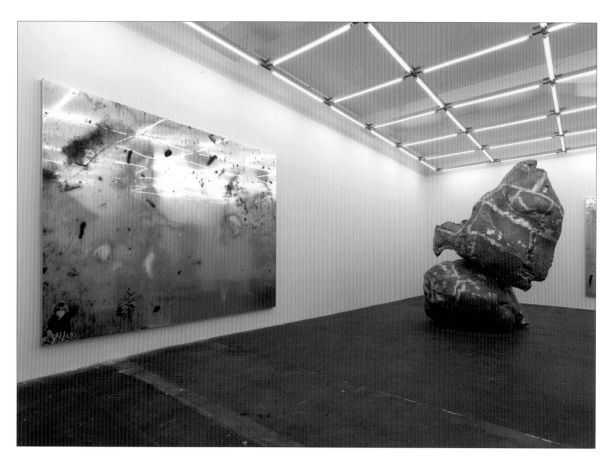

Installation view, "Blurry Renoir Debussy,"
Galerie Eva Presenhuber, Zurich, 2008
Blurry Renoir, 2008; *Miss Satin*, 2006–2008

Installation view, "Blurry Renoir Debussy,"
Galerie Eva Presenhuber, Zurich, 2008
Marguerite de Ponty, 2006–2008; *Ix*, 2006–2008;
Zizi, 2006–2008; *Blurry Renoir*, 2008;
Miss Satin, 2006–2008

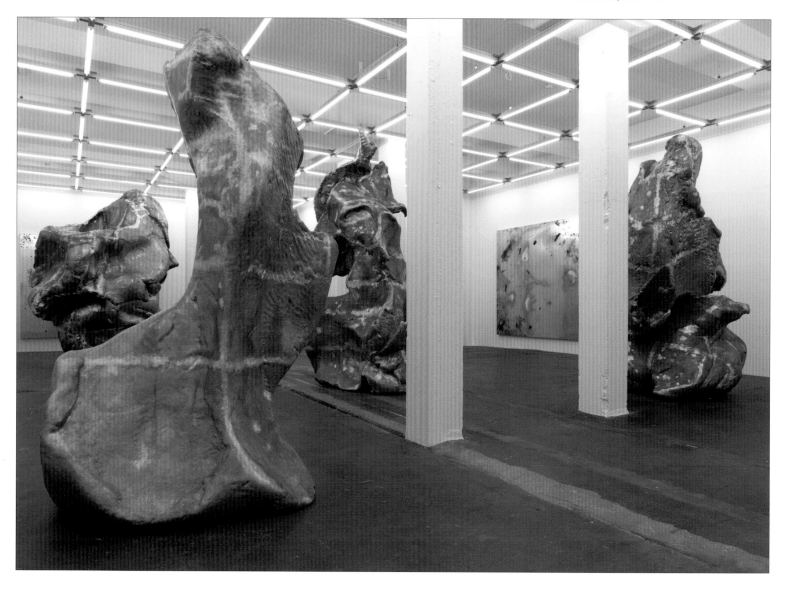

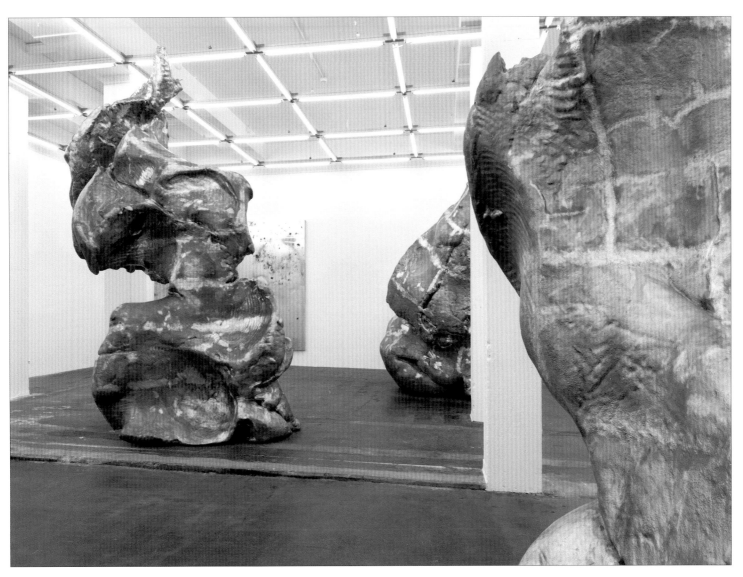

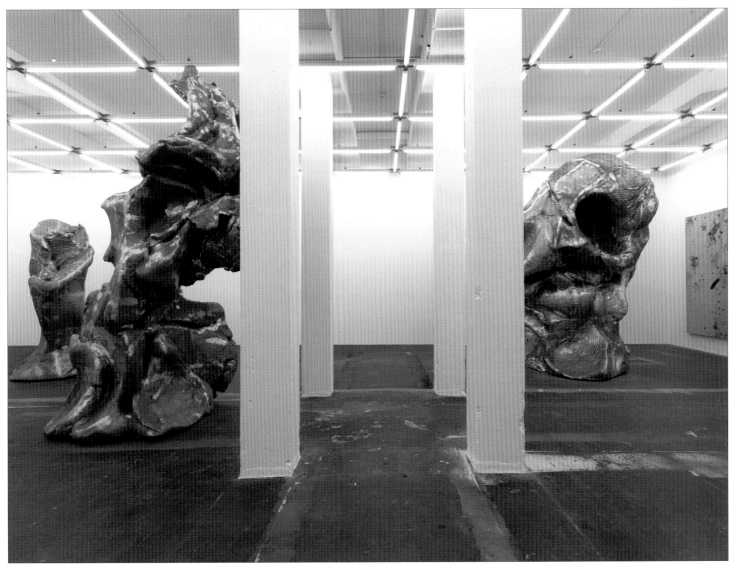

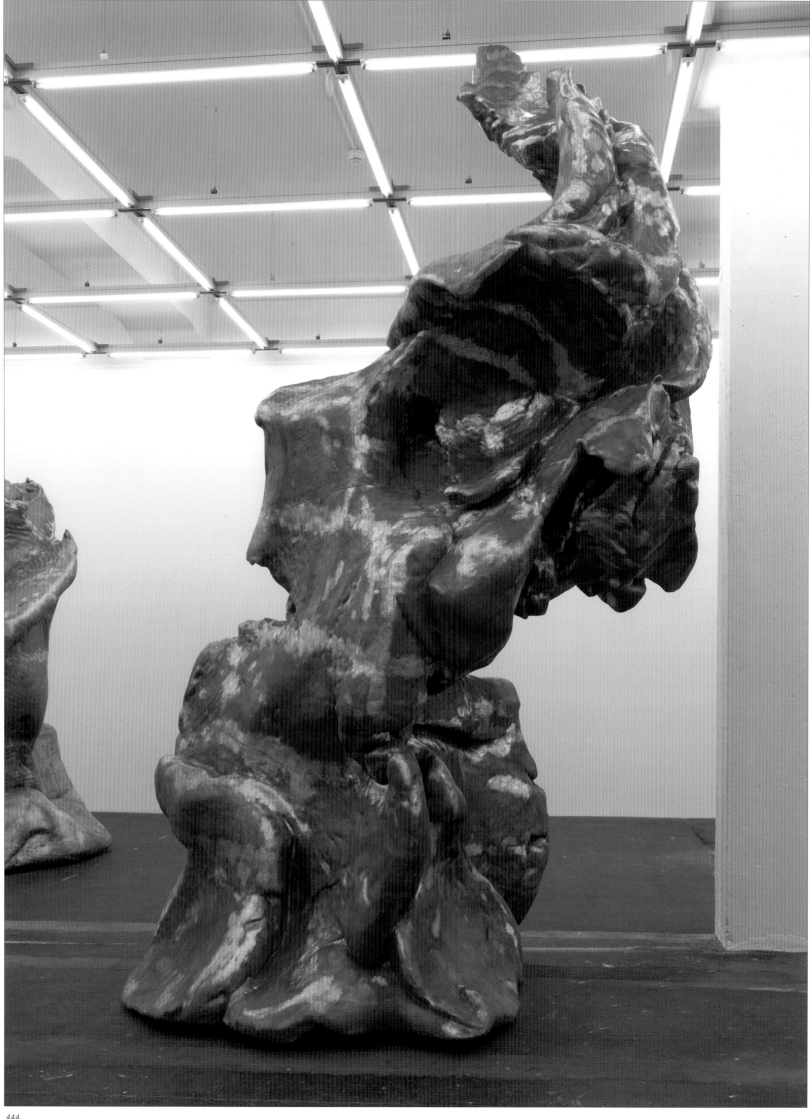

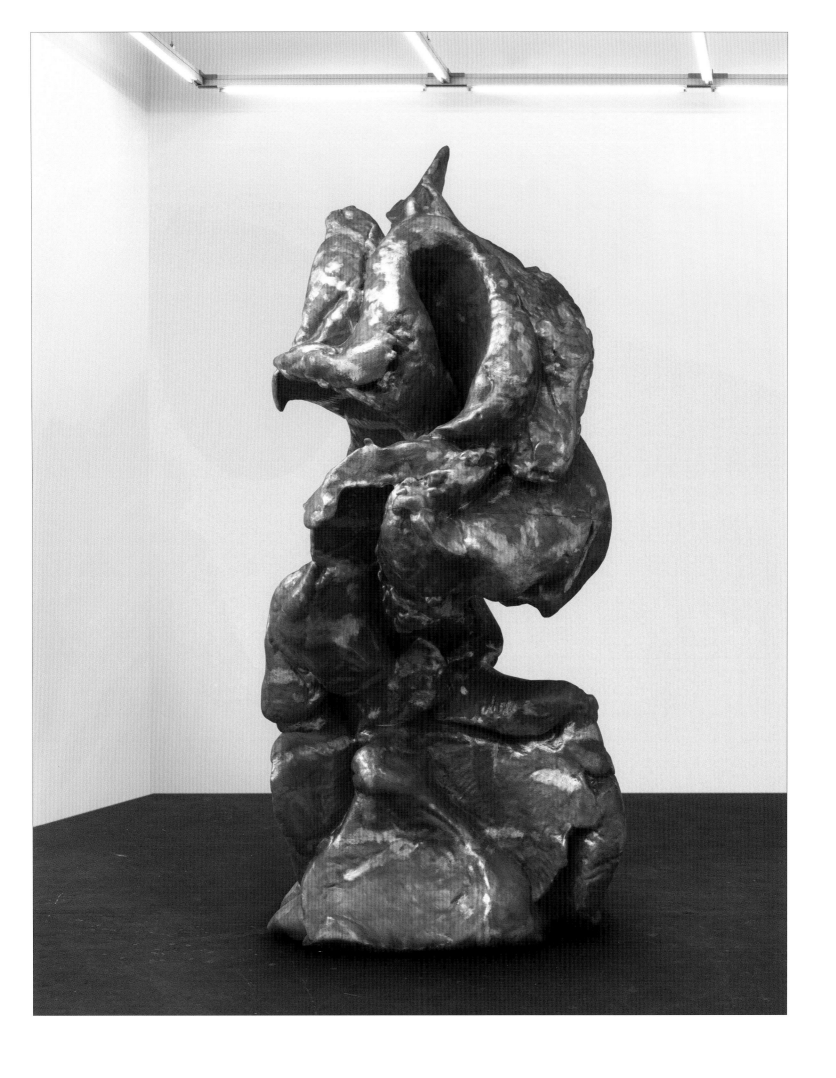

Zizi
2006–2008
Cast aluminum, steel
410 x 230 x 226 cm; 161 ⅛ x 90 ½ x 89 in.

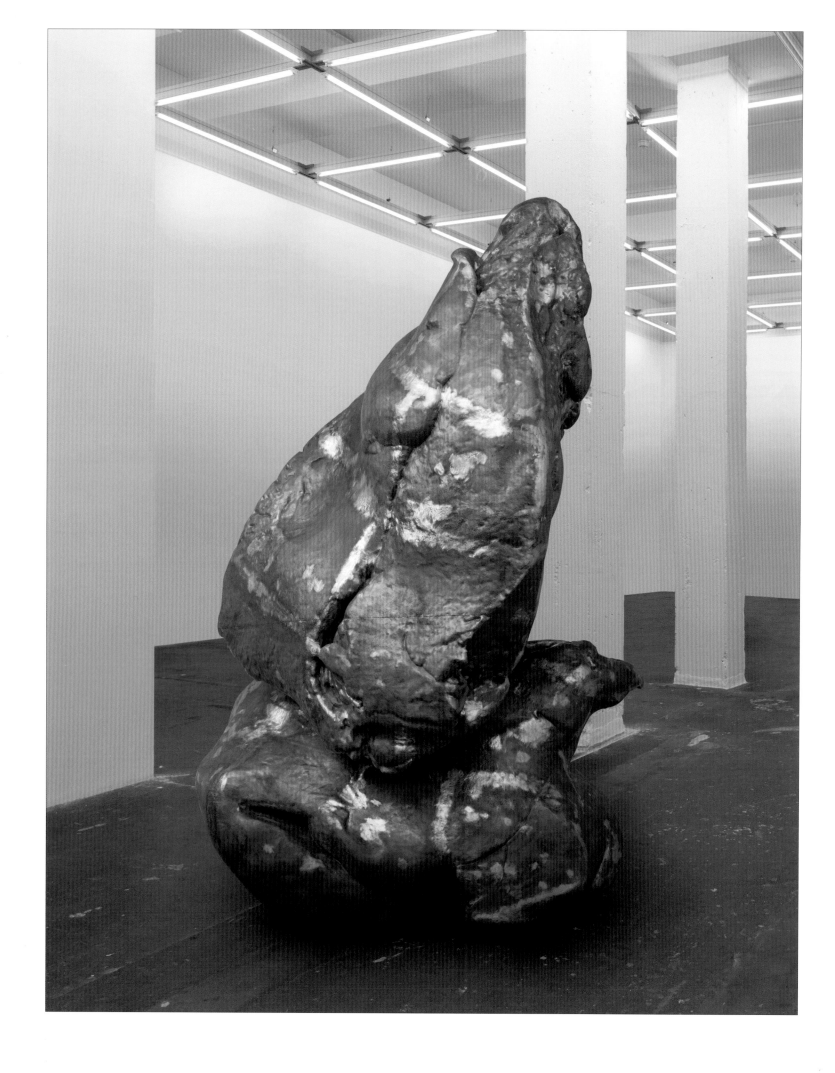

Miss Satin
2006–2008
Cast aluminum, steel
340 x 257 x 220 cm; 133 ⅞ x 101 ⅛ x 86 ⅝ in.

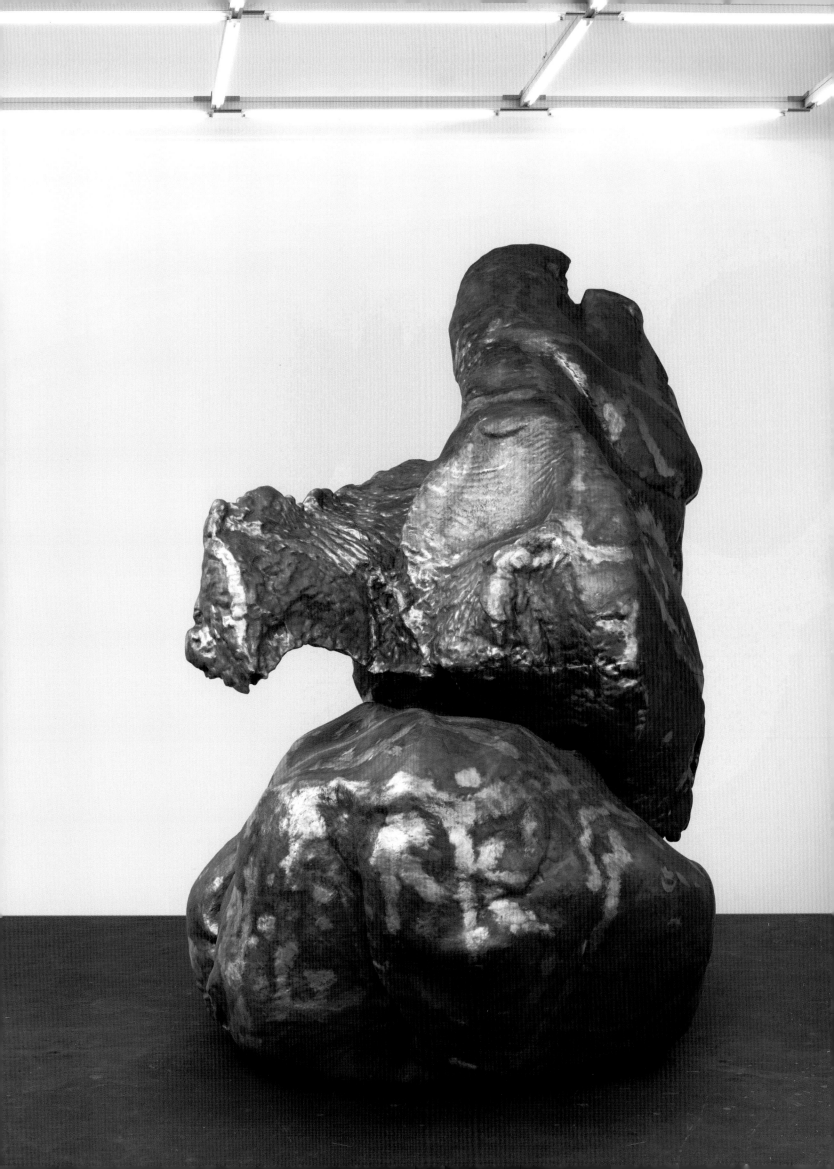

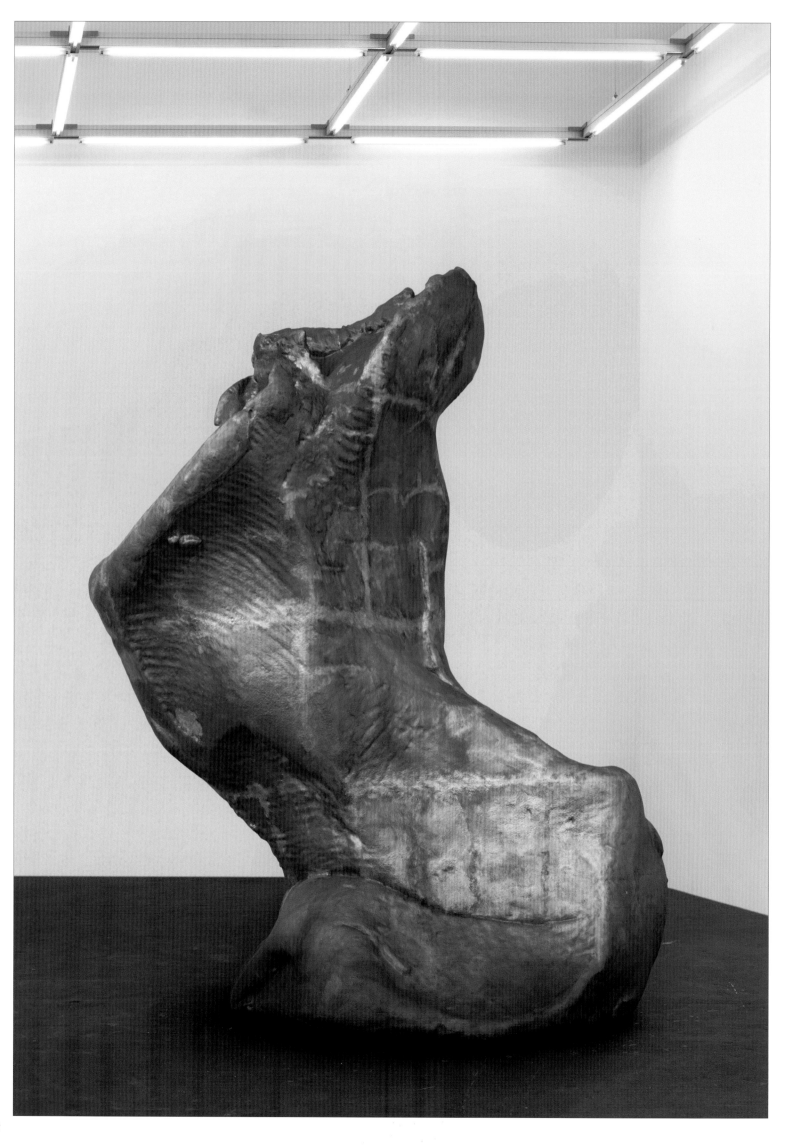

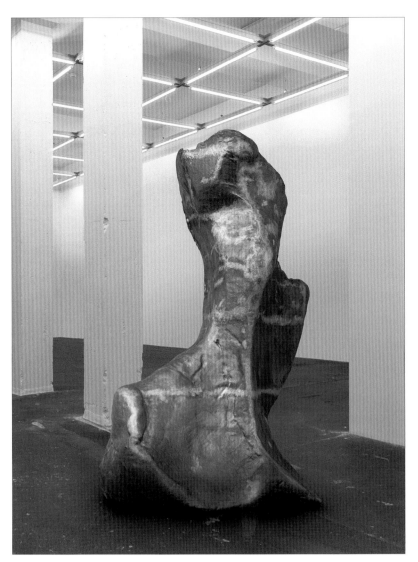
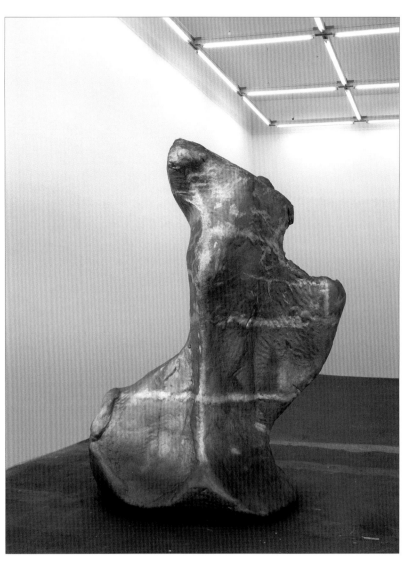

Ix
2006–2008
Cast aluminum
300 x 225 x 157 cm; 118 ⅛ x 88 ⅝ x 61 ¾ in.

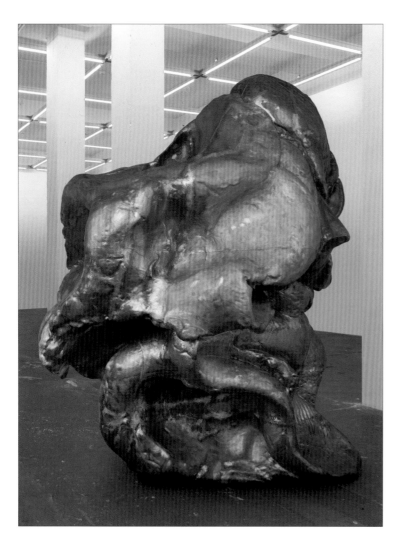

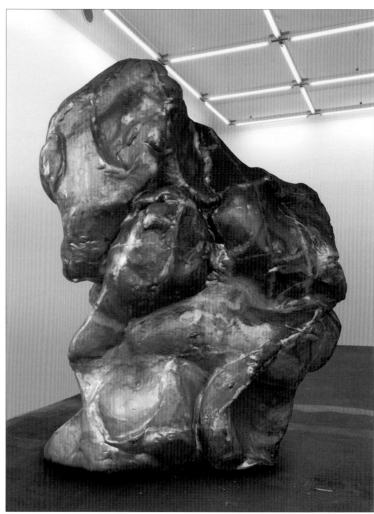

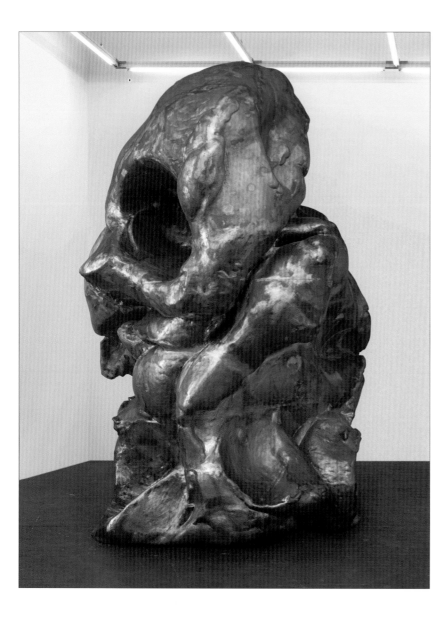

Marguerite de Ponty
2006–08
Cast aluminum, steel
400 x 280 x 260 cm; 157 ½ x 110 ¼ x 102 ⅜ in.

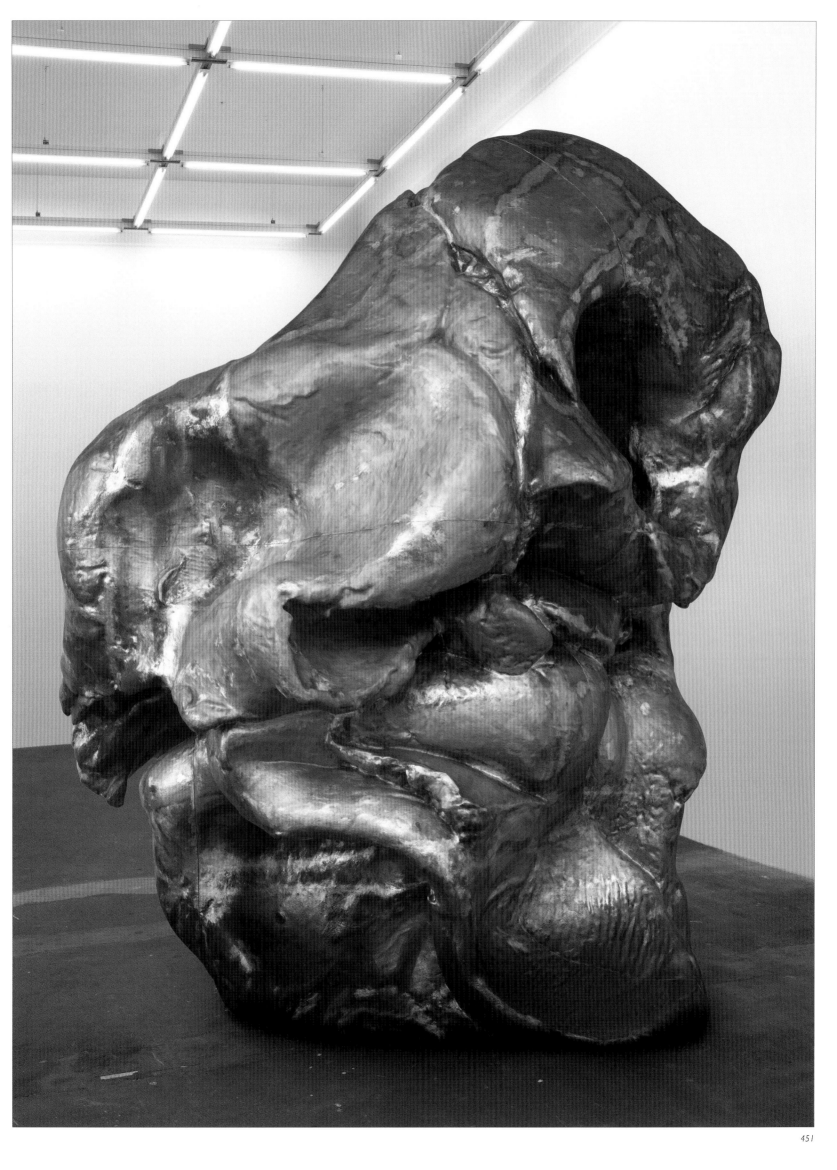

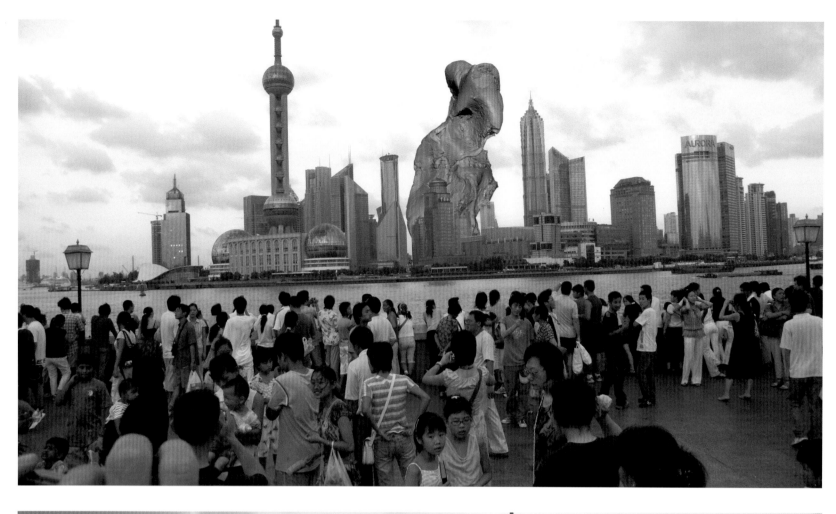

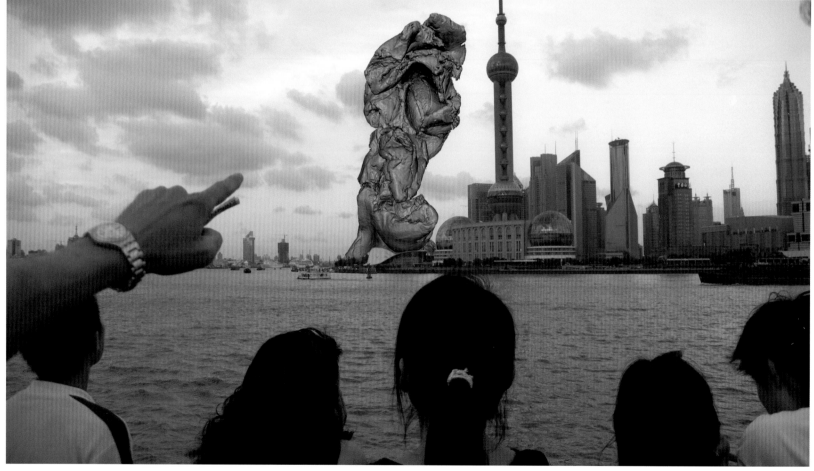

This page and opposite:

Excerpts from the book *Helmar Lerski*, 2008

452

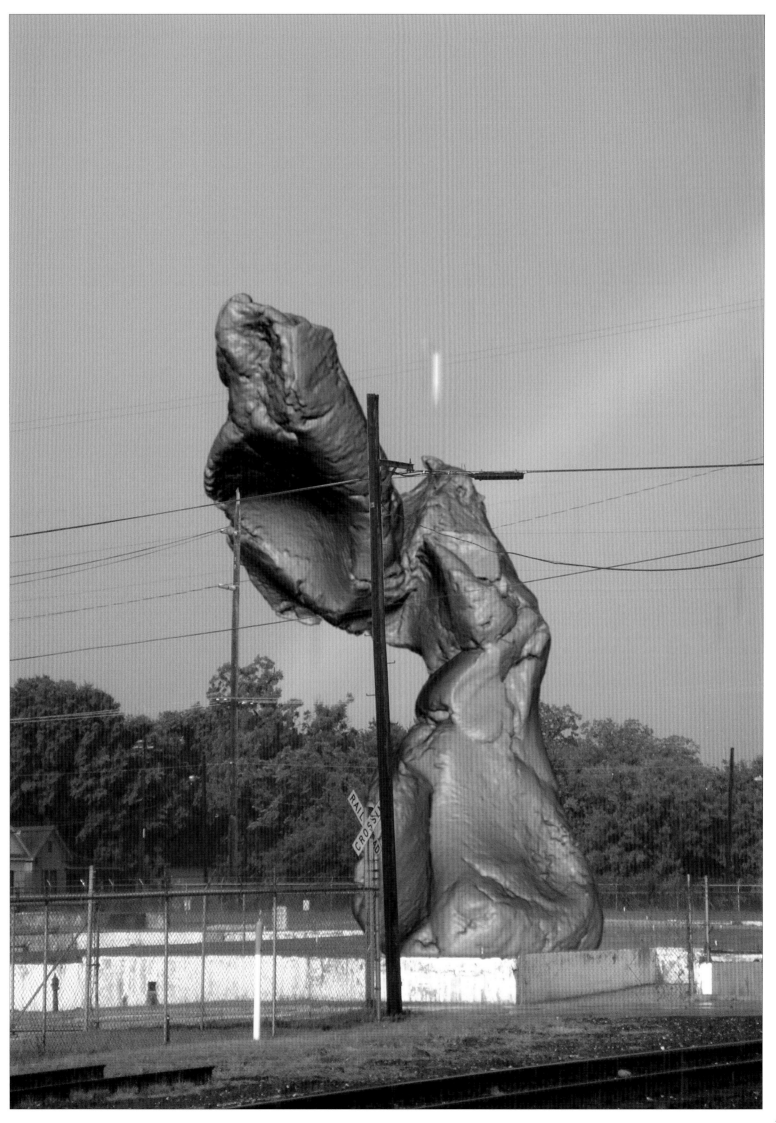

453

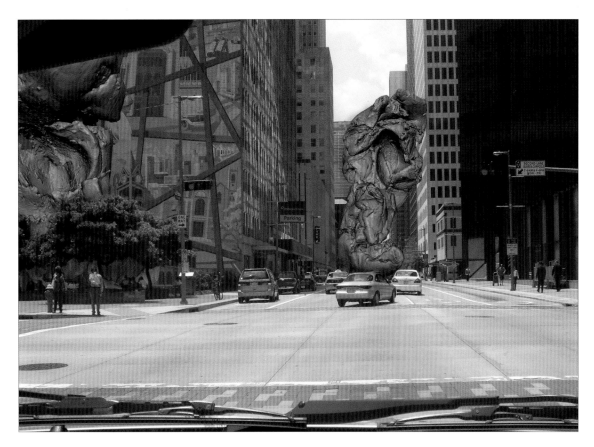

Excerpt from the book *Helmar Lerski*, 2008

Below and opposite page:

Kratz
2009
Bed, bedding, concrete
60 x 200 x 200 cm; 23 ⅝ x 78 ¾ x 78 ¾ in.

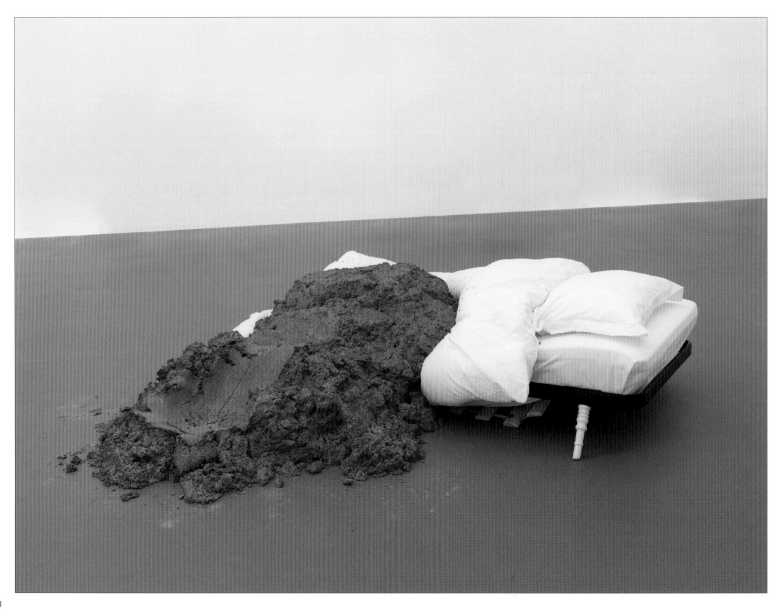

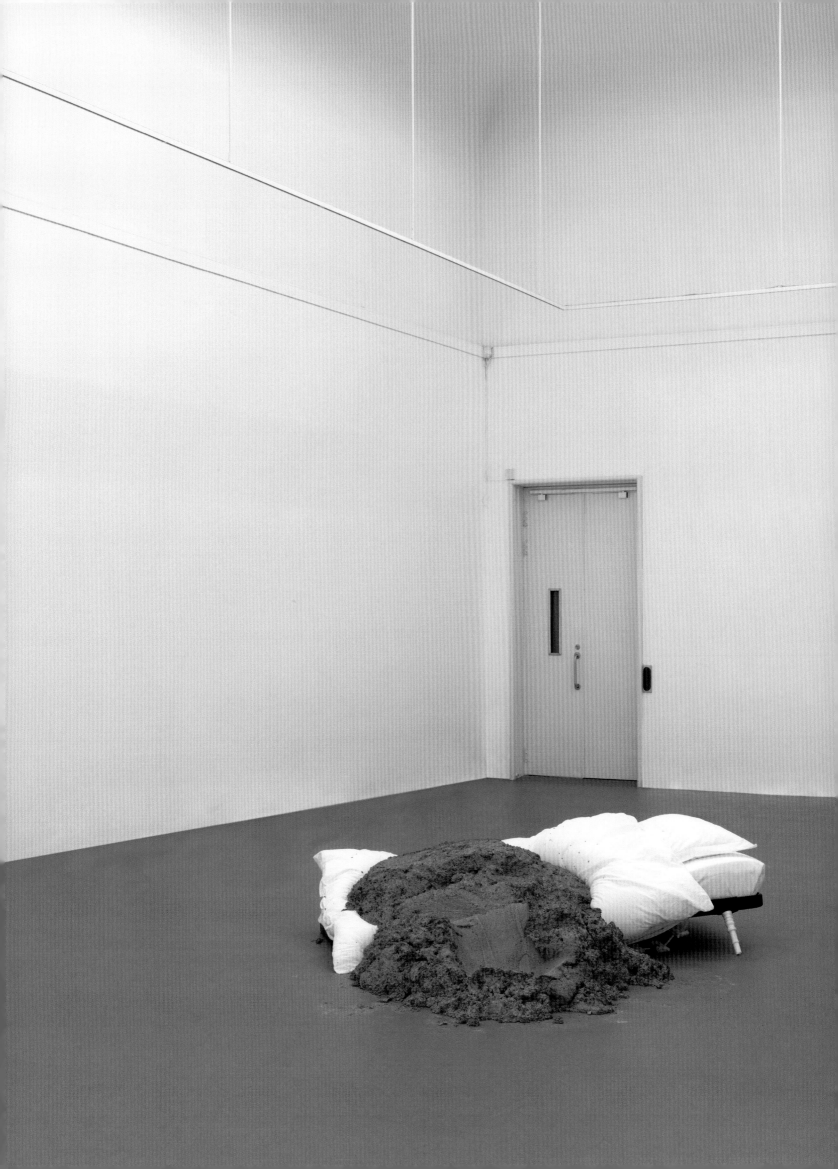

Cape Carneval
2000–2001
Wood, glass, particleboard, paper, photocopies on polyester film, slide film, latex paint, oil paint, acrylic paint, marker, wood glue, spray adhesive, UV-protective lacquer, staples
266 x 194.5 x 12.5 cm; 104 ¼ x 76 ⅝ x 4 ⅞ in.
Sammlung Ringier, Switzerland
265

Cappillon
2000
Wood, plaster, polystyrene, filler, latex paint, glass, cast tin
115 x 90 x 172 cm; 45 ¼ x 35 ⅜ x 67 ¼
Hauser & Wirth Collection, Switzerland
90–91

The Cat with the Broken Leg or The Cat Who Laid the Golden Egg
2000
Polystyrene, plaster, oil paint, acrylic paint, filler, screws
Dimensions variable
Private Collection, Los Angeles
89

Chagall
2006
Polyurethane foam, nails, spray enamel, acrylic paint, expanding polyurethane foam, filler, polyurethane glue, electric motor, aluminum, control unit, battery, cables
225 x 61 x 104 cm; 88 ⅝ x 24 x 41 in.
Private Collection
252–253

Chair
2002
Chair vibrates at a high frequency, appearing blurry
Wood, oil paint, electric motor, mechanism, glue, silicone, battery
82 x 42 x 42 cm; 32 ¼ x 16 ½ x 16 ½ in.
Private Collection
244–245

Chair for a Ghost: Thomas
2003
Cast aluminum, enamel paint, lacquer, wire
95 x 62 x 52 cm; 37 ⅜ x 24 ⅛ x 20 ½ in.
The Dakis Joannou Collection
247

Chair for a Ghost: Urs
2003
Cast aluminum, enamel paint, lacquer, wire
95 x 62 x 52 cm; 37 ⅜ x 24 ⅛ x 20 ½ in.
Sammlung Ringier, Switzerland
247

Chair (Sewn)
1999
Found chair frame, silicone, thread, acrylic paint
82 x 52 x 57 cm; 32 ¼ x 20 ½ x 22 ½ in.
Courtesy of the artist and Galerie Eva Presenhuber, Zurich
431

Chairs
1998–1999
Silicone, sawdust, plastic, found chairs, spray enamel, metal
75 x 57 x 153 cm; 29 ½ x 22 ½ x 60 ¼ in.
Private Collection, Switzerland
431

Change of Taste for Miss Cocktail
2005
Cast nickel silver, acrylic paint, gesso
15 x 20.5 x 6 cm; 5 ⅞ x 8 ⅛ x 2 ⅜ in.
Private Collection, courtesy Sadie Coles HQ, London
379

Chemical Wedding
2009
Pine, MDF, ACM panels, acrylic adhesive, gesso, ink, acrylic paint, screws
243.8 x 181.6 x 4.1 cm; 96 x 71 ½ x 1 ⅝ in.
Collection Michaela Neumeister, Berlin
iii

Cioran Handrail
2006
Epoxy resin, pigment, enamel paint, wire, aluminum
Approx. 350 x 860 x 125 cm; 137 ¾ x 338 ⅝ x 49 ¼ in.
Edition of 2 + 1 AP
Courtesy The Brant Foundation, Greenwich, Connecticut; Sender Collection, New York; The Dakis Joannou Collection
330–333

Clouds
2002
Polystyrene, wire, theater spotlight with pink gel
Cloud 1: 100 x 150 x 16 cm; 39 ⅜ x 59 x 6 ¼ in.
Cloud 2: 45 x 63 x 16 cm; 17 ¾ x 24 ¾ x 6 ¼ in.
Courtesy Sadie Coles HQ, London
244

Cold Coffee Waits
2003
Iris print in frame of polyurethane resin, acrylic paint, glass, cardboard
46 x 38.3 cm; 18 ⅛ x 15 ⅛ in.
Collection of J. and M. Donnelly, courtesy Sadie Coles HQ, London
400

Cork
2009
Silkscreen print on mirror-polished stainless steel sheets, aluminum, Alucore, two-component epoxy, stainless steel screws
45.2 x 98 x 45.5 cm; 17 ¼ x 38 ⅝ x 17 ⅞ in.
Private Collection
426

Count Negroni
2005–2009
Digital image
From the artist's archive of bullshit
back cover

Cup / Cigarettes / Skid
2006
Wood, polyurethane glue, acrylic paint, nails
Coffee cup: 19 x 24.3 x 18 cm; 7 ½ x 9 ⅝ x 7 ⅛ in.
Cigarettes: 26 x 13.8 x 8.9 cm; 10 ¼ x 5 ⅜ x 3 ½ in.
Pallet: 81.1 x 67.8 x 8.9 cm; 31 ⅞ x 26 ¾ x 3 ½ in.
Private Collection
327, 420–421

Cutting a Cake with a Hammer
2000
Wood, polystyrene, latex paint, spotlight, enamel paint, filler, nails, screws
110 x 70 x 70 cm; 43 ¼ x 27 ½ x 27 ½ in.
Collezione Maurizio Morra Greco, Naples
93

Daylight Pillow
2004
Aluminum, acrylic paint, light bulb, socket, electric cable
125 x 140 x 94 cm; 49 ¼ x 55 ⅛ x 37 in.
Edition of 2 + 1 AP
Bischofberger Collection, Zurich; Private Collection; Goetz Collection, Munich
97

Dead Pigeon on Beethoven Street
2005
Aluminum, ACM panels, acrylic paint, marker, UV inkjet print, UV-protective lacquer
208 x 273 x 6 cm; 81 ⅞ x 107 ½ x 2 ⅜ in.
Private Collection
325

Death of a Moment
2007
Mirrors tilt back and forth in a wavelike pattern
Mirrors, aluminum, hydraulics, control unit
Dimensions variable
The Dakis Joannou Collection

Die Hungry
2003
Polyurethane resin, acrylic paint, clay, screws
70 x 50 x 38 cm; 27 ½ x 19 ¾ x 15 in.
Private Collection, courtesy Sadie Coles HQ, London
124–125

Digital Sperm 1
Digital image
2002
402

Digital Sperm 2
Digital image
2002
402

Digital Sperm 3
Digital image
2002
402

Dörrfrucht und Nussschale (Dry Fruit and Nut Bowl)
1999
Plaster, clay, wood glue, acrylic, dried fruit, nuts, wooden beams, latex paint
Bowl 1: diameter 50 x 20 cm; 19 ⅝ x 7 ⅞ in.
Pedestal: 100 x 22 x 20 cm; 39 ⅜ x 8 ⅝ 7 ⅞ in.
Bowl 2: diameter 35 x 12 cm; 13 ¾ x 4 ¾ in.
Pedestal: 110 x 24 x 20 cm; 43 ¼ x 9 ½ x 7 ⅞ in.
Hauser & Wirth Collection, Switzerland
207

Drip of Thought
1994
Wax
Dimensions unknown
Collection of the artist
238

Dr. Katzelberg (Zivilisationsruine)
1999
Mirrors, wood, polystyrene, silicone, three theater spotlights on tripods
210 x 500 x 350; 82 ⅝ x 196 ⅞ x 137 ¼ in.
Kunstsammlung der Stadt Zürich
80–81, 432

Eckwurst
1997
Wood, plaster, chicken wire, latex paint, acrylic paint, newspaper, screws
181 x 76 x 67 cm; 71 ¼ x 29 ⅞ x 26 ⅛ in.
Collection Marcel Brient, Paris
38

ESPRESSOQUEEN
1998
Wood, glass, tires, silicone, latex paint, acrylic paint, neon light, sound
284 x 628 x 254 cm; 111 ¼ x 247 ¼ x 100 in.
Destroyed
211

Eternal Soup of the Day
1999
Wood, glass, MDF, plastic film, acrylic paint, marker, ink, chalk pastel, duct tape, wood glue
161 x 201 cm; 63 ⅜ x 79 ⅛ in.
Private Collection, Vienna
258

Failed installation of green leaves on winter tree outside exhibition window, "Without a Fist—Like a Bird," Institute of Contemporary Arts, London, January 2000
6

Fiction
2006–
Table vibrates at a high frequency, appearing blurry
Work in progress
252

Formenscheisser
1998
Ballpoint pen, marker, chalk pastel, and fixative on paper
29.7 x 21 cm; 8 ¼ x 11 ¼ in.
132

Frozen
1998
Wood, particleboard, latex paint, enamel paint, candle, vase, dishes, glasses, branches, wool yarn, wood glue, nails, silicone
220 x 230 x 160 cm; 86 ⅝ x 90 ½ x 63 in.
Collection Migros Museum für Gegenwartskunst, Zurich
241

Fuck You Thank You
2007
Cast aluminum, acrylic paint
172 x 305 x 97 cm; 67 ¾ x 120 ⅛ x 38 ¼ in.
Edition of 2 + 1 AP
Collection of Amalia Dayan and Adam Lindemann; Collection Angela and Massimo Lauro, Naples; Collection Erling Kagge, Oslo
76, 392

G

Gänseeier Eclipse
2002
Two goose or chicken eggs, nylon filament, glue, theater spotlight
Dimensions variable
Collection of the artist
22

Gedanken kommen zurück 'bitte'
2000
Wood, wax, silicone, clay, spray enamel
80 x 160 x 120 cm; 31 ½ x 63 x 47 ¼ in.
Friedrich Christian Flick Collection
213

Girl Foam Studio
from the portfolio *Thinking about Störtebeker*
2005
Portfolio with 18 bound screenprints on transparent paper and
18 framed prints on Epson Enhanced Matte paper
Edition of 25 + 5 AP
Portfolio: 57.4 x 43.1 x 2 cm; 22 ⅝ x 17 x ¼ in.
Prints: 56 x 41 cm; 22 x 16 ⅛ in.
106

Glaskatzen—Mülleimer der Hoffnung
1999
Carpet, wood, glass, silicone (casts of room corners), acrylic
paint
Approx. 100 x 385 x 270 cm; 39 ⅜ x 151 ⅝ x 106 ¼ in.
Friedrich Christian Flick Collection
72–73

Glaskatzensex / Transparent Tale
2000
Particleboard, wood, silicone (casts of room corners), glass,
acrylic paint, marker
158 x 560 x 600 cm; 62 ¼ x 220 ½ x 236 ¼ in.
Collection of Migros Museum für Gegenwartskunst, Zurich
82–83

Good Good Breath / Good Bad Breath
2002
Polyurethane resin, wire, enamel, varnish, primer
Dimensions unknown
Collection Marcel Brient, Paris
122–123

Good Luck / Bad Luck Bowl
2002
Clay, wood, acrylic paint, wire, cast polyurethane pear, real
strawberry, screws, wood glue
19 x 38 x 29 cm; 7 ½ x 15 x 11 ⅜ in.
Collection Marcel Brient, Paris
10

The Grass Munchers
2007
Cast aluminum, pigments, wax
56 x 62 x 44 cm; 22 x 24 ⅜ x 17 ⅜ in.
Edition of 2 + 1 AP
Burger Collection, Hong Kong; Private Collection, Rome,
Italy; Private Collection
76, 383

Guerkli
2009
Oak, ACM panels, gesso, ink, acrylic paint, polyurethane glue,
screws
243.8 x 182.9 x 3.8 cm; 96 x 72 x 1 ½ in.
The Dakis Joannou Collection
282

Hand Lemon
2006
Hydrocal, acrylic paint, polyurethane glue, hair
18.4 x 18.4 x 18.1 cm; 7 ¼ x 7 ¼ x 7 ⅛ in.
380

Hands
2002
Cast aluminum, wire, enamel paint
73 x 30 cm; 28 ¼ x 11 ¼ in.
Sammlung Ringier, Switzerland
399

Head Side Frontal
from the portfolio *Thinking about Störtebeker*
2005
Portfolio with 18 bound screenprints on transparent paper and
18 framed prints on Epson Enhanced Matte paper
Edition of 25 + 5 AP
Portfolio: 57.4 x 43.1 x 2 cm; 22 ⅝ x 17 x ¼ in.
Prints: 56 x 41 cm; 22 x 16 ⅛ in.
402

Hear a Junkie Say Thank You
2005
Cast aluminum, acrylic paint
15 x 150 x 6 cm; 5 ⅞ x 59 x 2 ⅜ in.
Collection of Florence and Philippe Segalot, New York
227

Hear an Old Lady Laugh Out Loud
2005
Cast aluminum, acrylic paint
15 x 150 x 6 cm; 5 ⅞ x 59 x 2 ⅜ in.
David Gill Private Collection, London
227

**The Heart of the Ocean, May Yohe & Putnam Strong,
Zero Year Curse, Tavernier Blue, Hope Diamond**
One from a suite of three framed prints
2006
Epson ultrachrome inkjet print on Enhanced Matte paper, in a
frame of glass-fiber-reinforced plaster
79 x 62 x 3.5; 31 ⅛ x 24 ⅜ x 1 ⅜ in.
Source photo: Sari Carel
front cover

Helmar Lerski
2008
Self-published artist's book
Edition of 500
452–454

Highway—Northern California, 1995
Photograph
i–ii, 482–483

Hormonparty
1996
String, assorted colored thread
Dimensions variable
Collection of the artist
240, 319

Horses Dream of Horses
2004
Plaster, resin paint, steel, nylon filament
Dimensions variable: 1,500 raindrops, each up to 17 x 7 x 7 cm;
6 ¼ x 2 ¼ x 2 ¼ in.
Sammlung Ringier, Switzerland
114, 137, 337–339, 366, 407

Hotel
2001
Polyurethane foam, acrylic foam, wood, nails, screws
85 x 45 x 85 cm; 33 ½ x 17 ¼ x 33 ½ in.
Speyer Family Collection
92

How to Tell a Joke
2007
Polyurethane resin, polymeric plaster, steel, pigments, acrylic
paint, matte varnish, dust
100 x 95 x 100 cm; 39 ⅜ x 37 ⅜ x 39 ⅜ in.
Private Collection, Israel, courtesy Sadie Coles HQ, London
435

Hudson
1995
Particleboard, latex paint, screws
Dimensions unknown
Collection of the artist
397

The Human Layer
1999
Plaster, clay, acrylic paint, silicone, fruits
20 x 50 x 50 cm; 7 ⅞ x 19 ¾ x 19 ¼ in.
Private Collection
441

I Can Smell Your Words
2002
Polyurethane resin, synthetic hair, acrylic paint, particleboard,
marker, fake eyelashes, powdered sugar, egg whites
Dimensions unknown
Disposed of
367

Imaginary Pain
2007
Cast plaster, screws, enamel paint
60 x 60 x 20 cm; 23 ⅝ x 23 ⅝ x 7 ⅞ in.
Private Collection
382

In Dubio Pro Reo
2007
Found cabinet, found stool, found bowl, epoxy glue,
polyurethane glue
155 x 110 x 80 cm; 61 x 43 ¼ x 31 ½ in.
Dimitris Gigourtakis Collection, Athens
43

The Intelligence of Flowers
2005
Cuts in wall with relocated cutouts
Dimensions variable
Sammlung Ringier, Switzerland
138–139

Internal Backdrop (Jealous House Blends & Airports)
2001
Cement, sand, iron, steel chains, polystyrene, polyurethane
foam, polyurethane resin, acrylic filler, acrylic paint, candles,
cables, light bulb, socket
Dimensions variable
Collection FRAC Provence-Alpes-Côte d'Azur, Marseille
221

Ix
2006–2008
Cast aluminum
300 x 225 x 157 cm; 118 ⅛ x 88 ⅝ x 61 ¼ in.
Courtesy of the artist and Galerie Eva Presenhuber, Zurich
312, 442–443, 448–449

Jet Set Lady
2000
Color copies, wooden frames, wood, iron base, acrylic glass,
wood stain, acrylic lacquer, wood glue, screws
450 x 450 x 420 cm; 177 ⅛ x 177 ⅛ x 165 ⅜ in.
Destroyed
179

Jet Set Lady
2000–2005
2,000 framed color prints of drawings, 24 fluorescent tubes,
wooden frames, iron, metal primer, UV-protective lacquer
900 x 700 x 700 cm; 354 ⅜ x 275 ⅝ x 275 ⅝ in.
Private Collection
181–185

Joe
2003
Wood, glass, slide film, acrylic paint, marker, glue, screws,
staples
201.2 x 250.5 cm; 79 ¼ x 98 ⅝ in.
Private Collection, Monaco
56–57, 270

K

Kantenwurst
1997
Wood, plaster, chicken wire, latex paint, acrylic paint,
newspaper, screws
63 x 23 x 182 cm; 24 ¼ x 9 x 71 ⅝ in.
Private Collection, Athens
38

Keep It Going Is a Private Thing
2001
Mechanical robot half-dog wags its tail
Synthetic fur, polystyrene, electric motor, control unit, acrylic
paint, polyurethane foam, wood glue
70 x 30 x 79 cm; 27 ½ x 11 ¼ x 31 ⅛ in.
Sammlung Ringier, Switzerland
219

Kerzenständer (Candlestick)
from *6 ½ Domestic Pairs Project*
2000
Wood, clay, enamel paint, chain, electric motor, candle, wood
glue
Dimensions variable
Friedrich Christian Flick Collection
243

Kir Royal
2004
Plaster, polyurethane resin, acrylic paint, gauze
45 x 30 x 35 cm; 17 ¾ x 11 ¾ x 13 ¾ in.
Centre National d'art et de culture Georges Pompidou, Paris
366

Kommt Zeit, Kommt Unrat
1999
Mixed media, wood, glass, latex paint, paper
250 x 625 x 40 cm; 98 ⅜ x 246 x 15 ¾ in.
Theo + Elsa Hotz Privatsammlung, Meilen, Switzerland
168

Köpfe (Heads)
1997–1999
Wood, clay, acrylic paint, wax
Head 1: 30 x 30 cm; 11 ¾ x 11 ¾ in.
Pedestal: 130 x 33 x 30 cm; 51 ⅛ x 13 x 11 ¾ in.
Head 2: 30 x 30 cm; 11 ¾ x 11 ¾ in.
Pedestal: 122 x 32 x 32 cm; 48 x 12 ⅝ x 12 ⅝ in.
Private Collection
73, 322, 360

Kratz
2009
Bed, bedding, concrete
60 x 200 x 200 cm; 23 ⅝ x 78 ¾ x 78 ¾ in.
Courtesy of the artist and Galerie Eva Presenhuber, Zurich
454–455

Krise
from *6 ½ Domestic Pairs Project*
2000–2005
Cast aluminum, enamel paint
171 x 190 x 220 cm; 67 ⅜ x 74 ¾ x 86 ⅝ in.
Edition of 2 + 1 AP
Dimitris Gigourtakis Collection, Athens; Collection of Art Gallery of NSW, Australia, gift of Kaldor Family Collection; Collection of the artist
39

Kuckuck Backwards
2004
Wood, aluminum, cement, sawdust, enamel paint
162 x 200 x 64 cm; 63 ¼ x 78 ¾ x 25 ¼ in.
Collection Kunsthaus Zürich
114

L

The Lady
2000
Laser prints, wooden frames, wood, iron base, silicone, wood glue, screws
Dimensions unknown
Destroyed
179

Lamp
from *6 ½ Domestic Pairs Project*
2000–2005
Cast aluminum, enamel paint, light bulb, electric cable
200 x 75 x 130 cm; 78 ¼ x 29 ½ x 51 ⅛ in.
Edition of 2 + 1 AP
Collection of Jeanne Greenberg Rohatyn, New York; Kaldor Family Collection gift to Art Gallery of NSW, Australia; Collection of Florence and Philippe Segalot, New York
217

Last Call, Lascaux
2007
Wallpaper prints of black-and-white reproductions of individual artworks exhibited in the Galerie Eva Presenhuber booth at the Armory Show in New York in 2007
Dimensions variable
Courtesy of the artist and Gavin Brown's enterprise, New York
156, 293, 481 (study for)

Last Chair Standing
1997
Wood, clay, silicone, latex paint, string, wire, caulk, wood glue
64.5 x 79 x 64.5 cm; 25 ⅜ x 31 ⅛ x 25 ⅜ in.
Collection Marcel Brient, Paris
34–35

Last Dice Throw Up
1994
Dice, acrylic paint, lead
Dimensions variable
Collection of the artist
30

Late Late Night Show
2002
Polystyrene, acrylic paint, wood glue, polyurethane foam, screws
117 x 97 x 66 cm; 46 x 38 ¼ x 26 in.
Collection of Dean Valentine and Amy Adelson
401

Late Night Show
1997
Found chairs, newspaper, plaster, latex paint, pigments, glue
Chair 1: 81 x 55 x 65 cm; 31 ⅞ x 21 ⅝ x 25 ⅝ in.
Chair 2: 86 x 45 x 50 cm; 33 ⅞ x 17 ¼ x 19 ¼ in.
Chair 3: 77 x 55 x 65 cm; 30 ¼ x 21 ⅝ x 25 ⅝ in.
Hauser & Wirth Collection, Switzerland
37

Léger Joke
1993
Marker and pencil on paper
42 x 29.7 cm; 16 ½ x 11 ¼ in.
Collection of Avocado
389

Leiter (Ladder)
1997
Aluminum ladder, latex paint, spotlights
Dimensions variable
Collection Migros Museum für Gegenwartskunst, Zurich
18

Lemon Hand
2006
Hydrocal, acrylic paint, polyurethane, glue, hair
8 x 23 x 14 cm; 3 ⅛ x 9 x 5 ½ in.
The Frank Mosvold Collection, Norway
380

Lie to a Dog
2005
Cast nickel silver, acrylic paint, cheese
53 x 45 x 21 cm; 20 ⅞ x 17 ¾ x 8 ¼ in.
Private Collection, courtesy Sadie Coles HQ, London
229

Light
2002
Early version of "Mr. Watson—come here—I want to see you."
Light bulb, electric cable, electric motor, control unit
120 x 10 x 10 cm; 47 ¼ x 4 x 4 in.
Private Collection, Switzerland
244

Living on the Phone
1998
Wood, glass, paper, resin, acrylic paint, latex paint, ink, pencil, marker, coffee, sugar, tape, screws
174 x 232.5 x 7.5 cm; 68 ½ x 91 ½ x 3 in.
Friedrich Christian Flick Collection
164, 241

The Lock
2007
Cast polyurethane, steel pipes, electromagnets
184 x 75.5 x 55 cm; 72 ½ x 29 ¼ x 21 ⅝ in.
Edition of 2 + 1 AP
The Dakis Joannou Collection; Collection Maja Hoffmann, Switzerland; Collection of Amalia Dayan
232

M

Mackintosh Staccato
2006
Epoxy resin, pigment, enamel paint, wire, aluminum
Approx. 250 x 904 x 248 cm; 98 ⅜ x 355 ⅞ x 97 ⅝ in.
Edition of 2 + 1 AP
Private Collection; The Dakis Joannou Collection; Collection of the artist
327, 331–333, 421–422

Madame Fisscher
1999–2000
Mixed media
Dimensions variable
Hauser & Wirth Collection, Switzerland
174–177

Make a Duck Out of a Cow
2003
Wood, acrylic glass, plywood, inkjet print on film, latex paint acrylic paint, marker, spray adhesive, glue, screws, varnish
231 x 309.9 x 7.6 cm; 91 x 122 x 3 in.
Lindemann Collection, Miami Beach
301

A Man and His Head Like a Hand with a Bread Unfiltered Summer / Autumn 99 Poetry and Brain Waste
1999
Iron, glass, zinc phosphate paint, photocopies on polyester film, adhesive tape
234 x 273 x 101 cm; 92 ⅛ x 107 ½ x 39 ¼ in.
Friedrich Christian Flick Collection
172

Marguerite de Ponty
2006–08
Cast aluminum, steel
400 x 280 x 260 cm; 157 ½ x 110 ¼ x 102 ⅜ in.
The Dakis Joannou Collection; Courtesy of the artist and Galerie Eva Presenhuber, Zurich
126, 442–443, 450–451

Mastering the Corner
from the portfolio *Thinking about Störtebeker*
2005
Portfolio with 18 bound screenprints on transparent paper and 18 framed prints on Epson Enhanced Matte paper
Edition of 25 + 5 AP
Portfolio: 57.4 x 43.1 x 2 cm; 22 ⅜ x 17 x ¾ in.
Prints: 56 x 41 cm; 22 x 16 ⅛ in.
85

Meatloaf
2009
Oak, ACM panels, gesso, ink, acrylic paint, polyurethane glue, screws
243.8 x 182.9 x 3.8 cm; 96 x 72 x 1 ½ in.
Private Collection
285

Meer
2002
Wood, glass, particleboard, slide film, polyester film, latex paint, acrylic paint, marker, screws
238 x 310 x 8.5 cm; 93 ¼ x 122 x 3 ⅜ in.
Burger Collection, Hong Kong
300

The Membrane (Half Full, Half Empty)
2000
Polyurethane rubber (casts of furniture), pigments, aluminum tubes with plastic connectors, theater spotlights on tripods
300 x 600 x 300 cm; 118 ⅛ x 236 ¼ x 118 ⅛ in.
Collection of the artist
432–433

Memories of a Blank Mind
2004
Aluminum, two-component polyurethane foam, wood, aircraft cable, acrylic paint, marker, steel, screws
400 x 600 x 600 cm; 157 ½ x 236 ¼ x 236 ¼ in.
Goetz Collection, Munich
24

Middleclass Heroes
2004
Cuts in wall with relocated cutouts
Dimensions variable
Private Collection
114, 135–137, 339

Miss Satin
2006–2008
Cast aluminum, steel
340 x 257 x 220 cm; 133 ⅞ x 101 ⅛ x 86 ⅝ in.
Courtesy of the artist and Galerie Eva Presenhuber, Zurich
442–443, 446–447

Money Bowl
1999
Iron, metal primer, plaster, caulk, acrylic paint, wax, coins, bills
Bowl: 70 x 70 x 14 cm; 27 ½ x 27 ½ x 5 ½ in.
Pedestal: 70 x 70 x 46 cm; 27 ½ x 27 ½ x 18 ⅛ in.
Kunstsammlung der Stadt Zürich
206

Moody Moments
2003
Clay, polyurethane resin, wood, dough
Head 1: 38 x 33 x 30.5 cm; 15 x 13 x 12 in.
Head 2: 38 x 30.5 x 30 cm; 15 x 12 x 11 ½ in.
Private Collection
364–365

More Sweet Feelings, Worries and Other Stuff
1998–1999
Wood, tinted glass, paper, marker, ink, latex paint, acrylic paint, spray enamel, staples
181 x 250 x 9.5 cm; 71 ¼ x 98 ⅜ x 3 ¼ in.
Collection Migros Museum für Gegenwartskunst, Zurich
167

Mr. Flosky
2001–2002
Wood, latex paint, lamp, cable, plaster, polystyrene, glass, glue, screws
Stove: 98.5 x 105 x 59 cm; 38 ¼ x 41 ⅜ x 23 ¼ in.
Cat: 33.5 x 46 x 14.5 cm; 13 ¼ x 18 ⅛ 5 ¼ in.
Burger Collection, Hong Kong
96

Mr. Toobad
2003
Wood, plywood, glue, acrylic paint, polyester film, paint marker, tape, staples, screws, fittings, glass, latex paint, UV-protective lacquer
210 x 268 x 10 cm; 82 ⅝ x 105 ½ x 4 in.
Goetz Collection, Munich
269

"Mr. Watson—come here—I want to see you."
2005
Light swings back and forth, accelerating and decelerating in a 12-minute cycle
Electric motor, control unit, electric cable, light bulb, wire
Dimensions variable
Edition of 2 + 1 AP
Private Collection, courtesy Sadie Coles HQ, London; John Kaldor Collection, Australia; G.F. Collection
143, 254–255

N

Nach Jugendstiel kam Roccoko
2006
Empty cigarette pack moves erratically along floor, occasionally flying up into the air
Electric motor, wire, carbon rod, elastic band, nylon filament, empty cigarette pack, control unit
Installation radius 400 cm; 157 ½ in.; height variable
Edition of 2 + 1 AP
La Colección Jumex, Mexico; Private Collection; Collection of Amalia Dayan and Adam Lindemann
303, 344–347

Napoleon, Is There Something You Didn't Tell Me / Napoleon, Misunderstood
2001
Polyurethane resin, stearin, oil paint, synthetic hair, pigments, marker
Part 1: 31 x 27 x 23 cm; 12 ¼ x 10 ⅝ x 9 in.
with pedestal: 26 x 26 x 116 cm; 10 ¼ x 10 ¼ x 45 ⅝ in.
Part 2: 24 x 27 x 30 cm; 9 ½ x 10 ⅝ x 11 ¾ in.
with pedestal: 28 x 27.5 x 119 cm; 11 x 10 ⅞ x 46 ⅞ in.
Hauser & Wirth Collection, Switzerland
120–121

Neon
(with Georg Herold)
2009
Modified fluorescent light fixtures, carrot, cucumber, sausage, plaster, acrylic paint
Carrot: 8 x 24 x 4 cm; 3 ⅛ x 9 ½ x 1 ⅝ in.
Cucumber: 8 x 38 x 4 cm; 3 ⅛ x 15 x 1 ⅝ in.
Sausage, fingers: 7 x 23 x 9 cm; 2 ¾ x 9 x 3 ½ in.
Courtesy of the artist and Galerie Eva Presenhuber, Zurich

Next Time I Break an Egg, I Will Think of You
2004
Polystyrene, polyurethane resin, car paint, duct tape, screws, steel wire
Table: 120 x 100 x 80 cm; 47 ¼ x 39 ⅜ x 31 ½ in.
Chair: 70 x 70 x 70 cm; 27 ½ x 27 ½ x 27 ½ in.
Centre National d'art et de culture Georges Pompidou, Paris
337, 391

Nickname
2009
Nylon filament, preserved croissant, preserved butterfly, steel
Dimensions variable
Edition of 2 + 1 AP
Courtesy of the artist and Galerie Eva Presenhuber, Zurich
236

Noisette
2009
Viewer's approach triggers tongue to emerge from hole
Silicone, motion sensor, mechanism
13 x 14 x 50 cm; 5 ⅛ x 5 ½ x 19 ⅝ in.
Edition of 3 + 1 AP
Courtesy of the artist and Galerie Eva Presenhuber, Zurich
385–386

No Need for Ketchup with the Ice Cream
2004
Aluminum, ACM panels, acrylic paint, latex paint, marker, UV acrylic varnish
308 x 398 x 6 cm; 121 ¼ x 156 ¼ x 2 ⅛ in.
The Dakis Joannou Collection
272

Noodles
2009
Oak, ACM panels, gesso, ink, acrylic paint, polyurethane glue, screws
243.8 x 182.9 x 3.8 cm; 96 x 72 x 1 ½ in.
The Dakis Joannou Collection
284

Not My House, Not My Fire
2004
Polyester resin, polyurethane resin, polystyrene, epoxy glue, acrylic paint, acrylic primer, steel hinges, screws, wood glue
323 x 186 x 56 cm; 127 ⅛ x 73 ¼ x 22 in.
Private Collection
134

A Novel and Its Novelist
2005
Aluminum, ACM panels, gesso, UV inkjet print, latex paint, acrylic paint, marker, UV-protective lacquer
208 x 273 x 6 cm; 81 ⅞ x 107 ½ x 2 ⅜ in.
Vanhaerents Art Collection, Brussels, Belgium
190, 324

Nurse Random (Hymn to the Self-declared Sane)
2000
Wood, glass, particleboard, photocopies on polyester film, latex paint, acrylic paint, oil paint, marker, wood glue, spray adhesive, plaster, screws, metal brackets, tape
190.3 x 237.2 x 12 cm; 74 ⅞ x 93 ⅜ x 4 ¾ in.
Sammlung Falckenberg, Hamburg
260

O

office theme / addiction / mmmh camera
2006
Wood, ACM panels, Epson ultrachrome inkjet print on canvas and Somerset velvet fine art paper, cardboard, primer, oil paint, acrylic paint, paper cement, epoxy polymer, varnish
245.3 x 183 x 8.3 cm; 96 ⅝ x 72 x 3 ¼ in.
Private Collection
251, 280–281, 291

office theme / the nineties / blah is the new bushwa
2006
Wood, ACM panels, Epson ultrachrome inkjet print on canvas and Somerset velvet fine art paper, primer, oil paint, acrylic paint, paper cement, epoxy polymer, varnish
305.5 x 245 x 8 cm; 120 ¼ x 96 ½ x 3 ⅛ in.
The Dakis Joannou Collection
278

Oh, Sad, I See
2006
ACM panels, wood, acrylic paint, gesso, epoxy glue
Each 48 x 54.5 x 2.2 cm; 18 ⅞ x 21 ½ x 1 in.
Private Collection, Belgium
327, 421–423

Old Pain
2007
Plaster, pigment, screw, polyurethane glue, wire
26 x 25 x 15 cm; 10 ¼ x 9 ⅞ x 6 in.
John Kaldor Collection, Australia
11

Olé!
2003
Sugar cubes
Dimensions variable
Private Collection
38

One More Carrot Before I Brush My Teeth
2001
Wood, polystyrene, polyurethane foam, particleboard, glass, latex paint, silicone, pencil, spray adhesive, screws, dust, glue
131 x 81 x 97 cm; 51 ⅝ x 31 ⅞ x 38 ¼ in.
Private Collection
41, 108–109, 218

P

Paper sculpture photographed with silver tray and pear, 1997
7

Paris 1919
2006
Tar, plaster, iron, aluminum, rubber
340 x 85 x 85 cm; 133 ⅞ x 33 ½ x 33 ½ in.
Collection of Amalia Dayan and Adam Lindemann
115

Paris 2006
2006
Left leg jitters impatiently
Electric motor, aluminum tracks, silicone, pigment, cable
85 x 63 x 68 cm; 33 ½ x 24 ¾ x 26 ¾ in.
The Dakis Joannou Collection
143, 254, 370

Partisan Hangover
2000
Wood, glass, particleboard, photocopies on polyester film, acrylic paint, oil paint, marker, wood glue, spray adhesive, plaster, screws, metal brackets, tape
188.3 x 215.5 x 12 cm; 74 ⅛ x 84 ⅞ x 4 ¼ in.
Sammlung Falckenberg, Hamburg
261

Peanuts in Comparison (Erdnüsse im Vergleich)
2004
MDF, aluminum, construction adhesive, acrylic paint, acrylic lacquer
11 parts: 265 x 1000 x 900 cm; 104 ⅜ x 393 ¾ x 354 ⅛ in.
Courtesy of the artist and Galerie Eva Presenhuber, Zurich
86–87, 137

Performance on the occasion of the opening of the exhibition "Frs Uischer," Galerie Walcheturm, Zurich, 1996
Co-performers: Kerim Seiler, Cyril Kuhn, and Maurus Gmür
32-33, 66

Personal Titanic
1998
Glass, wood, paper, plastic, acrylic paint, felt, ink, pencil, marker, ballpoint pen, tape
174.5 x 233.5 x 7.5 cm; 68 ¾ x 91 ⅞ x 3 in.
Hauser & Wirth Collection, Switzerland
165, 241

Personal Weather
2000
Wood, glass, paper, photocopies on polyester film, acrylic paint, marker, spray adhesive
189 x 277 cm; 74 ⅛ x 109 in.
Sammlung Ringier, Switzerland
260

Pick a Moment You Don't Pick
2003
Wood, acrylic glass, inkjet print on film, acrylic paint, marker, glue, spray adhesive, varnish, screws
231 x 310 x 7.5 cm; 91 x 122 x 3 in.
Private Collection
270

Picky Eater
2003
Polystyrene, polyurethane foam, acrylic paint, spray enamel, screws, glue
41 x 15 x 29 cm; 16 ⅛ x 5 ⅞ x 11 ⅜ in.
Private Collection, Athens
377

A Place Called Novosibirsk
2004
Cast aluminum, epoxy resin, iron rod, string, acrylic paint
249 x 77.5 x 105 cm; 98 x 30 ½ x 41 ⅜ in.
Edition of 2 + 1 AP
The Dakis Joannou Collection; Private Collection, courtesy Sadie Coles HQ, London; Sammlung Ringier, Switzerland
340

Poem-Donkey (Unfiltered Autumn 99 Poem)
2000
Iron, glass, zinc phosphate paint, photocopies on polyester film, adhesive tape
195 x 280 x 120 cm; 76 ¾ x 110 ¼ x 47 ¼ in.
Hauser & Wirth Collection, Switzerland
173, 323

Pop the Glock
2006
Cast nickel silver, gesso, oil paint
12.7 x 5 x 7.5 cm; 5 x 2 x 3 in.
Private Collection
289, 469

Portrait of a Moment
2003
Aluminum, two-component polyurethane foam, aircraft cable, steel tubing, acrylic paint, metal fittings
370 x 720 x 380 cm; 145 ⅝ x 283 ½ x 149 ⅝ in.
Burger Collection, Hong Kong
25

Portrait of a Single Raindrop
2003
Cuts in wall with relocated cutouts
Dimensions variable
Collection The Museum of Contemporary Art, Los Angeles
Purchased with funds provided by the Acquistion and Collection Committee
133

Poultry
2009
Pine, MDF, ACM panels, acrylic adhesive, gesso, ink, acrylic paint, polyurethane glue, screws
243.8 x 181.6 x 4.1 cm; 96 x 71 ½ x 1 ⅝ in.
Collection of Anita and Burton Reiner, Washington, D.C.
287

R

Range R
from *Range R / Range L*
1996
Photocopy, tape, stamp
Edition of 60 (30 right, 30 left)
22 x 18 x 7.5 cm; 8 ⅝ x 7 ⅛ x 3 in.
374

Remembering the Polyester Pirate (Instant Apathy)
2000
Tulle, rocks, lacquer, acrylic paint, chain, aluminum pipe, wood, wood glue
Curtain: 400 x 400 cm; 157 ½ x 157 ½ in.
Bench: 80 x 200 x 50 cm; 31 ½ x 78 ¾ x 19 ⅝ in.
Courtesy of the artist and Galerie Eva Presenhuber, Zurich
82, 323

Reversed Scene of a Lost Internal Backdrop
2002
Wood, acrylic paint, glue, marker, acrylic glass, slide film, tape, glass, particleboard
200 x 250 cm; 78 ¾ x 98 ⅜ in.
Private Collection
268

Rotten Foundation
1998
Bricks, mortar, fruits, vegetables
Dimensions variable
Courtesy of the artist and Galerie Eva Presenhuber, Zurich
70–71

Routine (Automatic Melancholy)
2002
Polystyrene, polyurethane foam, screws, gouache
Chair: 53.5 x 89 x 43 cm; 21 x 35 x 17 in.
Installation dimensions variable
Collection Marcel Brient, Paris
20

A Ruin Looking Good in Dawn
2003
Iris print in frame of two compound polyurethane, acrylic
paint, glass, cardboard
46 x 38.3 cm; 18 ⅛ x 15 ⅛ in.
Collection of J. and M. Donnelly, courtesy Sadie Coles HQ,
London
400

Saggy Tit / Stiff Cock
2008
Cast aluminum, acrylic paint
Left to right:
Shelf: 176 x 107 x 30 cm; 69 ¼ x 42 ⅛ x 11 ¼ in.
Shelf: 257 x 131 x 81 cm; 101 ⅛ x 51 ⅝ x 31 ⅞ in.
Box: 117 x 80 x 99 cm; 46 x 31 ½ x 39 in.
Courtesy of the artist and Gavin Brown's enterprise, New York
395

Salami
2009
Oak, ACM panels, gesso, ink, acrylic paint, polyurethane glue,
screws
243.8 x 182.9 x 3.8 cm; 96 x 72 x 1 ½ in.
The Dakis Joannou Collection
283

Say Hello / Say Good Bye
2003
Dried white flowers, polyurethane resin, acrylic paint, screws
76.2 x 73.8 x 48.26 cm; 30 x 29 x 19 in.
Private Collection
125

Schimmelteppich (Mold Rug)
1994
Rubber, foam
Dimensions unknown
Whereabouts unknown
429

Schwerelosigkeit
1998–1999
Wood, glass, paper, latex paint, acrylic paint, ballpoint pen,
acrylic binder, screws
204 x 284 x 9.5 cm; 80 1/4 x 111 3/4 x 3 3/4 in.
Private Collection
73, 257, 322

September Song
2002
Polystyrene, glue, paint, wire, screw, marker
23 x 60 x 10 cm; 9 x 23 ⅝ x 4 in.
Sandra and Giancarlo Bonollo Collection, Italy
375

Servile Serenade / Servile Symphony
2001
Epoxy, lacquer, wood, MDF
Part 1: 21 x 25 x 83 cm; 8 ¼ x 9 ⅞ x 32 ⅝ in.
Part 2: 39 x 31 x 61 cm; 15 ⅜ x 12 ¼ x 24 in.
Burger Collection, Hong Kong
118–119

Shadow Replacement
2005
Portfolio with 18 bound screenprints on transparent paper and
18 framed prints on Epson Enhanced Matte paper
Edition of 25 + 5 AP
Portfolio: 57.4 x 43.1 x 2 cm; 22 ⅝ x 17 ¼ in.
Prints: 56 x 41 cm; 22 x 16 ⅛ in.
21

She Called Her "Taxi"
2004
Aluminum, ACM panels, acrylic paint, latex paint, marker,
UV-protective lacquer
308 x 398 x 6 cm; 121 ¼ x 156 ¾ x 2 ⅜ in.
Private Collection
273, 339

A Shovel and a Hole
2005
Aluminum, ACM panels, UV inkjet print, latex paint, acrylic
paint, marker, UV-protective lacquer
208 x 273 x 6 cm; 81 ⅞ x 107 ½ x 2 ⅜ in.
Collection of Jeanne Greenberg Rohatyn, New York
324

A Sigh Is the Sound of My Life
2000–2001
Overlaid by silicone skin, core rotates on a horizontal axis at a
speed of one revolution every four minutes
Polystyrene, polyurethane foam, wood, steel axle, electric
motor, silicone, gauze, hairs, wood glue
200 x 200 x 280 cm; 78 ¼ x 78 ¼ x 110 ¼ in.
Collection of the artist
41, 218

Skelett
1996
Bricks, cement, unfired clay
Dimensions variable
Collection of the artist
66–67

Skinny Afternoon
2003
Cast aluminum, mirror, lacquer paint, acrylic paint,
polyurethane foam, screws
200 x 160 x 120 cm; 78 ¼ x 63 x 47 ¼ in.
The Dakis Joannou Collection
112–113

Skinny Sunrise
2000
Polystyrene, wood, wood glue, dust, spray adhesive, flour,
acrylic paint, silicone, screws, fabric
70 x 120 x 70 cm; 27 ½ x 47 ¼ x 27 ½ in.
Sammlung Ringier, Switzerland
102–103

Skyline
2002
Cast bronze, acrylic paint
28 x 44.5 x 49 cm; 11 x 17 ½ x 19 ¼ in.
Private Collection, courtesy Contemporary Fine Arts, Berlin
94

Sodbrennen
2000–2004
Mirrors, aluminum, steel frame, silicone, orange juice, coffee,
cigarettes
155 x 155 x 155 cm; 61 x 61 x 61 in.
Dimitris Gigourtakis Collection, Athens
40, 339

So Long Good Smell
2000
Wood, clay, ink, silicone, glass, raw egg, carved egg
(polystyrene, filler, acrylic paint), wire, wood glue
Dimensions variable
Collection James-Keith Brown and Eric Diefenbach
8

Some Say Kumquat, Others Say Vacuum
2003
Aluminum, polyurethane resin, nylon filament, metal
mountings, aircraft cable, acrylic paint, rivets
310 x 200 x 380 cm; 122 x 78 ¾ x 149 ⅝ in.
Vanhaerents Art Collection, Brussels, Belgium
24

Soulkebabish Nosyness
2001
Wood, glass, particleboard, paper, photocopies on polyester
film, photocopies, slide film, latex paint, oil paint, acrylic paint,
marker, wood glue, spray adhesive, UV-protective lacquer,
staples
212 x 266.5 x 12.5 cm; 83 ½ x 104 ⅞ x 4 ⅞ in.
Sammlung Falckenberg, Hamburg
264

Spaghetti and Rilke
1999
Wood, unfired clay, wax, makeup, powder, acrylic paint, car
paint
180 x 200 x 100 cm; 70 ⅞ x 78 ¾ x 39 ⅜ in.
Destroyed
34

Speedy, Smokey, Peegee, Charly, Mungo
2000
Fruits, vegetables, nylon filament, screws
Dimensions variable
Collection of the artist
214

Spinoza Rhapsody
2006
Epoxy resin, pigment, enamel paint, wire, aluminum
Approx. 340 x 905 x 1360 cm; 133 ⅞ x 356 ¼ x 535 ⅜ in.
Edition of 2 + 1 AP
The Dakis Joannou Collection; Sammlung Ringier,
Switzerland; Collection of the artist
326, 331–334

Stalagmites of Love
2001
Aluminum, ACM panels, UV inkjet print, acrylic paint,
marker, UV-protective lacquer
276 x 356 x 6 cm; 108 ⅝ x 140 ⅛ x 2 ⅜ in.
Collection Marcel Brient, Paris
137, 277, 339

Stormy Weather
1999
Bark, acrylic paint, tulle, chains, aluminum tube, plastic letters,
wood, wood glue
Curtain: 600 x 400 cm; 236 ¼ x 157 ½ in.
Stool: 55 x 48 cm; 21 ⅝ x 18 ⅞ in.
Hauser & Wirth Collection, Switzerland
73, 322

Studies for chairs for individual seating positions
Part 1 of 3
1993
Sawdust and rubber
Dimensions unknown
Destroyed
428

Studio views
18, 20, 24, 96, 100–101, 159, 165, 168, 230, 321, 367, 390, 429,
430, 465, 472, 474–475, 481

Stühle
2002
Two-component polyurethane foam, polyurethane foam,
cardboard, tape, acrylic paint, imitation leather, brass pins
97 x 85 x 91 cm; 38 ¼ x 33 ½ x 35 ⅞ in.
Private Collection
398

Stuhl mit (Chair with)
1995–2001
Wood, foam, latex paint, acrylic paint, fabric, screws
100 x 65 x 100 cm; 39 ⅜ x 25 ⅝ x 39 ⅜ in.
Hauser & Wirth Collection, Switzerland
200

Tea Set
2002
Clay, wood, glue, acrylic paint, silver leaf
23 x 45 x 39 cm; 9 x 17 ¼ x 15 ⅛ in.
Private Collection, Germany
222

Tea Set
2002
Clay, acrylic paint, plywood, copper leaf
20 x 38 x 32 cm; 7 ⅞ x 15 x 12 ⅝ in.
Sammlung Ringier, Switzerland
224

Tea Time with Miss Cocktail
2005
Found couch, two-component polyurethane foam, pigments,
screws
37 x 37 x 17 cm; 14 ⅝ x 14 ⅝ x 6 ¼ in.
Installation dimensions variable
Private Collection, courtesy Sadie Coles HQ, London
378–379

Telefon
2003
Polystyrene, acrylic paint, marker, filler
Dimensions unknown
Private Collection, Switzerland
225

Telephone
2002
Polyurethane resin, oil paint
12 x 20 x 11 cm; 4 ¾ x 7 ⅞ x 4 ⅜ in.
Private Collection
223

The Temple of BlaBla Technique
2000
Wood, glass, paper, acrylic paint, marker, wood glue
246 x 306 cm; 96 ⅞ x 120 ½ in.
Private Collection, Athens
259

Thank You Fuck You
2007
Cast aluminum, acrylic paint
153 x 185 x 141 cm; 60 ¼ x 72 ⅞ x 55 ½ in.
Edition of 2 + 1 AP
The Dakis Joannou Collection; The Frank Mosvold
Collection, Norway; Private Collection, Rome
76, 392, 394

**That's the Way It Is with the Magic. Sometimes It
Works and Sometimes It Doesn't**
2000
Plaster, silicone, marker, acrylic paint, spray enamel, glass vase,
polyurethane foam, fresh white lilies
200 x 40 x 40 cm; 78 ¼ x 15 ¼ x 15 ¼ in.
Dr. Barbara Bernoully Collection, Frankfurt
220

A Thing Called Gearbox
2004
Cast aluminum, copper, iron rod, string, acrylic paint
231 x 68 x 67.5 cm; 91 x 26 ¾ x 26 ½ in.
Edition of 2 + 1 AP
Collection Shane Akeroyd, London, courtesy Sadie Coles
HQ, London; Private Collection, courtesy Sadie Coles HQ,
London; Private Collection, London
341

Thinking About Gandhi
2004
Polyurethane resin, acrylic paint
31.8 x 28 x 36.2 cm; 12 ½ x 11 x 14 ¼ in.
Private Collection, New York, courtesy Sadie Coles HQ,
London
228

Thinking about Störtebeker
2005
Portfolio with 18 bound screenprints on transparent paper and
18 framed prints on Epson Enhanced Matte paper
Edition of 25 + 5 AP
Portfolio: 57.4 x 43.1 x 2 cm; 22 ⅜ x 17 x ¼ in.
Prints: 56 x 41 cm; 22 x 16 ⅛ in.
21, 85, 106, 402

Tisch mit (Table with)
1995–2001
Wood, lacquer, acrylic paint, string, mattress, fabric, two-
component epoxy
106 x 123 x 98 cm; 41 ¼ x 48 ⅜ x 38 ⅝ in.
Friedrich Christian Flick Collection
201

To be titled (Y-Chair)
2007
Polyurethane resin, polymeric plaster, steel, pigments
100 x 95 x 90 cm; 39 ⅜ x 37 ⅜ x 35 ⅜ in.
Collection of Matt Aberle, Los Angeles
331, 436–437

The Trick Is to Keep Breathing
2001
Wood, glass, particleboard, photocopies on polyester film, latex
paint, acrylic paint, marker, acrylic glue, tape, screws
219.5 x 281 cm; 86 ⅜ x 110 ⅝ in.
Hauser & Wirth Collection, Switzerland
267

Tuxedo
2009
Pine, MDF, ACM panels, acrylic adhesive, gesso, ink, acrylic
paint, polyurethane glue, screws
243.8 x 181.6 x 4.1 cm; 96 x 71 ½ x 1 ⅝ in.
Collection of Peter Morton, Los Angeles
286

Undigested Sunset
2001–2002
Cast aluminum, wax, wood, acrylic paint, pigments, fabric,
silicone, wood glue, screws
77.5 x 183 x 72.5 cm; 30 ½ x 72 x 28 ½ in.
Goetz Collection, Munich
111

Untitled
1993
Ink and marker on paper; framed
34.2 x 25.5 x 2.8 cm; 13 ½ x 10 x 1 ⅛ in.
Sammlung Ringier, Switzerland
419

Untitled
1993
Blue paint applied to wall to neutralize orange glow from
streetlight
Latex paint, pigments, existing streetlight
Dimensions variable
Collection of the artist
17

Untitled
1993
Marker and pencil on paper
2 drawings, each 29.7 x 21 cm; 11 ¾ x 8 ¼ in.
Private Collection
388

Untitled
1993
Particleboard, velour, staples, screws, contact cement
120 x 155 cm; 47 ¼ x 61 in.
Private Collection
373

Untitled
1995
Cardboard, wood, rubber bands, hinges, coat hanger, string,
screws, tape
Dimensions unknown
Destroyed
100–101

Untitled
1995
Sculpture can be lifted when viewers pull on levers
Concrete, wood, expanding foam, steel wool, metallic car paint,
string, levers
Dimensions unknown
336

Untitled
1995
Cotton fibers, string, polyurethane foam, wood
Dimensions unknown
336

Untitled
1996
Found stool, found bottle, hammer, strawberry jam
Dimensions variable
Collection of the artist
18

Untitled
1996
Wood, lime, bricks, mortar
Dimensions variable
Collection of the artist
202

Untitled
1997
Bark, caulk, latex paint, and acrylic paint on paper
Dimensions unknown
Collection of the artist
320

Untitled
1997
Beam, log, gauze, staples
Dimensions unknown
418

Untitled
1997
Bricks, mortar, wooden beams
Dimensions unknown
68

Untitled
1997
Cut-up pallet, household candles
104 x 100 x 23 cm; 41 x 39 ⅜ x 9 in.
Private Collection, courtesy Sadie Coles HQ, London
203

Untitled
1997
Found furnishings, found clothes, latex paint, acrylic binder,
marker, wood glue, silicone
Dimensions variable
Private Collection
204

Untitled
1997
Wood, wood glue, stain, dishes, glasses, epoxy adhesive,
silicone, acrylic paint
Table: 105 x 184 x 78 cm; 41 ⅜ x 72 ½ x 30 ¼ in.
4 chairs, each 80 x 34 x 40 cm; 31 ½ x 13 ⅜ x 15 ¾ x in.
Hauser & Wirth Collection, Switzerland
439–440

Untitled
1999
Branch, tulle, wax, glue, staples
Dimensions unknown
419

Untitled
1999
Mixed media
Dimensions unknown
169

Untitled
1999
Particleboard, clay, screws, wood glue, acrylic paint, spray
enamel
Dimensions unknown
360

Untitled
2000
Apple, pear, nylon filament, screws
Dimensions variable
Edition of 2 + 1 AP
Private Collection; Friedrich Christian Flick Collection;
Collection of the artist
215

Untitled
2000
Particleboard, wood, unfired clay, candle, wire
Dimensions unknown
Collection of the artist
259

Untitled
2001
Wax, pigment, wick, brick, metal rod
170 x 46 x 29 cm; 66 ⅞ x 18 ⅛ x 11 ⅜ in.
Edition of 3 + 1 AP
Burger Collection, Hong Kong; Collection Marcel Brient,
Paris; David Gill Private Collection, London; Courtesy of the
artist and Galerie Eva Presenhuber, Zurich
51

Untitled
2003
Steel, concrete, screws, hair, polyurethane glue, wood glue,
plastic, burlap, wood, chicken wire
193 x 243.8 x 162.6 cm; 76 x 96 x 64 in.
The Steven and Alexandra Cohen Collection
406

Untitled
2003
Nylon filament, banana, theater spotlight
Dimensions variable
Collection of the artist
23

Untitled
2004
Concrete, iron, steel, wax, cement, soot, pigments, hair,
polyurethane resin, acrylic paint
200 x 227 x 170 cm; 78 ¼ x 89 ⅜ x 66 ⅞ in.
The Dakis Joannou Collection
137, 339, 407

Untitled
2004
Polyurethane resin, acrylic paint, metal pin
15 x 12 x 5 cm; 5 ⅞ x 4 ¼ x 2 in.
Edition of 4
Private Collections
226

Untitled
2006
Polyurethane foam, spray enamel, aluminum rod, screws
106 x 42.5 x 76.5 cm; 41 ¼ x 16 ¼ x 30 ⅛ in.
Collection of Amalia Dayan and Adam Lindemann
144–145

Untitled
2006
Polyurethane resin, acrylic paint
Dimensions unknown
230

Untitled
2006
MDF, gesso, acrylic paint, wood, wood glue, screws
Lighter: 36.6 x 11 x 5.2 cm; 14 ⅜ x 4 ⅜ x 2 in.
Book: 15.8 x 55 x 41.5 cm; 6 ¼ x 21 ⅝ x 16 ⅜ in.
Toast: 54 x 58.8 x 7.8 cm; 21 ¼ x 23 ⅛ x 3 ⅛ in.
Private Collection, Monaco
424

Untitled
2006
Silicone, wood, found chair, shellac
Dimensions variable
434

Untitled
2007
Cast nickel silver, gesso, oil paint
Mouse 1: 6 x 12.5 x 4 cm; 2 ⅜ x 4 ⅞ x 1 ⅝ in.
Mouse 2: 6 x 3.5 x 5 cm; 2 ⅜ x 1 ⅜ x 2 in.
Edition of 1 + 1 AP
Private Collection; Private Collection
290

Untitled
2007
Cast nickel silver, gesso, oil paint
8.5 x 8 x 5.5 cm; 3 ⅜ x 3 ⅛ x 2 ⅛
Edition of 1 + 1 AP
Private Collection; Private Collection
291

Untitled
2007
Cast nickel silver, gesso, oil paint
Edition of 1 + 1 AP
13 x 13 x 5 cm; 5 ⅛ x 5 ⅛ x 2 in.
Private Collection; Private Collection
291, 471

Untitled
2007
Aluminum, transparent primer, vinyl paint, pigments, silicone,
screws
Panel 1: 336 x 450 x 8 cm; 132 ⅛ x 177 x 3 ⅛ in.
Panel 2: 343 x 445 x 8 cm; 135 x 175 x 3 ⅛ in.
Panel 3: 361 x 465 x 8 cm; 142 x 183 x 3 ⅛ in.
Private Collection
308–311

Untitled
2007
Aluminum, transparent primer, vinyl paint, pigments, silicone,
screws
284.5 x 361.9 cm; 112 x 142 ½ in.
Collection of Peter Morton, Los Angeles
306

Untitled
2007
Aluminum, transparent primer, vinyl paint, pigments, silicone,
screws
274.3 x 350.8 cm; 108 x 138 ⅛ in.
The Dakis Joannou Collection
306

Untitled
2007
Aluminum, transparent primer, vinyl paint, pigments, silicone,
screws
284.5 x 361.9 cm; 112 x 142 ½ in.
Private Collection, New York, courtesy Sadie Coles HQ,
London
307

Untitled
2009
Plaster, acrylic paint, bread
10 x 21 x 15 cm; 3 ⅞ x 8 ¼ x 5 ⅞ in.
Private Collection
384

Untitled
2009
Latex paint, found chair, found hand truck
280 x 280 x 380 cm; 110 ¼ x 110 ¼ x 149 ⅝ in.
Courtesy of the artist and Galerie Eva Presenhuber, Zurich
27

Untitled (50 Rocks)
1996
50 found river rocks
Dimensions variable
Collection of the artist
66–67, 240, 319

Untitled (Baum)
1999
Cork, wood, silicone, acrylic paint, moss, glue, wire, wooden
bird model, dried leaves
280 x 150 x 200 cm; 110 ¼ x 59 x 78 ¼ in.
Collection Fondazione Sandretto Re Rebaudengo, Turin, Italy
212

Untitled (Branches)
2005
Cast aluminum, chains, candles, low-speed electric motors,
control units
Branch 1: 50 x 320 x 40 cm; 19 ⅝ x 126 x 15 ¼ in.
Branch 2: 50 x 310 x 40 cm; 19 ⅝ x 122 x 15 ¼ in.
Installation dimensions variable
Edition of 2 + 1 AP
Courtesy Sadie Coles HQ, London; Sammlung Ringier,
Switzerland; Rubell Family Collection, Miami, Florida
248–251

Untitled (Bread House)
2004
Bread, wood, marzipan, screws
400 x 400 x 430 cm; 157 ½ x 157 ½ x 169 ¼ in.
Self-destroyed
187–189

Untitled (Bread House)
2004–2005
Bread, bread crumbs, wood, polyurethane foam, silicone,
acrylic paint, screws, tape, rugs, theater spotlights
406 x 372 x 421 cm; 159 ⅞ x 146 ½ x 165 ¼ in.
Collection Angela and Massimo Lauro, Naples
190–195

Untitled (Bread House)
2004–2006
Bread, bread crumbs, wood, polyurethane foam, silicone,
acrylic paint, screws, tape, rugs, theater spotlights
500 x 400 x 500 cm; 196 ⅞ x 157 ½ x 196 ⅞ in.
The Dakis Joannou Collection
196–198

Untitled (Brick)
2005
Polyurethane resin, acrylic paint
22.9 x 7.6 x 8.9 cm; 9 x 3 x 3 ½ in.
Courtesy of the artist and Gavin Brown's enterprise, New York
231

Untitled (Cabinet)
2007
Cast aluminum, mirror, local plants
261 x 188 x 155 cm; 102 ¼ x 74 x 61 in.
Private Collection, courtesy Sadie Coles HQ, London
154–155

Untitled (Candle)
1999
Fiber cement, candles
Base: 100 x 100 cm; 39 ⅜ x 39 ⅜ in.
Pedestal: 125 x 20 x 20 cm; 49 ¼ x 7 ⅞ x 7 ⅞ in.
Wax: 70 x 85 x 70 cm; 27 ½ x 33 ½ x 27 ½ in., growing
Hauser & Wirth Collection, Switzerland
208–209

Untitled (Chair)
1997–2000
Wooden chair, clay, oil paint, acrylic paint, wax, spray adhesive,
matte varnish, silicone
84 x 51 x 48 cm; 33 x 20 x 18 ⅞ in.
Friedrich Christian Flick Collection
361

Untitled (Cut) / Untitled (Cut)
1991
Acrylic and pencil on paper; framed
2 drawings, each 34.2 x 25.5 x 2.8 cm; 13 ½ x 10 x 1 ⅛ in.
Courtesy of the artist and Galerie Eva Presenhuber, Zurich
391

Untitled (Door)
2006
Cast aluminum, enamel paint, steel hinges
215 x 136 x 51 cm; 84 ⅝ x 53 ½ x 20 ⅛ in.
Private Collection
146–147

Untitled (Door)
2006
Cast aluminum, enamel paint, steel hinges
242 x 157 x 27 cm; 95 ¼ x 61 ¼ x 10 ⅝ in.
The Dakis Joannou Collection
151–152

Untitled (Door)
2006
Cast aluminum, enamel paint, steel hinges
247 x 156 x 27 cm; 97 ¼ x 61 ⅜ x 10 ⅝ in.
Private Collection
151–153

Untitled (Door)
2006
Cast aluminum, enamel paint, steel hinges
256 x 172 x 27 cm; 100 ¼ x 67 ¾ x 10 ⅝ in.
Heinz Peter Hager / Bolzano / Italy
148–149

Untitled (Door)
2006
Cast aluminum, enamel paint, steel hinges
281 x 183 x 27 cm; 110 ⅝ x 72 x 10 ⅝ in.
Collection Angela and Massimo Lauro, Naples
150–151

Untitled (Doors)
2007
Two doors installed in wall
Cast aluminum, enamel paint, steel hinges
Door 1: 250 x 185 x 33 cm; 98 ⅛ x 72 ⅞ x 13 in.
Door 2: 242 x 175 x 32 cm; 95 ¼ x 68 ⅞ x 13 in.
Rubell Family Collection, Miami, Florida
156–157, 293

Untitled (Doors)
2007
Two doors installed in wall
Cast aluminum, enamel paint, steel hinges
Door 1: 235 x 155 x 33 cm; 92 ½ x 61 x 13 in.
Door 2: 220 x 135 x 33 cm; 86 ⅝ x 53 ⅛ x 13 in.
156–157, 293

Untitled (Eierschale)
2000
MDF, clay, acrylic paint, wood glue, oil paint, marker, eggs,
hairspray, matte varnish
19 x 38 x 29 cm; 7 ½ x 15 x 11 ⅛ in.
Collection Max Wandeler, Switzerland
9

Untitled (Floor Piece)
2006
Black adhesive vinyl, latex paint
Dimensions variable
La Colección Jumex, Mexico
42–43, 144–145, 252–253, 302–303

Untitled (Garbage Pile)
1995
Garbage and latex
Dimensions unknown
Whereabouts unknown
161

Untitled (Hole)
2007
Cast aluminum
540 x 340 x 270 cm; 212 ½ x 133 ⅞ x 106 ¼ in.
Edition of 2 + 1 AP
The Dakis Joannou Collection; Private Collection; The Brant
Foundation, Greenwich, Connecticut, courtesy Sadie Coles
HQ, London
126–129

Untitled (Holes)
2006
Carved polyurethane, plaster, acrylic paint, screws, wire
Ear: 13 x 34 x 9 cm; 5 ⅛ x 13 ⅜ x 3 ½ in.
Nose: 8 x 31 x 8 cm; 3 ⅛ x 12 ¼ x 3 ⅛ in.
Arse: 15 x 19 x 13 cm; 5 ⅞ x 7 ½ x 5 ⅛ in.
Willy: 7 x 34 x 9 cm; 2 ¾ x 13 ⅜ x 3 ½ in.
Mouth: 15 x 33 x 14 cm; 5 ⅞ x 13 x 5 ½ in.
Collection Angela and Massimo Lauro, Naples
140–143

Untitled (Lamp / Bear)
2005–2006
Cast bronze, lacquer, acrylic glass, gas discharge lamp, stainless
steel framework
700 x 650 x 750 cm; 275 ⅝ x 255 ⅞ x 295 ¼ in.
Edition of 2 + 1 AP
Private Collection; Collection of Amalia Dayan and Adam
Lindemann; The Steven and Alexandra Cohen Collection
410 (study for), 411–416, 412 (prototype)

Untitled (Landscape)
1998
Mixed media, plastic bottle, magnets
Dimensions unknown
Destroyed
242

Untitled (Nude on a Table)
2002
Two-component polyurethane foam, cardboard, polystyrene,
polyurethane foam, tape, screws, powdered sugar, egg whites,
pigments, acrylic paint
141 x 157 x 126 cm; 55 ½ x 61 ¼ x 49 ⅝ in.
Vanhaerents Art Collection, Brussels, Belgium
110

Untitled (Nürnberg)
2006
Wood, ACM panels, Epson ultrachrome inkjet print on
Somerset velvet fine art paper, primer, oil paint, acrylic paint,
paper cement, paint marker, varnish
305.5 x 245 x 8 cm; 120 ¼ x 96 ½ x 3 ⅛ in.
Private Collection
279

Untitled (Paper Hand)
1993
Photocopy, tape, stamp
Dimensions unknown
Destroyed
374

Untitled (Pink Chair)
1996
Found chair, gauze, acrylic paint, glue, staples, lacquer
103 x 41 x 50 cm; 40 ½ x 16 ⅛ x 19 ¾ in.
Collection of Amalia Dayan and Adam Lindemann
430

Untitled (Pink Lady)
2001
Polystyrene, polyurethane resin, polyurethane foam, oil paint, acrylic paint, fluorescent pigments, sugar, egg whites, screws
100 x 100 x 150 cm; 39 ⅜ x 39 ⅜ x 59 in.
Collection Fundação de Serralves—Contemporary Art Museum, Porto, Portugal
104–105

Untitled (Self-destroying Cat)
2009
Unfired clay
Dimensions variable
Self-destroyed
98

Untitled (Skinny)
2001
Polystyrene, epoxy, strings, screws
Dimensions unknown
Destroyed
107

Untitled (Step Piece)
1995
Intervention activated by visitor's entrance into gallery; when stepped on, slightly elevated wooden board slaps the floor, producing a loud noise
MDF, aluminum trim, bungee cord, hooks
Dimensions variable
Collection of the artist
131

Untitled (Swings)
1995
Rope, wood, knives
Dimensions unknown
Collection of the artist
239

Untitled (Tongue / Léger Shift / Cookie Cutter)
1993
Marker and pencil on paper; framed
25.5 x 34.2 x 2.8 cm; 10 x 13 ½ x 1 ⅛ in.
Collection Maja Hoffmann, Switzerland
388

Untitled (Wand der Angst)
1997
Ytong, wood glue, silicone, coffee
320 x 830 x 203 cm; 126 x 326 ¼ x 79 ⅞ in.
Courtesy of the artist and Galerie Eva Presenhuber, Zurich
34, 68–69, 440

Vain Whining
2001
Wood, glass, paper, photocopies on polyester film, slide film, latex paint, acrylic paint, marker, wood glue, wallpaper paste, spray adhesive, screws, laminate
186.2 x 238 x 12 cm; 73 ¼ x 93 ¾ x 3 ¼ in.
Friedrich Christian Flick Collection
262

Verbal Asceticism
2007
Wallpaper prints of black-and-white reproductions of artworks exhibited in these rooms in the previous exhibition "Where Are We Going?"
Dimensions variable
Courtesy of the artist, Galerie Eva Presenhuber, Zurich, and Sadie Coles HQ, London
289–292

Verhängnis
(with Maurus Gmür)
1995
Wood, plastic film, latex paint, acrylic paint, sawdust, fabric
Dimensions unknown
Whereabouts unknown
29

Vieille Prune
2005
Two-component polyurethane foam, pigments, screws, epoxy glue
53 x 45 x 21 cm; 20 ⅞ x 17 ¾ x 8 ¼ in.
Private Collection, courtesy Sadie Coles HQ, London
378–379

Vintage Violence
2004–2005
Plaster, resin paint, steel, nylon filament
Dimensions variable: 1,700 raindrops, each up to 19 x 9 x 8 cm; 7 ½ x 3 ½ x 3 ⅛ in.
Private Collection
342–343

Violent Cappuccino
2007
Cast aluminum, lacquer, motor oil, glue, dust
202.5 x 130 x 73 cm; 79 ¾ x 51 ⅛ x 28 ¼ in.
Edition of 2 + 1 AP
Bischofberger Collection, Zurich; Private Collection; Private Collection, Switzerland
116

Walking Heads / Thinking Feet
2002
Polystyrene, polyurethane foam, acrylic paint, latex paint, screws
56 x 19 x 15 cm; 22 x 7 ½ x 5 ⅞ in.
Private Collection
95

Wandnarbe (Wall Scar)
1996
Plaster, newspaper, wire, latex paint
Dimensions variable
Collection of the artist
319

Warum wächst ein Baum / Kann man zuviel Fragen (Nr. 1) Why does a tree grow / Can one ask too much (No. 1)
2001
Polyurethane resin, UV-protective varnish, acrylic paint, polystyrene
13 x 100 x 93 cm; 5 ⅛ x 39 ⅜ x 36 ⅝ in.
Courtesy Sadie Coles HQ, London
218

Warum wächst ein Baum / Kann man zuviel Fragen (Nr. 2) Why does a tree grow / Can one ask too much (No. 2)
2001
Polyurethane resin, UV-protective varnish, acrylic paint, polystyrene
13 x 80 x 70 cm; 5 ⅛ x 31 ½ x 27 ½ in.
Collection Marcel Brient, Paris
218

Warum wächst ein Baum / Kann man zuviel Fragen (Nr. 3) Why does a tree grow / Can one ask too much (No. 3)
2001
Polyurethane resin, UV-protective varnish, acrylic paint, polystyrene
13 x 86 x 73 cm; 5 ⅛ x 33 ⅞ x 28 ¼ in.
Hauser & Wirth Collection, Switzerland
41, 218

Watching a Three-Legged Cat Cross a Street
2005
Cast aluminum, acrylic paint
20 x 200 x 6 cm; 7 ⅞ x 78 ¾ x 2 ⅛ in.
Private Collection, Switzerland
227

The Way You Move
2003
Polystyrene, glue, acrylic paint, marker
12 x 9 x 13 cm; 4 ¾ x 3 ½ x 5 ⅛ in.
Private Collection, Switzerland
403

What if the Phone Rings
2003
Wax, pigment, wick
Figure 1: 106 x 142 x 46 cm; 41 ¼ x 55 ⅞ x 18 ⅛ in.
Figure 2: 200 x 54 x 46 cm; 78 ¾ x 21 ¼ x 18 ⅛ in.
Figure 3: 94 x 99 x 54 cm; 37 x 39 x 21 ¼ in.
Edition of 3 + 1 AP
The Dakis Joannou Collection; Sender Collection, New York; Sammlung Ringier, Switzerland; Friedrich Christian Flick Collection
52-59, 137, 270, 339

What Should an Owl Do with a Fork
2002
Wax, wick, wood, garbage
178 x 71 x 30.5 cm; 70 ⅛ x 28 x 12 in.
Destroyed
50

Whiny Vanity
2001
Wood, glass, paper, photocopies on polyester film, slide film, latex paint, acrylic paint, marker, wood glue, spray adhesive, screws, laminate
186.2 x 238 cm x 12 cm; 73 ¼ x 93 ¾ x 3 ¼ in.
Friedrich Christian Flick Collection
263

Window-smashing with Cyril Kuhn and Akira, "Assistent," Stiftung Binz39, Zurich, 1995
31

Yes / No Crossfade
1996
String, wire, plaster, newspaper
Unfinished
321

You
2007
Excavation, gallery space, 1:3 scale replica of main gallery space
Dimensions variable
Courtesy The Brant Foundation, Greenwich, Connecticut
349–358

You Can Not Win
2003
Polystyrene, acrylic paint, Aqua-Resin, screws, fiberglass
137.2 x 76.2 x 129.5 cm; 54 x 30 x 51 in.
Collection of Laura Steinberg and Bernardo Nadal-Ginard, Chestnut Hill, Massachusetts
133, 404

You Can Only Lose
2003
Polystyrene, acrylic paint, Aqua-Resin, screws, fiberglass
312.4 x 111.8 x 106.7 cm; 123 x 44 x 42 in.
Private Collection
133, 405

Your Deaths Your Births
2004
Aluminum, ACM panels, UV inkjet print, acrylic paint, marker, UV-protective lacquer
356 x 276 x 6 cm; 140 ⅛ x 108 ⅝ x 2 ⅛ in.
Private Collection
137, 274–275

Youyou
2004–
Work in progress
Private Collection
26

Zizi
2006–2008
Cast aluminum, steel
410 x 230 x 226 cm; 161 ⅜ x 90 ½ x 89 in.
Courtesy of the artist and Galerie Eva Presenhuber, Zurich
442–445

Opposite page:

Studio view, work in progress
Van Brunt Street, Brooklyn, 2009

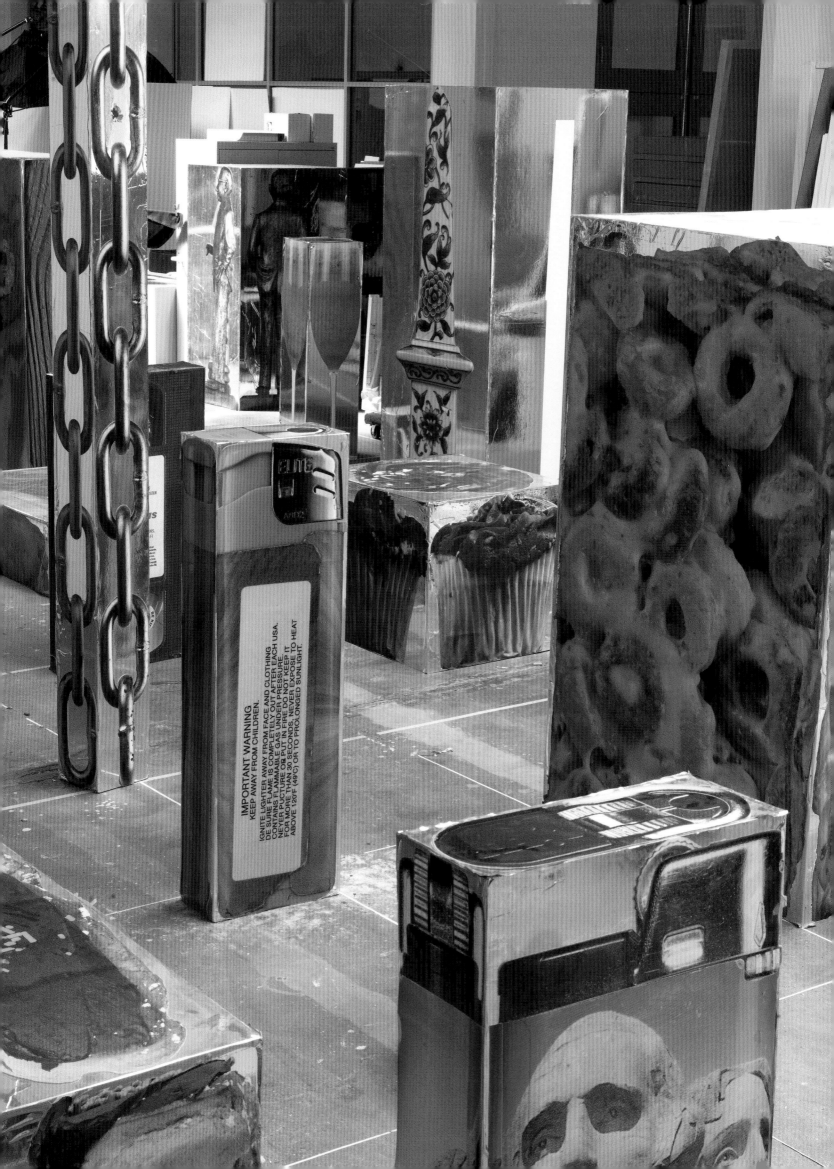

BIOGRAPHY

URS FISCHER

Born 1973, Zurich

Studied photography at the Schule für Gestaltung, Zurich
Visited De Ateliers, Amsterdam
Artist in residence, Delfina Studios, London

Lives and works in New York

Solo Exhibitions

2009
"Marguerite de Ponty," New Museum, New York, October 28, 2009–
January 24, 2010
"Dear _____! We _____ on _____, hysterically. It has to be _____
that _____. No? It is now _____ and the whole _____ has changed
_____. all the _____, _____" (with Mark Handforth and Georg Herold),
Kunstnernes Hus, Oslo, May 15–July 26

2008
"Blurry Renoir Debussy," Galerie Eva Presenhuber, Zurich, October 25,
2008–January 31, 2009

2007
"Agnes Martin," Regen Projects, Los Angeles, December 15, 2007–
January 19, 2008
"you," Gavin Brown's enterprise, New York, October 25–December 22
"Uh...," Sadie Coles HQ, London, October 11–November 17
"large, dark & empty," Galerie Eva Presenhuber, Zurich, September 8–
November 17
"get up girl a sun is running the world" (with Ugo Rondinone), Church
San Stae, Venice Biennale, June 10–November 21
Cockatoo Island, Kaldor Art Projects and the Sydney Harbour Federation
Trust, Sydney, April 20–June 3

2006
"Urs Fischer e Rudolf Stingel," Galleria Massimo de Carlo, Milan,
November 30, 2006–January 20, 2007
"Oh. Sad. I see.," The Modern Institute, Glasgow, November 4–
December 16
"Mary Poppins," Blaffer Gallery, The Art Museum of the University of
Houston, Texas, May 13–August 5
Galerie Eva Presenhuber, Zurich, May 12–June 2
"Paris 1919," Museum Boijmans Van Beuningen, Rotterdam, April 1–
May 25

2005
"Mr. Watson—Come Here—I Want to See You," Hydra Workshop,
Greece, July 23–September 10
"Urs Fischer. Werke aus der Friedrich Christian Flick Collection im
Hamburger Bahnhof," Hamburger Bahnhof, Museum für Gegenwart,
Berlin, June 20–August 7
Camden Arts Centre, London, May 13–July 10
"Jet Set Lady," Fondazione Nicola Trussardi, Milan, May 3–June 1
"Fig, Nut & Pear," Gavin Brown's enterprise, New York, February 4–
March 5

2004
"Elton John?" Sadie Coles HQ, London, December 1, 2004–
January 15, 2005
"Feige, Nuss, und Birne," Gruppe Österreichische Guggenheim, Vienna,
October 9–November 28
"Kir Royal," Kunsthaus Zürich, July 9–September 26

"Not My House Not My Fire," Espace 315, Centre Georges Pompidou,
Paris, March 10–May 10

2003
"Portrait of a Single Raindrop," Gavin Brown's enterprise, New York,
April 12–May 10
"need no chair when walking," Sadie Coles HQ, London, January 29–
March 8

2002
"What Should an Owl Do with a Fork," Santa Monica Museum of Art,
California, July 13–August 30
"Mystique Mistake," The Modern Institute, Glasgow, June 28–July 26
"Bing Crosby," Contemporary Fine Arts, Berlin, January 12–February 16

2001
"Mastering the Complaint," Galerie Hauser & Wirth & Presenhuber,
Zurich, August 25–October 17

2000
"Cappillon—Urs just does it for the girls" (with Amy Adler), Delfina,
London, September 21–November 5
"The Membrane—and why I don't mind bad-mooded People," Stedelijk
Museum Bureau Amsterdam, April 16–May 28
"Tagessuppen / Soups of the Days" and "6 ½ Domestic Pairs Project"
(with Keith Tyson), Kunsthaus Glarus, Switzerland, April 1–June 12
"Without a Fist—Like a Bird," Institute of Contemporary Arts, London,
January 20–February 27

1999
"Espressoqueen—Worries and other stuff you have to think about before
you get ready for the big easy," Galerie Hauser & Wirth & Presenhuber,
Zurich, January 16–March 13

1997
"Hammer," Galerie Walcheturm, Zurich, August 29–October 4

1996
"Frs Uischer," Galerie Walcheturm, Zurich

Group Exhibitions

2009
"Mapping the Studio: Artists from the François Pinault Collection,"
Palazzo Grassi and Punta della Dogana, Venice, June 6, 2009–
December 2010
"A Guest + A Host = A Ghost: Works from the Dakis Joannou
Collection," Deste Foundation Centre for Contemporary Art, Athens,
May 7–December 31
"Saints and Sinners," The Rose Art Museum, Brandeis University,
Waltham, Massachusetts, January 15–April 5
"Nothingness and Being," La Colección Jumex, Ecatepec, Mexico

2008
"Open Plan Living," Tel Aviv Museum of Art, September 27–October 18
"Archeology of Mind," Malmö Konstmuseum, Sweden, September 14–
November 9
"Château de Tokyo / Palais de Fontainebleau," Château de Fontainebleau,
Fontainebleau, France, September 7–October 5
"An Unruly History of the Readymade," La Colección Jumex, Ecatepec,
Mexico, September 6, 2008–March 7, 2009
"Sammlung / Collection," Migros Museum für Gegenwartskunst, Zurich,
June 1–August 17

Züri Hünd sind Fründ

"Who's Afraid of Jasper Johns?" Tony Shafrazi Gallery, New York, May 19–July 18
"The Hamsterwheel," Malmö Konsthall, Sweden, May 17–August 17
"Blasted Allegories: Works from the Ringier Collection," Kunstmuseum Luzern, Lucerne, Switzerland, May 16–August 3
"God is Design," Galeria Fortes Vilaça, São Paulo, March 29–May 31
"Countdown," CCS Galleries, Bard College, Annandale-on-Hudson, New York, March 16–30
"Schweiz über alles," La Colección Jumex, Ecatepec, Mexico, January 26–March 19

2007
"Euro-Centric, Part 1: New European Art from the Rubell Family Collection," Rubell Family Collection, Miami, December 5, 2007–November 28, 2008
"Unmonumental: The Object in the 21st Century," New Museum, New York, December 1, 2007–March 30, 2008
"Hamsterwheel," CASM Centre d'Art Santa Monica, Barcelona, November 9, 2007–January 5, 2008
"Jubilee Exhibition," House Eva Presenhuber, Vnà, Switzerland, October 19, 2007–January 26, 2008
"The Third Mind: Carte Blanche to Ugo Rondinone," Palais de Tokyo, Paris, September 27, 2007–January 3, 2008
"The Hamsterwheel," Le Printemps de Septembre, Toulouse, France, September 21–October 14
Lyon Biennial, France, September 19, 2007–January 6, 2008
"Makers and Modelers: Works in Ceramic," Barbara Gladstone Gallery, New York, September 8–October 20
"Fractured Figure: Works from the Dakis Joannou Collection," Deste Foundation Centre for Contemporary Art, Athens, September 5, 2007–July 31, 2008
"Traum & Trauma: Werke aus der Sammlung Dakis Joannou, Athen," MUMOK and Kunsthalle Wien, Vienna, June 29–October 4
"The Hamsterwheel," Tese della Novissima, Arsenale di Venezia, Venice, June 7–September 2
"Domestic Irony: A curious glance on private Italian collections," Museion, Bolzano, Italy, May 26–September 2

"Sequence 1: Painting and Sculpture in the François Pinault Collection," Palazzo Grassi, Venice, May 5–November 11
"Disorder in the House," Vanhaerents Art Collection, Brussels, March 16, 2007–June 30, 2010

2006
"The Studio," The Hugh Lane Gallery, Dublin, December 1, 2006–February 25, 2007
"The François Pinault Collection, a Post-Pop Selection," Palazzo Grassi, Venice, November 11, 2006–March 11, 2007
"Defamation of Character," P.S.1 Contemporary Art Center, Long Island City, New York, October 29, 2006–January 15, 2007
"Contrabando," Galleria Luisa Strina, São Paulo, October 4–November 10
"The Vincent Award 2006," Stedelijk Museum, Amsterdam, September 15, 2006–January 14, 2007
"Cinq milliards d'années," Palais de Tokyo, Paris, September 14, 2006–January 14, 2007
"Strange I've Seen That Face Before," Museum Abteiberg, Mönchengladbach, Germany, May 7–September 17
"Where Are We Going? Selections from the François Pinault Collection," Palazzo Grassi, Venice, April 29–October 1
"Infinite Painting—Contemporary Painting and Global Realism," Villa Manin Centre for Contemporary Art, Codroipo, Italy, April 9–September 24
"Day for Night," Whitney Biennial, Whitney Museum of American Art, New York, March 2–May 28
"Collection 1," Museum Boijmans Van Beuningen, Rotterdam, January 2006–December 2008

2005
"Looking at Words: The Formal Presence of Text in Modern and Contemporary Works on Paper," Andrea Rosen Gallery, New York, November 2, 2005–January 4, 2006
"Ma Non Al Sud," Galleria Civica d'Arte Contemporanea di Siracusa, Syracuse, Italy, September 24–November 30
"Closing Down," Bortolami Dayan, New York, September 21–October 29
"Big Bang. Destruction and Creation in 20th Century Art," Centre

Pompidou, Paris, June 15, 2005–April 3, 2006
"Put It In Your Mouth / I'll see you on the dark side of the prune," Rivington Arms, New York, June 10–July 24
"Bidibidobidiboo: Works from Collezione Sandretto Re Rebaudengo," Fondazione Sandretto Re Rebaudengo, Turin, Italy, May 31–October 2
"Material Time / Work Time / Life Time," Reykjavik Art Museum, Iceland, May 14–August 21
"Swiss Made (The Art of Falling Apart): Works from the Hauser & Wirth Collection," CoBrA Museum of Modern Art, Amstelveen, Amsterdam, March 19–June 12
"Universal Experience: Art, Life, and the Tourist's Eye," Museum of Contemporary Art, Chicago, February 12–June 5

2004
"Skulptur: Prekärer Realismus zwischen Melancholie und Komik," Kunsthalle Wien, Vienna, October 15, 2004–February 22, 2005
"Group Show," Regen Projects, Los Angeles, July 10–August 7
"Monument to Now," Deste Foundation Centre for Contemporary Art, Athens, June 22, 2004–March 6, 2005
"L'Air du Temps—Collection Printemps / Été 2004," Migros Museum für Gegenwartskunst, Zurich, April 3–May 31

2003
"Silver Convention," Galerie Giti Nourbakhsch, Berlin, December 6, 2003–January 4, 2004
"Unplugged," Galleria Civica di Arte Contemporanea, Trento, Italy, November 23, 2003–February 28, 2004
"Inaugural Group Exhibition," September 20–October 4
"Dreams and Conflicts: The Viewer's Dictatorship," Venice Biennale, June 12–November 6
"Bewitched, Bothered and Bewildered: Spatial Emotion in Contemporary Art and Architecture," Migros Museum für Gegenwartskunst, Zurich, March 22–May 25
"Kunstpreis der Böttcherstrasse," Kunsthalle Bremen, Germany, March 2–April 13
"Breathing the Water," Galerie Eva Presenhuber, Zurich, February 8–March 14
"Durchzug / Draft: Zwanzig Jahre Stiftung Binz39," Kunsthalle Zürich, January 25–March 9

2002
"Exile on Main Street," New International Cultural Center (NICC), Antwerp, June 22–September 15
"The Object Sculpture," Henry Moore Institute, Leeds, England, June 1–September 1
"My head is on fire but my heart is full of love," Charlottenborg Exhibition Hall, Copenhagen, May 8–June 9
"The House of Fiction," Sammlung Hauser und Wirth, Lokremise, St. Gallen, Switzerland, May 5–October 13
"Lowland Lullaby: Ugo Rondinone with John Giorno and Urs Fischer," Swiss Institute, New York, March 26–May 11

2001
"Squatters," Museu Serralves, Porto, Portugal, June 26–September 16
"Ziviler Ungehorsam—Zeitgenössische Kunst aus der Sammlung Falckenberg," Kestner-Gesellschaft, Hanover, Germany, April 7–June 23
"Enduring Love," Klemens Gasser & Tanja Grunert, Inc., New York, February 23–March 24

2000
"Borderline Syndrome. Energies of Defence," Manifesta 3, European Biennial of Contemporary Art, Ljubljana, Slovenia, June 23–September 24
"Sammlung (1). The Oldest Possible Memory," Sammlung Hauser und Wirth, Lokremise, St. Gallen, Switzerland, May 14–October 15

1999
"Drawings," Sommer Contemporary Art, Tel Aviv, December 29, 1999–February 26, 2000
"Eidgenössische Preise für Freie Kunst," Kunsthalle Zürich, November 6–December 30

"Pizzeria Sehnsucht" (with Marko Lehanka), Ateliers du FRAC des Pays de la Loire, Saint-Nazaire, France, October 23–December 14

"999," Centro d'Arte Contemporanea Ticino, Bellinzona, Switzerland, July 18–September 19
"Le repubbliche dell'arte," Palazzo delle Pappesse, Sienna, Italy, June 27–October 3
"Holding Court," Entwistle Gallery, London, January 9–February 13

1998
"Morning Glory. De Ateliers 1993–1997," De Ateliers, Amsterdam, September 4–20
"ironisch / ironic: maurizio cattelan, urs fischer, alicia framis, steve mcqueen, aernout mik / marjoleine boonstra," Migros Museum für Gegenwartskunst, Zurich, June 27–August 9

1997
"été 97," Centre d'édition contemporaine (formerly Centre Genevois de Gravure Contemporain), Geneva, September 29–December 13
"Guarene arte 97," Fondazione Sandretto Re Rebaudengo, Turin, Italy, September 28–November 6
"Dokumentation," Hotel, Zurich

1995
"Calypso" (with Antonietta Peeters and Avery Preesman), Stedelijk Museum Bureau Amsterdam, December 2–31
"Preisträgerinnen und Preisträger des Eidgenössischen Wettbewerbs für freie Kunst," Kunsthaus Glarus, Switzerland, September 24–November 19
"Karaoke 444&222 too," South London Gallery, London, July 11–August 20
"Assistent" (with Maurus Gmür), Stiftung Binz39, Zurich, March 25–April 30

Awards and Grants

1999
Providentia-Preis, Young Art
Bundesamt für Kultur, Eidgenössisches Stipendium für freie Kunst, Zurich

1997
Kiefer-Hablitzel Stipendium

1995
Bundesamt für Kultur, Eidgenössisches Stipendium für freie Kunst, Zurich

Books

Becher, Jörg. *Die 50 wichtigsten Künstler der Schweiz*. Basel: Echtzeit Verlag, 2007.

Berard, Emmanuel, and Emanuela Mazzonis, eds. *Sequence 1: Painting and Sculpture from the François Pinault Collection*. Milan: Skira; Venice: Palazzo Grassi, 2007.

———. *Sommario. La collezione François Pinault. Una selezione Post-Pop*. Venice: Palazzo Grassi, 2006.

Bidner, Stefan, ed. *Franz West—Soufflé, eine Massenausstellung*. Innsbruck: Kunstraum, 2008.

Bonami, Francesco. *Infinite Painting*. Codroipo, Italy: Villa Manin Centro d'Arte Contemporanea, 2006.

Bonami, Francesco, and Hans Ulrich Obrist. *Sogni / Dreams*. Turin: Fondazione Sandretto Re Rebaudengo per l'Arte, 1999.

Bundesamt für Kultur, ed. *Swiss Art Award 2007*. Berne: Bundesamt für Kultur BAK, 2007.

Cros, Caroline. *Qu'est-ce que la sculpture aujourd'hui?* Paris: Beaux-Arts éditions, 2008.

Deitch, Jeffrey, ed. *Monument to Now: The Dakis Joannou Collection*. Athens: Deste Foundation; New York: D.A.P., 2004.

Fischer, Urs. *Good Smell Make-up Tree*. Geneva: JRP Editions, 2004. Music by Garrick Jones.

———. *Helmar Lerski*. Self-published artist's book, 2008.

———. *Livre numéro 2. Espace trois-cent-quinze, création contemporaine et prospective*. Paris: Éditions du Centre Pompidou, 2004.

———. *The Membrane—and why I don't mind bad-mooded people*. Amsterdam: Stedelijk Museum Bureau Amsterdam, 2000.

———. *Mr. Watson—Come Here—I Want to See You*. Hydra: Hydra Workshops, 2005.

———. *Paris 1919*. Zurich: JRP | Ringier, 2006. Essay by Rein Wolfs.

———. *Time Waste. Urs Fischer. Radio-Cookie und kaum Zeit, kaum Rat*. Zurich: Edition Unikate; Glarus: Kunsthaus, 2000. Essay by Beatrix Ruf and interview by Dominic van den Boogerd.

———. *Who's Afraid of Jasper Johns?* Self-published artist's book, 2008.

Fischer, Urs, and Eugen Blume. *Urs Fischer: Werke aus der Friedrich Christian Flick Collection im Hamburger Bahnhof*. Cologne: Dumont, 2005.

Fischer, Urs, and Claudia di Gallo. *Urs Fischer, Claudio Di Gallo, Ugo Rondinone, Markus Schwander*. Lucerne: Kunstmuseum, 1992.

Fischer, Urs, and Cassandra MacLeod, eds. *Fractured Figure, Volume I: Works from the Dakis Joannou Collection*. Athens: Deste Foundation for Contemporary Art, 2007.

Fischer, Urs, and Scipio Schneider, eds. *Fractured Figure, Volume II: Works from the Dakis Joannou Collection*. Athens: Deste Foundation for Contemporary Art, 2008.

Fischer, Urs, and Rudolf Stingel. *Urs Fischer / Rudolf Stingel*. Milan: Galleria Massimo de Carlo, 2007.

Fischer, Urs, and Mirjam Varadinis, eds. *Kir Royal*. Zurich: JRP | Ringier, 2004. Essays by Mirjam Varadinis, Jörg Heiser, and Bruce Hainley.

Flood, Richard, Massimiliano Gioni, and Laura Hoptman, eds. *Unmonumental: The Object in the 21st Century*. New York: Phaidon / New Museum, 2007.

Gingeras, Alison, and Jack Bankowsky. *Where Are We Going? Selections from the François Pinault Collection*. Palazzo Grassi, Venice, 2006.

Heiser, Jörg. *All of a Sudden: Things that Matter in Contemporary Art*. New York: Sternberg Press, 2008.

Hoffmann, Jens, and Christina Kennedy, eds. *The Studio*. Dublin: Dublin City Gallery The Hugh Lane, 2007.

Kaiser, Firma Renate, ed. *The Hamsterwheel / Wheeeeel*. Toulouse: Le Printemps de septembre, 2007.

Kurjakovic, Daniel. *Album—on and around Urs Fischer, Yves Netzhammer, Ugo Rondinone, and Christine Streuli, participating at the 52nd Venice Biennale*. Zurich: JRP | Ringier Kunstverlag, 2007.

Lacagnina, Salvatore. *Ma non al sud: Paolo Chiasera, Enzo Cucchi, Urs Fischer, Peter Fischli & David Weiss*. Milan: Silvana, 2005.

Lindemann, Adam. *Collecting Contemporary*. Cologne: Taschen, 2006.

Matt, Gerald, Eedelbert Köb, and Angela Stief, eds. *Traum & Trauma: Werke aus der Sammlung Dakis Joannou, Athen*. Ostfildern, Germany: Hatje Cantz; New York: D.A.P., 2007.

Moisdon, Stéphanie, and Hans Ulrich Obrist, eds. *Lyon Biennial 2007: The 00s: The History of a Decade that Has Not Yet Been Named*. Zurich: JRP | Ringier Kunstverlag, 2007.

Manifesta 3. Borderline Syndrome. Energies of Defence. Ljubljana: Cankarjev dom, 2000.

Migros Museum für Gegenwartskunst: Sammlung / Collection 1978–2008. Zurich: JRP | Ringier Kunstverlag, 2008.

Parkett No. 72: Monica Bonvicini, Richard Prince, Urs Fischer. Zurich: Parkett Publishers, 2004.

Rehberg, Vivian, and Hans Werner Holzwarth, ed. *Art Now, Volume 3*. Cologne and London: Taschen, 2008.

Ruf, Beatrix, ed. *Blasted Allegories: Works from the Ringier Collection*. Zurich: JRP | Ringier Kunstverlag, 2008.

Schmuckli, Claudia. *Mary Poppins*. Houston: Blaffer Gallery, 2006.

Swiss made (the art of falling apart): Works from the Hauser & Wirth Collection. Zwolle, The Netherlands: Waanders, 2005.

Unterdörfer, Michaela, ed. *The House of Fiction. Sammlung Hauser und Wirth, Lokremise, St. Gallen*. Nuremberg: Verlag für moderne Kunst, 2002.

Urs Fischer: Cockatoo Island, Sydney. Sydney: Kaldor Public Art Projects, 2007.

The Vincent van Gogh biennial award for contemporary art in Europe. Amsterdam: Stedelijk Museum, 2006.

Vitamin D: new perspectives in drawing. London; New York: Phaidon, 2005.

Vitamin 3-D: new perspectives in sculpture and installation. London; New York: Phaidon, 2009.

Webster, Toby. *Strange I've seen that face before: Objekt, Gestalt, Phantom*. Cologne: Dumont, 2006.

Wolfs, Rein, ed., *ironisch / ironic. maurizio cattelan, urs fischer, alicia framis, steve mcqueen, aernout mik / marjoleine boonstra*. Zurich: Migros Museum für Gegenwartskunst, 1998. Essays by Rein Wolfs and Frank Hyde-Antwi.

Periodicals

2009

Beasley, Mark. "Looking back: Group Shows." *Frieze*. January–February 2009: 102.

Brown, Gavin. "Urs Fischer." *Interview*. December–January 2009: 186–91.

Krienke, Mary. "Urs Fischer at Galerie Eva Presenhuber." *ARTnews*. February 2009: 115–16.

"Urs Fischer at Galerie Eva Presenhuber." *Mousse* No. 16. December–January 2009: 97.

2008

Amacher, Lukas. "Lukas Vernissagenbericht." *Prisma* No. 319. December 2008: 42.

Azimi, Roxana. "Das Kunstmarkt-Briefing." *Monopol* No. 10. October 2008.

Becher, Jörg. "Schweizer Meister." *Bilanz* No. 11. June 2008.

Boucher, Brian. "Urs Fischer at Gavin Brown's enterprise." *Art in America*. March 2008: 166–67.

Donoghue, Katy. "Profile: Mark Fletcher." *Whitewall* No. 9. Spring 2008: 40.

Fabian, Daniela. "Interview: Michael Ringier." *Schweizer Illustrierte Style* No. 01 / 02. January / February 2008: 52–59.

Fyfe, Joe. "Things the Mind Already Knows." *Art in America*. September 2008: 148–51.

Grabner, Michelle. "Makers and Modelers: Works in Ceramic." *X-Tra* Vol. 10, No. 3. Spring 2008: 54.

Hess, Ewa. "Die Riesen kommen." *Sonntagszeitung*. October 26, 2008: 53.

Higgs, Matthew. "'Who's Afraid of Jasper Johns?' at Tony Shafrazi Gallery." *Artforum* Vol. 47, No. 4. December 2008: 266.

Hudson, Suzanne. "Who's Afraid of Jasper Johns?" *Artforum* Vol. 47, No. 1. September 2008: 459.

Marinos, Christopher. "Dakis Joannou." *Flash Art*. October 2008: 100–01.

Marti, Silas. "Mostra compara arte com religiao." *Folha de S. Paulo*. March

29, 2008: E11.

Molina, Camila. "God is Design abre novo espaço na Barra Funda." *Caderno* 2. March 29, 2008: D9.

Nickas, Bob. "Urs Fischer at Gavin Brown's enterprise." *Artforum* Vol. 47, No. 4. December 2008: 292.

Saltz, Jerry. "Two Coats of Painting." *New York*. June 15, 2008.

"Seeing Warhol." *Interview*. June–July 2008: 124.

Smith, Roberta. "When Artworks Collide." *New York Times*, May 16, 2008.

Sonnenborn, Katie. "Makers and Modelers." *Frieze*. March 2008: 182.

"Unmonumental: The Object in the 21st Century." *New Museum Paper* Vol. 3. Winter 2008: 5.

Wolin, Joseph R. "Who's Afraid of Jasper Johns?" *Modern Painters* Vol. 20, No. 7. September 2008: 108.

2007

Borchhardt-Birbaumer, Brigitte. "Die dunkle Seite der Mondnacht." *Wiener Zeitung*. June 29, 2007: 15.

Cattelan, Maurizio. "Interview with Urs Fischer." *Mousse* No. 11. November 2007: 28–31.

Cerruti, Silvano, "Frischer Fischer." *20 Minuten Week* No. 36. September 6, 2007: 7.

Chaplin, Julia. "A Night Out with Alison Gingeras: Follow that Motoscafo." *New York Times*. June 10, 2007.

Diez, Renato. "Le avanguardie di Monsieur Pinault." *Arte* No. 406. June 2007: 148–54.

Fischer, Urs. "Production Notes." *Artforum* Vol. 46, No. 2. October 2007: 351.

Fitzgerald, Michael. "Impressario of the New." *Time*. March 22, 2007.

Gioni, Massimilano. "Where the wild things are." *Tate Etc*. No. 11. Autumn 2007: 34–38.

Hauger, Caroline Micaela. "Nur die Künstler fehlten—Schweizer Party-Marathon in Venedig." *Schweizer Illustrierte* No. 24. June 11, 2007: 40.

———. "Starker Auftritt." *Schweizer Illustrierte* No. 21. May 21, 2007: 98–99.

Herzog, Samuel. "O sole mio—viel Kunst aus Frankreich für Venedig." *Neue Zürcher Zeitung* No. 106. May 9, 2007: 45.

Higson, Rosalie. "Visions on a haunted isle." *The Australian*. April 17, 2007.

Jana, Reena. "The Dancing Camel." *art on paper* No. 5. May / June, 2007: 38–39.

Karrer, Eva. "Bäume statt Barock." *SonntagsZeitung*. June 3, 2007: 53.

Kazanjian, Dodie. "Body and Mind." *Vogue*. September 2007: 634–38.

Knoll, Valérie. "Urs Fischer at Eva Presenhuber." *Artforum* Vol. 46, No. 4. December 2007: 368.

Koch, Carole. "Hardware." *annabelle* No. 11. June 6, 2007: 80–85.

"Kunst hoch vier." *Schweizer Illustrierte Style* No. 6. June 2007: 20.

Mack, Gerhard. "Urs Fischer und Ugo Rondinone in San Staë." *Neue Zürcher Zeitung am Sonntag*. June 10, 2007: 68.

Mathonnet, Philipe. "A Venise, l'art s'humanise." *Le Temps*. June 9, 2007: 19.

Matt, Gerald. "Liebe, Tod und Trauma." *Art Quarterly*. July 2007: 27–32.

Morgan, Clare. "Surprise twist on the convict island." *Sydney Morning Herald*. April 17, 2007.

Probst, Ursula Maria. "Traum & Trauma. Eine Überreizung der Psyche." *Kunstforum International*. October / November 2007.

Renner, Sascha. "augenschmausen." *Züritipp*. January 4, 2007: 27.

Ringel, Stephanie. "Anarchie in der Lagune." *Sonntagsblick*. June 10, 2007: 44–45.

Roeschmann, Dietrich. "Schweizer Meister." *annabelle* No. 11. June 6, 2007: 50.

Rondinone, Ugo. "The Third Mind." *Palais Magazine* No. 04. Fall 2007.

Saltz, Jerry. "Can You Dig It? At Gavin Brown, Urs Fischer takes a jackhammer to Chelsea itself." *New York*. December 3, 2007: 90–92.

Scharrer, Eva. "Biennale Venedig—Wechselvoller Parcours mit ernstem Unterton." *Kunst-Bulletin* No. 8. July / August 2007: 42–48.

Searle, Adrian. "Venice takes flight." *The Guardian*. June 12, 2007.

Schoch, Ursuala Badrutt. "Viele Bilder und ein paar Bäume." *Der Bund*. June 9, 2007: 37.

Smith, Roberta. "It's Just Clay, But How About a Little Respect?" *New York Times*, July 9, 2007: E29, E38.

Stolz, Noah. "San Stae. Urs Fischer e Ugo Rondinone." *Kunst-Bulletin*, No. 8, July / August 2007, p. 49–50

Thon, Ute. "Kaufrausch der Milliardäre bei der Art Basel Miami Beach." *Art, Das Kunstmagazin Online*. December 2007.

Thornton, Sarah. "Supermarket Sweep." Artforum.com. June 14, 2007.

"Traum & Trauma. Werke aus der Sammlung Dakis Joannou, Athen." *Vernissage* No. 267. September 2007: 16–19.

Tröster, Christian. "Die Liebe des Tycoons." *Monopol*. July 7, 2007.

"Urs Fischer." *Bilanz* No. 16. 2007: 110.

Vetrocq, Marcia E., "The Venice Biennale: All'Americana." *Art in America*. September 2007.

Vogel, Carol. "In for a Penny, In for the Pounce." *New York Times*. June 14, 2007.

Ward, Vicky. "François Pinault's Ultimate Luxury." *Vanity Fair* No. 568. December 2007: 172–77.

Wüst, Karl. "Farben, Schatten und tote Bäume." *Der Zürcher Oberländer*. June 11, 2007.

2006

Ayar, Afshan. "Niets is wat het lijkt." *R'Uit Magazine*. May 2006: 26–27.

Cerizza, Luca. "City Report." *Frieze*. October 2006: 253.

Clausen, Eva. "Der unaufhaltsame Aufstieg des Monsieur Pinault." *Neue Zürcher Zeitung*, No. 99. April 29–30, 2006: 49.

"Crème de Yvette." *Another Magazine* No. 10. Spring 2006.

Erbslöh, Roswitha. "Palais Pinault." Artnet.com. March 6, 2006.

Fong, Marjorie Tjon A. "Stoere Alpenhut van gezaagde broken." *AD zaterdag*. April 15, 2006: 15.

Gingeras, Alison. "La Collection François Pinault: Le Défi du Choix." *art press*, No. 323. May 2006: 50–55.

Gioni, Massimilano. "Le monde instable de Urs Fischer." *art press*, No. 324. June 2006: 27–33.

Kerwin, Jessica. "On With the Show." *W*. May 2006: 128, 130.

Klaasmeyer, Kelly. "Space and Quiet." *Houston Press*. June 22, 2006.

Leij, Machteld. "Fischers beelden speels en wreed." *NRC*. May 2, 2006: 9.

Neil, Jonathan T. D. "The Fischer King" *Art Review*, December 2006: 70–74.

Plagens, Peter. "Madison Avenue Ennui." *Art in America*. June–July 2006: 76–69.

Rauterberg, Hanno. "Ein Freibeuter der Künste." *Die Zeit*, No. 18. April 27, 2006.

Schümer, Dirk. "Nur Tiepolo weint Tränen aus Gips." *Frankfurter Allgemeine Zeitung*, No. 99. April 28, 2006: 35.

Smith, Roberta. "More Than You Can See: Storm of Art Engulfs Miami." *New York Times*. December 9, 2006

"Urs Fischer." *AD*. March 30, 2006: 26

"Urs Fischer." *Tate Etc.*, No. 6. Spring 2006: 38.

Van der Beek, Wim. "Urs Fischer." *Kunstbeeld.Nl*, No. 5. 2006: 14.

Van der Klaauw, Richard. "De Vakantie." *Metro*. May 2, 2006: 19.

Vetrocq, Marcia E. "A Museum of His Own." *Art in America*, October 2006: 96–101.

Yablonsky, Linda. "Art Miami Fair, Art Market Showed its Blood and Bones." *Bloomberg News*. December 12, 2006.

2005

Bonami, Francesco. "L'arte a sorpresa fermata." *Vanity Fair*. April 28, 2005: 150.

Bonazzoli, Francesca. "Le briciole pazze del visionario Fischer." *Corriere della Serra*. May 3, 2005: 59.

Bono, Donatella. "Le sculture 'logorate' di Urs Fischer." *Il Giornale*. May 6, 2005: 50.

Capelli, Pia. "L'arte? Bisogno guardarla, non ragionarla." *Libero*. May 4, 2005: 36.

———. "O'Chair, per Trussardi arrivano le Jet Set Lady." *Libero*. April 15, 2005: 21.

Casadio, Mariuccia. "In / Out." *Casavogue*. April 2005: 139–143.

Casavecchia, Barbara. "Da Cattelan a Urs Fischer Trussardi colpisce ancora." *La Repubblica*. May 3, 2005: 10.

Cobolli, Nicoletta. "Giocattoli per adulti. Nella realtà senza consuetudini." *Arte*. May 2005: 96.

Comer, Stuart. "Double Deutsche." Artforum.com. October 22, 2005.

Didero, Maria Cristina. "La materia delle Favole." *Ottagono*. May 2005: 30.

Ghizzardi, Federica. "Tutti a spiare il Ricciolo proibito." *La Prealpina*. May 7, 2005: 9.

———. "Una cassa tutta da mangiare." *La Prealpina*. May 5, 2005:16

Hoffmans, Christian. "Glamouröser Newcomer." *Welt am Sonntag*. October 23, 2005.

Mammi, Alessandrea. "Horror con humour." *L'Espresso*. April 29, 2005: 141.

Montrasio, Giuliana. "Usato Sicuro." *Max*. May 2005: 262.

Margutti, Flavia Fossa. "Vi farò ridere." *Glamour*. May 2005: 188.

Masoero, Ada. "Una signora del jetset nell'Istituto dei Ciechi." *Il Giornale dell' Arte*. May 2005: 24.

Olcese, Roberta. "Il rilancio di Miart." *Secolo XIX*. 5 May 2005: 16.

Romeo, Filippo. "Urs Fischer at Fondazione Trussardi." *Artforum* Vol. 44, No. 1. September 2005: 313.

Smith, Roberta. "The Listings." *New York Times*. February 25, 2005.

Spanier, Samson. "At London's Frieze fair, art in full bloom." *International Herald Tribune*. October 22–23, 2005: 8.

Van de Velde, Paola. "Wij zijm verslaafd aan kunst." *Telegraaf*. April 12, 2005: 15.

Vincent, Steven. "Urs Fischer at Gavin Brown's enterprise." *Art in America*. October 2005.

2004

Arx, Ursula. "Fischer das Untier." *Das Magazin*, No. 10, and *Tages-Anzeiger*. March 6–12, 2004: 8–14

Basting, Barbara. "Vitalitätstest glorreich bestanden." *Tages-Anzeiger*. July 10, 2004: 41.

Binswanger, Daniel. "Langeweile beim Nasenbohren." *Weltwoche*, No. 12. March 2004: 9.

Burnett, Craig. "Urs Fischer: Elton John?" *The Guide*. December 4, 2004: 37.

Carmine, Giovanni. "Urs Fischer: Personal Weather." *Flash Art*. January–February 2004: 84–87.

Gingeras, Alison. "My Pop: Urs Fischer." *Artforum* Vol. 43, No. 2. October 2004: 243

Herbert, Martin. "Urs Fischer: Arts Review." *Time Out London*. January 5–12, 2004.

Herzog, Samuel. "Le roi est mort—vive le Kir." *Neue Zürcher Zeitung*, No. 158. July 10–11, 2004: 43.

Hess, Ewa. "Fischers Sicht der Dinge: Der Zürcher Künstler Urs Fischer verblüfft die Kunstwelt—und steht vor dem internationalen Durchbruch." *Sonntagszeitung*, January 4, 2004: 35, 37.

Hubbard, Sue. "Things are not what they seem." *The Independent*, January 10, 2005: 12.

Jones, Jonathan. "Urs Fischer: Arts Review." *Guardian*. January 7, 2004.

Kraft, Martin. "Kir Royal: Ausstellung von Urs Fischer im Kunsthaus: Fast ein Klassiker." *Züritipp*, No. 28. July 8–14, 2004: 15.

Marzahn, Alexander. "König Artus im Wunderland: zwischen Stuhl und Bänken." *Basler Zeitung*. July 29, 2004: 27.

Morton, Tom. "Roll With It." *Frieze* No. 86. October 2004: 138–141.

Spinelli, Claudia. "Leicht, nicht seicht." *Weltwoche*, No. 29. July 2004: 83.

Ulmer, Brigitte. "Der Kunst-Rebell" *Bolero Men*. Spring 2004: 50–52.

Zweifel, Stefan. "Im Universaalschaum." *Frankfurter Allgemeine Zeitung*. July 23, 2004: 36.

2003

Clem, Chivas. "Portrait of a Single Raindrop." *Time Out New York*. May 2003.

Gingeras, Alison. "Openings: Urs Fischer." *Artforum* Vol. 41, No. 9. May 2003: 158–159.

Lafuente, Pablo. The failure man." *ArtReview*. January 2003: 64.

Subotnick, Ali. "Unplugged, a Casa per le vacanze." *Work: Art in Progress*. October–December 2004: 10.

2002

Bell, Kirsty. "Firing Line." *Artscene UK*. June 2002: 3.

Daniels, Corinna. "Neues von Urs Fischer bei Contemporary Fine Arts—Der Schweizer hat keine Angst vor Kitsch." *Die Welt*. February 8, 2002: 34.

Dezeuze, Anna. "The Object Sculpture." *Art Monthly*. July–August 2002.

Hickling, Alfred. "The Object Sculpture." *The Guardian*. June 2002.

"Lowland Lullaby." *The New Yorker*. April 22–29, 2002: 36.

Lubbock, Tom. "Colourvision." *The Independent*. June 2002.

Schwabsky, Barry. "The Object Sculpture" *Artforum*. Summer 2002.

Siepen, Nicolas. "Nichts für Bing Crosby." *Berliner Seiten, Frankfurter Allgemeine Zeitung*, No. 29. February 4, 2002: 6.

"Ugo Rondinone, John Giorno & Urs Fischer." *Village Voice*. March 5, 2002: 79.

"Ugo Rondinone with John Giorno and Urs Fischer." *Village Voice*. April 2, 2002: 89.

2001

Spinelli, Claudia. "Berührend skurril. Hauser & Wirth & Presenhuber zeigen Urs Fischer." *Neue Zürcher Zeitung*, No. 207. September 7, 2001: 46.

2000

Allfree, Claire. "Miriam Bäckström and Urs Fischer: Art from Europe." *Metro*, January 20, 2000.

Arb, Eugen. "Der Schöne und das Biest, Urs Fischer." *Die Südostschweiz*. April 7, 2000: 5.

Baumer, Dorothea. "Köln ist ein guter, ein idealer Platz. Die 34. Art Cologne." *Süddeutsche Zeitung*. November 6, 2000.

Becker, Jochen. "Manifesta 3." *Kunstforum International*, No. 152. October–December 2000: 438–442.

Coomer, Martin. "Urs Fischer: ICA." *Time Out London*. February 16–23, 2000: 54

Goldschmeding, Eugénie. "Speelsheid is het sleutelwoord." *Bldz*. May 2000.

Jones, Jonathan. "Exhibitions: Urs Fischer." *The Guardian*. January 24, 2000.

Maurer, Simon. "Der Künstler als 'Büetzer.'" *Tages-Anzeiger*, No. 63. April 25, 2000: 63

Meier, Philipp. "Der leise Seufzer der Kunst. Die Art Cologne: Deutschlands führende Modernmesse." *Neue Zürcher Zeitung*. November 11–12, 2000.

Meister, Helga. "Zu viele kindliche Seelen." *Düsseldorfer Nachrichten*. November 6, 2000.

Nebelung, Sigrid. "Kronleuchter aus Plastiktüten. 21 Künstler profitieren in diesem Jahr vom Förderprogramm der Art Cologne. Der Trend geht zur Installation." *Handelsblatt*. November 3, 2000.

Posca, Claudia. "Die Kunst, Kunst zu sehen. Eindrücke von der 34. Art Cologne." *Neue Rhein Zeitung*. November 6, 2000.

Sandmann, Monika. "Installationen dominieren. Förderprogramme." *Weltkunst Moderne*, No. 10. 2000.

Schroeder, Annette. "Prima leben im Videobunker. Förderprogramm auf der Art Cologne präsentiert 21 Künstler." *Kölnische Rundschau*. November 8, 2000.

Wessling, Janneke. "Staketsels zonder inhoud." *NRC*. May 1, 2000.

1999

Chelotti, Chiara. "Le Repubbliche dell' Arte." *Flash Art*, Vol. 32, No. 217. Summer 1999: 91.

Coomer, Martin. "Holding Court: Entwistle (Upmarket)." *Time Out London*. February 3, 1999: 49.

"Gespenstige Welt der Dinge. Urs Fischer bei Hauser & Wirth." *Neue Zürcher Zeitung*. January 27, 1999: 50.

Helwing, Anna "Fundamentgefummel. 'Stormy weather' von Urs Fischer." *Kunst-Bulletin*, No. 3. March 1999: 18–24.

"Surfen / Pilgern. Urs Fischer: Gemütsmensch." *Züritipp*. January 4, 1999.

1998

Feller, Elisabeth. "Ironie oder blosse Eselei?" *Südkurier*. July 21, 1998.

Gerster, Ulrich. "Mindestens amüsant: Ironisches im Museum für Gegenwartskunst, Zürich." *Neue Zürcher Zeitung*. July 28, 1998.

"Hinterfragte Wirklichkeit." *Berner Rundschau*. June 27, 1998.

"Ironie ist, wenn man trotzdem lacht." *Voralberger Nachrichten*. July 11, 1998.

Maurer, Simon. "Das apportierwillige Hundeskelett." *Tages-Anzeiger*. June 30, 1998.

1997

"Alles mögliche nebeneinander." *Stehplatz*, No. 54. September 1997.

"Une Fiac aux couleurs de la Suisse." *Le Journal des Arts*, No. 44. September 26, 1997: 13–14.

1996

"Besetzt: Urs Fischer in der Galerie Walcheturm." *Neue Zürcher Zeitung*, No. 77. April 1, 1996.

Maurer, Simon. "Sexy Kuhfladen." *Tages-Anzeiger Züritipp*. 1996: 50.

Spinelli, Claudia. "Urs Fischer in der Galerie Walcheturm." *Kunst-Bulletin*, No. 4. April 1996: 40.

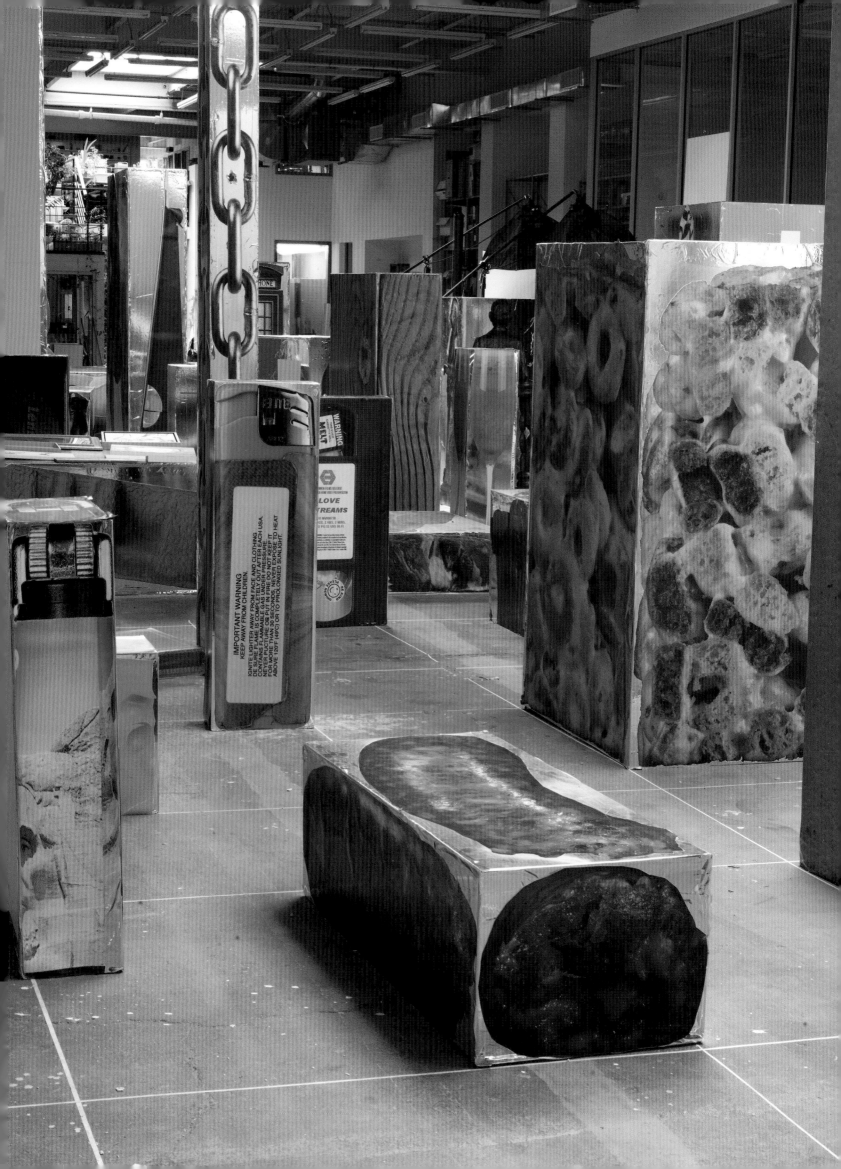

Bice Curiger completed studies in art history at Zurich University. In 1984 she co-founded *Parkett*, and has since been Editor-in-Chief of the book series with contemporary artists, published in German and English three times a year in Zurich and New York. Since 1992 Curiger has been a curator at Kunsthaus Zürich. Since 2004 she has also been Editorial Director of *Tate Etc.*, the magazine of the Tate in London. Curiger was 2006–07 Rudolf Arnheim Professor at Humboldt University in Berlin. In 2007 she was awarded the Heinrich Wölfflin-Medaille of the City of Zurich.

At Kunsthaus Zürich, Curiger has curated the following exhibitions: "Signs and Wonder: Niko Pirosmani and Contemporary Art" (1995), "Birth of the Cool: American Painting from Georgia O'Keeffe to Christopher Wool" (1997), "Martin Kippenberger: Early Paintings, Sculptures and the Complete Posters" (1998), "Hypermental: Rampant Reality from Salvador Dalí to Jeff Koons" (2000), "Public Affairs: From Joseph Beuys to Andrea Zittel" (2002), "Georgia O'Keeffe" (2003), "Sigmar Polke: Works & Days" (2005), "The Expanded Eye: Stalking the Unseen" (2006), "Peter Fischli & David Weiss: Flowers and Questions" (2007), and "Katharina Fritsch" (2009).

As a freelance curator, Curiger has organized exhibitions for international institutions such as Centre Georges Pompidou, Paris ("La revue *Parkett*," 1987), Hayward Gallery, London ("Double Take: Collective Memory and Recent Art," 1992, curated in collaboration with Lynne Cooke), and the Solomon R. Guggenheim Museum, New York ("Meret Oppenheim," 1996, curated in collaboration with Jacqueline Burckhardt).

Curiger is the author of the following books: *Meret Oppenheim: Defiance in the Face of Freedom* (German edition Zurich, 1982; MIT Press, 1990); *Looks et tenebrae* (Peter Blum Editions, 1983); *Meret Oppenheim: Beyond the Teacup* (Independent Curators International, 1997); *Sigmar Polke: Music from an Unknown Source* (ifa Stuttgart, 1997); *Kunst expansiv zwischen Gegenkultur und Museum* (Lindinger+Schmid Verlag, 2002); and *Maurizio Cattelan* (Three Star Press, 2008), and several catalogues.

Massimiliano Gioni is the Director of Special Exhibitions at the New Museum in New York and the Artistic Director of the Fondazione Nicola Trussardi in Milan. He is currently the director of the 8th Gwangju Biennale (Gwangju, 2010).

Gioni curated "Of Mice and Men," the 4th Berlin Biennial for Contemporary Art (Berlin, 2006) with Maurizio Cattelan and Ali Subotnick. In 2004 he curated Manifesta 5 (San Sebastián, Spain, 2004) with Marta Kuzma. He was part of the curatorial team of "Monument to Now" (Athens, 2004) and "Fractured Figure" (Athens, 2007), two exhibitions originated by the Dakis Joannou Collection, with which Gioni frequently collaborates. In 2003, for the 50th edition of the Venice Biennale, Gioni curated "The Zone," a temporary pavilion for young Italian art.

Since 2003, he has been directing the Fondazione Trussardi, a nomadic museum that has staged solo exhibitions, special projects, and interventions in abandoned buildings, public spaces, and forgotten monuments of the city of Milan. For the Fondazione Trussardi, Gioni has organized exhibitions by, among others, Paweł Althamer, John Bock, Maurizio Cattelan, Martin Creed, Tacita Dean, Elmgreen and Dragset, Urs Fischer, Fischli and Weiss, Paola Pivi, Anri Sala, and Tino Sehgal.

At the New Museum, since 2008, Gioni co-curated the inaugural cycle of exhibitions "Unmonumental" with Richard Flood and Laura Hoptman; organized Paul Chan's first institutional exhibition in America; and curated "After Nature," a group exhibition featuring works by, among others, Allora and Calzadilla, Micol Assaël, Huma Bhabha, William Christenberry, Nathalie Djurberg, Reverend Howard Finster, Nancy Graves, Werner Herzog, Robert Kusmirowski, Zoe Leonard, Thomas Schütte, August Strindberg, Eugene Von Bruenchenhein, and Artur Zmijewski. With Lauren Cornell and Laura Hoptman, he recently curated "The Generational: Younger Than Jesus," a 2009 exhibition on a new generation of artists, all born around 1980.

Gioni has published articles in *Artforum*, *Flash Art*, *Frieze*, *Parkett*, and *art press*, and contributed to numerous other magazines and catalogues. With Cattelan and Subotnick he runs *The Wrong Times* and *Charley*, two magazines produced by the Wrong Gallery, which he co-founded in 2003.

Jessica Morgan is Curator of Contemporary Art at Tate Modern. She has organized group exhibitions such as "Common Wealth" (2003), "Time Zones" (2004), and "The World as a Stage" (2007) at Tate Modern. She curated the 2005–06 program for Tate Modern's Level 2 Gallery for which she developed a series of solo exhibitions of new commissions by international emerging artists including Meschac Gaba, Roman Ondàk, Catherine Sullivan, Simryn Gill, and Brian Jungen. In addition she curated the retrospective of Martin Kippenberger (2006); the 2006–07 Unilever commission, "Test Site" by Carsten Höller; and "TH.2058," the 2008–09 Unilever Commission by Dominique Gonzalez-Foerster. Morgan is curating the first UK retrospective of the work of John Baldessari, "Pure Beauty" (2009), and Gabriel Orozco (2011), all for Tate Modern.

Morgan was previously Chief Curator at the Institute of Contemporary Art, Boston, where she organized solo exhibitions by, among others, Carsten Höller, Ellen Gallagher, Olafur Eliasson, Rineke Dijkstra, Marlene Dumas, Marijke van Warmerdam, and Cornelia Parker. Prior to that she was a curator at the Museum of Contemporary Art, Chicago, where she organized the first US survey of the work of Mona Hatoum. Morgan curated "Work Time / Life Time / Material Time," the first Reykjavik Art Festival in Iceland in 2005, and the exhibition "An Unruly History of the Readymade" for La Colección Jumex in Mexico City (2008). She is the curator of Damian Ortega's survey exhibition at ICA Boston to open in 2009 and the exhibition "Recent Ruins and Other Remains" for the Cycladic Art Museum in Athens. Morgan has served on the jury for Beck's Futures, ICA London, and the Paul Hamlyn Award, and she is a Trustee of Chisenhale Gallery in London. She has published and lectured extensively on contemporary art with essays appearing in numerous exhibition and museum catalogues as well as art journals such as *Parkett*, *Artforum*, *ArtReview*, and the *Art Newspaper*. Morgan is currently writing a monographic book for Tate Publications on the work of Gabriel Orozco (2011).

PHOTO CREDITS

Images of the artist's work that appear in this book were photographed or provided by:

Stefan Altenburger
Nathan Beck
Bureau Amsterdam
A. Burger
Santi Caleca
Pio Corradi
Urs Fischer
Rick Gardner
Barbara Gerny
Serge Hasenboehler
Georgio and Peter Hunkeler
ICA London
Dean Kaufman
Andy Keate
Jean-Pierre Kuhn
Jochen Littkeman
Mancia / Bodmer FBM Studio
Roger Marshutz
Georges Méguerditchian
Isabelle Messina
Isa Nogarra

Mats Nordman
Prudence Cumings Associates Ltd., London
Adam Reich
Martin Rivers
Caleb Rogers
Sadie Coles HQ, London
Niklas Stauss
Lukas Wassmann
Joshua White
The Whitney Museum of American Art
Ellen Page Wilson
Alessandro Zambianchi

All possible efforts were made to contact and credit the rights holders for the material published in this book. In case of a pending rights credit, please contact the publisher.

Pages 472, 474–475:

Studio view, work in progress
Van Brunt Street, Brooklyn, 2009

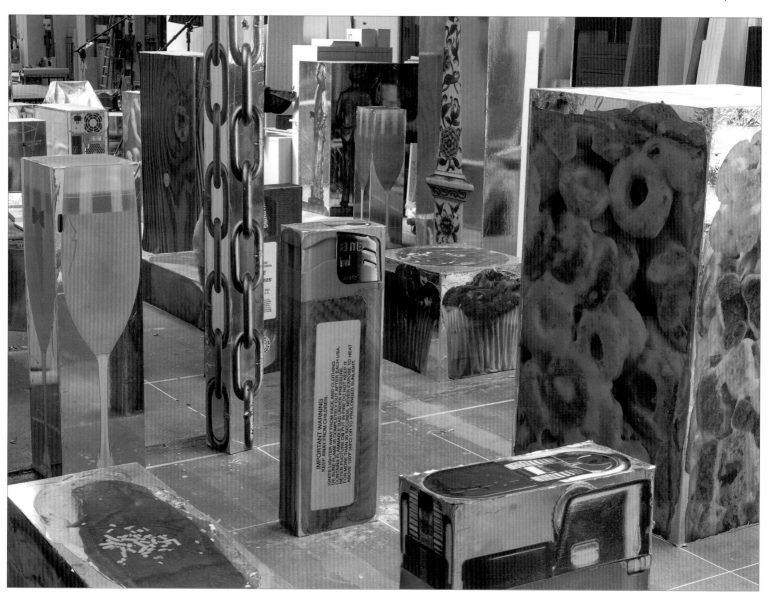

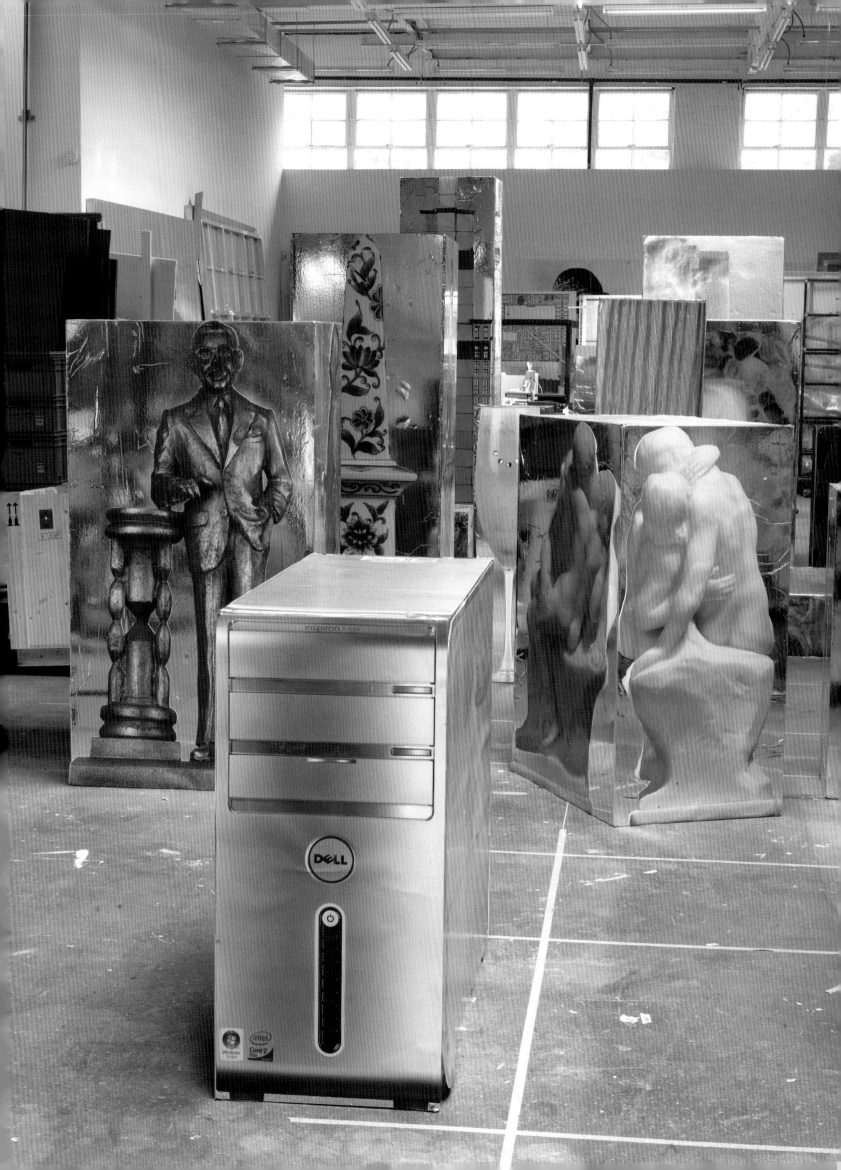

ACKNOWLEDGMENTS

Curator's Acknowledgments

This exhibition would not have been possible without the help of a group of very dedicated individuals.

First of all I want to thank Jarrett Gregory for pulling off another ambitious project: without her assistance, dedication, and sense of humor, this and many other exhibitions would never have been possible.

At the New Museum I would also like to thank Lisa Phillips, *Toby Devan Lewis Director*; John Hatfield, Deputy Director; Karen Wong, Director of External Affairs; Sarah Valdez, Senior Editor; and Regan Grusy, Director of Development. Shari Zolla, Registrar; Bobby Ives, Assistant Registrar; Hendrik Gerrits, Exhibitions Manager; and Joshua Edwards, Production and Installation Manager, successfully presided over a particularly demanding installation. Curatorial Interns Abigail Scholar and Lora-Faye Whelan helped immensely with the catalogue and the exhibition.

Thanks to Carmen D'Apollonio, Caleb Rogers, and Darren Bader at Urs's studio for all their tireless work on this project. Additional thanks to the team that orchestrated the production of the mirror boxes: Scipio Schneider, head of production, with Dominique Clausen, Mats Nordman, and Mia Marfurt.

I would like to thank Jessica Morgan and Bice Curiger for their thoughtful and rigorous contributions to this catalogue, Scipio Schneider for his phenomenal design, and Carmelo Buffoli and Lionel Bovier at JRP | Ringier for their hard work and commitment to this project.

I would also like to thank each of Urs's gallerists for their help and support: Gavin Brown, Sadie Coles, and Eva Presenhuber have been incredibly generous and contributed greatly to this exhibition. At Gavin Brown's enterprise, New York, we would like to thank Alex Zachary for supervising every detail with great attention and patience; at Galerie Eva Presenhuber, Zurich, we would like to thank Gertraud Presenhuber, Thomas Jarek, Kristina von Bülow, Silja Wiederkehr, Melanie Bidmon, and Markus Rischgasser; at Sadie Coles HQ, London, we want to recognize Heather Ward and Pauline Daly.

A very special thanks goes to our exclusive group of funders and supporters: the Brant Foundation; the Burger Collection, Hong Kong; the Steven A. and Alexandra M. Cohen Foundation, Inc.; Jeffrey Deitch; Dakis Joannou; Amalia Dayan and Adam Lindemann; Eugenio López; the LUMA Foundation; the Peter Morton Foundation; François Pinault; the Ringier Collection; Tony Salame; and the Teiger Foundation. It has truly been an honor to bring together such an exceptional group of art lovers. Your help and support made this exhibition possible and I wish to thank you personally for your generosity, which stands as a testament to the power of Urs's work. I also would like to acknowledge the National Endowment for the Arts and Pro Helvetia, Swiss Arts Council, both of which provided an early grant for this exhibition.

Lastly, I would like to extend my warmest thanks to the artist.

—*Massimiliano Gioni*, Director of Special Exhibitions

Artist's Acknowledgments

THANK YOU!

My gallerists: Eva Presenhuber, Gavin Brown, and Sadie Coles.

The X-Men: Scipio Schneider, Alex Zachary, Darren Bader, Jane Mount, Stefan Altenburger, Massimiliano Gioni, Dominique Clausen.

Book and show: Priya Bhatnagar, Jarrett Gregory, Graham Stewart, Hendrik Gerrits, Kristina von Bülow, Markus Rischgasser, Melanie Heit, Melanie Bidmon, Gertraud Presenhuber, Silja Wiederkehr, Thomas Jarek, Michou Szabo, Katy Moran, Caleb Rogers, Carmen d'Apollonio, Mats Nordman, Jaz Harold, Mia Marfurt, Clifford Borress, and Sam Kusack.

Production and fabrication teams for the sculptures in this exhibition: Scipio Schneider, Mario Winkler, Stefano Reggiani, Claudio Balbo, Marco Rieser, Dominic Sturm, Moritz Schlatter, Maui, Thomas Rutz, Patrick Hari, Ivo Nievergelt, Simon Oswald and Bigi Marolf at ACRUSH Zürich; Dominique Clausen, Jaz Harold, Darko Karas, Jane Mount, and Thomas Wirthensohn for Studio 318; photographers Mats Nordman, Nicolas Duc, and Michael Vahrenwald; Jürg Bader, Michèle Elsener, Peter Gerber, Martin Hansen, Sonja Michel, Sven Mumenthaler, Raphaël Schmid, Wink Witholt, and Annina Zimmermann; and their associates in China, John Chen, Wang Qiming, Luo Jingmu, Wang Genfa, Wei Luyan, and Wu Yingneng at Kunstbetrieb AG Münchenstein; Joris Akeret, David Andermatt, Gabriel Bardetscher, Sämi Bischof, Martin von Bülow, Tim Büchel, Damian Dünner, Fitze Hunziker, Urs Jordi, Axel Kirchhoff, Michael Koch, Felix Lehner, Christian Meier, Emil Meier, Andres Mock, Marianne Rinderknecht, and Urs Supersaxo at Kunstgiesserei St. Gallen; and their associates in China, Mr. Feng, Mrs. Guo, Mr. Wu, Mr. Dai, Mr. Jing, Mr. Ji, and Mr. Wu; and all the other people who helped make it happen.

The studio team: Carmen d'Apollonio, Darren Bader, Caleb Rogers, Scipio Schneider, Mia Marfurt, Domie Clausen, Mats Nordman, Gina Peer, and Reggie.

Georg Herold, Rudolf Stingel, Sari Carel, Tony Shafrazi, Adam McEwen, Ugo Rondinone, Jeffrey Deitch, Jimmy Jung, P.R., Cyril Kuhn, Andreas Ilg.

To my family, Leila, Marlo, Spot, and Pingu and, above all, Cassandra MacLeod & LOTTI.

—*Urs Fischer*

Untitled
2007
Cast nickel silver, gesso, oil paint
13 x 13 x 5 cm; 5 ⅛ x 5 ⅛ x 2 in.

Page 477:

Pop the Glock
2006
Cast nickel silver, gesso, oil paint
12.7 x 5 x 7.5 cm; 5 x 2 x 3 in.

First edition published October 2009 in conjunction with the exhibition "Urs Fischer: Marguerite de Ponty," organized by Massimiliano Gioni, Director of Special Exhibitions, New Museum
Curatorial Assistant: Jarrett Gregory

Exhibition dates: October 28, 2009–January 24, 2010

"Urs Fischer: Marguerite de Ponty" is made possible with generous support from the Brant Foundation; the Burger Collection, Hong Kong; the Steven A. and Alexandra M. Cohen Foundation, Inc.; Jeffrey Deitch; Dakis Joannou; Amalia Dayan and Adam Lindemann; Eugenio López; the LUMA Foundation; the Peter Morton Foundation; François Pinault; the Ringier Collection; Tony Salame; and the Teiger Foundation.

Additional support provided by the National Endowment for the Arts and Pro Helvetia, Swiss Arts Council.
Support for the accompanying publication *Urs Fischer: Shovel in a Hole* is provided by the J. McSweeney and G. Mills Publications Fund at the New Museum and Mr Keet, LLC, New York.

Urs Fischer: Shovel in a Hole produced by:

Editors: Urs Fischer, Alex Zachary
Copy editors: Darren Bader, Priya Bhatnagar, Jane Mount
Design: Dominique Clausen, Urs Fischer, Jane Mount, Scipio Schneider
Production: Scipio Schneider
Separation: Daniel Möhrle, Wolfgang Müller, Jaz Harold, S. Schneider
Color and image management: referenceimage.com
Additional production assistance: Carmen D'Apollonio, Jaz Harold, Mia Marfurt, Mats Nordman, Caleb Rogers, and Alex Zachary

New Museum
Massimiliano Gioni, Jarrett Gregory, and Sarah Valdez
Translator of Bice Curiger's text: Michael Foster

JRP|Ringier
Carmelo Buffoli, Production management

Printed in Switzerland, NZZ-Fretz AG

Front cover:
The Heart of the Ocean, May Yohe & Putnam Strong, Zero Year Curse, Tavernier Blue, Hope Diamond
One from a suite of three framed prints
2006
Epson ultrachrome inkjet print on Enhanced Matte paper, in a frame of glass-fiber-reinforced plaster
79 x 62 x 3.5 cm; 31 ⅛ x 24 ⅜ x 1 ⅛ in.

Pages i–ii and 482–483:
Highway—Northern California, 1995
Photograph

Page iii:
Chemical Wedding
2009
Pine, MDF, ACM panels, acrylic adhesive, screws, gesso, ink, acrylic paint
243.8 x 181.6 x 4.1 cm; 96 x 71 ½ x 1 ⅝ in.

Page 481:
Study for *Last Call, Lascaux*
Studio view, Van Brunt Street, Brooklyn, 2009

Back cover:
Count Negroni
2005–2009
Digital image

JRP|Ringier books are available internationally at selected bookstores and from the following distribution partners:

Switzerland
Buch 2000, AVA Verlagsauslieferung AG, Centralweg 16, CH-8910 Affoltern a.A., buch2000@ava.ch, www.ava.ch

France
Les Presses du réel, 35 rue Colson, F-21000 Dijon, info@lespressesdureel.com, www.lespressesdureel.com

Germany and Austria
Vice Versa Vertrieb, Immanuelkirchstrasse 12, D-10405 Berlin, info@vice-versa-vertrieb.de, www.vice-versa-vertrieb.de

UK and other European countries
Cornerhouse Publications, 70 Oxford Street, UK-Manchester M1 5NH, publications@cornerhouse.org, www.cornerhouse.org/books

USA, Canada, Asia, and Australia
D.A.P./Distributed Art Publishers, 155 Sixth Avenue, 2nd Floor, USA-New York, NY 10013, dap@dapinc.com, www.artbook.com

For a list of our partner bookshops or for any general questions, please contact JRP|Ringier directly at info@jrp-ringier.com, or visit our homepage www.jrp-ringier.com for further information about our program.

jrp|ringier

JRP|Ringier
Letzigraben 134
CH-8047 Zurich
Switzerland
Tel. +41 (0) 43 311 27 50
Fax +41 (0) 43 311 27 51
info@jrp-ringier.com
www.jrp-ringier.com

NEW
235 BOWERY
NEW YORK NY
10002 USA
MUSEUM

New Museum
235 Bowery
New York, New York 10002
Tel. (212) 219-1222
newmuseum.org

ISBN 978-3-03764-037-1